EAST CHRISTIAN
ART

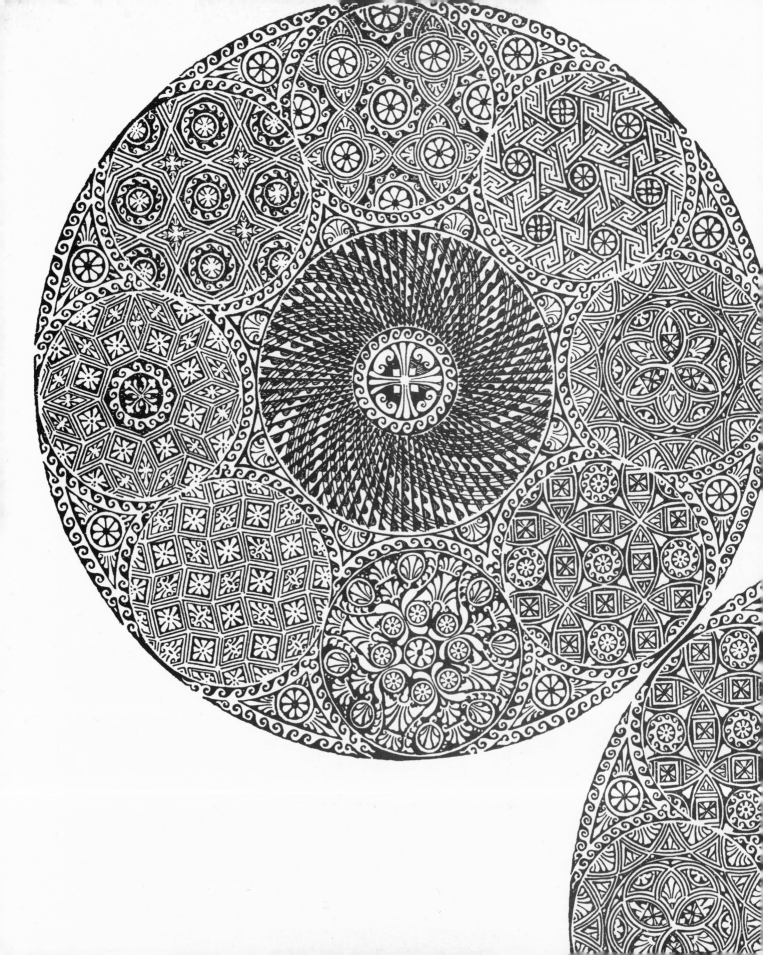

EAST CHRISTIAN ART

A Survey of the Monuments

BY

O. M. DALTON

Hacker Art Books

New York

1975

First published 1925
by Oxford at the Clarendon Press.

Reissued 1975 by arrangement
with Oxford University Press
by Hacker Art Books, Inc.
New York.

Library of Congress
Catalogue Card Number 73-76792

ISBN 0-87817-135-5

Printed in the
United States of America.

EAST CHRISTIAN ART

ART

A Survey of the Monuments

BY

O. M. DALTON

OXFORD

AT THE CLARENDON PRESS

1925

PREFACE

THE arrangement of the present book is similar to that of *Byzantine Art and Archaeology*, but apart from some of the purely descriptive matter, the chapters are all new, and written from a somewhat different standpoint. The chief results of research for the period between 1912 and 1924 have been incorporated, with references to the books or articles in which they were published ; but for the literature of material known before 1912 the reader is referred to the foot-notes of the earlier work, cited throughout as *B. A. and A.* A chapter on architecture has been added, in which the aim has been to bring out certain dominant features and problems of development, rather than to repeat one of those condensed summaries which are already represented by such good and accessible examples. The subject has been treated from the historical point of view, with special reference to such problems as the origin and dissemination of domical types ; detailed descriptions of particular buildings, which only those with architectural training can properly give, have not been attempted, and a survey of geographical distribution is added at the close. The illustration of the chapter is limited to general views, the principal object being to convey the character and variety of the buildings, and suggest comparison with those of other civilizations, not to provide plans and elevations in scale and number too limited to be of service, and better studied in books and monographs to which references are given.

It was justly observed that in *Byzantine Art and Archaeology* such opinions as were expressed on artistic values ignored the lessons taught by recent theory. In the present volume the view has been adopted that a writer approaching the monuments from the historical side is wise to abstain, as far as possible, from the expression of such opinions. But in more than one place the value of modern art-criticism to our studies has been recognized as a powerful influence compelling attention to the great qualities of Byzantine art. It is a matter for regret that the monuments have been left too exclusively to the historian and the archaeologist. The time is ripe for a comprehensive treatment of the whole material from the

purely artistic point of view, as far as possible in abstraction from historical considerations. Such a work, serving as the text to a chosen series of fine reproductions, would form a valuable contribution to the general history of art.

It may appear to many that in presence of conflicting views on outstanding problems I have too often failed to take sides, or to express a decided opinion. It may be answered that in a province so largely unexplored as that with which we are concerned, the emergence of the unknown is always possible, and sweeping hypothesis has still its dangers. Various opinions now confidently proposed remain hypotheses rather than established theories ; and a mere recorder who prematurely accepts hypothesis exceeds his proper function.

My gratitude is due both to the Delegates of the Clarendon Press for the appearance of this book in so attractive an outward form, and to Mr. J. de M. Johnson for the unwearying pains which he has taken in its production. My further thanks are due to Mr. Arthur Henderson, F.S.A., R.B.A., for generously placing at my disposal several of his fine drawings and various photographs ; to Mr. R. W. S. Weir and Mr. S. H. Barnsley, for the loan of many excellent photographs ; to Professor G. Millet of the Sorbonne, for permission to use photographs in the collection of the Hautes Études ; to Mrs. Robert Moon, for lending the water-colour drawing reproduced in Plate L ; to the Rev. Father G. de Jerphanion, for the photograph used in Plate XLIII ; and to Mr. Eric Maclagan and Mr. H. P. Mitchell of the Victoria and Albert Museum, for those seen in Plates XLVI and LXII. Other photographs (Plates VIII, IX, XIX, and XXI) were the friendly gift of the late Professor Howard Crosby Butler of Princeton University, by whose death the study of Christian architecture in the Nearer East has suffered a most serious loss. Finally, I owe a special debt to my friend and colleague Mr. G. F. Hill for once more kindly undertaking the labour of reading my proofs.

<div style="text-align: right">O. M. DALTON.</div>

BRITISH MUSEUM,
November 1924.

CONTENTS

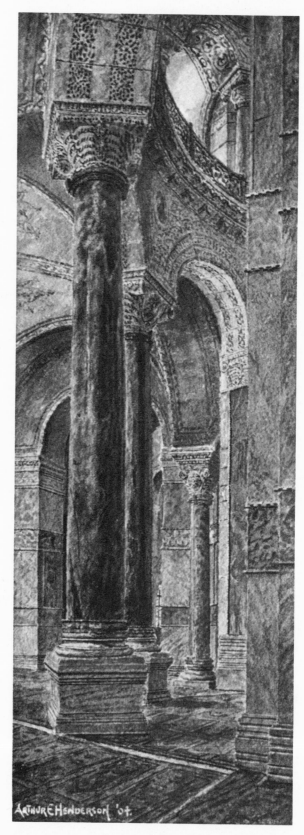

S. SOPHIA

PORPHYRY COLUMNS IN THE SOUTH-EAST EXEDRA, LOOKING WEST

(p. 52)

LIST OF PLATES

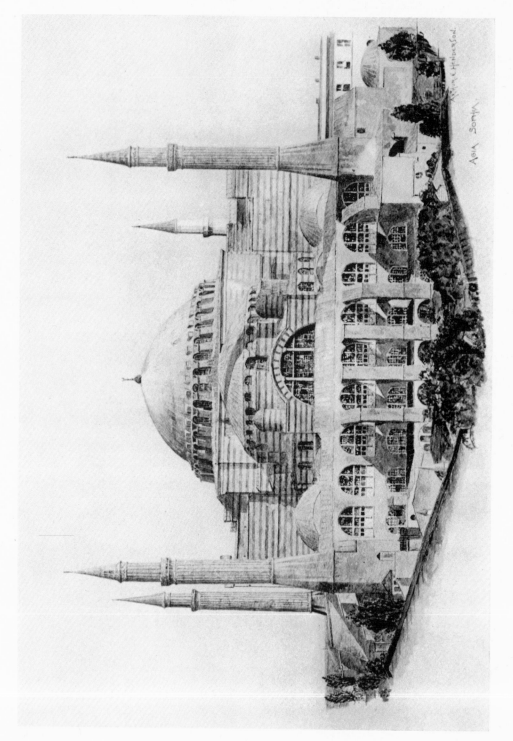

I. CONSTANTINOPLE. S. SOPHIA, WEST FRONT

(p. 92)

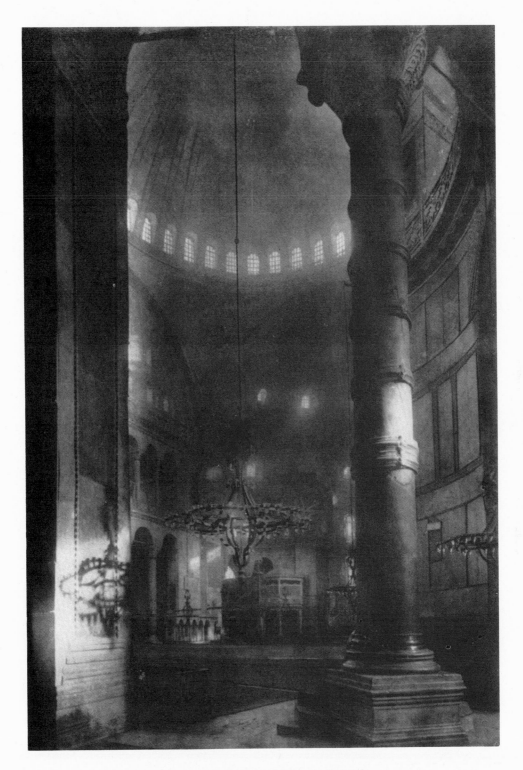

II. CONSTANTINOPLE. S. SOPHIA
INTERIOR, FROM THE SOUTH-WEST EXEDRA
(p. 92)

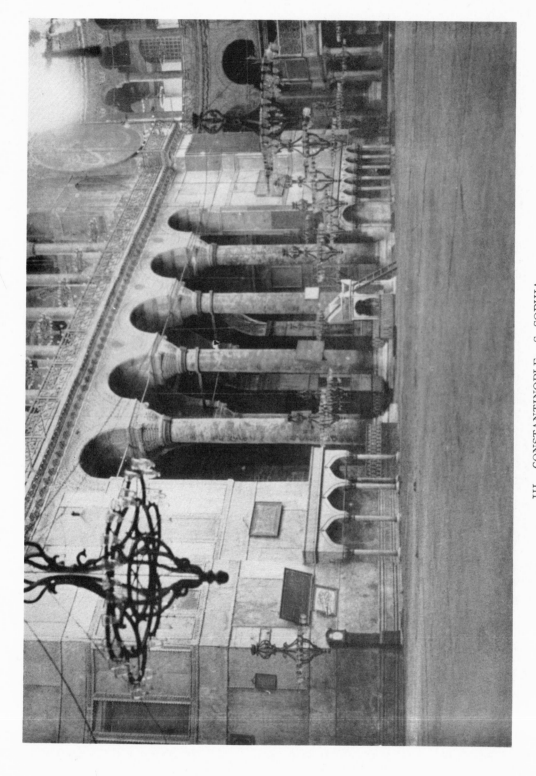

III. CONSTANTINOPLE. S. SOPHIA

AN INTERIOR VIEW, NORTH SIDE OF NAVE, LOOKING NORTH-EAST

(p. 92)

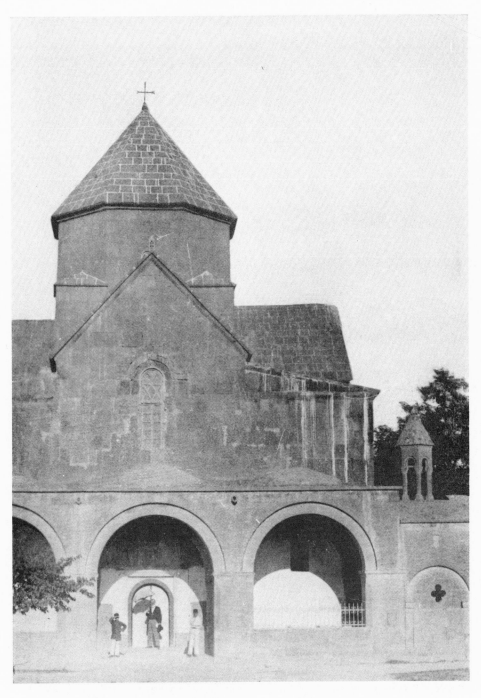

IV. ARMENIA. CHURCH OF GAIANA, EDGMIATSIN

(p. 139)

V. 1. CONSTANTINOPLE. CISTERN OF PULCHERIA (p. 115)

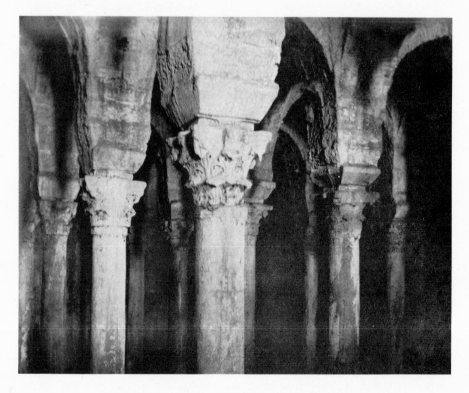

V. 2. CONSTANTINOPLE. CISTERN OF PULCHERIA (p. 115)

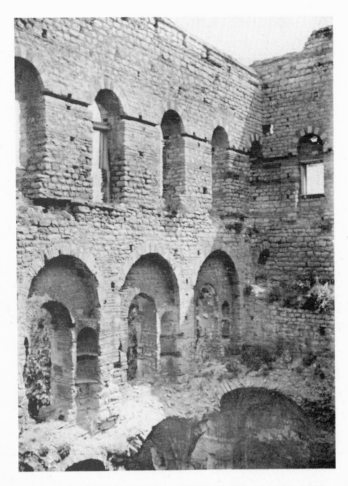

VI. 1. CONSTANTINOPLE. TEKFUR SERAI, INTERIOR

Looking North-east (p. 123)

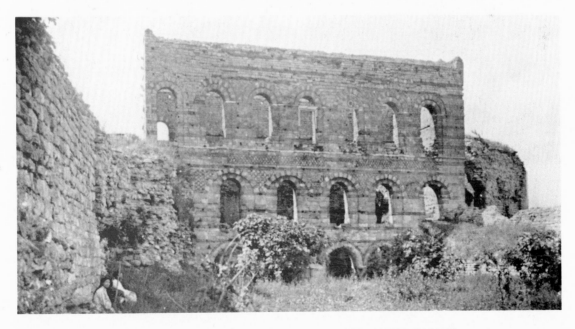

VI. 2. CONSTANTINOPLE. TEKFUR SERAI, NORTH FAÇADE

(p. 123)

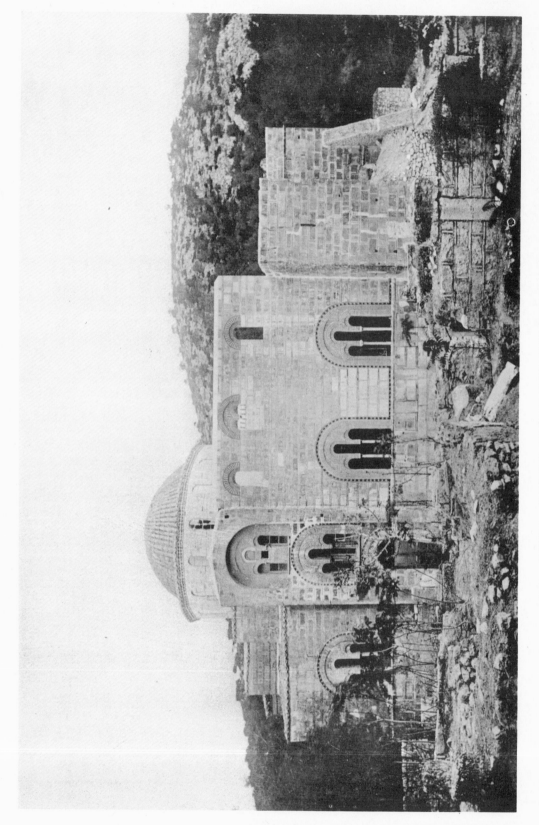

VII. ATTICA. CHURCH OF THE MONASTERY OF DAPHNI

(p. 145)

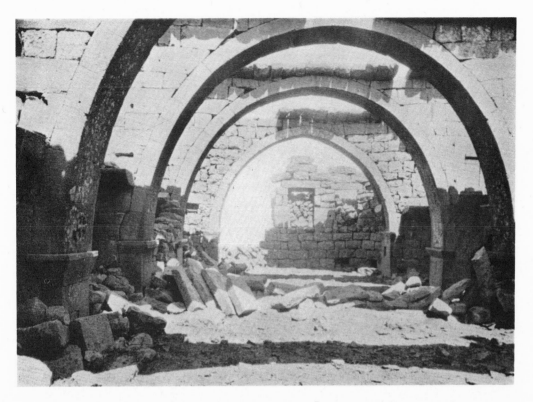

VIII. 1. SYRIA. CHURCH AT ṬAFHĀ. IVTH CENTURY (p. 131)

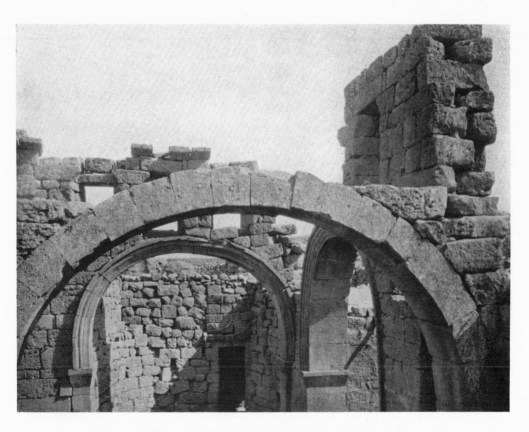

VIII. 2. SYRIA. RUINS OF EPISCOPAL PALACE, BOSRA (p. 131)

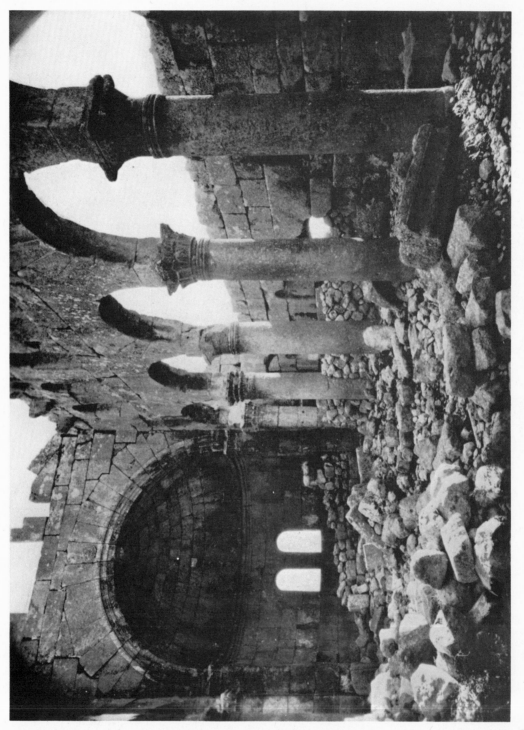

IX. SYRIA. CHURCH OF MSHABBAK

(p. 131)

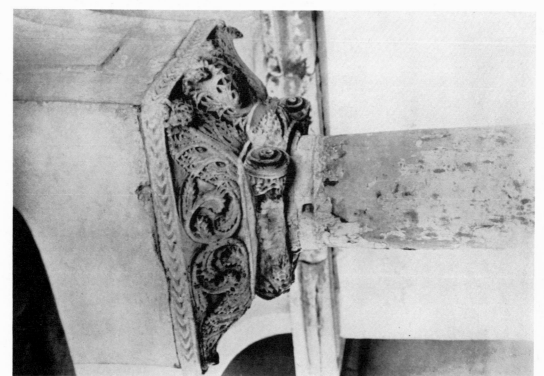

X. 2. SALONIKA. CAPITAL, S. SOPHIA

(p. 197)

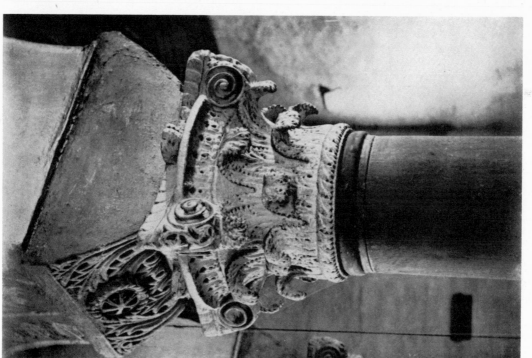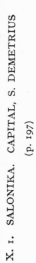

X. 1. SALONIKA. CAPITAL, S. DEMETRIUS

(p. 197)

XI. SALONIKA. S. DEMETRIUS, INTERIOR

(p. 143)

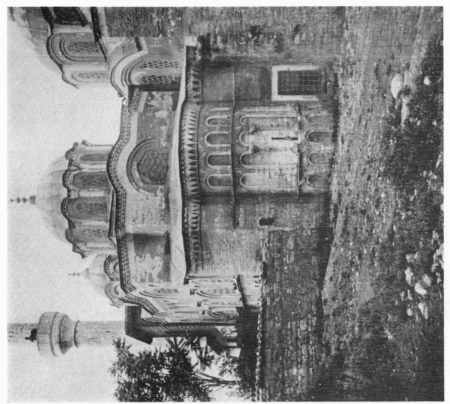

XII. 2. CONSTANTINOPLE. SOUTH CHURCH OF PAMMAKARISTOS

East End (p. 142)

XII. 1. CONSTANTINOPLE. S. IRENE, SOUTH FRONT

From roof of S. Sophia (p. 92)

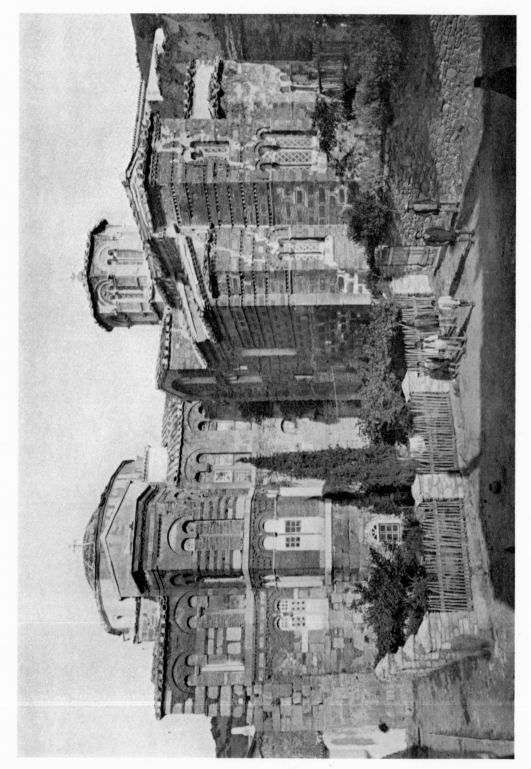

XIII. PHOCIS. THE TWO CHURCHES, S. LUKE OF STIRIS

(p. 145)

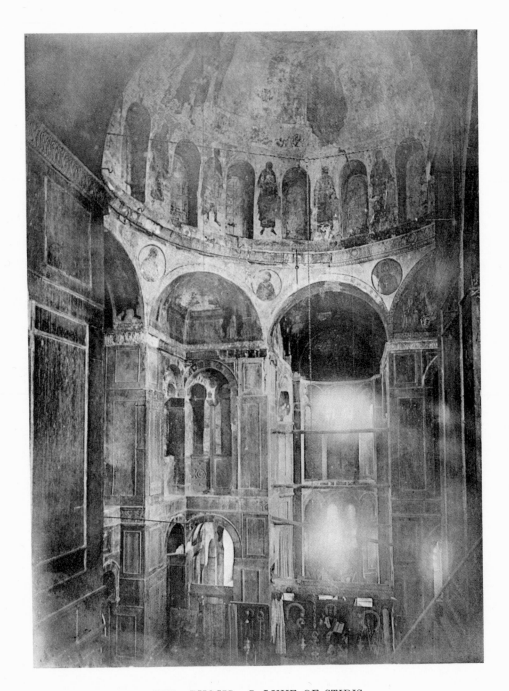

XIV. PHOCIS. S. LUKE OF STIRIS

INTERIOR OF THE GREAT CHURCH

(pp. 106, 145)

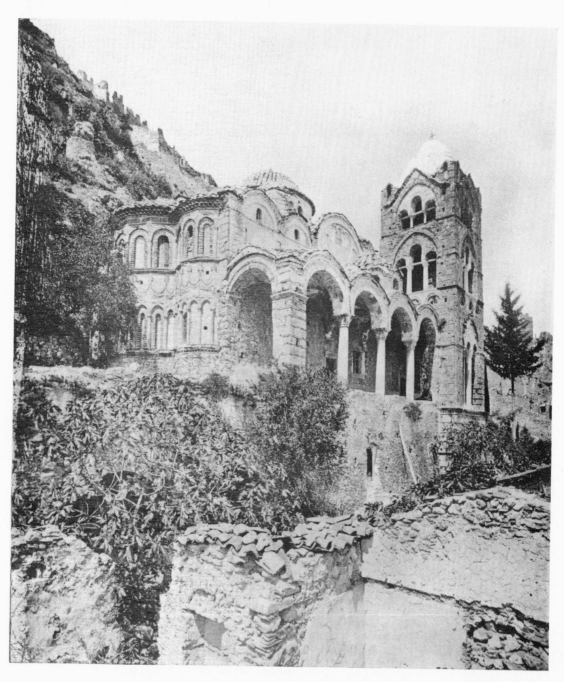

XV. MISTRA. CHURCH OF THE PANTANASSA

(p. 145)

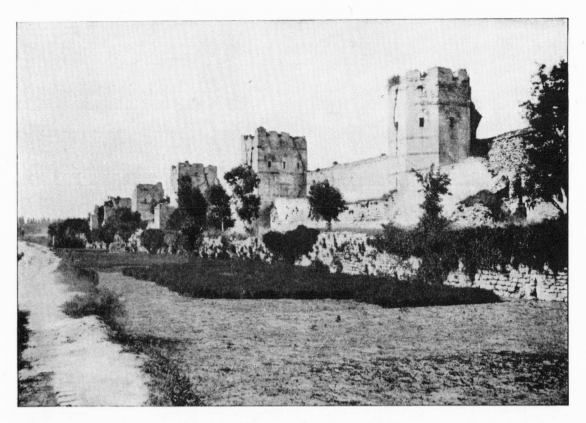

XVI. 1. CONSTANTINOPLE. LAND WALLS (p. 113)

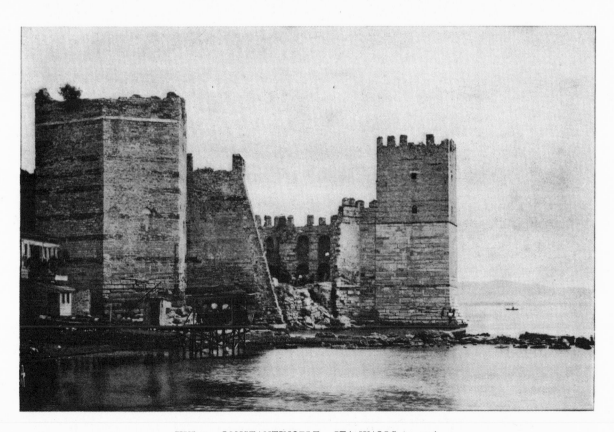

XVI. 2. CONSTANTINOPLE. SEA WALLS (p. 113)

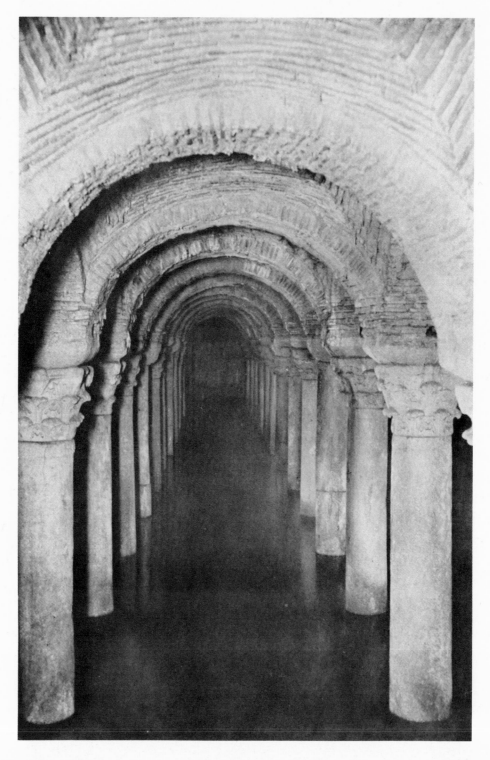

XVII. CONSTANTINOPLE. UNDERGROUND CISTERN, YERIBATAN SERAI

(p. 115)

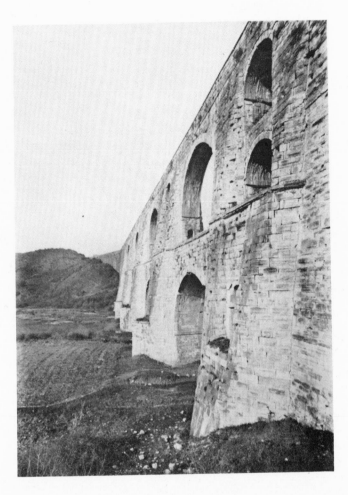

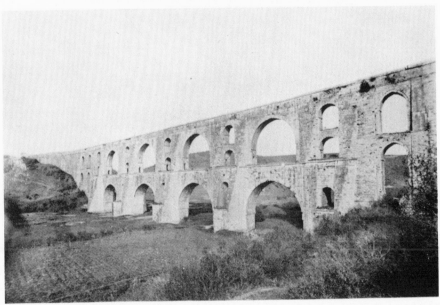

XVIII. NEAR CONSTANTINOPLE. TWO VIEWS OF AQUEDUCT OF JUSTINIAN

(p. 115)

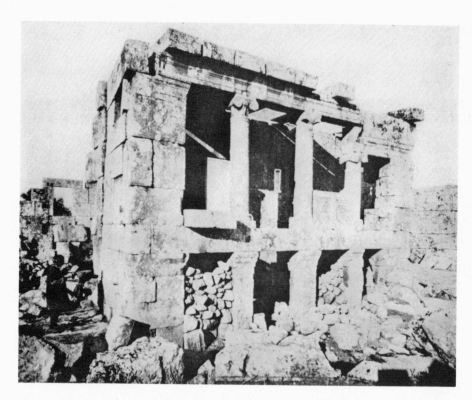

XIX. 1. SYRIA. HOUSE AT KOKOMAYŪ (p. 125)

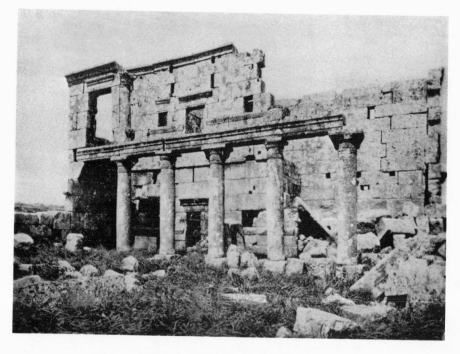

XIX. 2. SYRIA. HOUSE AT DER SAMBĪL (p. 125)

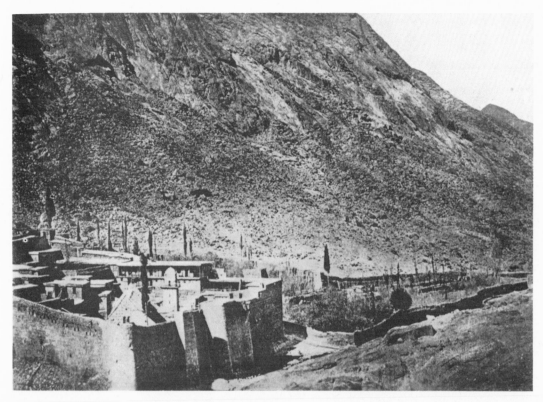

XX. 1. MONASTERY OF S. CATHERINE, MOUNT SINAI (pp. 128–30)

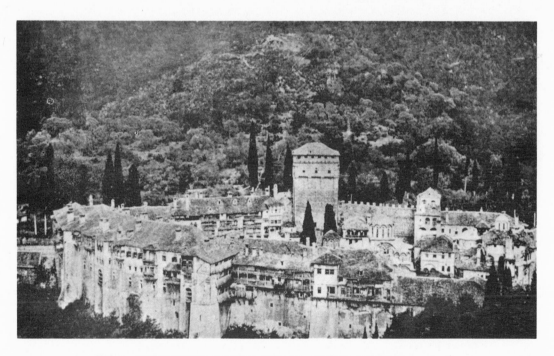

XX. 2. MONASTERY OF CHILANDARI, MOUNT ATHOS (pp. 128–30)

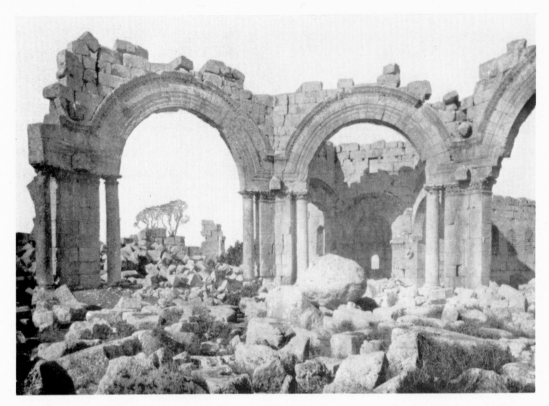

XXI. 1. SYRIA. KAL'AT SIMĀN. THE OCTAGON, NORTH-WEST ANGLE (p. 131)

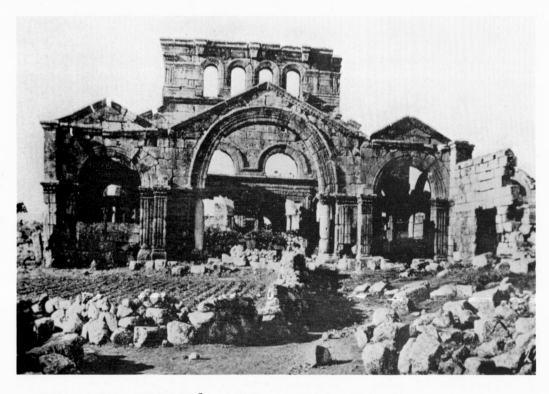

XXI. 2. SYRIA. KAL'AT SIMĀN. CHURCH OF S. SIMEON, S. WING; FAÇADE (p. 131)

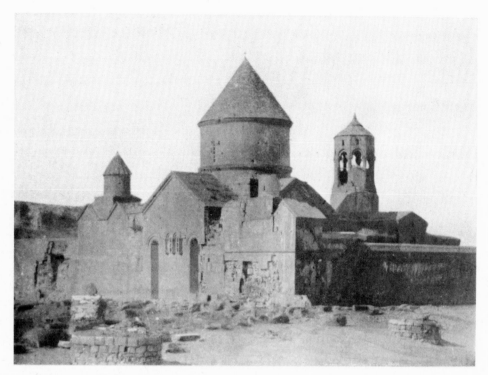

XXII. 1. ARMENIA. CHURCH OF KOSHAVANK (p. 139)

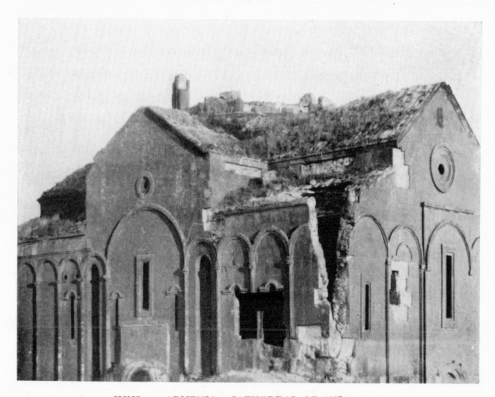

XXII. 2. ARMENIA. CATHEDRAL OF ANI (p. 139)

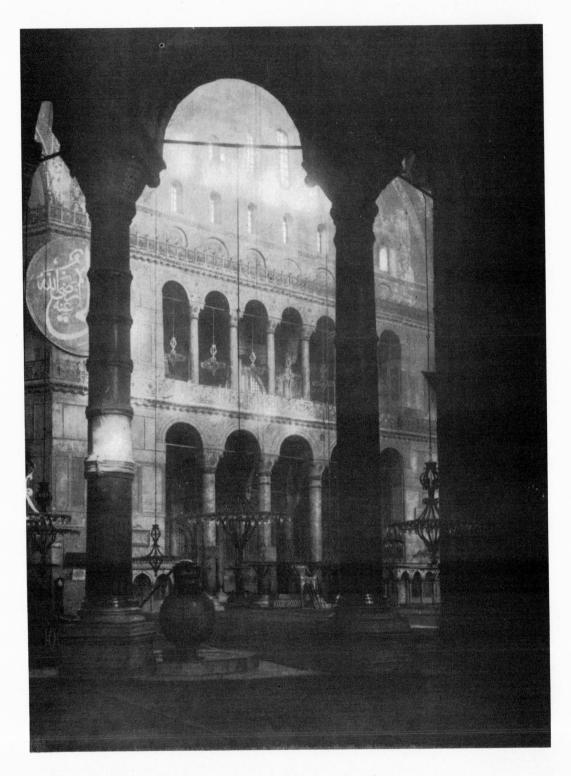

XXIII. CONSTANTINOPLE. S. SOPHIA
INTERIOR. GENERAL VIEW FROM THE SOUTH-WEST ENTRANCE

(p. 92)

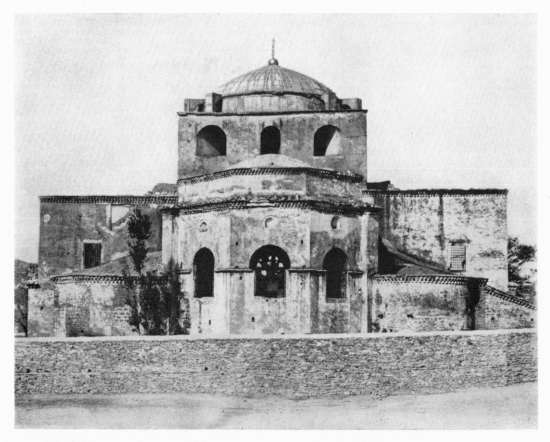

XXIV. 1. SALONIKA. S. SOPHIA, FROM EAST (p. 143)

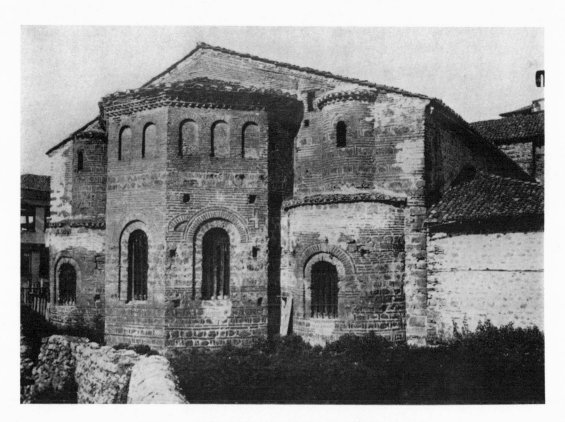

XXIV. 2. MACEDONIA. OCHRIDA, S. SOPHIA (p. 147)

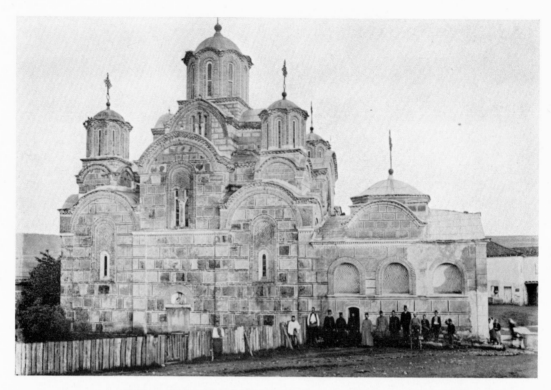

XXV. 1. SERBIA. CHURCH OF GRATCHANITZA (p. 150)

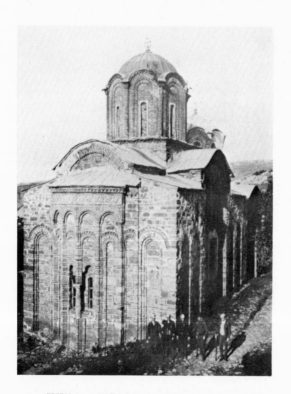

XXV. 2. SERBIA. LESNOVO (p. 150)

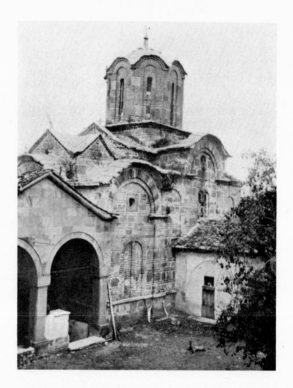

XXV. 3. SERBIA. MARKO MONASTIR (p. 150)

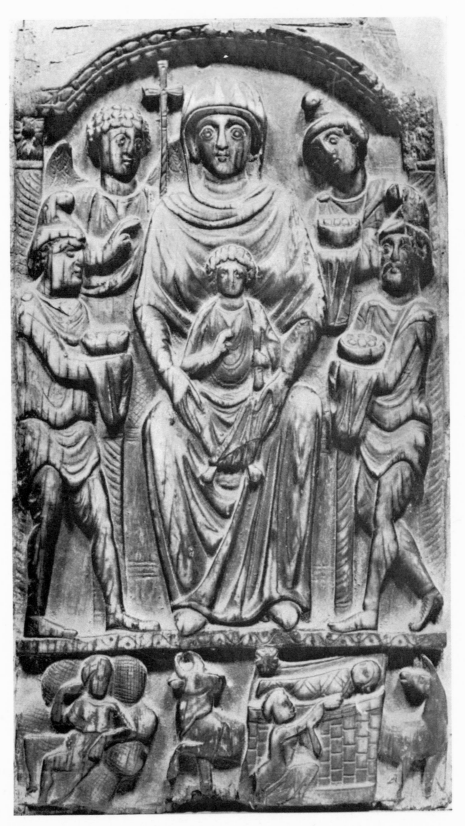

XXVI. SYRIA. IVORY CARVING, VITH CENTURY

ADORATION OF THE MAGI AND NATIVITY

(p. 205)

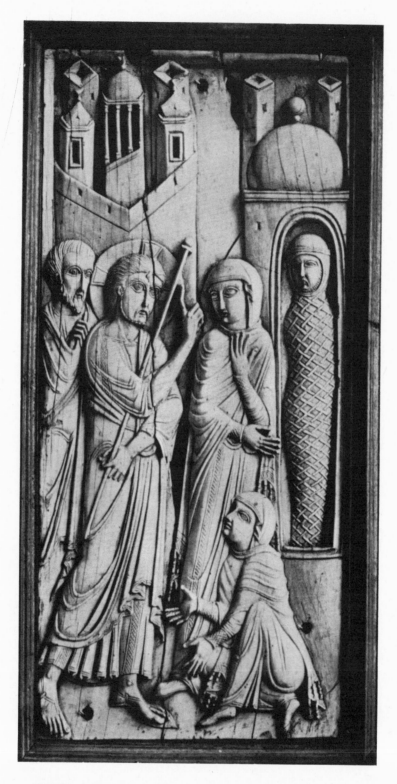

XXVII. IVORY CARVING. VITH CENTURY OR LATER
THE RAISING OF LAZARUS

(p. 207)

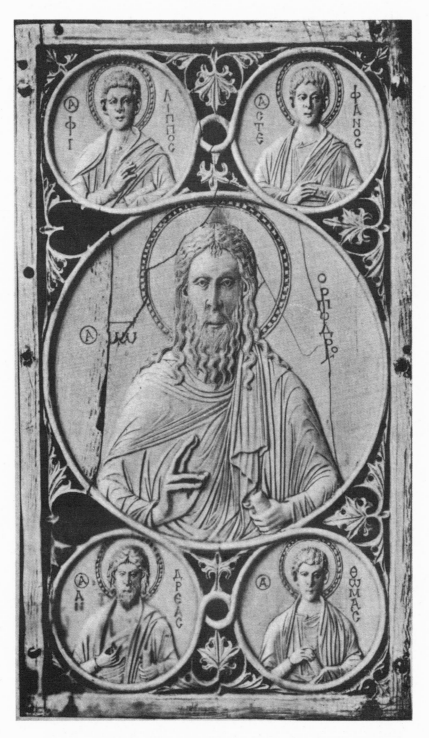

XXVIII. IVORY CARVING. XITH CENTURY

S. JOHN AND OTHER SAINTS

(p. 217)

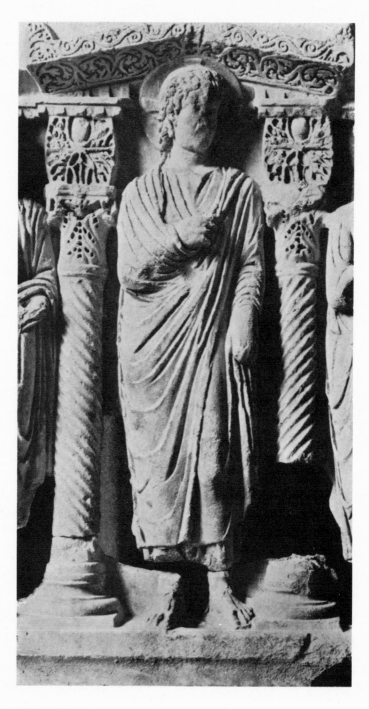

XXIX. SCULPTURE. OUR LORD, PART OF A MARBLE SARCOPHAGUS
IVᵀʜ CENTURY (p. 182)

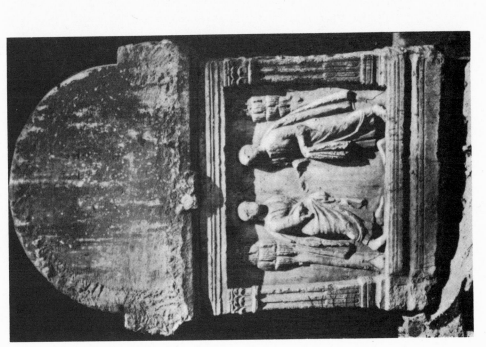

XXX. SCULPTURE. THE PIGNATTA SARCOPHAGUS, RAVENNA, Vᴛʜ CENTURY

(p. 184)

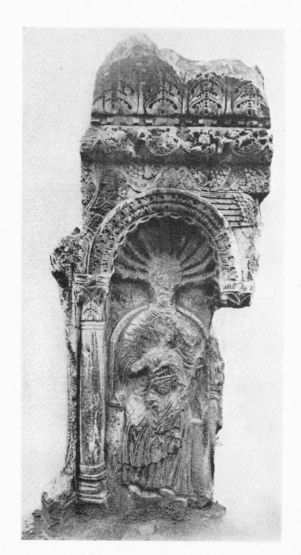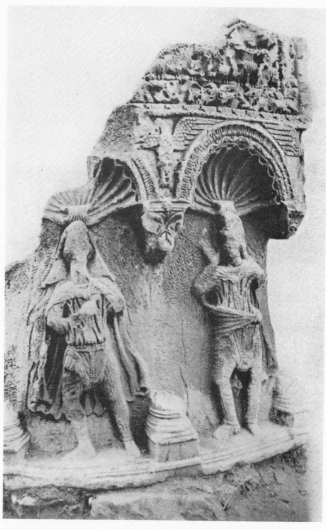

XXXI. SCULPTURE. FRAGMENTS OF MARBLE AMBONS FROM SALONIKA, NOW AT CONSTANTINOPLE

(p. 185)

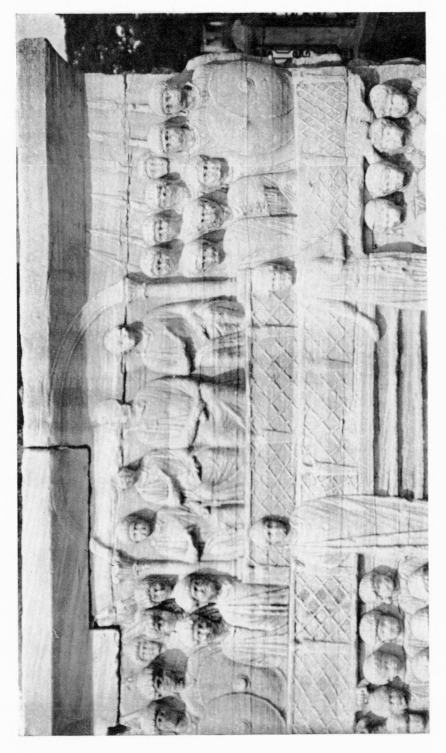

XXXII. CONSTANTINOPLE. SCULPTURE ON THE BASE OF THE OBELISK IN THE HIPPODROME

THE EMPEROR THEODOSIUS WATCHING THE GAMES (p. 192)

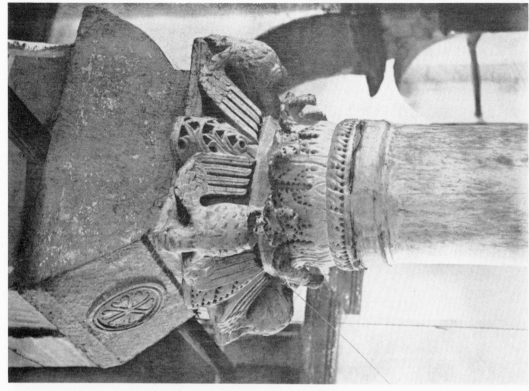

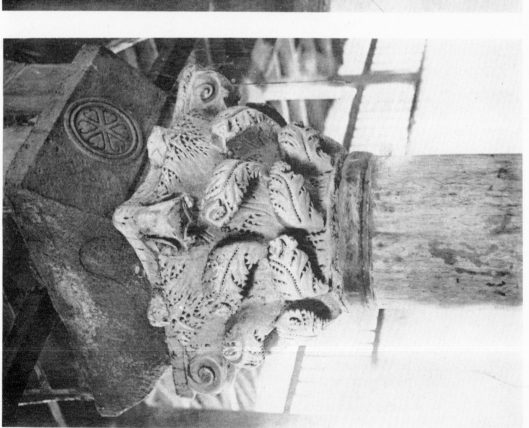

XXXIII. SALONIKA. CAPITALS IN S. DEMETRIUS WITH EAGLES AND 'WIND-BLOWN ACANTHUS'

(p. 197)

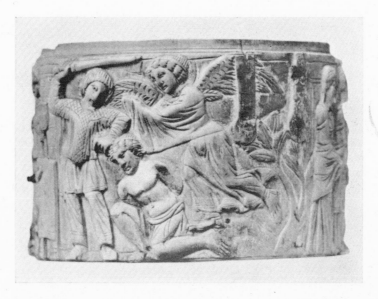

XXXIV. 1. IVORY CARVING. PYXIS FROM ALEXANDRIA
WITH MARTYRDOM OF S. MENAS (pp. 207–8)

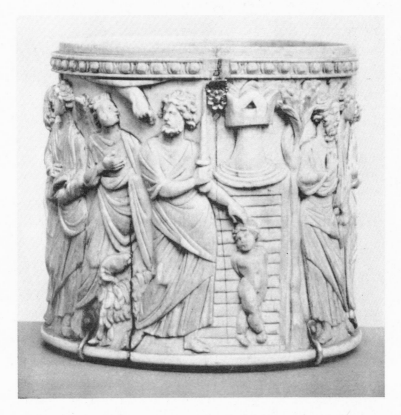

XXXIV. 2. IVORY CARVING. PYXIS FROM ANTIOCH WITH
SACRIFICE OF ABRAHAM (pp. 207–8)

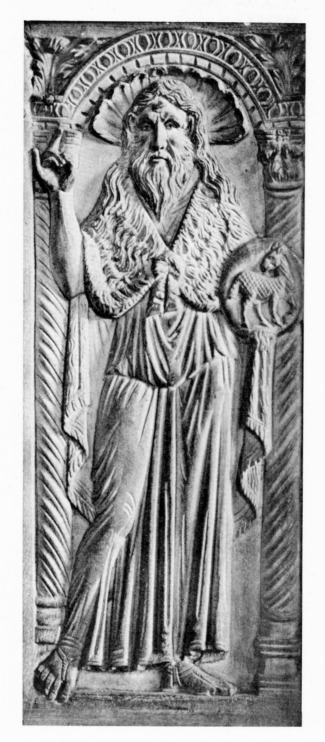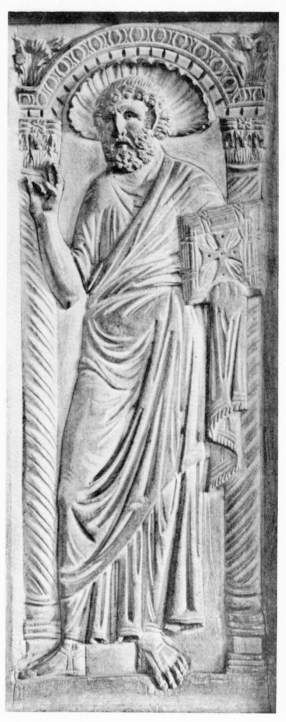

XXXV. IVORY CARVINGS. S. JOHN BAPTIST AND AN APOSTLE, ON THE THRONE OF
BISHOP MAXIMIANUS AT RAVENNA, VIth CENTURY

(p. 205)

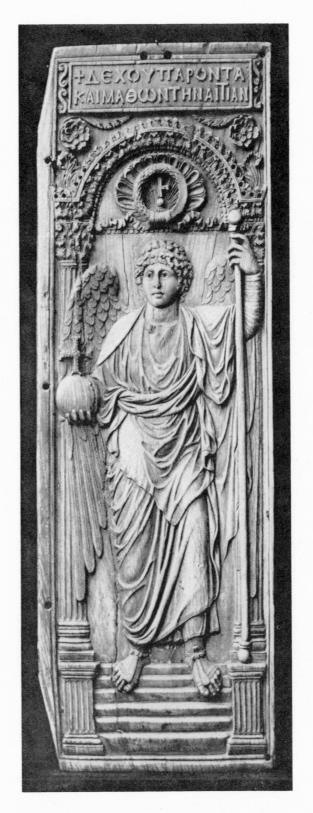

XXXVI. IVORY CARVING. DIPTYCH-LEAF WITH THE
ARCHANGEL MICHAEL, Vth CENTURY

(p. 210)

XXXVII. 1. IVORY CARVING. SIDE OF THE VEROLI CASKET. IXTH CENTURY (p. 213)

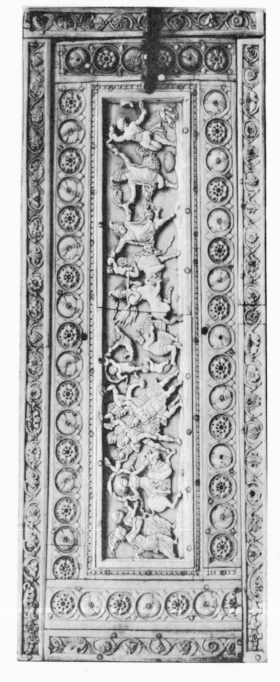

XXXVII. 2. IVORY CARVING. TOP OF THE VEROLI CASKET. IXTH CENTURY (p. 213)

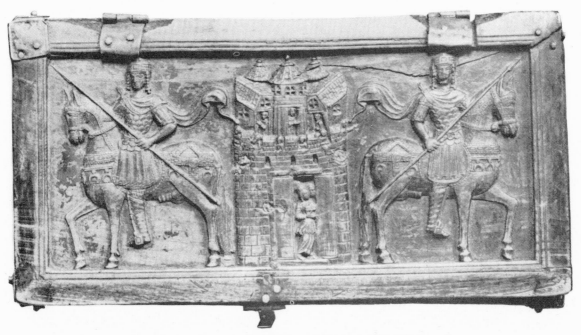

XXXVIII. 1. IVORY CARVING. TOP OF A CASKET (p. 218)

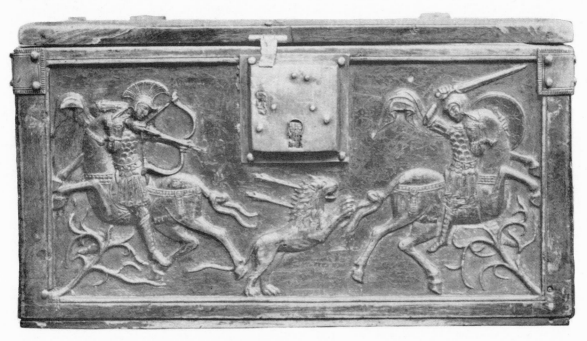

XXXVIII. 2. IVORY CARVING. FRONT OF A CASKET (p. 218)

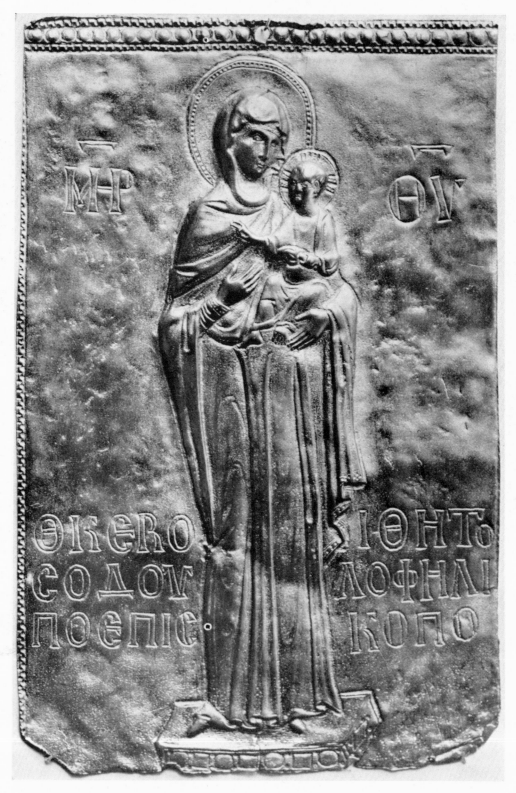

XXXIX. GILT BRONZE RELIEF. THE VIRGIN AND CHILD, XITH CENTURY

(p. 220)

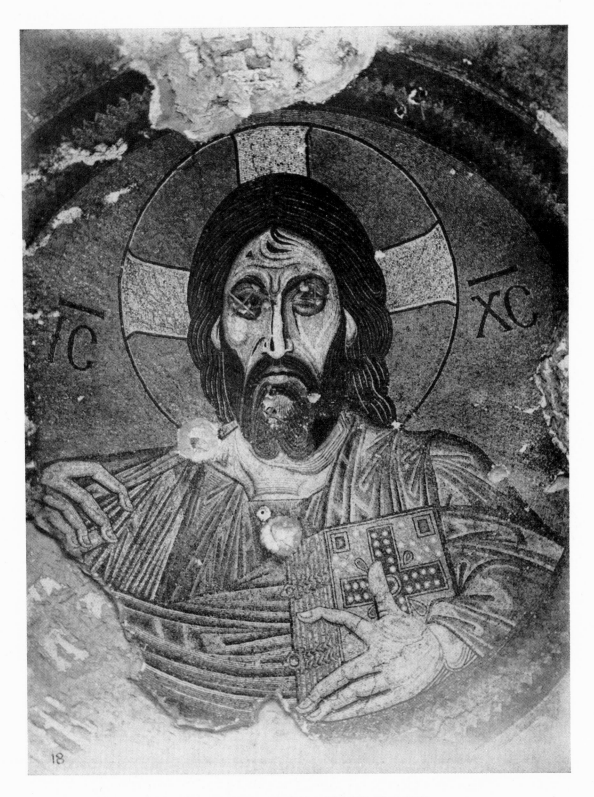

XL. DAPHNI, ATTICA. MOSAIC IN DOME

CHRIST PANTOKRATOR, XItʜ CENTURY

(p. 288)

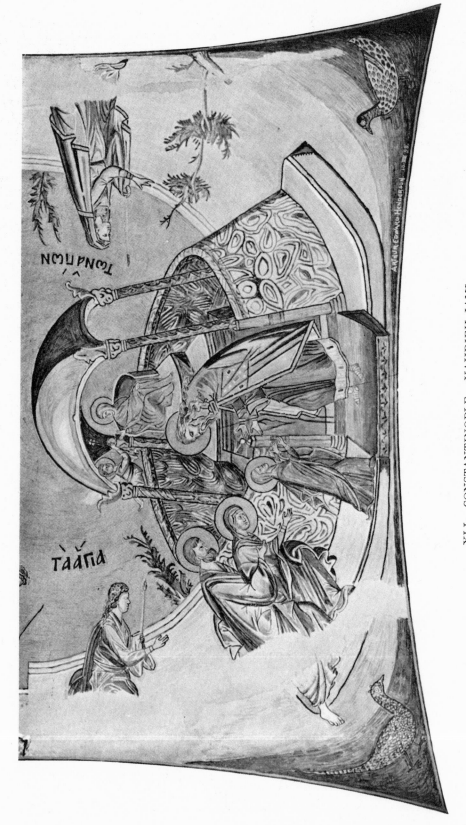

τ ἀ ἅγία

Τωναγιων

XLI. CONSTANTINOPLE. KAHRIEH JAMI

MOSAIC. THE PRESENTATION OF THE VIRGIN IN THE TEMPLE. XIVᴛʜ CENTURY

(p. 293)

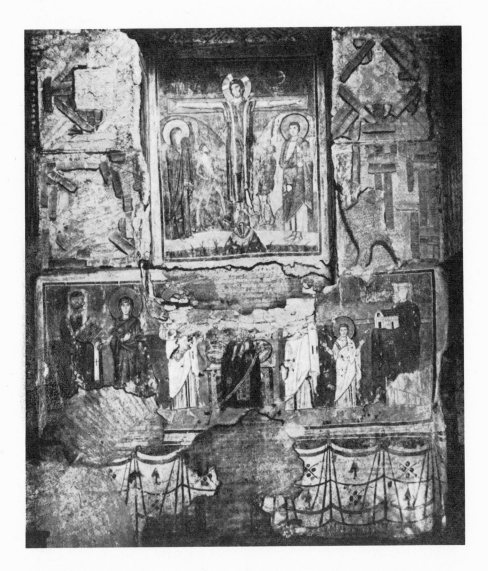

XLII. ROME. S. MARIA ANTIQUA, MURAL PAINTINGS

(p. 249)

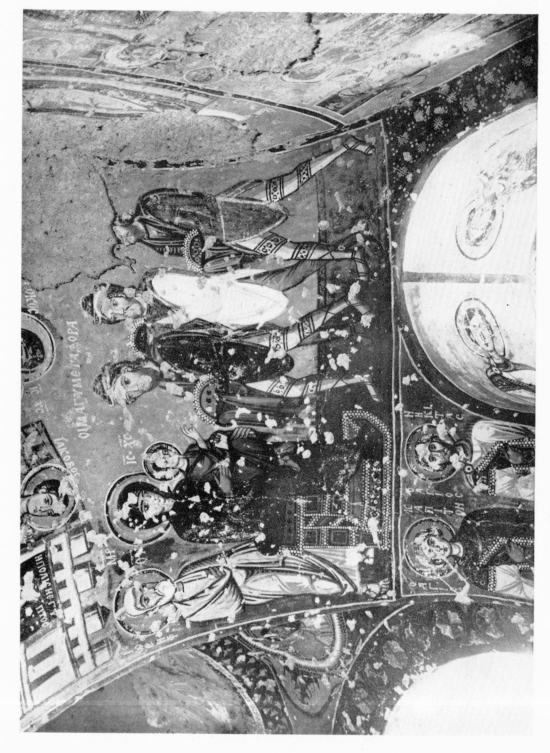

XLIII. CAPPADOCIA. CHURCH OF QELEDJLAR
WALL PAINTING. THE ADORATION OF THE MAGI

(p. 250)

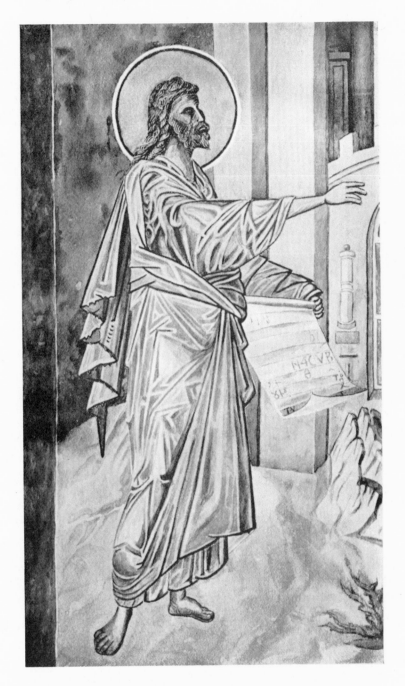

XLIV. CONSTANTINOPLE. KAHRIEH JAMI
MURAL PAINTING. A PROPHET. XIVᴛʜ CENTURY

(p. 255)

XLV. PAINTING ON PANEL
ANNUNCIATION, NATIVITY, BAPTISM, TRANSFIGURATION. XIIITH CENTURY
(p. 264)

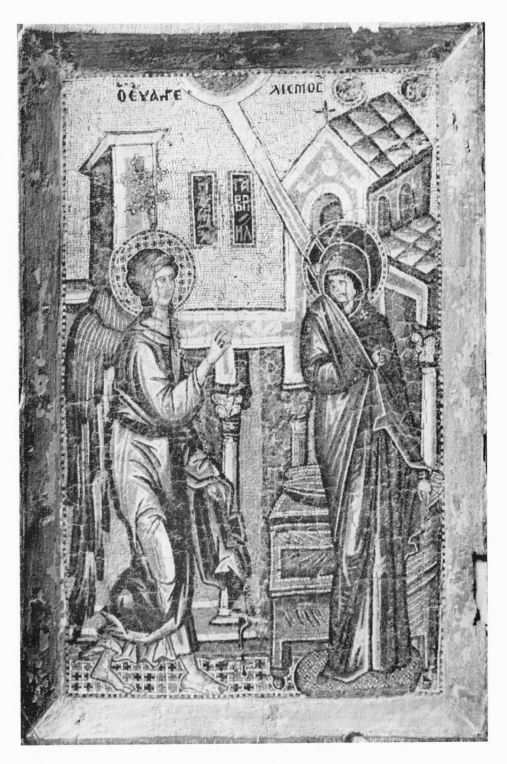

XLVI. MINIATURE MOSAIC. THE ANNUNCIATION

(p. 265)

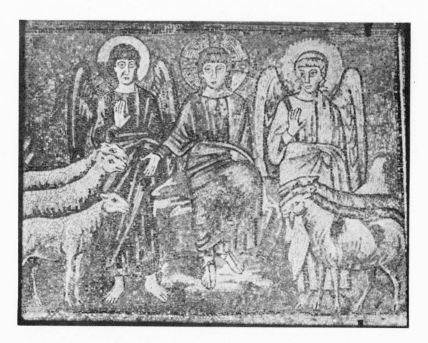

XLVII. 1. RAVENNA. MOSAIC. NAVE OF S. APOLLINARE NUOVO

The Separation of the Sheep and Goats (pp. 275–6)

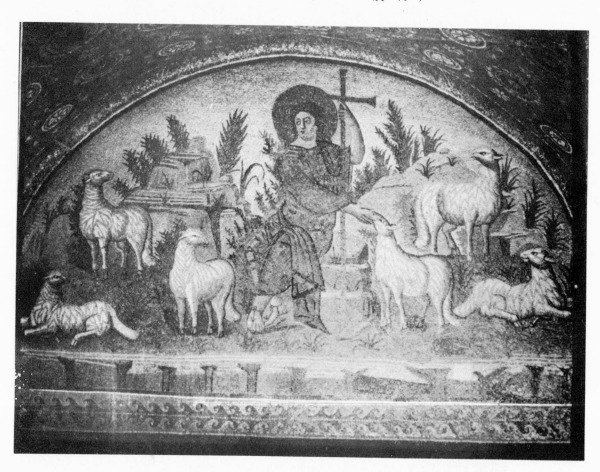

XLVII. 2. RAVENNA. MOSAIC. MAUSOLEUM OF GALLA PLACIDIA

The Good Shepherd (pp. 275–6)

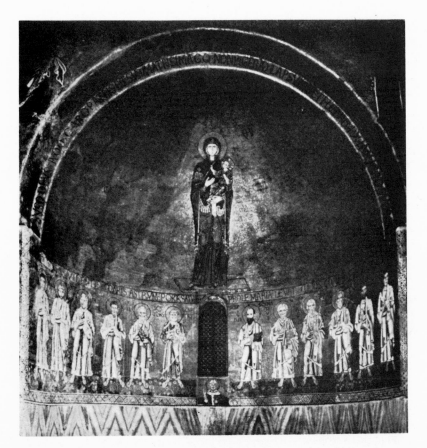

XLVIII. 1. MURAL MOSAIC. TORCELLO. APSE OF THE CATHEDRAL

The Virgin and Child, with Apostles (pp. 276, 290)

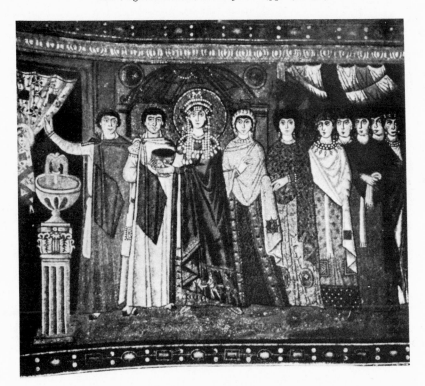

XLVIII. 2. MURAL MOSAIC AT RAVENNA, S. VITALE

Theodora and her Ladies (pp. 276, 290)

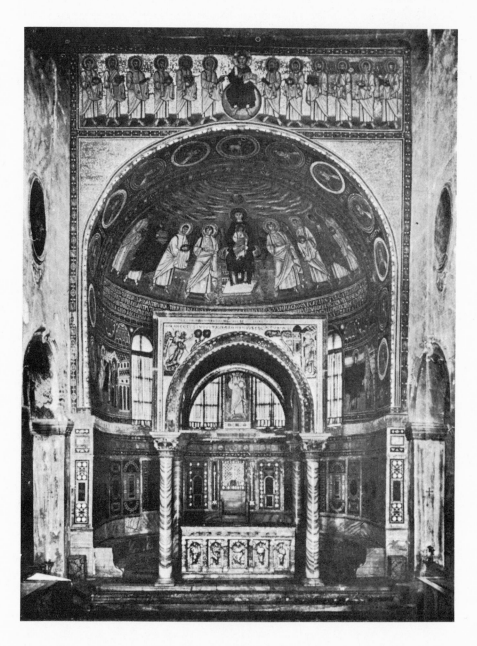

XLIX. MURAL MOSAICS. PARENZO, APSE OF THE CATHEDRAL
VITH CENTURY

(p. 278)

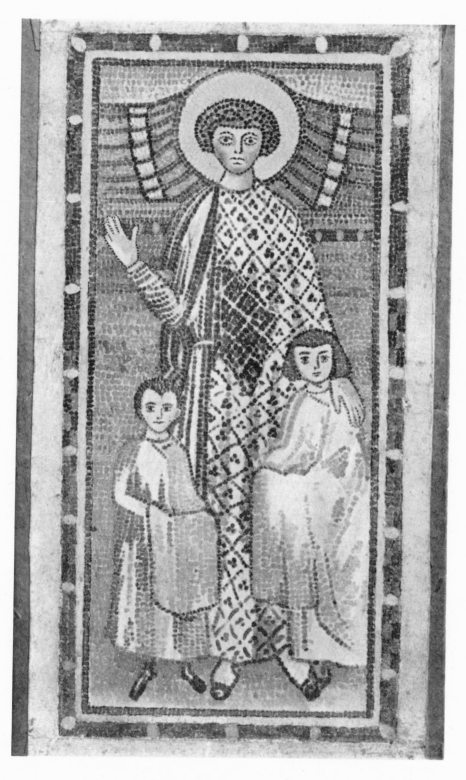

L. MURAL MOSAIC. SALONIKA

S. DEMETRIUS. THE SAINT WITH TWO BOYS. VITH CENTURY

(p. 281)

LI. MURAL MOSAIC. DAPHNI, ATTICA

THE HEAD OF S. JOHN IN THE SCENE OF THE CRUCIFIXION. XITH CENTURY

(p. 281)

LII. MONREALE. MURAL MOSAIC
THE WOMAN TAKEN IN ADULTERY. XIITH CENTURY

(p. 291)

LIII. 1. CONSTANTINOPLE. MURAL MOSAIC. KAHRIEH JAMI

The Nativity. XIVth Century (p. 293)

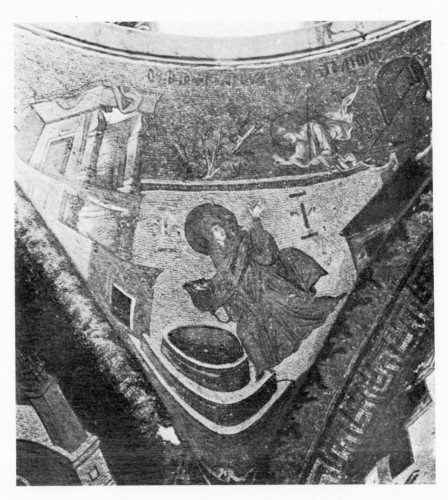

LIII. 2. CONSTANTINOPLE. MURAL MOSAIC. KAHRIEH JAMI

The Annunciation. XIVth Century (p. 293)

LIV. ILLUMINATION. LEAF FROM A GOSPEL OF THE VIth CENTURY

(p. 314)

LV. 1. ILLUMINATION. JOSHUA AND THE GIBEONITES

From the Joshua Roll in the Vatican (pp. 305, 318)

LV. 2. ILLUMINATION. PAUL ON THE ROAD TO DAMASCUS

From the MS. of Cosmas Indicopleustes in the Vatican

(pp. 305, 318)

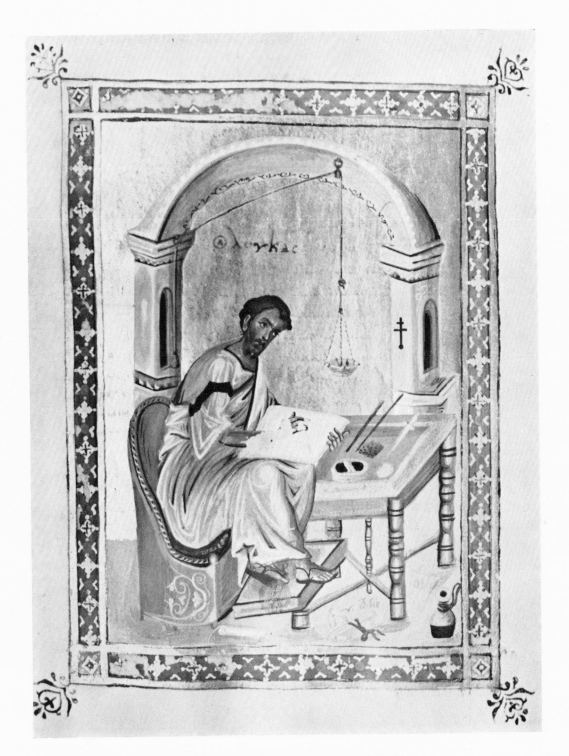

LVI. ILLUMINATION. S. LUKE SEATED

FROM A GOSPEL OF THE XIIᴛʜ CENTURY

(p. 314)

LVII. 2. ILLUMINATION. GOSPEL OF THE XIITH CENTURY
The Incredulity of S. Thomas (p. 311)

LVII. 1. ILLUMINATION. MENOLOGIUM OF SIMEON
METAPHRASTES
S. Euphrosyne of Alexandria (p. 316)

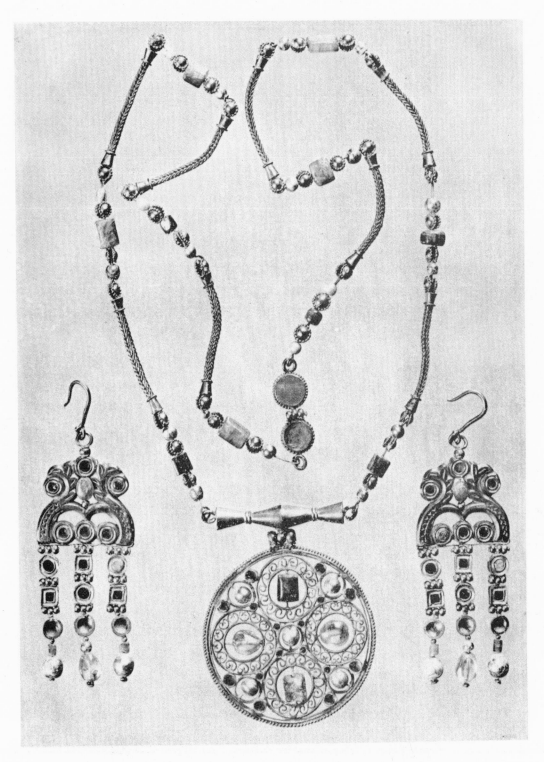

LVIII. GOLD NECKLACE WITH PENDANT, AND EAR-RINGS
FOUND IN EGYPT. VITH CENTURY

(p. 321)

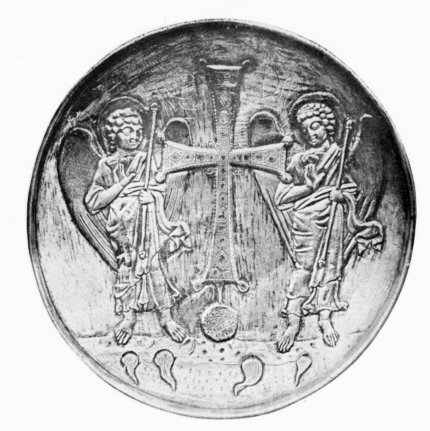

LIX. 1. SILVER DISH

The Cross, with Angels. VIth Century (p. 325)

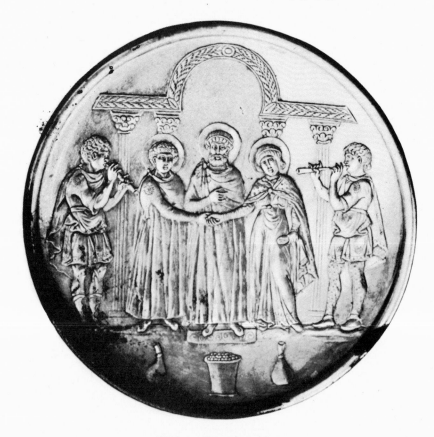

LIX. 2. SILVER DISH

The Marriage of David. VIth Century (p. 328)

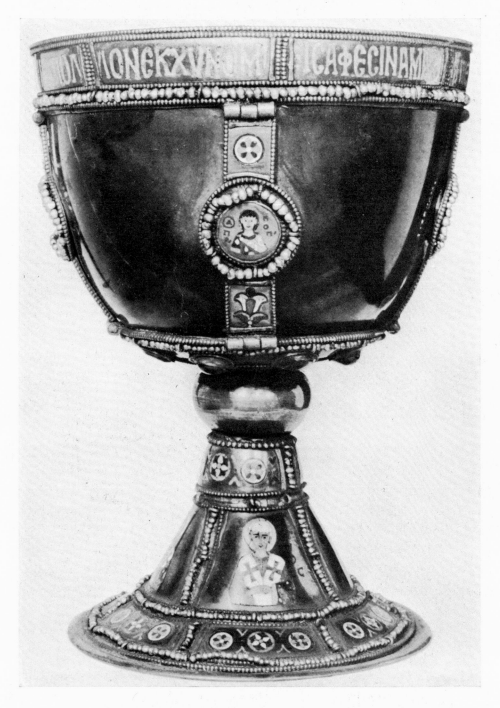

LX. TREASURY OF S. MARK, VENICE
CHALICE ENRICHED WITH ENAMELS AND PEARLS
(pp. 325, 340)

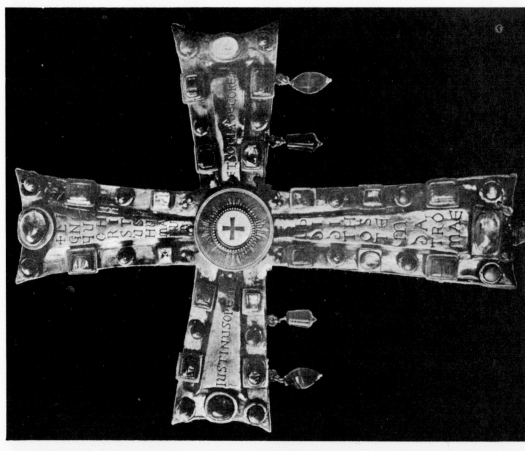

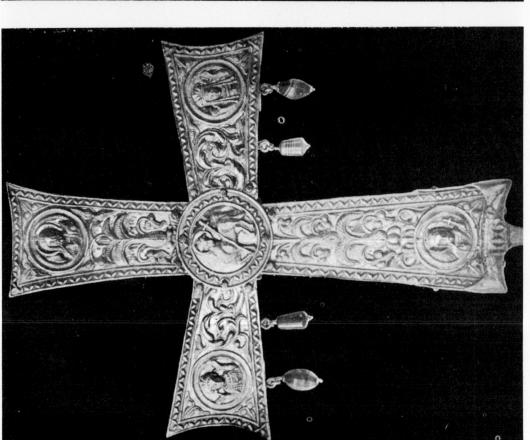

LXI. ROME. S. PETER'S. GOLD CROSS OF JUSTIN II AND SOPHIA. VITH CENTURY

(p. 331)

Medallion with Saint

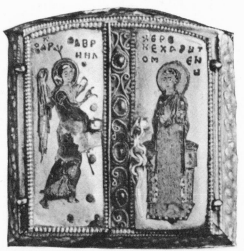

Triptych with the Annunciation

Medallion with Saint

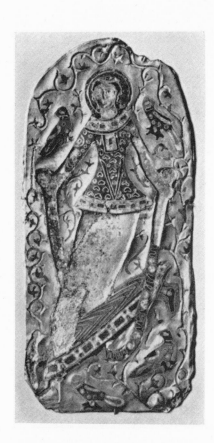

Figure of a Dancer, front

Figure of a Dancer, back

LXII. ENAMELS

(pp. 338–9)

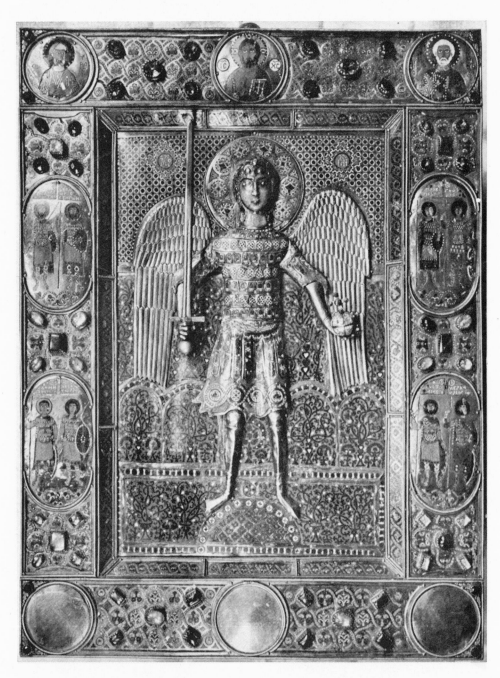

LXIII. ENAMEL. TREASURY OF S. MARK, VENICE
BOOK-COVER WITH S. MICHAEL
(p. 340)

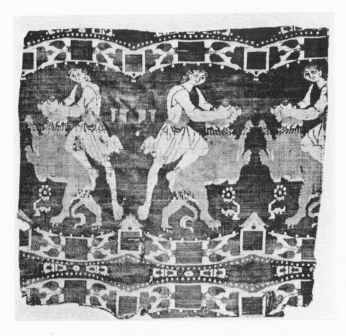

LXIV 1. SILK TEXTILE.—SAMSON (?) AND THE LION

(p. 355)

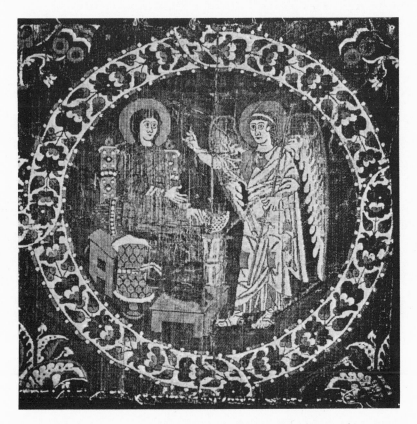

LXIV. 2. SILK TEXTILE. THE ANNUNCIATION

(p. 354)

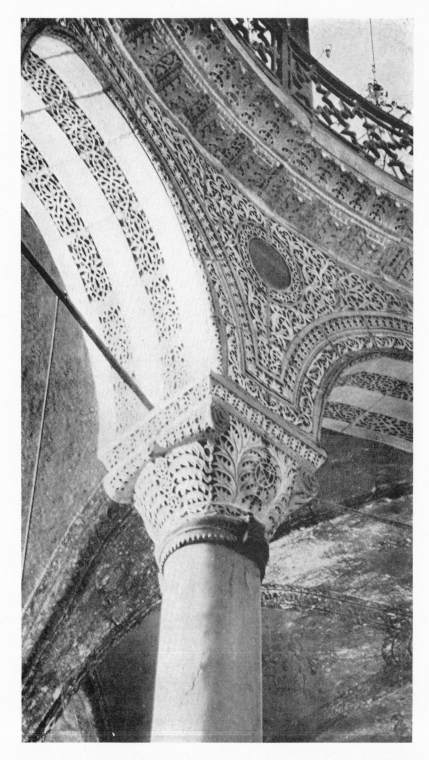

LXV. CONSTANTINOPLE. S. SOPHIA. SCULPTURED ORNAMENT

(p. 377)

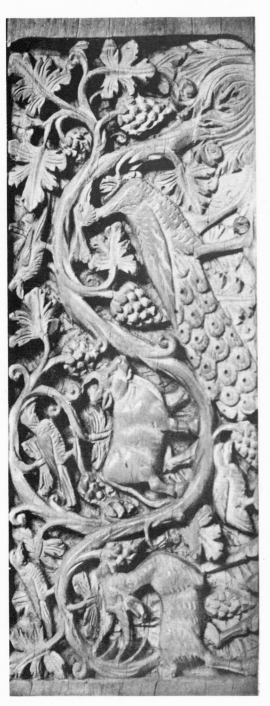
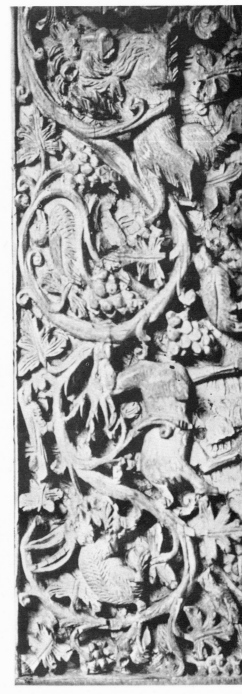

LXVI. SCULPTURED ORNAMENT. DETAILS FROM THE IVORY THRONE AT RAVENNA

(pp. 205, 379)

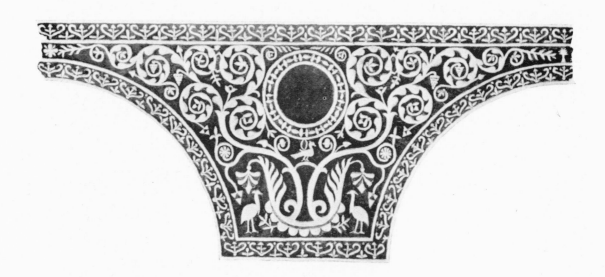

LXVII. CONSTANTINOPLE. S. SOPHIA
MOSAIC ORNAMENT (*OPUS SECTILE*). VIᴛʜ CENTURY
(Cf. plate XLIX)

LXVIII. CONSTANTINOPLE. S. SOPHIA. ORNAMENT
RELIEFS IN GREEN PORPHYRY ON THE GREAT PIERS OF THE AISLES

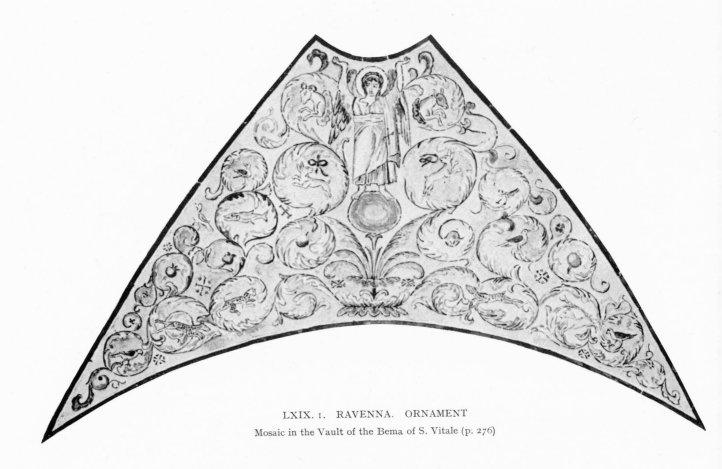

LXIX. 1. RAVENNA. ORNAMENT

Mosaic in the Vault of the Bema of S. Vitale (p. 276)

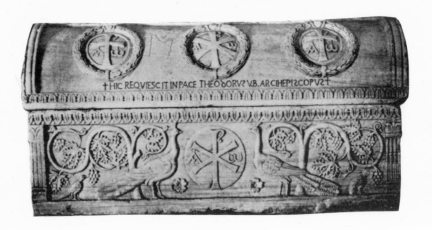

LXIX. 2. RAVENNA. ORNAMENT

Sculptured Sarcophagus of Archbishop Theodore. VIth Century (p. 184)

EAST CHRISTIAN
ART

I

GENERAL SURVEY

IN any survey of East Christian and Byzantine archaeology we are early confronted with the sacred art established by the Church in the fifth century, that is to say, with an historical and dogmatic art largely devoted to the representation of events and the setting forth of definite beliefs. It was a particular representational system which gave the art of Christianity its distinctive character as opposed to that of paganism, a system which has survived on the greatest scale in monuments saved by a religious association when others of secular origin were destroyed. Essentially a Church art, it was enabled by organized ecclesiastical support and by this fortune in survival to seize and maintain a position of lasting advantage.

But though it is necessary to recognize this fact, we cannot confine the whole of East Christian and Byzantine art within the pales thus deeply and permanently driven. The Church, deciding for her own purposes upon a system of representation, never wavered in her purpose of illustrating facts for edification and important points of dogma; to her, art was a means towards an end external to itself; the aesthetic was subordinated to the practical. But the artists and craftsmen whom she employed could not wholly accept this attitude. Though they were themselves among the faithful, and a high proportion of them were monks, they could not renounce the artistic instincts of their several races and countries. They were in large part men born either in the Eastern provinces or in places where Eastern influences penetrated. They introduced a new appreciation of decorative design; they treated even historical subjects on inherited principles, foreign to those of Greece and Rome. In this way the art of the Church, despite its representational basis, was touched by the spirit of decoration. Since the present volume is primarily concerned with historical development, and since representational Church art looms largest throughout the period of Byzantine history, it is well to begin with this, and examine the compromise by which it came into existence. But both in this chapter and in those that follow we shall not fail to note the non-representational influences constantly in evidence; in a separate chapter on ornament, we shall endeavour to see how, in a field which the Church herself did not regard as of the first importance, these influences are disengaged from impeding factors and exhibited in their simplest terms.

Christianity, rapidly expanding in all directions, and transcending racial boundaries, had from the first to deal with diverse peoples, the psychology of which determined its artistic expression. The art of the

scattered Early Christian communities varied with race and with environment; the manner of envisaging the world of appearance was not everywhere the same. In one part it was Greek, in another Aramaean, in others again Iranian or Coptic. An art representative of Christianity as a whole could not exist until a single unifying power arose, demanding a common denominator in expression, and attempting to unite opposing elements. We began with the statement that unification did not come before the establishment of a centralized Church in the fifth century, and that a distinctively Christian art dates only from that time. The Church secured coherence by establishing a compromise between the chief contributory forces. But coherence is not organic unity. Although it presented a single front for a thousand years, this Church art was an artificial construction and not a natural growth; it was never wholly at one with itself. Its constituents had centrifugal tendencies never completely subdued by a power imposing external control from above. We have now to examine the several factors upon which the compromise depended.

Among the civilizations which the new faith first encountered was that of the Hellenistic cities on the Mediterranean littoral, and in the interior of Hither Asia. The late representatives of Greek culture had still the intellectual curiosity of their race; the wide contact with other peoples which followed the expedition of Alexander had given them a new receptiveness. The Macedonian invader, by flinging wide the doors of the East, had opened vast fields to Greek speculation, which learned to compare the beliefs of oriental countries with its own, to compose eclectic systems of philosophy and to devise syncretic forms of religion. Platonism was replaced by Neo-Platonism, polytheism gave way before a theology which allowed the individual soul direct access to a single and supreme godhead. Greek thought received and judged with tolerance all that came to it out of the East, the Mithraism and Manichaeanism of Iran no less than Christianity and the magic and apocalyptic ideas of Judaism. Before the second century of our era the general restiveness of thought had caused a religious revival throughout the Roman world, in which oriental speculation was the spur, while Greek logic was the instrument of conciliation. It was on the face of it impossible that a people so interested in art as the Greeks should have absorbed the religious ideas of the East and left the artistic ideas alone. In its later phases, Greek art had assimilated Eastern features. Yet it retained its essentially Greek qualities, and, if contaminated, was never absorbed. It is a mistake to believe, because much that it produced was perfunctory reproduction, that everywhere and always it was without life and vigour. The Greek communities, scattered as they were from the Rhône to the Oxus, held tenaciously to their hereditary art. They made many concessions to Eastern feeling, but they did not surrender what they regarded as primary and fundamental. While, under pressure of the Church, they compromised in the matter of sacred historical art, in the freer field of

secular representation they retained their old traditions with much less change. The Greek population was large enough to make us doubt the suggestion that Hellenistic art in Byzantine times was wholly confined to the Court, the university, and a small cultivated class; it could hardly have survived as it did unless it had possessed a wider and more popular basis. In the extreme west of Asia the existence of such a basis has always been admitted; it is unnecessary to do more than mention the cities of the Mediterranean area: Alexandria, Antioch, Ephesus, and, from the fourth century, Constantinople. But the cities of the far interior were by no means passive under a continual encroachment of oriental ideas; they were not helpless in their isolation, nor always reduced to a weak defensive. It was not indeed to be expected that outposts of Greek culture in inner Asia could carry on ancestral traditions with the tranquillity of Ephesus. But that they did maintain them is proved by the manner in which they transmitted both style and motives to alien peoples. Granted that the outposts on both shores of the Black Sea, in Mesopotamia, in Bactria, were permeated by Iranian influences from Sarmatian South Russia and from Central Asia; granted that Hellenistic art was largely ' Iranized ', especially in its decorative aspects, yet the naturalism which was one of its chief characteristics survived in Parthia and Persia, in Bactria and Turkestan, at a date when Greek art is usually regarded as defunct. Parthian coins, and such sculpture as that of the rock-reliefs at Behistun, executed for Mithridates II and Gotarzes II, are Hellenistic in style and accompanied by Greek inscriptions.[1] In our haste to emphasize the nationalism of Sassanian Persia, we tend perhaps to under-estimate the continuity of Greek influence discernible in its art; Seleucia, doubtless one of the greatest Hellenistic centres in the interior of Asia, was situated immediately opposite the Persian capital, Ctesiphon. It is not only that Sassanian rock-sculptures are translations of Eastern motives into a Hellenistic style; sometimes Greek motives take their place among the oriental.[2] Of Sassanian painting, which probably suggested both rock-sculpture and the minor arts, we hardly know more indeed than we do of painting in Achaemenian times, though to some extent we may infer its nature from literary references and from the character of the glyptic art which it inspired.[3] But if at Quseir 'Amra (p. 3) a predominant Greek influence amid much that is Persian derives its origin from Seleucia, we must suppose no small persistence of tradition to produce work of such quality as late as the eighth century. Connected with this is the no less remarkable persistence still farther

[1] Flandin et Coste, pl. 19; Herzfeld, *Das Tor von Asien*, pl. 21-3. In ornament Parthia may have followed Asiatic influences (p. 367). The influence which Strzygowski assigns to the Saka in the origination of domed construction is noticed elsewhere.

[2] e.g. the representation of mounted figures, and of triumphal and festal scenes.

[3] Cf. Herzfeld, *Archäologische Parerga*, in *Orient. Lit.-Zeitung*, 1919. The remains of Parthian painting at Merkez (Babylon) are under Hellenistic influence (Herzfeld, in *Der Islam*, xi, 1921, p. 154).

towards the centre of Asia.[1] The kingdom of Bactria was, indeed, over-thrown more than a hundred years before the beginning of our era (p. 37). But the peoples who invaded the country were themselves brought under the spell of Greek art ; the torch was handed on. Through Bactria must have passed those influences which, even before the Sassanian dynasty began, imposed a purely Greek style upon the Buddhist iconography of Gandhāra, and at a later time spread into Chinese Turkestan. The Greeks were fortunate in their contact with two proselytizing religions, each accepting their aid in the development of a representational art. From their bases round the Eastern Mediterranean they established their position in the Christian West. From Antioch and its sphere of influence, as from Seleucia and Bactria, they spread Hellenistic conceptions through the trans-Oxian region and Chinese Turkestan. The mural paintings of Quseir 'Amra (p. 261), dating from the eighth century, contain work of remarkable quality for such a date ; those discovered in Turkestan, together with a corresponding figure-sculpture, show us a Greek style beginning to merge in a Chinese.[2] Thus all across the continent a late-Hellenism was so active a force at the time when Christian art was in the making that it cannot be treated as a negligible factor in the process. Though we must allow for its extreme good fortune in serving both Chris-tianity and Buddhism, which between them extended across almost the whole land-mass from the Pacific to the Atlantic, it must be conceded that luck does not account for all, but that much should be placed to the account of vitality and competence. Islam, the third great religion, which came after the other two, owed in its turn a debt to Greek art in Asia ; it incor-porated in its decorative system ornamental motives which the Greeks had long ago carried far into Hither Asia.[3] The persistence of Hellenistic decoration surprises us the more when we remember the competition to which it was exposed from non-Hellenic sources. Whatever view we may take as to the real age of the North Mesopotamian churches (p. 133), the survival on their walls of a luxuriant Greek ornament is a remarkable fact. Whether we place it in the fifth century or in the seventh or eighth, the rich sculpture of these churches proves Hellenistic decoration still capable of life as far east as the Euphrates at a time when Greek art is commonly believed to have lost its reproductive force.[4]

[1] We may recall, in connexion with this point, local and occasional reinforcements received by the Greek settlers in the interior of Asia, such as those due to Sassanian de-portations into Persia of Greeks from Antioch.

[2] Traces of Hellenistic influence may be observed in the Chinese art of the Han dynasty ; thus the Greek style penetrated even China itself as early as the third century.

[3] Strzygowski believes that the persistence of the Greek palmette in inner Asia down to the time of the Arab conquests explains the singular purity of the palmette motives in much of the earliest Islamic art.

[4] In the last chapter attention will be drawn to the question as to the share of Hellenistic ornament in the development of the scroll and the arabesque. The claims made by Riegl on behalf of the Greeks are repudiated by Strzygowski, who traces both geometric scroll and arabesque to Central Asia.

The evidence of the monuments great and small in Asia and Europe alike goes to show that late-Hellenistic art retained a healthy vigour in the earlier phases of East Christian artistic development. Its power of endurance is one of the primary facts which a study of that development reveals. Though we may recognize the predominance of oriental influences in various directions, to be discussed below, we are not for that reason justified in under-estimating the Greek. It is true enough that Hellenism in the Christian East, and especially in Constantinople, was consistently helped by the favour of the Court and the sympathy of educated classes brought up on Greek literature. But in an empire where populations Greek in sentiment were large to the end, the periodic revivals of Hellenizing art were more than artificial movements imposed from above ; they answered to a feeling which must have extended far beyond the precincts of courts and universities. In later Byzantine times, the neo-classical revival which followed iconoclasm would hardly have lasted so long if the sole forces behind it had been political or social ; nor would Greek influence have survived as it did the succeeding ' liturgical ' period, and recovered after the Latin interregnum, unless it had been nourished by deep and perennial springs. The picturesque art which reappeared in the last two Byzantine centuries would not have thus returned unless it had been truly at home in the nearer East and still found there a natural soil. The secular figure-art of Constantinople, to the last faithful to personifications and mythologic fancies, never ceased to be Hellenistic ; religious art, as the comparative study of manuscript illumination shows, owed an enduring debt to the Greeks for the composition of themes and the ordering of cycles.[1] It is not our immediate task to answer the question whether this continued influence of late-Hellenistic art was a good or a bad thing, whether it might not have been better for the world if a contaminated late-Greek art had been completely dispossessed by oriental rivals less careful of natural forms, or with no care for imitating nature at all. Our business is merely to insist upon the fact that late-Hellenistic art did actually last throughout the thousand years of the Byzantine Empire, not merely as the amusement of emperors, nobles, and officials, or as the accomplishment of metropolitan schools, but as an influential force representing the taste of a large Greek population. We know the worst that can be said of it. Idealism it had sacrificed to a graceful and generalized naturalism. For austerity and aspiration it had adopted the mere desire to please. It was generally a facile and rather shallow art of superficial intellectual sympathies, absorbed

[1] It has become usual in recent times to depreciate the part played by Constantinople in the development of Christian art. Though the capital was not in the primary sense creative, yet, as in the case of later capitals, the stimulus of its metropolitan life may have maintained conditions favourable to artistic life. Even though the material on which it worked was not strictly its own, while many of the artists were resident aliens, or provincials, it provided a quickening atmosphere, and this, after all, is to have a share in creation. Cf. p. 44, below.

in copying nature and too often content with the cliché and the common-place. It evaded the hard realities of life, staking all upon grace and charm ; it was an art averse to deep feeling. All this may be true, but this art must have had an approving constituency, and there must have been qualities balancing these shortcomings. No art ever lived a thousand years on negative virtues or positive defects.

The importance of the Greek element in East Christian art is most easily traced in the graphic arts and in sculpture because the evidence of these is obvious. In the field of architecture there is more obscurity. Did this art, by which the Christian East was most distinguished, win its greatest triumphs with little or no assistance from the Greeks ? Was the part played by this people, so extensive in other arts, insignificant in this case alone ? The argument has been developed with great brilliance ; but it is difficult to accept without reservations. The problems which confront the student of Christian architecture are stated in another chapter (pp. 70 ff.), where it will be seen that different schools of thought stand over against each other in irreconcilable opposition, calling upon the perplexed layman, sometimes almost with passion, to take sides with them or against them. Perhaps the time is not really ripe for absolute decisions. The spade has still so much to do in Asia, the explorer has still so wide a field to traverse, that a final judgement, here and now, is premature. Greek influence cannot be definitely ranged among negligible factors until we know much more than we do about the buildings erected on the sites of great Hellenistic cities. There are serious practical difficulties in the way of attaining such knowledge. But until it is attained it is wise to remember that at present all the facts may not be before the court, and that, however confident the opposing counsel, the judge may not be satisfied ; he may order the post-ponement of the trial pending the completion of the evidence.

Greek influence upon Christian art was active and persistent, but it was only one influence. It was impossible for Greek modes of thought or expression to satisfy the Christian mind. Christianity was oriental in spirit and in vision. It was concerned with the person in his experience and his redemption ; in art it sought the spiritual meaning beneath the surface of things. For this penetration behind the veil Hellenistic art could be of little service. It was a secularized art of generalizations, of smooth-worn types, of idylls and myths, of graceful shapes and of the picturesque, of balance and logic, of selection and arrangement. To such an art indi-viduality was an intrusive and disturbing factor, the expression of ardent personal emotion almost a vulgarity. It could never render what Eastern Christianity was determined to see expressed : the character, the inward difference of things, the emotion of the individual soul. If art was to serve the new faith, there was needed a new informing power, and the assertion of other nationalities than the Greek ; the Hellenistic vision playing over the surface of natural appearance could never suffice for Christendom.

New racial influences had to intervene, disturbing the still stream of antique art. Of these the first was the Semitic, and its agent the Aramaean people.

The Semitic peoples, and those of different race united with them in a common discontent with the Greek conception of the visible world,[1] occupied a wide belt of interior country, extending in a semicircle behind the Greek coast lands from the Anatolian plateau, round by Syria and North Mesopotamia, to Palestine, the Roman province of Arabia, and the Nile Valley. This great area included the homes of the ancient monarchies, traditions of which survived in popular memory long after they themselves had passed away, and had their inevitable reaction upon art, teaching men still to regard it as an instrument for the exaltation of kingly and divine power.[2] The display of the King's majesty, the setting forth of his conquests or his personal prowess, and of his near relation to the gods—all this was in the ancient days the task and obligation of the artist, Egyptian, Babylonian, or Assyrian; even Hellenistic art had not escaped it, though here the association between kingship and divinity was more superficial and probably less sincere. But this glorification of the royal and the divine was only one evidence of a general psychological difference, and of an outlook distinct from that of the Greeks. Semitic feeling, partially suppressed under the Diadochi, had long been gaining ground as the Greek kingdoms weakened. Its influence rapidly increased with the spread of Christianity; it now flowed strongly into Greek centres, and there challenged the Greek prerogative. The cheerful Hellenistic satisfaction with the present world was no part of this philosophy; the Semite suspected the present world; he drew a sense of mystery and magic from a belief in a world beyond it, the forms of which need not always resemble those which we see. Aramaeans thought little of grace and beauty, restraint or measure; they did not select the things which charm the eye, but sought to bring out the essential meaning, eager for the immediate impression unchilled by the touch of the interpreting mind. It was not their aim to modify the strength and violence of feeling, but to render it in its warmth and fullness. Thus where Hellenistic art was gracefully naturalistic, Syrian art pursued the real; it would dissimulate nothing, and make no sacrifice to pleasing conventions. It revealed a strong rather than a subtle dramatic sense, openly displaying extreme emotions, and hiding nothing because it was unlovely. The Semitic mind had other qualities tending to estrange it from the art of the Greeks. It loved a story, not composed with a careful eye for logical construction, but told as it came to the lips, and from end to end; it loved the legendary and the marvellous, and placed no limit upon episode. It was the mind for which the canonical accounts of Christ's life were not enough, the mind which created the apocryphal gospels. The Hellenistic and the

[1] Among these are not only the population of inner Asia Minor, but also the Copts of Egypt.

[2] The long survival of this idea has been particularly noted by Prof. Bury (*The Hellenistic Age*, pp. 14, 15 : Cambridge, 1923).

Aramaean factors in Christianity were antithetic. On the one side were intellectuality and cleverness, selective composition, logical arrangement ; on the other, ill-trained zeal, love of narrative for itself, acceptance of things in the order of their event. On the one side, restraint, and the desire for grace and balance ; on the other, fervour, and the resolve to reach truth in emotion, however ugly the reality. On the one side, pleasing artifice ; on the other, sincerity, ruthless and severe. Late-Hellenistic art was accomplished and composed, but paid for refinement in shallowness ; Syrian art was without academic skill, and often crude, but strongly dramatic and intense. The one was essentially secular, the other essentially religious ; the one appealed to eyes trained in schools, the other to the general heart of men. But it was precisely this heart which Christianity sought to reach.

Was Syrian influence confined to representational art, and were the Semites without a formal ornament of their own ? It seems unnecessary to make so radical an assumption. It is perhaps doubtful whether any race or people is capable of nothing but representation, or nothing but formal decoration ; it is more than doubtful whether the inhabitants of a long-civilized country can be labelled as representationalists pure and simple. Even were they of a wholly unmixed strain they might belie the description ; they cannot but do so if they occupy a land like Syria, crossed by trade-routes and penetrated for centuries by diverse influences from beyond their borders. It matters little if the seed that germinates on their soil was first carried there from a distance ; if it is multiplied through many seasons the harvest belongs properly to the land that bears it. It may be that, centuries before Christianity, contact with Assyrian civilization,[1] or with an Iranized Cappadocia, or with Egypt, implanted or awakened taste for ornament in Syria. But by the time Christianity demanded her own art, that country surely made her own contribution to abstract ornament no less than to the dramatic rendering of historical subjects. Few would wish to deny the value or importance of later waves of influence, bringing fresh schemes of abstract decoration from the East. But these waves may have found their way into old channels ; they supervened, reinforcing what was already in existence, but overshadowed by a more conspicuous form of art.

The Hellenistic Greek and the Aramaean factors were both so strong and so attached to their own principles, that neither could be called upon to withdraw in favour of its rival. The Church had no course but to demand a compromise between the Greek and the oriental points of view.

[1] It seems difficult to deny either to Egypt or to Assyria a sense for conventionalized form, for colour-contrast, and for continuous pattern geometrically designed. The pleasure which they took in polychromy is obvious ; and whether they reached geometrical design from a starting-point of naturalism or not, they did not fail to attain it. Both Egyptians and Assyrians made cloisonné gold jewellery with regular effects of massed coloured stones ; they did this for no other end than the aesthetic pleasure which they derived from the massed colours. Their reason was, in fact, identical with that which in later times actuated Central Asian nomadic peoples. Cf. Ch. VI, below.

If the Greeks did not wish to see a new ecclesiastical art committed to hands which they regarded as barbarous, they had to accept the arrangement and submit their art to a 'contamination' greater than any yet experienced. If the Aramaeans needed the help of Greek technical accomplishment and Greek power of composition, they had to accept the aid of a people which may have seemed to them worldly and without depth of feeling. On grounds of expediency they complied with the demand; a new and definitely Christian art, which may be called Syro-Hellenistic, came into existence. It was a mixed art; the proportion of the two chief component factors, the Hellenistic and the Syrian, varied according to locality. On the Mediterranean seaboard, where the Greek element was large, the style and composition might be almost wholly Greek, and the Eastern influence little more than iconographical. In Palestine, on the other hand, in Syria, Mesopotamia, or Upper Egypt, that influence would be strongly asserted against the Greek, not only in content but in form and method. The East had always one advantage over its rival, of signal importance in the first centuries after Constantine: it was the home of monasticism, the great missionary force in Christendom. The first monasteries were founded in the East; and in the coenobitic houses, where art and learning were pursued, the Aramaean influence was strong from the beginning to the end of the Byzantine Empire. It was the monks of these houses who carried Christian art into East and West alike, and the form of representation which they diffused was one in which the Syrian factor was first and the Greek second. Monks trained chiefly in the Aramaean theological schools of Edessa and Nisibis flocked to the religious houses soon founded in numbers in Palestine. From the fifth century it was they who determined Christian iconography, and imparted to its artistic expression the un-Hellenic qualities to which attention has been directed. Their intercourse with the monasteries now rapidly extending through the West ensured there also the prevalence of the Syrian point of view, and every pilgrim returning from the Holy Places became in his degree a representative of Syrian theory and method. Entrenched in strength in North Mesopotamia, they controlled the art no less than the doctrine of monastic Cappadocia and Pontus; their voice was heard in Armenia, their influence penetrated Central Asia and even China. To this Semitic art the Jews of Palestine contributed but little, for, after the first two generations, as a nation they held aloof from Christianity and preserved their ancient faith. Jewish influence on Christian art was exerted rather through the Hellenized Jews of the dispersion in Alexandria, Antioch, and other foreign cities; it did not affect the style or form but only certain aspects of the matter and the spirit. But these Jews contributed to the body of Christian thought apocalyptical and magical ideas, conceptions of the celestial hierarchy which found their reflection in Christian art; in a general way, despite their association with the Greeks, their deeper feelings were nearer to those of Syria. The position of the Copts was in some ways

similar. They were not, indeed, Semites, and, in so far as figure art was concerned, were largely dependent upon Alexandria. But their conception of the visible world was more akin to the Syrian than to the Greek; and from the fourth century Aramaean influence spread rapidly through the Holy Land into Egypt. The ancient art of that country was for the most part neglected under this pressure from the north-east. But it was not wholly forgotten; and since many of its principles were congenial to the superseding art, we find reminiscences of ancient practice; parts of the old mythology were taken up into the new system, and familiar old forms assimilated to those of Christianity. We find links between the conception of Osiris, Isis, and Horus, and that of Christ and the Virgin; the types of the mounted saint and of the *orans* have been associated with Egypt; the *ankh* became a substitute for the cross; the beast symbolism of the old belief was in part adopted by the new.[1]

The influence of the Mediterranean Greeks and of the Aramaeans upon the development of a distinctively Christian art was thus of primary significance; their uneasy alliance endured down to the last years of the Byzantine Empire. But their influence may not have been the only factor. Strzygowski has pointed out that Christianity crossed the Euphrates before the Church had become a centralized power eager to enlist art in the service of didactic religion. In Persia, in Armenia, and in Northern Iran the first Christian communities may have encountered and adopted an art differing in character from that of Syria and the Hellenistic cities, an art not aiming at representation, but based upon formal design, sometimes admitting natural shapes as symbols, but in general using them as conventional parts in a system of geometrical ornament. We have suggested above that some of the features characteristic of Iranian art may have been already present in that of ancient Mesopotamia, the tradition of which seems certainly to have survived in Syrian representation; that a definitely Iranian influence may have penetrated Northern Asia Minor long before the Christian era; and that such facts may in great part explain certain influences underlying Syrian art between the fourth and sixth centuries, without the need for supposing a fresh Iranian importation. Strzygowski does not thus recognize the Mesopotamian claim, and regards the Iranian influence as coming directly from contemporary Iran into a country given over to the representational system. In his opinion, two racial influences met about the middle of the second century B.C. in the region between the Caspian and the Altai, destined by their alliance to modify the whole character of medieval art. The first was that of the nomadic Saka, a late Sacian (Scythian) tribe closely allied to the Parthians, which had just conquered the Greek kingdom of Bactria; the second was that of the Turki or Mon-

[1] The old Egyptian features introduced by the Copts into Christian iconography are well summarized by O. Wulff (*Altchristliche und byzantinische Kunst*, pp. 143–4). Cf. also P. D. Scott-Moncrieff, *Paganism and Christianity in Egypt*: Cambridge, 1913.

golian nomads encountered by the Saka in the 'Altai-Iran corner'. From this region the influences issued along two lines.[1] A southern line ran through the trans-Oxus country and Iran round the salt desert to Arabia and Egypt, and was primarily that followed by ornamental ideas and motives of Turkish derivation. The second line passed through North Iran and the Caucasus to the Black Sea, and thence to Northern and Western Europe. This second line was primarily Sacian, and therefore the chief line of Indo-Germanic [2] (North Iranian) influence. Its contact with Armenia revolutionized the architecture of the Christian world by introducing the dome over the square bay [3] (p. 80); its contact with Europe through the south of Russia introduced the style of ornament which we associate with the time of the great migrations, a style which found congenial soil in parts of Europe as yet unschooled in representational art.[4] Particular stress is laid on the fact that both Sacians and Turks were nomads, for it is an essential part of Strzygowski's theory that the nomadic life is naturally favourable to an art of geometrical ornament.[5] Until the beginning of the great migrations, Central Asian influence followed the lines of peaceful penetration, but it was then carried on by a broad tribal movement into the heart of Europe. In South-western Asia, the arrival during the seventh century of the Arabs, a Semitic nomad people with like ideas as to artistic methods, secured a complete triumph for the Iranian and Turkish style. The Altai-Iran corner is thus to be regarded as the home of Islamic art no less than of the great domical architecture of the West; this region, and not the South-Iranian territory of Persia where the Sassanian dynasty arose, seems to Strzygowski in both cases the creative centre.[6] But he holds that certain motives suggested by the text of the *Zend-Avesta* united with forms of decorative ornament to constitute a Mazdean symbolic art which acted directly on that of Early Christianity (p. 232).

The insistence by Strzygowski on the importance of the region between the Caspian and the Altai may be accepted as yet another service rendered by this distinguished scholar to the study of East Christian art. But many may be disposed to think that he does not make sufficient allowance for the

[1] *Altai-Iran*, p. 187.

[2] It should be noted that Strzygowski freely gives an ethnological sense to the word Aryan, which English writers commonly use as a philological term. In the present volume Indo-Germanic is substituted for Aryan where an ethnological meaning is intended.

[3] As stated in Ch. II, p. 80, almost all the domes known to the ancient civilizations were placed upon circular walls. The Iranian dome, translating the roof of the Aryan wooden house into terms of sun-dried brick, was again translated into stone by the Armenians, by whom, in Strzygowski's view, it was introduced into the Byzantine Empire and into Europe.

[4] Rostovtzeff assigns to the Sarmatians the part given by Strzygowski to the Sacians. The former had been in Russia before the Christian era.

[5] It has been suggested above that the truth of this proposition need not imply that of the converse; that settled life is unfavourable to formal geometrical ornament.

[6] Sassanian art, as already noted, was largely influenced by Hellenistic. In the transmission of the dome over a square bay, the Armenians are held by Strzygowski to have been the chief intermediaries between Iran and the Byzantine Empire.

already mentioned earlier infiltrations from this area into Hither Asia, by which the soil was prepared and the rapid success of later influences from the same quarter assured ; and that he may in like manner under-estimate the capacity of Syria to develop a decorative art of her own, an art which, as has been suggested, Assyrian tradition may have also enriched. For we seem to find geometrical surface-covering designs, conventional beast-ornament, and a love of polychromy all present in Assyrian art, the influence of which upon Scythia is sufficiently well known.[1] Thus Assyria, and a more ancient Northern Iran than that of the Saka who conquered the Greek Bactrian kingdom, may have combined to implant in Syria at a remote period artistic qualities which, upon Strzygowski's theory, she only received from the East in later times. Without denying the great impor-tance of the reinforcement, these critics somewhat discount its value ; in their view it need not have come as a novelty ; it may have supervened as like to like. They suspect that since the earlier Scythians and Sarmatians were probably not of pure Iranian blood, but already had a Mongolian strain, some Turki influence may have been present in Eastern Asia Minor before the Christian age. They find that both in the assumptions with regard to a domical stone architecture in Armenia as early as the fourth century, and of a Mazdean symbolic art, the argument from presupposition or retrospective inference is used with some temerity, since no remains of Armenian buildings dating from that period have yet been discovered,[2] and the examples of Mazdean symbolism, in some cases at least, are open to question. In the case of architecture and of ornament they find the evidence more convincing for the period between A.D. 500 and 1000 than for the earlier centuries. They feel, therefore, as mere pedestrians, that for the present they would do well to walk with caution, and not to be carried off their feet by too prompt a surrender to a winged enthusiasm. But while they may adopt this procedure, they may freely express their admira-tion for the wide research and the command of the comparative method of which Strzygowski gives continual proof ; they feel that his claim to have enlarged the horizon is fully justified. They hold it a good thing that every influence which can have contributed to the development of Christian art should be brought out and passed in review, in order that we may judge what is sound and what is not. The process is a healthy one ; it seems to give us, in place of the confined atmosphere of catacombs, the fresh breezes of the steppes. Exclusive preoccupations, such as a too fervid local patriotism, or an academic tradition too conservatively held, lose importance when measured by a larger scale. Closed doors are opened ; new paths are made where formerly impassable barriers seemed to rise. Enthusiasm

[1] The custom of covering brick buildings with some kind of facing, generally decorated, was common to Egypt, Minoan Crete, Assyria, and Persia. It was an obvious device, partly decorative, partly economic, which can hardly be regarded as of North Iranian invention.

[2] Cf. G. Tschubinasvili, *Monatshefte für Kunstwissenschaft*, 1922, p. 222.

may carry theory too far ; too great a relative influence may be assigned here, too little there ; but at length the world, the οἰκουμένη of Early Christian times, has been surveyed for the purposes of Christian art, which, indeed, requires nothing less. We are reminded, as we ought to be, that since Christianity was world-wide, its art may have been the same. If it was ever to be a language universally understood, it could not but receive suggestions from the various countries in which Christian communities were found, and adopt such as particularly suited its needs. For the establishment of this point Strzygowski has done more than any other scholar. The analysis of the vague term 'oriental' into plain constituents, and the attempt to determine their respective influences, is in itself a service. We have now more definite Eastern factors to set over against the Hellenistic ; their very clash and interaction make it impossible to regard the earlier Christian art as nothing more than antique art in decay. There is little in the history of Western and Central Asia to justify the idea that these homes of ancient culture had lost all power of spontaneous action because princes of Macedonian descent asserted their Greek sympathies for about three hundred years. As the frontiers of research are extended, it grows more evident that the Hellenistic factor, important though it was, does not stand alone ; that in fact those aspects of Christian art which are most individual and arresting, which furnish its most distinctive character, were largely of non-Hellenic origin. The emergence of a Christian as distinct from a classical art was thus determined by the sheer force of circumstances. How, indeed, could a religion which cut across the frontiers of ancient civilized races, but at the same time sought to include all in a single fold, how could a religion of this kind fail to embody their several characteristics in the sacred art which it organized for the use of all ? Hellenistic art could not be the sole factor. With the union of Syrian, Coptic, Mesopotamian, and Iranian elements with the Greek, inevitably there came into being an art neither Greek nor Syrian nor Iranian, but a synthesis of all ; and since the uniting force was Christianity, it is properly described as a Christian art. The existence of a distinctively Christian art could only be denied as long as its forms were regarded as merely Graeco-Roman forms in degradation. But the great and vigorous art of the Middle Ages could never have grown so luxuriantly from a withering root.

Those whose studies have perforce led them into several archaeological provinces and into different periods of development will be less dismayed by the progressive expansion of the horizon than those who have remained constant to the narrow field once traditional in the study of Christian antiquity. They know that motives of Minoan art may well have reached China in the second millennium before Christ ; that in the first millennium, Assyrian, Persian, and Greek motives crossed the Caucasus and the Black Sea to the north, while Greek influences from the Mediterranean seaboard penetrated Hither Asia from Iran to India and Turkestan,

and Central Europe from the head of the Adriatic. It is now a common-place of archaeology that culturally, no less than physically, Eurasia was from the remotest times a single continent, traversed by many influences flowing in more than one direction.[1] It is time to realize that it would have been strange indeed had such a state of things abruptly ceased after the coming of Christianity, when Rome had made communications better than ever before. When the matter is considered in this light, the existence of Asiatic influences in Early Christian art is no matter for surprise; it is, on the contrary, the obvious result of natural causes.

The recognition of non-Hellenic modes of vision and of new and remote centres acting upon Christian art could not but prove distasteful to those who ascribe the whole initiative to Rome, or to the Hellenistic centres from which Rome drew so much of her artistic life. Those who would assert on behalf of Christian Rome claims wider than any made by antiquity itself are probably a decreasing number. Yet though the pagan art of Rome was more strongly marked by Italian genius than that of the Early Christian period, the ancient Romans recognized their debt to Greece in the arts no less than in letters. They claimed little more than the adaptation of Greek ideas to the Roman genius; by Roman art they largely meant an art assimi-lative in this sense. Such a view, at once dignified and just, erring, if anything, on the side of modesty, was probably shared in their humbler degree by the first Roman Christians with reference to their own limited artistic effort; it might not have occurred to them to formulate the exclusive claims so long made on their behalf in modern times. In the following chapters Rome will be considered in the light rather of a foster mother than of a mother, developing and cherishing qualities to which she had not given birth. But the belief that Rome did not lay the foundations of Christian art is not inconsistent with the view that she developed an adopted Hellenistic art on individual and often most majestic lines, and that at times her influence returned upon those Eastern provinces of the Empire from which she drew her first inspiration.

In the reign of Justinian a certain equilibrium was reached between the different racial and other factors contributing to the eclectic art of the Church. But after the death of that Emperor the balance was disturbed in the stormy period of the Persian wars and of iconoclasm. At the end of these troubles there began a prolonged period of unrest, in which oriental and Hellenistic factors acted and reacted upon each other, gaining or losing as conditions of time or place gave one or other the advantage, but never to the extent of endangering the compromise to which they were com-mitted. The opposing forces were not unequal. But taking the whole duration of more than five hundred years, we find the Hellenistic element

[1] Though during the first millennium of our era, especially in its second half, the move-ment was generally from East to West, if we review the whole course of history, this cannot be taken as an invariable direction.

in the end more strongly asserted than its fortunes during the early centuries might have led us to expect. A critic has said with truth that down to the time of Justinian the movement of the arts betrayed a progressive orientalization ; to this he added the further opinion that after iconoclasm the process was reversed, and that Hellenistic principles recovered much of their lost ground. Before we give reasons for agreement with this verdict, it is necessary to touch upon the iconoclastic period, and its effects upon art in the Christian East.

The first disturbance of equilibrium was introduced by the growth of ikon-worship, which meant less the worship of images or statues than the veneration of sacred paintings, since in the seventh century the art of the sculptor was already in decline. This veneration may have had its birth in the wonder-loving Syrian spirit ; at any rate, it was powerfully furthered in the monasteries, where the Aramaean element was especially strong. Its progress soon awakened fierce hostility in regions of Western Asia opposed to 'images' of all kinds, notably the eastern part of Asia Minor towards Armenia. The enemies of pictures waited their opportunity with growing exasperation. It came after the Arab conquests in the first part of the seventh century, which followed earlier losses at the hands of the Lombards in Italy, and the exhaustion of the Persian wars. A feeling of soreness and humiliation was general and natural, when men saw the empire stripped of the great provinces of Syria and Egypt, and the Holy Land itself left under the dominion of Islam. In this feeling the elements opposed to ikons saw their advantage.[1] Many of those who had fought in the Byzantine armies had been embittered by the abstention from national defence of the able-bodied monks in the religious houses throughout the Empire ; and an obvious association of ideas might well suggest to them that since the monks were the especial champions of picture-worship, this worship was itself a contributory cause of imperial decay. It was easy to contrast with monastic defection the furious valour of the Arabs, and to remember that this was kindled by a faith which forbade the representation of God. The connexion of victory with contempt for image-worship, and of defeat with devotion to it, seemed to angry minds more than a coincidence. Political and religious feelings thus combined to render iconoclasm a formidable and concerted movement against a practice honestly regarded as a cause of national disgrace, and a source of danger to the State. In this way art was entangled in the mesh of politics. But the Arabs, though rejecting sacred pictures, were by no means hostile to decorative art. Though they had little art of their own, they were charmed by rich ornament, and this

[1] The feeling against representation of sacred persons in art prevailed in Buddhism before Greek influence affected its art, and Strzygowski has put forward reasons for thinking that in Persian Mazdaism a like antipathy existed. The sentiment was widely distributed even among sedentary peoples in Asia ; while among the nomadic tribes of the steppes it was more general still. There was thus a great weight of opinion in the Eastern world as a whole behind the movement within the Byzantine Empire.

they found in profusion as they advanced into Asia. The iconoclasts had naturally turned their attention to ornament ; partly influenced, perhaps, by its distinction from a sacred art associated in their minds with humiliating thoughts. Had they proved victorious, they might have raised it from a subordinate place to a dominant position in the Christian East, and later Byzantine art, possibly even the art of Western Europe, might have borne a strong resemblance to that of the Mohammedan East. Even as it was, Byzantine ornament, through increase of oriental influences, assumed a close relationship to that of Islam.[1]

They did not win the victory, and their indirect support of a non-representational art was followed by a reaction in the opposite sense. From beginning to end, the struggle lasted, with intermissions, more than a century, the emperors standing now upon one side, now upon the other. But at last the disciplined and obstinate resistance of monasticism, in spirit the same in every region, broke down a movement less consistently supported. The end was perhaps hastened by the fact that representational art had other than religious aid. The educated classes among the Greek population of Western Asia Minor and the capital were not in sympathy with iconoclastic forms of expression ; and, for the moment, the immunity which their secular art enjoyed was indirectly to the advantage of pictorial art. The iconoclasts had paid little heed to the Greeks, whose mythological and idyllic subjects continued to be reproduced without hindrance. But when the struggle was over, the Hellenizing element in Constantinople had become so much stronger that the Hellenistic factor, even in religious art, was relatively more powerful than before. In the time before Justinian it had stood on the defensive against the oriental ; it now did more than hold its own. When the monks regained influence, they found that the Greeks, who had not shared the burden and heat of the day, had established themselves in an impregnable position ; Hellenistic art had fortified itself, and was now less pliable than before. In the reduced empire over which the

[1] In Europe west of the Byzantine Empire iconoclasm had been rejected ; there was neither a prolonged religious struggle for or against sacred pictures, nor a conflict between artistic principles absorbed into a religious quarrel. Rome remained unmoved by the upheaval in the East, and the Christian West followed her example. The Syro-Hellenistic art now implanted in Italy was strengthened by an influx of Byzantine refugees ; from the beginning the adversaries of sacred art had no prospect of enduring success. But though there was no bitter struggle for supremacy in Europe, non-representational art remained strong in the unconverted countries of the North, in Ireland, and in those parts of England and continental Europe where the Irish missions of the sixth and seventh centuries had brought traditions of Celtic decoration. The old Teutonic and Celtic principles of design, which had always subordinated figure art to decoration, persisted ; in this they were essentially the same as those of Asia now adopted by Islam, and not destined to be overcome until the extension of the Frankish power and the spread of missions connected with Rome brought with them a religious and historical art based upon representation. In the south of Europe, as a result of Mohammedan conquests, Spain and Sicily may almost be regarded as enclaves of Islamic art. But if the iconoclasts had triumphed at Constantinople, the European flank of sacred representational art might have been turned.

Macedonian dynasty began to reign, Constantinople bulked even more largely than at earlier periods, and not only the Court but the whole governing class of the capital continued Greek in sympathy. The tenth century was distinguished by an intensive study of classical literature, of which a revived Greek art was the natural corollary. Thus began in Constantinople what has been described as the Byzantine neo-classical period, in which a general reversion to Greek models left its obvious mark both on the monumental and the lesser art of the time. This new Hellenism was too strong and too fashionable, in many ways too meritorious, for monastic and ecclesiastic art to overthrow; it could only be counteracted. There were times when the monastic party had even to witness the intrusion of an almost purely secular Hellenistic art into sacred illustration, as in the case of the 'aristocratic' psalters (p. 307); they had to tolerate an enhanced Greek influence in the old compromise. Such art, which copied early Alexandrian models, has the spirit of the Hellenistic age. But the obstinate patience of monasticism, and the long tradition of the Church, to which fashions and phases were of no account, had powers of resistance which could not be overcome. In the eleventh century oriental influences were once more successfully at work. Whatever the lettered class or the Court might desire, it was impossible for Byzantine art to be wholly Greek. In the capital itself, the citadel of Hellenism, stood the monastery of the Studium which had played a leading part in a successful resistance against the iconoclast emperors. Bound to it by ties of common thought and sympathy were all the monasteries in the provinces, notably those of Cappadocia, resolute upholders of old Syro-Palestinian tradition. The cause for which these collectively stood received an access of strength even from monasteries now outside the Empire, such as those still existing in Palestine, where the caliphs had not put an end to monastic life. The formidable strength of monasticism, ceaselessly exerted, began to readjust the balance between the Hellenistic and the oriental elements. The roughness and uncouth vigour, the disarming sincerity of the old Syro-Hellenistic art were not indeed restored; the Hellenizing tendency of late years was too strong ever to permit its return in its pristine and spontaneous force. But the academic naturalism of the Greeks was prevented from dominating religious art.

The Greek element was relatively stronger than in the age before iconoclasm. The study of ancient models had based resistance on better foundations. The revived Greek style of the Macedonian and Comnenian periods was able to contribute something more than the physical grace of the fourth-century Hellenistic manner; it had gathered to itself much of the gravity and strength of an earlier age. These qualities imposed themselves upon Middle Byzantine expression. Their influence excluded the clumsy forms of the sixth century, which continued only in religious centres in remote provinces where the power of the capital was not felt. They

lent a dignity and graciousness, a restraint and balance, an undisturbed refinement, which became notable characteristics of Byzantine design in its maturer period. They grew into harmony with religious emotion; they had a seriousness which the work of Hellenistic times had not possessed. Though there may be exaggeration in saying that in its later centuries Byzantine art was systematically and progressively Hellenized, it is certain that a thorough and complete orientalization was now no longer possible.

In the eleventh century the Church drew closer than ever before the links connecting sacred art with ritual; in the history of Byzantine art the period which now ensued is sometimes described as the liturgical period. The new compromise in ecclesiastical art passed into its most durable phase under the shadow of this movement. The influences which now prevailed were less and less favourable to originality. The rules by which liturgy controlled art were codified like laws. In one of the interludes of the iconoclastic struggle the Church had decided that the composition of the subjects decorating the walls of the sacred building did not concern the artists, who had merely to follow a scheme ecclesiastically prescribed (p. 242). She now in her enhanced authority enforced this principle; and since the scenes relating to the feasts of the ritual year were regarded as mystically connected with the rite itself, to alter or recompose became almost impiety; the accepted design was sacrosanct. In the compositions thus dictated, the strength of Hellenism is shown by its continuous effect upon style. The Eastern influence still dominated the content; the iconography of this art remains largely Syro-Palestinian in its details, transmitted in great part through the living influence of Cappadocia. But though old oriental methods such as inverted perspective were readmitted, Greek influence controlled form; it was more powerful in some places and at some times than others through the action of special causes, but as a whole it did not tend to diminish. The Middle Byzantine style is distinct in general character from that of the sixth century; the position of the two contributory factors was changed; the Greek element was now rather the more active of the two.

The new compromise reached a comparative stability in the eleventh century, but lost the capacity for further active change. Since forms of art, like physical organisms, must either grow or begin a gradual decline, Byzantine art after a short stationary period declined, and the change corresponded in a general way with the dwindling fortunes of the Empire. The great captains, Nicephorus Phocas, John Zimisces, Basil II, were gone, and with them the energy which had restored the prestige of the imperial arms and once more extended the frontiers towards the East. The Byzantine standards which had been carried into Armenia were by degrees withdrawn; those of the Seljūk Turks advanced. At home there reigned the spirit of immobility which finds its expression in ceremonies and displays, the spirit of an Alexius Comnenus and his Court. All this was

reflected in the art of the century preceding the invasion of the Crusaders from the West. The springs of progress dried up ; there was no longer any power of organic growth ; the only change now possible was a passive acceptance of external forces. Religious fervour was absorbed in formal preoccupations. The liturgical system, by controlling design, led to the production of manuals, or painter's guides, in which the path to be followed was exactly traced ; the composition was stereotyped, the very colours were prescribed. As the Comnenian period advanced, sacred art became itself a kind of ritual, memorized and performed with an almost unconscious direction of the faculties. It no longer had fire or fervour ; it moved insensibly towards formalism. The method of the average monastic painter was doubtless much the same as that which Didron saw in operation on Mount Athos.[1] Yet this art was saved from insignificance by the excellence of its tradition ; the designs which it reproduced had rhythm to which both Greek and oriental feeling had contributed. The artists, men from various parts of the East, sometimes from Cappadocia or Armenia, often had the Asian feeling for line and colour which breathed mysterious life into their work and transformed the prescribed subject of the manual into a decoration full of a strange and serious charm. Its worth, even in those phases which provoked the scorn of eighteenth-century critics, has been recognized in modern times. In its detachment, it possesses something which Graeco-Roman art never attained. It is still judged indeed, but no longer by hanging judges. Those who discover in it the merits of abstract design perceive a certain irony in its development. These compositions, intended to hold the fullest dogmatic and mystical intent, passed into a formal scheme ; all the artist in the monk, forbidden to express his personality by individual creation, was driven back upon pure design. Thus ecclesiastical prescription defeated its most cherished end. The didactic picture turned, as it were, against those who had devised its fixity ; it became hardly less a pattern than the ornament by which it was accompanied or framed. The very methods enforced to ensure sacredness made an end of sacred representation as a teaching system. They left the Church with an art, but an art of which the aesthetic principles were in some ways akin to those governing the contemporary decorative art of Islam. The spectator who considers the formal painting of the twelfth century finds it admirable less in its power to quicken religious emotion than in its quality as design. A change in this art could only follow the impact of some external force, and this came with the Fourth Crusade.

The capital was occupied by the Latins for fifty-seven years, from 1204 to 1261. Byzantine princes fled to Nicaea and Trebizond ; a Greek despot established himself in Epirus, but Frankish principalities spread through other parts of Greece. Old traditions were broken ; the artists of Constantinople and those of Salonika sought new fields in the now powerful

[1] Cf. *B. A. and A.*, p. 247.

Serbian kingdom, or joined those already established in Venice ; there was a *diaspora* of the painters. These missionaries of Byzantine art gave direction to the Slav schools, the full achievement of which at a rather later time we are now only beginning to understand. From Venice they moved through Northern and Central Italy, guiding the early steps of the Italian painters. The dispersion brought them into contact with other peoples and with other modes of thought. The thirteenth century in the east of Europe was a time of movement, of the circulation of ideas, of a general change in sentiment. Interest in human life, with its moving destinies and infinite variety, was inevitably quickened ; humanizing influences were diffused, which in the field of religious art worked to the disadvantage of a rigid liturgical style ; it was a period in which lay painters multiplied. The Byzantine genius entered in its old age upon those years of wandering which are more commonly the privilege of youth. It had been too much confined ; it now saw and appreciated the wider world. Under such conditions the interregnum could never have been an empty interlude. It was in more than one sense a seed-time ; unhappily the seeds were too various and too confusedly sown.

When the Empire was restored, it came back to a changed world. The old order could not be replaced as it was before the coming of the Franks. Two generations of foreign rule, neither sympathetic nor orderly, had deeply disturbed the quiet course of existence. The succession of artists through whom tradition lived had been broken. Much of the talent which might have best helped to re-knit old threads and restore continuity in a difficult conjuncture remained in Serbia and in Italy (p. 236). Such influences as reassembled after the restoration to guide the art of the Palaeologi were at first themselves disordered. There was a longing for a national expression, for a reassertion of a Byzantine life. There was an eager desire to go back to old models ; the deliberate reversion to these in some ways recalls that which had followed the earlier disturbance of iconoclasm. Now, as then, many circumstances favoured the Hellenistic factor, though not altogether for the same reasons. The thirteenth century had all over Europe witnessed an emancipation from the sole dominion of monastic schools ; such a process of detachment had taken place not only in Italy but in the Western countries where the greater artists were no longer always monks. Constantinople, whether willingly or not, was now more European than before, the secular element was relatively stronger. But an increase of the secular element in the Eastern capital always meant a verging of the scales in favour of Hellenism. The quickened interest in human life and the scenes upon which its drama was played encouraged the picturesque naturalism of the old Hellenistic art ; it was adverse to the formal ecclesiastical traditions of the monasteries. It is certain that the trend of the last two Byzantine centuries was once more towards a revived interest in the visible world as the theatre of human action and passion ;

what remained of the old Syrian dramatic force might play its part, but the methods and forms adopted for expression were those of Hellenistic rather than those of Syrian practice. There was a return towards modelling, towards perspective, towards the embodiment of 'scenery' as an organic element in presentation. The change was not due merely to contact with the West, though this was a factor of increasing importance. The movement was general, and resulted from a gradual development of thought and feeling to which the east of Europe now made its own contribution. Thus there was a reinforcement of the influences which in the preceding period had lent the mosaics of Daphni their peculiar quality, and more recently had revealed themselves with less restraint at Monreale. On the walls of Kahrieh Jami and of the Mistra churches, in the pages of illuminated books, the spirit of the new age became articulate, and its voice was no longer the liturgic voice of the Middle Byzantine period. It is interesting to ask what the result might have been had the Turkish peril dissolved, had the restored Empire regained a sound economic basis and succeeded in prolonging its life, not for a troubled span of less than two hundred years, burdened by impoverishment and in the perpetual anxiety of invasion, but through a long period of prosperity and peace. Such speculations are perhaps of little profit. But at least it seems certain that if the secular power had survived and prospered, the old liturgic system would not have been restored in its old power. Probably an art would have arisen in which the Hellenistic traditions of the Byzantine Court would have developed on lines parallel with those of Italian art, becoming more amenable to the influence of the West. As it was, the Turkish conquest, by destroying the Christian Empire, left East Christian art once more to the monasteries, where the breath of the larger world no longer penetrated. Byzantine art was dead.

The last two centuries of the Empire present a brave rather than a miserable spectacle. There was a feverish effort to recover what was good from the work of the past. But the time had to be redeemed too fast, and in the face of insuperable difficulties. There was poverty, there was the ever-growing Turkish menace, there was the Black Death, which visited the city on the Bosphorus with a desolation no less than that which it carried through the west of Europe. The art of these unsettled times was imitative and uncertain of itself, but not barbarous, not grotesque, and above all not hieratic. It has phases which in their strange suggestion of vitality suggest less the weariness of age than the restlessness of youth in a decline.

Since the eighteenth century, it has been a very general belief that East Christian art was a petrified system. A fuller understanding of the inner conflict which that art sustained betrays the insufficiency of such a view. The difference in the spirit and the achievement of successive periods is so marked that the old habit of dismissing the whole of East Christian art as something fixed, frozen, and hieratic, though still too often dearly

cherished, is no longer defensible. It persists only because until recent times there has not been in the case of the Christian East the same wide comparative study and intensive research long since demanded in the case of Western medieval art. But the series of richly illustrated monographs and careful studies which has appeared in the course of the present century has made it possible at length to apply the high Western standards to the East. The old superficial view which judged all East Christian art by fragments picked up here and there can no longer be allowed to pass. Too many of us are still in the same position with regard to East Christian and Byzantine painting as our fathers were with regard to ' Gothick ', upon which, a hundred and fifty years ago, they poured a facile contempt. They condemned the whole as the creation of barbarism, unaware, sometimes, of any essential difference between the styles of the thirteenth and the fifteenth centuries. To-day, after the patient labours of medieval archaeology in the Western field during the past hundred years, it would require some ingenuity to confuse the work of these two centuries, in whatever medium expressed. The time has now arrived in which a similar precision becomes possible in defining the periods of East Christian art. With its coming we should have reached the end of the old prejudices ; yet there are those who still contrive to see no difference between the art of Justinian's reign and that of the Comnenian periods, a feat comparable to that of the eighteenth-century connoisseur who should confuse the style of the time of S. Louis with that of Louis XI. It is true, however, that, superficially at least, Byzantine sacred art was apt to be more conservative than that of the West. Fundamental changes such as that which occurred when Gothic replaced Romanesque were lacking in the East ; nor was there the same rivalry between independent nationalities, tending to differentiation and individual growth. But periods of stagnation were few ; there was generally movement and interaction. The statement may sound paradoxical, but if the charge of immobility is still to be levelled against Byzantine art, it can be brought with more effect against that section which lay outside the purview of the Church. In the case of Hellenistic secular art, which persisted side by side with the art of the Church, the imputation is less easily refuted. In this field the artist could not plead ecclesiastical control ; the sameness and the iteration were uncompelled. But this secular art was never East Christian or Byzantine art ; it was always a ghost from the classical past, against which it is vain to discharge modern artillery.

In its effort to remove the undeserved reproach which lay so long like a cloud over Byzantine art, archaeology has received powerful aid from art-criticism, the horizon of which has in recent years been widely extended. In the analysis of the different modes in which emotion is expressed by art, comparative material has been sought upon all sides and from the work of all periods ; it was soon perceived that the Early Christian centuries afforded material of peculiar value. The figure art of that period was seen

to mark a transition from the academic representation of Graeco-Roman times to representation of a more spontaneous nature, obeying a different mode of vision ; an ornamental system was recognized, older than that of Islam, but revealing the same indifference to exact reproduction of natural forms, the same use of flat colour and geometrical surface-covering design. The principles governing this Christian art have received their due ; that which the eighteenth and nineteenth centuries refused to consider has been regarded with favouring eyes. Thus aid has come from another side to those who have striven to combat the erroneous view that Early Christian art was nothing more than classical art in decadence. The very features for which Hellenistic art was once praised are now condemned as its worst ; those which once brought scorn upon the ' Byzantines ' are recognized as having value and significance. Even the later formalism, of old the mark of ingenious wits, is praised for qualities which Graeco-Roman naturalism conspicuously lacked. In no field of research have archaeology and criticism better helped each other to overcome ungenerous tradition. Their association has so changed the whole prospect that a student returning to the subject after an absence of twenty-five years would find himself almost as perplexed with the new world round him as the awakened sleepers of Ephesus in the old Christian legend.

Geographical Survey : Syria-Palestine and Mesopotamia

In this region there were four principal elements in the population : the Jews, Hellenistic Greeks, Aramaeans (Syrians), and Arabs.

The home-staying Jews did not make any extensive contribution to Christian art. Such art as they possessed was purely decorative, consisting of geometrical and conventional floral motives of a simple kind ; what remains of it suffices to show that the Jew saw the visible world like the other Eastern peoples who had not developed a representational art, and that native Jewish feeling and influence would instinctively favour the East against Hellenism. The Jews scattered through the great Hellenistic cities, and present in exceptional numbers at Alexandria, imparted to their Greek neighbours apocalyptic, magical, and other ideas which made themselves felt in Christian artistic expression ; but they themselves remained oriental in sympathy, and the Hellenized Jew of the dispersion was seldom a Hellenizing artist. Some Jews wandered southward into the west of the Arabian peninsula, where, in the fifth and sixth centuries, there were colonies in the permanent settlements of the Hejaz. But these colonies were in great part composed of Judaized Aramaeans, not of pure Hebrew stock, and their influence upon art was small.[1] The great importance of Palestine to Christian artistic development depended upon its possession

[1] D. G. Hogarth, *Arabia*, p. 6. The Jews of Irak appear to have had a like origin. For Jews in Arabia see also Prof. Margoliouth, Schweich Lectures (British Academy), 1921, *Lecture III*.

of Jerusalem and the Holy Places which drew pilgrims, traders, and monks from all countries, and the devotion of the imperial house ; it did not depend upon the Jews. The Greek population in this region was principally urban. It was numerous not only on the Mediterranean, but in many interior cities in North Syria and east of the Jordan. The great centre of Hellenistic culture was Antioch, which maintained relations with Palestine, Mesopotamia, and South-eastern Asia Minor, and by sea with Constantinople, Alexandria, Italy, and the West. Antioch was the chief intermediary between Hellenistic and orientalizing art, but the city lies so deeply buried that the large share which it must have taken in architectural development can at present be only inferred from references in literature, and from the ruined buildings of Northern Syria in its immediate sphere of influence.

It was the Aramaeans who counted for most in the development of Christian art, for it was they who first strongly differentiated it from the symbolism of the first centuries ; it was they who chiefly compelled recognition of oriental points of view when the Church determined upon an historical and dogmatic sacred art (p. 7). In the North their relationships reached into Cappadocia and Northern Mesopotamia ; their connexion with the latter region was of high importance, since it included Osrhoëne, the first country to adopt Christianity as the official religion, with the cities of Edessa and Nisibis, where monastic theology flourished in its own schools apart from Greek influence, and Aramaic was raised to a position equal to Greek as a liturgical language. This was the literary region of monasticism, whence monks of Syrian origin or affinity carried Aramaean influence into the houses founded in Syria proper, in the Holy Land, and in Egypt. It is hard to over-estimate the effect upon Christian sacred art in East and West alike of the Aramaean element in the monastic houses in Palestine, which survived even the Mohammedan conquest. When we speak of the oriental influence in that art of the Holy Places which, through the agency of the pilgrims and emigrant monks, became familiar throughout the Christian world, we mean primarily an Aramaean influence, emanating in the first resort from the great culture-centre in Northern Mesopotamia. This was the power which rapidly gained upon late-Hellenism, forcing it into an alliance, and thus creating Syro-Hellenistic sacred art, the art which entered so largely into the foundations of Early Italian, Carolingian, and Ottonian painting, penetrating as far as Britain and Ireland. The importance of Jerusalem as a centre of diffusion for artistic methods and motives depended upon the Eastern monks who filled the Palestinian religious houses. When we consider the part played by a monasticism trained in Aramaic theology, and the wide missionary activity of which Edessa was the base, the importance of the Syrian element in Christianity is at once realized. The missionaries who crossed the Tigris and the Oxus and carried Christianity into China were Syrians, or trained in schools in which Aramaean influence predominated, the Nestorians. The Syrian element

was equally powerful in the monasteries of the West. Cassiodorus was acquainted with the methods of Edessa and Nisibis ; monks of Syrian origin were to be found not only in Italy but in Gaul and in the west of Europe. Constantinople was early penetrated by the same Syrian influence.[1] For Western Christianity the importance of Syrian monastic art depended largely upon its above-mentioned predominance in the Holy Land. When memorial churches were erected over the Holy Places, the mosaic decoration which they ultimately received came largely under Aramaean influence, to which features in their iconography must be ascribed ; the same was evidently the case with illumination and with the minor arts.[2] From the fifth century onwards Jerusalem was for these reasons an unrivalled centre of Syro-Hellenistic influences. The enthusiasm of Constantine for the Holy Places and the splendour of his artistic endowments placed Palestine in a position of advantage as regards Syria proper, the real creative source.[3]

The chief Hellenistic city in Syria was Antioch, the rival of the imperial capital and of Alexandria, the metropolis of Greek culture for Mesopotamia and the interior of Hither Asia, the terminus of a main trade-route to the East, the great emporium where Asiatics not merely from Syria proper, Mesopotamia, and Armenia, but from Persia and from yet more distant regions met and mingled with the Greeks of the Mediterranean and of the inland towns for which the great city on the Orontes was a metropolis. Antioch was important for Hellenistic Christian sculpture because the influence of the city extended along the south coast of Asia Minor ; from Antioch the methods which transformed that sculpture crossed Anatolia to Constantinople. One of the two great redactions of gospel illustration was Antiochene, and this, not that of Alexandria and Constantinople, was followed in the Holy Land (p. 299), where the strength of Aramaean monasticism gave it the advantage. Through her varied relations with the East by the ancient land routes and with the West by sea, Antioch may be said to have occupied a commanding position during the Early Christian period before the rise of Islam. From here came the original inspiration of Ravennate art, from here much of the Greek influence in Northern Mesopotamia, and in part, perhaps, that which modelled the historical art of Buddhism in Gandhāra.[4] It was from Antioch that Shapur carried away great numbers of Greeks to be settled in his province of Persis, a deportation which cannot but have affected the local development of the arts. The

[1] For possible relations between North Mesopotamia and Chinese Turkestan attested by the presence of Manichaeans in Turfan, cf. L. von Schroeder in Van Berche and Strzygowski's *Amida*, pp. 379, 380. It is conjectured that the Charri of Charrae near Edessa were Indo-Scythians, and related by blood to peoples of Central Asia (*ibid.*).

[2] The lead ampullae which were carried home from the Holy Land by pilgrims bear subjects showing this influence and probably reproducing mosaic subjects in the memorial churches.

[3] O. Wulff, *Altchristliche und Byzantinische Kunst*, p. 10.

[4] Some think, however, that Gandhāran art represents a direct Bactrian tradition. Cf. also pp. 3, 4.

city now lies deeply covered ; its excavation would be so difficult a matter that it will not be lightly undertaken ; it will be long before the spade more fully reveals the share of Antioch in Christian building. But from historical sources we know that great constructions erected there must have determined in no small degree the general course of architectural development. Diocletian built a palace in Antioch, described by Libanius, which appears to have had close affinities with that at Spalato and may have been the work of the same builders (p. 116) ; Constantine erected an octagon which is thought to have served as a model for other structures of similar plan. The position of Antioch in the north-western corner of Syria, so close to Cappadocia and the east of Asia Minor, may have connected the city with old architectural traditions from this part of the world which seem to have left traces in certain early churches of Northern Syria, notably in the type of façade flanked by two towers (p. 138). While Antioch remains unexcavated, evidence essential for a final judgement on the evolution of Christian building for the early history of vaulted and domed construction may lie concealed. For here, as at the Holy Places in the South, imperial patronage may also have encouraged experiments and the introduction of new structural forms.

In view of its manifold advantages and its unique central position in the Christian world, Antioch was a better centre of diffusion even than Alexandria, and must be regarded as a primary agent in the accommodation of Hellenistic to Eastern modes of expression.

The Arabs were chiefly represented east of the Jordan and in the Syrian steppe-desert. Long before the Christian era, the overflow of population in Yemen, the cultivated south-west corner of Arabia, had led to emigration northward through the peninsula, and there was a Yemenite strain in some of the Arab elements which pushed as far as Northern Syria, mingling with the Aramaeans along the desert line. The founders of the Ghassanid Arab state, which succeeded that of Palmyra, had such a strain,[1] and adopted a monophysite Christianity in this region. The Ghassanids became the wardens of the marches for the Byzantine Empire ; Harith (Aretas), their prince, was recognized by Justinian as a king, and named Patrician by Justinian. Ghassanid princes grafted something of Byzantine culture on their own, and upon that of Palmyra ; and it is clear that they lived in a certain state, erecting considerable buildings on the edge of the Syrian desert. They thus became the natural rivals of another Arab tribe, the Lakhmid, the chiefs of which, themselves of Yemenite descent, were the clients of Sassanian Persia, and had their capital of Hira in the valley of the Euphrates, south of (the later) Kufa.[2] While the Lakhmid princes were forced to disavow Christianity for political reasons, their people were gradually influenced by Christian, ultimately Nestorian, beliefs.

The connexion between Arabia and the Christian East was thus one of

[1] For a summary of Arab relations with Syria see D. G. Hogarth, *as above*, pp. 10 ff.

See also E. Herzfeld, *Jahrb. der K. Preuss. Kunstsammlungen*, xlii, pp. 129 ff.

[2] Herzfeld, *as above*, p. 110.

long standing, the Ghassanids and Lakhmids transmitting to the peninsula a certain knowledge of Byzantine and Sassanian civilization. It is important to remember that Arabia proper was prepared for monotheism before Mohammed, partly through the 'Jewish' immigration noticed above, partly through Christian influence entering from Abyssinia and established in Yemen from the fourth century down to the time of the Prophet. The state of Yamama, south of Nejd, which in the sixth century made its power felt as far east as Bahrein in the Persian Gulf, was probably acquainted with Christianity, which it encountered in other forms farther north when it attacked, and for a short time superseded, the Lakhmids of Hira. Over the whole Arab region, and beyond to Syria and to the Persian border, the tribal movements brought with them cultural and religious influences ; and we need be no more surprised to discover old Yemenite building traditions in the Hauran than to find the half nomadic wardens of the marches reproducing in their degree the settled royal state of their imperial patrons.[1]

The Arabs, like the Jews, had little art of their own. But it has been observed that methods of building which had become characteristic of Christian architecture in the Hauran by the sixth century are thought to have come from Yemen.[2] The constant pressure of the Arabs towards the North carried emigrant groups all the way up the desert borders of Palestine and Syria as far as Moab and even beyond. Their princes had partly adopted settled life. They came into contact with the civilization which the Nabataeans had borrowed from the valley of the Nile and exemplified in the strange art of Petra, related in its architectural forms to the types of Ptolemaic and Roman Egypt. We have seen the Ghassanids along the Roman *limes* building themselves camps and residences influenced by Roman models. When Islam brought a new influx at the beginning of the seventh century, the Ummayad Caliphs, whose capital was at Damascus, showed a like interest in the art of contemporary Syria. The removal of the caliphate in the eighth century to Baghdad not unnaturally tended to increase Persian influence, though even there Greek and Aramaean traditions still reached the Abbassid capital through Mesopotamia. But in the graphic arts Islam as a whole preferred formal decoration to Hellenistic naturalism or the Syrian style of historic representation. We have already alluded to the arguments of Strzygowski that there is an essential connexion between a non-representational art and the nomadic manner of life, and that a religion founded by a nomadic people would naturally reject a religious art in which the imitation of natural forms was practised.

In addition to the above four chief racial influences, there were others from Cappadocia and Pontus in Eastern Asia Minor. The Iranian element,

[1] The old Sabaean culture of Yemen was already at an end at the beginning of our era, but some of its artistic traditions may well have survived to later times.

[2] Remains of houses are mentioned in the Sinai peninsula (Th. Wiegand, *Wissenschaftliche Veröffentlichungen des Deutsch-Türkischen Denkmalschutz-Kommandos*, Heft i).

perhaps Scythian and Sarmatian,[1] strong in this area (p. 29), may not have been without an action upon Northern Syria, to some extent affecting its art. If there are signs of Hittite survival in a certain feature of North Syrian Christian architecture (p. 138) we need not doubt the probability of some Iranian influence, though perhaps less definitely expressed, and in the first instance felt in the field of ornament. In Mesopotamia the feeling and tradition of Assyrian art was not extinct. On a previous page we have noted the survival of the idea of divine monarchy, with its attendant qualities of majesty and power, an idea which passed into Byzantine through Syrian and Persian art. It has also been urged that old decorative conceptions and practices, in part inherited by Assyria from the more ancient Babylonian and Sumerian art, were transmitted by that country to neighbouring regions, were there assimilated, and thus shared in their artistic development.[2]

We find, then, that geographical and ethnological and religious conditions combined to lend Syria and Mesopotamia a position of exceptional importance. This region was traversed by the main routes connecting the interior of Asia with the Mediterranean coast whence it transmitted to the West oriental influences reaching it by land. A glance at the map shows the advantage of this position over that of Egypt, which was at a further remove from the flow of ideas out of Asia. Syria received constant inspiration from other parts of Hither Asia; it thus became a focus radiating on all sides, and not least towards Egypt itself, into which in the fourth century it introduced new artistic motives. Hellenistic civilization was distributed over a very wide area, from Antioch to Seleucia, from Damascus to Jerash (Gerasa); Aramaean civilization interpenetrated the Greek; Iranian influences came in from the North; old Assyrian influences survived and spread from Mesopotamia. The area as a whole was marked out as the home of the compromise between the late-Greek and oriental influences which produced Syro-Hellenistic art. This art, indeed, could hardly have originated elsewhere, for the Copt with all his technical powers was not the intellectual equal of the Syrian; and after the first period of eremitic enthusiasm Coptic monasticism receded into the background as a cultural force. Finally, the inclusion of the Holy Land within its borders gave the region a religious and sentimental advantage which directly reacted upon art. Jerusalem with its numerous monasteries, some Syrian, some Armenian, became a centre whence artistic, no less than religious, ideas were diffused through the Christian world. The veneration for the Holy Places was never without its effect upon art, especially between the Peace of the Church and the seventh century, from the time when Constantine erected his memorial churches, various in form and splendid in decoration, down to

[1] M. Rostovtzeff, *Iranians and Greeks in South Russia*, Oxford, 1922, pp. 10, 83, 148. Rostovtzeff believes that a Scythian population settled in this part of Asia Minor at the time of the great Scythian invasion in the seventh century, and that the Iranian colonization did not come from Persia.

[2] *Ibid.*, pp. 55, 142, 173.

the period when Syro-Hellenistic art reached its full development. In these years Jerusalem may have had an influence upon Christian art only second to that which it exerted in the sphere of religion. The significance of the wide Syro-Palestinian area is illustrated by the various works of art noticed in the following chapters: church buildings, mosaics both for walls and pavements, mural paintings, architectural sculpture, ivory carvings, illuminations. Nor did its importance cease with the Arab conquest. The Ummayad dynasty borrowed much from Christian architecture and even from Christian decoration. The monasteries were tolerated, and Syrian monasticism continued its relations with the Byzantine houses and those of the West. Even at the time of the Latin kingdom of Jerusalem mosaic artists working in the old traditions re-decorated the Church of the Nativity at Bethlehem; for Amaury the Eastern illuminator joined with the 'Frank' to enrich the gospels of the Princess Melisenda.

Asia Minor

Like Syria, Asia Minor was inhabited by peoples of different race with a different outlook upon the world. Round the coast, especially upon the western coast, and along the greater river valleys, were Greek cities. On the plateau were populations of which the affinities were partly with the East and South-east, with Northern Syria and with Armenia, partly with the North and North-east, with Armenia, and, for a part of our period, with the Iranians of Southern Russia and the Kuban.[1] This interior region was once the seat of an ancient civilization, the Hittite, traces of which, as noted above, survived in Christian buildings; and in Christian times it was on the eastern and south-eastern side of the country, especially in Cappadocia, Pontus, and Cilicia, that the Asian and the Greek traditions met. Here we find an early vaulted construction of great significance for the development of Christian architecture. In this region, for instance, occur very early examples of the domed basilica (pp. 91, 138). From Cappadocia and Pontus Christianity reached the Goths (p. 55), and from Bithynia, the Danube region (p. 50). Caesarea on the eastern border was the mother city of Armenian Christianity. At a later time down to its occupation by the Seljūk Turks, Cappadocia was a focus of various oriental influences in Anatolia. It became at an early date a great monastic centre deriving its theology and the foundations of its sacred art from Syria-Palestine and Mesopotamia. When Syria was lost to the Arabs, Cappadocia became a stronghold of monasticism; here, in the rock-hewn monasteries and churches, with their numerous frescoes, the older Syro-Hellenistic art was preserved, and the iconography of the sixth century lived on to the eleventh.

[1] While the Scythians and Sarmatians were powerful in the south of Russia they maintained communications with the northern coast of Asia Minor through Sinope and Trebizond, and there was a strong Iranian element in the interior behind these towns (see note 1, p. 28).

Mural and other paintings, and figured garments, are mentioned by Asterius, Bishop of Amaseia (d. 403); the latter suggest a culture of oriental tastes. The interior felt and thought orientally; through its monastic relations it asserted the Eastern point of view in medieval Constantinople, and the influences which it transmitted survived in the Byzantine capital and in the Balkans long after the Seljūks had choked the spring from which they flowed.

If the interior of Asia Minor was among the most permanent sources of Eastern influence, its coasts, with their many Greek cities, preserved Greek art in a purer form than other areas. The presence of a large Greek population in the maritime cities was a cardinal fact in the history of East Christian art. Ephesus, Smyrna and Miletus, Sardis, Tralles and Magnesia, were centres of Hellenistic life and thought. The Anatolian Greeks of the Early Christian centuries held to the traditions of Greek sculpture, the later developments of which were not unconnected with that of Pergamon. The Lydian group of marble sarcophagi, with their statuesque reliefs inspired by older Hellenic work, could only have been produced in a province where a good tradition had survived (p. 182). In the North-west, Proconnesus, the island containing the great Byzantine marble quarries, and the home of a widely-exported decorative sculpture, likewise received the Greek tradition, but, as a point attracting stone-masons and sculptors from all quarters, played a notable part in the blending of divergent styles. In architecture not less than in sculpture Western Anatolia was the chief representative of traditional Greek art in Christian times. Inland, on the contrary, Greek genius more freely assimilated oriental elements; the adaptation of the high vault and the dome to the basilica has been ascribed to the interaction of Hellenistic and Eastern influences in the province. The invention of the pendentive has also been attributed to the Greek builders of Anatolia; and the country which produced Anthemius of Tralles and Isidore of Miletus is likely, on the face of it, to have possessed other architects of creative capacity. The variety of types in buildings already studied by explorers confirms the belief that in the development of East Christian architecture the Greek factor in Anatolia was always important.[1] The Arab conquests of the seventh century left Asia Minor still a part of the Byzantine Empire. But the advance of the Seljūks began the conquest of the province, finally completed by the forces of the House of Othman. The dispossession of the Byzantine Greeks was gradual. In the early thirteenth century the north coast witnessed a revival of their influence, when the Empire of Trebizond was founded after the Latin seizure of Constantinople in 1204. Interesting late churches with their decoration have survived to illustrate the Byzantine art of the time. Farther to the west the Empire of Nicaea came into existence through the operation of similar causes.

[1] Without claiming too much importance for the fact, we may note that the oldest examples of the dome over square plan appear to be Greek tombs of the sixth century B. C. in Asia Minor itself, or in a region (South Russia) closely connected with it (p. 80).

Armenia[1]

This country was a borderland receptive of influences from more than one side. Through Transcaucasia it received Scythian immigration as early as the seventh century B.C. The districts of Sakasene and Skythene were for centuries held by an Iranian (Scythic) aristocracy, the social structure resembling the feudalism usual in Iranian countries.[2] Under the Achaemenian Persian dynasty Armenia enjoyed a position of comparative freedom; but after the establishment of the Greek kingdoms it abandoned fire-worship and returned to ancestral forms of worship. Down to 190 B.C., when the Romans defeated Antiochus the Great, the country was under Seleucid domination; after this date it became for a while independent, but was subdued about 165–160 B.C. by Antiochus IV; the coins prove by their type and epigraphy that at this time it was under the influence of Greek culture. In the first half of the first century B.C. the Armenian King Tigranes (94–54 B.C.) became the ally of Mithridates of Pontus. Both kings, alarmed at the growing Roman menace, sought to extend their boundaries, Tigranes capturing Edessa, Adiabene, and the region of Nisibis, and founding a new city south of the Tigris, to which he gave the name of Tigranocerta (Miafarqīn ?). But the Armenian king was drawn into conflict with Rome, and defeated at Tigranocerta by Lucullus. He and his ally seemed now committed to a decisive struggle with the Western power, but finding resistance vain, he surrendered to Pompey, and Armenia for a time became practically the protectorate of the Roman republic.[3] Under Tigranes Greek culture had been fostered in Armenia; Greek actors played in the theatre of Tigranocerta, Greek sculptors enriched the town with works of art, the Greek language was spoken at Court. It is to be remembered that this king held Antioch, where his coins were struck.

In the second half of the century Armenia, under various princes, remained between the two rival states of Rome and Parthia, both of whom coveted a country in physical conformation resembling a great natural fortress. Though nominally independent, Armenians were now subjected alternately to Parthian and Roman influence. During the first fifty years of our era princes of various nationality reigned in Armenia, supported by Rome or Parthia, but in A.D. 53 the Parthians established an Arsacid dynasty on the throne, of which the first member, Trdat (Tiridates) I,

[1] J. de Morgan, *Histoire du peuple arménien*, Paris, 1919; F. Macler in *Cambridge Modern Hist.*, iv, 1923, ch. vi, with bibliography, pp. 814 ff.; Strzygowski, *Baukunst der Armenier und Europa*, 1919. Armenia, always regarded with interest by students of East Christian building (Choisy, *Hist. de l'arch.*, pp. 60, 84; Rivoira, *Moslem Architecture*, pp. 187 ff.), has come rapidly into the foreground of discussion since the publication of Strzygowski's work, based upon the researches of an Austrian expedition in 1913.

[2] Rostovtzeff, *Iranians and Greeks in South Russia*, pp. 10, 36.

[3] Like the kingdom of the Bosporus, or Commagene, it was a Hellenized oriental autocracy (Rostovtzeff, *as above*, p. 158).

was brother of the Parthian king. This prince, to allay Roman suspicions, went to Rome and received investiture from the Emperor Nero. Exedares, successor of Trdat, ceded Lower Armenia to Rome, which had already become possessed of Lesser Armenia; later Arsacids steered a skilful course between the two great rivals for the mastery of Western Asia. In the reign of Trdat II (A.D. 217–238) the Sassanian dynasty, the power of which was based on the south of Persia, overthrew the Arsacid (Parthian) rule in Persia, and under Ardashir began in A.D. 226 a strong national policy, reverting to Zoroastrianism and putting an end to the Greek culture of the Arsacid Court.

The Persian national movement and the return to a militant fire-worship soon reacted upon Armenia. The Arsacid dynasty in that country took alarm, and under Trdat III (A. D. 250–330), a prince brought up in Rome, it was decided to adopt Christianity as the national religion in order to counteract Zoroastrian influences from Iran. This change was largely due to Gregory ' the Illuminator ', himself a member of an Arsacid princely family, who had embraced Christianity when a refugee at Caesarea in Cappadocia. Assured of the support of Trdat, he was consecrated bishop at Caesarea, and, returning to Armenia, succeeded by a mixture of persuasion and force in overthrowing the paganism of the country. Edgmiatsin was founded as the patriarchal see, but Gregory died soon after the Council of Nicaea (A. D. 325), which had been attended by his son. The whole movement conducted by Gregory and Trdat had a political character, and was definitely directed against Sassanian Persia, which persisted in its attempt to force Zoroastrianism upon Armenia down to the end of the fifth century. Trdat reigned under Roman support until A. D. 330; and according to Agathangelos, a historian of the fifth century,[1] Gregory built many churches throughout the country, including the district of Taron on the Syrian border. In A. D. 387 Armenia, though keeping native kings, was divided between Rome and Persia. In the second half of the fourth century the Catholicos Nerses (A. D. 358–383) began a ' Greek ' movement in the Armenian Church; under Byzantine and Syrian influence he introduced monasteries organized on the Basilian system. He further strove to make Christianity a religion for the people instead of a dynastic and political instrument, thus coming into conflict with the Court and the nobility. After his time, during the fifth and the greater part of the sixth century, the influence of the priests and monks was strong; close relations were maintained with Northern Mesopotamia and with the Greek element at Caesarea, Melitene, Sebaste, and Karin (Erzerum) on the west: it was through such connexions that the long-naved church building penetrated

[1] Down to the beginning of the fifth century the Armenians had no national system of writing. At that time (A. D. 407) Sahak charged the learned Mesrop to prepare a national alphabet, for hitherto the country had no written history, and the Church relied upon Greek and Syriac texts.

Armenia. The spread of Aramaean influence was checked by the adoption of the new alphabet ; the interpenetration of Syrian and Armenian culture was now confined to the extreme south of the country. The first stage of Armenian history, represented by the national or Arsacid period, came to an end when the last Arsacid lost his throne in A.D. 428. The middle of the fifth century witnessed a more than usually formidable attempt by the Sassanian Persians to force fire-worship upon Armenia; the war ended in A.D. 484 with the success of the Armenian resistance. The Armenians, now Monophysites, in A.D. 507 declared their formal separation from the Byzantine Church. The change brought no political hostility to Constantinople, but there was a revolt in Armenia against the ikons which the earlier Greek influence had introduced ; the country had always been ill disposed to pictures, and though in later centuries the churches were often adorned with mural paintings, this seems to have been chiefly due to renewed Byzantine influence. Towards the close of the sixth century another Persian war caused great devastation in the country, and the destruction may have been a main cause of the great revival in architectural activity which took place at the beginning of the seventh century under the leadership of the Catholicos Komitas. Several types of churches were now produced together, and the national form was not the basilica, but the type with a dome over a square. Many of the best-known buildings in Armenia, such as the cathedral of Edgmiatsin, the church at Bagaran, and the Hripsimeh church at Vagharshapat, were erected at this time.

The middle of the century saw the commencement of another troubled period : difficulties with the Arabs began, destined to last for more than two hundred years. The Moslems ravaged the country, which was now divided among weak local chiefs ; relations with Christian Syria were interrupted ; many Armenians emigrated to Melitene and Karin. Churches of importance were still, however, erected, including that at Thalish, the first known example of the type which ultimately dominated Armenian architecture. Ummayad and Abbāssid Caliphs between them ruined almost all the Armenian princely families, but towards the close of the ninth century better times began. The head of the Bagratid house was recognized as king by both Caliph and Byzantine Emperor, and inaugurated a new era of peace and prosperity. In the first half of the tenth century the Arab yoke was definitely shaken off, and, except for Byzantine encroachment about A.D. 1045, the country remained free until the arrival of the Seljūk Turks. The Bagratids had made Ani their capital in A.D. 971, and to this period belongs the varied architecture of that now ruined city, reproducing many old national types (Plate XXII). But in the late eleventh century storms again broke over the country. The Seljūks overran Armenia and Georgia ; Alp Arslan sacked Ani. In 1081 a fugitive Bagratid prince founded the Armenian kingdom of Cilicia, which was to last until destroyed by the Mameluks in A.D. 1375. For a long time the region was at the mercy of

hostile peoples—Turks, Kurds, and Mongols—until at last the Ottomans
established an undisputed sway.

The Armenian, a trader and traveller like the Syrian, was a familiar
figure in the Mediterranean cities and in Rome under the Empire ; he
appears even in the west of Europe. We find Armenians of position resident
in imperial Rome ; Trdat III and his suite lived there in the reign of
Gallienus. Talented Armenians, like talented Syrians, were attracted to
the capital of the world. In the Byzantine Empire they soon rose to high
positions : Narses, the general of Justinian, was an Armenian ; so was Isaac
the exarch at Ravenna.[1] The Emperors Maurice, Philippicus, Leo V, and
Basil I were Armenians ; their great successors Nicephorus Phocas and
John Zimisces were also of Armenian descent. Emigration into the West
began on a larger scale perhaps as early as the fourth century ; it certainly
occurred after the Persian inroad into Armenia in A.D. 571–572. About this
time Armenians were settled as colonists in the Balkans ; the Arab con-
quests in Asia increased the number of emigrants to Europe. Paulicians of
the race were placed at Philippopolis by Constantine V in the middle of the
eighth century, and under Basil II Bulgaria received further immigrants.
Soldiers of Armenian Cilicia fought on the Christian side in the Crusades.
There were intermarriages, and fresh relations with Europe ; in the thir-
teenth century Armenian churches were built in Italy. The Armenians
played no small part in the development of monasticism. Like the Ara-
maeans, they soon had their religious houses in Jerusalem, where mosaic
pavements with Armenian inscriptions, probably of the sixth century,
remain to attest their presence. They are also found in the Holy Land
sharing monastic life with Greek-speaking monks. Soon after the founda-
tion of the monastery of Theodosius the Cappadocian, not far from Jeru-
salem, we hear of a group of Armenians among Greeks and Thracians.
The successor of Theodosius, Sophronius (d. 543) was himself an Armenian,
whose brother occupied an important position at the imperial Court.[2]
Armenians were probably established at a no less early time in Egypt.[3]
Both intellectually and artistically the Armenian people were without doubt
highly gifted. Their architecture is remarkable for its strength and severity,
for its fine conception of mass, and for the purity of its constructional form.
In the time of the Emperor Basil I and his successors, Armenian architects
must have enjoyed a special patronage at Constantinople. His *Nea*, or
New Church, may have reproduced an Armenian plan ; when in the tenth
century the dome of S. Sophia was damaged by earthquake, it was to an
Armenian architect, Trdat, builder of the cathedral of Ani, that the work of
restoration was entrusted. Though in painting the national feeling was

[1] Armenians entered the Byzantine army :
under the exarchate there was an Armenian
regiment at Ravenna.

[2] E. Weigand, in *Byz. Zeitschr.* xxiii, p. 168.

[3] Strzygowski, attributing the triconch or
trefoil end to Armenian invention, finds
Armenian influence in the White and Red
Monasteries at Sohag.

originally opposed to representational art, in course of time Armenian monks produced many mural paintings, some of which remain on the walls of their own churches ; inscriptions of the tenth and eleventh centuries on frescoes in Egypt show them the work of Armenian hands : one, at the White Monastery, is signed by Theodore, an Armenian from the province of Keisun. In illumination Armenian painting was represented from an early date down to modern times.

The above summary will at least help the student to understand the place in history of a land occupied by a people of exceptional ability and Christianized at a very early period. The history of Armenia is that of a land occupying so important a strategic position that control over it was always of importance to the greater powers in Western Asia. Its value was well understood by the Romans, by the Byzantine emperors, by the Parthian and Sassanian kings, by the Arabs, and by the Turks, all of whom, as we have seen, at one time or another influenced or possessed Armenian territory. The problem as to the relation of Armenia to Christian art depends upon the extent to which the country received suggestion from without or itself originated forms and plans which it imposed upon other peoples. It was conterminous with Northern Mesopotamia and Eastern Asia Minor, to which it owed its Christianity; was it also a debtor in the province of art, or did it here give all and receive nothing ? This problem is most important in relation to architecture (Ch. II). Strzygowski maintains that Armenia as the transmitter of Iranian influence occupied a place second to no other country from a date as early as the fourth century [1]; others, not satisfied with the existing evidence, consider this too sweeping a judgement.[2] They remember the long political relations with Rome and Byzantium, the religious connexion with the Greek Church, the general hostility to the Sassanian power, the probable readiness of an alert people to adopt motives and principles from more than one side, especially that which gave them their religion. They are ready to admit a strong Armenian influence in the West after iconoclasm, but hold that a similar influence in earlier periods is not proved. They also doubt the purity of Armenian Aryanism.

Transcaucasia—Georgia [3]

This region, known from prehistoric times as a centre of bronze civilization, and sought for its iron and its gold, formed the connecting link between Mesopotamia and Persia, and the Kuban area north of the Caucasus. Through it the Scythians obtained access by land to Asia Minor, coming into contact with the Iranians of Persia; through it, in a contrary direction and in an earlier time, the art of Assyria and Achaemenian Persia penetrated

[1] See especially his *Baukunst der Armenier und Europa.*

[2] G. Tschubinasvili, in *Monatshefte für Kunstwissenschaft*, 1922, pp. 217 ff.; Diehl, in *Revue des études arméniennes*, i, 1921, pp. 221 ff.; F. Macler, in *Syria*, i, 1920, pp. 253 ff.

[3] Cf. *Cambridge Modern Hist.*, iv, 1923, Index, *s.v.* ' Iberia '.

the Kuban. In Roman and Byzantine times the country was still an avenue through which Asiatic art entered Europe ; by this path Armenian types passed into Russia (p. 56). The importance of the country for the art of enamelling[1] (p. 343) suggests a possible development of glass manufacture.

The Eastern Countries

It is clear from what has been said in the preceding pages that Christianity was by no means confined within the Byzantine frontiers, and that many influences determining its art came in from beyond them.

The first and most important of foreign regions in the East was that once ruled by the old Persian Empire and in the early Christian centuries for the most part politically controlled first by the Parthians, and after A. D. 226 by the Sassanian Persian dynasty. The Parthians, who had revolted from the House of Seleucus in the middle of the third century B. C., were ruled by a dynasty of Saka origin[2] which became noted for its Hellenizing tendencies. But it may be doubted whether the Hellenism went very deep, and whether it affected the mass of the people. According to one view, the reaction against Greek influence in Hither Asia began with Parthia ; in the opinion of Strzygowski[3] this was the region which transmitted to Mesopotamia, Syria, and the West the impulse to non-representational methods which so deeply affected late-Hellenistic art in Roman times and lent Christian art its essentially un-classical qualities. The Parthians, in close relation with the steppe-country of Western Turkestan and Armenia, were, on the face of it, likely to share the non-representational mode of expressing the visible world in art, and may have exerted a powerful influence on the development and diffusion of formal decoration (p. 366). To the period of Parthian supremacy belong the earliest Christian settlements east of the Euphrates, of which we read in the Chronicles,[4] and

[1] It is well known that some of the earliest champlevé enamels have been discovered at Koban, the culture of which dates from the late Bronze to early Iron Age. But in the tenth and eleventh centuries the country became a most important centre of enamelling in the Byzantine cloisonné style.

[2] The origin of the Saka themselves, for whom see below, p. 38, is still disputed. The most general view seems to be that they were Iranians (Indo-Germanic) who wandered east round the north end of the Caspian. But it seems to be agreed that they early included Mongolian elements, and that their different branches in the later periods of their history were often accompanied by Mongolians in their migrations.

[3] Strzygowski, *Altai-Iran*, p. 135.

[4] The evidence for an early Christian culture in these regions, and for the building of churches there as early as the second century, is derived from the Chronicles of Edessa (Guidi, in *Scriptores Syri*, third series, iv, *Chronica Minora*, i, pp. 3 ff.) and of Arbela (E. Sachau, *Abhandlungen der K. Preussischen Akad. der Wissenschaften*, 1915, *Phil.-hist. Klasse*, No. 6). Strzygowski has developed this evidence in *Repertorium für Kunstwissenschaft*, xli, 1919, pp. 128 ff. ; *Die Baukunst der Armenier und Europa*, p. 652 ; *Monatshefte für Kunstwissenschaft*, viii, 1915, pp. 359 ff. ; and *Christian Church Art*, p. 24. The evidence of the Chronicles is not contemporary, but it is argued that they represent historical occurrences. For Christianity in Persia see Sachau's paper in *Sitzungsberichte* of the above-mentioned Prussian Academy, xxxix, 1916, pp. 958 ff.

at a very early period churches may have been built in Adiabene which in
structure and decoration represented the feeling of Central Asia rather than
that of the countries influenced by Mediterranean. Southern Iran, where
the Sassanian dynasty arose, was probably more influenced by Mediter-
ranean art than was the North. The dynasty was indeed ' national '; but
its monumental art was affected by Hellenistic and Semitic traditions from
the lands west of the Euphrates. Nevertheless, here also an underlying
popular art was probably adverse to representation, and might conceivably
have served Mazdaism. The inspiration of the *Zend-Avesta* would have
favoured a formal symbolism expressed in terms of decoration; this would
have been the art natural to the country; the monumental art which we
have hitherto regarded as characteristically Persian might rather be con-
sidered an aristocratic and exotic system imported from Mesopotamia and
Greek sources to celebrate, after the fashion of the ancient monarchies, the
achievements of the royal house. The real influence of Iran alike in North
and South would on this theory have been exerted through an art of decora-
tion expressed in formal design and patterns of rhythmic line and colour
rather than in historical or didactic representation. The reasoning is in
part conjectural, but deserves more than a passing attention.

But though we may agree that popular and national feeling in Iran may
have run counter to representation, in estimating the influence of Iranian
Asia upon Christian art we must not forget the Greek colonies which still
existed on Asiatic soil. In Hither, and even in Central Asia, Hellenistic
influences survived, and Seleucia on the Tigris may have been the chief
centre to which they looked for inspiration, though lesser cities must have
also played their part.[1] These influences were strong and enduring; they
were still affecting Islamic art at Samarra under the Abbāssid caliphate,[2] and,
as we shall see below, extended far into the East. But in Persia we may
suppose Hellenistic art to have been strongly permeated by the principles
of formal decoration, the Greek culture to have become an ' Iranian
Hellenism '.

In the provinces of the old Persian Empire on the borders of India, the
future of Hellenistic influence was assured by its entry into the service of
Buddhism. The political power of the Greeks in this part of Asia had long
departed. Diodotus, the Seleucid satrap, had revolted at the same time as
the Parthians, but the independent Greek kingdom which he had estab-
lished with the help of a Greek or Macedonian military aristocracy was

[1] *Der grosse Hellenistische Kunstkreis im
Inneren Asiens, Zeitschrift für Assyriologie*,
1912, pp. 139 ff.; *Amida*, pp. 365 ff.; *Reper-
torium für Kunstwissenschaft*, xli, 1918, pp.
125 ff.; *Die bildende Kunst des Ostens*, Leip-
zig, 1906, p. 20; where a persistence of
Hellenistic traditions under the Saka is recog-
nized. Strzygowski has argued that there was

a reflux of this Hellenistic art of Hither Asia,
to which such features as the sculptured
ornament in the North Mesopotamian churches
may have been due, rather than to any influ-
ence from the Syrian side.
[2] Herzfeld, *Jahrb. der K. Preussischen
Kunstsammlungen*, xlii, 1921, p. 134.

overthrown in 135 B.C. by Saka, advancing first from Sogdiana (Bokhara), a region itself once under Achaemenian supremacy, but making their final advance from Seistan, where they had merged with the Parthians.[1] The Saka did not conquer the country south of the Hindu Kush. They left unassailed the Kabul valley and the Panjab, which one of the Greek kings, Euthydemus, had annexed to the Bactrian state, and here a Greek line maintained itself for about a century longer. The Kabul region of Gandhāra had also formed part of the Achaemenian Empire ; the kingdom of Taxila (north-west of Rawal Pindi), within its boundaries, had joined Alexander, and at this time Taxila itself was a capital of the last Graeco-Indian kings.[2] Gandhāra, in old Persian times the channel through which Iranian influence entered India, was still serving Hellenistic culture in the same way. About the middle of the first century B.C. the Saka were displaced in Bactria by the Kushana, a branch of the Yueh-chi, another nomad tribe, certainly of Turki stock, coming down from north of the Syr Daria. But the new invaders, crossing the Hindu Kush, at last put an end to the surviving Graeco-Bactrian dominion of the Kabul valley and the Panjab. About A.D. 60 Kujūla Kadphises consolidated the five principalities of the Yueh-chi, establishing an empire from the Pamirs to the Caspian,[3] while his son, Wema Kadphises, held wide territories in Northern India. Greeks and Saka, Parthians and Hindus, were now welded into a single Kushan state, in which Greek influence still dominated Buddhist art. Kanishka extended his sway over North India eastwards as far as Benares, and southwards to Sind, and Kushan chiefs ruled in Northern India until the fourth century. The sculptures of the Gandhāra topes and monasteries (*vihāras*), of which so many examples are preserved in our museums, belong to the period of Kushana dominion, and show that Hellenistic art was full of vitality long after the extinction of Graeco-Bactrian power.[4] In the middle of the fifth century the Ephthalite or White Huns attacked and overthrew the Kushan kingdom of Kabul.

In Hindustan proper, Greek and Persepolitan art had penetrated the Mauryan kingdom in the northern plains before the Christian era.[5] After the treaty of 305 B.C. between Seleucus Nikator and Chandragupta, King of Magadha, relations were established between India and the Macedonian kingdom of Syria, and the other kingdoms ruled by the successors of

[1] E. J. Rapson, *Cambridge History of India*, vol. i, 1922, p. 563.

[2] Taxila has been excavated in recent years. Sir John Marshall, *Guide to Taxila, Annual Report* for 1918–19, and *Archaeological Survey* for 1920.

[3] E. J. Rapson, *Ancient India*, p. 146. See also L. D. Barnett, *Antiquities of India*, 1913.

[4] The art of the sculptures appears to have degenerated less rapidly than that of the coins.

[5] *The Cambridge History of India*, vol. i, 1922

(ch. xxvi by Sir John Marshall) ; Vincent Smith, *History of Fine Art in India*, Oxford, 1911, ch. xi ; Sir John Marshall, in *Cambridge History of India*, vol. i, 1922. All Greek influence was over by about A.D. 400 in India proper (*ibid.*, p. 390). The medieval Hindu revival and the advance of Islam both meant revolt against Hellenistic ideas, and a reversion to ancient Asiatic modes. The art of Açoka's time was influenced from Bactria, where trade routes from India, Iran, and Central Asia converged.

Alexander. The embassy of Megasthenes to India is well known. In the reign of Antiochus I (Soter, 280–261 B.C.) Daimachus was sent as ambassador to Magadha ; at the same time Ptolemy Philadelphus of Egypt (285–247) dispatched Dionysius to the Indian Court. When Açoka, the great Buddhist Emperor of Magadha (269–227), endeavoured to spread the tenets of his faith in the West, he sent missionaries to Syria and Egypt, Cyrene, Macedonia, and Epirus.[1]

The native art of Northern India in the centuries immediately before and after the beginning of the Christian era is chiefly represented by the sculptures of Sarnāth, Bharhūt, Budh Gaya, Sānchī, and Amaravati.[2] In spirit it is essentially independent of foreign influence, but as early as the reign of Açoka the famous capital at Sarnāth shows evidence of contact with the Hellenistic art of Bactria, an art itself affected from Iran. There was an increase of Hellenism in the Mauryan Empire after the period of Açoka in the second century B.C., and the interaction of the Greek and native styles in the reliefs at Bharhūt is very evident ; the indigenous manner is often similar in method and effect to that which dominated in East Christian sculpture from the fourth century (cf. p. 161). The two styles also co-exist in the reliefs of the temple railing at Budh Gaya, where Greek influence is often clear, and at Sānchī, though at the latter place the bulk of the work is Indian in feeling. In later work at Mathurā there is a return towards the native style as represented at Bharhūt. Throughout, this early Indian sculpture accepted foreign elements with discrimination ; it never abandoned its characteristic qualities or renounced its independence.[3] Like Syria, early India delighted in the relation of stories, in this case Jataka legends of the life of Buddha ; it differs profoundly from medieval Hindu art, which sought to give formal expression to the infinite and spiritual, removing itself from consideration of earthly persons and events. The ancient Indian reliefs as a whole are of great interest through the above-mentioned parallelism with East Christian art. At Bharhūt we see figures treated as silhouettes clearly detached from the background ; the modelling in this work is represented by a mere grading of the relief with a sharp distinction of planes ; there is a general aversion to depth.[4] At Sānchī and Amaravati the use of ' vertical projection ', a consequence of ignoring depth, is much in evidence. If we have here parallelism, and not a direct influence of India upon Syria, we must admit the independent origin of

[1] Rapson, *as above*, p. 104.

[2] See Marshall, in *Cambridge History of India*, i, ch. xxvi, pp. 612 ff. ; Vincent Smith, *as above*, pp. 68 ff., 148 ff., 378, with references to the earlier works, e. g. J. Ferguson, *Tree and Serpent Worship*, 1873, and A. Cunningham, *The Stûpa of Bharhūt*, 1879. Cf. also A. Foucher, *La porte orientale du Stûpa de Sānchī*, and Grünwedel, *Buddhist Art in India*, 1901.

[3] India accepted Sassanian and East Christian influence in the same manner as Hellenistic and early Persian. The former is evident in some of the paintings in the Ajanta caves, the latter in the diaper ornament on the facing of the stûpa at Sarnāth.

[4] Marshall, *as above*, p. 625.

this kind of sculpture in unconnected centres—a fact which would justify us in asking whether a similar claim to independence may not be made in the case of Syria. The only alternative is to suppose a common action exerted upon both.[1]

The countries beyond Iran had less influence upon East Christian art than might perhaps have been expected. They were connected with Syria and the Mediterranean coast by important trade-routes, but the result upon the art of the West was small, and they received more than they gave. Greek forms advancing from Gandhāra through Chinese Turkestan long retained their hold on the sacred art of Buddhism, and Iranian ornament followed the same routes to China. The deserts of Chinese Turkestan have now yielded many of their secrets, and we know that the art of the settlements along these routes was largely influenced by the same factors which had contributed to the formation of Christian art. The Semitic element alone was not directly felt. It may have suggested the realistic and historical conception of Buddhist subjects, but the form here was Hellenistic, and the realism was soon entirely in the spirit of inner Asia. The penetration of the Far East by late-Hellenistic art in Buddhist service, and the duration of this influence long after the Greek kingdoms had come to an end and one alien race of conquerors had superseded another, is one of the most remarkable facts in the history of artistic development, and one upon which historians of the early phases of art in Northern India have done well to insist. Far away in the now desert sites of Chinese Turkestan, we find not only a general affinity with the art of Gandhāra and the Hellenistic cities of Asia, but even the most striking resemblance in particular features and motives;[2] a Hellenistic predominance lasted well into the second half of the first millennium, when it was gradually eliminated by the great but tolerant art of China. This tolerance on the part of China cannot but arouse our wonder when we remember the quality of the sculpture and of the ceramic art produced under the Han dynasty, and recall the fact that as early as the fourth century the Chinese painter was doing work which nothing in the Persian or Byzantine Empires could approach; there seems to have always been in the Chinese character an innate dislike for external aggression and for propaganda, religious or artistic. In the second century (*c.* 136–123 B. C.), under the Emperor Wu-ti there was indeed a military

[1] Strzygowski would perhaps find this in an early Aryan influence from Central Asia. It would be interesting to know what principles governed a possible ancient Dravidian sculpture in the south of India. If this existed, did it also avoid depth and flatten down relief ? if so, it would not be necessary to bring in the Aryan influence. It is interesting to note that in India abstract and formal tendencies in figure sculpture co-exist with a remarkable naturalistic ornament.

[2] Strzygowski has called attention to the likeness between the motive of the bathing lady at Dandan Uiliq (M. A. Stein, *Ancient Khotan*, pl. ii) and the same motive on the walls of Quseir 'Amra on the western border of the Syrian desert, painted by Hellenistic artists, perhaps from Persia, for an Ummayad prince. Cf. p. 261.

expedition as far as Ferghana, led by the general Chang Chi En,[1] and some centuries later Chinese power again advanced in West Central Asia. But it is perhaps characteristic that the most conspicuous effect of that first expedition upon art was not any Chinese gift to the West, but the adoption by China from Bactria of the vine in ornament. Throughout the Middle Ages, early and late, the people which was creating works of art supreme in their quality was disposed to admit the importations of Western countries, to amuse itself with them and satisfy a certain curiosity, rather than to impress upon other peoples the superiority of its own achievement. Some influence from China may perhaps be traced in the pottery of Central Asia and Mesopotamia,[2] but this is outweighed by the admission of Hellenistic motives into Chinese art. While Persian and Syrian figured silks were copied by the Chinese, the ancient figured silks of the Han period remained unknown to the West until, almost yesterday, the first examples were discovered by Sir Aurel Stein (p. 352). The existence of the Sung landscape-painting was never even imagined by the East Christian and Byzantine artist. The effect of Christian expansion from North Mesopotamia across Turkestan to China appears to have had little effect upon art; what cultural influence there was moved eastward and seems to have been chiefly Iranian. Thus the explorations in Turfan yielded MSS. of the Psalter in Pehlevi, and in a Syro-Persian script; there is also evidence that Manichaeanism reached this part of Asia. The Nestorians reached China in the sixth century, perhaps through Balkh, and in the seventh were permitted to build a church in Si-ngan-fu. In the latter part of that century their church-building was widely extended, and their influence reached its height in the eighth, when they enjoyed imperial favour.[3] The well-known inscribed monument at Si-ngan-fu dating from the year 781 remains as a witness to their missionary success.[4] But in the ninth century Christianity was driven back by Buddhism, and in the tenth was practically extinct. Such influence as Chinese decorative design may have exerted on East Christian ornament was conveyed westward by nomadic tribes of North Central Asia, and present evidence hardly suffices to establish a serious Chinese contribution to the art of Christianity. In the early Middle Ages China had no continuous political unity, and in religion and art alike she lacked the desire to make proselytes. In Chinese Turkestan, Chinese

[1] The object of the expedition was to open communications with the Yueh-chi in the Oxus region with a view to alliance against the common enemy, the Huns. (M. A. Stein, *Ruins of Desert Cathay*, i, p. 512 ; in the following pages the routes across Turkestan are described.)

[2] Strzygowski, *Altai-Iran und Völkerwanderung*, 1917, pp. 260 ff. ; Laufer, *Chinese Pottery of the Han Dynasty*, pp. 142 ff.

[3] In the opinion of Strzygowski, the churches

built by the Nestorians in China may have been decorated in the Iranian manner.

[4] Strzygowski, *Christian Church Art*, pp. 23, 24, gives the principal dates, noting the suggestion of Iranian influence in Nestorian churches afforded by later historical documents. For the monument at Si-ngan-fu the student may consult Bury's edition of Gibbon's *Decline and Fall*, iv, p. 569 f., and *Monatshefte für Kunstwissenschaft*, viii, 1915, pp. 358 ff.

art gradually absorbed Hellenistic. But Turkestan was not only near ; it was regarded by the Chinese as their own province, whereas all that lay beyond it towards the West was indifferent to them. The history of ancient Chinese art in relation to the West, as far as it can be deciphered, is a story of relative passivity. The monsters on the bronzes of the Chou dynasty are of Mesopotamian origin transmitted through Turkestan more than a thousand years before our era ; they come from the same source as those of early Scythian art, of which they are not parents but cousins. Nor is it as yet demonstrated that China gave the western world the geometric scroll which forms the foundation of the arabesque.[1]

Africa[2]—*Egypt*

Egypt was most important to the development of East Christian art in the earlier centuries. The influence of Alexandria in the province of painting can hardly be exaggerated ; this great Hellenistic city was the teacher of Rome, and the art of the catacombs belongs to its tradition. When, after Constantine, a compromise with orientalism was not to be avoided, Alexandria was the chief representative of Greek feeling in the graphic arts ; she probably originated the illumination of manuscripts, and to her was due one of the two great redactions of gospel illustration which continued to serve the Byzantine illuminator through the Middle Ages (p. 311). In sculpture her part, if less predominant, was still distinguished. She had possessed a pagan school which produced reliefs of a picturesque character ; and in Christian times still practised the glyptic art, creating the remarkable free sculpture and reliefs in porphyry noticed in a later chapter ; in ivory carving she occupied a leading place. Her textiles, jewellery, and silversmith's work were of the first order ; in short, down to the Arab conquest she was the worthy rival of Antioch and Constantinople.

But in the fourth century influences from Western Asia came down into Egypt, and these, from this time until the Arab conquest, in great measure determined the development of Christian art even in Alexandria.[3] Apart from the Semitic realism which entered so largely into Christian representation and changed the old Alexandrian style, there was an influx of ornamental

[1] The position of Chinese art with regard to that of Central and Western Asia is ably defined by Rostovtzeff, *Iranians and Greeks in South Russia*, pp. 197 ff., with a bibliography on p. 237 ; in *South Russia and China*, in *L'art russe*, i, Paris, 1922, and in *Aréthuse*, April 1924, pp. 81 ff. The arguments in favour of a Chinese initiative in geometrical ornament are set forth at length by Strzygowski in his *Altai-Iran*, pp. 113 ff. See also Münsterberg's *Chinesische Kunstgeschichte*, i, pp. 36 ff. For Chinese adoption of Sassanian motives, see M. Dieulafoy, *Compte-rendu de l'Acad. des Inscr.*

et Belles-Lettres, 1910, p. 362, 1911, p. 386. For influence of the Hellenistic centres and of India upon China, see F. Hirth, *Ueber fremde Einflüsse in der chin. Kunst* ; Münsterberg, *Hist. de l'art du Japon* (Exhib. of 1900), pp. 11, 51 ff., 62 ; and Sir Aurel Stein's works, *Ancient Khotan, Ruins of Desert Cathay*, and *Serindia*.

[2] North-west Africa looked to Italy rather than to the Christian East down to the Vandal invasion. It was a Byzantine province from 533 until 709, but is not of the first importance for the study of Byzantine art.

[3] O. Wulff, *Altchr. und byz. Kunst*, p. 145.

motives and methods coming through Syria, and in part affected by the orientalizing Greek art of Hither Asia. Such a fact as the resemblance of the swastika-fret design on the stûpa of Sarnāth, near Benares, to motives of Christian ornament in Egypt is to be explained less by an Egyptian influence on India than by a common influence upon both these countries from Mesopotamia, where similar designs were produced. The Greeks of Alexandria in some branches of art—for example, in certain schools of carving in ivory—appear to have preserved a good Hellenistic tradition down to the sixth century; but in other ivories the Eastern influence is obvious even where a Greek foundation remains : in general, after the fourth century even Hellenistic Egypt was occupied in developing foreign suggestions. The old dynastic art of the country, which had lingered on in Ptolemaic times, played but a small part in the art of the Christian period. We are struck by the fact that, as far as motives go, there is a more distinct breach between Christian artistic expression and that of ancient times in the Nile Valley than in Semitic Hither Asia, where the tradition of the old dynasties seems more strongly to have affected the spirit of all later art. In Syria we have noted an evident persistence of artistic ideas inherited from the ancient monarchies. In Egypt there is indeed some influence of the kind, but far more restricted in its action. There were survivals of old Egyptian mythology, and in some cases of technical methods.[1] But it has been observed above that Hamitic Egypt saw the visible world in a similar way to Semitic Asia, thus the intrusive art from Syria and Mesopotamia, superior in vigour and richer in its treasure of motives, now readily imposed its forms upon the land of the Pharaohs.[2] When we look beyond Alexandria, we find an easy acceptance by the Copts of Asiatic methods and designs naturally sympathetic to a people psychologically akin, and welcoming any aid against an unpopular Hellenistic domination. This community of feeling, coupled with the high technical capacity of the Copts, notably in the textile art (p. 349), explains the far-reaching achievement of Coptic art in the province of decoration; it was not a creative art, but it was spirited and prolific. In its development of imported motives it attained admirable results, furthered, in the case of sculpture, by the possession of materials perfectly adapted to its purpose, such as the soft limestone of the Nile Valley. The products of this art, exemplified in portable objects, were freely exported to the West, since relations between the ports of the Western Mediterranean and Egypt were easy and continuous through Frankish

[1] P. D. Scott-Moncrieff, *Paganism and Christianity in Egypt*, Cambridge, 1913 ; O. Wulff, *as above*, p. 144. We may note the resemblance between the Emmanuel type and Horus, and the relationship between representations of Isis with Osiris and those of the Virgin with the Child; possibly also the Descent into Hell (*Anastasis*) may have had an Egyptian proto-type. The encaustic method of painting (p. 263) was apparently Egyptian, and certain aspects of Christian sculpture in Egypt suggest dynastic reminiscences.

[2] It is possible that these Asiatic influences were partly transmitted by the Nabataeans, whose culture spread to Syria, and at Petra came into relation with that of Egypt.

times. It was thus that the textiles and the metal-work of the Copts were imported into the new Teutonic kingdoms in Italy, Spain, and Gaul, were transmitted to Britain and Ireland, and played their part in the artistic development of all these countries; it is for this reason that bronze vessels of Coptic design and workmanship are discovered in Anglo-Saxon cemeteries in England, and Coptic influence is seen alike in the art of the Lombards and of the Irish.[1] Thus although the Copts may have owed much to imported ideas and motives, the decorative quality of their industrial art lent its products a wide popularity, and gave it an influence in the field of ornament superior to that attained by more originative races. When the Arabs conquered Egypt in the seventh century they absorbed much from an art congenial to their taste, and Coptic crafts were still practised. Christian figure art under Islam was chiefly confined to the monasteries, where Syro-Hellenistic principles remained predominant.[2]

Constantinople and its Sphere of Influence

The new Byzantium began its career as imperial metropolis without an artistic tradition of its own. Some ideas must have come from Rome affecting, for example, the style of many buildings, public and domestic. But it can hardly be doubted that the great flood of influences contributing to the formation of what was to become Byzantine art flowed from the Hellenistic cities of the East Mediterranean littoral and from the interior country beyond them.[3] The Greek cities, which had founded Roman art, helped to found that of the new Rome. But in the fourth century the influence of the interior countries steadily increased; the self-consciousness of their peoples was more developed. With the fifth century came the organization of the Church, and the ecclesiastical ideal of a uniform sacred art in which the feeling of these peoples won recognition. From this time there was a natural tendency for the organized Church and the State to gravitate together, and in the course of the century the understanding between the Eastern Church and the Byzantine imperial system was complete. But in such alliances the State is apt to use the Church for its own aggrandizement, and in the sixth century we find the State, in the person of Justinian, expending vast sums on the building and decoration of churches, the splendour and impressiveness of which depended more and more upon Eastern methods and Eastern feeling. Thus, for all its natural sympathy with classical art, Constantinople itself was drawn into the Eastern orbit. Even in the capital, the sacred art which we have called Syro-Hellenistic

[1] Strzygowski, *Altai-Iran*, pp. 292–3.

[2] To the references on Coptic art given in *B. A. and A.*, p. 74, add V. de Grüneisen, *Les caractéristiques de l'art copte*, Florence, 1922, and Mr. A. F. Kendrick's *Catalogue of Textiles from burying-grounds in Egypt*, 1920–23.

[3] As Bury insists (*Cambridge Modern Hist.*, iv, Introduction), in law and political tradition, Constantinople was Roman to the end. It is because its religion was oriental, and its ornament also came from the East, that in art Western influence had by no means the same exclusive position.

seemed in a fair way to triumph over the symbolic and naturalistic art which had been chiefly inspired by the Greeks of the Mediterranean. The oriental methods were better adapted than the Greek for the dazzling display by which an empire, since Diocletian imbued with Eastern ideas, sought to impress the world with its riches, its majesty and power. In Justinian's time Constantinople was really the centre of an art which may be called imperial in the sense that the Emperor caused it to be represented in widely distant parts of his dominions, erecting on all sides churches and other buildings decorated on the same principles. This art, through the oriental character of these principles, was in fact divergent from the Hellenistic art still cherished by the more highly educated and aristocratic circles in the capital, and perpetuated in works of art produced for their private use. We have seen in what manner the rise of iconoclasm temporarily arrested the first orientalizing tide of Syro-Hellenistic art which reached its high-water mark in the reign of Justinian: the demand for pictures to be venerated had been met by a certain development of sacred art, upon which the wrath of the reformers fell. The concentration of their wrath upon the sacred picture and the monastic system which chiefly encouraged its production, left the field more open to the secular Hellenizing art of the capital, which now again came into the foreground. When the religious struggle died down, Hellenizing forces at Constantinople were in a strategic position from which they could never afterwards be dislodged, and it can be said without too much exaggeration that after the end of the iconoclastic struggle Byzantine sacred art was progressively disorientalized. In the sixth century the city had become the most brilliant centre of East Christian art. The architectural experiments of two hundred years were brought to a head in the great buildings, the cost of which only the wealth of an imperial exchequer could have sustained; the churches of S. Sophia and the Holy Apostles,[1] to name but two, were the wonder of Eastern Christianity; the marble quarries of Proconnesos dispersed throughout the Mediterranean forms of capitals and fashions of ornamental sculpture the decoration of which was unified and co-ordinated by the influence of the neighbouring capital. The metropolis was a home of learning, sacred and profane. In its university the literature of Greek antiquity was studied; in its monasteries the Scriptures and the works of the Fathers were expounded and received illustration. One of the two great redactions of gospel illumination is peculiarly associated with Constantinople (p. 311); in the scheme and principles illustrated on the walls of the Holy Apostles this redaction received its greatest and most famous embodiment.

In Constantinople the several influences of Alexandria, Antioch, and Syria-Palestine were brought into a permanent relation: the process was already far advanced in the sixth century. The city was a place of centralization in art no less than in government. Here the experiments of Western Asia—architectural, sculptural, and graphic—were sifted and developed

[1] This church and its mosaics survived until the eighteenth century.

along the lines best suited to Byzantine culture and the needs of the Ortho-
dox Church. The capital was throughout the Middle Ages the great
home of secular education, and after the iconoclastic period and the Arab
wars its relative importance as a centre of sacred learning increased. In its
libraries, civil and religious, were preserved great numbers of manuscripts
drawn from all the Eastern provinces; in the revival which began with
Basil I these stores of books formed no small part of the material from
which scholars and artists created a new phase of Byzantine civilization.
No other city contained so many splendid monuments; her palaces and
churches, with their mosaics and frescoes, their marble linings, and
innumerable examples of the skill of metal-workers, enamellers, silk weavers,
and other craftsmen, were fabulous throughout the West until the Crusade
of the year 1204 proved that the reality equalled the legend. 'Byzantium with
the unexhausted powers of the Greek race sifted the rich artistic heritage of
the Christian East and incorporated it in the great system of its religious
and political life. Within its walls even in the late Middle Ages the old
stem, after a thousand years of growth, could still put forth new branches.'[1]

It must be insisted that the rise of neo-classicism under the new
'Macedonian' dynasty which brought a second golden age to a reduced
but consolidated Empire was essentially metropolitan, though naturally its
influence extended to the wealthy Greek commercial city of Salonika. It
flourished by favour of the Court and of a cultivated class brought up on
Greek literature, and therefore necessarily attracted by Greek forms of art.
The history of Byzantine literature shows that the period was marked by
much research and much imitation of the classics; this literary movement is
naturally reflected in the art of the tenth and eleventh centuries. In painting
and in the minor sculpture which, especially in the form of ivory carvings,
now so largely represented glyptic art, the old Greek qualities of restraint
and graceful dignity were reasserted. The Hellenizing movement was not
indeed allowed to hold all its positions. The liturgical trend in church art
(p. 18) and the orientalizing influences of a monasticism which had now
recovered its power united to enforce in sacred representation the old Syro-
Hellenistic compromise. But Constantinople gave this compromise a new
style; it produced a new version, differing in a subtle manner from that of
pre-iconoclastic times. The sacred art of Middle Byzantine times is distinct
from that of the age before iconoclasm; it is informed by another spirit,
and Constantinople itself was chiefly instrumental in bringing about the
change. During the period from the close of iconoclasm to the capture of
Constantinople by the Latin powers, the city enjoyed a prestige throughout
the west of Europe which made the influence of Byzantium felt in the art of
all the western countries until the rise of a new art in Italy and Northern
France. Through the whole of this period Constantinople bore the chief
part in the development of later Byzantine style in architecture. The

[1] O. Wulff, *Altchristliche und byzantinische Kunst*, p. 14.

European prototype of the Greek cross plan, destined to supersede all others, was the church known as the Nea, erected by Basil I in the grounds of the Great Palace (p. 102). Whether this plan was originally Anatolian, or, as Strzygowski holds, Armenian, does not concern us here; for the moment we have only to remember that it was from Constantinople that it issued on its career of conquest through the territory still remaining to the Empire.

The Latin occupation interrupted and disorganized the life of the capital. A breach was made in old traditions, the continuity of which must rather be sought in Epirus and Nicaea, in Macedonia and Serbia, and in Italy. After the restoration, for almost two hundred years the city was once more the head of Byzantine civilization. Her art was restored, but upon uncertain foundations; an imitative age, with less knowledge and with ill-digested new experiences, determined for the last time the relations between the two permanent factors, the Hellenistic and the oriental. We have touched above upon the fortunes of this remarkable time (p. 20), which show us Constantinople in decline, but to the last quick with intellectual activity and sedulous in the practice of the arts.[1] The achievement of the city in its last Christian centuries was sufficiently remarkable when we remember the Turkish menace, the insistent poverty, and the visitation of the Black Death.

In a sense it is true that Constantinople was a clearing-house for ideas derived from the provinces. But an injustice is done to this famous city by deducing from this fact that it did no more than receive and pass on something in which its contact produced no change. Every great metropolis is apt to be a clearing-house; but if some never rise above the commerce and exchange of art, there are others which, like Paris, have in their atmosphere and influence a power which stimulates the genius of immigrant artists, co-ordinates the achievement of those who work within its walls, and give organic unity to elements which without her genius would be diffused and lifeless. Such a city was Christian Constantinople. In her long life of more than a thousand years there were too many movements and revivals in art to justify the view that in this field she was without significance.

At all periods of Byzantine history, the influence of the capital was powerful in Salonika;[2] but this wealthy commercial city enjoyed free communications with other parts of the world.[3] It lay on the old Via Egnatia, the main road between Constantinople and Durazzo, and the trade between the Adriatic and the Bosporus passed its gates. It was connected by sea with the ports of Western Asia. Its ancient churches, with their wonderful mosaic decoration, attest its position as a centre of the arts from an early period. During the iconoclastic trouble it was a refuge for

[1] For activity in the minor arts at this time see J. Ebersolt, *Les arts somptuaires de Byzance*, 1924, ch. v.

[2] O. Tafrali, *Thessalonique au XIV° Siècle*, 1913; W. Miller, *Engl. Hist. Rev.*, xxxii, 1917, pp. 161 ff.

[3] J. Zeiller, *Les origines chrétiennes dans les provinces danubiennes de l'Empire romain*; *Bibl. des Écoles Françaises d'Athènes et de Rome*, fasc. cxii, Paris, 1918.

worshippers of pictures who fled the capital. In the tenth century it suffered severely from Arab pirates, who in 904 took and looted it, carrying off twenty-two thousand of its inhabitants as slaves. The same period saw it threatened by the rising Bulgarian power; at the end of this century and the beginning of the eleventh, Basil II made it his military base during the campaigns which resulted in the subjection of the Bulgarian people. In the twelfth century it was the base of Alexis Comnenus against the Normans, who, however, captured it in A.D. 1185. During the Latin Empire it became the capital of a Frank kingdom under the Marquis of Montferrat; Venetians, Genoese, and Pisans, who had even earlier discovered its commercial importance, had now their regular quarters in the city. Salonika remained Latin for twenty years, but for a short space was ruled by Theodore Angelus, Despot of Epirus. During all this time, as the market for Macedonia, Serbia, and Bulgaria, it continued to prosper. In the fourteenth century it was once more an integral part of the restored Empire; at this time it was the centre of democratic and revolutionary movements, the result of its international relations and of the unsettled times through which it had passed.

Salonika was always a great religious city. Its pride was the cult of S. Demetrius, whose splendid basilica, dating from the fifth century, and enriched with the finest mosaics (pp. 280–82), was celebrated throughout the Empire. Among its churches the most various architectural types were represented, from the ancient rotunda of S. George to the graceful late Byzantine structures of S. Pantaleemon and the Holy Apostles. A city standing in such varied relations to religious, artistic, and commercial life, and serving as the gate of the Balkans towards the south and east, was necessarily of cardinal importance to the development of the peoples of the peninsula. The town transmitted East Christian and Byzantine influence to Macedonia, and during the Byzantine occupation of A.D. 1014 to A.D. 1186 (see below) the ecclesiastical art of the period was doubtless in large measure inspired from the great maritime town. The Macedonian school of painting, to which the art of Serbia, Bulgaria, and Mount Athos directly owed so much (p. 237), was connected with and probably based upon Salonika, of which Manuel Panselinos, the last great representative of the school (p. 238), was a citizen.

Greece and the Islands

The history of Greece in the fourth and fifth centuries of our era is somewhat colourless, or coloured by reminiscence of the great past rather than by interest in the present or hope for the future. It was not until the closing of the schools of philosophy by Justinian in A.D. 529, and the introduction of the silkworm under the same Emperor, that the country began to take its proper place in the new order under the influence of a revived prosperity. The Greeks became noted silk weavers; it was from

Greece that the Norman princes imported workmen when they established a silk industry in Sicily. The great age of church building began with the tenth and eleventh centuries, when Byzantine art, in the stricter sense of the term, was at its zenith. It is thus natural that Byzantine influence should affect the architecture of the country; but Millet has shown how far it was from suppressing Greek individuality: certain features, such as the pointed gable, were maintained against later Byzantine styles. Moreover, Greece showed a peculiar tendency towards oriental methods in construction. In eleventh-century monastic churches, Daphni and S. Luke of Stiris in Phocis (pp. 86, 145), the squinch is used instead of the usual pendentive, and this presumed oriental feature, accompanied by beast-ornament of Mesopotamian character, and Cufic lettering used in a purely decorative way both in church brickwork and upon a sculptured slab, suggests that Greece, like Serbia and Bulgaria, may have maintained communications with the East independently of the Byzantine capital (p. 146). The Latin occupation did not change the foundations of Greek life, and in Epirus 'despots' belonging to the family of the Angeli maintained themselves in Epirus with Arta as their capital. In many ways the Greek civilization seems to have charmed and influenced the Western princes who now ruled the country. The story of the Dukes of Athens and the Princes of Achaia has been well told by English writers from Gibbon and Finlay to living authors, and we need not dwell upon it here.[1] When, in the second half of the thirteenth century, the Frankish power was broken in the Morea, Mistra, on the site of Sparta, rose below the Frankish castle to become the capital of a flourishing Byzantine province; the mural paintings of its churches are among the most interesting of those produced in the times of the Palaeologi (p. 238). In the north of Greece, in Thessaly, the monasteries of Meteora were at the same period a centre of religious and artistic life (p. 257).

The Greek islands were always of some importance, lying, as many of them did, on the route between Constantinople and Italy. They contained fortified castles, and churches with fine mosaics, like Nea Moni on Chios (p. 288), or like those of Paros (p. 145, n. 3), interesting from other points of view. Byzantine Cyprus was prosperous at an early date; we infer monastic and private wealth from the quality of the silver plate and jewellery dating from the sixth century discovered near Kyrenia in the north of the island (p. 328). In the church of S. Barnabas, at Salamis, we find a type related in plan to that of the church of the Holy Apostles at Constantinople. Three small churches, one near Larnaka, the other two in the Karpass, contain in their apses mosaics of fine quality (p. 283).

[1] See especially W. Miller's recent *Essays on the Latin Orient*, Cambridge, 1921, a valuable supplement to his earlier *Latins in the Levant*. In this later work the first two chapters review the history of Greece in ancient and in earlier Byzantine times; Sir Rennell Rodd's *Princes of Achaia* is also indispensable. In these books the student will find abundant references to earlier and contemporary work by scholars of different countries.

The artistic history of Crete is of great interest. Little is known as to the first centuries of its existence under the Byzantine Empire. It suffered under Arab occupation from the early ninth century to A. D. 961, when it was recovered by Nicephorus Phocas. A second Byzantine period lasted until the beginning of the thirteenth century; the island then passed into the hands of the Venetians, who held the whole of it until the seventeenth century. At this period the Turks, who in the previous century had carried out numerous raids, established themselves in Crete, and gradually reduced the Venetian strongholds. But the last of these held out till A. D. 1715. The types of Cretan churches appear to come from Anatolia: the fact suggests that Crete may have been the half-way house on the road by which Cappadocian influences reached Italy. The most interesting Byzantine church is that of S. Titus at Mitropolis, the ancient cathedral of the bishops of Gortyna, which is of an early Greek cross type, with single central dome (p. 145, n. 3); churches of the second Byzantine occupation are numerous. At Marzalo, a rock-cut church reminds us of Cappadocia and Southern Italy; other churches abut upon surfaces of rock, and have one or more constructed walls.

The island is very rich in mural paintings, the earliest to which an authenticated date is given belonging to the end of the twelfth century; but others are probably earlier. Cretan ikon-painting in tempera on wooden panels in later centuries is noticed in another chapter (p. 242). The names of many painters have been preserved; although none of those more directly connected with Byzantine art can be called eminent, it should not be forgotten that Domenico Theotokopoulos, commonly known as El Greco, was a Cretan.

The Balkans

Bulgaria.[1] Long before the Bulgarians came from Russia to the Danube, the region to which they have given their name was connected with Asiatic culture. The Scythians, also advancing through Russia, established themselves in the Dobruja in the fourth century B. C.; as in the south of Russia they were a ruling aristocracy, forming a kind of state in which the native original agricultural population was subjected to a foreign domination.[2] Scythian tumuli are frequent in Bulgaria and Roumania; the Dobruja remained Scythian until Roman times.

Thus when the Romans advanced to Thrace and Moesia they came into a region already penetrated by Eastern influences, and these were not interrupted by the spread of Christianity. The new religion came into the country not from the European side but from the north of Asia Minor. By the beginning of the fourth century there was a high proportion of Christians

[1] W. Miller in *Cambridge Med. Hist.*, iv, 1923, ch. viii and xvii, and bibliographies, pp. 826, 871.

[2] Rostovtzeff, *Iranians and Greeks in South Russia*, pp. 42 ff., 89, 165, 221.

among its population.[1] We should therefore expect to find upon its soil remains of churches built by the community of which we have historical record. Recent excavation has justified the expectation, revealing an architecture with affinities of a Hellenistic and oriental character (p. 146). At Tirnovo and at Sofia there have also been discovered sculptured capitals of columns, a relief apparently representing Our Lord, and frescoed sepulchral chambers, dating from the fifth and sixth centuries.[2] The presence of these remains tends to confirm the belief that the Danubian region was an important link between the Christian East and the West, and that artistic motives, and even types of building, may have been introduced into Central and Western Europe along this line.[3]

At the time of conflict with Byzantium in the tenth century the imperial capital imposed artistic forms upon Bulgaria ; but influences from the East, perhaps independent of Constantinople, continued to enter the country : we may point to the appearance of orientalizing beasts in sculptural reliefs, and to the discovery at Patleina of glazed tiles with figures and decorative designs, suggestive of a Mesopotamian origin (p. 347). In the ninth century the Bulgars had begun a series of encroachments which by the third decade of the tenth gave them possession of the greater part of the Balkan area, with most of the territory held by the Serbs. The Emperor John Zimisces recovered the eastern half of their lands in A.D. 971, but the western part, including Macedonia and Albania, held out as an independent state under the house of Shishman, its seat of government being first changed from Sofia to an island in Lake Prespa, while fortresses were erected by Lake Ochrida. The death of Zimisces was followed by a revolt of the eastern Bulgarians, aided by Samuel, tsar of the western state. Their combined forces were, however, defeated by Basil II in A.D. 1018, the greater part of the Balkans remaining under Byzantine control, with Ochrida as chief city, until A.D. 1186. In that year, as a result of a revolt in Macedonia under the house of Asen, the second Bulgarian kingdom was

[1] A. Harnack, *Mission und Ausbreitung des Christentums in den ersten drei Jahrhunderten*, 1902, pp. 489, 540. The Emperor Maurice (A.D. 582–602) settled Armenian families in Thrace on more than one occasion. Constantine V in the eighth century settled Paulicians from Armenia in the country, who in A.D. 810 had eight churches. Basil II after his victory over the Bulgars again introduced Armenians (Strzygowski, *Baukunst der Armenier*, p. 736). The Bulgarians crossed the Danube in the second half of the seventh century and for about two hundred years were regarded as nominal subjects of the Byzantine Empire.

[2] Strzygowski has discussed and illustrated the sculpture in *Byzantinisch-Neugriechische Jahrbücher*, i, 1920, pp. 17 ff. The significance

of Moesia and Bulgaria in the diffusion of East Christian art he had previously treated in 1910 : ' Die nachklassische Kunst auf dem Balkan ', in *Jahrbuch des freien deutschen Hochstiftes*, pp. 30 ff. Further mention of Bulgaria will be found in Strzygowski's *Amida*, p. 375 ; *Baukunst der Armenier*, pp. 727 and 736 ; *Christian Church Art*, and in *Altai-Iran*. The reader should also consult B. Filov, *Sophiiskata Zerkva, Sophia* (Materials for the history of Sofia), Bk. iv, and *Early Bulgarian Art*, Berne, 1919.

[3] For the possible mediation of Bulgaria at a later time between the Mohammedan East and Greece, especially in ornament, see Van Berchem and Strzygowski, *Amida*, p. 375.

established and the Bulgars were never again subject to the Empire. Kaloian, a brother of the founder of the new dynasty, after successful engagements, made peace with Constantinople, establishing his capital at Tirnovo. His dominions included Belgrade, Nish, and all modern Serbia east of the Morava, extending from the mouth of the Danube to the Struma and Vardar. The dynasty produced a second great ruler in John (Ivan) Asen (1218–1241), whose frontiers reached the Black Sea, the Aegean, and the Adriatic, comprising Bulgaria proper, part of modern Serbia with Belgrade, and all Macedonia and Albania as far as Durazzo. After his death, Bulgaria was ruled by a succession of weaker kings for about ninety years, when Serbia, now at the height of her power, defeated the Emperor Michael at Küstendil (then Velbuzhd) in A.D. 1330; after this, though free from servitude, Bulgarian princes followed the fortunes of the Serbian royal house, with which they were connected by matrimonial alliance.

Under the earlier Bulgarian kingdom, Serbia had been effaced. During the first part of the Byzantine supremacy over Bulgaria, after the victory of John Zimisces, she shared the consequences of her neighbour's defeat. But in 1040 she regained her freedom; her power began to increase; and with the accession of Stefan Nemanya, founder of the dynasty of that name, in the middle of the twelfth century, the greatness of medieval Serbia began. Stefan abdicated towards A.D. 1200, retiring to the new Serbian monastery of Chilandari on Mount Athos, where his third son, under the name of Sava, was already a monk: here, shortly afterwards, he died. Under his successors of the thirteenth century, the Serbian state was consolidated. The reign of the noted church-builder, Stefan Urosh II, Miliutin (A.D. 1282–1321) inaugurated the great century of Serb history. Hostilities with Michael Palaeologus and Andronicus II were followed by a Byzantine alliance against the Turks, and the Serbian arms were successful against Bulgaria. Miliutin's son, Stefan Urosh III, expanded Serbian influence on all sides, and in 1330 inflicted on the Bulgarians the severe defeat of Velbuzhd (see above). With the accession of his son Stefan Dushan in the next year Serbian power reached its zenith. During his long reign of nearly a quarter of a century, the frontiers stretched from the Danube to the Gulf of Corinth, and from the Adriatic to the neighbourhood of Adrianople. But the death of Dushan in 1355, almost at the gates of Constantinople, was soon followed by decline; the kingdom began to fall apart, and the Turks, already at Adrianople, threatened it with destruction. Under Lazar, a prince of Dushan's house, Macedonia was lost, and in 1389 the Serb armies were defeated on the plain of Kossovo, where Lazar was slain. Until 1459 the conquerors permitted Serb rulers to exercise nominal power with the title of despot; but in that year the country was formally annexed. The disaster of Kossovo was not immediately followed by the end of Serbian architecture and other arts, for a whole group of interesting churches was built under the despots (p. 151). Even when the Turkish

rule was firmly established art did not die, though general impoverishment prevented any great expansion.

The art of Serbia and Bulgaria is chiefly represented by the churches and their mural paintings, with the addition of illuminated MSS. and a few objects illustrating the minor arts. From the time of the first kingdom, church construction was mostly under Byzantine influence, though in Serbia, especially in the earlier Nemanya period, Dalmato-Italian influence is apparent (pp. 148–9); and after Kossovo there was a return to northern influences. Miliutin founded at Jerusalem a monastery in honour of the archangels Michael and Gabriel, which was enriched by later kings; in the fourteenth century monks from Serbia were connected with the monastery of S. Catherine on Mount Sinai. These relations kept the country in touch with the monastic art of the East, and it is believed by some that early Syrian illuminated books, copied in Sinai, in Jerusalem, or even at Chilandari, may be the source of oriental features in mural paintings, or manuscripts like the Psalter of about A.D. 1400 at Munich studied by Strzygowski (p. 309). Others, however, hold the opinion that much of this later influence came indirectly by way of Constantinople, old copies of Early Christian illuminated books, made in the capital after the iconoclastic period, being now used as sources. It seems, at any rate, established that in the fourteenth century artists looked back into the past, seeking suggestions in the work of earlier times, chiefly found in illuminated MSS., whether actually of Early Christian date or old copies of such; the process, as Millet has justly remarked, bears some analogy to that adopted in the West after the Renaissance in relation to antique models.[1] From such books were reintroduced into Byzantine art motives and types, some based upon the apocryphal gospels, which the liturgic art of the middle period had allowed to drop out of use. But at the same time the Slavs were enriching their art by borrowing to a slight extent from contemporary Italy, and to a great extent from the Byzantium of the post-iconoclastic and Comnenian periods. The frescoes of the greater church at Studenitza and of the churches at Gradatz, Nagoricha, Grachanitza, Mateitza, and Lesnovo betray the influence of the Macedonian school, while those of the churches built by the despots after Kossovo, like Manasiya and Ravanitza, show that of the so-called Cretan school (p. 259).

North of the Danube, in Roumania,[2] the Scythian influence which had continued until Roman times between the Crimea and the Dobruja must have extended some distance into the eastern parts of Moldavia and Wallachia. The culture which Roman colonization had introduced among Dacians and Getae was destroyed by barbaric invasion after the first century of our era. The remains of Byzantine frontier fortresses have disappeared; building in stone ceased in the seventh century. In the early Middle Ages the people were governed by voivodes, or dukes, who in the eleventh century

[1] *Iconographie de l'Évangile*, p. 688. [2] N. Jorga, *L'Art Rouman*, pp. 3 ff.

were in contact with the Byzantine Empire. But the real beginning of Roumanian art was not until the fourteenth century, when churches in brick and stone were erected under Greek and other influences.

Mount Athos became a cosmopolitan monastic centre from the tenth century, when the earliest monasteries were founded (see p. 130). By its relations with old foundations on Mount Sinai and in Palestine, and by the close connexion of certain of its houses with particular nationalities (as Chilandari with Serbia, Ivirôn with Georgia, Rossikôn with Russia), Athos became a centre for the dissemination of artistic influence coming through the national Slav states. Though the mural paintings in the monastic churches do not go back beyond the sixteenth century, they are of high interest as showing the successive influence of the Macedonian and Cretan schools. Painters trained in the first of these executed the oldest work for most of the fourteenth- and fifteenth-century churches (for instance, Vatopedi and the catholicon of S. Paul's); to artists belonging to the second are attributed the later mural paintings. But Panselinos, the last great representative of the Macedonian school, is said to have decorated the older church (no longer existing) of Rossikôn in A.D. 1554; another member of the school, if not the master himself, executed frescoes in the second church by command of the Russian tsar in 1571.[1]

The discovery in Albania of a treasure including a number of metal buckles and other objects ornamented with scrolls similar to those found on similar objects in Hungary, has suggested the presence in Albania in the seventh or eighth century of metal-workers using ornament of an Asiatic style; some of the objects are unfinished and the site seems to have been actually that of a workshop. This treasure has served Strzygowski as the text to a theory as to the development of certain forms of ornament which will be mentioned in a later chapter.[2] In view of the discovery of older oriental ornaments in more westerly countries, the presence of this treasure in the Adriatic region need excite no surprise. The presence of Asiatic craftsmen in the most various parts of Europe from very early times is a fact which can no longer be regarded as abnormal.

Russia

The Scythians and Sarmatians occupying the south of Russia in the Greek and Roman periods were nomads of Iranian stock;[3] the latter, coming from the north of the Caspian in the fifth century, were in the

[1] Millet, *Iconographie de l'Évangile*, p. 659.

[2] *Altai-Iran und Völkerwanderung*, 1917. Cf. p. 372.

[3] *Journal des Savants*, 1920, p. 121; *Iranians and Greeks in South Russia*, 1922, ch. vi. For the early culture of South Russia the reader should also consult E. H. Minns, *Scythians and Greeks*, Cambridge, 1913; and Rostovtzeff, *Les Grecs et les Iraniens au Sud de la Russie*, Petrograd, 1918, and *Études sur l'histoire de la Scythie et du Bosphore* (in preparation). For the importance of the contact between the Goths and Sarmatians see also Strzygowski, *Baukunst der Armenier*, p. 726. Both Scythians and Sarmatians had doubtless an admixture of Mongolian blood, and the latter may have had a proportion of Mongolians with them.

Kuban valley in the fourth, on the Don in the second half of the same century, and across that river in the third century B.C. Their culture had a general resemblance to the Scythian, but their mode of burial differed, as did their weapons and their ornaments, the latter being marked by profusion in the use of coloured gems. According to Rostovtzeff, it was this Sarmatian culture which inspired both the art revealed by discoveries in the tumuli of Siberia and that of the Goths. The Greek colonies on the Black Sea coast were of Ionian origin, and long lived in amity both with the Scythians and with the Sarmatians, the chief bond between them being that of commercial advantage ; the cities were gradually 'Iranized' by the Sarmatians, of whom the Alans were the most important tribe. Christianity was introduced among them from Asia Minor, and the remains of early churches have been discovered at Chersonesus and Panticapaeum (p. 152). The Goths received their Christianity from the same source, Ulfilas, their great missionary, coming from Cappadocia.[1] German tribes, unable to break through the Roman line of the Danube, had moved east to the Dnieper, where they established trading stations in touch with the Roman Danube provinces, and with the Goths. The influence of the more cultivated Iranian Sarmatians upon the latter people was of great significance for the earliest medieval art of Europe, not only because the Teutons assimilated Iranian culture, but because numbers of Alans and other Sarmatians accompanied the Goths on their westerly migrations.[2] The Goths had doubtless also in their company Cappadocians and Armenians, who may have been their masters in the art of building.[3] The south of Russia was probably a region of no small importance for the development of Christian art since it lay upon the land route between Asia and Central Europe.

The passage of the Huns in the fifth and sixth centuries left the country clear for the Slavs, who coming from the north of the Carpathians, established themselves on the middle Dnieper, and adopted the commercial life which from the time of the Scythians had been carried on in the great river valleys. They called in the aid of Scandinavian chiefs to defend their cities, the greatest of which was Kieff. Thus long before their conversion they were by no means savages, but lived under a settled government organized on traditional lines.[4]

It was during the time of this principality of Kieff that the Byzantine Empire came into closest contact with Russia. Princes and people were converted to Christianity in the tenth century, and the architecture and the

[1] It has been noted above that the Scythians and Sarmatians maintained constant relations with the northern shores of Asia Minor, especially Pontus and Cappadocia ; the Goths continued these relations through their Sarmatian neighbours.

[2] Rostovtzeff, *Iranians and Greeks*, p. 119.

[3] For Strzygowski's view that the presence of Armenian masons with the Goths accounts for the appearance of the earliest vaulted churches in Italy, France, and Spain, see below, p. 158.

[4] The system was Iranian, introduced half a millennium before Christ by the Scythians. The agricultural and trading population received protection from a foreign military nation occupying the country in inferior numbers, and exacting their full share of the wealth produced (Rostovtzeff, *as above*, pp. 218 ff.).

minor arts of the Dnieper valley from that time to the Mongolian invasion
some centuries later bear witness to the influence of the southern civilization.
At the same time the Russian people was trading with the Scandinavians to
the north (see below) and with Asia through the country round the Caspian,
held in these centuries by the Khazars, a peaceful Mongol tribe who had
preceded the Huns on the Volga.[1] To the period before the Mongol invasion
of the thirteenth century, when Russia had finally become a Slavonic nation,
we owe the cathedral of Kieff with its mosaics and frescoes (pp. 154, 289),
and a number of objects illustrating minor arts, notably enamelling. Byzan-
tine artists were sent from Constantinople to carry out the earlier buildings
and their decoration ; but it may be assumed that in course of time native
artists took an active share in all the arts. The most ancient churches in
addition to Kieff are those at Vitepsk, Chernigoff, Novgorod, and Polotsk,
all dating from the eleventh century ; through their influence southern
architectural plans and modes of decoration were transplanted as far north
as Vladimir before communications were interrupted by the Mongols. The
Russians were driven to the Carpathians on the west and to the forests of
the Upper Volga and the Oka in the north and east. In Vladimir Russian
culture survived and flourished. But the cutting of the trade-communica-
tions to the south changed Russia from a trading country into a land of
peasants, looking no longer to the south and east.[2] While Constantinople
inspired church-building in the western half of the country, influences
coming through Georgia from Armenia were predominant in the eastern
half, though the cathedral of Kieff itself follows a Georgian plan. Swedish
commerce early in this period carried the Iranian ornament of the Khazars
across Russia to Sweden.

With the fourteenth century, as we learn from Russian chronicles,
churches were built or decorated at Novgorod and Moscow (A. D. 1338,
1343, 1378, 1395) by 'Greeks' and their Slav pupils ; these Greek painters
belonged to the nearest and most flourishing school, the Macedonian
(p. 237). In the mural paintings of S. Theodore Stratelates at Novgorod,
recently discovered, dating from about A.D. 1370, and in those of churches
at Volotovo (A.D. 1363) and Kovaleff (A. D. 1380) in the same neighbourhood,
we recognize the free and bold Macedonian style of the earlier churches in
Old Serbia and at Mistra. Subjects are often chosen and arranged after
the manner of Cappadocia, because Cappadocia had been the great trans-
mitter of Syro-Palestinian types and forms, and these had been copied in
Byzantine illumination ; but on the whole, oriental influence plays a limited
and subsidiary part ; the ikons and miniatures of the same century are
likewise in the Macedonian style. Towards the close of the century, there
was more direct influence from Constantinople ; we know that Byzantine
models of various kinds were now entering Russia ; for instance, the *Sakkos*
of Photios, sent A. D. 1414–1417 (p. 357). About the same time, according

[1] Rostovtzeff, *Iranians and Greeks*, p. 219. [2] Rostovtzeff, *as above*, p. 221.

to Kondakoff and Likhacheff, the Cretan school, which must now have been established in Constantinople, replaced the Macedonian as it did in Serbia; the mural paintings of the Uspenski cathedral at Vladimir, attributed by Russian scholars to the first decade of the fifteenth century, have affinity to those of the Peribleptos at Mistra, which may be taken as representative of the new style (p. 255). Interesting mural paintings remain at Moscow in the Kremlin, and in the so-called House of the Romanoffs, in which can be traced a Byzantine influence encouraged by matrimonial alliances with the Byzantine imperial family. The mural paintings are disposed over the vaulted surfaces in a manner clearly inspired by Byzantine sources.

The West: Italy

We turn now to the countries west of the Adriatic.

At the beginning of the Christian era the artistic influence which entered Italy became definitely oriental through the mere expansion of Roman political power. Among its earliest sources were the great Hellenistic centres, first Alexandria, then Antioch, and finally Constantinople, where the various threads were gathered and woven together into a new fabric. From Alexandria almost all the Greek arts, greater and less, made their way to Rome through the southern ports and across Campania. Painting, architecture, sculpture, and the minor arts came rapidly into imperial Italy by this route; the spread of culture among the Romans began with a process of Hellenization, in which literature and art followed parallel paths. But it has been shown that the Hellenizing stream itself was never pure. Even in Alexandria, where the Greek element was very strong, Hellenistic art was affected by orientalizing factors. At Antioch, on the edge of the Aramaean countries, the Syrian and inner Asian influence was more immediately felt, and was rising to independence in the fourth century. At this time, and in the following century, when the seat of government was moved to Milan and Ravenna, the forces which lent Christian art its new and individual character became apparent in different parts of the peninsula. It must be remembered that the early Christianity of Northern Italy was based, not on Rome, but on Sirmium and Salonika, ultimately on Bithynia and Asia Minor, whence the oriental Christian influences now being traced on Balkan soil (pp. 50, 51) first made their way to the West. According to Agnellus,[1] all the bishops of Ravenna down to Peter (A. D. 396–425) were Syrians; and the ports of Classe and Aquileia were active centres for trade between the East Mediterranean coasts and the head of the Adriatic. At the time when Galla Placidia, living at Ravenna, was helping to restore the ancient buildings of Rome, such oriental influences from the Christian East must have been actively at work. But with the coming of the Goths the Eastern connexions of Northern Italy were increased; they were

[1] *Liber pontificalis ecclesiae Ravennatis*, c. xxiv.

especially connected with Cappadocia, where Aramaean, Armenian, and Iranian influences met. We have seen that the Goths had themselves derived their Christianity from Asia Minor, and while settled north of the Black Sea (p. 55) had lived in touch both with Iranian culture and with that of the new Christian capital at Byzantium. The Goths were thus more advanced in civilization than the other Teutonic tribes to which they handed on the artistic motives drawn from the Christian East and from Iran. They were skilled goldsmiths; it is quite probable that some of the earliest Christian work in cloisonné enamel which has survived was produced by their craftsmen (p. 335, n. 5); motives of ornament Asiatic in suggestion appear in other fields of art during their rule in Italy. But their contributions to the development of the minor arts would sink into relative insignificance if the theory advanced by Strzygowski were finally established. According to this view, the Goths brought westward in their train Armenian and other Eastern builders, through whom the knowledge of vaulted buildings was transmitted first to Italy and then to other Western countries. In S. Lorenzo at Milan Strzygowski sees an early Armenian plan; to the later plan of S. Satiro he attributes the same origin (p. 155);[1] from early buildings of Gothic origin, not from the Lombard churches of the close of the first millennium, he would derive the main impulse towards the style which we call Romanesque.[2] Ravenna, the port of the Goths, as of the dying Roman Empire, was in direct communication with Antioch, a centre of Asiatic no less than of Greek influence; and in the ornament of the Ravenna mosaics of Theodoric's time he sees Iranian forms brought by the same means. In short, he ascribes to the Goths, as carriers of oriental influence, a higher place than any assigned to them heretofore,[3] and a relatively important action on the ulterior growth of Western art: the north of Italy was the theatre in which they found fullest opportunity for development, a theatre less dominated than the south by the fascinations of Hellenistic art. But to the south too 'Syrian' commerce brought with it a constant influx of Eastern methods and motives. We have noticed on another page (p. 270) the suggestion that Iranian elements entered into the symbolic art of Early Christianity at Rome, and that such ornament as that in the fourth-century dome of S. Costanza was Iranian in character; the use of squinches in the construction of the Baptistery at Naples is ascribed by Strzygowski to a similar introduction of Eastern ideas.[4] The spread of monasticism added other oriental influences. Cassiodorus, ex-minister of

[1] *Die Baukunst der Armenier und Europa*, pp. 769, 828.

[2] This is an opinion which does not commend itself to the majority of architects. They are willing to recognize an infiltration of Eastern ideas, but still believe that a re-awakening Europe made use of the old Roman remains scattered through the Western provinces, and that in these remains lay the main source of their inspiration (W. R. Lethaby, *Cambridge Modern History*, iii, ch. 21).

[3] In this Rostovtzeff agrees, with the proviso that the basis of their culture was essentially Sarmatian.

[4] This has been denied by Rivoira (*Moslem Architecture*, p. 124).

Theodoric, and founder of two religious houses at Squillace, was acquainted with the Aramaean culture of the monastic schools at Nisibis, and sought to introduce their religious teaching into his own country. This system was accompanied by an art of like origin. In the sixth century, illuminated books from the East were already coming into Italy to serve as models in Italian *scriptoria* : the well-known Gospels of Rossano (p. 312) are thought to have entered the country at this period ; the gospels at Corpus Christi College, Cambridge, are perhaps an early copy of such an immigrant book.[1] The Latin Bible known as the Codex Amiatinus,[2] so interesting to the English student for other reasons, has at the beginning sixth-century illuminations, perhaps executed for Cassiodorus himself, the style of which is East Christian. Sicily and Calabria, where Eastern monasticism found early entrance, were centres whence like influences passed to Naples and Rome.

When the generals of Justinian had defeated the Goths and made Italy a part of the East Roman Empire, it was natural that an orientalizing art should obtain a firm footing in the country, spreading to Istria and the Dalmatian coast, where the influence of Ravenna extended. Down to this time Rome herself had shown a certain tenacity in adhering, through a troubled period of abandonment and barbaric invasion, to the Hellenistic art which she had derived from Alexandria ; certain Early Christian motives were frequently repeated, and we seem to mark a Roman conservatism averse to foreign innovation. But while the Roman school in Christian archaeology believes in a Rome following her own development and impermeable to external suggestion, the extreme oriental school claims that here too, and even before the Gothic wars, the East was changing the spirit and expression of Roman art :[3] their opposition reaches its climax in their respective views of the apse-mosaics of Roman churches : where the one sees a purely Roman conception, the other detects the influence of a symbolism imported from Iran.[4]

After the Gothic wars Rome was an impoverished city to which orientals flocked in increasing numbers. With the loss of great parts of Italy to the Lombards, and the increasing weakness of Byzantine power in those that remained, the popes became the real leaders of national life. But in the seventh and eighth centuries, between 606 and 752, no less than thirteen popes were of oriental birth, some of them coming to Rome from Calabria and Sicily, where Eastern elements were always strong ;[5] it was not until

[1] Millet, *Iconographie de l'Évangile*, p. 594.

[2] Zimmermann, *Vorkarolingische Miniaturen*, 1916, pp. 111, 260, and fig. 24.

[3] The protagonists in this dispute are Wilpert and Strzygowski, the former more especially in his great work on the mosaics and mural paintings of Rome. In the field of architecture, the Roman case has been powerfully stated by Rivoira.

[4] Wulff, while opposing in the main the idea of Mazdaist influence on Early Christian art in Rome, admits the possible presence of Iranian elements in certain iconographic motives such as the *Traditio Legis*.

[5] Out of ten popes reigning between 685 and 741, five were Syrian, four Greek, and only one Roman.

a later time that the papacy stood for a truly Italian and Western point of view. The Roman monasteries were now largely Eastern, the monks 'Syrians', or under the influence of Aramaean theology. Inevitably the art of Rome assumed the Syro-Hellenistic character, and in the later frescoes of S. Maria Antiqua and other Roman churches (p. 249) abundant evidence of the change survives. Only towards the end of the eighth century did this predominance begin to decline, when the appeal of Pope Stephen to the Franks for protection against the Lombards gave Rome a new orientation towards the North. But even then the popes confirmed 'Greeks' in the charge of certain churches; there were twelve of these in the ninth century, and in some of them oriental control persisted as late as the tenth.[1] The sacred art introduced by Eastern monasticism was naturally imitated by native painters,[2] and the oriental style spread not only in Italy but beyond it into the West. Between the late sixth and the ninth centuries the old imperial capital assumed a new importance as the great artistic centre of distribution. Bishops and monks came to Rome from all parts of the West to pay their court to the popes, and these carried back to their own country pictures and other works of art; their taste was influenced by that of an orientalizing Rome. The city of the popes was now the source of inspiration to all Western Europe : through Rome came the inspiration of Carolingian and early German sacred art. But throughout the whole period her part was that of the intermediary rather than of the creator.[3] In the ninth century Roman art sank to a low ebb, and for a time Roman influence was confused and ineffective. Political and ecclesiastical connexions with the East were broken off; a new Roman art had not awakened. The beginnings of a real revival were not seen until the eleventh century.

When Ravenna fell in 753,[4] Venice became the centre of East Christian influence in the north of the peninsula, and long retained her place without any serious rival. From her first emergence as a city down to the ninth century she was politically dependent upon Byzantium, but her great Byzantine monuments belong to the time of her freedom, when commercial enterprise increased her wealth. In the eleventh and twelfth centuries the art of Venice was Byzantine; the cathedral of S. Mark reproduced in plan the great church of the Apostles at Constantinople, the mosaics which decorated it were of Eastern inspiration. At this period Byzantine painters must have settled in the Greek colony at Venice, who in the thirteenth century aided the rise of a native Italian art (p. 241). The part played by

[1] Millet, *Iconographie de l'Évangile*, p. 594. Their influence was maintained through the increase of Basilian monks in South Italy, caused by a fresh influx during the iconoclastic troubles in the East.

[2] e. g. in SS. Nereus and Achilleus, S. Bastianello in Pallara, S. Saba, the oratory of John VII, S. Maria in Cosmedin, S. Praxed. In the later work an Italian, or perhaps rather

a barbaric spirit, begins to feel after an expression of its own.

[3] Millet, *as above*, pp. 595–6; Bertaux, *L'art dans l'Italie méridionale*.

[4] After the fall of that city, the imperial prefects resided at Zara, which, on the conclusion of peace between Charlemagne and Nicephorus I, became capital of Byzantine Dalmatia.

the Venetian forces in the Fourth Crusade enriched the city with sculptured reliefs and a great wealth of church plate, enamels and precious objects carried off from the East Roman capital: these spoils, mostly concentrated in and around S. Mark's, have made of that church a veritable museum of Byzantine art. To the orbit of Venice may be reckoned Murano and Torcello, where mosaics of a pure Byzantine style, with a rich decorative sculpture in marble, survive to attest the Eastern influence (p. 290). After the thirteenth century, Venice, which for many hundred years had turned her face eastward, assumed her natural place as an integral part of Italy.

The importance of Calabria and Apulia had increased in the Middle Byzantine period. In these regions Basilian monks had long established themselves in communities whose rock-cut chapels retain some of the most interesting mural paintings of the early Middle Ages (pp. 253-4); after the outbreak of iconoclasm in the East, their numbers, as we have seen, were increased by fugitives from Constantinople and other places. During the period of Byzantine expansion under the Macedonian dynasty there was a further colonization from the Peloponnese, and the influence of Basilian monasticism still further spread in South and Central Italy. This influence survived the severance of the political connexion with Byzantium. The Greek monks retained their ritual and their language, and though their art slowly yielded to that of an Italian Italy, it persisted as late as the thirteenth century. They established themselves almost at the gates of Rome. The monastery of Grottoferrata, remarkable for its mosaics, was founded in the early eleventh century by the Basilian, Nilus of Calabria. The introduction of Eastern workers in mosaic into the Benedictine house of Monte Cassino by the Abbot Desiderius in the eleventh century attests the enduring prestige of Byzantine art in this part of the peninsula;[1] the illuminated books produced in the abbey show the interaction of Eastern and Western styles. Monte Cassino was one of the places which at the same period imported the great Byzantine bronze doors damascened with silver, of which other examples were set up in maritime cities and in Rome itself, chiefly through the munificence of merchants trading with Constantinople (p. 358). In Sicily, reoccupied by the Byzantine Empire after the defeat of the Mohammedan conquerors in A. D. 965, churches were erected upon Eastern plans; minor works of art dating from this period are preserved in the museums of Syracuse and Palermo. After the establishment of the Normans in the island, both Arab and Byzantine tradition survived, and the churches at Palermo, Monreale, and Cefalù, with their admirable mosaic decoration, have left us noble memorials of an eclectic but mainly oriental art (p. 290). The south of Italy had always been a transmitter of East Christian illuminated manuscripts. In early times these books passed from monastery to monastery, from Palestine to Calabria, thence to the houses farther to the north, among the most important of which was that of Farfa,

[1] For gifts made by Byzantine emperors to Monte Cassino see J. Ebersolt, *Les arts somptuaires de Byzance*, p. 83.

in the old Sabine country. Millet has remarked that after examining the famous Farfa Bible we need no longer be surprised to recognize early East Christian iconography, and even artistic methods, in the thirteenth-century illuminated books of Italy and Germany.[1] Illumination throughout the peninsula retained an oriental character until the rise of a native Italian painting, a fact of fundamental importance to the art of the countries beyond the Alps with which Italy maintained regular communications.

France, Spain, Germany, and Scandinavia

A second avenue through which oriental influence entered the West lay through the south of France, where the trading ports of the Mediterranean maintained continual relations with the eastern shores of that sea. Traders and monks from Syria-Palestine, Egypt, and Armenia were early upon the scene, bringing with them minor works of art, illuminated manuscripts, textiles, ivories, objects in the precious metals. The first Christian sarcophagi of Gaul, at Arles, are allied in style to the Roman, which are themselves in the tradition of Antioch and Asia Minor. A later group reveals an influence which may have come by the overland route across Europe ; it is found in the Visigothic capital at Toulouse, and is decorated with conventionalized ornament of which the affinities are oriental.[2] Mention is made elsewhere of Strzygowski's hypothesis that the earliest vaulted architecture of France and Spain was introduced in like manner by the Goths through oriental builders following in their train from the south of Russia (p. 158), just as new styles of oriental jewellery were brought by them from the same quarter (p. 321). Historical evidence, derived from the writers of the late Roman and barbaric periods (Sidonius Apollinaris, Fortunatus, and Gregory of Tours), testifies to the erection of stone churches by non-Roman builders (*manu gothica*). The later church of S. Germigny-des-Prés near Orleans, built in the early ninth century by Bishop Theodulf, a Visigoth from Spain, has a plan regarded by Strzygowski as Armenian (p. 158).

Syrian (Aramaean) influence was diffused by the monasteries, erected from the fourth century onwards, the earliest being those at Liguaé near Poitiers, and that of Tours, both founded by S. Martin. The famous house on the island of Lérins was established by Honoratus in 410, and found a rival in the monastery of S. Victor at Marseilles, a foundation of Cassian, himself a monk in the Thebaid for seven years. Sidonius tells of

[1] *Iconographie de l'Évangile*, p. 610.
[2] It may be noted that Iranian (Sarmatian) influences had reached France long before the coming of the Goths ; a tomb at Valmeray in Calvados (Normandy) contained small gold plaques for sewing to garments of a Sarmatian character (E. de Robillard de Beaurepaire, *Bull. de la Soc. des Antiquaires de France*, viii, 1878, p. 155, quoted by Rostovtzeff, *Iranians and Greeks in South Russia*, p. 187). Other tombs in Eastern Europe have yielded similar objects. The Celts were in contact with Scythian and Sarmatian tribes in the east of Europe (Rostovtzeff, *as above*, pp. 128, 130, 139, &c.).

a Syrian hermit named Abraham at Clermont in Auvergne ; Gregory of Tours records the austere life of eremites in Central France in the sixth century. There was communication between the Merovingian courts and that of Constantinople ; Gregory tells us of the exchange of imperial and royal gifts chiefly in the form of silver or gold plate ; the enamelled reliquary of the True Cross at Poitiers still exists to attest these relations.[1] Decorative sculpture of Syrian type survives from the ancient church of La Daurade at Toulouse ; columns from that building are covered with vine-ornament quite in the Syrian manner.[2] The orientalizing ornament in the above-mentioned church of Germigny, executed in stucco and mosaic, seems to show that decorative design, originally from the Mesopotamian or Persian region, survived into the Carolingian age. That age witnessed a deliberate study of East Christian art, the results of which are especially clear in the cases of manuscript illumination and ivory carving, the dominant influence now being Syro-Hellenistic (p. 9). In early Romanesque times the Byzantine art of the middle period found its way to the south of France ; the influence of motives derived from mosaic or mural painting is seen in such work as that of the tympana at Vézelay and Moissac, and that of ivories at Cahors and again at Toulouse. Orientalizing decorative sculpture is seen on the capitals of many Romanesque churches, especially in Languedoc and Provence, examples of which have been reproduced by Bréhier (p. 197) ; in a few cases motives may have been directly borrowed from textiles. Some Byzantine influence is apparent both in the figures and in the ornament of early Limoges enamels, and other minor arts are similarly affected.

The earliest medieval art of *Spain* is still less well known than that of France : the country did not lie on a main line of communication. A certain number of figured sarcophagi are related to the earlier (Hellenistic-Roman) style in the south of France. After Justinian's conquest of Italy, there was for a time a local Byzantine influence on the Mediterranean coast, and a few Byzantine capitals show that the widely exported decorative sculpture of the Proconnesian quarries found their way early into the peninsula. Ornamental sculpture in the styles allied to those described by Bréhier have been found on Spanish sites and have been attributed by some to direct Coptic influence. But it must be remembered that the ornament of Coptic Egypt was largely of Syrian importation (p. 43), and that Syrian and Mesopotamian ornament was touched by the same Iranian influences which came in with the Visigothic conquest. The Saracenic occupation

[1] It was sent by Justin II to Radegund, Queen of Lothar I and foundress of the convent at Poitiers. Among recent works emphasizing oriental influences in France may be mentioned E. Mâle, *L'art religieux du XII⁰ siècle en France*, and Bréhier's Studies in Byzantine sculpture in the *Nouvelles Archives des Missions scientifiques*, N.S., fasc. 3 and 9, Paris, 1911 and 1913. For Byzantine gifts to Carolingian princes, cf. Ebersolt, *Arts somptuaires de Byzance*, pp. 56 ff.

[2] Now in the Metropolitan Museum at New York (*Bulletin*, Jan. 1923, p. 9).

again introduced oriental elements which were not primarily Coptic ; the relationship to Coptic art need not therefore be direct. Under these circumstances the fusion of Visigothic and Islamic elements was natural and easy ; the two arts were akin.[1] Attention is drawn on a later page to the barrel-vaulted churches at and in the region of Oviedo, which date from the ninth century and, on Strzygowski's theory, represent an Asiatic building style introduced by the Visigoths when they entered the peninsula.

Germany was penetrated by East Christian influence from two directions : from Italy into the southern area, from France up the valley of the Rhône and down that of the Rhine. Syrians were in Trèves in Roman times ; the first bishop of the city was Agritius of Antioch (A. D. 328). Ancient gravestones of these early times bear Syrian names ; one has that of an immigrant from Asia Minor. Trèves was in possession of East Christian ivory carvings at a very early date. One is still in the cathedral treasury (p. 209) ; the Barberini diptych in the Louvre (p. 209) has written on the back the names of four archbishops of the diocese living between the fourth and the sixth centuries, a fact which seems to show that it also was once preserved in the city ; a sixth-century ivory pyxis with aquatic scenes, now at Wiesbaden, once belonged to Trèves. The ivory panels in the pulpit at Aix-la-Chapelle (p. 209), with their evident Alexandrian influence, seem to afford another example of early importation, while the cathedral of Aix itself is held to reproduce the oriental type of *martyrion*. Ancient silk textiles in which relics at Aix and Cologne were wrapped have designs in Sassanian and Byzantine styles.

With the rise of the Ottonian dynasty in the tenth century, East Christian and Byzantine influence spread farther towards the north. The Saxon emperors maintained relations with Venice and the East ;[2] Otto III married a Byzantine princess, Theophano, whose coming was not without its effect upon the arts of luxury.[3] Otto was himself an enthusiast for Greek ideas, and founded an Eastern monastery in his capital ; in the tenth and eleventh centuries we find Greek monks travelling as far as the Oder. The illuminated books of the Ottonian period, which probably reached Germany through Italy, drew their inspiration from oriental models ; the style in some cases suggests that these models were painted in flatter colours than those generally employed in the Christian East, a fact which may point to the monasteries of Palestine.[4] Other books painted in Regensburg betray a certain Byzantine influence ; this city lay upon the trade-route into Italy.[5]

[1] Especially interesting sites for the early art of the Spanish caliphate are those near Cordova, above all that of Medina Azzahra.

[2] For gifts from Constantinople see Ebersolt, *Arts somptuaires*, as above, pp. 57, 64.

[3] Notably that of enamelling by the cloisonné method, an art which, however, had already entered the South German region from North Italy at the close of the eighth century (p. 337).

[4] Where, in the ninth century, MSS. in such flat colour appear to have been produced (Millet, *Iconographie de l'Évangile*, pp. 599, 600). Cf. also W. Vöge, *Eine deutsche Malerschule um die Wende des ersten Jahrtausends.*

[5] Cf. G. Swarzenski, *Die Regensburger Miniaturmalerei* ; cf. the same writer's work on

In Ottonian times embassies were sent from the German to the Byzantine court, and brought back works of art as gifts. Wibald of Stavelot, and Liutprand were among these ambassadors ; the latter has related his experiences in Constantinople. After the Fourth Crusade, Germans had their share of the treasures brought from Constantinople by the Western princes and nobles : some of these objects are still preserved in the church treasuries of Limburg, Aix-la-Chapelle, Hildesheim, Halberstadt, Munich, and Augsburg. The fine workmanship of these Eastern models was not lost upon native workmen. German Romanesque art was widely influenced by Byzantine models ; though the effect is most evident in the case of illuminated books, ivory carvings show the same tendency. German major sculpture, as at Bamberg cathedral, was inspired by Southern French sculpture, which itself owed much to Byzantine ivories ; but sometimes, as in the case at Hildesheim (p. 175), Byzantine ivory carvings exerted their influence directly.

Scandinavia was brought into direct connexion with the East by the advance of Swedish merchant adventurers through Russia to the Black Sea, down the Dnieper, and down the Volga to the Caspian, about the shores of which the Khazars (cf. above, p. 56) had established a kind of empire between the seventh and tenth centuries. The most important influence on Scandinavian art came through the Khazars and was concerned with ornament bearing an Iranian character, since east of the Caspian Iranian motives remained in favour during the early centuries of Islam ; it was by the Volga route, and from this region, that floral ornament entered Sweden in the Viking period.[1] A little Early Byzantine influence had filtered through from the Greek colonies north of the Black Sea, but this was largely increased by the conversion of the Russians in the tenth century. The few Byzantine and Byzantinizing works of minor art which reached the North chiefly belong to the time of Yaroslav, and the coins belong to the same period. The most active relations between Sweden and the Dnieper valley date from the time of the Russian princes whose capital was at Kieff (p. 55).

Britain and Ireland

In the British Isles Christianity, introduced at the time of the Roman occupation, affords evidence of oriental influence ; the remains of a basilica excavated at Silchester illustrate an Eastern type.[2] Both Ninian,

Salzburg illuminated books. For the influence of Reichenau as intermediary with the East see J. Sauer, in *Studien zur Kunst des Ostens*, pp. 72 ff. (Strzygowski, *Festschrift*, 1923).

[1] See T. J. Arne, *La Suède et l'Orient*, vol. 8 of *Archives d'Études Orientales*, 1914, p. 117 : for Byzantine coins and other objects see pp. 56, 89, 206 ; A. Romdahl, *Studien zur Kunst des Ostens*, pp. 217 ff.

[2] Cf. also British Museum, *Guide to Early Christian and Byzantine Antiquities*, 2nd ed., 1921, p. 56, where a summary of Early Christian monuments in Britain will be found. See also B. A. and A., p. 97 ; Strzygowski, *Kleinasien*, pp. 231 ff., *Altai-Iran*, p. 293, and *Christian Church Art*, ch. ix ; Zimmer, *Pelagius in Irland*, p. 5.

the evangelist of the Scots in Galloway, and Patrick, the apostle of Ireland, had been trained in the monasteries of Gaul, where, as we have seen, oriental influences were from the first predominant, the former at Tours, the latter at Auxerre. In the greater part of England between the departure of the Romans in 410 and the coming of Augustine in 597, the development of the Christian religion and of its art was ended by the Teutonic invasion. But in Cornwall, Wales, and, above all, in Ireland there was no breach in continuity, and the western island, secure in its isolation, now took the lead. The Christianity thus preserved was thus of Gaulish descent, permeated by Eastern monastic tradition, and retaining a knowledge of the Greek language; it is probable that the relations of Ireland with Gaul were continued during these three centuries. The oldest examples of Christian art in the island suggest such relations. The figures of evangelists and other subjects in Irish illuminated MSS. are of a type which can only have come from the Christian East. The Irish ornamental design of Early Christian times is marked by the appearance of new motives Syrian and Coptic by descent. From the sixth to the ninth centuries Irish saints and missionaries carried the gospel into North-western Europe, and Irish ornament reacted upon European. The monasteries of Ireland at this time enjoyed a high repute; Sigebert of Austrasia, in the middle of the seventh century, sent his son Dagobert to an Irish House, where he spent no less than seventeen years. On another page (p. 299) is noticed a point in connexion with the colours used in illumination, which seems to confirm the inference that special relations existed between Ireland and the East.

In Anglo-Saxon times[1] there was communication between Northumbria and the orientalized Rome of the seventh century. The building of stone churches now began.[2] Wilfrid of Hexham and Benedict Biscop of Jarrow visited Merovingian Gaul and Rome, and we read that the masons brought home by Benedict came from Gaul. Concurrently with the rise of stone building, there appears a figure sculpture so rapid in its growth and so evidently based upon a good tradition that it can hardly be a purely local development. The type of Our Lord treading upon the lion and dragon upon the Bewcastle Cross (late seventh century) belongs to an area familiar with sacred representational art; the same remark applies to the figure sculpture of the cross of Ruthwell, where the Christ raising his hand in benediction is of a similar quality. But monumental sculpture at this

[1] Pagan Anglo-Saxon art, like that of all the early Teutonic tribes, had been largely influenced by that derived by the Goths from the (Iranian) Sarmatians (p. 55) in the south of Russia; this is especially evident in the case of the jewellery enriched with garnets and glass pastes set in cloisons. Rostovtzeff (*Iranians and Greeks in South Russia*, p. 188) has noted the resemblance between the triangular plaques round the mouth of the drinking-horn from

Taplow, in the British Museum, and those seen on the gold vessels from Szilagy-Somlyö in Hungary; in both cases he sees survivals of a use which was general in the case of Sarmatian *rhyta*, made of horn or wood.

[2] See G. Baldwin Brown, *The Arts in Early England*, vol. i; G. Micklethwaite, *Arch. Journal*, liii, 1896, pp. 293 ff.; Strzygowski, *Origin of Christian Church Art*, ch. ix.

date in the Christian East had sunk to a low level, and a model of sufficient excellence to inspire work with so much style would be far to seek either in the Byzantine Empire, Ravenna, or Rome.[1] The solution of the enigma is perhaps to be found, as in France and Germany, in imitation of ivory carvings (p. 174). Rivoira's suggestion that the Northumbrian crosses are of Romanesque date has found little acceptance, and indeed would hardly help to explain the reliefs, since the character and feeling are different from those of Romanesque figure sculpture.[2] The incised figures on the wooden coffin of S. Cuthbert at Durham are inspired by the same early East Christian sources as those on the high crosses. Northumbria contributes further interesting evidence from the province of the minor arts. The rectangular casket of whale's bone in the British Museum, known as the Franks Casket, is carved with scenes in relief, some of which would appear to be suggested by illustrations in the fifth-century Alexandrian Chronicles of the history of the world, though perhaps immediately derived from reproductions of those subjects carved on ivory or wood ; coffers and ivory carvings were doubtless brought back, with textiles and MSS. (p. 302), from travels to Italy or beyond, by English pilgrims and ecclesiastics, like Benedict Biscop himself. Pieces of silk textile from the coffin of S. Cuthbert now in the Chapter Library at Durham are oriental ; one, at least, is older than the time of the saint, and perhaps came into Northern England in the seventh century (p. 355). With the eighth century sculpture began to pass under Scandinavian influence, though reminiscences of old motives survive in the high sculptured stones of the Picts in Scotland.

The native art of Ireland and Northern Britain was full of vigour when the Christian influences from the South and East began to act upon it. The decorative design is that of peoples with an old artistic heritage in which the imitation of nature had no part ; in the case of Celt and Teuton alike, it is a flat, surface-covering ornament of accomplished excellence, differing in style and manner, but identical in principle with that of the barbaric north of Europe and of the Asian regions with which the whole wide region was in contact. Irish and Anglo-Saxons shared in the common manner of vision which prevailed from the mountains and steppes of Asia to the Atlantic ocean, a vision which had been hardly affected by the intrusion of unappreciated Greek or Graeco-Roman methods, and were only to yield in Britain to the more enduring and penetrative influences of a religion officially committed to a narrative and imitative art. It is interesting to see the carvers of the Northumbrian high crosses subduing the human figure to the same laws of decoration which centuries earlier had transformed

[1] Strzygowski has suggested that the inspiration is derived from sculptured reliefs in Armenia, a country also remarkable for its high crosses (*Origin of Christian Church Art*, ch. ix).

[2] The best account of these crosses is in Prof. Baldwin Brown's *The Arts in Early England*, vol. v ; and in the Royal Commission on the ancient and historical monuments of Scotland : *Dumfries* (Edinburgh, 1920), pp. 219 ff., by the same author.

Graeco-Roman sculpture in the South and East, and doing it with such remarkable success. But in this art, as in that of contemporary illuminators, the realism of Syro-Hellenistic models already begins to make way; in Ireland, on the contrary, the old formal principles remained unmodified; the human figure, one decorative unit among others, was used as ornament still, with little appeal to human passion or intimate association with facts of life.[1]

It has been already stated that in the south of Britain there had been a break in Christian tradition in the eastern half of the country after the departure of the Roman government; with the advent of the Saxons, the earlier Christianity had taken refuge in the west, in Cornwall and in Wales. The pagan Saxon invaders brought with them their own forms of art; down to the coming of Augustine in A. D. 597 the general decorative and non-representational system of Northern Europe spread through the land. Before the arrival of the Roman mission a monastic religious movement from Ireland and Wales entered Cornwall and other parts of the west country, and it is considered probable that Irish influences continued to flow eastward.[2] Thus the sacred art for which Augustine and his followers stood had to encounter active opposition from two sides, and in both the Irish influence was strong: the western stream, of which the evidence is still indefinite, came across the country, perhaps from Glastonbury; the more evident and powerful stream flowed down from the north. These seem to have met at Canterbury, where a school of illumination strong in native decorative elements was holding its own in the eighth and early ninth centuries, and exerting a strong influence on Continental art. Nor was it only in the graphic arts that the Roman missionaries met opposition; it was the same in architecture. They reintroduced into England the basilican plan, which the Silchester church shows to have already entered the country during the Roman occupation. But though during the seventh century many basilican churches were erected, some in Northumbria by Wilfrid, who supported the Roman cause, yet a single-naved type, probably of Celtic origin, obtained the upper hand, and moving southward in a steady advance became the general type for Anglo-Saxon churches. Not till the Norman influence of Edward the Confessor's day did the basilican plan return to Britain to assume a permanent ascendancy.

The revival of art in Wessex at the close of the tenth century, culminating in the fine work of illuminators and ivory carvers at Winchester, and in the interesting stone roods and reliefs at Romsey, Bradford-on-Avon, and elsewhere, seems to have begun through foreign inspiration exerted through Northern France and Germany. The sculpture may have been influenced

[1] The greater accessibility of Northumbrian art to representational influence is well seen when we compare the figures of the Evangelists in the Lindisfarne Gospels with those in the Book of Kells.

[2] Cf. Zimmermann, *Vorkarolingische Miniaturen.*

by imported ivory carvings; the treatment of the Romsey Rood has analogies with that of Byzantine ivories. But such East Christian motives as appear in the miniatures of the MSS., for example, the tenth-century Benedictional of S. Æthelwold,[1] appear to be derived at second hand from imported models, none of which were earlier than Carolingian times: it is significant that the Carolingian style of minuscule writing was first substituted for the usual English forms at Winchester. Some of the rare Anglo-Saxon ivory carvings of the late tenth or the eleventh century may themselves have been influenced by Byzantine work, if only at second hand: such are the ivory seal-matrix of Ælfric in the British Museum, and the Alcester tau-cross in the same place. The large panel in the Victoria and Albert Museum with the Virgin and Child, by its ornate treatment and the elongation of the limbs, suggests a like inspiration to that which produced the art of Moissac and Vézelay.

Between the beginning of our era and the rise of Islam, Christianity had sent its missionaries into the four quarters of the ancient world. They had travelled east and west to China and to Ireland, to the lands beyond the Oxus, into the south of Russia, to Yemen, to Abyssinia, to Tripoli and Tunis. All races were represented among the widespread Christian communities; the new religion took colour and life from the differences in their modes of thought and vision. To understand the development of Early Christian art, it is essential to remember this world-wide distribution of Christianity and the conflicting influences which arose through the inclusion within one fold of peoples widely removed from each other in their sentiment and in their outlook upon life. Thus ethnology and geography, no less than history, have their direct bearing upon the study of the monuments; the apparatus of the old archaeology and the old criticism is no longer enough. If we would realize the action and interaction of these influences, we must recognize the continuity of the Eurasian continent and the north of Africa, and remember at what an early date Christianity became the universal agent for the transmission of ideas and forms across the whole expanse. No other agent had so wide a range or so constant a relation to formative art.

[1] In the possession of the Duke of Devonshire; edited by Sir George Warner for the Roxburghe Club, 1910.

II

ARCHITECTURE

Architecture [1]

IN the architecture of the Christian East, Hellenism did not hold its own with the same pertinacity as in painting. A permanent oriental predominance was here established before iconoclasm, and was never afterwards endangered. In the art of building we do not find that periodic reassertion of Greek influence which marks the history of the graphic arts and was perhaps most conspicuous in the last phase of the Byzantine Empire. The reason for the difference is probably due to the representational character of Greek painting. As a constituent of Syro-Hellenistic religious art, it was preserved by the Church; as the illustration of classical myth and idyll, it was in favour with the Court and the cultured classes. Greek architecture had no such exclusive claims, and, not being more practically useful than its oriental rival, was more readily superseded. The art of building is closely concerned with utility and the external needs of life. It is truly said of it that ' mere needful and experimental building is its main substance, force and origin '; and that ' so far as it has to meet changing conditions and ideals, it must be experimental '.[2]

The experimental period of Christian building had been preceded by an earlier experimental age, that following the death of Alexander, when Greek civilization explored the East. City life had expanded; large buildings for public use had been multiplied. It was a time of great activity for architects, who were engineers no less than masters of design, examining constructional possibilities for the benefit of peoples exposed to political and social change. One view of the development of architecture in Christian times ascribes it to the influence of new suggestions from the East upon the Hellenistic mind, and chiefly those received from vaulted and domical structures. If we look round the world as it was in these periods, and ask

[1] The following chapter can attempt to do no more than mention the elements, set out the principal types as illustrated by surviving examples, and give a general idea of the distribution of these types in different countries; in other words, the method adopted is mainly historical and geographical. Only an exceptional combination of the architect and the archaeologist could deal with all sides of an immense and intricate subject. But the historical and geographical aspects are a necessary beginning, and it is as an elementary survey that this chapter is intended. The numerous references in the foot-notes to the following pages will direct the reader to the original authorities.

[2] W. R. Lethaby, *Form in Civilization*, p. 67.

ourselves what race was most likely to adapt the art of building to fresh needs, we naturally turn to the nation which was demonstrating its powers of adaptation in other directions, in philosophy and religion, no less than in art, the race which was everywhere co-ordinating new facts, building up new systems, and incorporating the ideas of the various peoples brought into relation with each other after the Macedonian conquests. Other races, it is urged, contributed their individual suggestions; the Greeks considered them, and, if they found them good, combined them in new developments. The Hellenistic Greeks are often charged with lack of originality, and compared, to their disadvantage, with their Hellenic predecessors. But they borrowed with sagacity, taking the useful feature where they found it, devising new combinations from old elements, and drawing out undeveloped qualities; this is itself a kind of originality. There was no other race at once so able and so fortunately placed for the work of synthesis. The Persians had not the same adaptability or the same lightness of touch ; Iranian building as we see it in Southern Iran tends to heaviness ; it is ponderous, and suggests no power of self-development ; we cannot imagine the great buildings of the Byzantine Empire conceived and executed under such an inspiration. It is admitted that there was one people in the near East talented enough to rival the Greeks, the Armenian. But it is argued that at the time when, under the successors of Alexander, Eastern and Mediterranean ideas were first brought together, the opportunities of the Armenian can hardly have equalled those of the Greek ; and this must have been the crucial time. The beginnings of Armenian stone building are represented by no actual remains earlier than the sixth century, and the most favourable interpretation of the national chronicles cannot infer the existence of such buildings before the conversion of the country to Christianity. The first development of Armenian building may represent no more than a parallel growth to that which was taking place farther to the west, and the decisive influence which it exercised on Byzantine architecture may not have begun before the iconoclastic period.[1] The only other possible rivals of the Greeks were the Romans. But the Romans were less originative than the Greeks, from whom they borrowed in the case of all the other arts. It is more probable that they began their majestic architecture from elements transmitted through the Greeks than that they themselves invented a vaulted style. Imperial Roman architecture doubtless reacted upon Western Asia ; so far from being lifeless, it was active and tremendous. Yet the history of Roman church building may be symptomatic for the relation of all Roman building to East Christian art. At the time of Constantine, the vaulted construction in brick which had been one of the glories of imperial Rome came to an end. The old capital abandoned

[1] The idea of placing a dome over a square plan may have first come into Christian architecture through Armenia, though, as elsewhere noted, it seems to have been known in much earlier times. (Cf. pp. 80 ff.)

vaulting, and down to the end of the first millennium produced no other kind of church than the wooden-roofed basilica. All the experiment in vaulted and domed construction was carried on in the Christian East. This appears to be an awkward fact for those who maintain a dominant creative influence of Rome on Christian architecture. It suggests that the great Roman vaulted buildings represent an imported and not a national art, and that they may even have been carried out by foreign hands or under foreign supervision.[1] If this construction had been truly Italian, vaulted architecture would hardly have deserted Rome for seven hundred years just because a new capital was founded on the Bosporus. Such an abandonment is difficult to believe. It is more credible that the Greeks were the first to discern the practical value of oriental suggestions and that the Romans received these suggestions in a new development from the Greeks.

Such is what may be described as the conservative theory of development. It admits the oriental suggestions, but supposes them worked out to their conclusions in the Mediterranean area by Greek builders won over to the advantages of oriental plans. It is vigorously opposed by Strzygowski, to whom it appears hardly more defensible than that which assigns all initiative to Rome. He is convinced that the primary source of the new architectural movement was not Greek, but Sacian (Saka), of Khorasan and Bactria in North Iran.[2] The primitive wooden house of the 'East Aryan' was square, with a domed roof formed by continuous corbelling (cf. pp. 81, 84). This type was copied in unburned brick in North Iran, when the dome on squinches superseded the wooden prototype, and the walls were enriched with stucco, moulded into formal designs and coloured. From the Sacians the domed unit with square plan, the cell from which great organisms were to grow, passed into the stone-using country of Armenia, when rapid development of types followed.[3] These were carried by the enterprising and migratory Armenians into the Mediterranean area. Here, with burned brick, could be undertaken the articulated structures which the Sacians with their sun-dried brick could never have attempted. A logical system of abutment could be employed. Wall-linings could now be carried out not merely with stucco, but with white marble sculptured by oriental methods with oriental formal design, with plates of coloured marble, and with mosaic. Byzantine architecture, says Strzygowski, is unintelligible without presupposing the remoter Sacian origin and the immediate influence of Armenia. In Iranian-Armenian construction we may assume the fundamental qualities which distinguish Byzantine from antique. It had the

[1] As Strzygowski argues in his *Baukunst der Armenier und Europa*. The case for Rome has been ably stated by Rivoira in his *Lombard Architecture* and *Moslem Architecture*.

[2] Strzygowski makes the sharpest possible distinction between the Sacian-Parthian North, which he regards as inspiring the architecture of Armenia, and the uninventive Sassanian South.

[3] The dome does not appear to have been used over a square bay at Rome (p. 81).

feeling for spatial unity which produces the fine interior.[1] It treated the building not as one simple unit, but as a group of lesser units, a geometrical composition of masses combined in a harmonious whole ; its exteriors were organically conceived, and could be regarded with equal satisfaction from all sides ; height was not sacrificed to length, but the vertical axis had equal right with the horizontal. It employed a surface-decoration which was optical, not tactual, deriving its charm not from modelled forms imitating nature, but from geometric linear designs in colour, or in contrasting light and black shadow. Rejecting the types of the Mediterranean, the Armenian builders brought their own in triumph to the Bosporus ; they were the true inspirers of S. Sophia ; to them the consecrated type of later Byzantine church is due[2] (pp. 101 ff.), and not less the more elaborate types of the radial centralized church. The forerunners of their art reached the west of Europe as early as the sixth century, since builders, like goldsmiths and other craftsmen, attached themselves to the Goths and followed them in their migrations to Italy, France, and Spain.[3] S. Germigny-des-Prés, and the churches in and near Oviedo, though not earlier than the ninth century, perpetuate an Armenian-Visigothic tradition (p. 158).

The application of Strzygowski's views will be noted in the discussion of individual buildings noted below. Something has already been said as to the general theory of which they form a part (p. 10).

The rise of Christianity altered the character of the sacred building ; the change was determined by the practical needs of the new cult. In regions predominantly Greek, tradition held to a long plan, reminiscent of the pagan temple, adapting the basilican type to religious use in order to house a congregation of worshippers ; even to the end, the memory of a longitudinal axis remained, since the liturgy demanded no less. But architects were familiar with large secular buildings not only possessing vaulted roofs, but, as in the case of the great Baths, applying centralizing principles to rectangular plans ; these buildings were among the most admirable and practical in existence, and it was natural that they should be imitated. It was the great problem of Christian church architecture, through the early period of development in the Mediterranean area, to combine the long basilican and the centralized domical plans.[4] The domed

[1] This is a point which Strzygowski regards as of the greatest importance, though he concedes to the Hellenistic builders of the Pantheon a share in the same feeling (*Altai-Iran*, p. 244).

[2] As also, in Strzygowski's opinion, the domed church plans of the Italian Renaissance.

[3] *Altai-Iran*, p. 246. It has been noticed above (p. 55) that Rostovtzeff regards the goldsmiths who accompanied the Goths as Sarmatians.

[4] From Strzygowski's point of view these efforts would appear to be for the most part without much significance. They would be more or less clumsy attempts to achieve a satisfactory domical building, a goal which the Armenians reached by a straighter path. According to him the main development did not include modification of the basilica. The Greek-cross plan arose directly from an expanded Armenian domed unit, in which the dome rested upon four interior supports (p. 101).

basilica (pp. 91–3) represents the most serious attempt to effect the combination, and this type is considered by more conservative students of architecture to have reached its climax in S. Sophia at Constantinople; they do not admit a serious Armenian influence until after the iconoclastic period.

An art of building employing domes and vaults fulfils in a peculiar degree the mission of architecture to assert the play of natural forces, the weight and cohesion of hard and rigid substances. The appearance of rest and harmony which it produces must be attained by the most skilful balancing of oppositions. The action of stress and thrust, always present, forms, as has been well said, a silent drama evoked by the completed structure; the conflict of forces is divined in the equilibrium of the whole. This combat of forces gives life to the building, which is good when every part bears its full share in the latent struggle. In the fine building, the distribution of the thrusts is so perfectly adjusted that we could conceive the whole ruined by even a slight change in the relative positions of the parts, or in their weight; there is perfect economy, a complete absence of useless waste. If the building, appropriate to its purpose and to the material used in its construction, has also this evident control of forces, then it has that harmonious expressiveness which constitutes its proper excellence. It may be claimed that Byzantine architecture signally possessed these qualities even in the first centuries of experiment preceding the erection of S. Sophia, which may be regarded as the heroic period of construction. But the complete harmony of design was attained only with the adoption of the Greek-cross plan after the iconoclastic period. The small size of most Byzantine churches must not blind us to the great achievement of these later centuries. Not till now do we find buildings in which a masterly treatment of interior space is combined with that fine composition of masses which sets before the eye a balanced and harmonious exterior. Not till now do the somewhat monotonous lines of the basilica, or the church with plain exterior and low domes, give place to the pyramidal disposition in which a central dome on its elegant drum crowns a structure falling gradually by lesser cupola and roof to the square of the external walls; in which all sides of the exterior have their proper value; in which each member has its place and function in meeting the thrust of the upper mass, its calculable part in the drama of encountering forces. In its fine external contours, in its decorative surfaces, broken by recessed windows, eaves, cornices, patterned brickwork, or alternate courses of brick and stone, in the spatial unity of the interior, the Byzantine church presents without and within a combination of logic, economy, richness, and of appropriateness to an envisaged end, unsurpassed by the buildings of any other style. The Greek temple had noble harmony of line, but it was an exterior only; without, it was too long and unbroken a mass, and within it was a dark cell. The Greek temple was the background for the

sculptor ; its construction largely served another art. The Byzantine church was a free creature living its own life and obedient only to structural law.

We may now pass, after a short consideration of materials and of structural features, to an examination of the principal types characteristic of East Christian and Byzantine church construction, and a review of the chief kinds of secular buildings. The chapter will conclude with a brief geographical survey to illustrate the distribution of examples representing the several types.

Materials. It is natural that over an area so vast as that covered by the Byzantine provinces the material prevalent in any region should vary with physical conditions ; where serviceable stone was within easy reach, stone building predominates ; where it was absent, brick took its place. It has been observed that, speaking generally, the stone-using countries form a great central area between those making use of brick. Stone runs from Crete, Cyprus, and Syria northwards through the Anatolian plateau, Armenia, and the Caucasus into Eastern Russia as far as Vladimir and Moscow : brick was used to the south and east of this area in Lower Egypt,[1] in Mesopotamia, and (presumably) in Persia ; to the west of it, from the Balkan Peninsula to Western Russia as far as Novgorod. It will of course be understood that there is frequent penetration of lines thus broadly drawn, and sporadic appearance of a foreign material through the action of external influence. An example of this may be found at Qasr ibn-Wardān, where the brick palace and church may have been erected in a stone-using country by builders from Constantinople.[2] It will equally be understood that in either area stone and brick were on occasion used together in the same building, either for structural convenience, as in the Anatolian coast-lands, where brick domes and pendentives may be placed on stone walls (Dereh Aghazi ; Philadelphia), or for aesthetic reasons, to enliven the monotony of brick surfaces, the latter cause leading to the widespread adoption of alternating brick and stone courses, especially characteristic of the school of Constantinople and the regions under its immediate influence. All the brick is burned brick. This, as opposed to sun-dried brick, we assume to have been first used in Egypt and Mesopotamia and widely adopted in the

[1] It is much disputed whether Mesopotamia or Egypt first produced brick architecture of importance and developed its forms of vault and dome. Strzygowski is in favour of Mesopotamia ; Lethaby, of Egypt. The latter regards Alexandria as the great home of advanced building in brick, and holds that the traditions which alone rendered it possible to erect the great church of S. Sophia at Constantinople were Alexandrian. (*Cambridge Mediaeval History*, iii, p. 541.) It will be seen below that the system of vaulting by means of inclined courses was common to both countries from a very early time.

[2] H. C. Butler, *Publications of Princeton University Arch. Exp. to Syria in 1904–1909, Division II B*, Leyden, 1908 ; Diehl, *Manuel d'arch. byz.* Strzygowski, on the other hand, ascribes the adoption of brick here to Perso-Mesopotamian influence, comparing the Kharput Gate at Diarbekr, *Amida*, p. 292. For stone and brick buildings erected outside their normal areas, see Millet, *L'École grecque*, ch. iii.

great Hellenistic cities (Ephesus, Antioch, &c.), from which Rome learned its employment.[1] Hellenistic and Byzantine mortar, strengthened by gravel or fragments of stone, was very durable. To illustrate its power of resistance, we may quote a remark made by Millet,[2] to the effect that at the two extremities of the Byzantine world, in Cappadocia (Changli Kilisse) and in Laconia (Mistra), the same miracle confronts us : two piers or two columns out of four have fallen, yet the dome still remains in position. Mortar of this quality could be safely used in very thick joints ; in fact these are frequently as thick as the courses of flat, almost tile-like bricks above and below them. It is claimed by those who deny to Iran the initiative in the development of domical architecture on the large scale that fine mortar was first used by Hellenistic builders, and that only with its help was the construction of great domed buildings possible ; it is affirmed that such mortar was not known in the East before the time of Alexander.[3] These facts are denied by one side [4] and as uncompromisingly reaffirmed by the other.[5]

The free use of stucco facing, painted or moulded with decorative designs, is assumed by Strzygowski for the early brick buildings of Sacian origin to which he would trace back domical construction. The region of Northern Iran, poor in stone, originated a style of stucco wall-decoration which passed to Mesopotamia and Egypt on one side and into Turkestan on the other.[6] In the case of sumptuous buildings, like Mshatta, the cheaper substance was replaced by finely sculptured stone. In other cases moulded stucco was used to such effect as we see in the later Mohammedan work at Samarra, and the mosque of Tulun at Cairo, or the Christian work at Deir es-Suriyāni in the Natron valley. It must, however, be remembered that the custom of facing buildings of unburned brick with other materials was very ancient in Mesopotamia. The Babylonians faced the unburned with burned brick, and probably sometimes with glazed tiles. The latter material was in regular use for the purpose by the Assyrians, and was employed as a wall-decoration by the Achaemenian Persians.[7] It can hardly be assumed, therefore, that North Iranian builders initiated decorative facings, or that in this case racial influence was a predominant factor.

Stone walls are very commonly composed of rubble cased in worked stone. In Cilicia [8] and Armenia this method is applied also to the barrel-

[1] Choisy, *Histoire de l'architecture*, i, p. 520.

[2] *L'École grecque*, p. 246.

[3] R. Delbrück, *Hellenistische Bauten in Latium*, ii, pp. 63 ff. ; E. Herzfeld, *Iranische Felsreliefs*, 1910, and *Khorasan*, in *Islam*, xi, 1921, p. 158.

[4] *Die Baukunst der Armenier und Europa*, p. 342.

[5] *Khorasan, as above*, p. 159. The case well exemplifies the antagonism between mutually exclusive opinions, which meets the student of East Christian architecture.

[6] Strzygowski suggests that workers in stucco accompanied the builders of domed structures in brick who travelled from the North Iranian area to the south and west. Even the employment of stucco figure sculpture as an accessory to architecture he connects with this Central Asian descent (*Altai-Iran*, pp. 221, 228, &c.).

[7] Stucco reliefs covered walls in Minoan palaces in Crete.

[8] At Bin Bir Kilisse, Strzygowski, *Kleinasien, ein Neuland der Kunstgeschichte*, p. 21.

vaults of the roofs and to domes, which were thus constructed on different principles from those adopted by the brick-builders. Vaults and domes were moulded over a stout timber centring ; above this concrete-work was applied an external casing of stone ; but in Armenia the curved lines were not followed, with the result that, externally, the roof in that country is gabled and the dome conical.[1] To support vaults and roofs of this kind very thick walls were of course necessary, the walls, as noted above, being of similar construction.[2] The use of the concrete vault in Armenia would seem to raise the question whether the Armenian was related to the Roman system, of which the classical example is the dome of the Pantheon. The different schools naturally explain such analogies from their several points of view, one presumably arguing that the process came to Armenia from Rome, a second, that it is an Asiatic method which originally reached Rome through Hellenistic channels, a third, that it was Hellenistic, or early adopted by the Greeks in some intermediate region like Cilicia or Cappadocia.

Constructional Features. The Vault

The earliest method of roof-vaulting in brick appears to be that which Mr. Somers Clarke saw put into operation in Egypt, a country where it has remained traditional since the early dynasties.[3] This is the method by inclined courses, which gives a round or ' barrel ' vault without the use of centring. Instead of being laid horizontally with their beds radiating from the centre of the arch, and being allowed to overlap progressively over space, the thin bricks were laid on edge (*par tranches*), so that the vault consisted of a series of rings or arches side by side, of which the joints, and not the beds, radiated from the centre. To give each of these arches sufficient cohesion to hold it together until keyed by the final brick, they were all inclined backward, the first of them resting against an end wall of the chamber to be covered. Each arch, leaning backward against the preceding, adhered without difficulty until the last brick was in place, and no temporary wooden support was required.[4] The vaulting of the Ramesseum, constructed in this manner, is like that of the Persian palaces

[1] Strzygowski, *Baukunst der Armenier*, pp. 212 ff.

[2] At Kerkuk a church is described as built, vaults and all, of unhewn stone embedded in the mass of mortar : G. L. Bell, *Churches and Monasteries*, p. 101. It is interesting to note the appearance of a half-ashlar style of masonry at Taxila in the fourth century of our era (J. Marshall, *Memoirs of the Archaeological Survey of India*, No. 7, *Excavations at Taxila : the Stupas and Monasteries at Jauliāñ*).

[3] Somers Clarke, *Christian Antiq. of the Nile Valley*, p. 26. Very early vaulting has been

discovered by Professor Garstang at Reququah, in tombs ascribed by him to the third dynasty. A stone vault at Abydos is held to be of the sixth dynasty ; primitive corbelled domes and vaults in the same place date from the eighteenth and nineteenth dynasties. For a summary of the question see G. L. Bell, *The Thousand and One Churches*, p. 435.

[4] The process is described by Choisy, *L'art de bâtir chez les Byzantins*, pp. 31–47, and by Sir T. G. Jackson, *Byzantine and Romanesque Architecture*, i, p. 36.

of Firūz Abad and Sarvistan,[1] and some authorities hold that Egypt invented the barrel-vaulted roof, transmitting it northward to Mesopotamia ; others believe that the movement was in the opposite direction, that Mesopotamia invented and Egypt received.[2] The invention may have taken place independently in both areas ; but it seems on the whole more probable that brick vaulting entered Christian architecture from Mesopotamia rather than from Egypt.[3] Where stone was used for vaulting, a wooden centring was necessary, whether the vaults were built up in the usual way with voussoirs, or moulded of concrete, as in Armenia. In the constructed vault, the beds of the stones radiate from the centre of an arched wooden substructure used as a support while the building is in progress.[4] The *groined* vault, formed by the interpenetration at right angles of two barrel vaults and showing an arch in both directions, is considered to belong to the Hellenistic tradition, appearing about 75 B.C. in Pergamon and Rome. Used by Byzantine architects, more especially in the chambers filling the angles in churches of the Greek-cross plan, it does not appear on the Anatolian plateau or in Mesopotamia except under Syrian influence. Another method of covering a chamber with vaults was to place over it a succession of cupolas, as illustrated in the late example of the church of the Pantanassa at Mistra ; it is a method which anticipates the employment of the dome over square bays (see below).

The facts with regard to the great vaulted Baths and other buildings of Imperial Rome have been used by the opposed schools in furtherance of their respective views. The Roman school claims these structures as the product of Italian genius. To the oriental school they are the work of immigrant builders from the Perso-Armenian region, attracted to Rome by imperial patronage. The intermediate school assigns them to Hellenistic architects developing Eastern ideas. It certainly seems difficult to ascribe to Italian invention this advanced art, which reached its highest point as early as the second century, when the arts as a body came into Italy from abroad ; Romans doubtless shared in its development, but this is different matter from invention. A further argument against Italian origin lies in the fact, already noted, that when Christian church building began, vaulting

[1] These palaces are in the south-east of Shiraz. As is well known, Dieulafoy ascribed them to Achaemenian times, but most authorities believe them not earlier than Sassanian. Firūz Abad may date from the mid third century, Sarvistan from the second half. (Cf. Rivoira, *Lombardic Arch.*, p. 193.)

[2] Choisy, *Hist. de l'architecture*, i, p. 123 ; ii, p. 80.

[3] Barrel vaulting existed in Babylon as early as the time of Nebuchadnezzar. (Cf. Strzygowski, *Baukunst der Armenier*, p. 371.)

[4] Rivoira's belief that no Persian vaults and domes are earlier than the Sassanian period,

and that all are due to Roman inspiration, is shared by de Morgan, de Lasteyrie, and, in so far as great buildings are concerned, by others familiar with Mesopotamia. The Parthian palace at Hatra, where the ground floor is barrel-vaulted, dates, indeed, from just about the beginning of our era ; but the construction of the vaults of hewn stone is connected with regions to the west of the site, rather than with the East. (E. Herzfeld, *Hatra*, in *Zeitschrift der Deutschen Morgenlandgesellschaft*, 1914, pp. 655–667, and *Islam*, xi, p. 159. W. Andrae, *Hatra* in *Wissenschaftliche Veröffentlichungen der Deutschen Orient-Gesellschaft*, 1908, 1912.)

was abandoned at Rome in favour of timbered roofs, which remained the one Italian form down to the close of the first millennium. This sudden abandonment in so far favours Strzygowski's argument that imported foreign builders in imperial pay followed imperial patronage to the East when the capital was removed to Constantinople. But as there is as yet no evidence for great vaulted buildings in Iran or Armenia as early as the second century, it seems premature to describe these foreign builders as Armenians ; moreover, the dome over the square plan, claimed as the unit and chief characteristic of Iranian architecture, is precisely absent in Rome, where domes appear to have been only used over circular plans, and groined vaults cover the square bays. If, as is likely, Rome owed her vaulted structures to foreign influence, probabilities seem to favour the contentions of the intermediate school, though the difficulty of excavation on the sites of the great Hellenistic cities deprives it also of concrete proofs.

The relation of early Eastern vaulting to that of the Romanesque period in Europe shows the line of cleavage between the extreme orientalizing Western school and its opponents at its sharpest. The latter find the real origin of Romanesque in Roman buildings, but the chief immediate inspiration in the advance of Lombard architecture in the eleventh century.[1] The former sees the *manus gothica* at work in Spain and France at a much earlier time, and regards the ninth-century churches in and near Oviedo (p. 158) as representing an earlier tradition brought with the Goths from their settlement to the north of the Black Sea : this is the view maintained by Strzygowski.[2] It is certain that even those who do not take extreme views are struck by the remarkable resemblance in secondary forms of architecture afforded by churches and other buildings in various parts of the nearer East, and of very early date. Instances are the Golden Gate of Diocletian's palace at Spalato, and the church at Rusāfah (Sergiopolis) in Mesopotamia (p. 135), where the grouping and subordination might almost be Romanesque of the twelfth century. At Rusāfah the nave is divided from the aisles by three bays formed by big piers of a cross plan, and the spaces between them have columns, one in the middle, and two set against the piers : from these rise little arches under the main arch which passes from pier to pier. A like arrangement is seen at Ruweiha and Qalb Luzeh in Syria, both buildings of similar date to the church at Rusāfah. Of Armenian churches with piers enriched by clustered columns, especially the tenth-century cathedral of Ani, it has been remarked that they are nearer to Western Romanesque than to any other style. The blind arcading so

[1] So Rivoira in his *Lombard Architecture*. The general case for the development of Romanesque from Roman remains is well summarized by Lethaby (*Cambridge Mediaeval History*, iii, pp. 552 ff.), who, however, recognizes the constant absorption of Byzantine influences by the West.

[2] See especially his *Baukunst der Armenier und Europa*; *Spalato, ein Markstein der romanischen Kunst*, etc., in the *Festschrift* dedicated to F. Schneider, Freiburg, 1906, pp. 325 ff. ; *Kleinasien*, pp. 206 ff. ; *Amida*, p. 274.

frequent on their outer walls is probably of Eastern origin, as are external arcaded galleries, though here Rivoira's denial may be borne in mind. When we find these features on the walls of the Mausoleum of Galla Placidia, or the tomb of Theodoric at Ravenna, it is hard to ascribe both to an Italian origin, and to accept the theory that such façades as those of S. Michele at Lucca, or of the Baptistery and Campanile at Pisa, are inspired by Ravenna; it seems more natural to suppose that as Ravenna received a direct influence from the East, the same was probably the case at a later time with the other cities.[1] But the controversial questions connected with Romanesque are beyond the scope of the present volume.

The dome. It is easier to construct a dome over a circular plan than over a square; the oldest examples known to us, such as the Treasure House of Atreus at Mycenae, are of this kind.[2] A round space may be covered without too much difficulty by successive horizontal courses, each smaller than and projecting over the last; and it may be conjectured that something of the kind may have been independently invented in different places where the original unit in building was the round hut or house.

Thus the dome over circular plan does not raise any difficult problem in construction; this is only the case when we find a dome placed over a square, so that the plan changes at the top of the walls from rectangle to circle by the aid of some device such as corbelling, the squinch, or the pendentive (p. 85). The ingenuity required is here greater, and the probability of independent origin less.

Apart from claims made for very remote times,[3] the oldest demonstrable examples of the dome over a square plan may date from the fifth or sixth century B.C. Both are Greek stone tombs, one at Kerch in the Crimea,[4] the other at Mylasa in Caria. The second shows an attempt at a solution by methods recalling those of wooden building and suggesting to Fergusson the Jain vaults of India;[5] the conclusion is suggested that the area in which the dome over square plan first appeared was in the wide region between

[1] Van Berchem and Strzygowski, *Amida*, p. 217. The fondness of the Tuscans for alternate bands of black and white marble is ascribed by Strzygowski to an Eastern influence.

[2] Possibly some knowledge of dome and vault may have lingered on in Europe from this first wave of Eastern influence. A later wave may have come with the Etruscans, but in each case only buildings of round plan would have been in question, and the point is of secondary importance.

[3] Cf. Lethaby in the *Cambridge Mediaeval History*, iii, p. 546.

[4] J. Durm, *Jahreshefte des Oesterreichischen Arch. Inst., Vienna*, x, 1907, pp. 230 ff. In this tomb the transition from square to circle is effected by filling each angle with six curved courses increasing in size as they go upwards, the sixth forming a segment of the circle on which the dome rests. By chamfering the edges of these courses a pendentive would result. The buildings shown on a relief from Koyunjik may be erected over a square, but the fact is not proved.

[5] Fergusson, *History of Architecture*, i, p. 324: 'It is so completely what we find reappearing ten centuries afterwards in the Far East, that we are forced to conclude that it belongs to a style once prevalent and long fixed in these lands, though this one now stands as the sole remaining representative of its class.' (Cf. Strzygowski, *Baukunst der Armenier*, p. 623, fig. 628.)

the Central Asian mountain-system and the Mediterranean. This, as Strzygowski reminds us, is primarily an 'Aryan' region, and to members of the Indo-Germanic stock he would ascribe the first adoption of the plan under discussion, which may have come into use in wood before the Greeks diverged as a Western branch, and before the Eastern or Iranian branch had invaded India. This hypothesis suggests an ethnical connexion between widely separated early examples, but it does not exclude a Greek ('West-Aryan') initiative. It leaves obscure the point noticed above, the absence of the dome over square plan from the greater vaulted architecture of Rome.[1] The type would naturally have been employed by the Hellenistic builders who, in the belief of many authorities, introduced into Rome from Antioch or Alexandria methods of brick construction learned by contact with the East.[2] If the practical use of the dome was known to the Greeks of Asia Minor several centuries before our era, it seems strange that it should not have been transmitted westward in Hellenistic times at the same time as brick vaulting. It is equally strange if Armenian or Iranian builders served the Roman emperors. This difficulty, however, is not greater than that which attends some of the arguments on the other side. For if, as is frequently stated,[3] the builders of the great Roman vaulted structures covered square bays by intersecting groined vaults, and not by domes, it would seem that the invention of the dome over this plan did not come from Italy. It is further in favour of the oriental school that the plan has been preserved to this day in Asian domestic architecture, widely distributed, and bearing the signs of ancient local development. In the villages of Khorasan, and in Northern Syria and North Mesopotamia, the house unit is the dome over square.[4] At Miragram in the region of Kashmir Sir M. A. Stein found a square wooden house roofed by first laying timbers across the wall-corners, then by laying another course across the new corners thus formed, and so on, until only a small aperture was left at the top.[5] This recalls the method employed in stone to roof the Mylasa tomb; it also resembles the method by which the domed wooden churches of the Ukraine are constructed, churches which go back to the late Middle Ages, and seem to represent a much older tradition.[6] A painted representation of such a dome is seen on the roof of a cave at Ming Oi in Chinese Turkestan, which carries the type back to the earlier Middle Ages.[7] When we consider

[1] It seems to be exemplified in the Roman world only by small tombs.

[2] Delbrück, *Hellenistische Bauten in Latium.* Cf. Strzygowski, *Baukunst der Armenier*, i, p. 366.

[3] But Choisy, in his edition of *Vitruvius*, seems to suggest that some square chambers in the great Baths had domes rising from some kind of corbelling.

[4] G. L. Bell, *Palace and Mosque of Ukhaider*, p. 75.

[5] Sir M. A. Stein, *Serindia*, vol. i, fig. 16. Strzygowski, *Baukunst der Armenier*, fig. 626.

[6] Strzygowski, *Die Baukunst der Armenier und Europa*, p. 616; and *Ursprung der Christlichen Kunst*, p. 52; Th. Schmidt, *Ukraine*, Charkoff, 1919, pp. 14 ff.

[7] Strzygowski, *as above*, p. 623, fig. 627, after Grünwedel. For like early methods in India, cf. E. B. Havell, *Ancient and Mediaeval Architecture of India*, 1915, p. 38 and fig. 13.

these examples towards the West, and towards the East, and remember the Jain domes with their certain descent from originals in timber, we are inclined to argue that the Miragram house itself represents a general and ancient method not confined to any single race.

Thus the difficulties which have to be met by those who argue that all vaulted architecture was introduced into the East by Roman builders appear, as regards the crucial dome over square plan, insurmountable. Even if this plan were found at Rome, the Greek tombs are much earlier. The plan is also found in the brick-built palaces of Fars (Firūz Abad and Farsistan),[1] which it is safest to regard as early Sassanian (above, p. 78, n. 4). It occurs moreover in a smaller domed building at Bus-i-Hôr, south of Naishapur, where the method of building is analogous to that of the Fars palaces,[2] and again, this time only in sun-dried brick, in a building at Bäzäklik in Chinese Turkestan discovered by the German archaeological expedition, and dated by Grünwedel and Le Coq as not later than the eighth century.[3]

But the assumptions made by the oriental school in their turn make some demand upon the goodwill of the learner. We are asked to believe [4] that the early Indo-Germans built square houses of wood covered by domes, the tombs of their dead probably having the same form; that when they entered regions where wood was not obtainable in abundance they translated the wood form into sun-dried brick, producing such work as an extreme dryness of climate and an early abandonment of the site has suffered to survive at Bäzäklik, but less dry climates and more disturbed conditions have destroyed elsewhere; that where permanence was sought, and stone was plentiful, they reproduced their type in stone, as in the Mylasa tomb; that when the use of burned brick was learned, perhaps from Northern Mesopotamia, this material was preferred, and admitted development on a larger scale, as in the case of the Fars palaces; that in Armenia the type underwent translation into yet another material, stone and rubble-concrete; finally, that survivals of the original plan still exist in outlying places like Miragram, well supplied with timber. We are asked, in short, to believe that a form indigenous to West-Central Asia followed the movements of the Indo-Germanic peoples, persisting with the age-long obstinacy proper to a racial form, and translated everywhere into the most convenient local material; wood, sun-dried brick, burned brick, stone, rubble-and-stone.

[1] M. Dieulafoy, *L'art antique de la Perse*, and *Espagne* (*Ars Una*), pp. 1–4; J. de Morgan, *Miss. scient. en Perse : Recherches archéologiques*, ii, pp. 341 ff.; G. T. Rivoira, *Lombardic Architecture*, pp. 193–5, and *Moslem Architecture*, pp. 120, 124; Perrot and Chipiez, *Perse*, pp. 561 ff.; Van Berchem and Strzygowski, *Amida*, p. 180; Herzfeld, in *Der Islam*, xi, p. 160.

[2] Strzygowski, *Baukunst der Armenier*, p. 366.

Herzfeld notes, however, that this building has pointed arches, and considers it not earlier than the tenth century.

[3] Strzygowski, *as above*, p. 362.

[4] The evidence is developed at length in Strzygowski's above-mentioned works : *Die Baukunst der Armenier und Europa*, and *Ursprung der Christlichen Kirchenkunst*, translated into English as *The Origin of Christian Church Art*, 1923.

This hypothesis at least attempts a logical explanation for the early appearance of the dome over the square plan throughout the whole wide area between Northern India and Turkestan on the east, and the Mediterranean on the west. It is plausibly based on derivation from an original timber construction, and supported by survivals in a part of the world where they might naturally be expected to occur.[1] The wide distribution of the modern representative of the plan in North Persian villages is a point urged in its favour. But certain difficulties suggest themselves. If the dome over square plan is an Indo-Germanic invention, it occurs so early in Greek construction (Kerch tomb, Mylasa tomb) that the question may still be raised why it is necessary to ascribe the development to the 'East Aryans' of Iran.[2] The Greek contribution to Christian architecture is not limited to the timber-roofed basilica; in the south-east of Asia Minor the Hellenistic builders had a hand in the erection of vaulted churches as early as the fourth century, and the earliest domed basilica appears in this part of the world (Meriamlik). Excavation and discovery may yet tell us more of developments produced by Greek treatment of oriental suggestions from Mesopotamia and Cappadocia. The capacity of the Hellenistic Greek in East Anatolia may be as much underrated by the oriental school as, in the opinion of that school, it is overrated by the other side. We have noted on another page that the adoption by Armenia of an Iranian plan at the very moment when Christianity was adopted as a political measure against Persian influence is rather strange, more especially as the religious leader in the change, Gregory, was trained at the Greek city of Caesarea, whence he originally set out for Armenia, while the political leader, Trdat III, was also familiar with countries west of his own, and had made a considerable sojourn in Rome. The arguments based upon events in Armenia seem to need a firmer foundation. We have seen that in the earlier centuries of our era, first Rome, then Byzantium, continually disputed Armenia with Persia (p. 31). The continuity of this Western influence in the country, and its equality with that of Persia, cannot but strike the reader of Armenian history in these times. It is true that statements made by Armenian historians do suggest the erection of domed buildings as early as the days of Gregory and Trdat. But (i) they write *ex post facto*, not being contemporary authorities; (ii) no remains of any Armenian church have yet been found as old as Gregory's time: the earliest claim is for the sixth century,

[1] We may here again mention a piece of presumptive evidence as to the early occurrence of the dome over square plan in Mesopotamia: buildings with domes are shown on an Assyrian relief from Koyunjik in the British Museum (Layard, *Nineveh*, 2nd series, pl. 16); but though Delbrück accepts these, and with probability, as having square plans, the point is not beyond dispute. As to the domes there can be no doubt, and we may recall Philostratus (i. 25), with his statement that in Babylon there was a dome in the palace lined with sapphire. (Cf Strzygowski, *Baukunst der Armenier*, p. 367.)

[2] Prof. G. Tschubinashvili, in *Monatshefte für Kunstwissenschaft*, xv, 1922, p. 226, points out that the huts of Georgian peasants, who are not Indo-Germans, are also roofed by a method of corbelling.

but the seventh century seems to mark the beginning of real development. We have to ask, then, whether the possibility is really excluded that Armenian church architecture began across the western frontier. We must know more about this area before a final verdict can be given.

To these difficulties we must add others due to divergence of opinion as to the date of buildings important for the argument, and to the objection raised by opponents of the oriental theory that no vaulted construction of any size was erected in the East before Islamic times. These opponents, as we have noticed above, deny the importance of East and North Iran as a cultural centre in the earlier centuries of our era, and lay stress upon the persistence of Greek influence in this area. When the region enjoyed a second creative period, it was after the success of the Abbāsid caliphs, and too late to be important for Christian development.[1] They point out that the national Persian reaction against Hellenism centred in the south, in Fars, not in Khorasân, adding that all the Sassanian monuments are to be found not in North but in West Iran.[2] They note that the Median type of house with wooden columns, descended from the Ionian, has remained to this day the characteristic form in Western Persia. They deny the existence of the dome and the vault on the large scale in Achaemenian times, believing their appearance to depend on the much later discovery of a fine mortar.[3] In their opinion, great vaulting was developed by Hellenistic architects from humbler oriental suggestions : Hatra, the oldest large vaulted building, dating from about the time of the birth of Christ, points by the style of its ashlar, westwards and not to the East.[4] Finally, they draw attention to the important Hellenistic element in Sassanian sculpture, and to its presumable existence in Sassanian painting, asking whether it is likely that architecture alone was impervious to influences from the West.

It has been necessary to dwell at some length upon the divergent opinions on the origin of the dome over square, for the point is one of primary importance. We may now consider the principal methods by which the transition from the square to the circular plan was effected. The first method has been mentioned : it is that employing some kind of corbelling, which in timber construction leads to such results as that seen at Miragram (above, p. 81); it is a method which tends to produce an elliptical form, since the corbelling seldom extends from the corner to the middle of the walls. If the elliptical corbelled dome of the church of A.D. 515–516 at Ezra, the modern Zor'ah, were demonstrably ancient, it would be the most important surviving example, but its age has been doubted by good authorities.[5] Smaller examples occur at Shakka, Umm

[1] E. Herzfeld, *Khorasan*, in *Islam*, xi, pp. 107 ff.

[2] *Ibid.*, p. 147.

[3] *Ibid.*, p. 158.

[4] *Ibid.*, p. 159.

[5] H. C. Butler, *Architecture and other Arts* (Princeton Expedition to Syria), p. 315. Professor Butler notes that in having the vertical as its major axis, the dome at Zor'ah resembles the most ancient as well as the modern village

ez-Zeitun, Hassan, and Ruweihah [1] in Syria, and at Abydos in Egypt. The dome at Zor'ah rests upon eight supporting arches, the corbelling beginning across eight corners ; the spandrels between the arches are slightly curved forward towards the base of the dome, so as to present the appearance of pendentives ; [2] whatever the age of this dome, the methods of construction are ancient. Like the dome of the cathedral at Bosra it may have been originally built of wood. [3]

The pendentive. This device in its final form is a spherical triangle of brick or stone, filling the spaces between the arches supporting the dome, the base curving upward and forward until its angles meet those of its two neighbours on either side at the crowns of the adjoining arches : at this level the dome rises from a horizontal ring of masonry, so that the geometrical outline of each pendentive is clearly marked. [4] But this final form was preceded by a type in which the triangle was not thus delimited. This is the so-called continuous sphere (*Calotte sur pendentifs*, *Hängekuppel*) in which the dome itself reaches down without any break into the spandrels between the supporting arches. Hellenistic examples are seen at Jerash, the ancient Gerasa, near the desert border of Eastern Palestine, [5] and at Qasr-en-Nueijis, [6] at Hammâm es-Sarakh in Syria, dated by Butler to the second or third century of our era. [7] But the type has been traced back to pre-Christian times along the valleys of the Maeander and the Hermus in Asia Minor. It may have passed from Constantinople to Ravenna, where the tomb of Galla Placidia (SS. Nazaro e Celso) affords a well-known example.

The third method of adapting a dome to a square plan is by means of the *squinch* (*Trompe d'angle*, *Ecktrompe*), a diminutive vault or niche built across the angle of the square, either in a square drum above the four

houses of North Syria and Mesopotamia. Rivoira (*Moslem Architecture*, p. 121) declares the Ezra dome later than the walls because it is of concrete while these are of stone. This was essential for his theory that the oldest ovoid dome in existence is that of the Qasr es-Shirin, or palace of Chosroes II (A. D. 591–628). But the view is shared by Guyer and Herzfeld.

[1] The tomb of Byssos : de Vogüé, *Syrie Centrale*, pl. 91. This dome is the only intact example in Northern Syria ; the dome, built by corbelling, was common in the Hauran for small buildings ; Butler, *as above*, p. 315.

[2] In mentioning the Kerch tomb (p. 80) we have already noted an approximation to the mathematical triangle of the true pendentive.

[3] Choisy, *Hist. de l'architecture*, ii, p. 58.

[4] The pendentive proper is found in churches ascribed to the fourth and fifth centuries along the coast of Asia Minor (Korykos, Myra, Philadelphia, Magnesia, Sardis), and in the church at Ephesus ascribed to the sixth century ; the earliest Byzantine examples to which a certain date can be given are those in S. Sophia (Plate II). In Armenia the pendentive only predominated at a much later period.

[5] Choisy, *Histoire de l'architecture*, i, p. 519, fig. 7. Rivoira (*Moslem Architecture*, p. 234) rejects the Hellenistic dating of Jerash as arbitrary, and claims the honour of the earliest dated pendentive for that in the Domus Augustana on the Palatine (A. D. 85).

[6] Palestine Exploration Fund ; *Eastern Palestine, Memoirs*, 1889, p. 172 ; Strzygowski, *Kleinasien*, p. 135. Rivoira has claimed the pendentive for Italy because it is found in one or two small buildings of imperial Roman times ; but as a practical architectural feature it was hardly known in Rome.

[7] H. C. Butler, *Publ. of Princeton Univ. Arch. Exp. to Syria*, 1904–1909, *Division II, A2, Appendix*, p. xxi.

arches supporting the dome, or else upon the same level.[1] The local origin of this feature looms large in the dispute between the oriental and Roman schools. According to the former it is Persian, and the palaces of Firūz Abad and Sarvistan (see above, p. 82), in which it is employed, are older than the Baptistery of Soter at Naples[2] and S. Vitale at Ravenna. But the Western school regards Firūz Abad and Sarvistan as quite late Sassanian, and as showing affinity with Qasr es-Shirin, the palace of Chosroes II. Rivoira maintains that the squinches at Khoja Kalessi, a church generally ascribed to the fifth century, prove nothing against him, since this date is unsupported by documentary evidence; the White and Red Monasteries at Sohag are also inconclusive, since the domes of both are late substitutes for original timbered roofs ;[3] priority is thus secured for the Naples Baptistery and S. Vitale. Against these points his opponents urge that the objection to the date of Khoja Kalessi represents only a personal opinion ; that other early examples occur in the case of the ruined church at Rusāfah (Sergiopolis), and of the church of the Nestorian monastery on the walls of Amida.[4] Contrary to Rivoira's assertion, the squinch was the earliest method employed in Armenia,[5] and its appearance in a domed building over a square plan as far east as Chinese Turkestan (Turfan),[6] which dates from the eighth century at latest, supports their contention that it is an indigenous Asiatic invention, employed from the first in the domed Iranian dwelling-house, which is still erected in almost its primitive form to-day.[7] In short, the oriental school contends that the squinch was adopted both by Armenia and by Islam from Iranian sources before the seventh century, and that its presence in the Baptistery of Soter and in S. Vitale are just as much a proof of early Persian influence in the West in Early Christian times,[8] as its employment in the great Church of S. Luke of Stiris in Phocis, at Daphni, and at Nea Moni on Chios is a proof of the same influence in the eleventh century, when the transmitters are more likely to have been Armenian than Saracenic builders.[9]

[1] The former of these alternatives is employed in Cappadocia (H. Rott, *Kleinasiatische Denkmäler*, pp. 184, 277), the latter in Greece, where the church of Christianou in Triphylia affords an early instance (Millet, *L'École grecque*, p. 108).

[2] A. Muñoz, *L'Arte*, xi ; G. Millet, *Revue archéologique*, 1905, pt. i, p. 101 ; Rivoira, *Moslem Architecture*, p. 169 f. ; Strzygowski, *Amida*, p. 186, and *Baukunst der Armenier*, p. 755, where references are given for the squinch in Lombard and early French architecture. The squinch occurs in the ninth-century church of S. Germigny-des-Prés near Orleans, and the form seems to be indicated in paintings of the Roman catacombs.

[3] In this opinion Rivoira is supported by Somers Clarke, *Christian Antiquities in the Nile Valley*, pp. 145 ff.

[4] Strzygowski, *Amida*, pp. 173, 221–2. The first person to report the squinch in this church was the late General de Beylié.

[5] *Die Baukunst der Armenier*, p. 309. Strzygowski's assertion is based on the practical experience of the Austrian expedition of 1913. Cf. *Byz. Zeitschr.*, 1914, p. 332.

[6] Strzygowski, *Baukunst der Armenier*, p. 362.

[7] Choisy and Dieulafoy are of opinion that Iranians made the first dome over square plan by means of squinches.

[8] *Baukunst der Armenier*, p. 372.

[9] Millet (*L'École grecque*) holds the opinion that the squinch in these churches is due rather to Mohammedan influence, or derived from the inspiration of Parthia or Sassanian Persia.

The support of a high dome by whatever method erected, but especially when pendentives were employed, raised in an acute form the problem of the neutralization of thrusts,[1] in the solution of which Byzantine architects proved themselves masters of a logical and accomplished art. It was their general principle that a building should be self-contained, and that its supports should not appear beyond the external walls after the manner of Gothic buttresses.[2] The difficulty was met by co-ordinating the vaults of the building in such a way that they lent each other mutual support, thus neutralizing all dangerous thrusts. In the most usual type of cruciform church, that in the form of a Greek cross (p. 101), the high barrel-vaults of the four limbs themselves formed four great buttresses, receiving the thrust from the dome. But since the walls of these limbs were themselves high and thin, they also were unequal to the burden which they had assumed without receiving support in their turn. This was supplied by four lower chambers in the angles of the cross, to which the thrust was passed on, thus reaching the outer walls of the square within which the Greek-cross plan is inscribed. Below the drum the vaulted supports thus descend as it were in steps, and the pressure is distributed over the whole structure without the obvious suggestion of stress and tense resistance which the spectator receives from a Gothic church propped by external buttresses.

Another method of obviating thrust was to make it harmless at the source by constructing the dome of lighter materials, as was done, for example, in the Orthodox Baptistery, and in S. Vitale, Ravenna, where the domes are constructed of pottery tubes fitting into each other and disposed spirally.

The one region where the external buttress was originally used was Armenia. Here, in the architectural unit formed by a domed square, a projecting apsidal buttress was placed against each wall. These buttresses give the buildings a lobed or 'foiled' plan, and the number of lobes can be increased by placing them not only on the axes of the square, i.e. in the middle of the sides, but also on the diagonals, i.e. at the corners, thus producing an eight-foiled plan. Contrariwise, the number can be reduced by dropping one, if the square is extended on one side to form a nave, or two, if the dome is made to rest on four interior piers, and barrel-vaults are introduced both to the north and the south. The plan produced by the first of these reductions is regarded by Strzygowski as the origin of the *cella trichora* which yields the 'trefoil end', derived by other authorities from different beginnings (p. 108). That produced by the second, as seen at Bagaran, he regards as the origin of the Greek-cross plan (p. 101). He sees this Armenian principle of apse-buttressing expressed in a glorified

[1] On this subject see Choisy, *L'art de bâtir*, p. 128.

[2] External buttresses do appear, but are exceptional. The most familiar are those supporting the north and south sides of S. Sophia, Constantinople. Other instances occur at Eski Serai, Constantinople, and S. Sophia, Salonika; the external angles of the octagon at S. Vitale are also buttressed. Texier noted buttresses outside the dome of the basilica at Dereh Aghazi in Lycia, but this dome has now fallen.

and Hellenized form in S. Sophia at Constantinople, where the dome and semi-domes represent the old Armenian unit of the apse-buttressed dome.[1]

The arch.　The arch in most general use in the Christian East is the round form early known and employed in the Hellenistic world.

The horseshoe arch is much older than Islam.　It occurs in a Hellenistic vault at Chiusi apparently of the third or second century B.C.,[2] at Taq-i-Girrâ, where classical mouldings indicate an early period in the Christian era, and in the basilican church of Mayafarqîn in North Mesopotamia.[3] It is a feature of the early churches of the Tur Abdîn in the same part of the world, and in those of the Kara Dagh (e.g. Binbirkilisse), as well as in North Syria, Cappadocia, Armenia, and in the art of Islam everywhere.[4] It is found, together with the round and the pointed varieties, at Ctesiphon (Taq-i-Kesra) and at Bagaran in Armenia, the former building of the sixth century, the latter of later date.[5]　Rivoira suggests that it originated in the rock-cut temples of India, some of which are dated as early as the third century B.C.;[6] it may first have entered Western Europe before Islam through the mediation of the Goths.[7]　A precisely dated church with the horseshoe arch was that at Dana on the Euphrates, built in A.D. 540, standing in Texier's time but now destroyed.

The *pointed arch* is found at Qasr-ibn-Wardān, in North Syria, dated A.D. 564 (pp. 109, 118), and at Mshatta in Moab, the date of which is disputed (p. 118).　These examples are perhaps to be regarded as sporadic; the regular period of transition from ovoid to pointed took place in Mesopotamia during the eighth century; in the first half of the ninth it had come into systematic use to the exclusion of all other forms.[8]

The *arcade* (Plates III, IX, XI), in which arches spring from the supporting columns, replacing the old trabeated style with horizontal architrave, is commonly regarded as an oriental feature.　Rivoira, however, claims it as Campanian, adducing as the earliest example the House of Meleager at Pompeii.[9]　But the first example on a great scale is that of the peristyle in Diocletian's palace at Spalato, dating from the first years of the fourth century; while the existence of similar arcading at this time in the East is proved by a relief on the arch at Salonika, conjecturally ascribed to the time of that Emperor.[10]　It is quite possible that such earlier experimental instances as that of the House of Meleager may ultimately be discovered in

[1] *Baukunst der Armenier*, p. 745.

[2] Delbrück, *Hellenistische Bauten in Latium*, ii, p. 68; Haupt, *Zeitschr. für Gesch. der Architektur*, iv, 1911, p. 220; Strzygowski, *Altai-Iran*, p. 289.

[3] G. L. Bell, *Palace and Mosque of Ukhaider*, p. 166.

[4] Ramsay and Bell, *The Thousand and One Churches*, p. 316; Strzygowski, *Kleinasien*, p. 29.

[5] Perhaps later than the seventh century. (Cf. p. 101, n. 6.)

[6] *Moslem Architecture*, p. 110.

[7] *Baukunst der Armenier*, p. 756; E. T. Dewald, *Am. Journ. of Arch.*, xxvi, 1922, pp. 316 ff.

[8] G. L. Bell, *as above*, p. 164.

[9] *Moslem Architecture*, p. 70.

[10] K. F. Kinch, *L'arc de triomphe de Salonique*, pp. 34, 35, Paris, 1890; E. Hébrard, *Bull. Corr. Hell.* xliv, 1920, pp. 5 ff.　Behind the sacrificial group an archivolt is represented, and the scene is believed to be Antioch.

the East. In the palace of Diocletian oriental features predominate (p. 115); and it must always be remembered that Campania lay on the line along which Alexandrian influence in the arts made its way to Rome.

The column was a working member, and subjected to a greater strain than in the trabeated classical style. The change to the archivolt inevitably affected the development of the capital, which had now to bear its full share in the transmission of the downward thrust. And since each capital had to share in the support of two arches, the abacus of the composite Corinthian type was no longer either large or strong enough for the new task. To obtain the extended upper surface now required, architects as early as the first half of the fourth century, placed a separate impost-block between the capital and the springing of the arches, the form being that of an inverted truncate pyramid (Plates V, X). This device continued in use for the best part of two centuries; it was only in the early years of the sixth century that capital and impost were merged into an ' impost-capital ' formed of a single block. When the angles are conspicuous, it has been described as ' cubic ', when rounded sides predominated, as ' conical '; but the geometrical form is so often concealed or modified by sculptured ornament that this simple division has been complicated by classifications based upon the ornamental motives (p. 196). The composite Corinthian capital was modified in various ways in Byzantine times, chiefly between the volutes, where the line of oves was frequently replaced by a band of acanthus, and the rosette by a monogram or cross in a circle; otherwise it preserved the main features of its type—the two superposed rows of acanthus leaves, and the corner volutes. The Ionic capital, from its small size, could be easily combined with the impost, and its simplicity recommended it for use in the less conspicuous parts of a church. Thus at Eski Juma (the former church of the Virgin) at Salonika, while the nave capitals are ' Theodosian ', those of the gallery are Ionic. The Doric capital is rare outside Greece, where it occurs, with the impost, at Delphi and in Aegina. Later examples are seen in the north gallery in S. Sophia, Constantinople.

Types of Churches. The Basilica

By the latter part of the fourth century the basilican church had spread over the greater part of the Christian world, since in all the countries round the Mediterranean it provided in a simple form the long building adapted to ritual and congregational needs. The question regarding the origins of the developed Christian forms has been sufficiently discussed, and does not equal in importance that concerning the origin of the vault and dome. In whatever manner the long columned structure with aisles was first adopted by the Church, its elements belong to Greek architecture; and though Rome produced her own favourite type, so that it is fair to speak of

N

a Latin basilica, yet the timber-roofed basilican building can hardly fail to have existed in the Hellenistic cities earlier than in the West. Among surviving buildings, however, the basilica with architraves or lintels above the columns may be regarded as characteristically Roman, and we may reserve the name Hellenistic for the churches with archivolts instead of lintels above the columns. The basilicas of the Christian East will then fall into two main groups, the Hellenistic and the Oriental.

The former group, in addition to its timbered gable roof and archivolts, had galleries first above the aisles and narthex, later over the narthex only. The apse was polygonal externally, a feature which Rivoira claimed as Ravennate. The nave walls were high, with sufficient windows above to give abundant light. The church had usually three, but sometimes five aisles (Plate XI). It was preceded by an *atrium* with surrounding porticoes and central fountain (*phiale*). At the west end was a porch for catechumens and penitents, or a closed gallery (*narthex*) serving the same purpose. The Hellenistic basilica had commonly three projecting apses.[1] As a general type, it is chiefly confined to the coast-lands of the Eastern Mediterranean, extending westwards to the shores of the Adriatic, as at Parenzo and Ravenna. But it passed inland along the routes giving the Greeks easy access to the interior. It thus pushed from Antioch into Central Syria (Plate IX) and even beyond,[2] and its influence is seen in the stone-roofed basilicas of the Hauran, where, as already noted, timber was not available. These basilicas are thus described by Butler : ' The nave was divided into ' central and side aisles by two rows of low square piers.[3] These piers sup- ' port first, a series of great transverse arches which span the wide central ' aisle, secondly, a set of longitudinal arches of narrow span and about half as ' high as the transverse arches, and thirdly, two transverse arches, one ' above the other, one of which spans the side aisle, and the other the ' triforium gallery above it. The crown of the upper arch reaches to the ' crown level of the great arch. The arrangement is thus in fact a succession ' of transverse walls each pierced by five arches, and connected by longi- ' tudinal arches at the level of the gallery. From one of these walls to the ' other were laid the stone slabs which formed the flat roof of the basilica.' [4]

In the south of Asia Minor the easterly limit of the Hellenistic basilica seems to have been the chain of the Taurus.[5]

[1] Projecting apses were not common until the sixth century, at which time windows became general in apses. Clerestories also belong in the mass to this century.

[2] Antiochene Hellenism penetrated the hill-country of North Mesopotamia (*Baukunst der Armenier*, p. 381).

[3] Piers were used in basilicas wherever the columns favoured in the early centuries were not obtainable ; this more commonly occurred in the countries of the interior. The district where piers are commonest comprises the Hauran, the region between Central Syria and the Desert, and Osrhoene. (Guyer, in Sarre-Herzfeld, *Arch. Reise im Euphrat-Tigris Gebiet*, 1920, ii, p. 9.)

[4] H. C. Butler, *Architecture and other Arts*, p. 314 (Princeton Expedition to Syria).

[5] Strzygowski, *Baukunst der Armenier*, p. 381.

In the oriental basilica,[1] best represented by early examples in inner Anatolia, the roof was not timbered but vaulted, and, the nave walls rising but a short distance above the aisles, the nave was blind ; where a clerestory was introduced, Hellenistic influence is probable. The analogy between these blind naves and the halls of the Parthian palace at Hatra has been remarked, and the type may be presumed to come from North Mesopotamia. The pier is substituted for the column as better able to support the vaults, the columns, if retained, becoming merely adjuncts. An arcaded outer gallery or loggia, flanked by two towers, is sometimes found at the west end, which has no atrium before it like the Hellenistic and Latin examples : this kind of façade, based on an old Hittite form (p. 133, n. 3), is known in various buildings of pre-Christian date.[2]

The vaulted basilica, passing from Mesopotamia through Anatolia, penetrated to Cyprus, Crete, and Greece ; it obtained a temporary footing in Armenia, but was soon ousted in favour of national forms.

The basilica with transverse nave (*Breitkirche*), in which the entrance, opposite the altar, was in the middle of the side, is thought to have been a primitive Mesopotamian type. Outside Mesopotamia proper, it is found in the Tûr 'Abdîn,[3] in Armenia, and the Hauran.

More interesting than the simple timber-roofed or vaulted church is the type known as the ' domed basilica ' from the dome placed over its nave,[4] for here we may be in presence of a transitional form producing as its climax the S. Sophia at Constantinople (Plate I), but logically issuing

[1] G. Millet, *L'École grecque*, p. 16.

[2] The loggia between towers occurs in North Central Syria, where the basilica was not vaulted. (Cf. Strzygowski, *Kleinasien*, p. 214 ; F. Oelmann, *Bonner Jahrbücher*, Heft cxxii, 1922, pp. 189 ff.)

[3] The Tûr 'Abdîn, for which see G. L. Bell, *Churches and Monasteries of the Tûr 'Abdîn*, lies to the north-east of Nisibis. The dates here are disputed (see p. 134).

[4] For the domed basilica see Millet, *L'École grecque*, ch. iii ; Strzygowski, *Kleinasien*, pp. 104 ff., and *Baukunst der Armenier*, pp. 839 ff. ; Diehl, *Manuel*, pp. 90, 713 ; O. Wulff, *Die Koimesiskirche in Nicäa* and *Altchristliche und byzantinische Kunst* (see index, s.v. *Kuppelbasilika*) ; G. L. Bell, *Thousand and One Churches*, pp. 321, 397 ; S. Guyer, *Arch. Anzeiger*, 1909, p. 3.

Some hold that the primary motive of the innovation was not to give more light, but to enlarge the presbyterium by providing space between apse and nave. (C. M. Kaufmann, *Handbuch der christlichen Archäologie*, p. 206.) Among examples of the domed basilica are : probably the churches at Meriamlik (Guyer, *as above*), Ephesus, and Philippi ; Mayafarqīn (Tigranocerta), late sixth century ; Qasr Ibn Wardān in Syria (A. D. 561 ?) ; Khoja Kalessi, in Cilicia Tracheia (fifth century) ; S. Irene and S. Sophia, Constantinople ; S. Sophia, Salonika (but see *Rev. Arch.*, 1919, pt. i, p. 30) ; S. Clement, Ancyra (eighth century) ; S. Nicholas, Myra (eighth century or later) ; Dereh Aghazi (Cassaba) in Lycia ; Church of the Dormition (*Koimesis*), Nicaea (ninth century).

Churches in Constantinople of later date than S. Sophia and S. Irene, but having affinity with the domed basilican type, are : Gūl Jami (S. Theodosia, ninth century) ; Kalender Jami (S. Maria Diaconissa) ; and Khoja Mustapha Pasha (S. Andrew). In this group we have a cross-church, as it were superposed on a basilica ; superposition also occurs in the churches of the Brontochion and Pantanassa at Mistra, and the Paregoritissa at Arta. The Catholicon of Lavra on Mount Athos (completed about 1004) recalls the domed basilica, and its plan is followed by other early churches on the Holy Mountain. Reminiscences of the type are found in the three churches at Trebizond : S. Sophia, S. Eugenius, and the Chrysokephalos.

in the Greek-cross type of church which dominated the later centuries of Byzantine church-building. To some of those who accept this development, the type seems to have originated when the darkness of the blind nave in the vaulted oriental basilica was felt as a disadvantage; to introduce light without weakening the vault by inserting windows, a dome was erected resting on four piers in the nave, and interrupting the continuity of the long barrel vault. A fresh difficulty would now arise, since the north and south walls of the square bay under the dome would be called upon to resist a pressure to which they were unequal. Support might be given by raising the height of the aisles ; but a more effective way was to build two barrel-vaulted transepts, thus completing the abutment of the dome and giving the building a cruciform plan. The evolution of the new plan from the old is marked by the prolongation of the lines of nave-columns across the north and south sides of the bay covered by the dome, in order that the continuity of the long basilican plan may still be visibly suggested. At first, as at Meriamlik, the dome piers broke the continuous line ; afterwards, columns were allowed to fill the space beneath the north and south arches, in order that the line might be preserved. This regular continuation of the nave-columns is a feature not only of the earlier domed basilicas, but of advanced types like S. Irene (Plate XII) and S. Sophia at Constantinople, which have been brought into relation with them. Both these churches have been described in accessible monographs,[1] and in a short chapter concerned principally with the development of types, it is impossible to attempt an adequate description of such a building as S. Sophia. According to the more conservative view, we may find in this great church affinities to more than one type. The plan was the outcome of traditional forms, and seems a synthesis of three types : the basilican, the square church with a dome, like SS. Sergius and Bacchus, and the free-cross plan of the Holy Apostles.[2] For the influence of the cross type we need only observe that the width across the ' transepts ' is exactly the same as the length included by the eastern and western hemicycles (Lethaby). We have already observed the relation to the domed basilicas in the length of the nave and the continuation of the lateral arcades in two storeys along the north and south sides of the bay covered by the dome. The relation to S. Sergius appears in the columned exedrae ; Diehl notes that if the dome of S. Sergius were divided by a line running north to south, and a higher dome intercalated between the two halves ; if, further, the collateral aisles were added, a

[1] Lethaby and Swainson, *The Church of Sancta Sophia at Constantinople*, 1894 ; W. L. George, *The Church of S. Eirene at Constantinople* (Byzantine Research and Publication Fund), 1912. Among foreign books, see in addition to Salzenberg, C. Gurlitt, *Die Baukunst Konstantinopels*, pp. 20 ff. and Album i, pls. 25–39 ; E. Antoniades, Ἔκφρασις τῆς Ἁγίας Σοφίας, Athens, 1907–9 ; O. Wulff, *Altchr. und byz. Kunst*, pp. 375 ff. For the original dome see G. Millet, in *Revue belge de Phil. et d'Hist.*, 1923, p. 599.

[2] In a more recent work Lethaby notes smaller prototypes at Rusāfah (Sergiopolis) and Tralles (*Cambridge Med. Hist.*, iii, p. 543).

church like S. Sophia would result. To Strzygowski the employment of the exedrae, which serve not only as ornament but as support, suggests a descent from the apsidal niche-buttresses of Armenia, and he notes the trefoil form which, in conjunction with the main apse, they lend to the plan. He holds that without the previous development of Armenian architecture the creation of S. Sophia is unthinkable. For him the idea of such a plan is Persian, its first development Armenian, its final perfection Greek. He regards the domed basilica as the Armenian single-domed church, with the addition of galleries developed under Hellenistic influence in countries beyond the Armenian borders, in Mesopotamia or Asia Minor. To the objection that there are no examples of the type in Armenia he replies that galleries were not used in early Armenian churches and had to be supplied by Hellenistic or other architects.[1]

Another explanation of the domed basilica is offered by Wulff, who would invert the first-mentioned theory, make S. Sophia the beginning, not the end, and derive the domed basilican type from it. Against this it may be urged that the type surely existed before the sixth century.

These theories are still in conflict, and their relative truth or falsehood has yet to be finally determined : all are, however, agreed that the domed basilica owes its final forms to the Greeks, whether of North Mesopotamia or of Asia Minor. Whatever the result, the brilliant synthesis which we find in S. Sophia is such as to preclude any further development in the same direction.

Such representations as that of a square tower on the fourth-century ivory casket at Brescia and a round one on that from Werden in the Victoria and Albert Museum, and on the wooden doors of S. Sabina, seem to show that the tower was almost from the first known to Christian architecture and associated with the basilica, though its purpose was probably to contain stairs giving access to the upper part of the building, and not to carry bells ; façades flanked by towers are of pagan origin, as shown by representations of temples on coins of Caracalla, Philip the Arabian, and Otacilia (propylaea of great temple of Jupiter at Heliopolis). The tower by the sixth-century church of Pomposa was built as a lighthouse, and this might seem a confirmation of the theory that all church towers descend from the Pharos of Alexandria ; but the examples cited above suggest that the tower was an ancient feature in the architecture of the Nearer East. The earliest towers built to carry bells may have been those of old S. Peter's at Rome, erected by Popes Stephen II (752–757) and Hadrian I (772–795), and that of S. John Lateran ;[2] S. Apollinare Nuovo at Ravenna (A.D. 850–878) and of S. Apollinare in Classe follow.[3] Bells were used in the West earlier and

[1] But the rather square church of S. Mary (El Hadra) at Mayafarqīn (Tigranocerta), south of the Armenian border, has galleries (G. L. Bell, *Churches and Monasteries of the Tûr 'Abdîn*, p. 98). This church may have been that built by Chosroes II after A.D. 591.

[2] Rivoira, *Lombardic Architecture*, p. 49.

[3] Rivoira gives the date of the campanile of S. Apollinare Nuovo as 850–878 : *ibid.*, p. 45.

more regularly than in the East, where the *simandra*, or *simantron*, of stone or wood, suspended and struck by a bar, served the purpose of summoning to prayer. As late as A.D. 1200 S. Sophia at Constantinople was without bells, though more than three hundred years earlier the Doge Partecipazio of Venice had sent bells to Basil I (A.D. 867–886), probably for his new church called the *Nea*. The Latins introduced belfries as a regular feature in the twelfth century. It may be noted here that the low towers at S. Vitale were erected merely to give access to the galleries.

Though in general associated with the earlier centuries rather than with later periods, the basilica was never altogether superseded. It appears sometimes to be assumed that this type of church ceased to be erected after the first Christian centuries. This is an error, perhaps suggested by the rarity of the basilica in Constantinople. Elsewhere there are frequent examples dating from later times : in Macedonia (Serres, Ochrida, Aïl) ; in Thessaly (Kalabaka or Castoria) ; at Salonika (Ikisherif Jami and the restored church of S. Menas) ; on Mount Athos (an eleventh-century church destroyed in 1752) ; and in Greece (Arta, Athens, Elis, Laconia).[1] Basilican affinities are also marked in many domed churches (Skripú, Deré Aghassi, Trebizond).

The interior decoration of basilicas was carried out essentially on the same lines as that of the later domed churches (see p. 106). It was naturally more sumptuous when the structure was of brick, in which case all the walls were covered by a lining of coloured marble below, and by vitreous mosaics above. The floors were in like manner of marble or tesselated pavement.

Centralized Types

Round or polygonal buildings of Christian date are widely distributed both in East and West, and are commonly regarded as derived from pagan buildings of similar plan erected as mausolea or Baths. In Christian times these two destinations were in effect preserved, for structures of this character were built as memorial chapels (*martyria*) and baptisteries. Only the more complex types were used as churches, and even the most highly developed were ill adapted for liturgical purposes ; when Constantine and his mother erected their round churches in the Holy Land, basilicas were attached to them in order to receive the congregation of the pilgrims. Round buildings of Christian origin come into prominence in the reign of this emperor ; they may be conveniently divided into two main groups, those of simple, and those of complex plan.

Simple plan. Here the interior is a single chamber. The wall is thick in order to carry the dome safely ; for even when moulded in concrete, as in the case of the Pantheon at Rome, a massive cupola requires powerful

[1] The Prague expedition not long ago dis-covered an example in Isauria, and doubtless the area of distribution will be further ex-tended. (Cf. G. Millet, *L'École grecque*, p. 16.)

supports. To economize material and to ornament the chamber, deep niches were hollowed out of the wall, four or more in number. When brick was used in place of stone, the walls were thinner, and the ornamental effect of the interior could only be retained by making the niches project apsidally from the outer wall : in this way, according to one theory, began the lobed plans characteristic of the complex type. Good examples of the simple plan still standing are the cathedral at Spalato, erected as the mausoleum of Diocletian,[1] an octagon with circular interior ; the round church of S. George at Salonika,[2] a circular structure resembling a Roman sepulchral building, with massive walls, and a presbyterium added for liturgical use in the early fifth century ; and the tomb of Theodoric[3] at Ravenna (about A.D. 520). The last named is at the base a decagon with round upper part. It was originally cased in marble, and probably surrounded above by arcading presenting an appearance similar to that on the exterior of Pisa Cathedral. The cupola is hewn from a single block of Istrian stone and is thus not a constructed dome.

Complex type. Here the original circular or octagonal wall is as it were resolved into a ring of columns, and access is thus given to a surrounding ring-chamber enclosed by the outer wall. One group of the class, represented by Constantine's church of the Holy Sepulchre at Jerusalem (the *Anastasis*),[4] by the Church of the Ascension on the Mount of Olives, by S. Stefano Rotondo in Rome, and by an imperfect example, S. Angelo at Perugia, had wooden roofs, in some cases partly open to the sky, so that externally they resembled truncated cones ; in other cases, as at S. Stefano, with a raised wall above the inner circle of columns, containing windows, and surmounted by a complete roof. As S. Stefano is believed to have been erected by Galla Placidia to reproduce the plan of a church built in the Holy Land by her grandmother Eudoxia in honour of the same saint, these churches seem to form a series connected with the Holy Places ; and the Mosque of Omar or Dome of the Rock (*Kubbet Es-Sakkra*) at Jerusalem (seventh, ninth, eleventh, and twelfth centuries), though domed, adopts their general plan.[5] Centralized memorial churches without domes, though

[1] Hébrard and Zeiller, *Spalato, le palais de Dioclétien*, Paris, 1912, p. 81 ; N. Monneret de Villard, *Arch. Storico Lombardo*, xli, 1914, pp. 70 ff., asserts the oriental origin, and its imitation in Northern Italy.

[2] This building has by some been compared with the cathedral of Bosra, but a more general opinion finds its affinities in Rome (Diehl, Le Tourneau, and Saladin, *Mons. Chrét. de Salonique*, Paris, 1918, p. 22 ; E. Hébrard, *Bull. Corr. Hell.*, xliv, 1920, p. 5 ; Lethaby, in *Cambridge Med. Hist.*, iii, p. 542).

[3] Rivoira, *Lombardic Architecture*, pp. 53–5 ; de Beylié, *L'habitation byzantine*, pp. 152, 153 ;

Venturi, *Storia dell' arte italiana*, i, p. 82.

[4] This church had a ring-aisle and upper gallery : see the reconstruction by A. Baumstark, *Oriens Christianus*, 1905, p. 206.

[5] G. T. Rivoira, *Moslem Architecture*, pt. i, pp. 45 ff. ; H. Saladin, *Manuel de l'art musulman*, i, 56.

This famous building was erected by Abd El-Malik at the close of the seventh century, that by its splendour it might divert to the Holy Land a part of the pilgrims who enriched Mecca. It has been several times restored, the wooden dome dating from A.D. 690. Strzygowski considers that the original plan was not

of great historical importance, are naturally less significant for architectural development than those which are domed and vaulted ; before leaving them we may notice their probable connexion with the circular Marneion or temple of Marnas at Gaza in the extreme south of Palestine, which is thought to have been a prototype, though it may have had a dome (p. 98, n. 1).

The domed and vaulted variety of the complex type finds its earliest surviving representatives in the Church of S. Costanza at Rome,[1] built by Constantine as the mausoleum of his sister Constantia, and the baptistery of the Lateran,[2] much modified in the course of time, but erected by the same emperor. In these buildings, the first of which is circular, the second octagonal, the central chamber is domed, and the surrounding ambulatory vaulted. The Lateran baptistery was much imitated down to the time when baptism was performed within the walls of churches. The still standing church of S. George at Zor'ah (Ezra: A.D. 515) and the ruined cathedral of Bozra[3] represent in the East this first stage of the complex type, and both show affinities with the baptistery of S. Menas in the Mareotic desert. The elaboration of the type may have led to the breaking of the plain lines of an inner octagon by exedrae, on four or more of its sides, and to the use of upper galleries. The two best-known examples of this more developed structure are SS. Sergius and Bacchus at Constantinople, the so-called ' Little Sta. Sophia ',[4] and S. Vitale at Ravenna ; the former was built by Justinian and Theodora in the first half of the sixth century. Exedrae open from four sides of a central octagon, the piers of which are connected with the external walls by a system of arches and vaults. The lower columns support an architrave, above which is an upper row of gallery columns carried round the exedrae. S. Vitale,[5] the culminating example of the type, is more graceful than the Constantinople church. Completed in A.D. 547, it is an octagon with a central dome ; the eight piers supporting the dome are connected by a system of exedrae, with a lower and an upper tier of columns, and buttressed by powerful arches to the outer walls. The apsed choir opens from one side of the inner octagon, while the outer is crossed

derived from any round Christian Church, but copied a columned structure surrounding the Kaaba at Mecca (*Der Islam*, ii, pp. 7 ff., Strasburg, 1911). He thinks that it was at first open in the middle, and that hangings served in place of the present outer wall, which he regards as a later addition.

[1] For S. Costanza and the Lateran Baptistery see Leclercq in Cabrol, *Dict. d'arch. chrétienne*, s.v. *Baptistère*, sect. xx ; Dehio and Bezold, *Die kirchliche Baukunst des Abendlandes*, vol. i. For short notices, W. Lowrie, *Christian Art and Archaeology*, 1901, p. 143 ; A. L. Frothingham, *Monuments of Christian Rome*, 1908, p. 29.

[2] The foundation of the Lateran baptistery dates from the time of Constantine, but the lower part only from that of Sixtus III (A.D. 432–40). The upper part is modern.

[3] For S. George see H. C. Butler, *Architecture and other Arts* ; pt. ii of the publications of an American arch. expedition to Syria in 1899–1900, New York, 1903, p. 411 ; for the cathedral of Bosra, the same, in *Publ. of Princeton Univ. Arch. Exp. to Syria*, 1904, &c. ; Division II, *Architecture*, Leiden, 1914, pp. 282–3.

[4] A. Van Millingen, *Byzantine Churches of Constantinople*, pp. 62 ff. ; H. Gurlitt, *Baudenkmäler Constantinopels*, p. 18, pls. xxi–xxiv ; J. Ebersolt and A. Thiers, *Les églises de Constantinople*, p. 21, pls. v–xi.

[5] Venturi, *Storia*, i, p. x.

at the western angle by a narthex in two storeys flanked by stair-turrets. The dome is constructed of terra-cotta pipes fitting into each other, by which means its weight is much reduced; in this respect it follows the example of the orthodox baptistery.

It has been mentioned that the Lateran baptistery at Rome became a model for many baptisteries in other places. Baptisteries [1] varied considerably in form, being sometimes square, as at Gūl Bagche (Clazomenae), Bettīr in Central Syria (fourth century), Dar Kita in the same region (A. D. 422), Emmaus, Palestine, &c.; sometimes quatrefoil (Tigzirt, Algeria), rarely hexagonal (Deir Seta, Syria). But the octagon of the Lateran type became the prevalent plan, represented, among notable examples, by those at Ravenna, and at Parenzo in Istria (sixth century). In the Arian Baptistery at Ravenna four apses projecting at opposite points lend the outline the suggestion of a cross. At Torcello the central type is modified, the form being that of a Greek cross with dome on columns and extended chancel.

The dispute between the occidental and oriental schools of Christian archaeology has naturally extended to the origin of centralized domical buildings, the former assigning all types to Rome, the latter maintaining that the circular and polygonal plans belong to Hellenistic architecture, but discovering a definitely oriental influence in certain complex types. It is possible that since, as we have seen (p. 80), the covering even of a square plan by a dome was known to the Greeks of Asia Minor several centuries B. C., some knowledge of this kind of building may have reached Etruscan Italy, that some survival of tradition may have led to the translation into permanent material of such a small round structure as the circular peasants' hut, and that from such beginnings the power to erect a building like the Pantheon may have been gradually acquired.[2] But though Rivoira [3] has brought forward much interesting evidence as to the existence of domed centralized types at Rome in the second and third centuries, this only proves that so far as archaeological investigation has yet gone, the earliest known remains may be claimed by Rome. This is not, as already pointed out, the same thing as to prove that the oldest examples which ever existed were Roman; and we are again confronted with the difficulty caused by the disappearance of the greatest Hellenistic cities with all their architecture. Because the Tempio di Siepe dates from the third century, it by no means

[1] Baptisteries as separate buildings came into use from the close of the third century. They were by degrees brought into closer relation to the church, finally becoming chapels not far from the main door. In the south of France the Baptistery remained detached down to the Romanesque period, in Italy down to the Renaissance, as in the cases of Pisa and Florence.

[2] Cf. H. Stuart Jones in *Companion to Roman*

History, pp. 89, 190.

[3] *Moslem Architecture*, p. 68. Rivoira points to existing remains on the site of Hadrian's Villa, and produces plans by artists of the Renaissance and later, illustrating remarkable centralized buildings of the imperial age, mostly now destroyed. The 'Tempio di Siepe', still surviving in part, is regarded by him as an important piece of concrete evidence.

follows that earlier domed buildings were not erected in the Greek world, for instance in Asia Minor, a country where the dome had been known for centuries before Augustus. It would seem more probable that the centralized types of imperial Rome were due to living Hellenistic types than that they were developed by a revival of some Italian tradition due to an earlier wave of Hellenic influence. There is record of centralized buildings round and octagonal in plan erected in the Christian East in the fourth century. The memorial buildings of Constantine in the Holy Land [1] are well known, and the octagon erected by the same emperor at Antioch is briefly described by Eusebius.[2] In the funeral oration delivered by Gregory of Nazianzus in honour of his father (d. A. D. 374), he speaks of the *martyrion*, built by his father, as a domed structure with interior colonnade and surrounding ring-vault.[3]

In the letter of Gregory of Nyssa (A. D. 379–394) to Bishop Amphilochius of Iconium,[4] there is a description of a domed and vaulted polygonal type with rectangular projections at four opposite points, like that represented by the ruined church at Viran Sheher (*Constantina*) in North Mesopotamia (fourth to fifth centuries), where the plan suggests a cross laid over an octagon.[5] The representatives of the oriental school can produce various examples of round and polygonal memorial churches, especially in Asia Minor, which have all the marks of fourth- or fifth-century date, and by their variety in form and construction tend to prove the existence of local schools.[6] And since early documents recently studied,[7] and the results of the Austrian Expedition to Armenia in 1913, suggest the possibility that centralized buildings were among the churches recorded as built east of the Tigris in the second century, they believe that when intensive research becomes possible in Hither Asia the connexions required by their theory should be finally established. They see in the oriental *martyrion*, and not in any buildings erected in Italy, the prototype of S. Vitale, and of the cathedral of Aix-la-Chapelle,[8] which Rivoira would ascribe to Lombard builders. They contrast the tentative style of S. Costanza and the timorous

[1] See p. 95. The Marneion at Gaza may have had a dome. Mark the deacon, in his Life of Porphyry, says that it had in the midst: ἀναφυσητὸν κιβώριον καὶ ἀνατεταμένον εἰς ὕψος. See G. F. Hill, *The Life of Porphyry, bishop of Gaza, by Mark the deacon*, Oxford, 1913, p. 85.

[2] *De vita Constantini*, iii, c. 50.

[3] Strzygowski, *Kleinasien*, p. 94.

[4] Translated in Strzygowski's *Kleinasien*, p. 71.

[5] *Kleinasien*, p. 96 ; Van Berchem and Strzygowski, *Amida*, p. 219.

[6] Cf. churches at Binbirkilisse, Isaura, Soasa, Hierapolis. Sir W. Ramsay, at first doubtful as to the age of the Binbirkilisse churches,

afterwards expressed his belief in their Early Christian date (*Expositor*, iv, 1907, and *Thousand and One Churches*, 1909.

[7] *The Chronicle of Arbela in Adiabene, E. of Nisibis*, ed. E. Sachau, *Abhandlungen der K. preussischen Akad. der Wissenschaften, phil.-hist. Klasse*, no. 6, 1915. The Edessa Chronicle, ed. by Guidi in *Scriptores Syri*, 3rd series, vol. iv, *Chronica Minora*, i, pp. 3 ff. For a chronicle of the world, ed. by Rahmani, using in reference to Edessa a source dated between A. D. 460 and 480, see *Repertorium für Kunstwissenschaft*, xli, 1919, p. 128.

[8] Strzygowski, *Der Dom zu Aachen und seine Entstellung*, Leipsic, 1904 ; Rivoira, *Lombardic Architecture*, p. 56.

simplicity of the Lateran baptistery with the bold use of complicated forms in the baptistery of S. Menas in Egypt.[1] Their general conclusion is that the complex round and octagonal types used by Christianity had their immediate origin in the Hellenistic parts of Hither Asia, while other types were developed in Armenia through a purely Iranian inspiration, and sent westward through North Mesopotamia and Asia Minor at a very early time. An astonishing variety of centralized types dating from the seventh century is now known in Armenia, and this might well point to the gradual development of a local art ; moreover, Armenian tradition, recorded in the fifth century, describes in connexion with the vision of Gregory the Illuminator a type which points to the erection of centralized buildings as early as about A.D. 300. The Armenian centralized buildings which have only been studied in recent years certainly deserve particular attention. They differ from those of Hellenistic origin in that the plan is never a circle or an octagon but almost always a square ; it is argued that they belong to a different line of development, which Strzygowski believes to be North Iranian. We need not follow in detail his analysis of the Armenian centralized types.[2] The essential point is that the unit in Armenian architecture, as in the North Iranian architecture from which it is assumed to have been derived, is a square building surmounted by a dome, having this peculiarity, that the sides, and in the more elaborate forms the angles also, are supported by apse-like or niche-like buttresses [3] projecting externally, and giving the plan a lobed or ' foiled ' appearance. In the primitive unit four such buttresses were placed on the axes of the building, i.e. in the middle of each wall. But variations were played upon the theme : for instance, the apse-buttresses might be made co-extensive with the walls, so that the exterior of the building presented the appearance of a quatrefoil ; or buttresses might be placed on the diagonals, as well as on the axes, in which case an eight-foil resulted. An interesting variation is that found in the case of the ruined church at Zwarthnotz [4] (built between A.D. 641 and A.D. 661 (?)), and reproduced at Ani in the church of S. Gregory built by Gagik in A.D. 1001. Here we have a quatrefoil within a circular enclosing wall, the space between the two forming an ambulatory, to which access is given by transforming the solid buttresses on the north, south, and west sides into open exedrae each with an arcade of seven arches. This procedure recalls the Greek treatment of the octagon at S. Vitale, and

[1] Ramsay and Bell, *Thousand and One Churches*, p. 430.

[2] This will be found in *Baukunst der Armenier*, pp. 70 ff.

[3] The word chosen by Strzygowski to express this type of buttress is *Konche*, and if the word *concha* were a more familiar term, we might adopt the expression conch-buttress.

As already noted (p. 81), the square, domed unit is in current use to-day in North Syria, North Mesopotamia, and in Persia ; but it differs from the Armenian in not having the apse-buttresses.

[4] It was excavated in 1900, and first published by the Russian Imperial Archaeological Commission in 1903, but may be most conveniently studied in *Baukunst der Armenier*, pp. 108 ff., and pp. 682 ff.

Strzygowski seems to infer a Greek adaptation of an Armenian idea in the Ravenna church,[1] just as he has inferred it in the case of S. Sophia at Constantinople.

The use of the apse-buttress, and the resulting lobed or foiled plan, confront us with the problem of the 'trefoil' or 'triconch' east end, which is discussed elsewhere (pp. 108 ff.). Here we need only note that Strzygowski sees the origin of this form in the Armenian apse-buttress, a theory which has the advantage of giving the trefoil a definite structural origin. He supposes that when, for congregational purposes, a quatrefoil church had to be enlarged, the extension naturally took place on the western side ; the removal of the western buttress left a building with a nave and a trefoil end. The study of Armenian centralized buildings suggests a new solution of another problem, that of the all-important Greek-cross type of Byzantine church. The Armenians enlarged their square unit by supporting the dome on four internal piers and covering the spaces between these and the outer walls by barrel-vaulted chambers, as in the ruined cathedral at Bagaran, a church to which it will be necessary to refer again.

Cruciform Plans

Churches of cruciform plan form two main groups, according as the cross is free-standing, or inscribed in a square at the ground level and only discernible above. The second variety has been so commonly described as the Greek-cross plan that it has seemed desirable to retain a long-established term. The free-cross plan, like the basilica with projecting transepts, was probably intended to celebrate the triumph of the cross. It is found in small memorial churches with domes at the crossing, like the Mausoleum of Galla Placidia at Ravenna, which are regarded as the counterparts above ground of subterranean chapels of this form in certain catacombs.[2] It would seem, however, that the natural desire to reproduce the figure of the cross in the plan of a church may have found expression in different ways, for we detect an effort in this direction in such centralized buildings as the octagonal church of Viran-Sheher, where the four projecting chambers lend the whole the suggestion of a cross (above, p. 98). There are numerous examples of the plan in Asia Minor.[3] Farther west it was represented by

[1] His opponents doubtless attribute the characteristic features of Zwarthnotz to Hellenistic or Roman influence ; and it must be noted that the inscription on the building dating it to the time of Nerses III (A. D. 641–661) is in Greek. Others may argue that the ornamental niches in the massive walls of early centralized domed buildings, such as the Pantheon or S. George at Salonika, may have first suggested the exedrae, when it was desired to open up and enlarge the interior by adding a surrounding chamber, and that recourse to Armenia is not necessary to explain a natural development, which might have been attained by more than one way.

[2] Van Berchem and Strzygowski, *Amida*, p. 179.

[3] Binbirkilisse, Tomarza, Sivri Hissar, &c. See Ramsay-Bell, *Thousand and One Churches*, pp. 221, 363 ; H. Rott, *Kleinasiatische Denkmäler*, pp. 182, 192, 274 ; Diehl, *Manuel*, p. 95.

Justinian's Church of the Holy Apostles at Constantinople [1] (no longer existing) ; this famous structure, the model imitated by the architects of S. Marco at Venice, copied in its turn on French soil in S. Front at Périgueux. A notable example which has perished is the already mentioned church erected by order of the Empress Eudoxia on the site of the temple of Marnas (Marneion) at Gaza, destroyed in A. D. 402.[2] It may be observed that even in free-cross churches the angles of the cross are sometimes filled by lower chambers, as in the case of the Greek-cross type, and that here too the clear outline of the cross at the ground level is thus obscured. The added chambers, however, have in this case no structural purpose, and at first were isolated from the nave.

The Greek-cross plan, in which the cross is inscribed in a square, is generally derived from the domed basilica, by a line of development indicated below (p. 102). But there are other theories. Some authorities see the origin of the type in the crossing of two vaulted chambers in great structures like the Baths of Caracalla,[3] where the groined vaulting at the intersection might well have developed into a dome. Others recall the ' four-sided dome ' as seen in the Praetorium at Musmieh in Syria, built under Marcus Aurelius and Lucius Verus (A.D. 160–169), but destroyed in comparatively recent times ; they point out that if a true dome were substituted, a Greek-cross plan would result.[4] Yet others have seen approximations to the type in the rock-cut churches of Phrygia and Cappadocia, where a domed interior is represented by excavation from the solid rock.[5] The recent theory put forward by Strzygowski is that mentioned at the end of the last section, deriving the Greek-cross church from an Armenian prototype (above, p. 100). We have seen that in the case of Bagaran,[6] the dome rests on four piers, the interior being enlarged by the

[1] A. Heisenberg, *Grabeskirche und Apostelkirche*, vol. ii. The church was begun by Theodora in A. D. 536, and finished ten years later ; it had a central dome between four others It was destroyed by the Turks to make room for the mosque of Mahomet II.

[2] Strzygowski, *Kleinasien*, p. 137 ; G. F. Hill, *as above* (p. 98, n. 1), pp. 66, 137. The pilgrim Arculf mentions a cross-shaped church over Jacob's well at Sichem.

[3] G. Millet, in *Revue archéologique*, 1905, p. 105. Cf. Rivoira, *Moslem Architecture*, pp. 187-9, where the Greek-cross plan is derived from the *tepidarium* of imperial baths, and a drawing by Giocondo is given, showing a Roman domed building in a walled square.

[4] de Vogüé, *La Syrie Centrale*, p. 46 and pl. 7 ; Strzygowski, *Kleinasien*, p. 135. Guyer describes a curious church outside the walls of Rusāfah, possibly as early as the sixth century,

which shows the Greek-cross type of plan, though the square central bay was never domed. Guyer believes that the dome was added to such a plan in the Hellenistic area, Syrian side, whence the domed Greek cross was transmitted to Armenia. The latter country may have ultimately returned it westward, but this is not the same thing as to have originated it. (S. Guyer, in Sarre-Herzfeld, *Archäol. Reise im Euphrat-Tigris-Gebiet*, ii, pp. 41 ff., 1920.)

[5] Ramsay–Bell, *as above*, p. 397.

[6] *Baukunst der Armenier*, pp. 95, 655, 767. The seventh-century date assumed by Strzygowski for Bagaran is not admitted by others. Orbeli considers the inscription, on which the dating largely depends, to be much later (*Monatshefte für Kunstwiss.*, xv, 1922, p. 218). Similar doubts are expressed as to the date of other churches.

interposition of four barrel-vaulted chambers between the dome-bay and the outer walls. As these vaulted chambers now themselves provide the necessary abutment for the dome, the niche-buttresses become super-fluous ; the result is the type of Bagaran, the Gaiane church at Vagharshapat near Edgmiatsin, both dating from the first half of the seventh century, the cathedral of Mren dated by an inscription of the time of Heraclius, and the later cathedral of Ani, finished in A. D. 1001.[1] Strzygowski has not failed to note the striking similarity between the plan of Bagaran and that of S. Germigny-des-Prés near Orleans,[2] built in the time of bishop Theodulf in the beginning of the ninth century, a church which was, indeed, recon-structed in 1867, but of which the main features are undisturbed, and that of S. Satiro at Milan, built by archbishop Ansbert in 879.[3] These western churches are to Strzygowski proofs of an early influence of Armenian archi-tecture in Europe exerted through the mediation of the Goths, who must have been accompanied by builders acquainted with Persian and Armenian methods, from their seats to the north of the Black Sea where they were in contact with Iranian culture.[4] It is true that the Bagaran type was not one of those which had a long popularity in Armenia, where examples are rare. In that country the single-naved domed church, which provided an interior with more unity and unencumbered by columns, became the dominant form. But if the theory is well founded, we have at Bagaran an example older than the *Nea* or ' new church ' of Basil I,[5] known to us only by descrip-tion, but regarded as the immediate prototype of the Byzantine Greek-cross churches of the tenth century and later. The theory is obviously affected by the real date of Bagaran, which, as we have seen (p. 101, n. 6), is disputed.

Those who derive the type from the domed basilica conceive the process of development somewhat as follows. The erection of a dome over the nave of a vaulted basilica produced structural weakness, in that the part of the walls on the north and south above the central square bay had no abutment enabling them to resist the thrust transmitted by the dome. The method

[1] *Baukunst der Armenier*, pp. 179–84.
[2] For works relating to S. Germigny see p. 158.
[3] R. Cattaneo, *L'architettura in Italia dal secolo 6 al mille circa*, p. 216.
[4] *Baukunst der Armenier*, p. 767. The most remarkable are the ninth-century barrel-vaulted churches of S. Miguel de Lino, S. Cris-tina de Lena, and S. Maria di Naranco. Their type is not that of the Greek cross ; but they may be used as an argument for the existence of vaulted fabrics before the Lombard high-vaulted churches of the period after A. D. 1000. Strzygowski alludes to them in support of his theory as to the part played by the Goths in the diffusion of Eastern architectural types in the West. For though, like S. Germigny, they were built after Visigothic times, they appear to preserve a tradition differing from that of the Mohammedan conquerors. Dieulafoy notes points of resemblance in these churches to Syrian and Sassanian structures (*Espagne et Portugal*, 1913, pp. 59 ff.), though in the second he finds certain characteristics of the Latin basilica. Dieulafoy has in the same manner pointed out the existence in Spain of a Visi-gothic Christian architecture of oriental affinities exemplified in certain ancient churches in the region of Oviedo.
[5] J. Ebersolt, *Le grand palais de Constanti-nople*, p. 130. Cf. p. 142 below.

of strengthening them which finally commended itself was to place barrel-vaulted transepts against these parts of the walls; these, with the sanctuary, gave the church its cruciform plan. The neutralization of the thrust was further effected by the erection, within the angles of the cross, of four low but massively constructed chambers, those on the west co-extensive with the nave, those on the east forming the *prothesis* and *diakonikon* on either side of the sanctuary. These additions lent the building, as seen externally, the form of a rectangle or square, the outer walls of the angle-chambers being continuous with those of the transepts. On the ground level, the cross-form was thus concealed; above, it was emphasized by the four high barrel-vaults radiating from the base of the dome.[1] A subsidiary cupola was commonly placed over each angle-chamber.[2]

In the interior, the western angle-chambers were thrown open to the nave, which they now served as aisles, the whole structure thus forming a continuous room. But this unity tended to diminish the cruciform effect. The interior was therefore further disengaged in the smaller and later examples, by the adoption of columns in place of piers beneath the dome. These columns were sometimes four in number, sometimes two only on the west side, the base of the dome on the other side resting on the *antae* of the dividing walls of *prothesis* and *diakonikon*. The type with four columns is characteristic of Constantinople, and of those places or areas (Salonika, Mount Athos, &c.) strongly influenced by metropolitan methods. In this arrangement the sanctuary is not confused with the eastern limb of the cross plan, but separated by three intervening transverse bays, each under its own vault; the general effect is to give more space at the east end. Where there are only two columns, on the other hand, the sanctuary is, so to speak, incorporated in the cross, the eastern limb of which it absorbs; the dome and presbyterium are in immediate proximity without any intervening bay. This simpler type is the rule in the provinces (Greece, Crete, Anatolia) and in more remote countries (Armenia, Caucasus).[3] On the above theory the prototypes of the Greek-cross plan should date from as early as the sixth century in Asia Minor and in Crete. In different regions various transitional types were produced, the matured type appearing in the ninth century.

The earliest surviving example of the complete Greek-cross plan in Byzantine architecture is the church at Skripù in Boeotia, which dates from the late eighth century.[4] It reached its full development in all essential

[1] Ramsay–Bell, *as above*, p. 300.
[2] As already pointed out, S. Sophia, Salonika, presents peculiar features which would allow the development to follow rather different lines (L. Bréhier, *Rev. Arch.*, 1919, pt. i, p. 30).
[3] Millet, *L'École grecque*, pp. 55 ff. The introduction of intervening transverse bays is also found in other types of churches. The

Mosque of the Calendars (Kalender Jami) at Constantinople, and the Church of S. Titus at Gortyna in Crete, are of interest in this connexion: for the latter see Th. Fyfe, *Architectural Review*, 1907.
[4] A dated list of churches of the Greek-cross type is given by Diehl, *Manuel*, pp. 433 ff.

features in the second half of the eleventh century, when it is well illustrated by S. Theodore (Kilisse Jami) at Constantinople. But in the Comnenian period and under the Palaeologi it did not stagnate, it continued to progress in the direction of greater elegance and grace of line. The churches, at no time very large, became yet smaller, until in the late centuries the floor-dimensions did not on the average exceed some thirty feet, which means that the whole area covered was no more than that of a large reception room. Typical examples for the twelfth century are the Pantokrator and (c. A.D. 1124) Pantepoptes (Eski Imaret Jami) at Constantinople, the church at Merbaka in Argolis, and the Kosmosoteira (A.D. 1144), or Saviour of the World, at Ferejik in Thrace (A.D. 1152). For the late thirteenth or early fourteenth century we may take as examples Fetiyeh Jami at Constantinople, with its graceful memorial chapel, and the Holy Apostles at Salonika (A.D. 1312–1315).

The chief changes in these periods [1] were the heightening of the polygonal drum [2] until it almost resembles a tower (cf. Plates XII, XIII), the corresponding elongation of the windows, and an increasing preference for the curved over the straight line, leading to the abandonment of the horizontal cornice between drum and dome. The arches enclosing the windows, enriched by the recessing of their rings after the manner of the Gothic orders, are allowed to break into the line of the roof, which is made to conform to their rounded extrados, receiving thus a fluted appearance like the rind of a melon, and forming an undulating curve along its lower edge. The predilection for curves led to the abandonment of the gable over nave and transepts in Constantinople and its sphere of influence. Here again the extrados of the vault is allowed to appear, and is sometimes in whole or part covered with lead, thus diminishing the danger of fire always present if there is wood upon the roof, as must be the case where tiles [3] are employed ; the broad curves at the extremities, harmonizing with the small undulations at the edge of the dome, lend an air of elegance and lightness to the profiles of the structure, which contrasts with the severity of the earlier gabled ends. From their raised domes these churches descend

[1] For these changes see Sir T. G. Jackson, *Byzantine and Romanesque Architecture*, i, p. 122 ; Diehl, *Manuel*, pp. 436, 703 ff.

[2] Isolated examples of drums over round plans (Minerva Medica, S. Costanza) are found at Rome ; S. Sophia, Salonika, and Dome of the Rock at Jerusalem had also drums. Over a square plan the drum appears at Constantinople in the case of S. Irene (sixth century), and its use was also early in surviving Armenian churches. Its general adoption in the Byzantine Empire is rather later, and dates from early in the eleventh century, perhaps as a result of Armenian influence : the earliest dated examples are the Church of the Virgin at Salonika and the Church of S. Theodore at Athens (cf. also Rivoira, *Moslem Architecture*, p. 209).

[3] In the case of S. Luke of Stiris in Phocis both lead and tiles are used, the former for the main dome and the corners over the pendentives, the eastern apse, and part of the roof over the bema. It is possible that the whole of the roofs may once have been so covered. The church of the Chrysokephalos at Trebizond retains part of its original roof-covering, which consists of copper plates fastened by large-headed nails (Millet, *Bull. de Correspondance hellénique*, xix, 1895, p. 455).

pyramidally, first to the high limbs of the cross, thence to the lower angle-chambers and the outer walls. The number of domes, which in the parent church of the Holy Apostles at Constantinople had been only five, tended to increase, especially when cupolas were placed over the narthex. The exterior was progressively enriched by such features as the above-mentioned recessing of the window arches; the recessing of blank walls between windows and doors, with niches or great flutings terminating above in conches (S. Theodore, and Gul Jami, Constantinople); and the use of cornices of dentils, or vandykes, as at S. Elias (Eski Serai Jami) at Salonika. Bricks were disposed in geometrical and other forms (fret, herring-bone, lozenge, &c.) and in certain places in Greece (e. g. S. Luke of Stiris in Phocis) by bands of decorative Cufic letters.[1] To such enrichment of pattern must be added a developed system of colour-decoration, especially upon façades. Bands of brick, alternate with bands of stone (apses of S. Luke, S. Nicodemus at Athens, Holy Apostles, Salonika). Inserted dishes of glazed faience appear in Greece from the end of the twelfth century (Nauplia); in the following century the example of Persia made their use more popular.[2] The exterior of the small churches of the late centuries, in its studied ornateness, contrasts pointedly with the severe, undecorated exteriors of earlier times; the curvilinear profiles are no less sharply distinguished from the gables and horizontal cornices of the older style.

Windows[3] which are round-arched have single, double, or triple lights, all generally tall and slender, and enriched by their recessed arches. The lower part of each light is often closed by a carved marble slab, above which the aperture may be filled by a slab of marble, or more commonly stucco, pierced with holes symmetrically disposed: in the case of the stucco slabs, these holes are sometimes filled with pieces of glass pressed into position before the plaster had set. The marble slabs, sometimes opening on hinges, have often been replaced by wooden shutters; above them is sometimes a stucco tympanum pierced as above described. Double and triple lights are separated by mullions or by slender columns.

Doors are generally square-headed; they are enriched by mouldings, and often by the neighbourhood of panels with decorative sculpture (geometrical and foliate design, beasts, &c.). Mouldings are most extensively used in the stone-building countries. East Christian mouldings descend from those of Hellenistic times and are found in greatest variety in the early churches and houses of Syria and Anatolia; classical forms tend to disappear; in their place we find profiles unknown to antiquity, such as the concave moulding or the pendulous cyma.

[1] For Cufic lettering in architectural ornament see Van Berchem and Strzygowski, *Amida*, pp. 370 ff.

[2] For the faïence dishes in early churches at Ravenna see Rivoira, *Lombardic Architecture*, pp. 44–5.

[3] Some of the best examples of church windows are those of Daphni and the Church of S. Luke of Stiris in Phocis; Schultz and Barnsley, p. 25. Cf. Plates VII and XIII.

If we turn to the annexes of the church, porticoes, towers, &c., we find the same tendency to elaboration. Late churches often have open porticoes,[1] sometimes on three sides (S. Sophia, Trebizond ; Fetiyeh Jami, Constantinople ; Holy Apostles, Salonika) ; the example had been set by S. Theodore (Kilisse Jami) at Constantinople, with a single portico on the north, and the custom may perhaps be traced to Syria. A tendency in the same direction is the doubling of the narthex or western vestibule by the addition of a second preceding gallery (*exonarthex*). The narthex itself, as a feature clearly differentiated from the nave, appears to belong to Hellenistic tradition. It is not found in Armenia, and is rare in Georgia. In Russia it is only differentiated at Chernigoff ; in Serbia also it is seldom a distinct feature. Large open halls for prayers preceded many churches on Mount Athos (see below, p. 152).

Where belfries [2] occur, either detached from the church, or against it, or above a porch or narthex, Latin influence may be assumed. The belfry is usually quadrangular, with pyramidal roof (S. Sophia, Trebizond ; Vatopedi, Mount Athos ; Metropolitan Church, Brontochion, and Pantanassa, at Mistra : Plate XV). In the belfry of the Pantanassa, at Mistra, M. Enlart sees the imitation of a thirteenth-century model in Champagne.

The interior decoration of the more sumptuous churches followed the same paths through all the periods of Byzantine history ; they were most splendid in the case of brick buildings, where the whole surface had to be concealed by some form of polychrome decoration. In the more sumptuous examples the lower parts of the walls to the springing line of arches and vaults were covered with a lining ; the various marbles differing in colour, white Proconnesian, green Thessalian, red Phrygian, &c., were disposed in panels with contrasting borders.

The lining of the walls in S. Sophia (Frontispiece and Plates III, XXIII) and Kalender Jami, Constantinople ; and in S. Luke of Stiris in Phocis (Plate XIV), illustrates this method. Above the marble lining, perhaps divided from it by a string-course, began mosaics covering all the curved surfaces of vaults and domes. The kind of window-filling in general use, slabs of stucco or marble pierced with holes, was calculated to regulate or reduce the brilliant eastern sun, and probably the original decorators of Cefalù, for example, would have objected to the large windows which now flood the mosaic with light, producing an effect for which the building was not designed.[3]

The restored Empire, after the Latin interregnum, was so impoverished that the lavish use of marble and mosaic was no longer possible ; the variety

[1] Millet, *L'École grecque, les annexes* ; Diehl, *Manuel*, p. 718.

[2] Millet, *as above*, p. 135. The *simandra*, a suspended slab of resonant stone, was the only 'bell' in the East until the thirteenth century, and was sometimes hung in a small tower,

which, however, was hardly on the scale of a belfry.

[3] Choisy says that at Cefalù the windows now filled with glass originally contained sheets of lead cut in open work, which only admitted a dim light : 'et les colorations prenaient cette

of marbles was restricted, while paintings in tempera replaced the costlier mosaic designs. The only sumptuous church which remains of this period is that of the Chora, known as Kahrieh Jami, where the marble lining and the mosaic are both of great richness. Floors were covered with marble slabs relieved by broad bands of different colours ; in places which it was desired to distinguish by special decoration, marble mosaic was employed. Speaking generally, marble mosaic with figure and geometrical subjects is more common in the early period, when smaller churches or sanctuaries were almost entirely floored in this manner (p. 295).

The chief constituents of church furniture, apart from the altar, were the ambo or pulpit, the iconostasis, or altar screen, and the font.[1]

Ambons. Of these there were two, one for the reading of the gospel, the other for the epistle and the sermon ; sometimes they were richly sculptured, as in the early examples from Salonika (p. 185, and Plate XXXI).[2]

Iconostases.[3] These are sometimes architectonic structures of marble, with a row of columns, the spaces between which are filled below by closure-slabs carved in low relief and above by panels with ikons ; in the middle were the doors giving access to the sanctuary, on the sides those leading to the *prothesis* and *diakonikon*. Such altar screens have seldom come down to modern times in perfect condition, that at Torcello is probably the best. Fragments are not infrequent. A well-known example of a stone iconostasis is that of S. Luke of Stiris in Phocis ;[4] another, with a good deal of sixth-century work still in position, is in the Church of the Assumption at Paroekia, Paros.[5] A third example, smaller but fairly complete, is in the monastery church of Portes in Thessaly.[6]

In post-Byzantine times the iconostasis of the Greek Church has commonly been made of wood elaborately carved and gilded. These late screens, usually of the eighteenth century, often have three arcaded tiers, the lower of the height of a tall door, the others much smaller, the panels of all being filled with ikons. Of these it has been well said that they produce the effect of a richly-decorated façade with the saints gazing through the windows.[7] And in point of fact, the iconostasis is probably derived from the palace façade, as it actually stood or as it was represented on the scene of the theatre.[8]

sombre profondeur dont la Chapelle Royale (Cappella Palatina) nous aide à deviner l'effet.' (*Hist. de l'Architecture*, ii, p. 65.)

[1] Cf. Choisy, *Histoire de l'arch.*, ii, pp. 65 ff.

[2] H. Leclercq, in Cabrol's *Dict. d'archéologie chrétienne et de liturgie*, s. v. *Ambon*.

[3] Strzygowski, *Amida*, pp. 214, 215.

[4] E. Freshfield, *Archaeologia*, lv, pl. xxxiv (to illustrate the remains of the iconostasis in the Mosque of the Kalenders at Constantinople, *ibid.*, pl. xxix–xxxi), and Schultz and Barnsley. Other remains of carved marble iconostases exist in many places, for instance,

in S. Sofia at Ochrida in Macedonia (B. Filow, *Early Bulgarian Art*, 1919, p. 12).

[5] H. H. Jewell and A. F. Hasluck, *The Church of Our Lady of the Hundred Gates*, p. 36 (Byz. Research and Publication Fund, 1920).

[6] Lambakis, *Mém. sur les ant. chrét. de la Grèce*, p. 74.

[7] Filow, *as above*, p. 74. In some of the churches on Mount Athos parts of earlier marble screens have been left behind the more recent woodwork (Jewell and Hasluck, p. 38).

[8] Strzygowski, *Journal of Hellenic Studies*, xxvii, 1907, pp. 99 ff.

Fonts have not survived in great numbers. In S. Luke of Stiris there is a bowl-shaped font of marble with lion-masks on the sides, the animals' legs forming the column or stem.[1] Some fonts were cruciform.[2]

Ciboria. These, in the architectural sense, were canopies upon columns above the altar. A marble ciborium of the sixth century, of which only the cupola is restored, still stands in its place in the Church of the Assumption at Paroekia in Paros.[3] The splendid ciboria of S. Sophia at Constantinople and S. Demetrius at Salonika are now only known to us from descriptions.[4]

The foregoing summary of the principal church types may be concluded by mention of the *trichora*, or ' trefoil end ', found both in basilican and domed churches from very early times, and diffused throughout the whole Christian world.[5] The form has commonly been derived from the *cella trichora*, a small memorial chapel represented in Italy by the examples above the Catacomb of S. Calixtus, and at S. Sinforosa at the ninth mile on the Via Tiburtina, and found in Tunis, associated with groined vaulting, at Tebessa, Carthage, Henchir Maalria, and Sidi Mohammed el Gebroni.[6] An ancient and popular cemetery-type associated with the graves of venerated persons came to be incorporated in church architecture through the *martyrion*, a memorial church, the disposition of the three apses not being absolutely uniform, but sometimes showing curious variations, as in the case of the late sixth-century martyrion of S. Sergius at Rusāfah, on the borders of North Mesopotamia, rather more than a hundred miles east-south-east of Aleppo,[7] and the Church of the Virgin (El-Hadra) at Diyarbekr (Amida),[8] where a basilican plan is modified by lateral apses, or in the case of Khakh, where we find the transverse nave with the *trichoros*.[9] A recent theory of Strzygowski's derives the trefoil end from the home of the apse-buttress—Armenia. We have seen how this structural feature applied to the sides of centralized buildings gave rise to lobed or foiled plans, and it would be one obvious means of enlarging the Iranian or Armenian domed and apse-buttressed unit, to drop the western buttress, and elongate the building in that direction ; from this procedure a trefoil-ended church would result. Such a change would be naturally suggested if the large trefoil-ended halls in Eastern palaces, such as we see at Mshatta

[1] Schultz and Barnsley, pp. 32, 33.

[2] Dawkins, in *Ann. of British School at Athens*, xix, pp. 123 ff. ; Heisenberg, *Grabeskirche und Apostelkirche*, pl. ix.

[3] Jewell and Hasluck, *as above*, p. 43.

[4] For the ciborium in S. Sophia cf. J. Ebersolt, *Arts somptuaires de Byzance*, p. 28. For ciboria in general see H. Leclercq, in Cabrol's *Dict. d'arch. chrétienne*, s. v. *Ciborium*.

[5] Strzygowski, *Zeitschrift für christliche Kunst*, xxviii, 1916, pp. 181 ff. ; *Baukunst der Armenier*, pp. 828 ff. S. Guyer in Sarre-Herzfeld, *Archäologische Reise im Euphrat-Tigris-Gebiet*, pp. 28 ff. ; O. Wulff, *Die altchristliche Kunst*, Berlin, 1913, ch. ii ; L. H. Vincent, *Rev. Arch.*, 1920, pp. 82 ff. ; E. Weigand, *Byz. Zeitschrift*, xxiii, 1914, pp. 176 ff. Weigand gives a survey of the monuments. He concludes that the types are too various to come under a single formula. Cf. also *Byz. Zeitschr.*, xxiv, p. 245.

[6] E. H. Freshfield, *Cellae Trichorae* (Sicily, North Africa, Sardinia), vol. i, 1913.

[7] Guyer in Sarre-Herzfeld, *as above*, pp. 32 ff.

[8] Berchem and Strzygowski, *Amida*, p. 187.

[9] Bell, *Churches and Mon. of the Tûr ʿAbdîn.*

and Qasr ibn-Wardān were ancient features in Iranian palace architecture.[1] It is urged that the distribution of the trefoil-ended church favours its origin at a central point like Armenia, whence it passed early westward into Asia Minor (Binbirkilisse),[2] and southward through North Mesopotamia,[3] and Palestine,[4] into Egypt;[5] and that the diffusion of the type through the Nearer East after the sixth century is so wide as to suggest its origin in this part of the world; its appearance in the ninth century at S. Germigny-des-Prés near Orleans (p. 158) would be consistent with this, if other features of church are Armenian examples. In the Christian East the trefoil end is found almost everywhere. In Armenia itself it occurs in actual examples of the seventh century, and its earlier existence is deduced in older records. It spread into Georgia [6] and South Russia (Cherson).[7] At Khoja Mustapha Pasha Jāmi (St. Andrew), Constantinople, perhaps dating from the seventh century, the central dome is buttressed by half-domes on the north and south sides, and the plan thus assumes a trefoil form.[8] The religious and secular buildings added to the Imperial Palace at Constantinople by the Emperor Theophilus in the ninth century included a triapsidal throne-room (the *Triconchos*), and a church, S. Michael, with a trefoil sanctuary;[9] the Blachernae church, as described by Theophanes, had a trefoil end.[10] The trefoil occurs at S. Elias (Eski Serai) at Salonika [11] (eleventh century), in a whole series of monastic churches on Mount Athos; and in Macedonia and the Serbia.[12] Reminiscences of it are observed in the churches of S. Theodore (Kilisse Jāmi) and the Pantokrator at Constantinople,[13] and in the monastery church of Daphni in Attica, where hemispherical niches are placed in the sides of the main apse.[14] In Argolis (Merbaka, Areia, Chonika), churches

[1] It is true that Qasr ibn-Wardān dates from the late sixth century, and that the fourth-century date suggested by Strzygowski for Mshatta is far from being universally accepted, many authorities believing this palace to date from early Mohammedan times. But the type of trefoil hall might be earlier than the fourth century, whatever the actual date of Mshatta may be.

[2] Ramsay–Bell, *Thousand and One Churches*; Strzygowski, *Kleinasien*, p. 27.

[3] The El-Hadra Church at Khakh: G. L. Bell, *Churches and Monasteries of the Tûr 'Abdîn*, p. 82.

[4] W. Harvey and others, *The Church of the Nativity at Bethlehem* (Byzantine Research and Publication Fund, 1910); E. Weigand, *Die Geburtskirche von Bethlehem* (in J. Ficker's *Studien*, &c., Leipsic, 1911, and *Zeitschr. des deutschen Palästinavereins*, 1915, pp. 91 ff.); H. Vincent and F. M. Abel, *Bethléem, le Sanctuaire de la Nativité*, Paris, 1914; E. Weigand, *Das Theodosioskloster*, *Byz. Zeitschrift*, xxiii,

1914, pp. 167 ff.

[5] White and Red Monasteries at Sohag in the Thebaid; Monastery of S. Simeon at Assuan, Deir es-Suriyani, in the Natron Valley.

[6] Cf. Diehl, *Manuel*, p. 446.

[7] E. H. Minns, *Scythians and Greeks*, 1913, pp. 508 ff.

[8] Van Millingen, *Churches of Constantinople*, p. 106; Ebersolt and Thiers, *Les églises de Constantinople*, p. 75, pl. xix; C. Gurlitt, *Die Baukunst Constantinopels*, p. 40, and plates, vol. i, lvi–lviii.

[9] J. Ebersolt, *Le Grand Palais de Constantinople*, pp. 110 ff.

[10] Strzygowski, *Baukunst der Armenier*, p. 830.

[11] Diehl, Le Tourneau and Saladin, *Monuments chrétiens de Salonique*, p. 203.

[12] Strzygowski, *as above*, p. 770; G. Millet, *L'École grecque*, p. 94.

[13] C. Gurlitt, *as above*, pp. 32, 33, and plates xliv ff.; Ebersolt and Thiers, *as above*, pp. 149, 185, pls. 34–8 and 42–8.

[14] Millet, *Le Monastère de Daphni*.

are trefoil-ended, lateral apses serving as entrances to *prothesis* and *dia-konikon*.[1] The triconch is also found at Athens, in Crete in Macedonia and Epirus.[2] In the west its traces appear in Sicily, South Italy, and in Romanesque churches in France,[3] and in Germany.[4]

It will be seen that the variety of ' trefoils ' is very great, and their geographical distribution exceedingly wide, so much so that we are led to wonder whether Weigand may not be right in deciding that there were developments from different origins, and that no single formula suffices to explain the facts as they exist.

Secular Buildings

In periods which possess a style there is a natural relation between the manner in which ecclesiastical and civil buildings are designed and decorated ; thus the palace, castle and monastery of the thirteenth century in the west of Europe are obviously of the same family as the church. This connexion was a close one in the Christian East, especially between church and palace. The descriptions left by the historians of the Byzantine palaces illustrate this point. Not only do actual churches form part of the buildings, but banqueting-halls, halls of audience and Baths have domes, apses, trefoil ends, narthexes and other features familiar to us from our acquaintance with churches. The interior decoration of walls and roof-vaults is carried out with the same materials, and the subjects of mosaic or painted designs are often religious. De Beylié has well remarked that the narthex of S. Sophia is in all likelihood very like the vestibule of a Byzantine palace, and that the imperial apartments are so ecclesiastical in their treatment that an exchange of the movable furniture would almost suffice to convert a sleeping-chamber into a chapel, or vice versa. It is interesting to note that the plan comprising vestibule, domed room and apsed alcove was continued in bedrooms of houses in the Phanar at Constantinople after the Empire had fallen, and can be seen in a few of the older houses at the present day (see below, p. 127).

Secular architecture may be briefly considered under the following heads :

 (*a*) *Towns and fortifications.*
 (*b*) *Public buildings.*
 (*c*) *Palaces.*
 (*d*) *Private houses*, town and country ; *inns.*
 (*e*) *Monasteries.*

[1] A. Struck, *Athenische Mittheilungen*, 1909, vol. xxxiv, p. 223.

[2] Millet, *L'École grecque*, p. 93.

[3] The usual theory as to its appearance in these Western churches is that Lombard architects observed the type in Italy, imitated it, and finally carried it across the Alps with their newly developed vaulted architecture after *c*. A. D. 1000.

[4] H. Rathgens, *S. Maria im Kapitol in Köln*, Düsseldorf, 1913.

Towns and fortifications. Time, war, earthquake, conflagration, and careless ignorance have between them dealt hardly with the cities of the Byzantine Empire. Constantinople, notorious for its fires, has suffered so much from so many causes that a confusion of narrow streets has grown over its ancient plan; Alexandria is likewise overgrown; Antioch is a buried ruin, and of all the Hellenistic townships little remains to illustrate the later Byzantine city which reproduced so many of their features. We have to seek the borderland where Syria verges on the Arabian desert to find at Jerash (Gerasa) and Ammān (Philadelphia) enough standing above ground to give at least some idea of the Hellenistic city in the East. Jerash is of especial interest, having preserved until our own time columns of the arcades once lining its central street. Here a remote position beyond the common routes of armies, and the sparseness of population due to the misgovernment of the Turk, long combined to save from destruction much which might not have escaped if Gerasa had been situated on the Mediterranean shore.

The chief characteristics of Hellenistic towns[1] were their wide colonnaded streets, with shops under the arcades, which thus rendered the old Greek *agora* unnecessary: these shops were the forerunners of the modern Eastern bazaars. The towns were planned with care for architectural effect; the crossings of main streets were adorned by *Tetrapyla* or four-way arches, or *Tetrakiona*, groups of four piers surmounted by statues, under cupolas. Vistas were closed by arches, or by imposing monuments, and the towns were enriched by sculptured nymphaea or fountain-fronts, by theatres, hippodromes, and other ornate buildings. Though nothing is left of Antioch we can form some idea of its former glories from the description of Libanius, especially the account of its colonnaded main street running for four miles along the Orontes, and its five bridges, connecting the old city with the new walled town on an island, one quarter of which was occupied by a palace evidently laid out on the same principles as that of Diocletian at Spalato and probably by the same workmen. Constantinople was in the main a Hellenistic city, though at the beginning much that was Roman was introduced from Italy. The early patrician palaces reproduced the Roman plan; but by degrees the Syrian type of house began to prevail, and the Roman element was finally lost (p. 124, below). We must imagine the great middle Way or *Mesé*, with double line of arcades and squares at intervals, as a grander example of the style represented by Jerash, a style, as the mosaics teach us, once belonging to Jerusalem, Gaza, Ascalon and the Syrian towns,[2] and made real to us by the somewhat similar street arcades at Genoa, Turin and Bologna in Italy, by those of the Rue de

[1] R. C. Bosanquet, *The Town-planning Review*, vi, no. 1, 1915 (Liverpool University), p. 102.

[2] See especially the Madeba mosaic map (p. 295, below). The walls of Classis are shown in mural mosaics of S. Apollinare Nuovo at Ravenna.

Rivoli at Paris, and those of Tunis and Algiers in the Western Mediter-
ranean. Probably all the chief streets parallel to the *Mesé*, or intersecting it,
were also lined with porticoes ; while in prominent positions were palaces
of nobles, baths, and churches ; in and about the squares and open places
rose columns, fountains, and statues. Between the main streets and squares
we may suppose a network of narrow streets in which the houses were
probably from the first of the common Syrian type. The *Mesé* ran from
the walls and the Golden Gate on the south-west, to the square of the
Augusteion before S. Sophia in the north-east, leaving to south-east as it
neared the end of its course the great Hippodrome and the grounds of
the Imperial Palace, which extended to the Sea of Marmara.[1]

Little remains above ground of the Constantinople of the first few
centuries but the walls and the Golden Gate, with a few ruined monuments
such as the column of Arcadius. Apart from the churches, the city of the
middle periods is not more fortunate. From the miniatures of illuminated
MSS. of the tenth century and later we can form some notion of the streets.
Making the necessary allowance for the often fantastic character of the
drawing, we can at least infer the presence of the arcades below, we can
see balconies and loggias above, and the roofs, sometimes gabled, some-
times flat, with frequent intervening domes. These miniatures help us
somewhat better to understand the stray references in the historians, and
the enthusiasm of Villehardouin, when, at the vision of the great walls,
rich palaces, tall churches, and all the spaciousness of the renowned capital,
he declares that there was hardly a man who was not thrilled at the great
sight.

Of the later Constantinople our information is no less scanty. The
general view published by Banduri at the beginning of the eighteenth
century is of great interest as derived from an earlier plan drawn about
A.D. 1350, and engraved by Panvinio in A.D. 1600. It shows, however,
only the part of the city north-east of the Hippodrome on both sides of the
Mesé. We see domed buildings and houses with gabled or flat roofs, and
both square and rounded windows. Bondelmonte's pictorial plan, repre-
senting the city in 1422, shows an enclosure very sparsely filled ; that in
the Nuremberg Chronicle of 1493 included S. Sophia, the city walls as far
as Blachernae, the Golden Horn and Pera and Galata.[2]

Fortifications were generally in immediate or close relation to cities,
which were either continuously walled, or protected by detached forts.
Examples of the walled city are Constantinople, Antioch, and Tebessa and
Beja in North-west Africa ; of the detached strongholds, Lemsa, Haidra,
and Timgad in Africa.[3] Sometimes an isolated fortress at a greater distance

[1] See the plan of the city in A. Van Millingen, *Byzantine Constantinople*, .

[2] For the above facts cf. de Beylié, *L'habita-tion byzantine*, p. 57 ; Mordtmann, *Esquisse* *topographique de Constantinople* ; A. Van Mil-lingen, *Byzantine Constantinople*.

[3] Diehl, *L'Afrique byzantine*, and *Manuel*, pp. 182 ff.

commanded a point of strategic importance. The most important fortifications which have come down to us date from the age of Justinian.

The walled city had usually three lines of defence, separated from each
other by broad glacis. The innermost enclosure consisted of high crenellated
walls of rubble faced with brick or stone, with projecting towers, square,
hexagonal or round, at regular intervals, commanding the curtain walls ;
a *chemin de ronde* ran all round the interior. In front of the glacis before
this inner line rose an outer line of walls and towers, in its general character
similar to the first ; while beyond the second glacis was a deep and broad
fosse with a parapet of masonry and earth. The average height of walls
seems to have been eight to ten metres. Those of Constantinople are
eleven metres, but are easily eclipsed by those of Dara, which rose to
a height of eighteen metres and a half. The average thickness is in Africa
about two and a third metres ; at Constantinople it is four to five metres.
Towers were some seven to ten metres broad and seventeen to twenty
metres high ; at Constantinople there were nearly a hundred towers over
one hundred and fifty yards apart. Gates were narrow, and commanded
by adjoining towers. Important fortresses near the frontiers, like Dara
and Nisibis, had inner keeps for final defence.

A few examples of fortified cities and fortresses may be mentioned.
The walls of Constantinople (Plate XVI) date chiefly from the time of
Theodosius II (408–450).[1] The Golden Gate in the south-west, at which
the main street began, stood before the triumphal arch of Theodosius I,
and was remarkable for its ornament of colonnettes and pilasters enclosing
two rows of rectangular compartments with sculptured reliefs and coloured
marble panels.[2] The walls of Rusāfah, south-east of Aleppo, with square
towers, and a fine north gate, seem to be of Justinian's time.[3]

Among the fortified places in the African province the citadel of Haidra
may be selected as a noteworthy example ; a reconstruction has been
attempted by M. Saladin.[4] Interesting forts on the southern side of the
Anatolian plateau towards Syria may date from a later period than the
above. They have been ascribed to the ninth century, when a new line
of defence was required for the protection of a diminished Empire.[5] The
crenellated walls of Salonika [6] remain on the three land sides, climbing the
slopes surmounted by the citadel, those on the west have still in part a double

[1] An illustrated account of the walls is given
by G. B. Gordon in the *Museum Journal,
Philadelphia*, xii, December 1921, pp. 209 ff.
For a reconstruction see C. Gurlitt, *Die
Baukunst Constantinopels*, pl. ii e. Cf. also
Van Millingen, *Byzantine Constantinople* ; G.
Schlumberger, *Le siège, la prise et le sac de
Constantinople* ; E. Pears, *Destruction of the
Greek Empire*, pp. 238 ff.

[2] E. Weigand, *Athenische Mittheilungen*,
xxxix, 1914, pp. 1–64 ; Lehmann-Haupt, in

Klio, 1918, pp. 434 ff. ; J. Strzygowski, *Jahrb.
d. Deutschen Arch. Inst.*, viii, 1893, p. 10.

[3] S. Guyer in Sarre–Herzfeld, *Arch. Reise im
Euphrat-Tigris-Gebiet*, ii, pp. 16 ff., 1920.

[4] Diehl, *L'Afrique byz.* and *Manuel*, fig. 90.

[5] Ramsay–Bell, *The Thousand and One
Churches*, pp. 489 ff.

[6] Diehl and Le Tourneau, *Monuments chrétiens de Salonique*, Paris, 1918, pp. 225 ff. ;
O. Tafrali, *Topographie de Thessalonique*, pp.
30 ff., Paris, 1913.

line, of which there are also traces on the north; there is no trace of the fosse. The curtain walls, which were once ten to twelve metres high, have an inner *chemin de ronde*; at intervals rise square or polygonal towers, of two storeys, and crenellated, rising to a height of fifteen to sixteen metres, the gates were double, with drawbridge and portcullis : one or two of the present towers were added by the Turks. The walls were carefully constructed to prevent collapse if breached. In one method a brick wall has rows of small superposed arches in the structure, in another a wall of undressed stone has zones of brick courses at intervals, in which tie-beams are embedded. Though the walls of Salonika have been restored at various times, they mainly represent the work of the late fourth or early fifth century.

Public Buildings. The hippodrome and the theatre formed the chief centres of amusement in the great cities. The great Hippodrome at Constantinople was on the site of the present Atmeidan south-west of S. Sophia and of the square called Augusteion.[1] Nothing now remains of the structure surrounding the arena, the outer walls of which must have been of great height like those of the Coliseum at Rome.[2] Only an obelisk and the bronze serpent-tripod from Delphi remain upon the line of the ancient *Spina*, or 'backbone', round the *metae* at the ends of which the chariots raced. Originally built by Septimius Severus, the Hippodrome was improved by Constantine, who adorned it with statues. It was constructed of brick with a length of 370 metres and a breadth of 180 metres. The end towards S. Sophia was closed by the small occasional palace called *Kathisma*, which the emperor could reach by a private way from the Great Palace on the east side towards the Sea of Marmara. In front of the Cathisma was the imperial loggia or 'box', to right and left of which were places reserved for the guards; below were the *Carceres* whence the chariots entered the arena. Various ancient works of art give us partial views of the Hippodrome or scenes connected with its contests. We see the emperor placed high in his box, and below, chariot-races, mummers and acrobats; sometimes the lot-casting urn used in determining starting positions[3] is represented. There was a small private hippodrome in the north-east part of the enclosure of the Great Palace, not far from S. Sophia.[4] This ground seems also to have been used for polo and other sports, bearing the name of *Tzykanisterion*.[5] There were also circuses in provincial cities.

Of public *baths* the Eastern cities have no remains comparable to those

[1] De Beylié, *L'habitation byz.*, p. 106. Cf. A. Rambaud, *Études sur l'hist. byzantine*, ed. by C. Diehl, Paris, 1912.

[2] A reconstruction by M. Morard is published by de Beylié. The high tiers of seats are surrounded at the top by a colonnade.

[3] e. g. Reliefs on the base of the obelisk of Theodosius (p. 192); Monument of the charioteer Porphyrios (p. 193); Consular diptychs; Marble relief at Berlin (p. 193). Frescoes on the staircases of S. Sophia, Kieff (p. 262). Banduri's view in *Imperium Orientale* gives the state of the Hippodrome in A. D. 1350.

[4] J. Ebersolt, *Le Grand Palais de Constantinople*, p. 140, and plan.

[5] Cf. the notice of Bulgarian article by Welkow, *Byz. Zeitschr.*, xxiv, 1924, p. 478.

at Rome. The great baths at Constantinople, the Baths of Zeuxippus, between S. Sophia and the Hippodrome, we know only from literary evidence. Magnificently decorated with marble linings and mosaic, and adorned with numerous statues,[1] they were destroyed during the Nika riot in Justinian's reign; but it is believed that the *Chukhūr Hammām*, or Baths of Mahomet II, follow a similar plan.[1]

Aqueducts in general resembled the Roman examples. The aqueduct of Valens is a conspicuous object above Stambūl, seen from Pera. The aqueduct of Justinian,[2] near the capital, has two tiers of arches rising from massive buttressed piers (Plate XVIII).

Cisterns (Plates V, XVII).[3] Down to the fifth century the open-air reservoir as used in Syria was employed at Constantinople. But the growing need to economize space led at this period to the adoption of the underground type, with columned vaults after the Alexandrine model. The open reservoir is represented by that of S. Mocius (*Chukhūr Bostan*) at Exi-Marmara. The earliest example of the covered type was built in A.D. 407 beneath the forum; the cistern of Pulcheria in the Sultan Selim quarter is shown in Plate V. In the sixth century cisterns were constructed in two storeys, and are impressive through the number of their columns. The great examples are Binbir Derek (A.D. 528), and Yeribatan Serai (Plate XVII), which are covered by domes on pendentives. Two other cisterns may be mentioned: that under the military hospital at Gül Khaneh, dating from the end of the fifth century, was not originally intended for this purpose, and perhaps formed part of the establishment of Marina, daughter of Arcadius; the second is under the Church of S. John of the Studium.[4] In the provinces we may note a columned cistern under the abbot's lodging in the monastery of S. Luke of Stiris in Phocis.[5]

Palaces. The earliest imperial palace outside Italy represented by considerable remains is that built on the Gulf of Spalato, south of Salona in Dalmatia.[6] It cannot be described as strictly Byzantine, dating, as it does, some years before the reign of Constantine. But neither is it purely Roman, and it has many new features connecting it with the East and with the style ultimately developed in Western Europe in the Romanesque

[1] De Beylié, *as above*, p. 104. These baths were walled up after the earthquake of 1792.

[2] Diehl, *Manuel*, p. 168.

[3] Strzygowski and Forcheimer, *Byzantinische Denkmäler*, ii, 1893 : *Die byz. Wasserbehälter von Constantinopel*; K. Wulzinger, *Jahrb. des Deutschen Arch. Inst.*, xxviii, 1913, pp. 370 ff.

[4] Van Millingen, *Byz. Churches of Constantinople*, p. 54.

[5] Schultz and Barnsley, p. 14.

[6] The old work by the brothers Adam is still of great interest and value.
The most important modern account is :

E. Hébrard and J. Zeiller, *Spalato : le Palais de Dioclétien*, Paris, 1912. J. Strzygowski has an article : *Spalato : ein Markstein der romanischen Kunst*, in the *Festschrift* dedicated to F. Schneider, pp. 325 ff. The domed mausoleum of the palace, now the cathedral, is in good preservation, as is a part of the peristyle. The sea front is changed by the intrusion of modern work, but the character of the former open gallery, running from end to end, can be clearly seen. The northern gate (Golden Gate) still stands, as do three corner towers.

period. 'In the history of art, the palace of Diocletian serves as preface to the chapter of Byzantine architecture.'

This fortified imperial residence occupied a rectangle enclosed within high walls. On the north (strictly north-north-east) was the Golden Gate (the main gate from Salona); on the east and on the west were two other gates. The south side, fronting the sea, had walls of less strength and an arcaded open gallery along its entire length; on this side a small gate led to a landing-stage. Each gate except the last was defended by two octagonal towers; large square towers protected the four corners, and between these and the gates smaller towers projected from the curtain walls. The interior was divided into four parts by two main streets cutting each other at right angles, one, from the Golden Gate, running southwards towards the sea, but not reaching it; the other, from the eastern gate to the west. It will at once be seen that the general plan resembled that of a Roman camp, and Rivoira has not failed to lay stress upon this fact.[1] But granted the resemblance, there must also be granted differences which bring the plan into connexion rather with Eastern permanent camps showing variation from the regular Roman scheme: in that at Philippopolis (now Shabah) in Syria, built by Philip the Arabian, there is the same stopping short of one of the two principal ways, not far beyond the intersection, and before the entrance to the actual palace or residence. Further, Strzygowski has drawn attention to a passage in Libanius (*Orat.* xi, §§ 204–6) establishing a remarkable parallelism between Spalato and the palace at Antioch begun by Gallienus and finished by Diocletian. At Antioch the space before the residence was likewise divided by two intersecting ways forming a cross, one branch of which, shorter than the other three, led to an open court with *propylaea*. And as at Spalato the side of the residence remote from the chief gate fronted the sea, so at Antioch it rose along the Orontes. It is an interesting hypothesis that the very builders of the Antiochene palace may have been transported to Spalato to erect the new imperial refuge on the same model; the fact that the mason's marks discovered at Spalato are based on the Greek alphabet accords with such a supposition.

Entering the Golden Gate, the visitor probably saw to right and left the extensive quarters of the imperial guard, but this part of the site is over-built; only basements, explored with great difficulty, have been available for study, and the nature of the original buildings above ground can only be conjectured. Beyond the intersection, the southerly half of the enclosure more immediately connected with the imperial household was entered. On the right, standing back within its precinct, was a temple of Jupiter in the Roman style. On the left, also in its precinct, was the Imperial Mausoleum, now the cathedral, an octagon surmounted by a dome. The sides of the two precincts facing the street were lined by a free-standing

[1] *Moslem Architecture*, p. 70; cf. Frothingham, *Roman Cities in North Italy and Dalmatia*, p. 311.

arcade (the ' peristyle ') leading to the *prothyron*, or gate of the Residence, by which a domed vestibule was entered. Crossing the vestibule, to right of which were the stables, and to left the kitchens, the visitor passed down a great ceremonial hall (*tablinum*), from which there was access to the long promenade or open gallery on the sea front. To right and left of the *tablinum* were the library, dining-hall, and the imperial and court apartments.

The oriental relations suggested by the above-mentioned Syrian parallels are confirmed by details of the structure. It has been already noted that the peristyle affords the earliest example on a great scale of archivolts supported immediately on columns, a method at variance with the Vitruvian system. In several places along the open gallery facing the sea the architrave so to speak curves up in a bow, and forms a round arch, as it also does over the *prothyron* ; this is a feature more especially associated with Syria and Pisidia. Above the doorway in the Golden Gate, the upper wall is ornamented by blind arcades on columns rising from brackets, a decorative device so suggestive of far later Lombardic and Romanesque building, that Strzygowski was led by it to call Spalato a milestone on the way to the Romanesque style. The octagonal plan of the Mausoleum was little used in Rome and Italy at the beginning of the fourth century, where the rotunda was the prevalent form of sepulchral monuments ; on the other hand, the octagonal plan is frequent in Asia Minor and Mesopotamia. The construction of the dome by a series of small spherical triangles in light brick, resembling an imbrication, and enabling two-thirds of the cupola to be erected without centring, has no parallel in the great Roman architecture ; while it has analogy with that in the vaulting of the tomb of S. Demetrius, Salonika, and a niche in the monastery church at Isdib in Macedonia. The sculptured decoration on the jambs and lintels of the doors, with its un-classical scrolls enclosing animals, is not in the Roman manner ; it suggests rather that usual in Syria and Egypt. The interior of the domes of the Mausoleum and Vestibule was covered with vitreous mosaic, as the discovery of tesserae shows ; this method of decorating vaults is first found on a large scale at Spalato ; the only Roman example for which an earlier date is claimed, a *nymphaeum* in the Campagna, is by comparison a diminutive structure ; there is no parallel among the greater buildings. It is not, however, denied that there is much at Spalato which is Roman in tradition ; the palace shows more influences than one. But there is so much that is novel and experimental, so much that is strange, that it is impossible to regard the Roman influence as preponderant : 'Le palais de Spalato', says M. Zeiller,[1] 'est un édifice romano-oriental, mais, en définitive, plus oriental que romain' ; and it must not be forgotten that the man for whom it was built had been a resident in the East, with Nicomedia as his chief home. The incorporation of elements from both sides of the Roman world was a natural, we might almost say an inevitable, result in the home

[1] *As above*, p. 174.

of an orientalized Roman ruler on that Eastern Adriatic coast which after-wards became the frontier of the divided Empire. But M. Zeiller has rightly observed that while the purely Roman elements bear the marks of decadence, those attributable to Eastern influence suggest initiative and experiment ; in them, and not in the Roman, is discerned the character of a vital and expanding art. The troubled history of Dalmatia in the cen-turies after Diocletian apparently restricted the artistic influence of the palace at Spalato ; among surviving buildings within its range, the gate-house of the palace of Theodoric at Ravenna, with its affinity to the Golden Gate, is perhaps the only example in which such direct influence can be inferred. But the sources from which the architects of the palace had drawn were flowing strongly in the nearer East ; and these, in the opinion of Strzygowski, determined the ' Romanesque forms ' so impressive at Spalato. The palace of Diocletian, escaping the utter ruin of other great buildings of like kind, has survived as the representative of many structures now destroyed, even nearer than itself to the main stream of architectural development.

From what has been said above it may be inferred that the royal residence next in antiquity is represented by the remains at Ravenna.[1] The palace of Theodoric[2] once formed a complex of buildings in a walled enclosure extending to the sea, in so far resembling that at Spalato. The surviving remains are probably part of the gatehouse. The mosaics of the palace church of S. Apollinare Nuovo show us the façade of the old palace in some detail ; behind it, within the walled enceinte, are seen two round and two basilican structures. On a much smaller scale is the palace associated with the church at Qasr Ibn Wardān in Syria,[3] dating from the second half of the sixth century. Built of alternate courses of stone and brick, it had two storeys. On the ground floor was a three-aisled hall ending in a trefoil of apses ; above this was another great hall covered by a dome. Byzantine and Anatolian influences are discerned by some in this building, which, like the church, is constructed of materials unusual for Syria.[4]

The now well-known palace of Mshatta[5] on the edge of the Syrian desert near the Hejaz Railway was discovered by Tristram[6] in the middle of the nineteenth century. The ruins may not strictly fall within the compass of the present work, but, through the analogies which they present to other palaces, would at any rate deserve mention here. Strzygowski had

[1] De Beylié, *L'habitation byzantine.*

[2] Rivoira, *Lombardic Architecture,* pp. 40, 96 ; Rivoira attributes the surviving gatehouse to the eighth century, when the exarchs were living at Ravenna.

[3] H. C. Butler, *Publ. of the Princeton Univ. Arch. Exp. to Syria* in 1904–5, division ii, section b, part 1 ; Van Berchem and Strzygowski, *Amida,* p. 223 ; Strzygowski, *Kleinasien,* p. 121.

[4] Diehl, *Manuel,* p. 172.

[5] Strzygowski, in *Jahrbuch der K. preussi-schen Kunstsammlungen,* xxv, 1904, pp. 225 ff. ; Strzygowski and Glück, in *Repertorium für Kunstwissenschaft,* xli, 1918, pp. 125 ff. ; E. Herzfeld, *Mshatta, Hîra und Bâdiya, ibid.,* xlii, 1921, pp. 104 ff.

[6] See H. B. Tristram, *The Land of Moab.*

placed the date as far back as the fourth century, but Herzfeld,[1] as a result of his excavations at Samarra and of a passage in Mas'ūdi, considers it proved that the palace dates from the time of Yazīd II (A.D. 720–724). Like Spalato and the Mohammedan palaces of Balkuwārā at Samarra and Ukhaidir, it is based on the plan of the military camp. The material is brick on a stone foundation ; an elaborately carved stone facing formerly adorned the walls about the principal gate ; the plan of one hall shows the ' triconch ' end (p. 109).

Strzygowski abides by his original dating.[2] Though he places Mshatta about a century later than Hatra,[3] he regards the two palaces as alike built for pre-Mohammedan Arab princes by Parthians or Armenians, though Hellenistic hands may have shared in the decoration of the façade. The elaborate ornamentation carved in stone he considers to represent the less costly facing in stucco with which brick buildings were covered in North-east Iran, and in the ornament he finds features which point to Central Asian influences. Mshatta, in fact, is a frontier building, where an oriental art appears upon the borders of Graeco-Roman civilization. Whatever the true date of Mshatta, its decoration is of the highest interest for the history of ornament.

The Great Palace at Constantinople.[4] The modern conception of a royal palace in a city is a single building with a long façade behind which is at least one court ; in front of the building there may or may not be an enclosed open space, behind it a walled garden. The palace, in fact, is no more than an exceptionally large town house or hotel. The occupants can undertake restorations, but there is no room for new constructions which leave the old intact. The great palace at Constantinople was very different from this. To form any just idea of it the Londoner would have to imagine the whole of Hyde Park surrounded by high walls, with the sea all along the side towards Belgravia and Knightsbridge. Within this large space, laid out in terraces and gardens, he would see three great groups of buildings representing the architectural effort of three or four different emperors, the

[1] E. Herzfeld, *Vorläufiger Bericht über die Ausgrabungen von Samarra*, 1912, p. 39.

[2] *Altai-Iran und Völkerwanderung*, pp. 73, 151, 228, 258. In his *Origin of Christian Church Art*, p. 122, he hints at Mazdaistic significance in the case of particular ornament, such as the vine.

[3] Andrae, *Hatra*, 1908 and 1912. The palace is in North Mesopotamia. Its lower walls are of rubble masonry faced with stone, and the interior of the lower floor has barrel vaults, but no domes. The upper floor was not vaulted, but roofed in a style recalling that practised in the Hauran.

[4] Until conditions permit the palace enclosure to be excavated, the work of M. Jean Ebersolt, *Le Grand Palais de Constantinople*, Paris, 1910, will be indispensable ; the three earlier works are those of J. Labarte, D. F. Bielyayeff, and A. G. Paspatis. A bibliography of sources will be found in the work ; of these we need only mention the *De Caerimoniis* and *Life of Basil I* by Constantine Porphyrogenitus ; the *Continuation of Theophanes*, written by order of Constantine Porphyrogenitus ; and the account of the Palace Revolution of John Comnenus by Nicolas Mesarites (ed. A. Heisenberg, 1907). Cf. also Ebersolt's *Mission arch. de Constantinople*, Paris, 1921, Sect. ii ; Diehl, *Manuel d'art byz.*, p. 387 ; Gibbon, *Decline and Fall*, c. liii, &c.

oldest some five hundred years earlier than the most recent, as if (to return to our parallel) three or four palaces, Plantagenet, Tudor, and Jacobean, all stood in proximity within the same enclosure. These three great complexes were close together, and connected by galleries, since for official and ceremonial purposes they were all in continuous use, though the reigning emperor might inhabit only one. In the surrounding grounds were detached oratories, churches, reception-halls, and other buildings. The palace enclosure was flanked along the greater part of one side by the high wall of the great Hippodrome, with which there was communication by more than one stairway; along the other side was the Sea of Marmara, with the imperial private harbour, and the palace lighthouse, from which flare-signals were exchanged with stations on the Asiatic shore. At one end there was a private approach to the cathedral of S. Sophia, which the emperors could enter without crossing a street or public place. The buildings composing the palace were nearly all low, only one part having two storeys; but the horizontal line was broken by numerous domes, some of great size, and with gilded roofs. The chief material of all walls was brick, but façades were enriched with marble and sometimes with external mosaic, so that the effect of the grouped or isolated structures rising amid gardens and terraces was one of oriental magnificence. The 'sacred city' or imperial palace at Pekin, the Kremlin at Moscow, and the Alhambra all offer analogies to different features, but none can suggest quite the same combination of buildings so various in date spreading over an expanse so diversified by verdure and flowers; and none stood in the same close neighbourhood to the sea.

De Beylié has summed up the chief constituents of the great palace as follows. It included seven peristyles or forecourts, eight interior courts, four large churches, nine large chapels, nine oratories and baptisteries, four guard-rooms, three great galleries, five halls of audience, several independent suites of imperial apartments, three banqueting-halls, ten connecting galleries, a library, an armoury, a hall of trophies, two Baths.[1] These structures with their dependencies formed a kind of garden-town, of which the inhabitants must have numbered some thousands.

The three individual complexes above mentioned were the Daphne Palace, built by Constantine, the Chrysotriclinos, erected by Justinian and amplified by Basil I, and the Triconchos, the work of the iconoclast Emperor Theophilus in the ninth century. The first-named palace was situated south-west of the square of Augusteion in front of S. Sophia, and extended along the upper half of the great Hippodrome. The second lay to the south-east of it, completely detached, and much nearer to the sea. The Triconchos formed a connecting link between the two, filling the intervening space. The larger complex, formed by all three palaces, thus cut across almost the whole area between the Hippodrome and the sea, the

[1] De Beylié, *L'habitation byzantine*.

last terraces extending almost to the shore. Two considerable open spaces, filled by gardens with detached buildings, churches, oratories, &c., were thus left to the north-east and the south-west, each with a frontage on the sea.

We may first notice the Palace of Daphne. A great vestibule, the *Chalké*, with passages communicating with S. Sophia, was the building entered from the Augusteion : it had received its name from its original roof of gilt bronze. It was burned during the Nika riots, but re-erected by Justinian, and contained many statues of emperors, and a bronze figure of Our Lord, which remained till the reign of Leo the Isaurian ; over the entrance-gate was set an image of Christ, twice destroyed and replaced. The Chalké was further enriched with works of art by John Zimisces, who caused a tomb to be built there for himself. The visitor next crossed a court in which were the quarters of the Palace Guards, and, on the east side, the famous Church of the Holy Apostles. Continuing his progress, he passed the *Consistorium*, or great hall of the Imperial Council, where the emperor received foreign ambassadors, and was adored by his subjects. On his right he now saw a banqueting-hall known as the ' Triclinos of Nineteen Couches ', where foreign envoys were entertained ; on his left, the Church of the Saviour, in which the Holy Cross was kept. Traversing a terrace, to *Onopodion*, he entered Daphne proper, so named from a statue of that nymph which had been brought from Rome. Here the first structure was the great hall where imperial coronations took place ; to south-west of it was the Church of S. Stephen, used for coronations, and an Octagon used as a robing-room ; beyond, against the north-east side of the Hippodrome, was a corkscrew stair to the private passage leading round to the *Kathisma* (p. 114). The *Magnaura*, a great hall of audience, also built by Constantine, lay at some distance from Daphne across the gardens eastward, in the direction of the sea. This was the hall in which the emperor sat on a throne which could be raised or lowered, and where exhibition was made of the golden tree and the mechanically roaring lions.

Chrysotriclinos was the title given to the nucleus of the palace bearing the same name, a great domed hall built by Justinian on a central plan resembling that of the octagonal Church of SS. Sergius and Bacchus, and of S. Vitale at Ravenna (p. 96). Receptions of ambassadors, banquets, and investitures of officials took place here ; here also was displayed the *Pentapyrgion* or great five-towered cabinet containing thrones, plate, vestments, enamels, crosses and other precious objects. Against the north wall was a treasure-chamber. Imperial private apartments adjoined the Chrysotriclinos on the south side. Two long halls or galleries, the *Lausiacos* and *Justinianos*, forming an elbow or right angle, connected the Chrysotriclinos with the Hippodrome towards its more southerly end, where there was a palace entrance almost as important as the Chalké entrance into Daphne. North-east of the Chrysotriclinos was a group of three churches side by side, built at different periods ; that of the Virgin of the Pharos was in the

centre, flanked by S. Demetrius and S. Elias ; it was in this Church of the Virgin that Baldwin of Flanders was elected Latin Emperor in 1204. Beyond the churches, on a terrace by the sea, was the Pharos, or lighthouse, where lights were shown to guide sailors, and signals exchanged with the Asiatic coast. To the group of the Chrysotriclinos further belonged the *Kenourgion*, erected in the ninth century by Basil I, on the south side beyond the earlier imperial apartments. The chief structure was a basilican hall with sculptured columns ; all the walls and the vaulted spaces were covered with mosaics illustrating the high deeds of the emperor (p. 294). Adjoining the apse of this hall was the imperial sleeping-chamber with sumptuous mosaic floor and roof. The five-domed church, called the *Nea*, or New Church, also erected by Basil, and of such importance in the development of Byzantine ecclesiastical architecture, lay some distance north-east of the Chrysotriclinos, between the Pharos and Magnaura. The Nea was built on the site of the old palace Manège, or sports ground (*Tzycanisterion*), Basil now laying out a new ground farther to north-east. The Church of S. Elias, one of the group of three churches already mentioned, was also built by Basil.

This palace-group, called the Triconchos, built in the ninth century by the Emperor Theophilus,[1] took its name from the principal structure, a hall with a trefoil of great apses on three sides. This hall stood between the Chrysotriclinos and Daphne, and on the side towards the latter palace opened into a crescent-shaped hall called the *Sigma*, the roof of which was supported by columns. Both these buildings had lower floors, that under the Triconchos was a chamber called Μυστήριον, or Mystery, either because, like the Whispering Gallery in S. Paul's Cathedral, its walls conveyed a whisper round its sides, or on account of the fountain near it. This was in an open space between Sigma and Triconchos, and was commonly called the Phialé of the Triconchos ; on certain festivals it ran spiced wine and had its basin filled with fruits.[2] Both on the northern and southern sides of the Triconchos Theophilus erected private apartments for his empress and himself.

In the open ground south-west of the great palaces, between them and the sea, were various detached buildings. By the harbour of Bucoleon was a small palace often known as the Castle of Hormisdas,[3] built in the fifth century by Theodosius II, enlarged by Nicephorus Phocas in the tenth, and still standing in 1204 : it derived its name from a group of sculpture representing a lion overcoming a bull. To west of the Bucoleon, and south-west of the Hippodrome, were two churches side by side, SS. Sergius and Bacchus, a centralized building of the sixth century, in plan resem-

[1] This emperor had procured plans of the Caliph's palace at Bagdad : de Beylié, p. 117.

[2] It would be 'mystic' on account of the 'pine-cone' through which the water flowed, this being symbolic of the Tree of Life (see

Proc. Soc. Antiq. London, xxxii, p. 61).

[3] De Beylié, p. 134. For a recent examination of the site see *Archäologischer Anzeiger*, 1914, pp. 100 ff.

bling S. Vitale (see p. 96) ; and SS. Peter and Paul. North-east and east of the Bucoleon were the oratory of SS. Paul and Barbara, and a hall known as the Pentacubiculum of S. Paul. One other building in the palace enclosure may be specially mentioned ; the *Mouchroutas*, named from an Arabic word, a building apparently with conical domes and stalactite pendentives in the Seljūk style, which was largely influenced by the Persian. It was erected by Greek architects who had worked for the Seljūks at Konia, and was known as the Persian House (Περσικὸς δόμος).[1]

We gather from the above that the Great Palace as a whole had little system or cohesion. Its three main groups of buildings, and its multitude of scattered structures, were erected at different periods to suit the caprice of different rulers. Only the earliest part, the palace of Daphne with its vestibule Chalké, had organic unity, suggesting in some degree the military regularity of Diocletian's palace (above, p. 115). The irregular form of the great enclosure, roughly triangular, its great size, and the long duration of the empire, tempted the emperors to erect new buildings wherever fancy inclined them. The gardens interspersed between the numerous buildings were too much interrupted to be individually of great extent.[2] Those of which we read were those in the oriental style planted by Theophilus about the Triconchos and Sigma, and by Basil I near his New Church. Probably the gardens sloping towards the sea were intermediate between the oriental and Roman styles.[3] The great palace began to be neglected from the second half of the twelfth century, when the Comnenian emperors transferred their residence to the palace of Blachernae near the famous church of that name built by Pulcheria at the extreme north-west of the city on the Golden Horn. Here there were pre-existing buildings, the oldest of which went back to Anastasius (A.D. 491–518); but reconstruction and addition now took place, and the new palace seems to have formed a series of great halls on a sort of acropolis in the angle of the city walls.[4] The palace of the Hebdomon is now represented by scanty remains at Makrikeui on the Sea of Marmora.[5]

The building still in part standing by the land walls [6] and known as the Palace of the Porphyrogenitus, or Tekfur Serai (Plate VI), probably depended on Blachernae. It stands between the two lines of the ancient fortifications and is a rectangular structure of two storeys, remarkable for the polychrome decoration on its façade, where coloured marble, in combination with geometrical designs in brick enriches the windows and arcades. On the ground floor was a large vaulted hall. The second storey contained a yet larger hall lighted by many windows.

The palace of the Despot at Mistra in the Morea is illustrated and

[1] Ebersolt, *as above*, p. 149.

[2] Cf. M. L. Gothein, *Geschichte der Gartenkunst*, i, Jena, 1914, ch. v.

[3] On these gardens see de Beylié, p. 142.

[4] De Beylié, *as above*, p. 139.

[5] C. Diehl, *Comptes-rendus de l'Acad. des Inscr.*, 1922, pp. 198 ff. ; H. Glück, *Das Hebdomon von Konstantinopel*, Vienna, 1920.

[6] C. Gurlitt, *Baukunst Constantinopels*, p. 7, and plates i, ix–xiii ; de Beylié, p. 136.

described by de Beylié;[1] the slight remains of the palace at Trebizond are noted by Texier.[2]

It has been already suggested that some idea of a Byzantine palace is conveyed by the Kremlin at Moscow, built in 1484–1505 for Ivan III, who had married Sophia Palaeologus, daughter of the last Byzantine Emperor.[3] Here the enclosure has survived to our time ; but of the ' great palace ' in the interior only a small portion remains. This, as far as its exterior is concerned, is in the style of an Italian palazzo ; the builders were in fact Europeans. The interior, however, has a series of vaulted reception-rooms, preceded by vestibules, suggesting, like the rooms in the great palace of Constantinople described by Byzantine historians, the general arrangement of a chapel or church. The private apartments follow the same model on a small scale, the bedrooms being in like manner preceded by a vestibule ; the house of the Romanoffs at Moscow, built in the sixteenth century and restored in the nineteenth, resembles the above in having an oriental interior and an exterior in the Italian style.

The vaulted chambers in these two buildings, covered with mural paintings in a Byzantine manner, dimly suggest the greater splendours at Constantinople. The Golden Hall in the Kremlin, perhaps belonging to the apartments of Sophia, has on its vaulted surfaces representations of Constantine and Helen, figures of saints and Tsaritsas, and pictures of the Councils held against the iconoclast Emperor Theophilus. The seventeenth-century palace of the Belvedere, built by Russian architects for Michael Feodorovich, preserves the same tradition of vaulted and painted halls and chambers.

The palaces of nobles doubtless reproduced the characteristics of the imperial residences upon a smaller scale. The earliest, between Constantine and Justinian, followed the type of the Roman patrician house. When space became scantier, they adopted Syrian models, rose higher, and covered less ground. None of these private palaces have survived ; at Venice, however, the older parts of several great houses (the Fondaco dei Turchi, now the Municipal Museum, and the Palazzi Dona or Sicher, Businello, Bembo, and Loredan) are regarded as Byzantine.[4] The general line of development at Constantinople was from a house standing back behind its own courtyard, to one abutting directly on the street, through an arcade sometimes forming part of the structure, sometimes detached.

Houses. Private houses at Constantinople soon adopted the Egypto-Syrian plan, best illustrated for us in the early period by the wonderful remains of towns in Central Syria and the Hauran,[5] which stood abandoned

[1] De Beylié, p. 140.
[2] Texier and Pullan, *Byzantine Architecture.*
[3] De Beylié, *as above*, pp. 160 ff.
[4] De Beylié, pp. 154 ff.
[5] First illustrated by de Vogüé in *La Syrie Centrale* ; later, by H. C. Butler in the publi-cations of the Princeton Archaeological Expedition to Syria. Cf. ruined houses in the Sinai Peninsula : Th. Wiegand, Heft 1 of *Wissenschaftliche Veröffentlichungen des Deutsch-Türkischen Denkmalschutz - Kommandos*, and *Arch. Anzeiger*, 1920, cols. 85 ff.

from the Mohammedan conquest until recent times. Though the roofs have suffered, the walls are often so good that many houses needed very little repair to make them serviceable for modern occupants : thus the large ancient house at 'Amra is to-day occupied by the local sheikh. Both town houses and villas are well represented. The former have at least one upper floor, often two, all upper floors having, as a rule, an open gallery or loggia along the front ; an exterior staircase gives access to the upper part. The first floor is sometimes entirely occupied by one room (as at Deir Sem'an).

The house of the Metropolitan at Athens,[1] as seen by Barsky in the eighteenth century in the enclosure of the small cathedral, was of the Syrian type with outside staircase and loggia.

Villas of the early period are well represented by examples at Serjilla El-Rabah, and other places ; here the dwelling-house and its dependencies are enclosed within a wall.[2] At Serjilla (fifth century), the house, of two storeys, had a gable roof and a columned loggia running along the whole side on each floor ; access to the upper part was by an external staircase. All windows, which are both square- and round-headed, open on the loggias. At El-Rabah (fifth century), the villa was larger and surrounded three sides of a court. The wing nearest the gate contained the hall, dining-room, and kitchens ; in the other two were the living rooms. A rather earlier villa at Ruweiha, dated A. D. 396, has a court entered by a porte-cochère with a tower. Plate XIX illustrates two Syrian houses.

De Beylié has published two interesting pavement-mosaics in the Museum of Bardo, Tunis, showing villas of the first period and their surroundings.[3] The first has two tower-like pavilions, each with upper floor and pyramidal roof, connected at the far side of a court by a covered gallery ; the front side of the court is closed by another gallery which appears to be roofed by a series of cupolas. If cupolas are really represented, we may compare the house on the Silver Casket of Projecta in the British Museum, where similar series of cupolas are seen. This method of roofing a gallery or aisle has already been noted (p. 78) ; it has always remained popular in the East. A caravanserai of the eighth century at Damascus, traditionally built by Copts, but now destroyed, showed this feature as employed in Early Mohammedan times.[4]

Inns or hostels (*Pandocheia*) for ordinary purposes were built in much the same way as other houses. Those of large size, for the accommodation of pilgrims, probably stood free, and had galleries on each floor round all four sides. Two known examples are those of Deir Sem'an[5] and

[1] De Beylié, p. 68.
[2] H. C. Butler, *Architecture and other Arts* (Princeton Exp., 1899), p. 179.
[3] *L'habitation byzantine*, p. 59 and plates ; see also Rivoira, *Lombardic Architecture*, p. 49,

fig. 76.
[4] De Beylié, p. 60, after Barsky.
[5] See de Beylié's restoration of the Pandocheion of Deir Sem'an, p. 44.

Tourmanin ;[1] the latter had two projecting wings, the rooms each occupying a whole floor, twenty-five metres in length. The steps of the external staircase were probably of wood. The caravanserai studied by Texier at Salonika, with its open quadrangle surrounded by chambers, and its exterior arcades, has apparently been destroyed.[2]

Houses of the later centuries are far to seek ; they are suggested, rather than presented, by the somewhat fantastic buildings of illuminated MSS. The miniatures can in fact only be utilized with safety by those having previous knowledge of the essential features of houses, and able to correct the faulty perspective.[3] At Melnic, on the frontier of Bulgaria and Macedonia, is a large house, still occupied, which probably dates from the fourteenth century.[4] It has on the front two storeys above the ground floor ; at the back there is only one storey, the house being built on a slope ; the roof is a low gable. The house is constructed of alternating rubble and brick courses, relieved by simple geometrical designs in the brick ; only the lower part of the watch-tower at one side of the entrance is of the date of the house, the rest is more recent. The windows, mostly round-headed, are only found on three of the four sides. In the interior is a great central hall, floored with hexagonal tiles, and rising to the roof. On this hall open the doors of ten chambers, five on each floor, all communicating with each other ; a wooden interior gallery may have run round the hall. The plan is in fact that of Syria adapted to a cold climate, the high central hall representing the open court. In Bulgaria itself there are important remains of early secular buildings at Pliska (Aboba), the first Bulgarian capital ; their lower parts were built of hewn stone, and they date from the eighth or ninth century : an inscription on one of the monolith columns erected by King Omortag (A.D. 814–831) alludes to the construction of a bridge ornamented with bronze lions. Numerous fortresses were erected in the time of Tsar Samuel (A.D. 977–1014) ; of that at Ochrida considerable ruins still stand, with a gateway flanked by towers. The old castle at Vidin was built in the fourteenth century. Three private houses apparently of this period survived at Tirnovo until modern times, but have been destroyed by earthquake in recent years. At Arbanass, near Tirnovo, however, there are some seventeenth-century houses which preserve the medieval type ; the living rooms are all on the upper floor.[5]

A square-windowed house at Trebizond, examined by Millet, also with a tiled roof, is considered earlier than the fourteenth century.[6] The interior

[1] Plan in de Vogüé ; also de Beylié, p. 46.

[2] Texier and Pullan, *Byzantine Architecture*, pp. 64, 130, and pl. xxvii. The caravanserai was said to have been built by Amurath II ; but the plan seems older, and the methods of construction appeared both to Texier and to de Beylié (p. 71) to be Byzantine.

[3] For houses of these periods the reader may be referred to de Beylié, pp. 76 ff., where a number of illuminations from MSS. are reproduced and discussed.

[4] De Beylié, p. 73. Local tradition ascribes the house to the twelfth century.

[5] B. D. Filow, *Early Bulgarian Art*, Berne, 1919, p. 46, and pl. x.

[6] De Beylié, p. 75.

consists of one large chamber; the present divisions are not original. The same author has made known several fourteenth-century houses at Mistra, the Byzantine capital of the Peloponnese after the withdrawal of the Latins. These also had gabled roofs, and one or two storeys above the ground floor, sometimes with balconies.[1]

De Beylié has expressed the opinion that of about ninety houses in Constantinople, more or less recalling the Mistra houses, four or five alone may be anterior to the capture of the city by the Turks : all the rest, though retaining many traditional characteristics, have grafted upon them Saracenic features.

In Stambul, the house of Kūm Kapu,[2] near the railway, about half a mile to west of the station of the same name, has one storey above the ground floor; it was formerly considered Byzantine, but is now regarded as Turkish. The roof is gabled; the windows on the first floor project upon corbels; they were originally round-headed. The Vizir Khan, in Jemberli Tash Street,[3] is ascribed to the fifteenth century; the arches here are pointed. Ruins of baths, presumably built in the tenth century but restored later, have been published by Paluka.[4] The quarter of Phanar, lying outside the walls along the shore of the Golden Horn, was long occupied by Byzantine families after the conquest. The old houses here are in the main street, and seem to be almost all subsequent to the conquest, though retaining features undoubtedly common to Byzantine dwelling-houses of earlier date. Especially interesting are nos. 270 and 272.[5] No. 270 has two upper storeys, the first with two vaulted rooms, the second with a single large apartment, also vaulted, preceded by a columned vestibule; the space between the vaulting and the roof is filled with empty pots fitting into each other, as in the dome of S. Vitale at Ravenna. The windows project over the street on corbels, as they are often represented in the MS. of Skylitzes. The adjoining house, no. 272, has also a great hall on the second floor; other old houses are nos. 302, and 222 and 224. In the first of these there is again, as in 270, a large vaulted room on the top floor, preceded by a vestibule. De Beylié remarks that this arrangement strikingly recalls that of rooms in the Imperial Palace, as described in the Book of Ceremonies of Constantine Porphyrogenitus : only the mosaics are wanting.

In Galata, on the opposite side of the Golden Horn, are about a dozen houses reproducing the Byzantine style, mostly in Pershembeh Bazaar Street. Here the house known as Hamdi Pasha Khan, or the Palace of the Podestà of Pera, and now let in floors for shops and workrooms, dates from

[1] G. Millet, *Mistra*, Album, pls. 12, 13 ; de Beylié, p. 76.
[2] De Beylié, *Supplément*, pp. 4–5.
[3] *Ibid.*, pl. i. The disposition of the Buyuk Yeni Khan, built in the seventeenth century, is interesting as recalling that of the Syrian Pandocheia, or the mons. of Athos (de B., pl. ii).
[4] Plan and sketch reproduced by de Beylié, *Supplt.*, pp. 6 and 7.
[5] *Ibid.*, pp. 10 and 11 and pl. ii. The old houses at Phanar are also illustrated by Gurlitt, *Baukunst Constantinopels*, Plates ii, lxxvii–lxxix.

the fourteenth or fifteenth century. It has round-headed windows, but the style of its walls, the system of vaulting, and the use of covered balconies recall the Phanar houses.

De Beylié concludes that the old houses of Stambul, Phanar, and Galata, whether built before or after the conquest, present the characteristics of one and the same architecture, which is that of Mistra, of the Skylitzes miniatures, or even, under certain aspects, of medieval Europe, and is directly inspired by old Byzantine tradition. This is seen in such features as the alternation of brick and stone in courses, the use of pots above the vaults, the scheme of a vaulted chamber preceded by a narthex, and the projection of windows upon corbels.

Monasteries

The possible connexion of groups of rock-cut cells in Asia Minor and Armenia with similar cells discovered in Chinese Turkestan has given rise to interesting speculation whether the earliest Christian monasticism did not borrow much from that of Buddhism, and whether the Christian monastery is not ultimately related to the *viharas* of Buddhist India.[1] Cave-cells were in frequent use farther to the west after the end of the first millennium; we may instance those of Cappadocia and those of Calabria. Another centre where they occur is on Mount Latmos near Miletus. Here among the remains of numerous monasteries, monastic churches are anchorites' cave-cells. These monasteries were fortified citadels, which appear to date from the period between the tenth century and the fourteenth, when the Turkish advance put an end to monastic life in a region which must have been comparable to that of Mount Athos.[2]

The most ancient Christian monasteries seem to have been irregular in plan, a fact which may be connected with the unordered existence of monks before the establishment of the strict monastic rules. ' As long ', says Lenoir, ' as no rule or discipline determined a methodical course in the general arrangement of the buildings or in their social attributions, a certain hesitation and incoherence was inevitable when any new construction had to be undertaken.[3] At first communities of hermits and anchorites grouped themselves round holy men like S. Anthony, or S. Paul of Thebes, and their earliest dwellings were huts and caves. The organization of monastic groups was begun by S. Pachom in the early part of the fourth century, and from that time onward ordered communities rapidly increased. Egypt seems to have disseminated the monastic idea, but as above noted, in view of the discoveries of cave-cells in Turfan (Chinese Turkestan), and of their analogy to those of Cappadocia, it has been asked whether it may not have

[1] Strzygowski, *Kleinasien*, pp. 145 ff., and *Baukunst der Armenier*, p. 245.

[2] K. Museen zu Berlin, *Milet, Ergebnisse der Ausgrabungen*, &c., iii, 1913. Th. Wiegand,

O. Wulff, and others.

[3] A. Lenoir, *Architecture monastique*, 1852–6, p. vi. Cf. Ramsay–Bell, *Thousand and One Churches*, p. 456.

been an Asiatic system which was first introduced into Egypt,[1] and attention has been drawn to the intermediate position in theology of the Manichaeans between Buddhism and Christianity.[2] The looseness of the first associations of hermits was to a certain extent perpetuated in the *lavra*, a type of monastery in which each monk had his separate cell, and could withdraw himself in many matters from the common life. In the West, the *coenobium*, or structure adapted to the use of a true community, soon entirely ousted the *lavra* ; but in the East, where the eremitic idea was deeply rooted, the type continued to be recognized, and the monastery of Rossikon on Mount Athos remains the true heir to the groups which occupied the scattered shrines and cells of establishments like Bawît in Egypt.[3] In addition to Bawît, described by Clédat and by Maspéro,[4] the early monasteries best known to us are those of S. Menas,[5] Saqqara,[6] and El-Khargeh in Egypt ; Qal'at Sem'an, Khirbet Hass, and El-Barah in Syria,[7] monasteries in Tûr 'Abdîn in North Mesopotamia ;[8] Tebessa in North Africa. In Asia Minor, where S. Basil established his Rule in the fourth century, the oldest monasteries should be looked for in Cappadocia and Lycaonia.[9] (For the monasteries in the Natron Valley see p. 140.)

When definite monastic plans began to be followed, there were naturally many tentative efforts before we reach the more or less stereotyped plan of a walled enclosure with the church in the middle, and the refectory, cells, offices, and abbot's residence round the sides. At Qal'at Sem'an (late fifth century) the residential quarters are confined to the northern end of a large court, the south and east sides of which are closed by parts of the great quadruple basilica. But the plan of a regular court was before long adopted wherever the nature of the site permitted it, the monastery probably beginning as an expansion of the typical dwelling-house. Local variations were, however, to be expected ; thus in Asia Minor the church seems to have formed one side of the court.[10] On hill tops the exterior wall might be omitted. At the original monastery of Daphni, about five miles from Athens, built in the fifth or sixth century, the enclosure was a square with a tower at each corner. The cells opened like the rooms of Syrian houses on an upper gallery. On the entrance side of the court were the guest-house, infirmary, and various offices. On the left was a hall, beyond

[1] *Zeitschrift für Ethnologie*, 1909, p. 891.

[2] F. Cumont, *La propagation du Manichéisme dans l'Empire Romain*, in *Rev. d'hist. et de litt. relig.*, 1909.

[3] Cf. Ramsay–Bell, *as above*.

[4] Jean Maspéro, *Rapport sur les fouilles entreprises à Baouit*, in *Comptes-rendus des Inscriptions et Belles-Lettres*, 1913, pp. 213–25 ; J. Clédat, *ibid.*, 1902; and in Cabrol, *Dict. d'arch. chrét. et de liturgie*, s.v. Baouit. Bawît was a large walled monastery, with divisions for monks and nuns, as was the case in the monastery of Shenute at Sohag.

[5] C. M. Kaufmann, *Ausgrabung der Menas-Heiligthümer*, &c.

[6] J. E. Quibell, *Explorations at Saqqara*, 1908, &c.

[7] H. C. Butler, Princeton Arch. Exp.

[8] G. L. Bell, *Churches and Monasteries of the Tûr 'Abdîn*. Excavation is necessary before the plans can be understood. Cf. Van Berchem and Strzygowski, *Amida*, p. 263.

[9] Remains have been noted in the Sinai peninsula : Wiegand, *as above* (p. 124, n. 5).

[10] Ramsay–Bell, *as above*, pp. 460 ff.

which, on the same side, began the cells of the monks.[1] At S. Luke of
Stiris some of the original barrel-vaulted cells are now used as store-rooms
on the ground floor ; the upper part of the buildings is of more recent
date. The plan of the old refectory can be traced, a hall 85 ft. by 25 ft.,
with an apse at the east end.[2]

Though the buildings of the large monastery of Edgmiatsin in Armenia
are of more recent date than the time of the foundation (seventh century ?),
they are erected in accordance with the old plan.[3] There is an outer walled
enclosure, within which is a court recalling to Lynch the great court of
Trinity College, Cambridge, *minus* the gate, hall, and chapel, and measuring
some 350 ft. by 335 ft. The entrance is on the west side, where is the
residence of the *Catholikos*, the cathedral church standing in the middle of
the square. The north side is occupied by cells, the refectory being on the
south. Other important monastic sites in Armenia are those of Ketcharus
(Daratshitshak), Horomos (Khoshavank) near Ani (tenth to eleventh
centuries), and Narek, south of Lake Van. The monastery of S. Catherine
on Mount Sinai is also an example of a reconstructed building on an
ancient site (Plate XX).[4]

Later monasteries are best illustrated by the famous group on Mount
Athos, the first of which were founded in the tenth century.[5] No existing
house is, however, entirely of so early a date, and about half are more
recent than the fall of Constantinople ; but all carry on old tradition and
reproduce earlier types. They were fortified against attack by pirates, and
are surrounded by great walls in which windows only appear at a consider-
able height above the ground (Plate XX). The interior reveals a quad-
rangle, with church and fountain in the open ; round the sides are the
monastic buildings, mostly of more than one storey. The upper rooms open
upon outer galleries, as in the old Syrian houses (Plate XIX) ; these galleries
are sometimes supported on corbels, and overhang the outer walls, as seen
in the case of the Serbian monastery of Chilandari (Plate XX).

An interesting example of an old monastery rebuilt in modern times
in its original style is that of S. John of Rila in Bulgaria.[6]

Geographical Distribution

The following summary sketch of geographical distribution is not
exhaustive or intended for the use of the specialist. Its purpose is to give
the reader a general notion what to expect in the different countries reviewed,

[1] G. Millet, *Le monastère de Daphni*, plan on
plate ii.

[2] Schultz and Barnsley, *Mon. of St. Luke,*
&c. ; H. R. Hall, *Proc. Soc. Bibl. Arch.*, 1913,
141–9.

[3] Strzygowski, *Baukunst der Armenier* ; H.
F. B. Lynch, *Armenia*, i, p. 244.

[4] Strzygowski, *as above*, p. 247.

[5] Uspensky, *History of Mount Athos*, St.
Petersburg, 1877, &c. ; Strzygowski, *as above*,
p. 769 ; Diehl, *Manuel*, pp. 692, 705, 708, 716,
761–2, 775–6 ; F. W. Hasluck (a posthumous
work in preparation) ; G. Rémond in *L'Illustra-
tion*, Dec. 4 and 25, 1920.

[6] B. Filow, *Early Bulgarian Art*, p. 46, and
pl. x.

and an idea of the local distribution of the more important types. Even an imperfect summary of this kind has its value, indicating the prevalence or absence of particular types in particular districts, the paths followed by migrating forms, the meeting-points of different streams of influence, and other facts of interest for the study of development.

Syria-Palestine

The buildings of this region, numerous in the Hauran and Northern Syria, are well illustrated in the admirable publications of the Princeton University Archaeological Expeditions,[1] and in the older but still valuable work of the Marquis de Vogüé.[2] It has already been indicated above that Syria was distinguished by ashlar building as opposed to the rubble core and stone facings used in other countries, and that it did not take a prominent part in the development of vaulted or domed construction, supporting its roofs either on timber or on rib-arches carrying stone slabs (Plate VIII), a method regarded as of South-Arabian origin.

Syrian architecture is represented by two main groups, a northern, to the east of Antioch, and a southern, in the Hauran south of Damascus. The sites in Northern Syria show the greatest wealth of decoration ; among the most notable are that of S. Simeon with its remains of four basilicas round a central octagon (Plate XXI), Qalb Luzeh, and many more ; their number was once enriched by the fine church of Turmanin, standing in de Vogüé's time, but now destroyed to provide materials for a village. The buildings of the Jebel Riha, among which those of Ruweihah may be specially mentioned, fell more directly under the influence of Apamea than of Antioch.

The churches and houses of the Hauran (*Auranitis*), south of Damascus and east of Lake Tiberias and the Upper Jordan, represent the construction of a district devoid of timber but rich in basalt ; they were entirely of stone, including the roofs and doors.[3] It is here that Arab influence is found.[4]

The region is of especial interest for the numerous examples of domestic architecture which it has preserved (Plates VIII, XIX). It was abandoned at the time of the Arab conquest and remained unoccupied until brought once more under cultivation in the nineteenth century. The durability of houses constructed entirely of stone was such that many of them looked as if the occupants had only just gone out instead of having abandoned them about twelve hundred years ago. Unfortunately the re-population of the area resulted in much destruction, the progress of which has been

[1] They represent the work carried out in 1904–1905 and in 1909. The results of the earlier expedition are to be found in the volume entitled *Architecture and other Arts*, the later results appear in *Publications*, Leiden, 1909. All the architectural material is by Professor H. C. Butler.

[2] De Vogüé, *La Syrie Centrale*, 1860.

[3] For the Hauran, in addition to Butler, see G. L. Bell, *Monthly Review*, 1901, pp. 105 ff.

[4] For Arabian influence see H. C. Butler in *Studien zur Kunst des Ostens* (Strzygowski, *Festschrift*), 1923, pp. 9 ff.

marked since the time of de Vogüé. The churches of Ezra (Zor'ah) and Bosra south of the Hauran have been already mentioned (pp. 85, 96) as examples of domical buildings, of which the former alone is now domed, though the date of the dome is disputed by some authorities. While some authorities assign it to the fourth century, and consider it as old as the church itself, Rivoira, Wulff, and others regard it as of much later date than the rest of the building.[1] The original methods of construction may, however, have been followed.

Farther to the south, East Syria contains two buildings of interest for Christian architecture, though not actually Christian. One is the remaining dome of the Baths at Gerasa (Jerash), a Hellenistic city itself of interest for comparison with Christian towns. This dome, by most authorities dated before our era, presents as noted above (p. 85) an interesting example of the dome with spherical pendentives in stone, and over a square plan.[2] The second is the square apse-buttressed building at Philadelphia (Ammân), believed by Strzygowski to have been covered by a dome.[3] The interior is decorated with blind arcading containing formal foliate ornament in low relief of an Iranian character. The plan of this building and the nature of its ornament suggest that it is an intrusive oriental type from the far side of the desert.

In *Palestine* only one of Constantine's memorial churches remains, the basilica at Bethlehem.[4] Other churches were erected by the emperor and his mother at the site of the Holy Sepulchre,[5] and on the Mount of Olives at Jerusalem,[6] at Nazareth, under the oak at Mamre, and elsewhere. In general it may be assumed that the basilicas were of the Hellenistic type with timbered roofs; that connected with the Holy Sepulchre, known from the difficult description of Eusebius and accounts of certain early pilgrims, is of the greatest interest on account of its relation to the actual sepulchre,

[1] *Moslem Architecture*, p. 121. The plan of S. George, Ezra, Rivoira compares with that of the Tempio di Siepe erected in the time of Hadrian (*ibid.*, p. 68); O. Wulff, *Altchristliche und byzantinische Kunst*, p. 253.

[2] Strzygowski, *Baukunst der Armenier*, p. 360, fig. 397; Choisy, *L'art de bâtir chez les Byzantins*, pl xv; Rivoira, *Lombardic Arch.*, pp. 34, 35.

[3] Strzygowski, *as above*, pp. 446 ff., 467 ff. It was perhaps a gate-house of the citadel.

[4] W. Harvey and others, *The Church of the Nativity at Bethlehem* (Byzantine Research and Publication Fund, 1910); E. Weigand, *Byz. Zeitschrift*, xxi, pp. 645 ff., and *Zeitschr. des Deutschen Palästina-Vereins*, xxxviii, 1915, pp. 89 ff.; A. Baumstark, *Römische Quartalschrift*, pp. 128 ff.; H. Leclercq, in Cabrol's *Dict. d'arch. chrét. et de liturgie*, s. v. Bethléhem. The Constantinian origin is supported by most authorities. The church is remarkable for the trefoil of its east end; while Lethaby and others would connect this feature with early sepulchral chapels (cf. p. 109, above), Strzygowski would connect it with Armenian influence (*Baukunst der Armenier*, pp. 770, 834.

[5] A. Baumstark, *Die Modestianischen und die Konstantinischen Bauten am Heiligen Grabe zu Jerusalem*, Paderborn, 1915, vol. i (Görresgesellschaft, *Studien*, &c., vol. vii); A. Heisenberg, *Grabeskirche und Apostelkirche*, vol. i; K. Schmaltz, *Mater Ecclesiarum, die Grabeskirche*, &c., 1918.

The question has been raised whether the description in Eusebius would not fit a domed basilica with galleries. The Constantinian basilica was destroyed by the Persians in A.D. 614.

[6] R. Vincent, *Revue Biblique*, April 1911, pp. 219 ff. Cf. *Oriens Christianus*, NS. i, 1911, pp. 119 ff.

which was enclosed within a domed rotunda. The nature of Constantinian buildings at the site of the Holy Sepulchre is still the subject of dispute, some holding to the view of Mommert that the *Anastasis*, or round church above the actual sepulchre, was under one roof with the basilica, others that the two were separate buildings.[1] The conclusion of Baumstark is that from east to west the visitor passed in succession a first atrium, the basilica, a second atrium, and finally the Anastasis. The church of S. Sergius at Gaza, erected on the site of the *Marneion*, with a dome upon an octagon, and containing frescoes of great importance described by Choricius, was a domed building in which the squinch is thought to have been employed.[2]

The architectural remains of Syria must be studied in relation to those of North Mesopotamia and of North-eastern Asia Minor, over both of which regions the intellectual and artistic influence of Antioch extended. Syria also shares structural forms with Asia Minor, though it may be that here the relationship is not one of direct dependence but of descent from a common stock.[3]

Mesopotamia

Though the churches of North Mesopotamia have a type with transverse nave (*Breitkirche*) apparently peculiar to this region,[4] in general their forms connect them with Syria. Syrian and Central Anatolian buildings show, when compared, a mixture of resemblances and differences suggesting less direct connexion than descent from a common stem.[5] The buildings of East-Central Asia Minor, Syria, and North Mesopotamia must therefore be considered as representing groups in various ways related to each other.[6] The surviving Mesopotamian churches present a problem which at present it is difficult to solve. For while they have an appearance of great antiquity, and at first sight their ornament suggests the fifth or the sixth century, these early dates, which seem to suit their style and have been adopted by

[1] In view of the testimony of the fourth-century pilgrim Silvia and of the evidence afforded by the *typikon* published by Papadopoulos Kerameus (Ἀνάλεκτα, &c., vol. ii, pp. 1–254), and discussed by Baumstark (*Oriens Christianus*, v, 1905, pp. 227 ff.), it is very difficult to see how Mommert's view can now be defended. According to Baumstark, the basilica, preceded by an atrium, and with its altar towards the west, itself preceded a second, more easterly atrium, at the end of which was the round church of the Anastasis; on a bema in the centre of the Anastasis was the *aedicula* above the sepulchre, which we see represented on early ivories and lead ampullae.

For the round churches erected by Constantine in Palestine see Strzygowski, *Orient oder Rom*, p. 138.

[2] Millet, *Rev. Arch.*, 1905, i, pp. 99, 100.

[3] Cf. the case of the towered western façade conjecturally derived from a Hittite type adopted by the Assyrians (Puchstein, *Jahrb. des K. deutschen Arch. Inst.*, vii, p. 9); or from a feature of old Persian palaces (F. von Bissing in *Studien zur Kunst des Ostens* (Strzygowski, *Festschrift*), 1923).

[4] G. L. Bell, *Churches and Monasteries of the Tûr ʿAbdîn*, Heidelberg, 1913 (*Beiheft* to *Zeitschrift für Geschichte der Architektur*), p. 84.

[5] Strzygowski (*Kleinasien*, p. 42) long ago made this observation.

[6] For the lost churches of Edessa, dating from before Justinian, see Baumstark, *Oriens Christianus*, iv, pp. 164 ff. The oldest was erected in the last quarter of the second century on the site of a heathen temple. Many churches are stated to have been built in the fourth and fifth centuries.

Strzygowski, are denied by Guyer and by Miss Bell,[1] both of whom have travelled extensively in the district. In support of his argument in favour of a much later period, the former [2] takes as his starting-point the dated ruins of the monastery-church of Surp Hagop in Commagene, shown by a carefully cut inscription to belong to the first half of the ninth century. He then points out that this church has close affinities with that of Mar Ya'kūb el-Habîs at Salaḥ in the Tûr 'Abdîn, the resemblance extending not only to the general type, but to the profiles of mouldings and details of ornament. Both churches are of the local type with transverse nave, reckoned among the oldest in the district, but if the evidence of the inscription stands, the other affinities suggest that most churches of this type are of post-Mohammedan date, the exception being Mâr Gabriel, which may go back to the sixth century.[3] Guyer's arguments find confirmation in features of Deir ez-Zaferân at Mardîn, where elaborate sculptured ornament of classical type is found on examination to include details which seem inconsistent with any early period.[4] Churches of the monastic type with transverse nave, other than those already mentioned, are Mâr Syriacus at Arnas, Mâr Ibrahim, Mâr Baschius, near Mâr Gabriel, and perhaps of similar age, Mâr Augen, and Mâr Yuhannen—all in the Tûr 'Abdîn.[5] Mâr Yakûb at Nisibin (Nisibis) [6] is exceptional; here there are two churches side by side, the southern with a restored dome. In Miss Bell's opinion no part of these structures is as old as the fourth century, and the sculptured ornament is of a type resembling that at Deir ez-Zaferân at Mardîn, already mentioned as presumably late. Strzygowski believes Mâr Yakûb to date from the fourth century.[7]

The parochial churches in the Tûr 'Abdîn, as distinct from the monastic, have the nave with the longitudinal axis; but the doors are not at the west ends but in the north or south sides. The chief basilican churches are that at Meiafarqīn, once having a gable-roof, a building suggesting a date as early as the fourth or fifth century; [8] that at Kerkûk, the nave with

[1] Miss Bell, at first inclined to place the churches rather early, at the end of *Churches and Monasteries in the Tûr 'Abdîn*, gives reason for a change of opinion.

[2] *Repertorium für Kunstwissenschaft*, xxxv, 1912, pp. 483 ff.

[3] *Ibid.*, p. 498. Mâr Gabriel contains a mosaic which looks as if it should belong to the sixth century, and carved details point in the same direction (Bell, *as above*, pp. 64 ff.; C. Preusser, *Nordmesopotamische Baudenkmäler*, 1911, pp. 30 ff. (*Wiss. Veröffentlichungen der Deutschen Orient-Gesellschaft*, no. 17). Deir Mâr Yakûb, Salaḥ, is illustrated by Preusser in plates xliv to xlviii.

[4] Preusser, pp. 49 ff. and plates lxii–lxv. The statements of Baumstark as to the strong

Hellenistic influences in East Syria and North Mesopotamia even down to the beginning of the Mohammedan occupation may be read in connexion with Guyer's arguments: see *Oriens Christianus*, xxii, 1908, pp. 17 ff. Strzygowski derives this ornament from Hellenistic traditions surviving far in the interior rather than from Antioch.

[5] These churches are described and illustrated by Miss Bell, *as above*, and Preusser, *as above*. At Arnas, traces of stalactite-ornament are noted by Guyer (*Repertorium*, xxxii, 1912).

[6] G. L. Bell, *as above*, p. 96; Preusser, pp. 40 ff., plates xlix–lii.

[7] *Amida*, pp. 173, 187.

[8] G. L. Bell, *as above*, pp. 86, 92. Guyer thinks it probably not earlier than the last decade

arcades on piers in a clumsy Sassanian tradition, is probably not earlier than the sixth century ;[1] two basilicas at Khalabiyyah on the Middle Euphrates are ascribed to the reign of Justinian (A. D. 527–565) ;[2] the basilica of S. Sergius at Rusāfah (Sergiopolis),[3] about 110 miles east-south-east of Aleppo and 75 miles north-north-west of Ed-Deir on the Euphrates, is related to the preceding two churches and itself again related to the basilicas of Andarīn and Karrātīn in Syria.[4] At Rusāfah the three arches of the nave are filled by a smaller arcade of two arches supported by three columns ; it had a wooden roof. At Karakôsh, south of Mosul on the east bank of the Tigris, and at Deir Makortaie, Preusser passed remains of barrel-vaulted basilican churches.[5]

Domed basilicas are represented by the El-Hadra church at Meiafarqīn, apparently of the sixth century,[6] the plan, which recalls that of S. Sophia, Salonika, the builder in both cases imperfectly distinguishing between the domed basilican and domed cruciform plans. Another example is the citadel church at Diyarbekr [7] (Amida), only the eastern part of which is believed by some authorities to be Christian work ; Strzygowski observes that this church still shows apse-buttressing, the barrel vault terminating in two half-domes. The *martyrion* at Rusāfah is of an unusual type, a kind of ' centralizing ' basilica, with an apse-like projection in the middle of each side ; these projections, with the eastern apse, suggest the *trichoros*.[8] The El-Hadra church at Amida is somewhat similar in plan.[9] Another domed church is the El-Hadra church at Khakh,[10] which has a trefoil end ; it is regarded by many as dating from about A. D. 700, but Strzygowski would place it earlier. The most remarkable centralized building in North Mesopotamia was that at Viransheher,[11] the former Antoninopolis, between Edessa and Mardin. The plan here is circular with rectangular chambers projecting at the cardinal points, and giving the idea of a circle intersected

of the sixth century (Sarre–Herzfeld, *Arch. Reise im Euphrat- und Tigris-Gebiet*, ii, p. 23.

[1] Bell, p. 103.

[2] Guyer in Sarre–Herzfeld, *as above*, p. 9. The churches are, however, said to belong to the same tradition as the El-Hadra Church at Khakh in the Tûr 'Abdîn, which elsewhere Guyer dates rather later.

[3] Guyer, *as above*, ii, pp. 42 ff. Guyer believes the arcading within the large arches to be a later addition.

[4] H. C. Butler, Princeton Exp., *Arch. and other Arts*.

[5] *As above*, pp. 13, 14.

[6] G. L. Bell, p. 88. The church may possibly be that built by Chosroes (Khosrau) II for the Emperor Maurice at the end of the sixth century. But Guyer places it later (in Sarre–Herzfeld, *as above*, p. 36).

[7] Bell, pp. 92 ff. ; Strzygowski, *Monatshefte*

für Kunstwissenschaft, viii, 1915, pp. 349 ff. The nave is covered by an oval dome generally ascribed to Mohammedan times.

[8] Guyer, in Sarre–Herzfeld, *as above*, pp. 31 ff. Guyer thinks that the trichoros is suggested in the plan of this church because the trefoil plan was of traditional use as a cemeterial form, and therefore appropriated to a *martyrion*.

[9] Van Berchem and Strzygowski, *Amida*, pp. 187 ff.

[10] G. L. Bell, *Churches and Monasteries*, p. 82, figs. 23, 24, plates ix and x ; Guyer, *Repertorium für Kunstwissenschaft*, xxxv, 1912, p. 501.

[11] Some have identified Viransheher rather with Constantia or Constantina (G. Le Strange, *Lands of the Eastern Caliphate*, p. 121). For the ruins see Strzygowski, *Baukunst der Armenier*, p. 503 ; C. Preusser, *Nordmesopamische Baudenkmäler*, &c. (no. 17 of *Wiss. Veröffentlichungen der Deutschen Orient-Gesellsch.*), p. 57.

by a cross. The church outside the walls of Rusāfah, which seems a possible prototype of the Greek-cross plan, has been noticed above (p. 101, n. 4).

The position taken up by the opponents of an early date for the North Mesopotamian churches is that before A.D. 600, the type of barrel-vaulted church with transverse nave was the usual form for monastery churches, neither the basilica nor the single-halled church for congregational use being vaulted as early as the reign of Justinian. They maintain that vaulted churches in Asia Minor are older than those of Mesopotamia, Binbirkilisse I being dated by an inscription to the fifth century; and that at this time Mesopotamian churches were flat roofed. Mesopotamia was not original either in construction or ornament; it repeated old designs century after century; the chief centre of inspiration upon which it drew was Syria, and it is impossible to rule out Syria until we know what the site of Antioch may conceal.[1]

Asia Minor[2]

Asia Minor ranks among the most important areas for the early development of Christian architecture. The coast-lands are of interest for their basilicas of the timber-roofed Hellenistic type; but the centre of attraction for the student of development lies rather in the south-eastern provinces of Cilicia, Lycaonia, and Cappadocia, an area in touch with Antioch, and through Antioch connected with Syria and North Mesopotamia; an area, moreover, which on its north-eastern side was conterminous with the Armenian border. In this part of Hither Asia many conditions of architectural progress seem to have been fulfilled. Ecclesiastically, these lands looked to Antioch, and that great city, linked by trade-routes with the East, contained in its population not only a large proportion of Greeks, but also great numbers of Aramaeans, of Armenians, and doubtless many Persians. In a word, it was here that the most inventive brains of the time were presented with the richest material to work upon.

In reviewing, however briefly, the chief facts concerning architectural development in this country we must always bear in mind the evidence contained in the letter of Gregory of Nyssa to the bishop of Iconium in the last quarter of the fourth century. In this letter the saint, proposing to

[1] S. Guyer, *Repertorium, as above*, pp. 500, 502, 503.

[2] A useful topographical index of churches, with references to the books or articles in which they are discussed, is given by C. M. Kaufmann, *Handbuch der christlichen Archäologie*, Paderborn, 1913, pp. 106–11. Strzygowski's *Kleinasien, ein Neuland der Kunstgeschichte*, treats of types and development, starting from Binbirkilisse in Isauria, the churches in which place are published by Sir W. Ramsay and Miss G. L. Bell in their *Thousand and One Churches*. G. Millet, 'L'Asie Mineure', in *Rev. Arch.*, 1905, i, pp. 93 ff., criticizes Strzygowski's work, insisting on Hellenistic and Byzantine initiative in the architecture of Asia Minor. A number of churches in Lycia, Pamphylia, Pisidia, and Cappadocia are noticed, with illustrations, by H. Rott, *Kleinasiatische Denkmäler*, Leipsic, 1908.

build an octagonal martyrion, asks for the loan of builders capable of constructing vaults without centring, i.e. by the method of inclined courses (p. 77), describes in some detail a building like S. Vitale at Ravenna, and states that the dome is to be 'conical'.[1] The letter proves that as early as the fourth century complex domed and vaulted churches were being erected in Asia Minor, and that the bishops were familiar enough with architectural matters to describe such buildings in an intelligible manner. With the letter of Gregory should be compared the oration of his namesake of Nazianzus, another Cappadocian city, delivered in A.D. 374 in honour of his father and predecessor in the see. Here the bishop describes for us the church in which the oration was delivered, another octagon with galleries. With such evidence as this, together with that of the vaulted basilica at Binbirkilisse, dated by an inscription, it is hardly possible to doubt that vaulted churches were frequently erected in Asia Minor in the fourth century.

Basilicas. Mention may first be made of a few interesting basilicas of Hellenistic type. The agora church at Pergamon appears to be typical for the west coast ; it has a single apse without lateral chambers, three aisles, narthex and atrium, and a timbered roof. Examples farther south are at Alaja Kisleh in Lycia, north of Myra ;[2] Perga in Pamphylia, with five aisles ;[3] Kremna in Pisidia, of the Alaja Kisleh type ; Sagalassos not far from Kremna.[4] In Cilicia and Lycaonia a number of basilicas have been photographed and planned by Miss Bell.[5] At Gül Bagche on the Gulf of Smyrna is a basilica with a round-ended narthex, a form of not infrequent occurrence in Asia Minor.[6]

The 'oriental' or vaulted type of basilica is represented at Binbirkilisse, and in the south of Central Anatolia, where it is but rarely replaced by the timber-roofed type. These basilicas generally have a nave and two aisles, all barrel-vaulted and often strengthened by rib-arches, a narthex, and, at the west end of each aisle, a chamber communicating with that aisle alone, so that the narthex only extends across the nave.[7] The narthex is sometimes flanked by two tower-like structures,[8] and the entrance doors are not

[1] Migne, *Patr. Gr.*, xlvi, 1093 ff. The letter is translated by Bruno Keil in Strzygowski's *Kleinasien*, p. 71. The 'conical dome' referred to may be a real cone, but is more probably one of the high domes, of the type of that at Ezra, which seem to represent an ancient traditional form.

[2] Petersen and von Luschan, *Reisen in Lykien*, p. 38.

[3] Lanckorowski, *Die Städte Pamphyliens und Pisidiens*, i, p. 34 ; Rott, pp. 48, 49.

[4] Lanckorowski, *as above*, ii, p. 151.

[5] *Revue archéologique*, 1906, 1907. The sites visited include Budrum, Kars Bazaar, Anazarbus, Kanytelideis (Kanidivan), Yemishkūm, Korghoz, Olba, Ura ; and, above all, Daouleh, below Binbirkilisse, where there are six basi-

licas with other buildings. Some of the Cilician sites have been previously described by Heberdey-Wilhelm, *Reisen in Kilikien*, 1891, 1892, in *Denkschriften* of the Vienna Acad. of Sciences, Philosophical-historical Class, xliv ; J. T. Bent (*Journ. Hell. Studies*, xi, 1890, p. 234), and Langlois, *Voyage dans la Cilicie*, 1861, 225.

[6] Weber, *Byz. Zeitschr.*, x, 1901, p. 568. Such a round-ended narthex is that of S. Vitale.

[7] It is rare for the narthex to extend across aisles as well as nave. It does so at Diner (Apamea Kibotos) ; but here two flanking chambers project beyond the sides of the church (Weber, *Dinair*, Besançon, 1892, p. 34).

[8] For the origin of this architectural feature see note 3, p. 133.

at the west end but in the sides, where there are also windows. In these last points the Anatolian basilica resembles the Syrian, from which it differs, however, in having no *prothesis* or *diakonikon*. The usual supports are not columns but piers, enriched with applied half-columns. Horseshoe arches are frequent. These basilicas are built of rubble faced with dressed stone, this method of construction extending to the vaults, which therefore required centring.[1] Among examples of the oriental type outside Binbirkilisse may be specially mentioned the basilica of Constantine at Andaval (Tyana).[2]

The domed basilica [3] is represented by perhaps the earliest example of the type at Meriamlik,[4] and by the example in church II at Binbirkilisse, which recalls the type of Kesteli in Cilicia.[5] The developed form is found at Khoja Kalessi in Isauria,[6] which is dated either in the fifth century, or possibly in the fourth;[7] Jürme in Galatia, and at Adalia (Jumamin Jamissi)[8] are of the same period. The domed church of S. Michael at Silleh is described as a basilica.[9] The above buildings are of stone. The type is represented in brick by the church of S. Clement at Ancyra,[10] and in brick and stone by Dereh Aghazi in Lycia.[11] Various buildings described by travellers as domed cruciform churches perhaps belong to the class of domed basilica.[12]

Centralized Buildings. The octagonal plan described by Gregory of Nyssa (p. 137) as combined with a cross is found among the churches of Binbirkilisse,[13] and shows affinity to the large octagon at Viransheher in North Mesopotamia (p. 135). Simple octagons without galleries are known at Suwasa in Cappadocia [14] and Ulu Bunar in Isauria. The existence of a type with galleries is attested by the above-mentioned funeral oration of Gregory of Nazianzus (p. 137), where the church mentioned suggests the lost octagon begun by Constantine at Antioch, A.D. 331.[15]

[1] *Kleinasien*, p. 21. These same materials are used in the same way in Armenian architecture.

[2] H. Rott, *as above*, p. 104. A number of basilicas are noted by Rott, who in many cases gives photographs and plans. His journey took him through Lycia, Pamphylia, Pisidia, and Cappadocia.

[3] For this type *see above*, p. 91.

[4] S. Guyer, *Arch. Anzeiger*, 1909, p. 3.

[5] A. C. Headlam, *Ecclesiastical Sites in Isauria*, Hellenic Society, *Suppl. Papers*, i, 1892, p. 20. Strzygowski, *Kleinasien*, p. 107, suggests that the round church at Derbe may represent an attempt to transform a rotunda into a basilica.

[6] Headlam, *as above*, p. 92. The dome construction here must have resembled that of the Sohag monasteries in Egypt. *Kleinasien*, figs. 81, 82.

[7] Headlam and Wulff are for the fifth century, Strzygowski for the earlier date.

[8] *Kleinasien*, pp. 109–14. For Jürme see Crowfoot, *Annual of the British School at Athens*, iv, 1897–8, pp. 86 ff.

[9] G. L. Bell, *Rev. Arch.*, 1907, pt. i, p. 18.

[10] *Kleinasien*, p. 115. With this may be compared other domed basilicas in brick: Qasr-ibn-Wardān in North Syria (p. 75), and S. Sophia, Salonika (p. 143).

[11] Rott, *as above*, p. 301.

[12] Various churches described by Rott, *as above*, e. g. Tomarza, Cheltek.

[13] *Kleinasien*, p. 70.

[14] H. Rott, *as above*, p. 250. Other octagons are at Derbe, Isaura, Dereh 'Aghazi in Lycia, Hierapolis, and other places (*Kleinasien*, p. 101).

[15] Eusebius, *Vita Const.*, iii, 50. Syrian parallels are the churches of Ezra and Bosra. An Armenian parallel is the church of Zwarth-

Among cruciform churches [1] the free-standing cross plan (p. 100) is represented at Binbirkilisse; the Greek-cross type (p. 101) perhaps at Alaja Kisleh,[2] the ruined church on the hill of Ajasoluk at Ephesus. Churches at Uchayak, Pergamon, and elsewhere afford further illustration,[3] as do various rock-cut or 'cave' churches in Cappadocia and other parts of Anatolia.[4] On the north coast of Asia Minor, at Trebizond, is a group of churches mostly Byzantine, the city having attained its chief importance after the foundation of the 'Empire of Trebizond' by Alexius Comnenus in A. D. 1204.[5] The Greek-cross type with dome supported on four piers or columns is represented by S. Sophia, S. Eugenius, the Chrysokephalos, S. Basil, and the present mosque Mum Haneh: the first three are larger than the usual Byzantine churches of this form, having naves lengthened towards the west. Two churches, S. Philip, and the Panagia Evangelistria, are single-aisled, and the dome is supported on the walls.[6]

Armenia and Georgia. The churches in this country are chiefly found in the districts of Edgmiatsin (Plate IV) and Ani (Plate XXII). The forms have been mentioned in connexion with building-types; for individual churches, too numerous for description in the present place, the reader is referred to Strzygowski's work,[7] where some information as to Georgian churches will also be found.[8] For the latter country he may consult G. Tschubinashvili's works, in which stress is laid on the independent character of Georgian building.[9]

Egypt

The churches which once existed in Alexandria are all destroyed;[10] they were probably for the most part basilicas of the Hellenistic type, and

notz (A. D. 641–661), for which see p. 99. The type in Europe is represented by S. Vitale at Ravenna, S. Lorenzo at Milan, and the Cathedral of Aix-la-Chapelle. In Constantinople, the Church of S. John Baptist in the Hebdomon, dating from the time of Theodosius, is held to have been octagonal.

[1] *Kleinasien*, p. 135.

[2] *Ibid.*, fig. 105; G. A. Sotiriou, 'Αρχαιολογικὸν Δελτίον, 1922, pp. 89 ff.

[3] *Ibid.*, pp. 32, 156–7.

[4] H. Rott, *as above, passim.*

[5] G. Millet, *Bull. de Corr. Hell.*, xix, 1895, pp. 419 ff. Older than the rest are two basilicas, S. Anne, and the church now Nakhip Jami: these are earlier than the reign of Basil II, but not of the sixth century. (*Ibid.*, p. 444.)

[6] *Ibid.*, p. 446. For Trebizond the reader may also consult J. Meliopoulos, *Pharos*, nos. 168, 169, 188, 199; and Th. Uspensky, *Izviestia of the Imperial Academy of Sciences*, 1916, pp. 1404 ff., and 1657 ff., noticed in *Byz.*

Zeitschrift, xxiii, 1920, p. 496.

[7] *Baukunst der Armenier*, 1918, pp. 47, 725.

[8] See also Brosset, *Rapport sur un voyage arch. dans la Géorgie et dans l'Arménie*, St. P., 1849–1851; *Description générale de la Géorgie*, and Atlas; N. Kondakoff, *Description of Ancient Monuments in Churches and Monasteries of Georgia*, St. P., 1890 (Russian); H. F. B. Lynch, *Armenia*; Choisy, *Hist. de l'arch.*, ii; F. Macler, in *Syria*, i, 1920, pp. 253 ff.; C. Diehl, *Rev. des études arméniennes*, i, 1921, pp. 221 ff.; Th. Kluge, *Versuch einer systematischen Darstellung der altgeorgischen Kirchenbauten*, Berlin, 1918; Rivoira, *Moslem Arch.*, p. 187.

[9] *Untersuchungen zur Geschichte der georgischen Baukunst*, Tiflis, 1921 &c., and *Monatshefte für Kunstwissenschaft*, xv, 1922, pp. 217 ff.

[10] A. J. Butler, *The Arab Conquest of Egypt*. Many are known by name: the cathedral church of Angelion or Euangelion, S. Athana-

some were probably of great splendour. The basilican plan was followed in the sphere of Hellenistic influence. The two basilicas at the shrine of S. Menas, one of the fourth century, the other built by Arcadius, are conspicuous examples,[1] with those on the site of the monastery of Bawît.[2]

It may be that from the fourth century an Asiatic influence, coming through Jerusalem, affected the architectural style of certain monastic churches, as Strzygowski believes to have been the case with the White and Red monasteries at Sohag, where trefoil-ended churches have central domes above square drums, the transition from square to circle being carried out by squinches.[3] The trefoil end of S. Simeon at Aswân connects this church also with Asiatic influence.[4] Others accept the Asiatic influence only on the proviso that the Asiatic features are of later date.

Monastic buildings in Egypt seem as a rule to have lacked uniformity of plan ; we know little more than that an approximately rectangular enclosure surrounded by a high wall contained at least one, and often two or three churches, a tower or keep with its own chapel or chapels and cells for monks, ovens, mills, oil-presses, a well, and where possible a garden. They are numerous along the Nile Valley, but for the most part appear to have been mean and slovenly in their building.[5] The best known are those in the Wādi 'n Natrûn (Natron Valley) north-west of Cairo,[6] where monastic life still continues. North of the First Cataract a common type of church is one without any trace of the basilican plan, but formed by an aggregation of domed units of square plan, capable of indefinite extension.[7] This type does not seem to occur to the south, where affinities with the basilican plan are again found. Churches in the Nubian valley from the First to the Second Cataract are of stone. Elsewhere stone enters little into construction ; nearly all churches are brick ; if the walls are of stone the heart is of poor rubble. Bricks are nearly always sun-dried north of the

sius, Caesarion, Cosmas and Damian, Euphemia, Faustus, John Baptist, Mark, Michael, Sophia, Theodore, &c.

[1] C. M. Kaufmann, *La découverte des Sanctuaires de Ménas* (*Société archéologique d'Alexandrie*, 1908), *Die Menasstadt*, &c., Leipsic, 1910, and *Die heilige Stadt der Wüste*, 1918.

The site was explored by the German (Frankfurt) expedition, 1905–1907.

[2] Jean Maspéro, *Rapport sur les fouilles . . . à B.*, Comptes-rendus de l'Acad. des Inscr. et Belles-Lettres, 1913, pp. 213 ff. ; J. Clédat, *Le monastère et la nécropole de Bawît, ibid.*, 1902, and article Baouît in Cabrol's *Dict. d'arch. chrét. et de liturgie*. For a list of other sites with early churches see C. M. Kaufmann, *Handbuch der christlichen Archäologie*, pp. 80 ff.

[3] For these monasteries see Somers Clarke, *Christian Antiquities of the Nile Valley*, Oxford, 1912, pp. 145 ff., and pls. xlv to li. Like Rivoira,

Somers Clarke believes the domes to be late additions. Strzygowski assigns them to the fifth century (*Baukunst der Armenier*, p. 731).

[4] Deir Amba Sam'an : Somers Clarke, *as above*, pp. 95 ff.

[5] Somers Clarke, *as above*, p. 105, who notes that the monasteries on Mount Athos are also irregular in plan.

[6] For the monasteries in the Natron Valley, Deir Amba Bishoï, Deir Es-Suriâni, Deir Abu Makar, and Deir el-Baramûs, see A. J. Butler, *Ancient Coptic Churches of Egypt*, 1884, pp. 287 ff. ; and H. G. Evelyn White, *Bulletin* of the Metropolitan Museum, New York, July 1920, Supplt., pp. 34 ff., and Nov. 1921, pp. 54 ff. Deir Es-Suriani, the Syrian monastery, has an ancient connexion with Syria ; in its principal church the choir is roofed by a dome and two semi-domes with interesting frescoes (p. 248).

[7] Somers Clarke, p. 109 f. Examples at

Sudan ; burned brick only becomes common when the Second Cataract is reached. In the old churches north of the Sudan it was only used for piers, arches, or the lowest courses of walls.[1] Churches were usually at some time covered with vaults and domes, though many were not originally built in that way ; they were so small in size that constructional difficulties were easy to overcome. The system of vaulting is that by inclined courses mentioned above (p. 77) and still practised in Egypt.[2]

Between Aswân in the north and Wādi Halfa in the south, Nubian churches have been explored by the University of Pennsylvania.[3] The district, though converted only in the sixth century, not very long before the Arab conquest, was at that time a stronghold of Christianity in East Africa.[4] The churches, which soon develop on their own lines, are chiefly of crude brick. The type is represented by the church near Abu Simbel : it has a rectangular plan, with nave and two aisles ; inbuilt apsidal sanctuary with lateral chambers ; the entrance is not at the west end, but on the north and south sides. The larger churches had galleries approached by a staircase in the south-west corner, opposite to which was a guest-chamber. A wall with large arch separates the nave from the sanctuary. There is no cruciform arrangement ; the dome, where used, is ' only an incident in the roofing '. The aisles are covered by barrel-vaulting with inclined courses. A small church a few miles north of Abu Simbel is covered entirely by domes or domical vaults, resembling in this the type found in the desert monasteries and those of the Natron Valley : the dome over the central bay is elliptical.[5] A number of Coptic churches in various parts of Egypt are described by Butler, including those of S. Anthony and S. Paul in the Eastern desert by the Red Sea.[6] The church of S. Barbara at Old Cairo has been recently published.[7]

The general verdict upon the Coptic churches along the seventeen hundred and odd miles between Cairo and Khartum seems to be that as a whole they show a certain incoherence and vagueness of plan, and a lack of inventiveness in construction. Coptic Egypt does not seem to have been a focus of architectural activity ; it cannot compare in this respect with the Syrian and Anatolian region north and east of Antioch, where the buildings are equally remarkable for variety of form and excellence of construction. This ineffective character of non-Hellenistic Christian architecture in

Edfu, Esna, Medinet Habu, Medammot, Ka- . mula, Nakâda, &c.

[1] Somers Clarke, *Christian Antiquities in the Nile Valley*, 1912, pp. 20 ff.

[2] *Ibid.*, p. 26.

[3] Egyptian Department of the University Museum : Eckley B. Coxe Junior Expedition to Nubia, ii, *Churches in Lower Nubia*, by G. S. Mileham, Philadelphia, 1910. (Some of the churches described are also to be found in

Somers Clarke, *as above*.)

[4] Two missions were dispatched by Justinian and Theodora after the defeat of the pagan Blemmyes by Silko.

[5] Mileham, *as above*, p. 12.

[6] *As above*, pp. 341 ff.

[7] A. Patricolo and U. Monneret de Villard, *La Chiesa di Santa Barbara al Vecchio Cairo*, Florence, Alinari, 1922.

Egypt tends to support the contention that, admirable as the Coptic craftsman was in many arts, his genius lay rather in developing ideas suggested by others than in producing inventions of his own. Inventiveness in Christian Egypt seems to have been chiefly confined to the Greeks and other foreigners of Alexandria.

Constantinople and Salonika

Though the remaining churches and other buildings of Christian date form but a part of what once existed, the former capital of the Byzantine Empire is still rich in Byzantine work. The walls, Golden Gate, and cisterns have been separately mentioned (pp. 112, 113, 115), as have the remains of lesser palaces, and a more extended account has been given of the Great Palace (p. 119). Of the Great Hippodrome hardly a trace remains above ground.[1] Mention has also been made of important churches now destroyed, such as that of the Holy Apostles, built by Justinian, and the *Nea* or New Church of Basil I. In the present place it is only intended to recall to the reader's attention a few of the surviving churches which illustrate the types discussed in earlier pages.[2] For all further information he may be referred to the books mentioned in the foot-note.

The only surviving basilica is that of S. John of the Studion, dating from the fifth century and used as a mosque under the name of Mir Achor Jami.[3] Octagonal types are the Baptistery of S. Sophia[4] and SS. Sergius and Bacchus,[5] the analogy of which to S. Vitale has been already noticed (p. 96). The domed basilica (p. 91) is represented by S. Irene[6] (Plate XII), and by S. Sophia,[7] the latter the climax of its evolution (Plate I). The free-cross plan (p. 100) has now no representative, but the great church of the Holy Apostles[8] had this form. Typical examples of the Greek-cross plan (p. 101) are S. Theodosia (Gul Jami),[9] S. Mary Diakonissa (Kalender Jami),[10] and SS. Peter and Mark (Hoja Atik Mustapha Jamissi).[11] The

[1] De Beylié, *L'habitation byz.*, pp. 111 ff.

[2] A. Van Millingen, *Byzantine Churches of Constantinople*, 1913, with introduction by Traquair; J. Ebersolt and A. Thiers, *Les églises de Constantinople*, Paris, 1913; C. Gurlitt, *Die Baukunst Constantinopels*, Berlin, 1912; Lethaby and Swainson, *The Church of Sancta Sophia in Constantinople.*

[3] Van Millingen, p. 56; Ebersolt, p. 1; Gurlitt, p. 31.

[4] Van Millingen, p. 78; Gurlitt, p. 21.

[5] Van Millingen, p. 70; Ebersolt, p. 21; Gurlitt, p. 18. Traquair notes Sanjakdar Mesjedi as an octagon containing a cross; and would regard S. Mary Panachrantos (Fenareh Isa Jami) (p. 139), S. Mary Pammakaristos (Fetiyeh Jami : Plate XII), and S. Andrew in Krisei (Khoja Mustapha Pasha Jami) as developments from an octagonal type.

[6] W. George, *The Church of S. Eirene* (*Byzantine Research and Publication Fund*, 1912); Van Millingen, p. 84; Ebersolt, p. 55; Gurlitt, p. 17.

[7] Lethaby and Swainson, *as above*; Antoniades, as on p. 92, n. 1; Gurlitt, p. 20.

[8] Gurlitt, p. 29; A. Heisenberg, *Grabeskirche und Apostelkirche*, vol. ii.

[9] Van Millingen, p. 170; Ebersolt, p. 113.

[10] Van Millingen, p. 185; Ebersolt, p. 93; Gurlitt, p. 38.

[11] Van Millingen, p. 193.

smaller and later form of Greek-cross church in which the dome is supported on columns instead of piers (p. 103) is well seen in S. Theodore (Klisse Jami),[1] and Pantepoptes (Eski Imaret Jami).[2] A lobed cruciform plan is seen in S. Mary of the Mongols.[3] Single-hall churches are represented by S. Thekla,[4] Bogdan Serai,[5] Monastir Mesjedi,[6] and the memorial churches of Pantokrator (Eski Imaret Jami)[7] and the church of the Chora (Kahrieh Jami).[8]

At Salonika[9] the basilica of S. Demetrius,[10] ruined in the recent fire, was built in the first half of the fifth century by Leontius, Prefect of Illyricum (Plate XI). It was a church of Hellenistic style much restored after an earlier fire of the seventh century. The present mosque of Eski Jumā,[11] probably the historic church of the Virgin *Acheiropoietos*, is also a basilica, with three aisles and galleries, narthex and exo-narthex; it was originally lighted by open arcading all along the sides, which the Turks closed when they turned it into a mosque. Its type suggests affinities with such Syrian churches as Ruweiha, Qalb Luzeh, and Turmanin; the type may be regarded as an imported one, due to the maritime relations of the city. For the late basilica, Kisherif Jami, see below.

The circular S. George,[12] dating as a church from the fifth century, had originally eight square niches in the interior, one of which was subsequently expanded to form a vaulted and apsed sanctuary. In its original form it resembled a Roman rotunda, the simplest type of central construction; this was changed into a church probably in the fifth century, when it was given a gallery, sanctuary, and mosaic decoration.

S. Sophia[13] (Plate XXIV), a fifth-century church formerly used as a mosque, was restored to the Greeks in 1912. It recalls the domed basilica, though it may be described as transitional between this and the Greek-cross type; it has narrow aisles, galleries, and three tiers of windows at the north and south transept ends. It must be studied in connexion with

[1] Van Millingen, p. 248 ; Ebersolt, p. 149 ; Gurlitt, p. 32.

[2] Van Millingen, p. 214 ; Ebersolt, p. 171 ; Gurlitt, p. 39.

[3] Van Millingen, p. 277.

[4] *Ibid.*, p. 211. [5] *Ibid.*, p. 284.

[6] *Ibid.*, p. 262.

[7] *Ibid.*, p. 235 ; Ebersolt, p. 185 ; Gurlitt, p. 33.

[8] Van Millingen, p. 288.

[9] For Salonika in general see O. Tafrali, *Topographie de Salonique*, 1912.

[10] G. Sotiriou, *The Church of S. Demetrius*, Athens, 1920 (in modern Greek), describing and illustrating the state of the building after the fire of 1917 ; Ch. Diehl, M. Le Tourneau, and H. Saladin, *Monuments chrétiens de Salonique*, Paris, 1918, pp. 65 ff.

[11] Diehl and others, *as above*, pp. 35 ff.

[12] Diehl and others, *as above*, pp. 20 ff. ; E. Hébrard, *Bull. Corr. Hell.*, xliv, 1920, p. 15. The present high drum and tiled roof are additions ; Texier's comparison to the church of Bosra is rejected by Diehl, who thinks rather of the Roman Thermae, other Roman buildings, and the Mausoleum of Diocletian at Spalato.

[13] Diehl and others, pp. 117 ff. ; G. Sotiriou, in *Byz.-Neugr. Jahrb.*, iii, 1922, p. 442. In support of the early date it is shown that some of the bricks have the same stamps as those used on the bricks of the city walls ; and its ornament is of the style of the fifth century ; the capitals of the columns, with their wind-blown acanthus, are of this date.

the later churches of S. Irene and S. Sophia at Constantinople, but more especially with the Church of the Assumption at Nicaea.[1]

The church of the Theotokos (Kazanjilar Jami)[2] is of the Greek-cross plan, standing in the line of development between the early example at Skripù in Boeotia and the perfected type seen in S. Theodore (Kilisse Jami) at Constantinople. Its dome is supported on four columns and has a high drum; a second dome is over the left side of the narthex. It is dated by a lintel inscription to the year A.D. 1038.

S. Panteleemon,[3] another Greek-cross church with dome on four columns, probably dates from the twelfth century. It has two domes on high drums, one central, the other over the middle of the narthex. The exterior is a fine illustration of the Greek-cross; galleries formerly surrounded it on three sides.

S. Catherine (Yakûb Pasha Jami)[4] dates from the late twelfth or early thirteenth century. This church with five domes is also a fine example of the Greek-cross type. It still has external galleries round three sides, the part extending along the west end forming the narthex.

The Church of the Holy Apostles[5] seems to have been inspired by S. Catherine and S. Panteleemon, and, like the former, has five domes. It also has external galleries round three sides, and at the west end has a narthex as well. The drums of the five domes are polygonal. The church should date from the close of the thirteenth century; its east end is often reproduced for its exceptionally fine brickwork decoration.

S. Elias (Eski Serai)[6] is a trefoil church preceded by a broad narthex. While some have ascribed it to the eleventh century on the analogy of churches on Mount Athos, where the trefoil is also found (pp. 109, 152), others put it as late as the thirteenth or even the fourteenth century.

Kisherif Jami,[7] probably the Church of the Archangels, is a basilican church with transepts, and external gallery round three sides; it perhaps dates from the twelfth century.

The Church of the Transfiguration[8] (Chauch Monastir), with a dome on a high drum, has been restored: it is probably of the fourteenth century.

[1] O. Wulff (*Die Koimesis-Kirche von Nicäa*) places S. Sophia Salonika after S. Sophia, Constantinople, in date.

[2] Diehl and others, p. 153.

[3] *Ibid.*, p. 168.

[4] *Ibid.*, p. 180.

[5] *Ibid.*, pp. 189 ff.; G. A. Sotiriou, as on

p. 143, n. 13, p. 443. In the narthex are an inscription and monograms of Niphon, Patriarch of Constantinople, A.D. 1312–1315.

[6] Kondakoff, *Macedonia*, p. 117; Diehl and others, pp. 203 ff.

[7] Diehl, p. 215.

[8] *Ibid.*, p. 217.

Greece [1]

Little is known of the earliest Christian architecture in Greece beyond the remains of basilican churches on various sites.[2] From the close of the sixth century to the beginning of the ninth Greece was troubled by Slav invasion, and the development of her arts hindered. The establishment of the Macedonian dynasty under Basil I in the second half of the ninth century marked a fresh period of construction, during which the new Greek-cross type made its appearance at Skripù in Boeotia, and domed churches were rapidly multiplied on the mainland and in the islands.[3] A reaction followed in the tenth century due to the raids of the Arabs, now masters of Crete, and to the Bulgarian menace in the north ; but the victories of Nicephorus Phocas and Basil II introduced a new period of prosperity lasting for two hundred years until the irruption of the Franks of the Fourth Crusade in the first years of the thirteenth century. To this period belong many Byzantine churches in the south of the Peloponnese and Macedonia. The great church of S. Luke of Stiris in Phocis[4] (Plates XIII, XIV) was probably completed in the second quarter of the eleventh century ; later in the same century came the Panagia Lycodimon and S. Theodore at Athens, Kaisariani and Daphni[5] in Attica (Plate VII), churches in Elis and Argolis.[6] After the interruption of the Fourth Crusade, Crete continued to prosper under Venetian rule,[7] a new Byzantine province was established in the Morea with its capital at Mistra, where there are churches of certain date : SS. Theodore (before A.D. 1296), Metropole (A.D. 1310, modified in the fifteenth century), Brontochion (before A.D. 1311), Peribleptos (early fourteenth century), S. Sophia (c. A.D. 1350), Pantanassa (c. A.D. 1430 : Plate XV). In the north, Epirus, Aetolia, Acarnania, and Thessaly remained in the thirteenth century under the rule of despots of the Ducas family, who were considerable church builders.[8] In A.D. 1259 the Palaeologi regained Macedonia, soon afterwards erecting S. Clement's at Ochrida, and the

[1] The reader should consult articles by Prof. G. Sotiriou ; G. Millet, *L'École grecque dans l'architecture byzantine*, Paris, 1916. R. Traquair, *Churches of Western Mani, Annual of British School at Athens*, xv, 1908. A. Struck, ' Vier Byz. Kirchen der Argolis,' in *Athenische Mittheilungen*, xxxiv, 1909, pp. 189 ff.

[2] In Thessaly (Wace and Droop, *Journ. Brit. School Ath.*, xiii, 1907–1908, p. 315, pl. x) ; at Athens (Strzygowski, *Röm. Quartalschrift*, iv, 1890, p. 3) ; at Chalcis, Argos, Olympia, and Thera (refs. in Millet, *as above*, pp. 1, 2) ; for Epirus see refs. in *Byz. Zeitschr.*, 1923, p. 240.

[3] For the large sixth-century domed Church of Our Lady of the Hundred Gates at Paroekia in Paros see the monograph by H. H. Jewell and F. W. Hasluck, *Byzantine Research and Publication Fund*, 1920 : cf. Buhlmann in *Zeitschr. für Gesch. der Architektur*, Beiheft 10, 1914. The Church of S. Titus at Gortyna in Crete (Th. Fyffe, *Architectural Review*, Aug. 1907, pp. 60 ff., and G. Gerola, *Monumenti Veneti nell' Isola di Creta*, Venice, 1905, ii, p. 31) is an early example of the Greek-cross type. Most Cretan churches are later than the tenth century ; some, noticed by Gerola, are partly rock-cut, partly constructed (p. 176).

[4] See the monograph by Schultz and Barnsley.

[5] G. Millet, *Le monastère de Daphni*.

[6] References in Millet, *L'École grecque*, p. 7.

[7] Gerola, *Monumenti Veneti nell' Isola di Creta*.

[8] Millet, *L'École grecque*, pp. 9, 10.

narthex of S. Sophia in the same place (Plate XXIV). We have noted above the churches built in Salonika from the eleventh to the fourteenth century. ‘ Thus the two “ marches ” of Greece, Crete in the south, Western Mace- ‘ donia in the north, long cut off from the Empire and deeply penetrated in ‘ the one case by Islamic, in the other by Slav influences, renewed contact ‘ with it under the hegemony of Constantinople. Next, Crete continued to ‘ live apart ; though her affinities with Greece were close she had a distinct ‘ tradition. This history is written in the monuments. The common ‘ features come from the East. After the defeat of the Bulgars, Macedonia ‘ maintained regular communication with Greece . . . but she was also in ‘ touch with Salonika, and through Salonika with Constantinople. . . . Thus ‘ Greece on one side touched the East, on the other Byzantium.’ [1]

The architectural influence of Constantinople itself was little felt in Greece before the fourteenth century. That country developed its forms in its own way, on which the influence of the Christian East is apparent.[2] In all the southern area, specifically Byzantine features are rare, and when adopted are modified by local feeling. The true affinities here are probably with Crete, Asia Minor, and Armenia in the case of the main forms and the severe stone-faced façade, while in ornament, for example in decorative Cufic lettering used on the walls of churches, recourse is sometimes had to Mohammedan art. To Salonika Greece owed the direct importation of certain Hellenistic motives not known to Constantinople, such as the vaulted basilica lighted from the nave, and doubtless the original of the *parement cloisonné*. The architecture of Greece is ‘ Byzantine ’, but beneath the Byzantine envelope it reveals features foreign to Constantinople, features which link it with the East. Like Asia Minor and Crete, Greece itself is a frontier province. Only with the fourteenth century at Mistra does the influence of the imperial capital become dominant.

The Balkans

Bulgaria. The Early Christian churches at present examined are held to date from the fourth to the seventh centuries ; some are still standing in part, the others were excavated.[3] At Hissar-Bania, Mesemvria, Belovo, Gradsko, and in the Vardar valley remains have been found of the columned basilica with timbered roof in the Hellenistic style. In other places we have

[1] Millet, *as above*, p. 13.

[2] *Ibid.*, p. 295. Millet thus enumerates the essential features : ‘ basilique à nef centrale aveugle, à nef transversale ; plan cruciforme apparenté à la basilique ; trompes d’angle, an- nexes discrètes ; façades unies, sans arcatures ; fermeté des frontons ; des absides à trois faces et des coupoles octogonales ; portiques simples ; berceaux en pierre: autant de motifs orientaux.’

[3] B. Filow, *Early Bulgarian Art*, Berne, 1919, p. 2, and *Studien zur Kunst des Ostens* (Strzygowski, *Festschrift*, 1923), pp. 33 ff. : cf. also *Arch. Anzeiger*, 1915, cols. 228 and 235. P. Montafcieff in *Izviestiya* of the Bulgarian Arch. Soc., v, 1915, pp. 85 ff. For various remains cf. Strzygowski, *Baukunst der Ar- menier*, pp. 43, 727, 843 ; and *Byzantinisch- Neugriechische Jahrbücher*, i, 1920, pp. 17 ff.

evidence of more definitely oriental influence from Anatolia, Mesopotamia, and from Armenia. The church of S. Sophia in Sofia is a vaulted domed basilica of the sixth century,[1] built on the site of earlier churches of the fifth and fourth centuries ; at Pirdop the large basilica is also vaulted in the Mesopotamian manner.[2] The so-called red church at Perushtitza (Philippopolis) has a dome supported on four apse-buttresses, the plan being apparently Armenian.[3] The Bulgarians themselves coming into the country round the north-west of the Black Sea from a region also in contact with Asia Minor, it is natural that the earlier churches built after their conversion should continue in the Asiatic tradition. Of the large basilica at Pliska (Aboba),[4] only the foundations remain ; but the bases of piers alternating with columns between the nave and aisles illustrate an arrangement characteristic of the Christian East. This church is attributed to the ninth or early tenth century. Another large basilica with galleries, ascribed to Tsar Samuel (A.D. 977–1014) who held Macedonia when Eastern Bulgaria had fallen under Byzantine dominion (p. 51), is partly preserved on the island of S. Achil on Lake Prespa.[5] The earlier part of the church of S. Sophia at Ochrida (Plate XXIV) is of the same date ; two lateral towers and the west end are late additions of A.D. 1317. It is a vaulted basilica with three aisles and apses, but without galleries.[6]

On the restoration of the Bulgarian kingdom with the thirteenth century under John Asen and his successors, the old basilican style of church reminiscent of Early Christian art disappeared and the church of Greek-cross plan, long dominant in the Byzantine Empire, was introduced. These churches, like those constructed elsewhere at this time, are characterized by small size and decorative exterior. The ruins of a large number of such churches exist at Tirnovo, the capital of the new kingdom ; at Mesemvria, near Prilep, and at Ochrida. Among existing churches[7] representing the work of the period is S. Demetrius at Tirnovo, where the east end is said to date from the close of the twelfth century : the more important church of the Forty Martyrs ascribed to the reign of John Asen (A.D. 1218–1241) has been restored out of all recognition. S. Peter and S. Paul at the same place, a church of the later Byzantine type with its dome supported on columns, was almost entirely destroyed by earthquake in 1913. The ruined church of S. John at the harbour of Mesemvria[8] presents a fine

[1] B. Filow, *Sophiiskata Zerkva*, Sofia, 1913 (*Materials for the history of Sofia*, bk. iv).

[2] B. Filow, *Sophiiskata Žerkva*, p. 139 ; Strzygowski, *Baukunst der Armenier*, p. 843, figs. 795–7. The plan has been compared with that of S. Irene at Constantinople. Cf. Montafcieff, *as above*, pp. 20 ff. It may be observed that early decorative sculpture in Bulgaria seems to show North Mesopotamian influences: Filow, *Early Bulgarian Art*, p. 6. The glazed tiles from Patleina point in the same direction (p. 347).

[3] Filow, in *Arch. Anzeiger*, 1915, *as above*.

[4] Filow, *Soph. Zerkva, as above*, p. 8, fig. 5 ; Millet, *L'École grecque*, pp. 21, 34, 53, 60.

[5] Filow, *as above*, p. 9. This was a three-aisled and three-apsed basilica with galleries considered to date from about A.D. 1000.

[6] H. Dragendorff, *Zeitschr. für bild. Kunst*, 1919, pp. 259 ff.

[7] For what follows see Filow, *Early Bulgarian Art*, pp. 17 ff.

[8] Millet, *as above*, Index, s. v. *Mésemvrie*.

example of a rich exterior in which zones of brick and stone alternate, and the walls are further enriched with chequer designs.

Among churches of the thirteenth and fourteenth centuries on the Macedonian side is S. John on the shore of the lake ; the church of the monastery of S. Naum in a similar position ; at Drevnovo there is a church of the time of Stefan Dushan.[1] There are other churches of the same period at Shtip near Prilep and near Skopliye. The church at Boiana, not far from Sofia, famous for its mural paintings, dates in greater part from A.D. 1259. The fortress-church near Stanimaka, south of Philippopolis, represents a single-naved domed type with two storeys, built rather as a mausoleum than a place of worship, the lower storey forming the burial vault.[2] The conquest of Tirnovo by the Turks in A.D. 1393 reduced but did not end Bulgarian church building. Small churches were built in remote spots ; an example is the church of Poganovo monastery in the Erma valley, built in the fifteenth century, which still has characteristics of the Greek-cross type. In the sixteenth century and later, simpler churches in the form of single halls with barrel vaults were erected ; the dome becomes rare.

Serbia. The architecture of Serbia has recently been brought within easier reach of students by the publication of books and articles treating the subject as a whole.[3] It is now divided into three principal sections representing in the main three periods of the national history. The first belongs to the time when the centre of the Serb power was in the western part of modern Serbia. The early Serbian school begins in the second half of the twelfth century in the reign of Stefan Nemanya, founder of the Nemanya dynasty, and his successors, and embraces a period of rather more than a century. The school was eclectic, borrowing much from Constantinople, much from Dalmatia and Italy, chiefly Lombardy ;[4] some elements came from the French Gothic introduced by the Cistercians into the south of Italy in the early thirteenth century, and encouraged in Serbia by Helen the French queen of Stefan Urosh I (*c.* 1243–1276).[5] This school built churches with a single nave, dome, and apse, a type known both at Cattaro and in Thrace.[6] But the general orientation at this time was towards the Adriatic, and for a long time Serbian commerce, based upon

[1] Filow in *Studien zur Kunst des Ostens*, 1923 (Strzygowski, *Festschrift*), p. 33.

[2] Filow, *Early Bulg. Art.*, p. 22 and pl. iv.

[3] G. Millet, *L'ancien art serbe*, Paris, 1919 : cf. *Burlington Mag.*, May 1924, p. 258. D. Petronievich, *Les cathédrales de Serbie*, Paris, 1917 ; M. J. Pupin, *South Slav Monuments*, i, London, 1919 ; Sir T. Jackson, *Proceedings Soc. Antiq. London*, xxx, 1917–1918, pp. 10 ff. The dates assigned by different authorities to the reigns of Serbian kings often differ in given cases by several years.

[4] Sir Arthur Evans has suggested that some of the Italian influence may have entered the country through the march of Friuli, no less than through Dalmatia (*Proc. Soc. Ant.*, as above). He notes the value of the mines to Serbia.

[5] Millet, *as above*, p. 47. This art had been made 'official' by Frederic II in Sicily between 1240 and 1250.

[6] Millet, p. 49. It has been noticed (p. 50) that Thrace was christianized from Asia Minor.

the possession of mines, was with the Adriatic ports (p. 151). The link with the East was that of a common faith.

The second school is dominated by Byzantine influence. It began at the close of the thirteenth century, and flourished during the greater part of the fourteenth under Stefan Urosh I, his brother Stefan Urosh II, Miliutin (A.D. 1282–1321), whose second wife was the Byzantine princess Simonida, and their successors, including the famous Stefan Dushan (c. 1331–1355), who in the second part of his reign assumed the title of tsar. The orientation was now changed from the Adriatic to the Balkans, Salonika, and Constantinople; the development took place in the valley of the Vardar in territory taken from the Empire.

The third school belongs to the time of Turkish invasion after the Serb defeat at Kossovo in 1389. The Serb princes, pressed by the invaders, withdrew eastward into the Morava Valley, where they were still in touch with Constantinople. The school derives elements from both of its predecessors. From the first it takes the single-naved plans, its stone façades, and its Lombard blind-arcading; from the second the long nave and aisles, and construction in alternate zones of brick and stone. It seems to have borrowed from Mount Athos the trefoil east end with two lateral apses at right angles to the central one.[1] Ornament follows an inspiration common to that now prevalent in Greece, the sources of which are oriental; the parallels are to be found in Asia Minor, in the Caucasus, and in Russia.[2]

We may briefly note the principal churches belonging to these three periods, premising that although the classification is in the main chronological, it is disturbed here and there by intervention of local influences. For example, the Serb monastery of Chilandari on Mount Athos, built as early as A.D. 1196–1200 by Stefan Nemanya, and chronologically belonging to group I, is placed in group II because it is entirely in the Byzantine style and takes its place more appropriately with other monuments erected later under the same influence.

Group I: churches of the first school. The beginnings of this group are doubtless to be sought on the Lim and the Upper Ibar. The ruined church at Pavlitza, in the valley of the latter river, may be first mentioned, though its precise date in the twelfth century is undetermined.

At Kurshumliya (c. 1168 or c. 1190) the church has a single nave built in brick, and Western influence is not so apparent as at Studenitza (c. 1190 or 1196), where we find a doorway with receding orders, arcaded cornices, and columns resting on lions, which reveal Dalmato-Italian influences.

[1] This is the opinion of Millet, *as above*, pp. 152 ff. For this feature see p. 198. Choisy (*Hist. de l'arch.*, ii, pp. 61, 84) notes Armenian influence in Serbian architecture, and Strzygowski is of the same opinion (*Baukunst der Armenier*, &c., see Index, s.v. *Serbien*; and *Die bildende Kunst des Ostens*, Leipsic, 1916). He believes that the trefoil plan came to Mount Athos directly from the East and not through Constantinople. Serbian examples occur at Ravanitsa, Liubostina, Manassia, and Kusheviste. For a triconch at Cherson see below, p. 153.

[2] *Ibid.*, pp. 187 ff.

At Zhicha (*c.* 1207–1219), the coronation church, the tower at the west end, but for its modern cupola, would recall an Italian campanile; the dome and roofs are modern, and there is a large pronaos or ante-church. The original church at Pek (Ipek) is said to date from *c.* 1263.[1] Sopochani (1272–1276) also shows Western influence. At Arilye (*c.* 1290–1307) the Lombard arcaded cornice is conspicuous, but the plan is Byzantine.[2]

Group II: churches of the period of Byzantine influence. The Serbian monastery of Chilandari on Mount Athos for reasons stated above should be placed at the head of this group, though it is much earlier than most of the other buildings; it was built under direct Byzantine inspiration. S. Clement at Ochrida in Macedonia, built about A.D. 1295 on the site of a tenth-century church, may appropriately follow it.[3] The ruined church at Gradatz was erected about A.D. 1300 by Helen, the French queen of Urosh I; it has a façade uniting Dalmatian with French Gothic features, and a west door with pointed arch. Churcher is ascribed to the years between A.D. 1308–1316. The king's church, a royal chapel, at Studenitza, distinct from the earlier church at the same place in group I, is a small votive chapel erected by Miliutin about A.D. 1314, and remarkable for its mural paintings (p. 258). Nagoricha and Grachanitza (Plate XXV) on Kossovo, founded by Miliutin about A.D. 1321, are tall five-domed churches, conceived, as Millet remarks, under Byzantine influence, but in a different and national spirit. The existing patriarchal church at Pek (Ipek) was probably rebuilt by Miliutin. Dechani, near Pek in the Northern Albanian Alps, was erected for Stefan Urosh III, son of Miliutin, by Frad Vita, a master mason of Cattaro. In so far as its ornament is concerned, it should be placed in group I, for the whole exterior is banded in white marble and pink quartz, showing strong Italian influence; but its plan is Byzantine. Shasovitza (A.D. 1330), Ishtip (A.D. 1332), Liuboten (A.D. 1337), Lesnovo (A.D. 1340–1341), and Kushevishte (A.D. 1348?) are all of the time of Dushan or of his vassals. The Church of the Archangel at Kushevishte shows again influences from the north and north-east; Mateyicha, built by the Tsaritsa Helen at the end of Dushan's reign, is a five-domed church like Nagoricha, but conforming in its proportions more nearly to the Byzantine rule. The church of Marko Monastir at Sushica near Prilep (A.D. 1344–1345?), once famous for the royal portraits painted on its walls, shows various influences, some from the north and ultimately from Italy, others from Greece. The list for this period may be closed with mention of Matka, and of S. Nicholas and S. Andrew on the Treska.

Group III: churches of the Morava. The churches of this group are in the northern and central districts; with the exception of Lazaritza, they

[1] Millet, p. 61.
[2] Millet, p. 68, includes the church of Dechani in group I; its architecture shows Dalmatian influence. Its plan however being Byzantine, it is placed by Pupin in group II.
[3] A fire in 1924 is said to have damaged this monastery.

are of the Greek-cross plan ; a characteristic feature is the use of apsidal ends to the transepts, probably introduced from Mount Athos. Ravanitza near Kupriya, founded by Lazar about A.D. 1381, has five domes on high drums, and a richly decorated exterior with arcading, carved friezes and borders, traceried rose-windows and geometrical patterns in brick. Lazaritza in Krushevatz, about A.D. 1380, is a small palace church without aisles, the *chef-d'œuvre* of the architect Rade Borovik. Pavlitza, on the Ibar, dates perhaps from A.D. 1375–1380. Liubostinya, near Trstenik, is a foundation (A.D. 1394) of Militza, consort of Lazar ; on this building is the signature of Borovik ; the windows have trefoiled heads, but the ornament appears to have oriental affinity. Rudenitza dates from A.D. 1402–1406, after the Turkish check at Angora in the former year. Manassiya, near Svilaynar, with five domes, was built by the despot Stefan Lazarevich, son of Lazar, about A.D. 1418, as also was Kalenik in Central Serbia, about A.D. 1427. Vrakevshnitza near Kraguevatz was built in A.D. 1430 by a general of Lazarevich : here, as in earlier days, Dalmatian influence appears. Smederevo, or Semendria, on the Danube, was erected about A.D. 1440 by the despot Brankovich. Several of these churches are of the late Byzantine type in which the dome is supported on four pillars. Sir Arthur Evans has pointed out[1] how the retention by the despots of the silver mining district about Novobrdo supplied the wealth which explains the erection of such elaborate churches at this time, and how the end of the Serb state came only when Novobrdo fell in 1450.[2]

The general characteristic of later Serb architecture lies in its subordination of logic to charm, its sacrifice of sobriety and balance to height and to effect.[3]

Apart from early remains of basilicas of the Roman period in the Dobruja,[4] the ecclesiastical architecture of Roumania [5] (Wallachia and Moldavia) began in the thirteenth century, but the earliest surviving churches are of the fourteenth and fifteenth centuries, as the second church of S. Nicholas at Arges,[6] and the church at Nicopolis.

The church at Arges, restored in recent times, represents the single chambered type with trefoil end in which Strzygowski detects Armenian influence.[7] The trefoil also occurs at Jassy (S. Nicholas Domnese) and

[1] *Proc. Soc. Ant. of London, as above*, p. 16.

[2] The mines had been opened by Miliutin and Dragutin (Millet, *L'ancien art serbe*, p. 16).

[3] ' Les Byzantins cherchaient avant tout des proportions justes, d'élégants combinations d'équilibre, et marquaient la structure sur les façades. Les Serbes visent à la hauteur et à l'effet. Ils ne se soucient point de mettre en harmonie le plan et les lignes de l'extérieur ' (Millet).

[4] Leclercq, in Cabrol, *Dict. d'arch. chrét.* s.v. *Dobrogea*. R. Netzhammer, *Das Vaterland*, 1920 ; *Quer durch die südliche Dobrudscha*.

[5] N. Jorga and G. Bals, *Hist. de l'art roumain*, Paris, 1922, where are references to Roumanian articles and books ; the volume contains a chapter by M. Bals.

[6] Jorga and Bals, *as above*, p. 19.

[7] *Curtea Domnească din Arges*, Bucarest, 1923 (*Buletinul Comisiuni Monumentelor Istorice* 1917–23) ; Strzygowski, *Die bildende Kunst des Ostens*, 1916, p. 44. Choisy (*Hist. de l'architecture*, ii, p. 61) had noted Armenian affinities.

Bucovetz; its appearance in Roumania suggests a connexion with the architecture of the third Serbian period (above, p. 150).

Mount Athos. The churches of the monasteries upon Mount Athos [1] are remarkable for the apsidal termination of their northern and southern arms, recalling the *trichoros* plan. Some connect the general plan of these churches with that of the domed basilica; but Strzygowski regards the type as connected with that of Bagaran in Armenia.[2] He recalls the fact that Iviron is the Georgian monastery, and regards the three apses as an adaptation of the regular Armenian abutment. In his opinion it was probably introduced into Mount Athos by direct means rather than by the intermediary of Constantinople.[3] It has been noted that the trefoil plan occurs in other parts of the Balkan peninsula and in Greece.[4] Some Athonite churches have a double narthex preceded by a porch and flanked by two chapels with a gallery opening on the west end of the nave. A rectangular hall for Saturday prayers, known as *leti*, sometimes precedes the church, which it may actually exceed in size (Chilandari, late thirteenth century; Kastamonitu, fifteenth century; and most of the later churches of the sixteenth century, Stavronikita, Xenophon, Dochiaru).[5] The oldest churches on the Holy Mountain (Lavra, Iviron, and Vatopedi) date from the early eleventh century. Four others belong to the period between the thirteenth and fifteenth centuries; the rest are later than the fall of the Byzantine Empire. (For monastic buildings, see p. 130.)

It is believed by some scholars that the dome was early introduced into Dalmatia from the East, possibly by Alans as transmitters of Iranian influence: the evidence is derived from a small church at Nin (Nona) near Zara.[6] Jelitch thinks that between the fourth and sixth centuries such an influence prevailed on the Dalmatian islands.

Russia. The most ancient remains of Russian churches are at Cherson,[7] and appear to date from the sixth to the tenth centuries, though remains of an earlier date may be discovered. Most of the churches are basilican,

[1] Uspensky, *History of Mount Athos*, St. Petersburg, 1877–1892; Kondakoff, *History of Art on Mount Athos* (both in Russian); F. W. Hasluck, *Athos and its Monasteries*, 1924. Plans of all the churches in Strzygowski, *Baukunst der Armenier*, p. 769, fig. 724.

[2] A four-apsed square with interior support of four piers for the dome.

[3] *Baukunst der Armenier*, p. 770.

[4] In Greece in the case of the Holy Apostles, Athens; at Kalavyrta; Chrysapha, Hagia Triada, and Geraki.

[5] Millet, *L'École grecque*, p. 123. The feature may have been introduced from Serbia in the fourteenth century. It may be noted, however, that similar annexes of earlier date occur in Armenia.

[6] Jelitch, in *Proceedings of the South Slav Academy of Sciences*, xix, Agram, 1911 (in Croatian). Mention in *Byz. Zeitschrift*, xxii, 1913, p. 286, and Strzygowski, *Altai-Iran*, p. 253.

[7] E. H. Minns, *Scythians and Greeks*, pp. 508 ff.; a valuable summary of the Russian evidence previous to 1913, with reproductions of the plans; D. V. Ainaloff, *Monuments of the Christian Chersonese*, Moscow, 1905 (in Russian). Bishops from the Tauric Chersonese appear to have been present at the Council of Nicaea. The Goths, though not converted in the mass until the time of Ulfilas, had been made acquainted with Christianity through Cappadocian Christians in the third century (A. Harnack, *Die Mission und Ausbreitung des Christentums in den ersten drei Jahrhunderten*, 1902,

but several are of the free-standing cruciform type. The finest basilica, that excavated by Count Uvároff (*c*. 158 ft. by 88 ft.), has three aisles with a narthex, but only a single original apse ; it was paved with mosaic, and the apse was covered with vitreous mosaic with a blue ground. The walls showed in parts remains of fresco. On the south side was a baptistery of trefoil (triconch) plan, the three apses composing it having been also covered with mural mosaic with blue ground, the lower walls lined with marble ; the central space may have been domed. The evidence of coins suggests about A. D. 600 as the date of Uvároff's basilica and baptistery. A basilica of identical plan at the north-west corner of the city seems to have been built at the same period and to have been deserted in the tenth century ; a cruciform baptistery was connected with the north side. In the west of the town are the remains of a large basilica once lined with marble like the Ravenna churches, and with a good mosaic floor ; a much smaller and later basilica is entirely contained within the earlier nave. In the middle of the town is a group of churches including a three-aisled basilica with single apse, and a church of free-cross plan originally roofed with timber, but with a vaulted *diakonikon*. A more remarkable free-cross church was explored in 1902.[1] This church, like that last mentioned, was timber-roofed except for a *diakonikon* in the south-east angle of the cross, which was vaulted. The interior walls were decorated with mural paintings on which are inscriptions in Greek and Armenian.[2] The floor had a fine mosaic of interlaced circles containing fruits and vases ;[3] the date assigned is A. D. 525–550. In 1906 a church apparently of Greek-cross plan was discovered, coins of Romanus I suggesting that it dates from the tenth century.[4] There was a central dome, but the limbs of the cross and the angle-chambers seem to have been roofed with timber.

Most of the above churches belonged to the Greek colony of the period before the conversion of the Russian people. They present certain peculiarities in the combination of two modes of roofing in the same building, but it is clear that vaulted roofs were being constructed in the sixth century. We may note the trefoiled baptistery, and the occurrence of Armenian inscriptions on the free-cross church examined in 1902.

With the close of the tenth century and the final conversion of the Russians under Vladimir[5] a new period of church building began in the valley of the Dnieper and in the farther interior of the country, the greatest founder of churches being Yaroslaff (A. D. 1015–1054), son of Vladimir. If the church of the Annunciation at Vitepsk is to be attributed, as

p. 493). We should therefore expect the earliest Christian remains in Russia, like those of Bulgaria, to show affinities with the architecture of Asia Minor, North Mesopotamia, and Armenia.

[1] Minns, p. 512, where the Russian references are given.

[2] *Bulletin de la Commission Impériale Archéo-* *logique*, ix, pp. 15 ff., 37 ff.

[3] *Ibid.*, pl. iii ; Ainaloff, fig. 81.

[4] *Compte-rendu de la Commission Impériale Arch.*, 1906, pp. 66 ff., 73 ff. ; Minns, p. 513.

[5] Before Vladimir, there had been approaches to Christianity, and individuals had been converted.

Russian authorities hold, to the time of Olga, this is the earliest Russian church in the Byzantine Greek-cross plan, for its date would be the year A.D. 974.[1]

More certain are the dates of S. Saviour, Chernigoff (A.D. 1031),[2] S. Sophia, Kieff (A.D. 1037),[3] S. Sophia, Novgorod,[4] and other churches at that place, S. Sophia at Polotsk,[5] the church at Pskoff, and other churches of the eleventh and twelfth centuries all of which belong to the 'Byzantine' tradition. The most famous is the cathedral of S. Sophia at Kieff, which is remarkable for the number of its aisles, an original five, recalling the church at Mokvi in Georgia, being extended by two more on each side, and giving the church an extraordinary breadth.[6] This tendency towards lateral extension is also to be noticed in the Michailovsky cathedral at Kieff, and at S. Sophia, Novgorod.

It has been observed above (p. 75) that the early stone churches of Russia of the time between the conversion of Vladimir and the Mongolian invasion fall into two groups—one in the western half of the country as far as Novgorod and dating from the first half of the eleventh century, influenced from Constantinople; the other in the eastern half as far as Vladimir, Suzdal and Moscow, influenced more directly from Georgia and Armenia. The above influences are not mutually exclusive, for it is expressly stated that the builders of the first group were drawn not from Constantinople alone, but from all parts. Thus the cathedral of Kieff, as already noted, has affinities with the church of Mokvi,[7] which is in its turn related to Armenian churches of the type of that Odzun (Usunlar) built in the eighth century. The old churches of Vladimir, Suzdal and Moscow, belonging to the twelfth century,[8] show the constructional methods used in the Caucasus, Armenia, and Asia Minor; rubble walls have a stone facing.

The Mongolian invasion of A.D. 1224 put an end to the construction of churches in Russia, except at Novgorod and Pskoff, which were not occupied by the invaders; the later period of construction began at Moscow in the fourteenth century.[9] Of special interest in later medieval ecclesiastical architecture are the domed wooden churches of the Ukraine. These seem

[1] A. Pavlinoff, *History of Russian Architecture*, Moscow, 1894, pp. 41 ff.; Millet, *L'École grecque*, p. 227.

[2] Pavlinoff, pp. 6–14.

[3] *Ibid.*, pp. 16 ff.; Kondakoff–Tolstoi, *Russian Antiquities*, iv, pp. 113 ff.; Grabar, *Hist. of Russian Art*, 1909, p. 145 (in Russian); *Kievskiy Sof. Sobor*, pl. i, ii; Ainaloff and Riedin, *Cathedral of S. Sophia at Kieff* (in Russian); Th. Schmidt, *Kieff Cathedral of S. Sophia*, Moscow, 1915, and *Art of Early Russia : Ukraine*, 1919, pp. 36 ff. (in Russian); Millet, *L'École grecque*, p. 135.

[4] Pavlinoff, pp. 23 ff.

[5] Pavlinoff, pp. 50 ff.

[6] Th. Schmidt, *as above*. For Mokvi, Strzygowski, *Baukunst der Armenier*, p. 846; Uvaroff, iii, p. 14; Brosset, *Descr. générale de la Géorgie*, p. 401 and Atlas, pl. 35.

[7] Kondakoff–Tolstoi, *Russian Antiquities*, iv, p. 55; Strzygowski, *Baukunst der Armenier*, p. 848; Millet, *L'École grecque*, p. 227; Choisy, *Hist. de l'Architecture*, ii, p. 61.

[8] Kondakoff–Tolstoi, vi; Pavlinoff, pp. 55 ff.

[9] Pavlinoff, pp. 113 ff.; *Byz. Zeitschr.*, 1924, p. 492 (a summary of N. Brunoff's studies).

to have preserved old traditions of domed construction in wood, perhaps originating in Central Asia.[1]

Italy. Much in the controversy between the oriental and Western schools in Christian archaeology depends upon the origin of the great Thermae.[2] According to Rivoira, the Baths of Diocletian sum up all the principles of construction and statics attained by imperial Rome, and they are the creation of Italian genius. According to Strzygowski, the whole inspiration comes in the first instance from the Christian East, but ultimately from the North Iranian area ;[3] in his opinion, oriental architects themselves erected the great vaulted buildings in the Western capital.[4] We cannot follow the controversy over the whole field of imperial Roman architecture ; it is only possible to deal in a summary way with certain churches and mausolea, chiefly at Rome, Milan, and Ravenna.

The Roman basilicas[5] have been discussed to weariness in many volumes ; and since they are all timber-roofed, from the constructional point of view they are of secondary interest. In the round church of S. Stefano Rotondo, also timber-roofed, the methods of the basilica are applied to a circular plan ; such buildings are, again, of minor significance. Even a domical building over a circular plan shares this relative unimportance. S. Costanza is a domed building with a drum of exceptionally early date, but the dome is not over a square and the great constructional problems are not raised (p. 80). From the point of view of development, the churches of Milan and Ravenna are more interesting than those of Rome. In the former city,[6] S. Lorenzo shows a quatrefoil plan with an interior octagon having eight piers, between which are columned exedrae. Some have explained the origin of the type by supposing the niches of solid walls pierced.[7] On the other hand, Strzygowski sees in San Lorenzo a later member in a chain which begins in an Armenian type like Zwarthnotz,[8] and has an intermediate link in the Red church at Perushtitza (Philippopolis) in the territory of modern Bulgaria, which, as above noticed, was a region christianized at an early period from the opposite shore of Asia Minor. A filiation is clear between these churches and S. Vitale at Ravenna, and the cathedral of Aix-la-Chapelle.[9] In San Satiro at Milan (late ninth

[1] Strzygowski, *Christian Church Art*, pp. 46 etc. ; Pavlinoff, pp. 209 ff. ; Th. Schmidt, *Art of Early Russia : Ukraine*, as above.

[2] Rivoira, *Journal of the British and American Arch. Soc. of Rome*, iv, pp. 353 ff.

[3] *Baukunst der Armenier*, p. 30.

[4] *Ibid.*, p. 737.

[5] H. Holtzinger, *Die altchristliche Architectur*, 1889 ; Dehio and Bezold, *Die kirchliche Kunst des Abendlandes*, 1884–1899 ; H. Leclercq, article ' Basilique ' in Cabrol's *Dict. d'arch. chrétienne* (with bibliography).

[6] It is recalled that S. Ambrose entertained close relations with the Eastern Fathers, who, as we know from the case of Gregory of Nyssa (p. 136), were both interested and competent in matters of church construction. Milan was capital of the Roman Empire in the West between A.D. 293 and 404.

[7] Monneret de Villard, in *Archivio storico lombardo*, xli, 1914, and *Politecnico*, nos. 11 and 12, 1911.

[8] *Baukunst der Armenier*, pp. 100, 776.

[9] S. Lorenzo is also held to offer points of comparison to the martyrion of Rusāfah (p. 135), and the church of the Virgin at Diyarbekr.

century)[1] Strzygowski sees similar Armenian connexions. Its original plan did not go beyond the square with four apse-buttresses and a central dome supported on four piers. This is the type of Bagaran, in Strzygowski's view transmitted to the West by Armenian builders in the train of the Goths.[2]

At Naples the baptistery (S. Giovanni in Fonte), built by Bishop Soter after A. D. 465, is remarkable for having a dome over square plan with squinches.[3] Rivoira, stating this to be the oldest building with squinches now standing, claims the invention of the squinch for Italy. For Strzygowski, on the other hand, who believes the squinch to be Iranian, this early occurrence of the feature at Naples is merely a natural result of the constant relations between Campania and the East.

At Ravenna, the basilicas of S. Apollinare Nuovo and S. Apollinare in Classe are of the Hellenistic type, with timber roofs. The domed buildings are the two Baptisteries (of which one copies the other), S. Vitale, and SS. Nazaro e Celso, otherwise the Mausoleum of Galla Placidia. The Orthodox Baptistery, or S. Giovanni in Fonte,[4] built in the fifth century, is an octagon, the dome of which is covered by pottery tubes fitting into each other and disposed spirally. In S. Vitale[5] (finished A. D. 547), an inner octagon, above which is a gallery, is supported on eight piers, with intervening columned exedrae, as in the case of S. Lorenzo at Milan, Zwarthnotz, and their group (see above). The exedrae open into a broad aisle enclosed in a walled octagon ; there is a narthex with round ends in which are the staircases leading to the gallery. The dome, constructed of pottery tubes like that of the Baptistery, is carried by squinches. Rivoira sees in the building few but Roman features ; Strzygowski, pointing to the obvious affinities of Ravennate art to that of Northern Syria, recalls the octagons of Gregory of Nyssa and Gregory of Nazianzus in Cappadocia, and those mentioned above in connexion with S. Lorenzo at Milan. SS. Sergius and Bacchus at Constantinople, a contemporary church, is closely analogous to S. Vitale, but is externally square. The Mausoleum of

[1] Cattaneo, *L'arch. in Italia dal secolo VI al Mille circa*, p. 210 ; Strzygowski, *Baukunst der Armenier*, p. 769.

[2] As S. Germigny-des-Prés, see pp. 73, 102, 109. The type is found in the eleventh-century church of the Apostles at Athens, which may represent an intermediate stage; also in monastery churches of Mount Athos (*Baukunst der Armenier*, as above).

[3] Rivoira, *Lombardic Architecture*, p. 192 ; Venturi, *Storia dell' arte italiana*, i, pp. 70, 126 ff. ; Dehio and Bezold, *Kirchliche Baukunst des Abendlandes* ; H. Leclercq, article 'Baptistère' in Cabrol's *Dict. d'arch. chrétienne*, § xxi ; Strzygowski, *Kleinasien, Christian Church Art*, &c.

[4] Rivoira, *Lombardic Architecture*, p. 37.

[5] Rivoira, *as above*, p. 56. Rivoira thinks that S. Vitale may have been suggested by baptistery types, or by the plan of the Minerva Medica (the Licinian Nymphaeum) by addition of the octagonal outer wall. He considers SS. Sergius and Bacchus at Constantinople a derivative of S. Vitale (pp. 67, 81). He admits, however, that some of the decoration of S. Vitale is due to Greek artists. Strzygowski's opposite opinions will be found in his books, *Orient oder Rom*, p. 138 ; *Der Dom zu Aachen*, p. 29 ; *Altai-Iran*, p. 290 ; *Baukunst der Armenier*, &c. He holds that S. Vitale reproduces the plan of the Octagon built by Constantine at Antioch. For excavations on the site in 1914 see *Byz. Zeitschr.*, 1923, p. 241.

Placidia, who died A.D. 450, is a small cruciform barrel-vaulted building with a cupola on spherical or continuous pendentives, and constructed with pottery tubes, concealed on the outside by walls and a pyramidal roof : the type is held to be sepulchral, and derived from such cruciform catacombs as those at Palmyra.[1] The continuous sphere is discussed on another page (p. 85). The tomb of Theodoric,[2] built about A.D. 519, is a decagon in two storeys, the upper perhaps formerly enriched by a surrounding loggia. The cupola covering it, thirty feet in diameter, is not a constructed dome but cut from a single block of limestone. Rivoira believes in a Roman inspiration ; the more general opinion is that the methods employed are Eastern.[3]

The researches of Orsi,[4] supplemented by those of Freshfield,[5] have made us acquainted with many early churches in Sicily. In the south-east, in the region of Syracuse, there is a barrel-vaulted basilica (S. Foca) near Priolo, north of Syracuse, which Orsi would date before A.D. 535, and at Vigna del Mare are free-standing cruciform domed churches ; at Maccari a 'triconch' church resembling S. Elias at Salonika, but without atrium, is considered by the same scholar to date from the period between the sixth and eighth centuries. A curious half-subterranean church near Syracuse, with the tower of La Cuba built over it, has also a trefoil of apses with central dome : Freshfield is inclined to connect these trefoil buildings with those in Tunisia (p. 108), but others look towards the East. Orsi points to the conflict of Roman and Byzantine influences in the island, the latter definitely prevailing after the time of Gregory the Great.[6]

In the later medieval period Sicily affords interesting examples of fusion of styles in the churches of Palermo[7] and Cefalù. The Cappella Palatina has a basilican nave with timber roof and a choir with dome upon squinches ; all the arches are pointed ; the details and the inscriptions are oriental. The cathedral of Monreale has a basilican plan, timber roof, and no vaulted work other than that in the apses. The Martorana has a dome upon squinches, all its arches being pointed.[8] The churches of Calabria may be mentioned in connexion with Sicily. La Roccella, at Squillace, is discussed at length by Strzygowski.[9] It is compared with Tekfur Serai at Constantinople by Freshfield,[10] who also notes other churches at Gerace, Stilo, and Rossano.

Sardinia[11] possesses in S. Gavino a basilican church, the exterior ornamented with blind arcades, ascribed to the eleventh century, but with

[1] *Orient oder Rom*, pp. 11 ff.

[2] Rivoira, *Lombardic Architecture*, p. 53 ; Venturi, *Storia dell' arte italiana*, i, p. 82.

[3] Strzygowski, who mentions the tomb in more than one of his works, takes this view.

[4] *Byz. Zeitschr.*, vii, 1898, pp. 1 ff. ; viii, pp. 618 ff.

[5] E. Freshfield, *Cellae trichorae*, &c., i, 1913.

[6] *As above*, viii, p. 642.

[7] Freshfield, *as above*, discusses the Sicilian domed churches with squinches in Palermo and district.

[8] Choisy, *Hist. de l'Architecture*, ii, p. 63.

[9] *Kleinasien*, pp. 220 ff.

[10] *Cellae trichorae*, 1913.

[11] *Byz. Zeitschrift*, xxiii, 1914, p. 342.

remains of an earlier period. S. Giovanni in Sinis is a three-aisled barrel-vaulted church with a low cupola before the apse, the type recalling that of the principal church at Deir Es-Suriâni in Egypt, and suggesting to Strzygowski North Mesopotamian and Armenian affinities.

Gaul and Spain : Britain. Late writers, such as Sidonius and Gregory of Tours, supply evidence that stone-built churches were being built in Gaul during the fifth and sixth centuries under Visigothic and Frankish kings : most of the churches were probably timber-roofed basilicas. For us the chief centre of interest lies in Visigothic architecture because of the possibility, urged by Strzygowski, that churches with vaulted roofs and even with domes over square bays may have been erected by this people, who in his view were accompanied in their journey into the West by oriental builders, presumably Armenians.[1] There seems literary evidence to show that the Goths were builders in stone, and that they were capable of erecting considerable buildings without Roman aid ; nor need the theory that oriental builders followed the Goths be regarded as impossible. But, as in the case of Armenia, actual buildings of the required early date fail us. The churches brought forward in evidence are all of the ninth century, when the Franks had long been masters in France, and the Arabs in Spain. We have alluded above to the domed church of S. Germigny-des-Prés near Orleans (built A. D. 806),[2] in which Strzygowski sees the plan of Bagaran. Mention has also been made of the early barrel-vaulted churches in Spain belonging to the same century—the Cámara Santa at Oviedo, S. Miguel de Lino, S. Cristina de Lena, and S. Maria de Naranco, S. Salvador, Val de Dios near Villa Viciosa. There seems little doubt that in all these buildings we have examples of vaulted roofs anterior to the time of Lombardic influence ; the question is, to what extent they are real prototypes of Romanesque or isolated appearances without influence on later development.[3] The arrangement of a sanctuary at Oviedo, with three apses preceded by a transverse bay, has reminded more than one writer of the old vaulted churches with transverse naves in the Tûr 'Abdîn.

In Britain, though subterranean vaulting was known in the time of

[1] *Altai-Iran*, p. 288 ; *Baukunst der Armenier*, p. 46. Cf. p. 62.

[2] Prévost, *La basilique de Théodulf*, 1889 ; C. Enlart, *Manuel d'archéologie française*, 1902, p. 68 ; A. Michel, *Hist. de l'art*, i, pt. i, p. 324 ; P. Clemen, *Die romanische Monumentalmalerei in den Rheinlanden*, 1916, pp. 54 ff., with a full bibliography of books and articles relating to the church ; Strzygowski, *Baukunst der Armenier*, p. 767 ; *Die bildende Kunst des Ostens*, p. 47 ; *Altai-Iran*, p. 290 ; Rivoira, *Lombardic Architecture*, pp. 54 ff. ; Dehio and Bezold, *Kirchliche Baukunst des Abendlandes*, pl. xli ; Leclercq, in Cabrol, *Dict. d'arch. chrét.*, fasc.

lxi, col. 1222.

[3] Lampérez y Romea, *Historia de la arquitectura cristiana-española en la Edad Media*, Barcelona, 1906, vol. i ; and *Revue hispanique*, xvi, Paris, 1907 ; C. Enlart, *Manuel d'archéologie française*, 1902, p. 168 ; M. Dieulafoy, *Espagne et Portugal*, 1913, pp. 58 ff. ; Rivoira, *Moslem architecture*, pp. 329 ff. ; Strzygowski, *Baukunst der Armenier und Europa*, p. 777 ; Dehio and Bezold, *Kirchliche Baukunst des Abendlandes*, vol. i ; Haupt, in *Zeitschr. für Gesch. der Architektur*, iv, 1911, and *Monatshefte für Kunstwiss.*, 1916, p. 242 ; Rivoira, *Moslem Arch.*, pp. 329 ff., 342, 351.

Bede, churches, whether basilican or not, were timber-roofed down to Norman times, when the vault was introduced from France. The oldest remains are those of the small fourth-century basilica at Silchester,[1] followed at some interval by those of basilican churches erected in the time of Augustine and in the seventh century by Benedict Biscop and Wilfrid in Northumbria. The basilican plan was ousted after the seventh century by the plainer Celtic plan with a single nave, preferred by the Anglo-Saxons.[2]

In Germany, the church of S. Maria im Kapitol at Cologne[3] deserves special notice. It is a trefoil-ended structure of the eleventh century, which may perhaps be brought into relation with S. Lorenzo at Milan, thus sharing at a second remove in oriental features possessed by that church. In Bohemian and Austrian churches Strzygowski would also trace Eastern characteristics.[4] In Austria, attention may be drawn to the remains of early churches (fourth to sixth centuries) in the territory of the ancient Noricum, now Carinthia and Tirol.[5]

[1] *Archaeologia*, liii, 1893, p. 563.

[2] Micklethwaite in *Archaeological Journal*, liii, 1896, pp. 319 ff. For Saxon churches in general see Baldwin Brown, *The Arts in Early England*.

[3] H. Rahtgens, *Die Kirche S. Maria im Kapitol in Köln*, Düsseldorf, 1913.

[4] *Baukunst der Armenier und Europa*.

[5] R. Egger, *Frühchristliche Kirchenbauten im südlichen Noricum*, in Sonderschriften des Oesterreichischen Arch. Inst. in Wien, ix, 1916. Cf. *Byzantinisch–Neugriechische Jahrbücher*, i, 1920, p. 406.

III

SCULPTURE

THE changed outlook on the world which at the beginning of the Christian era began to impose new principles of vision on the art of the Mediterranean countries produced its most remarkable effects in the field of sculpture. Its wide acceptance brought a change into the character of glyptic art, as known and practised by the Hellenes. The Greeks had conceived the human figure tactually, as a shape in a sharply defined cubic space; if they represented it in relief, they gave it close and visible relation to a material background by which it was connected with other figures. In the new art which superseded the Greek, even the free-standing figure was conceived as far as possible in two dimensions; in reliefs, each figure was isolated against a ground of space without apparent limit, and deprived of all the old material and tactual relations. This treatment of space as something infinite and dissociating was abhorrent to the Hellenic mind; still more, the notion of it as an independent element with an almost objective existence of its own, placing it on an equality with the subject to the contour of which it gave precision. The Hellene had defined his modelled forms by half-shadows which, in the case of reliefs, did not conceal the evident background. His work, based on tactual presuppositions, was calculated to produce its effect at short or at normal distance; as a rule, it impressed its details upon spectators attentively regarding it from near at hand; it made demands upon the intellect. The aim of the orientalizing sculptor was different. He purposely renounced the tangible and material background visibly connecting the figures, in order to adopt in its place an opaque shadow, indefinite in depth, and visibly cutting them off from each other. His work was done not for attentive contemplation by people standing near, but for the rapid and comprehensive view of spectators placed some distance away. He did not define modelled figures by a penumbra, but circumscribed flat figures with sharply contrasting shadow. He diminished all relief, at the same time narrowing and intensifying shadow until it became a black isolating contour-line round a pale form. The nice feeling for proportion which accompanied the Greek plastic sense was no longer essential; to the eye passing swiftly over superficial forms grace ceased to be a factor. The detachment of the figures against ideal space was the primary aim of the sculptor, who tended more and more, as the fourth century passed into the fifth, to reduce

the number of figures in order that the effect of isolation might be enhanced. He sought the striking, the instant impression produced by the whole scene, aiming not at tactual, but at optical effects. His appeal was less intellectual and deliberate than the Greek; it was simpler, swifter, and more directly sensuous. It must be compared to that made by orientalizing ornament (Ch. VI).

The progress of these changes is visible in reliefs and free sculpture from the time of the Antonines onwards; the new style was defined in the time of Constantine and fully realized in that of Theodosius. This steady and prolonged movement in one direction is too systematic to be explained as mere decay, though some may regard it rather as the resumption of an art more primitive than that of Greece and Rome, but instinct with rude virility. It was ascribed by Riegl to a revolution of taste within the limits of the Graeco-Roman world,[1] but it will be gathered from what has been said in earlier pages that the real cause is more probably an invasion from without, an oriental influence at first permeating and modifying late-Hellenistic art, then reaching a more open expression at the time when Christianity was preparing to expand through the ancient world. It need not be supposed that the adoption of a new means of expression was always a fully conscious process; the sculptors were instruments actuated by the spirit of their age and the general influence of their environment; the principles behind their procedure were not formulated in their minds. This does not alter the fact that the presence of these principles involved movement along a determined line, which is not the same thing as passive decadence.

It is important to consider in more detail the operation of these principles upon sculpture in the round, and upon reliefs.

Before the Eastern mode of vision, which was without understanding of perspective,[2] there lay, not a world of objective shapes in three dimensions but a scheme or pattern of coloured silhouettes. These it regarded as flat; they might have been pressed forward against an ideal vertical plane, as it were, against the glass of a high window. The art proper to such a vision was one of geometric and surface-covering design in line and colour; the relation of the several parts to each other was not plastically conceived by a spectator within touching distance, but optically determined from a point further removed. It is clear that a system embodying such principles could not retain the statue. The free positions of Greek art were denied to silhouette-like forms aligned against an ideal vertical plane, straight-kneed, and planted upon both feet in a rigidly frontal pose. If gestures were desired, they must needs be lateral,[3] not forward or backward; otherwise the

[1] The work of Riegl must always command respect. Whatever may be thought of the explanation which he offered, he discerned central facts. His analysis of sculpture will be found in his *Spätrömische Kunstindustrie in Oesterreich-Ungarn*, 1901, chap. ii.

[2] The appreciation of true perspective is only possible to minds brought up in a certain intellectual culture; it is not a necessary consequence of sight, but an illusion determined by reflection.

[3] The statues of the fourth century already show us the 'semaphore movement' of the arms.

plane would, so to speak, be broken through. The statue was eliminated by the action of aesthetic principles themselves; the process was aided by a popular antipathy to ' graven images ' on the part of a large oriental population, but was not initiated by it.[1] The rare free-standing figures and the rather more numerous portrait-busts dating from the period between the fourth century and the later sixth are naturally affected by these adverse influences. Their life was prolonged by the individuality and character which they derived from the vivid interest in personal existence accompanying the new religious belief. The individual with his hope in a life beyond the grave was now more important than before; the idealized Hellenic types gave place to realistic portraits which appealed with especial force to the Semitic mind. In Christian art the prime mover in this direction was probably the Aramaean, ever demanding the real, and seeking the inward significance behind or beneath the physical appearance (p. 7). The oriental religions which had been thrusting back Hellenic mythology all recognized the importance of the individual soul, and their growing power both in East and West could not but react upon the art of those who obeyed their inspiration. Their influence reinforced the new mode of vision in its indifference to grace and beauty. It favoured the characteristic rather than the normal or the ideal; and the individual at its most characteristic is less often beautiful than the reverse. The realism introduced by Aramaean influence into East Christian sculpture often led, in the above-named period, to what seems a positive cult of the unpleasing. The sculptor, in his desire to bring out a personality, concentrated his attention on the head; the articulation of the limbs and their essential relation to the draperies was but imperfectly understood. This part of his work became flat, and the lines of the folds formed a pattern without logical connexion with the body.[2]

The action of these optical principles upon reliefs was fundamentally the same as that upon free sculpture. In those presenting a subject rich in intellectual content violence was necessarily done to Greek tradition. There was a drastic flattening down of salient parts, modelling was reduced to a minimum, or its effect suggested by increased sharpness of contour. All sculpture grew more linear, the logical end of the process being the graffito, or engraving in stone. The oriental treatment of figures in groups which a ' scientific ' vision would dispose in receding planes had very interesting results. The adoption of an ideal vertical plane to which all figures must be uniformly applied, led to the elimination of scenery, and to the abolition of the tactual background. The figures were ultimately conceived in the

[1] Still less by any ecclesiastical prohibition. The definite ban was not imposed by the Orthodox Church until 1453, probably through Mohammedan influence.

[2] The one part of the body where high relief continued was the head, since it was through facial traits that the realistic element in Chris- tian art expressed personality. The heads thus tend to have more salience than the body and limbs, as in the case of the principal figures on the base of the obelisk of Theodosius at Constantinople (O. Wulff, *Altchristliche und byzantinische Kunst*, p. 167).

detachment of ikons, unrelated except by the common direction of their eyes upon the spectator; the scene was made consciously theatrical, the figures acting for an audience. But now came the problem of the elaborate scene with figures too numerous to stand in a single line, the kind of scene in which the commemorative art of the fourth and fifth centuries demanded. How, on the above principles, present the secondary persons which true perspective rendered on a reduced scale in receding planes? The only possible way was to build up the scene against the ideal vertical plane, placing a second zone directly above the first, and, if necessary, a third above that, until the horizon approached the upper border; this is the method conveniently described as ' vertical projection '.[1] The figures of the upper zones, as full sharers in the action, tend to a certain equality in size with those below. When marked reduction occurs, it is to accentuate the importance of the principal actors, always placed in the middle, and is often most drastically applied to figures in the foreground. This procedure, often called ' inverted perspective ', produces results exactly contrary to those of true perspective; it is, indeed, based on considerations independent of aesthetic values. However strange and primitive these methods may appear to those in the habit of considering figures in perspective, within their limits they are effectual. Their simplicity answers to spontaneous emotion. They bring the scene before the eye with astonishing vividness, and produce a general impression which captivates the spectator against his will; their disconcerting effect is in part due to the representational duties forced upon them by a power to which didactic utility and not art was the first consideration;[2] they were not made for representation. They impress us, despite a prejudice against them natural to classic traditions. That they do so is a proof that there is something forceful and purposed in them; the products of mere barbarism and decay could not thus compel our attention and extract from us a half unwilling recognition.

The reliefs of the third century, notably the pagan sarcophagi, illustrate the first rapid advance of optical methods. The severe classical composition breaks up; the figures overlap each other; they cover the whole surface, to the concealment of the old tactual background; they not only run together in a kind of continuous pattern, but begin to rise above each other in a manner which in fact begins vertical projection. The contact of the individual figure with the background is abolished; contours are undercut or surrounded by deep lines; the process of detachment and isolation makes rapid advance.[3] With the fourth century, relief flattens, though in regions such as Lydia, where Greek influence was particularly strong, the

[1] Late Greek sculptors were able to effect a compromise which lent a natural semblance to this projection. Behind the figures they introduced a steep hill on which those above and those below could alike stand, a device which had also been employed in Assyrian reliefs.

[2] That is, by the great religious and political organizations of Church and State.

[3] Riegl, *Spätrömische Kunstindustrie*, ch. ii.

old glyptic tradition held its own with stubbornness. Elsewhere, the oriental vision triumphs all along the line. Its principles are visibly at work in the secular memorial sculpture of triumphal arch and column. This historical art, through which the Hellenism of Asia transmitted ideas absorbed from the tradition of the ancient monarchies, reveals the Eastern influence in its strength as early as the time of Diocletian, and during the fourth century its new practice progressively displaced the tactual method of the Greeks. In the hundred years between the arch of Galerius at Salonika (p. 191) and the base of the obelisk of Theodosius at Constantinople, we follow the rapid supersession of the old mode of expression by the new.

If in secular reliefs Eastern realism and Eastern optical methods had transformed official sculpture by the reign of Arcadius, in religious reliefs the process was yet more decided. Even the classical style characterizing the sarcophagi of the Lydian group (p. 182) did not hold its own when the workmen began to serve Christian patrons. In the fifth century the sign-manual of Antioch, transmitted, perhaps, through Constantinople, lies on much of the sarcophagus sculpture of Ravenna, and the drums of capitals at Constantinople, with Christian subjects framed in vine-foliage, are typically Syrian in their treatment. In the sixth century, the figures lose salience ; in the seventh, a linear convention approaches the manner of the graffito.

The fifth century witnessed the climax of Christian figure sculpture upon the monumental scale. With the increase of ' storied ' mural painting, and above all of mosaic, it was found that the new mode of vision was better and more easily served by the painted than by the sculptured figure. In the art of the Church, attention was concentrated more and more upon the decoration of great interior wall- and roof-spaces ; the art which worked primarily with colour and line was here supremely adapted to the required task ; it executed the far-seen subject at such an advantage that no representational sculpture, however optical its processes, could hope to rival it with effect, though the stucco figures on the walls of the Orthodox Baptistery at Ravenna show us that the attempt was made. The palace and the public building were decorated in a similar manner to that adopted in the church ; their walls were covered with colour, marble lining below, mosaic or painting above ; salience and relief fell everywhere into a secondary place. Sculpture was indeed used for subsidiary purposes, such as the enrichment of capitals and closure slabs. Here it was rarely figure sculpture, even when living creatures entered the decorative scheme, but a non-representational system of design, producing its effect by contrast of light and shadow ; it became wholly ' coloristic ', but in variety of colour was eclipsed by the changing splendours of mosaic. It was perhaps only outside the building, in the open air, that sculpture really held its own. It could bear the effects of weather better than its rivals, and in the brilliant

sun of the East its black-and-white effects were admirably successful. As the associate of architecture, it enjoyed a well-deserved popularity during all the Byzantine periods, enriching doorways, windows, and other features with finely conceived designs in which oriental decorative principles completely triumphed. Figure sculpture had no such durable or wide success ; but if circumstance had been less unfavourable, it might yet have flourished, for sculpture is the natural adornment of buildings.[1] The reliefs with idyllic or mythological subjects, such as they were, which embellished the houses of Byzantine nobles do not really belong to East Christian art ; they were survivals of pagan-Hellenistic imitative modelling partly kept alive by a special literature.[2] Speaking generally, we may say that figure sculpture, though it long survived[3] in metal as well as in stone, fell into a secondary position before the Arab wars. The functions of sculpture as a craft of stone-workers and as the close ally of architecture were left to that branch of it which abandoned the human figure for geometrical design.

After this summary of the influences controlling the development of sculpture in the Christian East, a few words may be said as to the contemporary action of the same influences in adjoining countries where Christianity never predominated. In Southern Iran, under the old Achaemenian dynasty overthrown by Alexander, influences from Ionia had blended with others of Assyrian origin, to form an art which celebrated divinity and kingship. In Parthian times a later Greek art, active in various centres of Hither Asia, introduced the Hellenistic manner with its easy fluency and its naturalism. The establishment in A.D. 226 of the national Sassanian dynasty in the south (Persis) led to a modification of Greek influence. The methods of the older Iran were restored for the glorification of the new royal line ; the kings were represented engaged in ceremonial acts and in the pleasures of the chase. But in this restoration the style is modified in the Greek direction. The spirit and the idea are instinct with the religious and monarchic sentiment of Asia, but the form is more definitely affected by Western influence than it had been in Achaemenian times ; in the earlier Sassanian period, in the third and fourth centuries, we see an art which has plainly borrowed from Hellenistic or even Graeco-Roman sources. The costumes of the mounted royal figures are strictly Persian, but the forms and movements of men and animals are based upon an imitation of nature in the Hellenistic fashion ; in the ceremonial scenes, Greek contribution is

[1] As Gothic sculpture flourished, which is also conceived on optical principles, and intended for distant view.

[2] The history of Byzantine literature as a whole is sufficient evidence for a Hellenizing spirit. But there were also books concerned specially with the praise of Greek art, or containing whole passages devoted to descriptions of individual objects (ἐκφράσεις). Such was the Εἰκόνες of Philostratus, the method of which was reproduced by Byzantine writers down to the late times of Manuel Philes. The persistence of these works renders probable an equally persistent imitation by artists of Greek and Hellenistic models.

[3] Cf. J. Ebersolt, *Arts somptuaires de Byzance*, pp. 58, 131.

less obvious. In course of time Sassanian art to a great extent freed itself from Hellenistic tutelage. With the fourth century sculpture became more formal ; we have seen that the oriental mode of vision, with the spread of which Iran was actively concerned, had now changed the outlook of the sculptor even in Hellenistic countries ; it was inevitable that the art of a national royal house in Persia should feel its influence even more. But the Greek and the native elements seem still to have existed in a certain independence side by side, a fact perhaps to be explained by the presence of Greek settlements in Asia holding tenaciously to their old tradition (pp. 2 ff., 37). It has been noticed above that the mural paintings of Quseir 'Amra show us Greek and Iranian subjects in the same building (p. 261) ; it is evident that an unabsorbed Hellenistic art persisted late in Iranian territory, and in considering the conditions under which Early Christianity lived in Persia account must be taken of this.

The conditions affecting art in Bactria have been mentioned above (p. 37) ; we infer a persistence of Hellenistic influence after the overthrow of the local Greek monarchy. From whatever source it issued, whether from Bactria, Seleucia, or even Antioch, a purely Hellenistic style dominated the sculpture on the Buddhist monasteries and stūpas of Gandhāra beyond the Hindu Kush. The subjects are Buddhist, though Greek influence has introduced the representation of Gautama in human shape ;[1] the forms and the composition are Greek. From Gandhāra this Hellenizing sculpture entered Chinese Turkestan, where, in the sites explored by the European expeditions of recent years, many stucco and clay figures or reliefs reveal by their style their Hellenistic derivation. But in these regions the contact with the great art of China soon began to modify the Greek forms, and the Hellenistic motives which actually passed into China were translated into the Chinese idiom.

The figure sculpture of Northern India, as known to us by the stūpa reliefs of Bharhūt and Amaravati, is not in the same way affected by Hellenistic influence. We are in presence of an art originating in the peninsula and properly described as Indian.[2] The idea of representation, as Strzygowski suggests, may have been adopted by the early Indo-Germanic immigrants at a remote period from the Dravidians of the south ; but in the centuries towards the beginning of our era it was firmly implanted in the northern plains. Certain motives entered the country from Achaemenian Iran, but the sculpture as a whole is of native growth. The great interest of these reliefs lies in their employment in figure subjects of the same simplifying methods (vertical projection, inverted perspective) which we note in the art of countries lying much farther to the west at a rather later period (p. 192). We must suppose either that the mode of vision which this

[1] In the earlier Buddhist sculptures the Buddha is represented only by symbols.
[2] On this point see Vincent Smith, *History of* *Fine Art in India*, Oxford, 1911, pp. 8, 378 ff., and Marshall's chapter in the *Cambridge History of India*, vol. i.

involves was adapted by the immigrant Indo-Germanic stock to the representational art which they borrowed,[1] or that these methods, being essentially primitive, were also in use among the peoples in the south of the peninsula.

Iconoclasm was not wholly destructive of figure sculpture. Its intellectual affinity with Islam, and its inclination towards the Persian mode of decoration adopted by Mohammedans, were naturally to the advantage of a purely decorative style, which now began a fresh period of expansion. But since it waged no war against secular art, or indeed against any art as such, it may be said to have indirectly stimulated the secular Hellenistic work of Constantinople (p. 16).[2] By this toleration a continuity with the earlier period was maintained ; we possess certain marble reliefs with the Labours of Hercules and other subjects probably to be assigned to the iconoclastic period, and the classical motives on a group of ivory carvings (p. 213) are not far removed from these in date. But even a widespread tolerance did not suffice to preserve the crowded figure reliefs of the earlier centuries. When the cult of ' images ' was restored, such reliefs did not come back ; they were as extinct as the statues ; the work which they had done passed finally into the hands of the mosaicist and the painter. The monumental relief was now, for the most part, a single iconic figure, or a group of very few figures, inspired by painted rather than by carved models. The comparatively rare monumental works which date from the period between the late ninth century and the fall of Constantinople are usually figures of the Virgin and of favourite saints in a definitely iconic style. A somewhat greater freedom is observed in ivories, where scenes with various figures in action were still reproduced, again under the ever-increasing influence of painting, in this case of illumination. Yet even here the ikon-like treatment of isolated figures is a frequent and conspicuous feature. In short, during Middle and Later Byzantine times, sculpture as a whole was dominated by graphic art ; it had no longer a free tradition of its own. In its vigorous life as ornament, it was hardly less closely linked to the painter's art, since all its effects were visibly coloristic. There was no such feeling for an independent sculpture as we find stirring in the west of Europe in the eleventh century, when the wooden reliquaries in the form of heads or busts, made in Central France, may have occupied at the beginning of Western medieval sculpture a position like that of the *xoana* or wooden figures at the dawn of the Hellenic era.[3] The makers of these images, like

[1] The Indo-Germans of Northern India would on this supposition have applied their own principles to a borrowed system of representation, while the Aramaeans applied the same principles, perhaps acquired at a remote period, to subjects largely composed for them by the Greeks : in either case, the principles themselves might have originally come from the same part of the Eurasian continent. The second supposition would suggest an independent development, by different races, of the principles of vision leading to expression by formal art. Such a possibility is confirmed by the art of savage peoples, not always pastoral nomads.

[2] L. Bréhier has insisted upon this point in his essays on Byzantine sculpture.

[3] This is a suggestion made by Bréhier.

the primitive sculptors of Greece, lived in an experimental and aspiring age. But the Byzantine carvers of reliefs were satisfied with repetitions. Their work, indeed, is often marked by a fine sense of form, because their models were thus distinguished, especially in the neo-Hellenistic revival of the Macedonian period. Some of the eleventh-century figures of the Virgin and saints possess the fine qualities of contemporary carvings in ivory, and for the same reason : both were inspired by painted models of good Hellenistic descent. Among such figures may be mentioned several examples at S. Mark's at Venice, probably brought from Constantinople ; but work of this character did not endure, and where, in the last years of the Empire, we find figures in stone more plastically conceived, a Western influence is possible. The Byzantine relief tended to grow flatter, until in extreme cases it passed, as in earlier periods of degeneration, into what is almost line-engraving in stone. Examples of such work are to be seen at Mistra.

It is not improbable that statues and reliefs were coloured. The marble bust of a man in the Museum at Broussa, ascribed to the third century, is coloured in a realistic manner resembling that sometimes adopted in Italy in the fifteenth century ;[1] an example of this kind is not likely to be the only one, but traces of colour do not seem to be reported in the case of other free sculpture in marble. It is held by some authorities that early Christian sarcophagi were painted ; and we know that gilding at least was applied to the Hellenizing sculpture of Gandhāra. The probability that colour was generally used is increased by the fact that it appears on the stucco reliefs in the Orthodox Baptistery at Ravenna (see p. 201), and that gilding is mentioned in the case of wooden statues now lost.[2]

Allusion has already been made to the minor figure reliefs best represented by ivory carvings (see also below, pp. 201 ff.). These developed along the same lines as monumental sculpture. It also had its initial Hellenistic phase, and its subsequent modification under Aramaean influence, when it learned to obey optical rather than tactual principles ; in both these phases it was already drawing inspiration from graphic art, and in the second it was more and more estranged from the old Greek plastic tradition. Though miniatures were early a principal source, greater pictorial models were not neglected. The groups with the Virgin and Child as the central subject on five-panel diptychs may derive their large manner from imitation of mosaic models on the memorial churches in the Holy Land ; such mosaics doubtless inspired other compositions found on ivories, in which Syro-Palestinian iconographic themes are reproduced.[3] It is observed elsewhere that after iconoclasm there was no emancipation from the tutelage of the illuminator, which continued as long as ivory carving flourished.

[1] G. Mendel, *Bull. de Corr. Hell.*, 1909, pp. 315–17.
[2] *Chronicon Paschale*, temp. Heraclius. See F. Unger, *Quellen der byzantinischen Kunst-geschichte*, p. 67.
[3] As they inspired the subjects on the lead ampullae brought from the Holy Land by pilgrims.

Local distribution. Hellenistic sculpture was flourishing in the Greek cities of the Mediterranean area at the birth of Christianity. Alexandria was especially distinguished for the picturesque relief, and about the time of Constantine produced both statues and busts of porphyry in which we seem already to mark an intrusion of a Coptic realism. Alexandria was also prominent in ivory carving, where an almost pure Greek manner in the fourth century was gradually driven into a secondary position by intrusive Syrian influences congenial to a similarly inclined Coptic taste. The native population of Egypt being naturally in sympathy with a formal decorative art, its genius found its true expression, less in representational sculpture than in ornament. The result attained when its sculptors followed their real bent was no less distinguished for its excellence than that of their figure reliefs for its mediocrity. In such reliefs we mark a rapid degeneration of Hellenistic motives as we leave Alexandria behind. There is no understanding of the human form as an organic structure ; there is no appreciation of drapery, which is either abandoned altogether or treated without regard for the form beneath it. Limbs appear to have no bones ; bulging hips accompany spindle ankles. The relief sinks lower ; at last even the heads are almost flat. But the habit of representation derived from Alexandria was too strong to be eliminated ; surviving types of the old dynastic religion may also have contributed in some degree to their retention. And the arrival of fresh Christian motives from Syria in the fourth century was not favourable to an exclusively formal art.[1] Yet as the Hellenistic figure had been gradually transformed by Coptic feeling, so it was a second time with the Syro-Hellenistic types. The new sacred subjects were flattened and treated in the peculiar manner of the Copts. Such a relief as that of the symbolic Entry into Jerusalem, from Deir Amba Shenuti, now in Berlin, may be regarded as a typical example of this Coptic treatment ; we even find here a recrudescence of the ancient Egyptian practice which represents the upper part of the body frontally, the lower part in profile.[2]

In ornament, whether animal or floral, or a combination of the two, the Coptic genius for geometrically planned design went its way in freedom, unhampered by any restraint imposed by a set subject. The instinct for design here found full satisfaction, and the Copt may claim a high place among decorators working in stone. His own genius, and the possession in the limestone of the Nile Valley of an excellent medium for its expression, united to lend an admirable quality to his work.

[1] Cf. Wulff, *Altchristliche und byz. Kunst*, 145 ff. Wulff believes that the influence of Syria in figure sculpture was largely exerted by means of reliefs carved in wood ; we at once recall the doors of S. Sabina at Rome in this connexion. Among Syrian types now entering Egypt were the soaring angels supporting a wreath or medallion, so frequent on ivory book-covers and large diptychs, and the type of the standing apostle with the book. The type of the ' mounted saint ' which became popular in Egypt is now believed to have come from Iran, though the immediate transmitter must have been Syria.

[2] Wulff, *as above*, fig. 137.

Important as were Alexandria and Egypt to Christian sculpture down to the Arab conquest, the real centres of interest lay farther to the north, especially in Antioch, in the coast cities of Asia Minor and in Constantinople. Antioch was well placed to become the chief intermediary between Hellenistic and Eastern ideas of sculpture. On the one hand it stood in a regular relationship to Northern Syria, Mesopotamia, and Palestine; on the other hand it was intimately connected with the Greek cities of the South Anatolian littoral, while it had a large Greek population within its own walls. At Antioch Greek form was constrained to serve the Semitic narrative and dramatic mood; it gave plastic embodiment to iconographic themes of Palestinian origin. We have seen that before sculpture had definitely entered the service of the church it had decorated great imperial monuments, like the triumphal arch of Galerius at Salonika (p. 191), and had introduced oriental features, some of which may point back to Assyrian tradition.[1] The hand of Antioch is to be seen in the reliefs of the arch of Constantine at Rome; it was from here that the oriental mode of vision passed both to the old and to the new capitals, as well as to Jerusalem the focus of religious feeling. Constantinople may have been entered from an earlier outpost at Nicomedia; fragments of reliefs at Nicaea may mark its passage.[2] In sculpture of definitely Christian character the Syrian manner was asserted in Constantinople in the course of the fourth century, and in the fifth triumphed over its chief rival, the remarkably pure Greek style seen in the sarcophagi of the type formerly described as 'Sidamara' but now more accurately as Lydian (p. 182).[3] Sculpture of no small merit persisted in Antioch itself down to the sixth century, witness the great series of episodes on the ciborium columns of S. Marco at Venice, where the association of Greek form with oriental feeling is perhaps most perfectly exemplified (p. 186). Antiochene influence is clear in the sarcophagi of Ravenna, by the side of other influences from Asia Minor. But it is argued with some probability that in the fifth century the centre of activity must be sought in Constantinople, which had as it were at her gates that marble of Proconnesos which formed the material of the scuplture, decorative and other, produced in such quantities during the fifth and sixth centuries: it is stated that the sarcophagi of Ravenna are themselves of Proconnesian marble. Much of the decorative work is thought to have been produced at the quarries, whence capitals were directly exported by sea to distant ports of the Mediterranean, the reliefs even of large and important objects like sarcophagi may have been executed on the spot in the same manner, for there can be little doubt that in the neighbourhood of the quarries there

[1] Wulff, *as above*, pp. 163-4.

[2] *Ibid.*, p. 165. For the importance of Nicomedia see J. Sölch, *Byzantinisch-Neugriechische Jahrbücher*, i, pp. 267 ff.

[3] In the decorative parts of the sculpture upon these sarcophagi, in which the drill is profusely used to create effects of light and shadow, oriental principles had already triumphed.

was a colony of masons and sculptors drawn from widely distant parts of the Christian East.[1] But marble blocks must have been also shipped to the capital to receive their decoration there, and the rôle assigned by Wulff to Constantinople [2] would naturally result from the commanding position of the city in the Empire, the presence within its walls of great numbers of artists attracted by imperial, official, and private patronage,[3] and the inevitable establishment of large workshops and schools. The Byzantium of the fifth and sixth centuries was marked out as the destined unifier of the different artistic tendencies of the age ; what, indeed, more natural than that it should become the home of an eclectic art, in which Syrian intensity and realism were combined with an adherence to Hellenistic style. We seem to trace in work associated with Constantinople a finer feeling for organic form than in that which comes from Syria, but we certainly find a frank acceptance of ugliness foreign to the ideals of the Hellenistic sculptor. Thus in the province of glyptic art we see established the inevitable compromise enforced over the whole field of art by the fundamental opposition of two main factors, the Greek and the oriental, each too powerful to eliminate the other. Such a development was indeed a natural sequel to the modification of official and secular sculpture in the fourth century. The changes which we observe in the statues, the portrait-busts, and the reliefs of that period are intensified in the Christian work of that which followed. The sixth-century bust of S. Peter in the Ottoman Museum, virile, ugly, and full of character, is no less certainly an heir of secular prototypes than the late reliefs from the monastery of the Studium are successors of the sarcophagi at Ravenna. It is tempting to see in such work a confirmation of Wulff's hypothesis, though it has to be admitted that examples certainly to be ascribed to Byzantium are less numerous than might be wished.

It seems probable that the earliest Christian ivories may be claimed for Antioch, since the affinities of the oldest known to us are with the sculpture of the arcaded sarcophagi ascribed to that city. The unique Brescia reliquary, the large five-panelled diptych at Milan with the Lamb in *orfèvrerie cloisonnée*, the great pyxis at Berlin with the Sacrifice of Isaac, and the Bobbio pyxis with Orpheus, all appear to be Antiochene (p. 208). But with the fifth century the centre of gravity was displaced, and after the Syro-Hellenistic compromise (pp. 8 ff.), and the swift growth of oriental and especially of Aramaean influence, Palestine with its sacred sites and churches of imperial foundation, its monasteries and thronging pilgrims, may have become perhaps an important seat of the ivory carver's craft. The new principles which Syria had brought into Christian representation now

[1] Against this may be set the argument that sarcophagi are enormously heavy, while the ships of the time were small. Yet it is evident that the immense porphyry sarcophagi in Rome were brought from Egypt. A further analysis of the marbles is desirable.

[2] *Altchr. und byz. Kunst*, pp. 174 ff.

[3] Taxation was remitted to sculptors.

altered the Greek character of the work ; Palestinian iconography with its accretions from the apocryphal Gospels enriched the content : the ivory carving was a more important vehicle of new subjects than major sculpture, enjoying more freedom, and having a wider range of operation. Many ivories formerly attributed to other regions, some to Italy and Rome, are now claimed as the work of a Syro-Hellenistic school in the Holy Land ; among noteworthy early examples are the Milan diptych with scenes from the Passion, the panel with the Ascension at Munich, the panel in the Trivulzio collection with the Maries at the tomb, and the two sets of casket-panels in the British Museum. These are attributions which may still be contested.[1] More certainly from this region are five-panel diptychs or book-covers, which belong to the sixth century, and pyxides, which are of the same date. In all these objects a Syro-Palestinian theme is treated in a Syro-Hellenistic style.

While this development was taking place in the ivory carving of Syria and the Holy Land, Alexandria, which had possessed an early school of pagan bone-carvers continuing into Christian times, remained at first aloof from Syrian influence, only to fall so strongly under it by the sixth century that ivories produced in Egypt during that period can hardly be distinguished with certainty from those of Syria-Palestine. But Alexandria, with her strong classic feeling, produced before this epoch of confusion many fine pagan ivories in which Syria can claim no share, including such celebrated examples of the art as the beautiful diptych of the Symmachi and Nicomachi now divided between London and Paris, where we mark an analogy to late Attic sepulchral reliefs in marble, and the diptych-leaf with the Muse and Poet at Monza. Even when the Syrian influence had long penetrated the country, the old classical traditions survived in incongruous alliance with Eastern ornament, as in the curious panels on the pulpit in the cathedral of Aix-la-Chapelle, assigned to the sixth century. A Syro-Egyptian school of ivory-carvers has been suggested as affording the most plausible explanation of certain ivory carvings in which Syrian and Alexandrian features appear together ; and though the multiplication of schools must always be regarded with some suspicion, this particular school appears almost a necessity if ivories with these mingled affinities are to be classified at all. This school claims as its principal work the famous episcopal chair at Ravenna,[2] and the ivories, like the pyxis with the story of S. Menas in the British Museum, in close relation to it. Even with the help of the supposed Syro-Egyptian school, Alexandria still offers difficult problems. Such is that connected with the remarkable series of panels, perhaps from the episcopal

[1] The presence of a strong Syro-Palestinian influence need not imply manufacture in Syria-Palestine. We have to remember the numbers of oriental craftsmen now settled in Rome, and doubtless admitting a certain number of Italian pupils.

[2] The chair is particularly instructive since Greek sculptural tradition is evident in the figure subjects, more especially in the standing figures on the front, while the decorative designs are purely oriental.

throne called the chair of S. Mark (p. 207), some of which show a Hellen-istic art of great vigour and comparative purity, flourishing in the sixth century side by side with the above-mentioned work of less pure inspiration. Even when we have constituted the Antiochene, the Syro-Palestinian, the Alexandrian, and the Syro-Egyptian groups, there still remain important ivories which cannot be brought within any of these folds. For many cases Constantinople may be put forward as the most likely place of origin, since Wulff's advocacy of its real importance as a sifting and unifying centre, assimilating types and styles from the different provinces, is in itself probable, and supported by the parallel case of sculpture in marble. Constanti-nople is the natural home of the consular diptychs, which show with their ' vertical projection ' and inverted perspective a marked affinity with earlier official sculpture, such as that on the obelisk-base of Theodosius ; it will be noted below that of the considerable number of consuls represented by diptychs down to the year (A. D. 540) when the office was abolished, all but a very few held office in Byzantium. We have seen that Constantinople drew from Hellenistic art, including that of Alexandria, a finer feeling for organic form and for the flowing lines of drapery than Syria could compass, but adopted from Syria the love of individuality and the realism which never shrank from ugliness ; she would naturally develop an eclectic art in ivory as in marble. To the school of Constantinople Wulff would assign a number of secular diptychs with portraits, such as the diptych of Stilicho and Serena, the diptychs with portraits of Empresses at Florence and Vienna, the diptych of Probianus at Berlin, the famous Barberini diptych at Paris with its mounted Emperor, the no less famous archangel Michael in the British Museum.[1]

But even after the admission of Constantinople, a number of ivories remain outside the pales, where, pending new groupings, they may be temporarily left. For it may be confessed that the classification as it stands lacks finality. No system is universally accepted, all are provisional. But since they are of practical value, introducing order and coherence into an else hopeless confusion, the student will be wise to adopt that which seems most reasonable, prepared at any time on the appearance of new evidence to transfer individual objects or even whole groups from one quarter to another.

While the position of Constantinople at the close of the early period may be variously estimated, its primacy during the later centuries is beyond question. The great rivals of the capital, Alexandria and Antioch, had dropped out ; the imperial city now occupied a unique position.

The later period was ushered in by the production of the caskets with mythologic subjects, of which the finest example is that from the Cathedral of Veroli in Italy, now at South Kensington ; here once more we find

[1] Here again other authorities have classified differently, assigning for instance the Probianus diptych to Rome.

a Hellenistic influence at the foundations. The parallelism between the two periods is in so far continued that a fine Hellenistic phase is succeeded by an art of religious sentiment in which the Syro-Hellenistic compromise returns, though with a new equilibrium of the two factors (p. 17). It is significant that the change corresponds with that observed in the case of contemporary painting, for it must be repeated that from the tenth century, when the restored sacred style was firmly established, ivory carving follows painting, especially illumination, with an increasing fidelity and loss of freedom ; the inspiration of monumental sculpture which marked much of the work in the first period practically ceased in the second.

The influence of East Christian sculpture on the West was largely exerted through ivory carvings ; this was certainly the case in the later Byzantine period (cf. p. 175), but probably also in earlier times. One of the most remarkable possibilities is seen in the appearance of figure-reliefs with all the evidence of a good tradition in Northumbria about the year A.D. 700 (cf. p. 67). If figure sculpture on a monumental scale was the source of inspiration, it is difficult to know where to seek it at this particular date, when almost everywhere it was at its lowest ebb. Strzygowski has suggested a region as far afield as Armenia, and it would be difficult at this epoch of decadence in representational sculpture to find sculptors or masons in any of the better known and nearer centres. But perhaps here too we have rather to deal with the suggestion of the ivory or even of the illumination. Northumbria at the time in question was rich in talent (pp. 66–7), and perhaps no more may have been needed than the sight of a few miniatures to urge the admirable decorative sculptors of the time to attempt the conquest of new fields.[1] Together with illuminated MSS., portable like themselves, ivories went with the monk and the merchant from the Eastern provinces to the ports of Italy and Southern France, nor can it be doubted that they found their way over passes and up river valleys into Germany and Central Europe, across France to the shore of the North Sea ; why not, therefore, across the channel into our own islands ? Similar influences to those which may have affected Northumbria were active in the Frankish Empire, but stimulated minor sculpture rather than monumental ; in Frankish ivory carvings the inspiration of the East Christian model is plainly discerned. After the end of the Carolingian Empire, when the eleventh century brought with it new artistic ambitions, the part played by the Byzantine ivory was conspicuous. Reliefs at Moissac, Vézelay, Toulouse, and other places appear to owe it much ; and since these in their turn inspired the choir-sculptures at Bamberg, the influence was indirectly transmitted towards Central Europe. But that ivory carvings penetrated

[1] Though it must be admitted that when Northumbrian painters directly copied East Christian miniatures the result does not give the impression of style conveyed by the sculpture of the Ruthwell and Bewcastle crosses. In the figure subjects in the Lindisfarne Gospels and the Codex Amiatinus do not in the same way compel us to assume models of great quality.

to the north of Germany in the time of the Macedonian dynasty, when the art was at its finest, seems almost certainly established by the case of the tympanum in the church of S. Godehard at Hildesheim. Here a bust of Our Lord in relief so closely follows the type familiar to us from Byzantine diptychs of the tenth and eleventh centuries that direct imitation can hardly be doubted.[1] Here, as in the earlier instance in Northumbria, we find the same sudden improvement of style, too rapid to have resulted from a gradual and unaided local development.

The vitality which so early passed from figure sculpture remained a permanent quality in ornament from the earliest period to the latest. Here there is an enduring liveliness of fancy, and the confidence of those who feel themselves the interpreters of a genuine and universal feeling. Here, too, there is that constant association with buildings which figure sculpture was now less able to attain or to preserve. The sculptors who within the limits of the East Roman Empire developed oriental methods show in certain directions an originality and a mastery which oriental artists beyond the frontiers can hardly have excelled. The Byzantine capitals of Justinian's time are without rivals from purely Eastern sites ; the ornament filling the spandrels between the arcades of S. Sophia is unequalled by contemporary work in the East. In this decorative work high relief was progressively abandoned and is rare from the fifth century ; modelling gave place to flat low relief in a single plane, though a certain feeling for plastic effect is still found in the ornament of the bronze narthex doors of S. Sophia at Constantinople, where the borders of the panels have running scrolls, and bands of fret with high bosses at intervals.[2] The great aim was now to cover a surface with continuous pattern thrown into apparent relief against a ground deeply cut out so as to yield a strongly contrasting black shadow, or inlaid with some dark substance, or coloured. We reach a period when decorative sculpture produces an effect like textiles, or even lace.

These methods produced four kinds of work : (i) Drilled. (ii) Work imitating embroidery. (iii) Pierced work. (iv) Champlevé sculpture.[3]

(i) *Drilled work.* The drill had been used at an early date in combination with the chisel to punctuate a feeble relief with deep points of shadow. It was freely used on the capitals, modillions, &c., at Spalato, which are prototypes of later work produced in the time of Theodosius ; the sculptors who decorated the palace of Diocletian were already systematic employers of the drill. The early sarcophagi from Lydia (see p. 182) show us Hellenistic statues finely modelled against an architectural background in which the details are throughout treated with the drill. Greek modelling and

[1] *B. A. and A.*, p. 238.
[2] The inscriptions mention the Emperors Theophilus and Michael, and the year 838. (*B. A. and A.*, p. 618 and fig. 391 ; Salzenberg, *Altchristliche Baudenkmäler von Constantinopel*, pl. xix ; Lethaby and Swainson, *The Church of Sancta Sophia*, p. 269.) Cf. also *B. A. and A.*, p. 616.

[3] These styles form the principal subject of L. Bréhier's monograph, *Études sur l'histoire de la sculpture byzantine* (Missions scientifiques, N.S., fasc. 3, Paris, 1911).

oriental ' coloristic ' sculpture are found on the same object ; it is the
first stage of the oriental invasion. The effect of the drilled work is that of
tapestry with a pale design on a black ground. The date of these sarcophagi
lies between the second and fourth centuries of our era ; they are but
conspicuous examples of a method illustrated on various early sites in
Syria and Anatolia, and traced as far from its place of origin as the south of
France in Gallo-Roman times. The most conspicuous instance of its
employment is found in the capitals of the fifth century, of which the
' Theodosian capital ' is the most familiar. In this capital the use of the
drill gives, as it were, a new version of the acanthus, the leaves emerging
from a ground of black shadow ; in the type in which the leaves appear
blown by the wind, the incongruous alliance between the still boldly-
modelled leaves and the lace-like treatment of their surfaces proclaims
a hybrid art. The popularity of the style culminated in the fifth century,
but the drill was intermittently employed down to the latest period, and
in the West survived in Romanesque art, succumbing only before the
revival of modelling in the Gothic era. But the method was a barbaric one,
attempting to lend Greek ornamental motives an oriental colour. It
belonged thus to a transitional period, and properly made way for processes
of more radical change. It may be noted that on a Christian tombstone at
Urbino, a sculptor, Epitropos, is represented using two drills.[1]

(ii) In *embroidery sculpture* the flat stone is treated as if it were a canvas
on which the design is applied, either as *points de broderie*, or as ribbon-like
strips connected by loops, and interlacing. We may perhaps attribute the
introduction of this method to Iran, a country celebrated for decorative
textiles. The designs which it imposed were of the symmetrical and purely
conventional style proper to textile art : a central motive flanked by two
subsidiary figures, pairs of beasts confronted or addorsed, or combinations
of geometrical figures, such as the lozenge inscribed in a rectangle. Some-
times there is an evident imitation of a particular design. A well-known
example is found repeated on four capitals in the vestibule of S. Mark's at
Venice, and in an inferior example of the same motive in S. Sophia at
Trebizond ; here each face presents a stem with symmetrical leaf-scrolls
on either side flanked by two birds back to back perched on small globes,
their heads approaching the lion-masks which ornament the angles, their
tails crossing each other : an analogous design occurs on a sculptured
fragment in the Augustinian Museum at Toulouse, perhaps of the twelfth
century. The details of the well-known panels upon the walls of the
Little Metropolitan Church (Gorgoepekoos), and in the Byzantine Room
of the Theseion at Athens,[2] are treated in a manner which equally recalls
embroiderer's methods. The large series of closure or parapet slabs with

[1] H. Leclercq, in Cabrol, *Dict. d'arch. chré-
tienne*, ii. 283, 284.

[2] Well reproduced by Rivoira, *Lombardic*

Architecture (p. 149), who, however, assigns
them a very early date. Cf. also Bréhier, *as
above*, p. 37.

geometrical figures—lozenges, rectangles, circles enclosing rosettes or animal figures and executed by ribbon-like bands constantly interlacing with each other—recalls the technique of *passementerie*; this was a fashion which lasted for centuries: the examples from Delphi described by Laurent[1] date from before the seventh century, others at Broussa and Constantinople belong to the time of the Palaeologi; notable among the latter are fourteenth-century specimens from Mistra. The plaited band, single and double, common in Byzantine decorative sculpture, is also traced by some to oriental needlework; its most elaborate use is found on the front of a sarcophagus in the Museum at Constantinople, where the three crosses which form the principal part of the design are all composed of plait-work.[2] Embroidery sculpture was as popular in the West during the Romanesque period as it was in the East. Bréhier has illustrated a number of examples from various churches in Southern and Central France, remarking that the West produced a number of motives and combinations, many of which were unknown to Constantinople, and may have entered France from Saracenic Spain.

(iii) *Pierced sculpture*.[3] Here the design, instead of being visibly attached to a solid background, is apparently separated from it by a deep space, seen as black shadow, or else forms an openwork panel without any permanent background of its own. The former is the case with the pierced work which decorates cornices, tympana, and the sides of capitals; the latter is illustrated by openwork parapet-slabs at Ravenna, which might be pieces of suspended lace. Though the origin of the pierced style appears to be oriental, its elaboration is due to the Byzantine carvers who adapted it to the ornamentation of capitals. For slabs, the method seems to have fallen into disuse after the sixth century, to which belong some of the finest work seen in gallery-parapets of S. Vitale and S. Apollinare Nuovo; examples of similar date have been re-employed in the galleries of S. Mark's at Venice. The tradition, abandoned in the decoration of slabs, was carried on in the ornament of capitals, cornices, and wall spaces; the above-mentioned spandrels in S. Sophia, Constantinople, with their acanthus-diaper produce the effect of a rich lacework. The time of Justinian was the golden age of pierced sculpture. Though much has been lost at S. Vitale and at S. Irene, what remains in SS. Sergius and Bacchus suffices to show how far lacework in stone could go. In this church the capitals beneath the architrave, and the whole architrave itself, mouldings, modillions, cornice and all, are so elaborately pierced that the idea of solidity is almost destroyed. The capitals are of the lobed or melon variety, but openwork ornament was applied in profusion to all the types in favour at this time—the ' basket ', the ' bowl ', the Ionic, the trapezoidal, and others. But if with the seventh century pierced ornament lost its great popularity, it never quite disappeared. It is seen on the marble iconostasis of the Church of S. Luke

[1] *Bull. de Corr. Hell.*, xxiii, p. 206.
[2] Bréhier, *as above*, p. 44.
[3] This openwork in stone follows the same principles as pierced metal-work.

in Phocis (eleventh century), and in later work at Mistra ; in both cases the pierced boss or ' cabochon ' is characteristic. In the West it is frequently employed in the Romanesque period, especially on capitals and portals in France ; here the influence of East Christian art appears to be clear.

(iv) *Champlevé sculpture.* In this variety the design is reserved in the stone, as it is in the metal in the case of champlevé enamel ; the 'field', i.e. the ground, is removed to a sufficient depth to form a bed for an inserted coloured matter, the dark surface of which is destined to accentuate the white silhouette of the pattern. The inserted substance is usually a kind of mastic, or powdered marble mixed with red wax, the resulting colour being reddish brown ; but in perhaps the earliest known example of this technique, a marble fragment of about the fifth century, in all probability once forming part of the floor of the Basilica Ursiana, cubes of coloured mosaic are employed to enhance a reserved scroll-design, in which birds and deer are enclosed : mosaic also occurs, framing reliefs on a balustrade in S. Lucia at Gaeta. It was not, however, until after the iconoclastic period that this procedure really established itself in Byzantine art. It was used on the south and west façades of the church of SS. Theodore at Athens, but is most brilliantly exemplified in S. Luke in Phocis, at Daphni, at Monemvasia, and in S. Mark's at Venice. At Daphni [1] a marble cornice at the base of the dome and a frieze running round the church are ornamented with palmettes, scrolls, &c., the dark ground being formed of red wax and powdered marble. In S. Mark's the champlevé method is employed on a large scale. The rectangular abaci of the earlier capitals on the façade re-employed in building the church have vine scrolls on a ground of brown mastic ; the same ornament forms a cornice above the columns between the doors ; numbers of capitals and imposts within and without the church are likewise covered with champlevé. The fashion continued to the closing years of the Empire, and is represented at Mistra.[2] Very common in the ornamental sculpture of Islam, it is seen in Southern Italy on the throne of Archbishop Elias in S. Nicholas at Bari, executed in 1098.[3] Farther west, probably as a result of Moslem influence, it occurs in Spain on a doorway at S. Miguel de Lino in Asturias, dated A.D. 848.[4] But farther north champlevé was never generally adopted ; the incrustations in the cathedrals of Lyon and Vienne follow an inverse method : the design is excavated, the ground reserved, so that a pattern in coloured plaster appears on a ground of white marble.

It is noted elsewhere (p. 359) that the aesthetic need which created a new art at the beginning of the Christian era found its elementary expression in ornament. Here the optical principles opposing Greek plastic tradition

[1] Millet, *Monastère de Daphni*, p. 65.
[2] Millet, pl. xxx, xlix.
[3] E. Bertaux, *L'art dans l'Italie méridionale*, pp. 446–7.
[4] Lamperez y Romea, *Hist. de la arquitectura Cristiana-Española*, i, p. 273 and fig. 152.

are seen in their simplest operation unconfused by the intrusive factors, psychological or other, which tend to obscure their action in the representational field. No complications are added by the requirements of human personality seeking visible expression ; there is no trouble with literary content or with the third dimension ; intellect does not delay the response of sense to the immediate appeal of form and colour. Thus the key to much that is most distinctive in Christian sacred art is to be found in this essentially secular domain.

I. *Survey of the principal monuments. Free Sculpture*[1]

This means of expression practically ceased with the sixth century, though there is allusion to a few official statues much later ; Constantinople, with its strong Greek traditions and the demand for commemorative monuments due to the presence of the Court, was the natural place for its latest survival.

Religious. Free-standing figures of a religious character have survived in smaller numbers than those of secular origin. Some filled niches in churches ; others were for sepulchral use.

The group of half life-sized marble figures of the Good Shepherd, now increased by the inclusion of new examples, may have developed, like those of Orpheus, from the treatment of the subject in early sarcophagus reliefs.[2] The finest example is that in the Lateran ; all seem to date from between the third century and the fifth. A statuette of Our Lord, of Hellenistic type with long hair, recalling early sarcophagus forms, is now in the Museo delle Terme at Rome.[3] The torso of S. Hippolytus in the Lateran, perhaps executed at Rome as early as the third century, and that of S. Peter in the Vatican, lie perhaps outside our prescribed limits.[4]

Between the religious and secular groups we may place the large seated

[1] For the lost monuments see *B. A. and A.*, p. 121, and O. Wulff, *Altchristliche und byzantinische Kunst*, p. 149. Among these were Greek, Hellenistic, and Graeco-Roman works, from the great bronze Athena of Pheidias and the Herakles of Lysippus down to Roman portrait busts. We may specially note silver statues of Theodosius and of Eudoxia, empress of Theodosius II, the former placed upon his column ; the statue of Arcadius, also a colossal work surmounting the emperor's column, and the great equestrian statue of Justinian, erected in the Augusteion or square before the great Palace, where it was seen and described by Gyllius (Gilles) as late as the sixteenth century. Lost sacred figures include the statue of Our Lord set up by Constantine in the Chalké (vestibule) of the Palace, and statues of the Good Shepherd and of Daniel above public fountains. Earthquakes, fires, acts of vandalism, and the neglect of centuries are responsible for the loss of all this work. The imperial bronze statue now at Barletta (p. 180) is the only complete statue which remains, and that was saved from a wreck.

[2] Wulff, *Altchristliche und byzantinische Kunst*, p. 147. See also E. Becker in *Byzantinisch-Neugriechische Jahrbücher*, ii, 1921, pp. 379 ff. ; *B. A. and A.*, p. 128 ; F. Sarre, in *Studien zur Kunst des Ostens*, pp. 69 ff. A bronze statuette of this subject is in the Bargello at Florence (*R. Q.*, xxii, 1909, p. 246). The best figure of Orpheus is in the Central Museum at Athens ; it formed a cippus over a grave (Wulff, fig. 141). A relief with background cut away in the same style, and therefore almost a statue, is at New York ; it represents Jonah.

[3] P. Styger in *R. Q.*, xxix, 1915, pp. 26 ff.

[4] For the S. Hippolytus see Wulff, *as above*, fig. 142. Wulff regards the torso of S. Peter as the Early Christian model from which the medieval bronze statue in S. Peter's was produced (p. 150).

headless figure from Alexandria now in the Cairo Museum. This is regarded as perhaps a Christ by Strzygowski;[1] the alternative supposition is that it represents an emperor, probably Diocletian. The figure is of porphyry, obtained in the neighbourhood of Alexandria, which city must have been the home of the sculpture in porphyry which was produced in the early centuries of our era.

Secular. Two porphyry groups, each of two men embracing, one in the Vatican, the other at the south-east angle of S. Mark's at Venice, are now regarded as of the fourth century;[2] they may represent the widely known group of two sons of Constantine, mentioned by Codinus. Their furrowed brows and staring eyes are repeated in various heads which appear to date from the same period. Wulff explains their strangeness by supposing them the work of a sculptor who thought in Egyptian terms; and certainly there is little about them characteristic of Greek art.

Portrait heads and busts of the period between the fourth century and the sixth show the realism and effort to render character regardless of charm or beauty which, as we have seen, became a distinguishing mark of sculpture at this time. These are well illustrated by Wulff, who has discussed their attributions and analysed their qualities.[3] The same authority may be consulted for the official statues of the time, in which the same characteristics are apparent accompanied by an increasing tendency towards the frontal attitude, and a pose upon the soles of both feet: we may mention the Constantine of the Lateran, the Julians of the Louvre and the Cluny Museum, the consuls at the Capitoline, and the statues from Aphrodisias in the Ottoman Museum. In bronze only one imperial statue has survived, that which has stood since the close of the Middle Ages in its present position near the church of S. Sepolcro at Barletta.[4] It is certainly not Heraclius, but perhaps either Valentinian I or Theodosius.

Constantinople itself was probably the chief home of all this official sculpture; here it lasted to Comnenian times and even later.[5]

[1] *R. Q.*, xii, 1898, 4 ff.; *Beiträge zur alten Geschichte*, ii, 1902, pp. 120 ff.; *Koptische Kunst* (Cairo Catalogue), no. 7256, and pl. i. O. Wulff, *as above*, p. 154, believes the subject to have been an emperor.

[2] *B. A. and A.*, p. 126. O. Wulff, *as above*, p. 154 ff.; M. Conway, *Burlington Magazine*, December 1912. A marble torso in the Ottoman Museum at Constantinople (no. 1094) seems to be part of a more Hellenistic version of such a group; the period of Arcadius and Honorius has been suggested for it. A porphyry bust at Cairo, perhaps representing Maximian, may be compared with the heads of the embracing groups (Strzygowski, *Koptische Kunst*, no. 2, pl. ii).

[3] *As above*, pp. 156 ff.; see also, for some examples, his Berlin Catalogue, *Altchristliche und mittelalterliche, byzantinische und italienische Bildwerke*, 1909. Also R. Delbrück, *Römische Mittheilungen*, 1913, pp. 310 ff.; E. Michon, *Bull. Soc. Nat. des Ant. de France*, December 1913; P. Vitry, *Revue de l'art chrétien*, lxiv, 1914, p. 158; A. E. Conway, *Burlington Magazine*, xxv, 1914, pp. 346 ff. These busts are chiefly in Rome (Lateran and Palazzo dei Conservatori), in Paris (Louvre), Berlin (Kaiser Friedrich Museum), Milan, London, and Copenhagen.

[4] *B. A. and A.*, p. 125; Wulff, p. 158; H. Koch, *Antike Denkmäler*, iii, 1912, pp. 20 ff. The hands and legs are early restorations.

[5] J. Ebersolt, *Arts somptuaires de Byzance*, p. 131. The equestrian statues of the capital have not survived. For these see Wulff, p. 159.

II. *Reliefs: Period before Iconoclasm*

During the early years of Christianity the general use of the sarcophagus offered the sculptor a wide field and a regular employment. The Christian work insensibly developed from the pagan, both in the Eastern provinces and in Rome, becoming widespread in the fourth century. The tendency towards isolating the individual figure, already noted in the case of pagan sarcophagi, was yet more emphasized in that of Christian reliefs. The confused medley of figures overlapping each other, which occurs in Western work, made the desired isolation difficult ; [1] in the East the tendency was to reduce the number of persons represented, who were more obviously isolated before an uncrowded or void background, or by being placed separately each under its own niched canopy, so that, even if belonging to a common scene, they remained separated from each other by columns. This latter method is peculiarly associated with Asia Minor and Antioch, whence the principal influence in the development of the sarcophagus-relief appears to have been derived ; Western examples in which it appears owe the characteristic to these sources.[2]

Existing sarcophagus-reliefs with figure subjects from Egypt are practically confined to two massive examples traditionally associated with S. Helena and S. Costanza, now in the Vatican.[3] Each is in porphyry, the sides all bearing groups of mounted warriors with their captives ; the lid is ornamented with putti supporting laurel wreaths. The inappropriateness of the subjects for an empress's tomb has given rise to doubt whether the tradition with regard to S. Helena is correct, unless indeed Constantius Chlorus was buried in the same tomb, or the warlike subjects are to be regarded as symbolical, representing the triumph of the soldiers of Faith over the heathen, in which case the subject would not be so incongruous. There is a resemblance in style between the figures of the warriors and those on a wood carving also from Egypt, now in Berlin, the subject of which has received a like symbolic explanation (p. 189). Those who have rejected the association with S. Helena have drawn attention to a similarity of style to the Roman art of the Antonine period, and would carry the date back to the third century. But a resemblance is not less marked to the reliefs of the Theodosian period at Constantinople. And in each case

[1] The medley, however, so different from the logical Hellenic disposition, has itself been considered as a sign of oriental influence ; the surface, seen from a distance, appears to be covered with a continuous pattern.

[2] *B. A. and A.*, p. 132. The Roman sarcophagi are illustrated in Garrucci's *Storia dell' arte cristiana*, in Venturi's *Storia dell' arte italiana*, vol. i, and in the various handbooks to Early Christian art. For Gaulish examples (Soissons, Angoulême, Aniane, Arles, Moissac, Toulouse)

Le Blant's work (*Les sarcophages chrétiens de la Gaule*, 1886) is still valuable. For sarcophagi in Spain see D. J. Botet y Sisó, *Sarcófagos romano-cristianos en Cataluña*, Barcelona, 1895.

[3] Venturi, *Storia dell' arte cristiana*, i, p. 435, and figs. 172–5 ; Strzygowski, *Orient oder Rom*, pp. 76–7, figs. 33, 34 ; A. Riegl, *Spätrömische Kunstindustrie*, p. 96 ; O. Wulff, *Altchristliche und byz. Kunst*, p. 141 ; *B. A. and A.*, p. 131, fig. 76.

the inspiration was equally Hellenistic. It is scarcely possible to doubt that like the other sculpture in porphyry (p. 180) this sarcophagus was produced in the country where the stone was obtained, and that the artist worked in Alexandria. The sarcophagus of S. Costanza[1] is only to be noticed here for the genii or putti amongst its symbolical and decorative ornament; it also must have been sculptured in Egypt. The supposition is confirmed by the occurrence in Alexandria of a porphyry lid of the same kind, and of a fragment with similar vine-scrolls at Constantinople. The sarcophagus was apparently less popular in Egypt than in other provinces, for examples in the local limestone are far to seek. But the type of a limestone head in the Cairo Museum recalls those of the genii on the Vatican porphyry sarcophagi.

Examples of Christian sarcophagus-sculpture attributed to Asia Minor are also relatively few. The Berlin fragment of a sarcophagus, with a figure of Our Lord (Plate XXIX), obtained in Constantinople,[2] is a late member of a large group now widely dispersed in the Nearer East, Italy, and elsewhere; the group has hitherto been known as the 'Sidamara group', from Sidamara or Ambar Arassy, the site on which one of the finest examples was found. But arguments have been brought forward by Morey[3] in favour of assigning the earlier (pagan) examples to Ephesus, and later (Christian) to some place farther north, Nicaea, Cyzicus, or Nicomedia. The art which they represent produces a remarkable effect. The figures standing beneath columned niches are of such high relief as to be almost statues; they appear to be consciously based on ancient Greek sculpture of the fourth century B.C., the qualities of which they interpret with such originality and power that they recalled to Strzygowski Italian work of the Renaissance. While the figures are thus almost Hellenic, their architectural frame is treated in an oriental manner. On the capitals and imposts of the columns the drill is freely used to produce abrupt contrasts of light and heavy shadow. The distinction between the classical figures and this lace-like decoration is almost startling, more especially as the greater part of this work appears to date from the third century; the Psamatia fragment comes last in the series, and is placed by some about A.D. 300, by others nearly a century later.[4] On this fragment Christ, long haired and apparently beardless, with the cruciferous nimbus behind his head, stands in the dignified attitude of the Lateran Sophocles, his left arm at his side, his right bent and enveloped in the fold of his mantle. The head, turned slightly to his left, is unfortunately damaged, and the features are no longer clear. The later of the two dates suggested for this fragment avoids the difficulty raised by the use of a cruciferous nimbus as early as A.D. 300;

[1] *B. A. and A.*, fig. 77; Wulff, fig. 128.

[2] Strzygowski, *Orient oder Rom*, p. 40, and *Byz. Denkmäler*, III. xiii; *Journal of Hellenic Studies*, xxvii. For other references see *B. A. and A.*, pp. 128–30, and Morey, *as below*.

[3] *Art Bulletin*, New York, 1921, iv. Professor Morey will develop his argument in the Princeton publication on Sardis.

[4] O. Wulff, *Altchr. und byz. Kunst*, p. 170.

on the other hand, it creates an awkwardly long gap in a homogeneous series. About half of the known examples of the Lydian group come from Anatolian sites ; a few are at Constantinople or Athens ; a few in England ; nearly one-half in Italy. The case for Rome as their place of origin has been stated by Mendel ; but grave objections lie against it. The marble of an example of the group from Selefkieh has been analysed by Lepsius and pronounced oriental ; it seems unlikely that Romans, with their own marble at hand, should have imported a foreign for this style of work only. It is more probable that these characteristic products of some extensive workshop should have been sent to the Roman market, than that they should have gone from Rome to the obscure places in Anatolia where they were found ; the difficulty of geographical distribution is met if, with Wulff [1] and Morey, we suppose the Christian examples made at some place like Cyzicus or Proconnesus whence sculptured marble (e. g. capitals) was dispatched both to East and West. This school of sculpture seems to have stood in a comparatively near relation to the Hellenistic influence visible in the so-called Gandhāra sculpture of the Peshawar region on the north-west frontier of India ; Graeven observed the likeness between the Christ of the Berlin fragment and types of Buddha from that region : such an influence is more likely to have reached India from the west of Asia than from Italy.[2]

Some of the earlier sarcophagi at Ravenna [3] betray in their figure sculpture an apparent influence from the above Anatolian school. But the iconography, like the ornamental motives, of the majority points to Antioch, and in the majority the influence of the Antiochene school predominates. The optical methods of Syrian sculpture tend to prevail over the plastic methods of the Greeks ; the isolation of the figures by the columns of the niches under which they stand is produced after the Syrian manner by placing them upon a blank background ; all attempt at grace or beauty is abandoned in favour of an expressive ugliness. But the blending of Hellenistic and Semitic features, and the feeling for organic structure for which the Syrian was not distinguished, suggests to Wulff that the sarcophagi of Ravenna were made at Proconnesos or even in Constantinople ; the marble of some at least is Proconnesian. They are, on this theory, examples of the eclectic art of the imperial capital.[4] In view of the ignorance of East Christian sculpture imposed upon us by a relatively small surviving material,

[1] *As above*, p. 170.
[2] For other work in this style, from Makri Keui, see J. Ebersolt, *Revue Arch.*, xxi, 1913, pp. 333 ff.
[3] O. Wulff, *Repertorium für Kunstwissenschaft*, xxxv, pp. 217, 281, and *Altchr. und byz. Kunst*, p. 176 ; A. Riegl, *Spätrömische Kunstindustrie*, pp. 99 ff. ; H. Dütschke, *Ravennatische Studien*, 1909 ; K. Goldmann, *Die ravennatischen Sarkophage*, 1906. For other references see *B. A. and A.*, pp. 135 ff. Photographs of the sarcophagi by Alinari, and by L. Ricci of Ravenna.

[4] *Altchr. und byz. Kunst*, loc. cit. We have noted above the importance of an analysis of the marble for the question of provenance.

this theory should be considered with the others, though, if confirmed, it would show that with the advance of the fifth century sepulchral sculpture sank to a lower level than other branches of glyptic art.

The sarcophagi at Ravenna [1] range in date from the first half of the fourth century to the earlier years of the sixth. The best of the examples betraying the influence of the Hellenistic sculpture of Asia Minor is the tomb of Bishop Liberius; [2] here the figures and their attitudes are well conceived, and the drapery with its numerous and defined folds is logically disposed. The group under Syrian influence is perhaps most worthily represented by the Pignatta sarcophagus, [3] which also dates from the fourth century (Plate XXX), and by the example of the first half of the fifth century, which from its secondary use as the tomb of the Byzantine exarch Isaac, is now known by his name. The reliefs on these examples reproduce Syro-Palestinian iconographic types, and in their stiffer gestures, more thick-set figures, and heavier draperies, contrast strongly with the work of Anatolian inspiration; but in the case of the former there is Hellenistic influence enough to lend dignity and attraction, especially to the subjects on the ends. In the best work of both groups the relief is still comparatively high, there is a feeling for organic life, and frontality is not the general rule. But by the middle of the fifth century the relief flattens, proportions deteriorate, gestures grow more angular, and the frontal position predominates; the sarcophagi known by the names of Barbatianus, Rinaldus, and Exsuperantius illustrate the change. But while figure sculpture grew uncouth, the decorative design of a Syrian character became its serious rival; here the sculptor was not hampered by a representational task beyond his capability, and in quite late sarcophagi ornamental motives maintain a relatively high standard of excellence. [4]

Sarcophagi were still made in the middle and late Byzantine period, but the decorated sides were covered with ornamental designs analogous to those upon contemporary closure-slabs.

A certain number of reliefs other than those upon sarcophagi may be mentioned.

[1] A few conspicuous peculiarities distinguish the sarcophagi of Ravenna from those of Rome. The number of figures is as a rule less; only one scene occupies a side, whereas in Roman examples two or three subjects may adjoin each other on a single front; a rather stiff symmetry prevails in the arrangement of groups. Isolated figures standing under a columned arcade sometimes occupy the whole front. The general effect is thus very different, since the figures are spaced, and the void background is all the more conspicuous in that at Ravenna surfaces to be covered are often larger. *B. A. and A.*, pp. 135 ff.; Wulff, *Altchr. und byz. Kunst,* pp. 176 ff.

[2] In San Francesco: *B. A. and A.*, fig. 71; Wulff, fig. 172.

[3] In San Francesco. So called from the family of that name which at a later time used it as a tomb. *B. A. and A.*, figs. 78, 79; Wulff, p. 176.

[4] Sarcophagi in the West (S. Gaul) show a similar advance of formal decorative ornament against earlier figure subjects. This has been ascribed to Visigothic influence, itself derived from the East. Examples in Le Blant, *Sarc. chrét. de la Gaule*, pls. iv, xxviii, xxxiii, xxxvi.

In the Ottoman Museum are fragments of marble ambons or pulpits, originally brought from Salonika [1] (Plate XXXI). We see the magi, each in his own scalloped niche, bringing gifts to the Virgin, seated full face ; the separation of the figures under niches recalls the treatment of various sarcophagi at Ravenna, the style of which is supposed to have been influenced by Anatolian models. The spandrels between the niches show eagles displayed ; above them is a panel with vines, vases, &c., within an acanthus border which suggests a fifth-century date.

Other reliefs may be assigned with probability to the period from the fourth to the sixth centuries. [2] The limestone relief with *Kairos* or Opportunity in the Cairo Museum is probably of the fourth century. In the museum at Carthage a marble slab shows the Virgin seated with the Child, with an attendant angel ; and the angel appearing to the shepherds. A relief at New York with Jonah in the monster's jaws was found at Tarsus in 1876. The mutilated reliefs on the panels of the marble false doors built into a wall in Kahrieh Jami at Constantinople have subjects from the New Testament, and are supposed to date, like similar doors without reliefs, in S. Sophia and the mosque of the Calendars, from the first half of the sixth century.

A broken relief at Berlin with the death of Ananias, or a miracle of S. Peter, obtained between Sinope and Amaseia, and in a style recalling that of Ravenna sarcophagi, is probably of the fifth century. [3] The charming Virgin and Child on an engaged capital from the Church of S. Agatha at Ravenna, and now in the museum in that town, is thought by Bréhier to date from the fifth century. [4] A fragment of the same date in the same place from Constantinople [5] has two figures perhaps from the scene of the opening of Benjamin's sack : here again there are affinities with the art of Ravenna. A large marble medallion in the Ottoman Museum has a bearded Evangelist in high relief ; with it are fragments of three others. [6] The style is heavy, but not unoriginal, and the fifth century may again be suggested as a probable date. Two marble drums of columns in the same museum are finely carved with vines boldly and naturalistically treated, between the leaves of which appear single figures of men and animals, and two groups, one representing the Baptism, the other a secular subject. The figures are inferior to the ornamental framework, but of sufficient merit to justify their attribu-

[1] Ch. Bayet, *Bibliothèque des Écoles françaises de Rome et d'Athènes*, i, 1876, p. 249 ; *Recherches pour servir*, &c., p. 105 ; Bayet and Duchesne, *Mission au Mont Athos*, p. 249 and pls. i–iv ; Rivoira, *Lombardic Architecture*, fig. 71 ; O. Wulff, *Altchr. und byz. Kunst*, pp. 134, 135 ; F. X. Kraus, *Gesch. der christlichen Kunst*, i, fig. 189 ; Photos. H-E. C. 671, 674 ; *B. A. and A.*, fig. 84.
[2] For references see *B. A. and A.*, pp. 143, 148, and fig. 65.
[3] O. Wulff, *Altchr. und byz. Kunst*, p. 180 ; Berlin Catalogue, no. 29 ; *B. A. and A.*, p. 153 and fig. 88.
[4] Bréhier, *Études*, pl. iii, fig. 3.
[5] Wulff, Berlin Catalogue, no. 38.
[6] Strzygowski, *B. Z.*, i, p. 355 and pl. iii ; Wulff, *Altchr. und byz. Kunst*, fig. 1, and p. 180.

tion to the period between Theodosius and Justinian. Though this work may have been executed at Constantinople it reveals a strong Syrian influence.[1]

The two front columns of the ciborium in S. Mark's at Venice are generally attributed to the first half of the sixth century, the other two have usually been considered later medieval work of Western origin, but this opinion is not universally accepted.[2] The first pair, at any rate, are said to have been brought in the thirteenth century from Pola in Istria. Each is divided into nine zones with figures in high relief under continuous niched arcades; between the zones are plain horizontal bands with Latin inscriptions. These columns illustrate the characteristic Anatolian practice of isolating by columns personages engaged in common action; here the subjects are derived from the story of Joachim and Anna, and from the Apocryphal Gospels. The highness of the relief and the comparative excellence of much of the work give point to Venturi's argument that it cannot date from a period in which figure sculpture was already in rapid decline, though his contention that they are more likely to have been produced in Pola itself, presumably under Italian influence, will scarcely meet with general acceptance. The style is Hellenistic and points to Antioch, the iconography is Syro-Palestinian; thus the Death of Judas and the scenes in which Pilate appears resemble the corresponding scenes in the Codex Rossanensis (p. 312), and the disposition of the figures recalls that of the Salonika pulpits and of a group of Ravenna sarcophagi. In view of these facts we must prefer the opinion that the columns were produced in the region under the influence of Antioch, and represent Venetian booty taken in the East. The manner in which the Hellenistic sculptor has incorporated oriental types in his scheme, and clothed them in a Greek dress, lends these reliefs a peculiar interest.

To the sixth century also belongs a relief on the south side of S. Mark's, with a nimbed lamb and throne with cloth, cross, diadem and Gospels; on either side are six lambs representing the twelve apostles.[3] The subject is the *Hetimasia* or Preparation of the Throne, already depicted in the mosaics of the Orthodox Baptistery at Ravenna. Palm trees in the corners closely resemble those on sarcophagi at Ravenna, to which the relief has general affinities.

A fragment of a relief with the Nativity before a hilly landscape, now in the Church of S. Giovanni Elemosinario at Venice, is apparently of the same date. The Virgin and Child, the principal figures, are in the middle zone; Joseph and the women washing the Child occupy the foreground and are on a smaller scale, as are the magi coming down the slopes above: the

[1] Wulff, *Altchr. und byz. Kunst*, p. 175; *B.A. and A.*, p. 69.

[2] Wulff, *as above*, p. 127; Venturi, *Storia dell' arte italiana*, i, p. 454 and figs. 219 ff.;

B.A. and A., pp. 155, 156.

[3] Bréhier, *Études*, p. 69; O. Wulff, *Die Koimesiskirche in Nicäa*, p. 243.

fragment is of exceptional interest as illustrating more than one of the methods by which artists at this period treated the problems of perspective [1] (p. 161).

In a relief from the Studium at Constantinople, now in the Ottoman Museum,[2] we see the Entry into Jerusalem, dating from the fifth or early sixth century; here an early Hellenistic, probably Alexandrian, type is still preserved, a beardless Christ rides astride, and the accessory figures are adult and reduced to three. The technique shows flat silhouetted relief and dates from the sixth century, being probably a late work of the metropolitan school.

The relief at Berlin representing Moses [3] receiving a scroll from the hand of the Almighty, apparently a tombstone and formerly built into the walls of Constantinople, shows little or no modelling, and the folds of the drapery are hardly more than engraved. It might be regarded as a work of some later period were it not that the scrolls and other ornament of the upper part are not of the kind employed after iconoclasm. The probable date is the seventh century. With the Moses relief may be compared a fragment with Lazarus in the Ottoman Museum at Constantinople; [4] marble reliefs in the same place with the Three Children in the Furnace may be of the same date, if not rather earlier.

Much figure sculpture in limestone was produced in Egypt in this period; certain portrait heads and busts of Egyptians show a reversion from Greek to African types. A number of figure reliefs served to decorate buildings, like that with Orpheus [5] in the Cairo Museum (fourth century). As the native Egyptian taste definitely obtained the upper hand, the style and feeling both became coarser, and the relief flatter. The nude figures of genii gave place to the Virgin, and mounted saints, the latter type being characteristic of Egypt, though perhaps of Asiatic origin. A typical Coptic relief of the sixth or seventh century is seen in the Entry into Jerusalem, from Sohag, now in Berlin.[6] Coptic gravestones often have figures of persons in the attitude of the *orans* in feeble relief; they date mostly from the sixth and seventh centuries. Examples are chiefly in the Cairo Museum, the Kaiser Friedrich Museum, the Louvre, and the British Museum, Department of Egyptian and Assyrian Antiquities.[7]

Coptic figure sculpture, as already noted, shows little understanding of

[1] H. von der Gabelentz, *Mittelalterliche Plastik von Venedig*, p. 148; O. Wulff, *Kunstgeschichtliche Beiträge A. von Schmarsow gewidmet*, p. 10, Leipsic, 1907.

[2] O. Wulff, *Altchr. und byz. Kunst*, p. 184; G. Millet, *Iconographie de l'Évangile*, p. 559.

[3] O. Wulff, *Altchr. und . . . byz. Bildwerke* (Berlin Catalogue), no. 32; J. Strzygowski, *Jahrbuch der K. preussischen Kunstsammlungen*, xiv, 1893, p. 65.

[4] A. Muñoz, *Nuovo Bull. di Arch. Crist.*, xxii, 1906, p. 107.

[5] Strzygowski, *Koptische Kunst* (Cairo Catalogue), no. 7287; *B. A. and A.*, fig. 87.

[6] O. Wulff, Berlin Catalogue, no. 72; *Altchr. und byz. Kunst*, p. 146.

[7] See W. E. Crum, *Coptic Monuments*, 1902 (*Catalogue gén. des Antiquités*, Cairo Museum). On these tombstones the eagle of Horus replaces the Christian dove (Wulff, *Altchr. und byz. Kunst*, p. 143).

organic structure and of the logical treatment of draperies.[1] They flatten down the Hellenistic forms of Alexandria, and introduce native physical types.

Examples of figure sculpture both in stucco and wood have come down to us from this period.

In the Orthodox Baptistery at Ravenna the spaces between the windows are filled by stucco reliefs,[2] panels with Prophets under arcades are surmounted by others with small symbolic or iconographic scenes : the *Traditio Legis*, Christ trampling on the asp and basilisk, birds pecking grapes, &c. All this work belongs to the fifth century. The remarkable figure sculpture in the Church of S. Maria in Valle at Cividale[3] affords a later example of the same tradition of work in stucco ; they are variously dated between the eighth and twelfth centuries, but by most authorities held to belong to the Carolingian period.[4] For ornamental reliefs in stucco see below, p. 200. The well-known wooden doors in the Church of S. Sabina[5] at Rome with eighteen surviving panels, carved on the front with scenes from the Old and New Testaments, and on the back with formal ornament of Syrian style, are probably originals of the kind imitated in the stone doors of Kahrieh Jami. The style of certain figures, details of architecture, and other features suggest a Syrian origin ; the stone doors, all of them in Constantinople, reproduce the same arrangement of panels, the large and the small size alternating.[6] The date of the wooden doors is about A.D. 430. Their panels are perhaps the most perfect illustration of the primitive method of rendering parts of the subject belonging to different planes, and requiring treatment by perspective, by ' vertical projection ', i.e. placing the contents of each plane in zones directly over each other. In some panels, it is true, we see the Hellenistic compromise of a steep hilly landscape, on the sides of which the figures can be shown above each other in a half-naturalistic manner ; but in others the system of zones appears in its most abstract and uncompromising form. It was not by chance, as Wulff has observed, ' that we find a return to vertical projection in its most abstract form on work executed for a Roman basilica by a Syrian artist '.[7]

[1] O. Wulff, *Altchr. und byz. Kunst*, p. 143, and cf. p. 354.

[2] Alfredo Melano, in *Arte e Storia*, xx, 1901, p. 53 ; Venturi, *Zeitschr. für Geschichte der Architektur*, i, p. 216 ; Bréhier, *Études*, p. 79 ; *B. A. and A.*, p. 345 ; Cabrol, *Dict. d'arch. chrét.*, ii, col. 1509 ; C. Ricci, *Ravenna*, figs. 41-3.

[3] Strzygowski, in *Monatshefte für Kunstwissenschaft*, i, 1907, pp. 22 ff. Other references in *B. A. and A.*, p. 151.

[4] For the colouring almost always applied to stucco work, see F. von Thiersch, in *Deutsche Bauzeitung*, xxxii, 1898, p. 447.

[5] F. Wiegand, *Das altchristliche Hauptportal an der Kirche der heiligen Sabina*, Trèves, 1900 ; and O. Wulff, *Altchr. und byz. Kunst*, pp. 137 ff. ; for other references see *B. A. and A.*, p. 146. For illustrations see also Venturi, *Storia dell' arte italiana*, i, figs. 308-25. The conventional ornament carved on the back of the doors is distinctively Syrian.

[6] For these imitation doors see Bréhier, *Études*, as above, p. 66 and pl. xx, fig. 1 ; *Jahrbuch der K. preussischen Kunstsammlungen*, xiv, 1893, p. 75 and fig. 4 ; Rivoira, *Lombardic Architecture*, fig. 72 ; *Archaeologia* (Soc. Antiq., London), lv, pls. xxxvi-xxxvii ; *B. A. and A.*, pp. 147-8.

[7] O. Wulff, *Kunstwissenschaftliche Beiträge A. von Schmarsow gewidmet*, p. 10, Leipzig, 1907.

Another pair of wooden doors in S. Ambrogio at Milan may be even earlier.[1] The panels here represent scenes from the story of David ; one of them, with Samuel's messenger visiting David among the flocks, presents a close analogy to the corresponding scene on the silver dish from Cyprus (p. 328) ; there are also analogies to Coptic frescoes at Bawît and the miniatures of the Paris Psalter (gr. 139). The fact that the heads have been struck off all the figures is a further indication of Eastern origin, and they may be ascribed to the time of S. Ambrose. Other early wooden doors have been discovered in the Church of S. Barbara, old Cairo.[2]

Among smaller wood carvings may be specially mentioned that in the Kaiser Friedrich Museum at Berlin, probably once surmounting a pilaster, from Eshmunein in Egypt.[3] The subject represents warriors before a fortified city ; the date may be fifth century. There are analogies between the style of the figures and that of those on the porphyry sarcophagus of S. Helena (p. 181), which must have come from Egypt, while the architecture resembles that on an ivory carving in the Louvre, with S. Mark preaching before Alexandria. Resemblances of detail with subjects connected with the life of Joshua in the mosaics of S. Maria Maggiore, Rome, and in the Joshua roll, suggest a subject from the Old Testament ; but Strzygowski thinks that we have here a symbolic representation of the forces of faith triumphing over the infidel, while Wulff suggests that the subject is the defeat of a Libyan nomadic tribe in an attack on the Delta. Two reliefs with saints, in the Cairo Museum, executed in a good style, appear to date from the fifth century.[4]

Sculpture of the Post-iconoclastic periods

Under the arcade of the south door of S. Sophia at Trebizond, and dating perhaps from the twelfth century, perhaps before, is a frieze representing the story of Adam and Eve in coarse yellow sandstone.[5]

A fragment of ciborium in the Ottoman Museum [6] has part of the scene of the Last Supper surrounded by a plaited border : three seated apostles remain with an angel above them. Its date should be the eleventh century, for in style it recalls the ivory carvings of about that time.

To the same period we may ascribe the fine Panagia of S. Maria in Porto at Ravenna [7] which so closely reproduces the type of the Virgin *orans*

[1] A. Goldschmidt, *Die Kirchenthür des heiligen Ambrosius in Mailand*, Strasburg, 1902 ; Strzygowski, *B. Z.*, xi, p. 666. J. Sauer, *R. Q.*, 1902, p. 72, thinks the accepted date too early, but Wulff, *Altchr. und byz. Kunst*, p. 137, gives reasons for retaining it.

[2] A. Patricolo and U. Monneret de Villard, *La Chiesa di Santa Barbara al Vecchio Cairo*, Florence 1922, fig. 18.

[3] O. Wulff, *Altchristliche und byzantinische Bildwerke* (Berlin Catalogue, 1909), no. 253 and pl. vii, and *Altchr. und byz. Kunst*, p. 142 ; Strzygowski, *Orient oder Rom*, iii, p. 65 ; *B. A. and A.*, p. 149.

[4] Strzygowski, *Koptische Kunst* (Cairo Catalogue), pl. vii ; *B. A. and A.*, fig. 85.

[5] G. Millet, *B. C. H.*, 1895, p. 457 ; Bréhier, *Études*, i, p. 73.

[6] Bréhier, *as above*, p. 74 and pl. xxi, fig. 2.

[7] C. Bayet, *Art byzantin*, p. 187, fig. 60.

seen in the mosaics of church apses. The mutilated Panagia in the Theseion at Athens [1] is of the same group, though perhaps a little later (twelfth century). Three other examples of the Virgin are seen in S. Mark's, one on the west façade, another near the north door, represented between two angels; the third is above the altar in the chapel of Zeno in the north transept.[2] The last is a work of singular charm: the Virgin is seated on a throne with high back, and inclines her head towards the Child upon her knee. A Greek inscription tells us that this work was dedicated by an Emperor Michael and an Empress Irene; and the style recalls that of the Byzantine ivories of the eleventh century. Another fine relief of the Virgin was found at Makri Keui in 1921.[3]

The reliefs of S. George and S. Demetrius on either side of the great door of S. Mark's at Venice[4] are perhaps of the eleventh century. The style is Byzantine, though their inscriptions are in Latin. The saints are seated, wearing armour and swords, and the workmanship is of a high order. The angel Gabriel between the two south doors is in the same style. Another relief in S. Mark's belonging to this period is an angel holding a sceptre and orb, built into the wall on the right of the chapel of S. Zeno. A relief in the Theseion at Athens, representing an ecclesiastic, seems to be rather later. A bust of the Virgin with the Child in the church at Trani[5] is dated by an inscription giving the name of Delterios, Turmarch of Bari in A.D. 1039; it.is rather rough in style. Other Virgins at Ravenna, Venice, Athens, and Chalcis in Euboea appear to be contemporary.[6]

Christ in Majesty forms the subject of reliefs at Serres in Macedonia, and at Mistra; the latter example is little more than a coarse engraving in stone.[7] Our Lord is also carved above the arcading now in the south aisle of Kahrieh Jami at Constantinople, which an inscription shows to have once formed part of the tomb of Michael Tornikes, a relative of the Emperor Andronicus II (A.D. 1282–1328);[8] in the spandrels are angels with expanded wings. Mutilated reliefs on either side of the apse in the mosque of the Calendars[9] are in a similar style to the Kahrieh Jami sculpture; those on the left side seem to represent the Persons of the Deesis (*B. A. and A.*, p. 664), those on the right, the Hetimasia. The angels with orbs on the capitals

[1] Bréhier, *Nouvelles recherches sur l'hist. de la sculpture byzantine*, Paris, 1913, p. 28 (*Nouvelles archives des missions scientifiques*, N.S., fascicule 9).

[2] Bréhier, *Études*, p. 77.

[3] Ch. Diehl, *C.-R. de l'Acad. des Inscr.*, 1922, pp. 198 ff.

[4] Venturi, *Storia*, ii, p. 529; Bréhier, *Études*, pp. 77–8, and pl. xxiii. Two reliefs of saints are at Caorle; R. Egger, *Jahreshefte des Oest. Arch. Inst.*, 1922, p. 21.

[5] G. Schlumberger, *L'Épopée byzantine*, iii, p. 253; Bréhier, *Études*, p. 77.

[6] *B. A. and A.*, p. 159.

[7] Bréhier, *Études*, p. 78; G. Millet, *Monuments de Mistra*, pl. li. For late sculpture at Episcopi, Thessaly, see Millet in *Bull. Corr. Hell.*, xliv (1920), pp. 210 ff.

[8] Th. Schmidt, *Izviestiya* of the Russian Arch. Inst. at Constantinople, xi, 1906, pls. lxxxiii and lxxxiv; D. Pulgher, *Anciennes églises byz. de Constantinople*, p. 31 and pls. xxiii, xxvi, xxvii; C. Diehl, *Études byzantines*, pp. 416, 417; E. Freshfield, *Archaeologia*, lv, pl. xxxv; *B. A. and A.*, p. 162 and fig. 94.

[9] Ebersolt, *Rev. Arch.*, series IV, xiv, p. 22.

in the narthex of Kahrieh Jami appear to be of the Comnenian period, probably the twelfth century.[1] Other marble reliefs with religious subjects in the Theseion at Athens may be noticed.[2] Two represent the Nativity. The first, which was found in Naxos, shows the swaddled Child on a bed between two conventional trees, the ox and the ass standing behind; above there are slight remains of another subject, evidently the Flight into Egypt. In the second the Virgin lies on a couch; above her is the swaddled Child, and above again, appear ox and ass. Other fragments show figures of Our Lord with Adam, of the Magi and Shepherds, also of prophets, following the curves of arches, as we see them outside Western churches. The inscriptions on two of these reliefs indicate a late period; the form of the conventional trees in the first does not allow us to place them in any case earlier than the eleventh century. In the figures filling arches there is a more definite suggestion of Western influence. Bréhier compares arcades of the Romanesque church at Corme-Royal in Charente-Inférieure, and concludes that the examples at Athens probably date from the first years of the Latin Conquest. Another relief at Athens, representing the Baptist with wings, must also belong to a late period.

Turning to sculpture in wood, we again find the church door furnishing the important examples. The panels in the British Museum from Sitt Miriam (Al' Mu'allaka) in Cairo are filled with subjects from the New Testament, which in the main follow Syro-Palestinian types, the ornament on the contrary being in the Saracenic manner; they belong to the thirteenth century.[3]

Other remarkable doors are those of S. Nicholas at Ochrida in Macedonia, which are of about the same date. Here SS. George, Demetrius, and the two Theodores are seen among other panels bearing beasts and monsters.[4]

Secular Reliefs

We may notice at the beginning of the section a group of reliefs which are pagan in subject, and do not strictly fall within our scope, but are so closely related in other ways to Christian sculpture that the attention of students should be directed to them. The earliest ornament the piers of the arch at Salonika,[5] and celebrate a Persian victory, perhaps of Galerius; they are the work of Greek sculptors, and date from about A.D. 300–305. The subjects include battles, progresses, receptions, the offering of gifts, the passage of files of prisoners, with the interspersion of various allegorical figures : victories, personifications of cities, rivers, Earth, Ocean, the World,

[1] Th. Schmidt, *Kahrieh Jami*, Sofia, 1906, pls. lxxxv, lxxxvi.

[2] Bréhier, *Études*, p. 74 and pl. xxii ; *Nouvelles Recherches*, p. 30.

[3] *B. A. and A.*, p. 163 and fig. 95.

[4] Kondakoff, *Macedonia*, pp. 236–7 and pl.

iii ; Filow, *Early Bulg. Art*, 1919, pl. xxxiv.

[5] K. F. Kinch, *L'arc de triomphe de Salonique*, Paris, 1890, p. 128 ; E. Hébrard, *Bull. Corr. Hell.*, xliv, 1920, p. 5. A fuller publication is promised by the *Service arch. de l'armée d'Orient*.

Peace, &c. ; the conception and execution are in the main Hellenistic, and more than once the name of an allegorical figure is given in Greek. The scene representing a sacrifice to Jupiter and Hercules is well composed ; the interest of its architectural background has been already noticed above. The sculptors, however, employ methods which aim at optical effect, and may have come from Antioch, where oriental influences were in evidence.[1]

The later reliefs on the arch of Constantine at Rome date from the period of that Emperor, or the years immediately preceding.[2] These are : the flying Victories, in the spandrels, with the genii of the Seasons beneath ; the Sun and Moon, in medallions ; and the narrow friezes below the medallions on the front and back. In the groups, the progress of the new orientalizing ideas is to be observed ; the figures are undercut, thrown into relief against dark shadow, and cubically isolated from each other (cf. p. 162).

The reliefs on the base of the obelisk of Theodosius at Constantinople represent the Emperor watching from the Cathisma dancers and musicians (Plate XXXII), and receiving petitions and gifts.[3] The style shows affinities with that of the arch of Constantine, but a more advanced stage in the treatment of sculpture on optical principles ; in it we reach the climax of the movement which transformed the antique conception of relief. The new object aimed at by the sculptor, not beauty or harmony, but a vivid and immediate presentation, is achieved by a flattened relief, by frontality, and the methods of vertical projection and inverted perspective mentioned above (pp. 162–3) ; these scenes ' carry us instantly into the heart of the situation ' ; they are not so much the work of passive decadence as a means to a new end.

The column of Arcadius,[4] erected in a forum on the main street (*Mesē*) of the Byzantine capital, but in a side street of modern Constantinople, is now represented only by the base and lower part of the shaft. The groups on the sides of the base are either concealed by buildings or irreparably damaged, so that hardly a figure is intact. Within the base are two chambers, one of which has carved on its ceiling the sacred monogram between *alpha* and *omega* within borders, palmettes, &c. The column of Marcian [5] at Constantinople has on three sides of its base large wreaths

[1] O. Wulff, *Altchristliche und byzantinische Kunst*, pp. 160 ff.

[2] E. Strong, *Roman Sculpture*, ch. xiv ; O. Wulff, *as above*, pp. 164 ff. ; *B. A. and A.*, p. 142. A. J. Wace, *Classical Review*, xx, 1906, p. 235, and *Papers of the British School at Rome*, iv, p. 270, argues that two at least of the larger sculptures were executed for Diocletian.

[3] Wulff, *Altchristliche und byzantinische Kunst*, p. 166 ; for earlier references, *B. A. and A.*, p. 144. The reliefs are regarded by Wace as of the time of Constantine (*Journal of Hellenic Studies*, xxx, 1909, p. 60).

[4] Wulff, *as above*, pp. 168–9, with a reproduction of the anonymous drawing in the Gaignières Collection. For other references see *B. A. and A.* This column, like another erected by Theodosius, but destroyed by earthquake, commemorated wars with the Goths ; it was damaged at an early period, but the greater part was removed in 1720.

[5] J. Ebersolt, *Rev. Archéologique*, 1909, ii, p. 1, figs. 1 and 2 ; Salzenberg, *Altchristliche Baudenkmale von Constantinopel*, pp. 34–6, and *Album*, pl. i, fig. 5.

containing crosses. On the principal face is a much damaged relief once representing winged Victories, with a wreath containing a cross; the workmanship here is still in a good condition.

The monument of the charioteer Porphyrios, once in the Hippodrome, now in the atrium of S. Irene at Constantinople,[1] is really the base which once supported a bronze statue; it is of white marble with reliefs on all four sides. On two sides Porphyrios stands in his chariot holding the wreath and palm of victory, with acclaiming spectators below. On a third side the charioteer is again seen in his car with its four horses fronting the spectator, two Erotes stand to right and left below, while winged Victories soar above; on a panel below is a scene apparently representing an exchange of teams between two charioteers. On the remaining side Porphyrios is represented standing on foot, in his driving costume, with palm and wreath, this figure probably repeating the design of the bronze statue which the base once supported; to right and left are two Erotes, one holding his cap, the other his whip. The approximate date of the monument is A.D. 490–510. Messrs. Woodward and Wace draw attention to the similarity in style between these reliefs and those dating a hundred years earlier on the base of the obelisk of Theodosius, explaining the persistence of an earlier tradition by a possible conservatism in the style of charioteers' monuments, a conventional model being perpetuated by repeated copying. We observe here, as on the base of the obelisk, the same oriental method of representing the foreground figures on a smaller scale than the principal personage. Another series of reliefs connected with chariot-racing are on a marble block, found in the Hippodrome in 1834, and now in the Kaiser Friedrich Museum at Berlin, the date being probably the late fourth century.[2] On the sides are seen chariot-races, and an interesting representation of the urn used in casting lots for the starting-positions of the drivers. It is an interesting fact that this instrument was introduced in certain Carolingian ivories, where the soldiers at the foot of the cross use it in the division of Our Lord's garments: the intermediary was probably an early illumination.

Our ignorance of Byzantine secular art, which, compared with religious art, is ill represented by surviving monuments, renders difficult the dating of reliefs with mythological subjects. The iconoclastic movement, as already observed, appears to have diverted sculpture into pagan channels, and some of the existing examples may thus have been produced under its influence. The *Kairos* at Constantinople [3] may date from this time, and possibly two slabs in the west and north façades of S. Mark's, representing

[1] Wace and Woodward, in W. George, *The Church of S. Eirene at Constantinople* (Byz. Research and Publication Fund, 1912), Appendix, p. 79; J. Ebersolt, *Rev. Arch.*, 1911, p. 76.

[2] O. Wulff, *Altchristliche und . . . byz. Bildwerke* (Catalogue of the Kaiser Friedrich Museum, Berlin), 1909, no. 27; *Rev. Arch.*, ii 1845, pt. i, pl. xxviii; *B. A. and A.*, p. 144, and fig. 82; *Proc. Soc. Antiq. London*, xxi, 1906, p. 188.

[3] O. Wulff, Berlin Cat., nos. 73 ff.; A Muñoz, *L'Arte*, 1904, p. 135.

C C

Hercules with the Erymanthian boar and Lernaean hydra.[1] Here imitation of antique models is evident, as in the case of the contemporary ivory caskets with antique subjects (p. 213). A doubt as to the date of the Venice slabs arises from their resemblance to other panels with classical subjects in the Theseion at Athens, on one of which is Jason and the bull (?), which seem to belong to a rather later period.[2] A *Kairos* at Torcello appears to be of the eleventh century.[3] In the wall of a house at Campo Angaran, Venice, is a medallion with an eleventh-century Byzantine emperor holding orb and labarum.[4] The already mentioned stucco figures at the west end of S. Maria della Valle at Cividale,[5] variously dated between the eighth and twelfth centuries, if not Byzantine, reproduce East Christian models, perhaps in the precious metals. Two reliefs bear animal-headed figures, perhaps *cynocephali*, since in one case the word κέφαλος appears in the border. One, from Tusla in Anatolia, is in the Berlin Museum ; the second, from Hamidieh, is in the Ottoman Museum at Constantinople.[6] We are reminded of the fact that in late frescoes on Mount Athos (Karakallou) S. Christopher appears with the head of a wolf or a dog ; but in the present case the figures, if not representing theatrical types, like those painted on the staircase of the cathedral of Kieff, are probably fantastic, belonging to the same order of thought as that which inspired the sphinxes and other monsters popular in post-iconoclastic art. A relief with the legendary Ascension of Alexander in a gryphon-car, on the north side of S. Mark's at Venice, may be later than the thirteenth century.[7]

Ornamental Sculpture [8]

The material in this field is far too extensive for more than summary description. It is chiefly architectural, and used for the decoration of buildings, especially for enriching capitals, friezes, lintels, tympana, closure-

[1] Bréhier, *Études*, p. 71 ; Ongania, *La Basilica di San Marco*, iii, pl. liii.

[2] Bréhier, *Nouvelles Recherches*, p. 22 ; G. Supka, in *Jahresbericht des Ungarischen Nat.-Museums*, 1912, pp. 226 ff. A fragment, perhaps of a frieze, in the same place, indifferent work in low relief, appears to represent a combat between a pygmy and a crane : the costume suggests the late eleventh century. Other fragments at Athens represent a centaur playing a stringed instrument, and a sphinx.

[3] *B. A. and A.*, p. 158 and fig. 91.

[4] Bréhier, *Études*, p. 73 ; G. Schlumberger, *Byz. Zeitschrift*, ii, p. 192.

[5] Strzygowski, *Das orientalische Italien*, in *Monatshefte für Kunstwissenschaft*, i ; Diehl, *Manuel*, p. 362 ; Venturi, *Storia dell' Arte Italiana*, ii, p. 127, fig. 102 ; Rivoira, *Lombardic Architecture*, i, p. 99 ; Bréhier, *Rev. Arch.*,

1908, p. 435.

[6] *Jahrb. der K. Preussischen Kunstsammlungen*, xix, 1898, p. 57 ; *B. A. and A.*, p. 160.

[7] Bréhier, *Études*, p. 71 ; *B. A. and A.*, p. 159. The stone has on the back two confronted peacocks in an earlier style. Gryphons on a fragment at Mistra are thought to have formed part of a similar Ascension of Alexander.

[8] In addition to M. Bréhier's *Études* and *Nouvelles Recherches*, already often quoted (pp. 175 &c.), the reader may with advantage consult the two volumes of O. Wulff's *Altchristliche und byzantinische Kunst*, pp. 265 ff., 408 ff., and his two Catalogues for the Kaiser Friedrich Museum in Berlin, *Altchristliche Bildwerke*, 1909, and *Mittelalterliche Bildwerke*, 1911. Strzygowski's works are full of interesting material, beginning with his Catalogue *Koptische Kunst* for the Cairo Museum, 1911,

slabs, &c., though sarcophagi, pulpits and other movable objects received ornament of the same kind, as did wooden doors ; the chief technical methods by which this sculpture was carried out have been described above (p. 175). In a later chapter the derivation and development of ornamental motives will be specially discussed (Ch. VI), but in the present place we may notice a few examples of design favoured by decorative sculptors at different periods.

A favourite motive is formed by vine foliage symmetrically treated, and issuing from a vase with divergent scrolls, in which birds or beasts are seen. The laurel wreath with ribbons (*lemnisci*), or long stems with leaves in place of them, sometimes enclosed monograms or crosses. The acanthus was universal, sometimes naturalistically treated, at others in various stages of degradation ; equally popular was the palmette, from which the ' rosettes ' employed to fill circles and other spaces appear to be derived. Border scrolls both of acanthus and palmette, or bands of continuous leaves, are also general ; the acanthus covering a considerable space, as in spandrels at S. Sophia, Constantinople, is already on the way towards the arabesque. In the sphere of geometrical ornament we may note the prevalence, in the fifth and sixth centuries, of the lozenge inscribed in a rectangle, a motive well illustrated on closure- and parapet-slabs (pp. 198–9) in S. Sophia and S. Apollinare Nuovo. This arrangement, with foliations, rosettes, whorls, or animals and birds in the enclosed spaces, continued in later centuries ; but more characteristic of the middle and later periods are systems of circles, or circles and rectangles, formed of a continuous band, the connexion between the different figures being commonly effected through diminutive intervening circles or loops. For borders, the discontinuous fret, with the lines so disposed as to form a figure resembling a swastika, is common from the fourth or fifth century, the interspaces being filled by birds, leaves, and other motives ; an early instance of this principle is found on the cornice along the sea-wall at Spalato, ornamenting the loggia or gallery of Diocletian's palace.[1]

Animals as ornament (cf. p. 378) were in the early centuries generally treated in the naturalistic Greek manner, even those belonging to Early Christian symbolism. They are sometimes seen in a diaper of squares, as on the sixth-century ambo at Ravenna (Museo Nazionale), where beasts, birds and fish occupy the several panels ; in the convolutions of a diverging vine, as on floor- or wall-mosaics (Plate LXVI), or in those of acanthus scrolls

his smaller volume *Hellenistische und koptische Kunst*, and his long monograph on Mshatta (*Jahrbuch der K. Preussischen Kunstsammlungen*, 1904), down to his *Amida* (with Max van Berchem) and his more recent books, *Die Baukunst der Armenier und Europa* and *Altai-Iran und Völkerwanderung* ; a bibliography of his publications down to 1921 at the end of his

Ursprung der christlichen Kirchenkunst (translated into English as *The Origin of Christian Church Art*, Oxford, 1923) will direct the student to shorter publications. Riegl's books, *Stilfragen* and *Spätrömische Kunstindustrie*, may also be consulted.

[1] Hébrard and Zeiller, *Spalato: le palais de Dioclétien*, Paris, 1912.

forming borders, where sometimes only the fore part of the beast may be observed ; the latter is a fashion established quite at the beginning of the fourth century, in the carved border round the door of the Mausoleum in Diocletian's palace,[1] and is found at a rather later date in Coptic ornamental sculpture in limestone. With iconoclasm there was a new irruption of animal ornament from the East, in which the naturalism of the earlier Hellenistic treatment disappears. Gryphons and other monsters are now increasingly prominent in sculptured reliefs ; we find the old oriental motive of the bird, or beast of prey, or the monster, such as the eagle, lion or gryphon, seizing the harmless creature, such as the hare, gazelle or heifer. The ' heraldic ' treatment in which beasts are confronted, or addorsed on either side of a formal ' tree of life ' now becomes more general. But the bronze doors in the narthex of S. Sophia at Constantinople, with their scrolls and frets cast in relief round the panels, date from the year 838, their inscriptions giving the names of the emperors Theophilus and Michael.

A few words may be added on the decoration of the capital and the closure-slab, two of the most important fields for sculptured ornament.

On the capital,[2] of which the changes due to constructional use have been already noticed, modelled ornament still flourished from the fourth to the sixth century, and the acanthus leaves of the composite Corinthian form were plastically treated. The introduction of human or animal forms was probably suggested by the capitals of Achaemenian Persia (Persepolis, Susa) to the Greeks of Asia Minor ; bulls' heads ornament the capitals of the Didymaean Apollo ; busts of Zeus or figures of winged Victory were placed between the volutes. On the Propylaea of Eleusis winged monsters replaced the volutes of the Corinthian capital. The tradition was handed on to Roman sculpture ; it was common in the Hellenistic world, and in the country of its origin was continued in the sculpture of the later (Sassanian) monarchy. It was through Hellenistic channels that the fashion spread to East Christian art, and its popularity helped sculpture in the round to survive on capitals later than elsewhere. As a rule, the figures take the place of the volutes, and sometimes are found on the sides as well ; more rarely they occupy the sides only, the volutes remaining unmodified. The best examples of such capitals are those with rams in S. Mark's at Venice, where the heads are finely modelled ; these are of the fourth century, and may

[1] Hébrard and Zeiller, *Spalato, le palais de Dioclétien*, p. 90.

[2] For the capital the following may be consulted with advantage : Bréhier, *Études*, as above ; H. Leclercq, in Cabrol's *Dictionnaire d'archéologie chrétienne*, s. v. *Chapiteau* ; O. Wulff, in the two Catalogues mentioned in note on p. 194, in *Amtliche Berichte aus den Berliner Kunstsammlungen*, Jan. 1912, in *Die Koimesiskirche in Nicäa*, 1904, pp. 47–50 and 122, and in *Altchristliche und byz. Kunst*, pp. 275 ff. and 410 ff. ; J. Laurent, *B. C. H.*, xxiii, 1899, pp. 209 ff. ; Strzygowski, *Byzantinische Denkmäler*, ii, p. 241, iii, p. xx ; *Jahrbuch der K. Preussischen Kunstsammlungen*, 1904, pp. 256 and 354, and *Kleinasien*, pp. 117 ff. ; L. Bégulé and E. Bertaux, *Les chapiteaux byzantins à figures d'animaux*, Caen, 1911 ; G. de Jerphanion, *Notes d'archéologie* in *Bessarione*, 1922 ; E. Weigand, *Byz. Zeitschrift*, 1914, pp. 193 ff. (Cf. also p. 89 above.)

well have been brought from one of Constantine's churches in the Holy Land or at Antioch.[1] But the ram was widely distributed, and examples of later date are found at Ravenna and other places. In another type eagles take the place of rams, and were popular in the fifth century; they are seen on the column of Marcian, and at Salonika (Plate XXXIII); there are specimens in the museums at Constantinople and Brussa. At Constantinople Museum there is a capital from Atik Mustapha Pasha, with cherubs' heads at the four corners, which is later than the sixth century, and perhaps dates from the ninth, when Atik Mustapha Pasha was built.[2] The 'basket capital' has a lower part in pierced work roughly resembling a basket loosely plaited of reed. Upon the upper edge stand animals and birds, their heads modelled in the round; examples are to be seen in S. Mark's and S. Sophia; specimens at Ravenna and Parenzo with gryphons or ostriches have a lower part composed of openwork vine-scrolls.[3] The abacus in most cases has the re-entrant angles of the Corinthian form, which shows that these capitals are not later than the middle of the sixth century; we have seen above, that the straight-sided abacus was by that time generally established. They were for the most part made at Constantinople of Proconnesian marble, and exported in all directions; examples occur in Egypt, at Kairwan, Parenzo, Otranto, and Rome. Bréhier has compared the above capitals bearing animal and figure ornament with similar types in French Romanesque churches of Auvergne; in his belief these examples did not copy those of Byzantine origin, but derive directly from Graeco-Roman originals. In other words, they are drawn from a common source and developed with greater fertility of invention.

We have already seen how the use of the drill to produce effects of light and shadow affected capitals of the 'Theodosian' type, where the double row of acanthus leaves, still boldly modelled, is freely pierced with drill-holes producing a hybrid lace-like effect. Capitals with wind-blown acanthus of the same century, exemplified at the main door of S. Mark's at Venice, in S. Apollinare in Classe, and in the Piazza Vittorio Emmanuele at Ravenna, are treated in this way; other examples are at Salonika (Plate XXXIII), and in Syria. Acanthus leaves treated with the drill were also produced in Auvergne and elsewhere in France, and examples occur in Southern Italy (Salerno, &c.); but this kind of work did not survive the Romanesque period.

Capitals reproducing textile designs are rare; the best examples are the four in the narthex of S. Mark's at Venice with lion masks at the corners and on each side a pair of addorsed birds perched on orbs, with their tails crossing, and divided by a formal 'tree' of scrolls deeply undercut.[4] If this design were developed on a flat surface, we should have a pattern in

[1] Bréhier, *Études*, pl. i.
[2] *Ibid.*, pl. ii.

[3] Bréhier, *Études*, pl. iii, figs. 1 and 2; *Nouvelles Recherches*, p. 7.
[4] Bréhier, *Études*, p. 35 and pl. vi.

which the addorsed birds would occupy medallions with lion masks in the interspaces. Another capital with the same design is in S. Sophia at Trebizond, though the execution is inferior.

The capital was well adapted for pierced or openwork carving, which reached its highest development in the reign of Justinian. The treatment of the acanthus by the sculptors who employed this method gives evidence of extraordinary skill and much originality. In the lobed or melon-shaped capitals of SS. Sergius and Bacchus at Constantinople (Kuchuk Aya Sofia), with the mouldings of the architrave above them, the delicate acanthus leaves stand sharply out against almost black shadow; [1] capitals of the same type are in S. Mark's at Venice, though the work is not so fine, at Kilisse Jami in Constantinople, S. Demetrius Salonika, S. Vitale (gallery north of choir).

The basket-capital, already noticed for its sculpture, is of openwork in its lower part. Another openwork type is ' bowl-shaped ', the acanthus leaves which form its body being undercut : examples of the finest kind surmount the columns of the nave in S. Sophia ; others, of different design, are in the nave at Parenzo, in S. Mark's, and the Kaiser Friedrich Museum at Berlin (from Fostat). Ionic twin capitals with imposts carved in openwork are to be seen in the gallery of S. Sophia and the mosque of Sidi Okhba at Kairwan. Impost capitals of various types, all admirably adapted for this kind of work, are in S. Mark's, S. Vitale, and S. Apollinare Nuovo at Ravenna, and at Torcello. [2]

The pierced style was also well suited to the ornament of closure-slabs, of which beautiful examples are preserved in S. Vitale, in S. Apollinare Nuovo, and in the Museum, at Ravenna, [3] and on the west wall of the narthex and between the doors at S. Mark's, Venice : the acanthus and the vine provide the subject of the design. At Parenzo almost all the capitals are carved in openwork, and here different designs are employed, columns of the same pattern corresponding in pairs across the nave. [4]

Pierced work was also employed in the spandrels of the archivolts in S. Sophia ; and here it is employed with great skill to cover large spaces. [5] The style seems to have fallen into comparative disfavour after the sixth century ; but it never completely disappeared. It is seen, for instance, on the capitals of the iconostasis of S. Luke's in Phocis, which are of the tenth century, and on the architrave, where we note the openwork ' cabochons ' found in later centuries at Mistra. Bréhier has noted interesting examples of this technique in Romanesque churches in France. The closure- or parapet-slab, rather than the capital, was however the main field for ' embroidery ' sculpture (p. 176). Here not the design only, but the

[1] Bréhier, *Études*, pl. xiii ; Van Millingen, *Byzantine Churches of Constantinople*, p. 66.
[2] Bréhier, pl. xiv.
[3] *B. A. and A.*, fig. 439 ; Bréhier, pl. xi, fig. 3.
[4] Bréhier, *Nouvelles Recherches*, pp. 5 ff.
[5] Bréhier, *Études*, pl. xii.

appearance of the stuff, of the technique, is imitated. The fine panel in S. Mark's at the foot of the pulpit against the south pier of the choir, with two peacocks in disks, suggests such imitation, and, even more, the slabs or panels built into the façade of the small metropolitan church at Athens, or preserved in the Theseion in the same place. The tiger devouring a gazelle, the eagle with the hare in its claws, the sphinxes confronted on either side of the 'tree of life', the gryphons on either side of the fountain, are all executed in a style suggesting reproduction of embroidery;[1] a clue to the date of this work is given by another slab in the Theseion, with two lions, and a broad border of flowered Cufic script, which seems to have reached Greece in the tenth century.[2] Examples of this kind of scuplture at Athens represent the new stream of influence which came in from Mesopotamia after iconoclasm, persisting during the Seljuk predominance in the west of Asia. Very characteristic of these slabs is the division of the field into compartments by broad raised bands, often grooved or channelled, which form geometrical figures, circles, lozenges, &c. All of these are formed of a continuous band, the transition from one geometrical form to another being effected by a small intervening circular loop. This method certainly suggests that by which the 'galon' of gold or other lace is applied to a textile; and the descent is perhaps made more probable by the early occurrence of parallelograms containing lozenges interconnected with circles on ornamental mosaic such as that at Aegina, which is assigned to the second century, that from Tyre in the Louvre, which may be fourth, and that decorating the niches in S. George at Salonika, which are probably of the early fifth century.[3] For mosaics may be regarded as permanent hangings, and their ornament may have largely imitated that of oriental textiles (curtains, carpets, &c.) which have not been preserved to modern times. The system of interconnected circles was not of course confined to embroidery; it was equally conspicuous in the ornament of silk textiles (p. 354). The use of decorated closure-slabs had begun early, at any rate in the fifth century (Ravenna, Delphi, &c.), and they were common in the sixth. But they increased rapidly with the new beast-ornament, and other formal designs which became popular in the iconoclastic period reached their acme by the tenth century, and retained their popularity to the end of the Empire. S. Mark's at Venice is almost a museum of this kind of work, the galleries are lined with these slabs, re-employed as parapets. The church of S. Luke of Stiris in Phocis is also rich in examples, as is that of the Assumption at Nicaea.

Mention may be made in the present place of the two pilasters in the piazzetta at Venice, near the south-west corner of S. Mark's, brought from

[1] Bréhier, p. 37; Van Berchem and Strzygowski, *Amida*, p. 368; Rivoira, *Lombardic Architecture*, fig. 209; Michel and Struck, p. 299.

[2] Strzygowski, *Amida*, p. 370 and fig. 322; Bréhier, *Études*, p. 38 and pl. vii.

[3] C. Diehl, Le Tourneau and Saladin, *Monuments chrétiens de Salonique*, Paris, 1918, p. 24.

Acre in A.D. 1258.[1] The design of vine-scrolls, &c., shows Sassanian influences, but the treatment in the main is Syrian, and in Syria they were probably produced in the sixth century. Here too we may suppose an imitation of a textile pattern, though not as in the case of embroidery sculpture, of an actual fabric. We may also mention the elaborately carved façade of the palace of Mshatta [2] on the edge of the Syrian desert east of Moab ; the ornament is rich in Hellenistic elements, but the sculptors were probably of Iranian origin. The rich development of vine-scrolls diverging from vases again suggests the inspiration of textile ornament.

There is evidence that colour and gilding were employed to enhance the effect of ornamental sculpture ; at Kahrieh Jami the sculpture is thrown into relief by the use of colour,[3] and there are gilded floral scrolls on a blue ground. All the champlevé sculpture may be said to rely upon actual colour for its effect, since the inlaid substance is generally of a red tinge. But we may naturally suppose colour to have been generally used in the case of all sculpture based upon richly coloured textile originals.

It has been stated above that stucco as a material for ornament in relief was extensively used in buildings where a less costly covering for walls than marble was required ; such decoration was employed with great effect in combination with mosaic.[4] The tradition of its use was unbroken in the East, especially in Mesopotamia, where the concealment of brick walls in this manner was inherited by Mohammedan from Iranian art [5] and is brilliantly exemplified in the remains excavated at Samarra.[6] In Egypt the monastery of Deir es-Suriyāni in the Natron Valley affords the

[1] Strzygowski, *Oriens Christianus*, ii, p. 423 ; *B. A. and A.*, p. 170 ; Wulff, *Altchristl. und byz. Kunst*, p. 268. Cf. for relation to Merovingian sculpture at Toulouse, P. Clemen, *Die romanische Monumentalmalerei in den Rheinlanden*, 1914, p. 186.

[2] Strzygowski, *Jahrbuch der K. Preussischen Kunstsammlungen*, 1904 ; R. Brünnow, *Provincia Arabia*, ii, 1905, pp. 105 ff. Strzygowski's opinion that the date is as early as the fourth century is not accepted by other authorities. E. Herzfeld, on the ground of architectural discoveries at Samarra in Mesopotamia, considers it not earlier than the eighth century (Herzfeld, *Erster vorläufiger Bericht über die Ausgrabungen von Samarra*, 1912, p. 40), assigning it to Moslem times, and placing it in the reign of Yezid II.

[3] Th. Schmidt, *Kahrieh Djami* (*Bull. de l'Inst. Arch. Russe*, xi, 1906. Atlas, pls. 83, 84).

[4] For literary references to its use in Early Christian times see F. X. Kraus, *Geschichte der christl. Kunst*, i, p. 391. For the stucco in S. Vitale cf. J. Shapley in *Studien zur Kunst des Ostens* (Strzygowski, *Festschrift*), 1923, pp. 19 ff.

[5] Strzygowski regards stucco 'Verkleidung' as an essential feature of Iranian brick building, and finds Asiatic influence in almost all the early medieval examples in East and West. Others, while admitting that the method may have come originally from the East, contend that it was implanted in Europe in Roman times, and that later Western examples need not owe everything to contemporary Eastern art. For the use of stucco by the Parthians cf. Herzfeld, *Jahrb. der K. Preussischen Kunstsammlungen*, 1921, p. 139.

[6] E. Herzfeld, *Ausgrabungen von Samarra, Erster vorläufiger Bericht*, Berlin, 1912, pls. iv–viii. The palace of Medina Azzahra near Cordova, begun by Abdurrahman III in the tenth century, was faced, in parts at least, with stucco, though much of the decorative design is on stone. This Cordovan decoration, like that of the mosque of Tulun at Cairo, is descended from Mesopotamia, and should be compared with that of Samarra (R. Velazquez Bosco, *Medina Azzahra*, Madrid, 1912, p. 55, &c.).

richest example of such decoration,[1] while the mosque of Tulun illustrates its early development under Islam.

In Italy ornamental as well as figure sculpture was freely used in stucco at Ravenna and Parenzo in the sixth century,[2] and also at Cividale (p. 188). Very remarkable examples of early stucco ornament, doubtless related to that of the East and of Gothic and Byzantine Italy, are found in the territories of modern France and Switzerland. The first is the work in S. Germigny-des-Prés, the ninth-century church of which the Eastern plan and the remarkable mosaic decoration are noticed in other chapters.[3] Here stucco decoration was freely employed in place of coloured marble; it framed mosaic, and filled wall-niches, the most important work being in the eastern apse. We see diaper of interlaced circles containing rosettes, running floral scroll, and (in niches) formal ' tree ' designs. The second is the stucco decoration revealed by the excavations at the abbey of Disentis in Switzerland, chiefly in the apses of the church.[4] Here was discovered much ornamental work recalling that of S. Germigny, and also remains of large stucco figures reminiscent of those at Cividale. The cathedral of Aix-la-Chapelle was probably once enriched with stucco of this kind.[5]

Minor Sculpture

Ivory carvings.[6] (Cf. pp. 171–5.) The forms assumed by ivory carving in the first half millennium of our era were for the most part derived from the usage of pagan times. The life of the jewel- or trinket-box in both its types was prolonged, but relics were substituted for jewels, whether the box was rectangular and pieced together, or circular and made from a section of a tusk. The diptych underwent a transformation, losing by degrees its practical purpose to afford a field for carved design. Even in the case of consular and other diptychs, where the inner sides had sunk surfaces for wax, the outer sides had become the more important; the interest centred on the carved decoration.[7] Leaves of diptychs, either simple, or composite,

[1] Strzygowski, *Oriens Christianus*, ii, pp. 356 ff.

[2] Orthodox Baptistery, Choir of S. Vitale, &c. C. Ricci, *Ravenna*, pp. 41 ff.; A. Venturi, *Storia dell' Arte Italiana*, i, p. 128, and *Zeitschr. f. Gesch. der Arch.*, i, p. 216; *B. A. and A.*, p. 345; Cabrol, *Dict. d'arch. chrét.*, ii, p. 1510, &c. &c. For stucco in early Italian art see Giulio Ferrari, *Lo stucco nell' Arte Italiana*, Milan, 1910.

[3] The bibliography for this church is lengthy, and, as noted elsewhere, is most fully given by P. Clemen, *Die romanische Monumentalmalerei in den Rheinlanden*, 1916, p. 54, where an adequate description of the stucco ornament, with illustration, will be found.

[4] E. A. Stückelberg, in *Bull. de la Soc. nat. des antiquaires de France*, 1906, p. 324; J. R. Rahn, *Anzeiger für schweizerische Altertumskunde*, 1908, p. 35; P. Clemen, *as above*, p. 53.

[5] Clemen, *as above*, pp. 48, 58.

[6] *B. A. and A.*, pp. 179 ff. To the references there given may be added W. F. Volbach, *Elfenbeinarbeiten der Spätantike*, &c., 1916, and the *Catalogue of the Exhibition of Ivory Carvings*, Burlington Fine Arts Club, London, 1923, in which the fine ivories at Liverpool are reproduced.

[7] The Church, on taking over many consular and official diptychs for her services, still used the interior for writing prayers or commemorative lists of the faithful, living and dead.

i.e. fitted together from five separate plaques, were often used to ornament the covers of books of the Gospels. The composite type, being apparently borrowed from the elaborate kind of consular diptych made for emperors, was adopted as a regular form in decorating book covers and came to be specially made for the purpose, for which it was naturally adapted by its squareness. After the iconoclastic period, when devotional diptychs for private use became numerous, all connexion with writing was abandoned. For the better protection of the carved subjects, it was therefore found convenient to turn the tablets inside out, giving the carved surfaces the inner place;[1] the outer surfaces were either left plain or received carving of secondary importance and usually in lower relief. The triptych, a form unused in pagan times, developed from the diptych; the polyptych, with more than three leaves, did not find favour in the Christian East. So far as we know, statuettes were not made, and in this respect Byzantine ivories suffer in comparison with those of Western medieval origin, among which the figures of the Virgin and the saints are so conspicuous. The rarity of secular ivories which also increase the interest of Western medieval collections is another relative disadvantage. A certain number of caskets have survived, but there are no mirror cases or writing-tablets with subjects from daily life or from Romance, though Byzantine illuminated MSS. have many miniatures with scenes from the chase and similar motives, and medieval Greek literature has its own romances. It should, however, be remembered that secular objects are more liable to destruction than those from the first protected in the treasuries of churches or in monastic libraries, and that the absence of such objects in our collections to-day need not absolutely imply that they never existed.[2]

It has been mentioned on a previous page (p. 174) that the influence upon ivory-carving of painted models began at an early date. This continued influence of the miniature doubtless played much the same part as in the France of the high Middle Ages, lending to ivory carvings an increasing delicacy and refinement which sometimes tends towards virtuosity. The almost monumental character of many reliefs belonging to the earlier period is lost; the figures are smaller and more highly finished. But the exquisite quality of the finer work produced in the tenth and eleventh centuries, with the dignity which its forms derive from the fastidious Hellenizing taste of the time, lends to the best Byzantine ivories a charm only equalled by those of Northern France towards the beginning of the fourteenth century.[3]

[1] In this respect Byzantine ivory diptychs resemble those of the Middle Ages in the West.

[2] The subject on the lid of the casket of Troyes (Plate XXXVIII) has a certain romantic suggestion.

[3] Colour and gilding were employed to heighten the effect of ivory carvings, as was the case in the West. The characteristic mellow tone of old ivory which we so much prefer to colour is not that contemplated by those who carved the work, or by their patrons. Very few ivories have retained much of their original polychrome decoration. The large sixth-century book cover from Murano (p. 205) offers,

It is probable that both Africa and India contributed the raw material from which ivory carvings were made, but the literary and artistic evidence seems to point rather to India. The tributaries on the lower part of the Barberini diptych in the Louvre appear to be Asiatics ; Claudian speaks of Indian elephants in connexion with consular diptychs, and a passage in the panegyric of Anthemius by Sidonius Apollinaris points in the same direction. It is also a curious fact that elephant tusks seem to have been actually imported from India into Egypt.[1]

The classification of ivory carvings, a favourite pursuit of Early Christian archaeology, has not been neglected during recent years, and there is perhaps more certainty than before as to general lines of development. But particular attributions are still problematic, and rest upon no stronger foundation than hypothesis. To determine the origin of ivories made between the fourth and seventh centuries is a matter of exceptional difficulty. For there were various centres able to produce them, in most of which the same racial elements were liable to meet ; there were Greeks alike in Alexandria, Antioch, Constantinople, Rome, and Jerusalem ; there were Aramaeans and other orientals in the same cities ; and when, in the fifth century, the Church introduced her art of compromise, the different centres became even more difficult to distinguish. In a world penetrated by the same influences, and drawing on the same iconographical sources for the subjects of its religious art, a local style needed strong individuality to retain distinctive qualities. But local styles must have arisen, nor can Greeks and orientals have been the only carvers, they must have had pupils in Italy. Our difficulties are enhanced by the fact that surviving material, though large, is still too imperfect to justify generalizations sometimes made on evidence too slender to bear the superstructure erected on it. The frequent changes of attribution encountered by the reader of works on East Christian archaeology illustrate at once the complexity of the problem and the danger of affixing permanent labels too soon.

When positive evidence is lacking, style is the chief factor in determining origin. Ivories may be compared not only with major sculpture but with the work of the graphic arts ; by this means it is sometimes possible to associate types or groups with certain places or peoples. But however carefully we may compare, the migratory habits of Early Christian artists, who were the carriers of style, introduces a serious element of confusion. Another factor in determining origin is found in iconography : a subject may have a special connexion with a particular country or region. But here again migration intervenes ; a type may have been transported to a distance,

however, an early example on which considerable traces remain ; the casket in the Museo Kircheriano at Rome shows colour on the garments of certain figures (p. 214), and there are signs that the Harbaville triptych in the Louvre was partially gilded (p. 217).

Occasionally ivories, like the vellum of royal MSS., were stained purple all over ; this was the case with the above-mentioned casket in the cathedral of Troyes.

[1] L. C. West, *Journal of Roman Studies*, vii, 1917, p. 53.

acquired popularity, and become characteristic of a new home ; it thus loses its indicative value. For these reasons the precise attribution of ivories to local schools is still an intellectual adventure. Even so, if put forward tentatively and without pretence to infallible knowledge, it has a provisional value as bringing some perceptible order into a confusion where any guiding thread is welcome. Perhaps the best means of beginning a sound classification is that which groups round important examples such other carvings as appear to be identical or closely similar in style. Such groups at least provide rallying-points. If they can be definitely associated with a city or a region, a great step forward is made ; if they cannot, they give temporary shelter to units which would otherwise drift at random to the increase of the general confusion. Unfortunately, there is frequent disagreement about identity of style, and units which one authority would connect with one monument are by a second authority associated with another. Grouping and re-grouping continue, as new perceptions give rise to fresh conjectures ; there is no finality.

Recognizing the great difficulties inherent in this situation, the student must pick his way as best he can, trying to distinguish as far as possible between theories which may be regarded as finally added to the body of knowledge from hypotheses of two kinds : those which bid fair to establish themselves as theories, and those of the nature of a guess. The general classification suggested by Wulff may be taken as an example of what is possible under existing conditions. Objections may be raised against it from more than one side, but it holds the whole subject together, as it were, before the eyes of the student, and this in itself is no small service.

The group associated with the ivory book cover in Milan Cathedral [1] has been mentioned above as the subject of widely divergent attributions ; the principal other members of the group are the casket panels from Werden in the Victoria and Albert Museum, two panels from a composite diptych at Berlin and Nevers respectively, and a pyxis at Rouen,[2] the last two showing a certain kinship to the diptych of Probianus, *Vicarius* of Rome.[3] Wulff would assign these ivories to Antioch and Syria,[4] and Strzygowski also inclines to the East. But there are certain features, iconographical and other, which seem rather to connect the group with the West, and these have been discussed by Haseloff, Stuhlfauth, and Baldwin Smith ; the last-named would include in the group the casket panels with Passion scenes

[1] *B.A. and A.*, p. 202 ; Venturi, *Storia*, i, fig. 390 ; E. Baldwin Smith, *Early Christian Iconography*, &c., pp. 206 ff., Princeton, 1918 ; Stuhlfauth, *Altchristliche Elfenbeinplastik*, pp. 66 ff.

[2] Haseloff, *Jahrb. der K. Preuss. Kunstsammlungen*, xxiv, 1903, p. 47 ; Strzygowski, *Kleinasien*, p. 198.

[3] Molinier, *Ivoires*, pl. iv ; Baldwin Smith, *as above*, p. 245 ; Wulff, *as above*, p. 191. Wulff, however, regards the Probianus diptych-leaf as the work of a Syrian carver and assigns it to the East ; *as above*, p. 193.

[4] *As above*, p. 186. Wulff regards the Milan diptych as related in style to the Brescia reliquary, which he assigns to Antioch.

in the British Museum.[1] The result is that this group has been credited by different scholars to Antioch, Rome, Milan, and Provence.[2]

Wulff would form a group round the carved wooden doors of S. Sabina, regarded as a Palestinian work.[3] He would include the diptych in Milan Cathedral with Passion scenes,[4] the well-known panel in the Trivulzio collection at Milan with the Maries at the Tomb, the fine panel at Munich with the Ascension, and the Passion panels in the British Museum which, as we have just seen are attributed by Baldwin Smith to Provence, and have by earlier authorities been assigned if not to Rome, at least to Italy. A most interesting and important ivory must perhaps be added to this or to the preceding group. This is a diptych with six miracles of Our Lord. Once at Palermo, it is now in private possession in Great Britain, and has for the first time received adequate illustration and description.[5]

The nucleus of another group is the leaf of a book cover from Murano, now in the Museo Civico at Ravenna, with three plaques from the second leaf preserved in different collections.[6] Here again the central panel shows Our Lord, seated between S. Peter and S. Paul and two angels ; the top panel has the usual angels ; at the bottom are scenes from the story of Jonah, while each of the two side plaques has two of the Miracles. The panels are separated by borders of acanthus and vine-leaves, and there are traces of painting and gilding on all.

The ornamental details of this book cover once suggested Upper Egypt as the place of origin ; but the arguments advanced by Wulff on behalf of Edessa or its region have been received with some favour. The ivories related to the Murano book cover are a centre-panel from a book cover in the British Museum (Plate XXVI), with the Adoration of the Magi, and the Nativity ;[7] panels at Paris, Bologna, and Moscow, and a large series of ivory pyxides ; one in the British Museum, with Daniel between the lions,[8] others in various foreign collections.

The nucleus of a larger group is the above-mentioned throne of Maximianus (Plates XXXV and LXV), in the chapel of the archbishop's palace at Ravenna ; it dates from the first half of the sixth century.[9] This is a wooden

[1] As above, p. 187, note. For references with regard to these panels, see the British Museum Catalogues of Early Christian and Byzantine Antiquities, and of Ivory Carvings.

[2] Baldwin Smith, chiefly on iconographical evidence, seeks to establish a school of ivory carvers in Provence, whither sculptors fled from Rome during the troubles of the fifth century.

[3] Altchristliche und byz. Kunst, p. 187.

[4] Venturi, Storia, i, fig. 390, and p. 426.

[5] E. Maclagan, Antiquaries' Journal, iii, pp. 99 ff., has ably stated the case for the early date of this diptych (early fifth century). The alternative would be that it is of the Carolingian period. The work has a disconcerting

uncouthness, and, if ancient, may have been made in some less accomplished centre than Alexandria.

[6] B. A. and A., figs. 114 and 125 ; Venturi, Storia, i, p. 452 ; Strzygowski, Hell. und koptische Kunst, p. 87, and Byz. Zeitschrift, viii, p. 680 ; Wulff, Altchristliche und byz. Kunst, p. 189 and fig. 186, and Byzantinisch-neugriechische Jahrbücher, ii, 1921, p. 144.

[7] B. A. and A., fig. 126.

[8] British Museum Cats., as above, nos. 298, 13.

[9] For the older references see B. A. and A., p. 203. O. Wulff, Altchr. und byz. Kunst, p. 190. Illustrations in Venturi, Storia dell'Arte Italiana, i, figs. 278–307. The front well

chair with high rounded back once covered all over and still mostly covered
with carved ivory panels with sacred subjects framed or divided by plaques
with purely decorative designs—vine-scrolls with birds and animals in the
convolutions, &c.　The lower front has five large panels, three broad and
two narrower, containing standing figures of S. John the Baptist and four
Apostles ; above and below are broad bands of vine-scroll design, the
upper containing a monogram in the middle.　The panels decorating
the sides and back are carved with scenes from the New Testament and
from the story of Joseph ; the former are superior to the latter in style,
and the work of another hand.

There is no reliable evidence connecting the throne with Bishop
Maximianus, and we are thrown back upon comparison with other monu-
ments to determine its probable origin.　It is still a matter of dispute
whether Alexandria or Antioch should be regarded as its original home.
In favour of Antioch and its South Anatolian sphere of influence is the
suggested affinity between the statuesque figures on the front and those of
the Anatolian group of sarcophagi ; the arrangement of the panels on which
they are carved, with their niches of unequal breadth, is also reminiscent
of these sarcophagi.　The ornament, whatever the remoter origin of its
class, is immediately derived from Syria, and the iconography of the New
Testament scenes shows Syro-Palestinian influence.　On the other hand,
it is argued that the statuesque figures are equally in agreement with
Alexandrian sculptural tradition, with which the Joseph scenes also accord ;
and that the choice of these scenes points to Egypt, as does the prominence
given to John the Baptist, who was specially venerated at Alexandria.　For
these reasons Wulff ascribes it to his Syro-Egyptian group, which consists
of those ivories produced in Alexandria after the influx of Syrian influence
in the later fourth century.　Characteristics of style connect two ivory book
covers and various other ivories with the episcopal chair.　The two covers
are in the Bibliothèque Nationale at Paris,[1] and in the monastery of Edg-
miatsin (Etchmiadzin) in Armenia.[2]　The first, which is of indifferent
workmanship, has in the middle of one side Christ, bearded and without
nimbus, seated between S. Peter and S. Paul ; on the upper plaque two
angels, replacing the Victories of the consular panels, hold a wreath con-
taining a cross ; on the bottom plaque we see Christ with the Woman of
Samaria at the Well, and the Raising of Lazarus.　Of the lateral panels, that
to left has the Healing of the Blind and of the Paralytic, that to right the
Woman with the Issue of Blood, and the Healing of the Demoniac.　In the
middle of the other leaf is the Virgin seated with the Child between two
angels ; the top plaque has again angels with a wreath, the bottom the

reproduced in Molinier, *Ivoires*, pl. vii. F. Mar-
troye, *Bull. de la Soc. des Ant. de France*, 1910,
pp. 267 ff., would give the monogram to Maxi-
mus, bishop of Salona in the fourth century.
E. Baldwin Smith, *Am. Journ. of Arch.*, 1917,
pp. 22 ff., argues for an Alexandrian origin.

[1] *Bibl. Nat.*, no. 9384. Refs. in *B. A. and
A.*, p. 207.

[2] Strzygowski, *Byz. Denkmäler*, i : *Das
Etschmiadzin-Evangeliar*.

Entry into Jerusalem, while on the two sides are the Annunciation and Visita-
tion, and the Meeting of Joseph and Mary, with the Journey to Jerusalem.
A detailed description is given in this case to show the kind of subjects and
their arrangement adopted in the case of book covers ; the distribution on
the Edgmiatsin example is similar.

The other ivories associated with the chair include two large panels
with Apostles and Gospel scenes in the Fitzwilliam Museum at Cambridge,[1]
and related panels at Brussels and Tongres ; a panel with the Baptism in
the British Museum,[2] a plaque with S. Paul in the Cluny Museum at Paris,
and several pyxides : that with the Martrydom of S. Menas (Plate XXXIV)
in the British Museum,[3] and others in the Louvre, at Berlin, and in Russia.[4]
These objects are naturally of varying degrees of merit, the better belonging to
the earlier part of the sixth century, like the chair, the inferior to the later
part or to the beginning of the seventh.

A group of ivories chiefly in the Museo Archeologico at Milan, but
represented by examples in London and Paris, has subjects from the life of
S. Mark. They are connected by stylistic peculiarities, and, if all of the
same age, may have belonged to the episcopal chair of S. Mark, once at
Grado ; this would suggest a sixth-century date and an Alexandrian origin
for the whole.[5] Hitherto there has been a reluctance to treat all these
ivories as homogeneous, and of so early a period ; resemblances to the
panels of the twelfth-century paliotto at Salerno have been pointed out,
and an origin for some at least of the panels in the south of Italy has been
proposed, the date suggested being that of the paliotto.[6] A strong case
for unity and for the earlier date has been made out by Maclagan.[7] The
chief difficulty in accepting it lies in the peculiar mannered style, which
differs from that of other Alexandrian ivories of the sixth century known
to us, and in the case, for example, of the panel with the Raising of Lazarus
(Plate XXVII), seems to breathe the formalism of a later time.[8]

The consideration of the above groups is sufficient to show how different

[1] *Fitzwilliam Museum, McClean Bequest ;
Catalogue of the Mediaeval ivories, enamels*, &c.,
nos. 32, 33, and pl. iv.

[2] *Catalogue of Early Christian and Byzantine
Antiquities*, no. 294 ; *Catalogue of Ivory
Carvings*, no. 10.

[3] British Museum Catalogues, *as above*, nos.
297 and 12.

[4] *B. A. and A.*, p. 209 (references).

[5] E. R. D. Maclagan, *Burlington Magazine*,
April 1921, pp. 178 ff., with full references.

[6] E. Bertaux, *L'art dans l'Italie méridionale*,
pp. 433, 436. The miracle of Cana on the
paliotto reproduces the composition of the
same subject on the plaque at South Ken-
sington.

[7] If the Trivulzio ivory with the Annuncia-
tion in this group is sixth century, it becomes
difficult to deny that the Raising of Lazarus in
the British Museum is also of that date. The
occurrence of S. Menas upon one of the
plaques is also difficult to explain if the
theory of a late origin is accepted ; nor do
the peculiar mannerisms appear on the paliotto
panels.

[8] The final comment by Bertaux on the
S. Mark and Salerno series is as follows :
' Enfin, il faudrait se remettre en quête du
prototype inconnu de deux séries d'ivoires
qui, en se ressemblant singulièrement l'une à
l'autre, diffèrent de tous les ivoires byzantins
et latins du Moyen Âge' (*L'art dans l'Italie
méridionale*, p. 435).

theories based upon style and iconography cut across each other, and how whole groups, or single members of groups, may be transposed to suit this or that theory as to provenance.

We may now notice certain ivories of especial interest not hitherto discussed, concluding with the consular diptychs and other secular examples.

The oldest definitely Christian ivories appear to have been made at Antioch. The connexion of the great Berlin pyxis and the panels of a relic-casket at Brescia with this city seems to be established. The pyxis,[1] which bears the Sacrifice of Abraham (Plate XXXIV) and Our Lord among the Apostles, is related in style to the arcaded sarcophagi with statuesque figures, and dates from the mid fourth century. The manner of representing the sacrifice is common to other ivories attributed to the Eastern provinces, while the altar by which Abraham stands is a conventional representation of the Persian fire-altar, not likely to be adopted by an artist working in Rome, and occurring on a Christian mosaic discovered near Gaza in 1917.[2] The work as a whole is classically inspired, though later than the pyxis with Orpheus at Bobbio, made at the beginning of the century; and the Abraham may be derived from the Calchas in the picture of the sacrifice of Iphigeneia by Timanthes.

The Brescia relic casket[3] is carved with subjects from the life of Our Lord and Old Testament scenes relating to Moses, Korah, David, Jeroboam, Daniel, and Susanna; round the top of the sides are busts with medallions of Our Lord and the Apostles. Here too we find a classical treatment, and a relation to the arcaded sarcophagi. The date may be as early as the middle of the fourth century, and the iconography conforms to the Antiochene redaction which Millet's studies have established.[4]

Before the increase of Syrian influence, Alexandria was distinguished for pagan classical figures such as we see on the earlier bone carvings so frequently brought from Egypt. The beautiful diptych of the Symmachi and Nicomachi,[5] one leaf of which is at South Kensington, and the other in

[1] W. Vöge, *Elfenbeinbildwerke* (Cat. of the Kaiser Friedrich Museum), 1902, no. 1; O. Wulff, *Rep. für Kunstwiss.*, xxxv, p. 222; *Altchr. und byz. Kunst*, p. 183; *B.A. and A.*, p. 195. The pyxis with Orpheus at Bobbio (Venturi, *Storia*, i, figs. 404–5) is also regarded by Wulff as Christian and Antiochene. For the relation of these pyxides to the silver chalice of Antioch cf. p. 329.

[2] *Burlington Magazine*, Jan. 1919, p. 3; *Proc. Soc. Antiq. London*, xxxii, p. 47.

[3] Somewhat pedantically called the *lipsanotheca* of Brescia; the panels are now fixed to a board, forming a cross. The references for the Brescia casket are given by H. Leclercq, in Cabrol's *Dict. d'arch. chrét.*, s. v. *Brescia*; G. Stuhlfauth, *Elfenbeinplastik,* p. 41; illustra-

tions are given by Leclercq, *as above*; Garrucci, *Storia dell' Arte Cristiana*, vi, pls. 441–5; Venturi, *Storia*, i, figs. 273–7; H. Graeven, Photos, series ii, nos. 11–15; C. M. Kaufmann, *Handbuch der christlichen Archäologie*, p. 555; O. Wulff, *Repertorium*, as above, p. 220, and *Altchristliche und byz. Kunst*, p. 185. Strzygowski, *Kleinasien*, p. 213, assigns the casket to Asia Minor, partly on the ground of a type of church façade represented; O. Wulff, *Repertorium für Kunstwissenschaft*, xxxv, 1912, p. 220, derives its illustration from the Antioch redaction.

[4] *Iconographie de l'Évangile*, pp. 581, 589.

[5] Victoria and Albert Museum, *Portfolio of Ivories*; Venturi, *Storia*, i, fig. 354. The diptych may very well have been actually made

Paris, is in the Alexandrian style, the source of inspiration being probably a Greek sepulchral relief. Other panels with classical figures of less superlative merit (Muse and a Poet, Aesculapius and Hygieia, and other subjects), distributed in various collections,[1] are perhaps in like manner either Alexandrian work or made by followers of Alexandrian tradition. A late phase of this pagan art is represented by the panels in the cathedral of Aix-la-Chapelle, where they are inlaid in the pulpit. One of these has an equestrian figure which may be compared with that of the Barberini diptych, and the type of mounted saint popular in Egypt; on others Isis, Bacchus, and Nereids are represented. An Egyptian origin seems probable for the series, more especially as some of the figures recall those on the bone carvings.[2] A panel in the Kaiser Friedrich Museum at Berlin with Apollo, panels with personifications of Rome and Constantinople at Vienna, and an ivory at Ravenna with Apollo and Daphne, may be brought into relation with the pulpit panels.[3] A Syrian influence is apparent in the vine-scrolls and other ornament. It is noted elsewhere that Coptic ornament took up and developed motives introduced through Syria in the fourth century.

The Barberini composite diptych-leaf,[4] with a figure of a mounted emperor (probably Justinian), now in Paris, shows Alexandrian influence, and is assigned by some to Alexandria, though the resemblance of the heads to those of consular diptychs and other features lead others to connect it with Constantinople.[5] This diptych, through the angels bearing a glory with a bust of Our Lord, in the plaque at the top, is related to book covers with completely Christian subjects.

The remarkable relief in the Louvre with S. Mark (?) preaching to an audience of thirty-five persons before the walls of a city [6] is usually associated with Alexandria and in some points recalls the group ascribed to the lost chair of S. Mark at Grado mentioned above. The same attribution is generally given to the panel in the cathedral of Trèves representing a translation of relics in the presence of imperial persons, and with an interesting architectural background.[7] Wulff, however, would give both carvings to Constantinople.[8]

The presumed connexion of the episcopal chair now at Ravenna with Alexandria has been already noted, as has that of the group of panels attributed to the lost chair of S. Mark (above, p. 207).

in Rome. Professor Lethaby suggests that the model was a small marble relief now in the Museo delle Terme.

[1] See E. Molinier, *Ivoires*, and Westwood, *Fictile Ivories*.

[2] Strzygowski, *Hellenistische und koptische Kunst*, pp. 19 ff.; *Orient oder Rom*, p. 85; *B. A. and A.*, p. 212; Wulff, *Altchr. und koptische Kunst*, p. 189.

[3] *B. A. and A.*, p. 212.

[4] References, *B. A. and A.*, p. 199. Best illustration, *Monuments Piot*, vii.

[5] Wulff, *Altchr. und byz. Kunst*, p. 194.

[6] E. Molinier, *Catalogue des ivoires* (Louvre), no. 3; G. Schlumberger, *Monuments Piot*, i, p. 165; Strzygowski, *Hellenistische und koptische Kunst*, p. 79.

[7] *B. A. and A.*, fig. 127; Strzygowski, *Orient oder Rom*, p. 85. The subject is supposed to be the removal of the remains of the Forty Martyrs to the Church of S. Irene at Sycae in Constantinople.

[8] *As above*, p. 195.

We may pass to the ivories attributed to Constantinople. The great diptych-leaf in the British Museum [1] with Michael holding a staff in one hand and an orb in the other (Plate XXXVI), a work of singular grandeur and exceptional size, has qualities derived from various sources, some pointing to Alexandria, others to Antioch ; it is not unreasonable to ascribe it, on account of its eclectic treatment, to Constantinople. Strzygowski draws special attention to the theatrical associations of the doorway with flight of steps before which the angel stands like an actor about to descend upon the stage. The treatment of the figure is not faultless, but the effect of the panel as a whole is noble and impressive ; it appears to date from the fifth century, and may well have been made for presentation to an emperor.

The group of consular diptychs [2] represents a development of the custom of presenting diptychs in commemoration of family events or of accession to public office. The diptych of Rufius Probianus, already mentioned, is an early and fine example of this custom as practised under the Roman Empire. But the majority of these official tablets were made for Byzantine consuls, the series beginning early in the fifth century and ending with the abolition of the consulate in A.D. 541. About fifty of these diptychs survive, of which the six fifth-century examples were made for Rome. Of the remainder, only one, that of Orestes (A.D. 530), belongs to Rome, the others are Byzantine ; and the diptych of Orestes is so like the Byzantine type as to be hardly distinguishable from the rest. Only twelve consular diptychs are anonymous.

A common type of these diptychs shows the consul seated in the *sella curulis* holding a sceptre in his left hand, and in his right the *mappa* or napkin which he is to throw down as the signal for the commencement of the games in the circus. In a lower zone are charioteers, horses, acrobats and mimes to illustrate the games, or men with sacks of coins, representing the new-made official's largess. The consul is generally alone, though sometimes personifications of Constantinople and Rome stand on either side behind his chair ; in the earliest diptychs, before the introduction of the stock type, he is seen simply standing, alone or between two companions of rank, as in the case of the example in the cathedral of Halberstadt. The upper part of the diptych is commonly filled with an inscribed tablet, imperial busts in medallions, with perhaps a cross between them. The first leaf usually bears the consul's name, the second his titles ; apart from

[1] British Museum *Catalogue of Early Christian and Byzantine Antiquities*, no. 295, and *Cat. of Ivory Carvings*, no. 11 ; *B. A. and A.*, p. 195 ; Wulff, *Altchristliche und byz. Kunst*, p. 195 ; Strzygowski, *Journal of Hellenic Studies*, xxvii, 1907, pp. 99 ff., and *Burlington Magazine*, 1907, p. 10. A medieval inventory of Canterbury Cathedral (A.D. 1315) mentions among covers of gospel books : *angelus longus eburneus in ligno . . .* This may possibly refer to the British Museum panel. Written in ink on the back are the remains of a prayer in Greek characters.

[2] For consular diptychs see *B. A. and A.*, pp. 196 ff., where references will be found. The list given by E. Molinier in his *Ivoires* is valuable. See also Wulff, *Altchristliche und byz. Kunst*, p. 192.

this, the same design seems to have been repeated on both leaves. Sometimes a departure from the figured type is noted, almost with relief, as in the case of the diptychs of Flavius Petrus Sabbatius Justinianus (A.D. 516–521), now in the Bibliothèque Nationale, Paris, and in the Metropolitan Museum at New York, where figures are dispensed with; the middle is occupied by a dedication inscribed in a wreath of palmettes between four finely carved rosettes near the corners of each panel : another example without human figures is the diptych of Philoxenus (A.D. 525), represented at Paris and at Milan. We have noted that the quality of these presentation diptychs varied with the rank of the recipients, and it is clear that the ordinary type could not be offered to the emperor. For him tablets must be found made from a tusk of extraordinary size, like the archangel panel, or exceptional dimensions must be obtained by fitting round a flanged central panel four narrower plaques, so that the five together formed a composite whole. This destination of the composite diptych is proved by the inscriptions on two plaques in the Trivulzio collection at Milan.[1] They are the upper and lower plaques of a composite diptych; on the upper, which has the usual design of two winged Victories supporting a wreath, the legend refers to a *triumphator* and *semper Augustus* who can only be the emperor, while the lower mentions the consular donor. Other plaques at Basle and Munich afford confirmatory evidence ; that in the former place having the words *perpetuae semper Augustae*, which seem to show that these diptychs were also offered to empresses. As early as the sixth century the covers of Gospels were enriched with panels in five parts disposed like the imperial diptychs, sacred subjects taking the place of secular.

Consular diptychs served the Church in another way. At the commemoration of the faithful, living or dead, a list of names was recited, and for these lists the inner sides of the diptych-leaves were well adapted ; they were sometimes also used for liturgical prayers. In both cases the writing is usually in ink on the surface of the ivory, and not upon the wax which the diptych was originally made to receive. A very interesting example of a consular diptych used in commemoration is that of Boethius (A.D. 487) now in the Museum at Brescia, where the upper part of each leaf is ornamented with a subject painted in colours, on one side the Raising of Lazarus, on the other side half figures of S. Jerome, S. Augustine, and S. Gregory. Beneath the paintings is the formula *Quos Deo offerimus*, followed by the names. This diptych was changed at some indeterminate date from a diptych of the dead to a diptych of the living, and the names now most legible are of persons alive when the change was made ; but there are remains of the earlier list, which was imperfectly defaced.[2]

The leaf with the archangel in the British Museum has on the back

[1] W. Meyer, *Zwei antike Elfenbeintafeln*, &c., Munich, 1879, p. 50 and pls. i and ii.

[2] H. Leclercq in Cabrol, *Dict. d'arch. chré-* *tienne et de liturgie*, s. v. *Brescia* ; A. Muñoz, *Nuovo Bullettino dell' Arte Cristiana*, xiii, 1907, pp. 5 ff. and pl. i.

a largely effaced Greek prayer written in ink; the same is the case with another panel in the collection, with the Adoration of the Magi, once forming the centre of a composite book cover.[1]

Two panels in the Bargello at Florence and at Vienna respectively,[2] each representing an empress with orb and sceptre standing beneath a canopy, may be assigned to Constantinople; they have affinities to some of the ivories above mentioned, and the costume resembles that seen in the panel with the translation of relics in the cathedral of Trèves:[3] their date should be the sixth century.

We may briefly resume the more striking features of the work belonging to the early centuries. In the first place, certain forms are practically confined to it. The pyxis is exceedingly rare after the sixth century; the same is true of the composite diptych and book cover. Large panels such as those used for the consular diptychs are no longer found; the great tusks which alone could furnish them were perhaps less easily obtainable.

The style of the early ivories taken as a whole bears evidence of a relationship to larger sculpture, usually to that of sarcophagi of about the fourth century. The relationship is sometimes almost as close as that between French Gothic ivories and the sculpture of contemporary or almost contemporary cathedrals. In rarer cases, for instance those of the British Museum Archangel, and the front of the Chair of Maximianus, we find reminiscences of pre-Christian Greek art, and more definite imitation in the case of the Roman diptych of the Symmachi and Nicomachi. However bad the work of many objects, especially the later, may become, we are generally conscious of at least a remote descent from older and better plastic types. Yet even in the early centuries the subjects of Christian ivories were often given by mosaic and painting; the process of subjection to graphic art, which we have noted in the case of major sculpture, had already begun.

Partly in consequence of their relationship to monumental sculpture, the figures of the early period are larger and more massive than in subsequent times. Even when they become squat and uncouth, they have a solidity and suggestion of life not seen in the more finished work of later times. The ornamental features are distinctive. Arches and arcades, reminiscent of certain types of sarcophagi, are used to isolate the several figures. Again, ornament of vine-scrolls of Syrian type such as we see on the episcopal chair, is characteristic of this earlier time, less so of later centuries. In the same way, borders of acanthus [4] either round the panel itself, or parts of it, as in the case of the Murano diptych (p. 205), went out of favour in subse-

[1] British Museum, *Cat. of Ivory Carvings*, no. 14; *B. A. and A.*, fig. 126.

[2] *B. A. and A.*, fig. 128; Molinier, *Ivoires*, fig. 3; R. von Schneider, *Album auserlesener Gegenstände*, &c. (Vienna Museum), pl. 4.

[3] It has been noted above that Wulff regards this ivory as of Byzantine rather than Alexandrian origin.

[4] On certain early panels, e. g. the diptych of Probianus, *Vicarius* of Rome, and several others, borders of palmette occur.

quent times, when borders are plain, and ornament, when used, follows a new fashion.

The period from the first half of the seventh century to the close of the ninth, which included the iconoclastic disturbances, has left us hardly any ivories certainly to be dated within its limits, though the influence of new ideas appears in transitional groups produced in years between iconoclasm and the new era beginning with the Macedonian dynasty. We have seen (p. 16) that these unsettled times were marked by a reversion to antique figure subjects, and by a great influx of fresh oriental motives, including new types of beast ornament. Subjects from the antique are found upon a whole group of rectangular caskets [1] dating from the second half of the ninth century to the early part of the twelfth, the finest example of all being that in the Victoria and Albert Museum, South Kensington, formerly in the cathedral of Veroli in Italy (Plate XXXVII), and the best series in one place the group in the Pierpont Morgan collection in the Metropolitan Museum at New York. The lids may be flat, hinged, or moving horizontally in grooves, or they may be pyramidal, as in the Veroli example. The panels are applied to wooden cores and are sometimes framed in borders carved with formal rosettes which alternate with heads in profile resembling types on coins. This last feature suggests that the principal models of the caskets were pieces of embossed silver plate, for the borders of Graeco-Roman silver dishes or salvers were ornamented with inlaid coins bearing imperial effigies, while vessels in the Roman silver treasures found at Boscoreale, Bernay, and Pompeii have in their ornament genii and animals of a similar kind. The statue of Herakles by Lysippus, which stood in the Hippodrome at Constantinople, appears to have been copied by the carver of the casket at Xanten, but, this recourse to major sculpture is exceptional. It has been maintained that the whole group of caskets is itself antique ; but quite common mythological scenes are misunderstood, and their elements so unintelligently misplaced that the artists could not have lived in days when mythology was still a serious study. The work more probably belongs to the time which produced the Labours of Hercules on the façade of S. Mark's at Venice and analogous marble reliefs (p. 193). Many figures are of the same family as those ornamenting illuminated Psalters of the ' Monastic Group ' (p. 308), none of which is earlier than the ninth century ; and some resemble those upon other ivory carvings copied from a MS. the illustration of which is later than the sixth century.[2] Finally, on a casket in the Museum at Cividale there are people riding with stirrups, which were not generally known in Europe until about A.D. 600 ; while an enamelled glass cup in the Treasury of S. Mark's (p. 348), which has a Cufic inscription assigned to the early twelfth century, has heads and

[1] *B. A. and A.*, p. 215, for references; H. Graeven, *Jahrbuch der Kunstsammlungen des allerhöchsten Kaiserhauses*, xx, 1899, pp. 25 ff.

[2] The Joshua roll (p. 306); cf. Graeven, *Jahrbuch*, as above, xviii, pp. 1 ff.

rosettes very like those of the caskets, and on its sides, larger mythologic subjects. These considerations, taken together, persuade us to reject the antique origin. Not all the reliefs upon boxes of this kind are of classical derivation. Two panels in the British Museum,[1] with rosette borders, show jugglers and acrobats, such as those who performed in the Hippodrome. One small group, on which rosette borders are common, has scriptural subjects, the story of Adam and Eve, or sacred persons. The religious group is thought to come late in the series, and, in general, the relief is here lower than in the case of the finest secular subjects, such as those on the Veroli casket, which are in some places undercut. But no sharp line can be drawn between sacred and profane subjects, since the panels at New York with scenes from the story of Joshua resemble those of the Veroli casket in style. It is interesting to note that the panel in the Museum at Pesaro, with the Expulsion from Eden, appears to have been the model used by Bonannus for the same scene on the bronze doors of Pisa cathedral, dating from the last quarter of the twelfth century. Panels in the British Museum, and at Berlin,[2] illustrating the story of Joseph, appear to have once ornamented a casket of this style and period. The curious casket in the Museo Kircheriano at Rome,[3] with scenes from the story of David, is related to the religious group ; it would hardly seem to be contemporary, but to have been inspired by an earlier casket of the kind. The makers of the figured caskets appear to have influenced other ivory carvers. The panels with the Labours of Hercules on the chair of S. Peter at Rome are akin to their work. A panel in the British Museum with the Vision of Ezekiel,[4] perhaps of the early tenth century, shows the dead rising in the form of small curly-haired genii exactly of the casket type. A certain number of caskets are without figure subjects, but ornamented with beasts of oriental type, with borders of foliate design. These seem to have been imitated at an early period in Italy and elsewhere, and in this case it is not always easy to say whether a given example is Byzantine or not. The type is illustrated in England by a casket in the Fitzwilliam Museum at Cambridge, and by the Hoentschel casket in New York, on which human and animal figures are both employed.

Another group of ivory carvings apparently originating in the iconoclastic period, but long outlasting it, is formed by the horns of elephant's tusk, usually known as oliphants,[5] and dating from the ninth to the twelfth century. Some appear to be purely oriental, others Byzantine imitations of oriental models ; with a third class, composed of horns ornamented in the West reproducing Byzantine or oriental originals, we are not here directly

[1] Reproduced in the Brit. Mus. Catalogues of *Early Christian and Byzantine Antiquities* and *Ivory Carvings*.

[2] Brit. Mus. *Cat. of Ivory Carvings*, nos. 20, 21 ; W. Vöge, *Elfenbeinbildwerke* (Kaiser Friedrich Museum), nos. 13, 14.

[3] *B. A. and A.*, p. 221 ; *Monuments Piot*, vi, p. 191.

[4] *Cat. of Ivory Carvings*, no. 18.

[5] Molinier, *Ivoires*, pp 91 ff. ; J. Hampel, *Alterthümer des frühen Mittelalters in Ungarn*, ii, p. 920 ; *B. A. and A.*, p. 223.

concerned. Discrimination between representatives of these groups is often exceedingly difficult. The subjects of most of the oliphants consist of beasts, birds, and monsters of oriental type in a network of circles, suggestive of textile motives. But one group is of especial interest as having scenes from the Hippodrome, with chariot races, acrobats, jugglers, &c. In the example from Jasz Berény in Hungary, now in the Museum of Buda-Pesth, we see curly-haired figures, again suggestive, though remotely, of those on the caskets; we are especially reminded of the British Museum panels with their acrobats (see above). Other horns with chariot races are in the cathedral at Prague. A remarkable example of the type in England should not be later than the tenth century.[1] Only one horn has religious subjects— Our Lord, the Virgin, angels and apostles—and its existence suggests the inquiry whether the oliphants were made for various different purposes. It seems probable that this was the case. Those with circus scenes may have given the signal for performances to begin, or have been used during performances, for two actively engaged acrobats on the British Museum panels are seen blowing them. Those with hunting scenes, or with animals and monsters, may well have served in the chase. Those with religious subjects were perhaps used for such purposes as awakening monks, or enlivening processions,[2] or for containing relics in churches, as in the West. It is not easy to discriminate between horns made in the East and the West of Europe during the period between the ninth and thirteenth centuries, the art of which, as far as ornament was concerned, may almost be described as international, with an underlying oriental foundation. In connexion with such oliphants, and with the above-mentioned caskets with beast ornament, attention may be drawn to the similar use of beasts on ivory caskets and panels in Sicily and Spain under the Moorish princes about the same time. The similarity is explained by the common oriental origin of the types employed.

The ivories of the later centuries [3] are as different from those of the pre-iconoclastic period as they are alike among themselves. Similar conventions were retained for two or three centuries, and the manner of one century is so like that of another that it is difficult to attempt exact dating. We perceive this from the cases of the few ivories which do seem to furnish definite dates; we find for example, an ivory panel on a reliquary at Cortona,[4] apparently of the reign of Nicephorus Phocas (A.D. 963–969), almost exactly resembling in style a triptych-panel at Paris with Our Lord between Romanus (A.D. 1068–1071) and Eudocia;[5] thus a round hundred years, which in the West would certainly have shown marked difference in treatment, here has made no perceptible change. It is easy to see what pitfalls await the critic in dealing with an art so stationary, and how easily he may

[1] Dalton, in *Archaeologia*, lxv, p. 213.
[2] An oliphant is said to have been blown during the processions of the statue of S. Foy at Conques.
[3] *B. A. and A.*, p. 225.
[4] G. Schlumberger, *Nicephorus Phocas*, p. 189; Venturi, *Storia*, ii, figs. 411, 412.
[5] Molinier, *Ivoires*, p. 197; Venturi, ii, p. 583.

be led astray by purely local or personal considerations. For instance, there is a panel in the Musée de Cluny with Our Lord blessing Otto II of Saxony and Theophano his Byzantine consort, the scheme of which is similar to that of the panel with Romanus and Eudocia. The workmanship is however very inferior, and but for the evidence of the Cortona panel, which is approximately of the same date, it would be natural to conclude that the inferior style of the Cluny panel represents the average manner of the closing tenth century, whereas in fact it appears to represent the work of an inferior contemporary artist. Mistakes of this kind in the judgement of Byzantine art are made yet easier by the rarity of contemporary major sculpture, and by the monotony of accessory architectural features on the ivories themselves, arcades, canopies and the like, which do not change in fashion with a progressive architectural development as in the West of Europe. In Byzantine art the same type of canopy may serve for centuries, and its details may give no assistance at all. It must always be remembered that there are few precise points of comparison, and that when we get to any distance from these, criticism is subjective and uncertain. We conjecturally assign to a later date than the eleventh century the ivories with elongated figures and formal draperies, because such things occur in other branches of art.

The difference between the fine ivory carvings of the tenth and eleventh centuries and the best work of earlier times is seen not only in the character of the figures, which are slighter and with less suggestion of mass, but in their more careful finish and the nicety and precision of the work as a whole, in a word its greater polish. We are sometimes reminded of gem-engraving, so minute and careful is the execution. As a whole, these ivory carvers seek to manifest the Greek spirit; in their treatment of draperies especially they sometimes attain an almost classical excellence; attitudes expressive of grief and other emotions, for instance, those of the Virgin and S. John at the foot of the cross, are of classical derivation. They were essentially indoor workers, concerning themselves little with Nature or with new experiment, but drawing their inspiration from the models before them. These were in very large measure illuminated manuscripts of the type adhering most closely to Greek tradition, in which modelling in tone was always retained, and a reminiscence of Greek plastic art is constantly present. The definitely un-Hellenic feeling apparent in certain ivories of the first half-millennium is now rare; in form and composition Hellenistic influences prevail. In studying the technique we are more often reminded of French ivories of the thirteenth and fourteenth centuries than of earlier East Christian examples : however different the spirit, there is the same nicety and delight in perfection of finish. Both the Eastern and the Western work were freely inspired by painted models, and later Byzantine ivory carving was without free sculptural traditions.

Among the forms now in favour, the diptych and the triptych were

predominant; these forms were now widely used for devotional purposes, and the demand for them became general, as it did in Western Europe.

In the religious subjects the miracles and Gospel scenes so popular in the earlier period give place to scenes from the Passion; single figures are largely those of saints, frontally disposed, alone or in pairs, especially on the leaves of triptychs. Old Testament subjects survive, as in the case of the panels in the British Museum and at Berlin, with scenes from the Story of Joseph, but they are rare. Unlike the subjects upon the earlier carvings, both scenes and figures are now commonly accompanied by legends descriptive of the subject or giving the name of the person represented; in the latter case the deeply cut letters are arranged vertically beside the figures. This lettering is often deeply cut and of admirable quality; traces of red sometimes remaining in the hollows show that the inscriptions, like the subjects themselves, were usually coloured or gilded. We may regard as transitional among figure reliefs an ivory at Berlin, perhaps once enriching a cross, carved on all four faces, the larger sides having two groups of three half-figures each, one Our Lord between S. Peter and S. Paul, the other the Virgin, attended by the Archangel Gabriel, crowning a youthful emperor named in the inscription Leo.[1] Above the figures is a round arch, within which are three scalloped niches, the central niche showing three windows, and suggesting that we are looking towards the east end of a three-apsed church, possibly the church in the Great Palace at Constantinople in which coronations were celebrated (cf. above, p. 122). Details of ornament have been compared to similar motives upon oliphants, and the rather massive style of the figures, distinct from that usually found in later reliefs, makes it probable that this interesting work must belong to a relatively early time; the emperor cannot well be the iconoclast Leo V, and we conjecture that Leo VI, whose reign began in A.D. 886, may be the person represented.

The ivories of the eleventh and twelfth centuries are better represented abroad than in Great Britain, though fine examples are seen in the Victoria and Albert Museum (Plate XXVIII) and the British Museum, while the Bodleian at Oxford has an admirable panel with a seated figure of Our Lord. Conspicuous among all works of the period is the Harbaville triptych in the Louvre.[2] In this work, which dates from the eleventh century, the monotony of the saints standing in rows is redeemed by the mastery of the workmanship; the general scheme of the Harbaville ivory is repeated in later triptychs preserved in Italy. On the back is rich decorative carving supposed to symbolize the triumph of the Cross, in which oriental influences are discovered.

We may take as a second standard of the finer work of the time a diptych of which the separated leaves are now preserved in Venice and Vienna respectively;[3] each has two standing figures of apostles, full of dignity and

[1] Vöge, Elfenbeinbildwerke, no. 7; B. A. and A., fig. 138.

[2] B. A. and A., p. 227; Molinier, Ivoires, pl. ix.

[3] Gaz. des Beaux-Arts, 1895, p. 389; Venturi, ii, fig. 414.

strength ; accompanying metrical inscriptions mention a Constantine, who must be a member of the imperial family in the eleventh century. The number of devotional ivories is too large to admit of any enumeration here. We may, however, mention a rare example of secular art in ivory, the casket in the cathedral of Troyes (Plate XXXVIII), traditionally associated with the name of Garnier de Traisnel, almoner of the Fourth Crusade, who is said to have brought it back from Constantinople.[1] On the lid two mounted imperial figures with spears are seen back to back, one on each side of a building in the gateway of which stands a female figure ; on the back and front are hunting scenes, and on the ends birds in foliage ; the work of these is full of vigour, that of the lid symmetrical and more formal in style, possibly suggested by a textile subject. The casket has been stained purple, and may well have been an imperial possession ; the character of the reliefs is well rendered in the illustration. The date may be eleventh century.

In the ivory book covers of the Psalter of Queen Melisenda,[2] daughter of Baldwin II, King of Jerusalem (A.D. 1118–1131), and wife of Fulk of Anjou, King of Jerusalem (A.D. 1131–1134), the British Museum possesses an ivory standing in a class by itself. Each leaf contains figure subjects in a sequence of interconnected circles, with other subjects in the interspaces, and ornamental borders. On one side is the story of David with the Combat of the Virtues and Vices in the interspaces ; on the other, the Works of Mercy, the interspaces being filled by beasts attacking each other, and by single birds. The combination of subjects, paralleled upon Western works of art, and the Latin inscriptions, make it probable that the scheme of decoration was in the main dictated by the Latins ; on the other hand, the Byzantine royal costumes and the oriental style of the beast ornament and designs upon the borders suggest that the carver was of Eastern origin. As the miniatures within the book are chiefly the work of a Greek painter, Basilius, we may perhaps conclude that the Latin princes employed local talent for the covers also ; we may recall their patronage of Greek workers in mosaic when they were decorating the church of the Nativity at Bethlehem (p. 293).

On other pages we have noticed the service rendered by ivory carvings to greater sculpture in the west of Europe by providing models in which a good tradition survived. We may conclude by a reference to a similar influence exerted on Western sculpture in ivory. Book covers and pyxides of the sixth century were directly imitated in the West in Carolingian times : examples of the first form are that from Lorsch in the Victoria and Albert Museum,[3] the Vatican example,[4] and the panel in the Bodleian with Our

[1] Molinier, *Ivoires*, pp. 92, 93 ; G. Schlumberger, *L'Épopée byz.*, i, pp. 673, 714 ; *B. A. and A.*, figs. 144, 145.

[2] British Museum, *Catalogue of Ivory Carvings*, no. 29.

[3] Victoria and Albert Museum, *Portfolio of Ivories*, pl. vi ; *B. A. and A.*, fig. 146 ; Goldschmidt.

[4] R. Kanzler, *Avori*.

Lord trampling on the asp and basilisk;[1] of the latter the pyxis in the British Museum with the Healing of the Blind and the Demoniac,[2] all works of the Carolingian period. The panels of the paliotto or retable in the Cathedral of Salerno,[3] and others showing similar peculiarities, seem to date from about the end of the eleventh century, to have been made in Italy, and to derive from East Christian originals of earlier date (see above, p. 207). The Byzantine caskets with the story of Adam and Eve were imitated in Italy in the twelfth century, as were others with ornament of beasts of oriental type of similar derivation to those seen upon the oliphants; the horns themselves were reproduced in the West, and we have seen above that it is hard to distinguish in some cases the Byzantine from the oriental and the Western.

The casket in the cathedral of Sens,[4] with its unusual twelve-sided body and conical lid carved with scenes from the story of David, and with ornament consisting of beasts of prey, gryphons, and conventional foliage, has some points of comparison with the casket at Troyes (p. 218). We seem here to be in presence of a Western work translating East Christian models into a new language.

A number of panels with religious subjects scattered in European collections show clear traces of Byzantine inspiration, very evident in the case of the Crucifixions. The group described as Rhenish-Byzantine appears to have had its origin on the Middle Rhine; good examples are in the Victoria and Albert Museum. As will be seen in the section on Illuminated MSS., Germany was much influenced by Byzantine art in the early medieval centuries, not merely because Otto II married a Byzantine princess, but through a long infiltration of motives and ideas affecting more than one artistic province.

Steatite carvings. Allied in general treatment to ivories is a group of carvings in steatite, serpentine or fine schist, but only a few can compare with them in artistic merit. Some are of considerable size, and divided into a number of rectangular compartments, but most are only a few inches in height. The greater number appear to date from the eleventh and twelfth centuries, and the tradition of carving in this material was bequeathed to Russian and modern Greek religious art. The older examples are often much worn, the stone being soft and easily wearing down. Among the finest examples is a panel with the *Hetoimasia* and four saints in the collection of the Comtesse de Béarn;[5] many good specimens are in Italy (Florence, Rome, Naples, &c.); the cathedral of Toledo possesses a large plaque with twelve scenes in compartments surmounted by a tympanum with Our Lord

[1] Goldschmidt, *Elfenbeinskulpturen*, i, p. 10, pl. iii; Westwood, *Fictile Ivories*, pl. vi; E. Baldwin Smith, *Early Christian Iconography*, fig. 169.

[2] *B. A. and A.*, fig. 148; British Museum, *Catalogue of Ivory Carvings*, no. 43; Goldschmidt, *as above*, p. 11, pl. iv.

[3] E. Bertaux, *L'art dans l'Italie Méridionale*.

[4] Schlumberger, *Épopée, Nicephorus Phocas*, p. 647; Molinier, *Ivoires*, p. 106; Venturi, *Storia*, iii, figs. 346-59.

[5] Schlumberger, *Monuments Piot*, ix, 1902, p. 231 and pl. xx.

enthroned,[1] in which the execution is above the average in merit; another panel with the same twelve scenes (The Twelve Feasts, p. 243) is in the monastery of Vatopedi on Mount Athos;[2] a post-Byzantine example with these scenes is in the church of S. Clement at Ochrida in Macedonia. Small panels and carvings are to be seen in the British Museum, and in various museums and churches in France, Italy, Germany, and Russia.[3]

Minor sculpture in metal, &c. Such sculpture is various in period and miscellaneous in character; attention can here only be drawn to a few individual objects or groups.

The bronze Good Shepherd at the Bargello, already mentioned with other examples of the same subject in marble (p. 179), really belongs to this section. A bronze statuette in the British Museum, representing the type known as the *literatus*, which became that of the apostle in Christian art, is post-classical and appears to date from the fifth or sixth century: it may well be intended for an apostle.[4] An interesting bronze steelyard weight representing an imperial head, perhaps that of Phocas, is in the same museum.[5] Sculpture in relief with religious subjects is found upon certain small metal objects such as early bronze censers of about the seventh century with New Testament scenes,[6] and the moulded lead ampullae of the sixth century, with scenes from the life of Our Lord, originally brought from the Holy Places in Palestine.[7] The ampullae are of great interest as the subjects upon them may reproduce those of the mosaics or Constantine's memorial churches; the most remarkable are preserved at Monza.[8]

The period after iconoclasm produced bronze plaques with figures in relief, some of great merit: the example with the Virgin and Child in the Victoria and Albert Museum (Plate XXXIX) is amongst these; other good examples are in Paris and Berlin.

In the precious metals, repoussé figures and decorative designs are found on articles of jewellery such as gold bracelets and medallions, or crosses such as that of Justin II in S. Peter's at Rome[9] (Plate LXI). Embossed scenes from the Gospels, figures of saints, or decorative design are also seen on silver reliquaries, book covers, plaques, and triptychs.

Special attention may be directed to Byzantine silver plate of the first period on which scriptural subjects are treated in a manner related to that of the ivories (p. 328). Intaglio sculpture is represented by the work upon early

[1] Schlumberger, *Épopée byz.*, i, p. 465; *B. A. and A.*, fig. 149.

[2] Kondakoff, *Athos*, p. 147; Schlumberger, *Épopée*, ii, p. 273; *B. A. and A.*, fig. 150.

[3] *B. A. and A.*, pp. 241–2.

[4] Dalton in *Byz. Zeitschr.*, xxii, 1913, p. 143.

[5] British Museum, *Cat. of Early Chr. and Byz. Ant.*, no. 485.

[6] British Museum, Catalogue, *as above*, nos.

399, 540; O. Wulff, Kaiser Friedrich Museum Catalogue, *Altchristliche und byz. Bildwerke*, nos. 967 ff.

[7] *B. A. and A.*, pp. 623 ff. and figs. 398, 399; Wulff, *Altchr. und byz. Kunst*, fig. 306.

[8] Sixteen in number. Said to have been given by Gregory the Great to Theudelinda, queen of the Lombards.

[9] *B. A. and A.*, p. 548.

gold and other rings.[1] Small objects, plaques for applying to furniture, toilet articles, &c., chiefly found with Coptic remains in Egypt, or the utensils ornamented on the handles or elsewhere with figure reliefs, are far too numerous to be discussed in detail; they can be studied in detail in the manuals and in the catalogues of several great museums.

Coins.[2] The coinage of the East Roman Empire is apt at first sight to surprise those familiar with the numismatic art of Greece and Rome. With its flat relief, its sometimes stiff and jejune conventionalism, its gradual reversion to frontality in the portrait busts, it creates the impression of having sunk at an early date into a barbarism in which it was content to remain. It suggests a lower standard than other minor glyptic arts; at times, when ivory carving rises to a high level of distinction, the improvement in coin-types is hardly in proportion; nor have they the quality often found in the lead seals which were being made at the same time and by processes not so very different. Yet a familiarity with Byzantine coins will confirm the judgement of Wroth, that although examples of fine workmanship are rare and variety is limited, yet individual types are distinctly successful, while the coinage as a whole is adapted to its end; it has numismatic propriety. Moreover, the formalism which may at first repel is found to have a decorative quality conspicuously lacking to much of the coinage produced in our own day.

Coins were struck in gold, silver, and bronze; the standard gold coin, called the *solidus* or *nomisma*, weighed about 70 grains; in the eleventh century a saucer-shaped ('scyphate') nomisma came into use, and continued till the fall of the Empire. The ordinary rule was for all coins to represent the Emperor in bust or full figure on the obverse, generally alone, but sometimes with accompanying figures of Our Lord, the Virgin, or members of the imperial family. The reverse varies at different periods. At first Victory is common; in the sixth century we see the Tyché or Fortune of Constantinople, and mark the appearance of a more lasting type— a cross standing on three steps. A cross with double traverse was used in the late ninth century, when a half-figure of the Virgin was also introduced, under Leo VI. The enthroned figure of Our Lord came in under Basil I. The first saint is seen on a reverse at the beginning of the tenth century, in which standing figures of the Virgin are also adopted. In this century, too, the bust of Our Lord, which had been used for a short time in the seventh century, becomes usual in two types.

The imperial persons upon coins wear the ceremonial costume, tiara with pendants, and rich gemmed robes; something of the general barbaric effect must be ascribed to this elaborate adornment. The faces show

[1] *B. A. and A.*, p. 540; Wulff's Cat. of the Kaiser Friedrich Museum, *as above*; Strzygowski's Cat. of the Cairo Museum, *Koptische Kunst*; British Museum Cat., *as above*.

[2] W. Wroth, *Imperial Byzantine Coins* (British Museum Cat., 1908); Comte Jean Tolstoï, *Monnaies byzantines*, parts i and ii, St. Petersburg, 1912; *B. A. and A.*, pp. 625 ff.; K. Regling in *Jahrb. der K. Preuss. Kunstsamml.*, 1916, pp. 116–20.

a certain characterization, but there is hardly an instance of real portraiture ; indeed the same head frequently does duty for more than one emperor. Even where the execution is unusually fine, we may be deceived in the expectation of a likeness ; the head of Constantine Porphyrogenitus is delicately modelled, but upon investigation is found to be almost identical with that of Leo VI. The empresses who figure upon coins are in like manner conventional types ; the Byzantine mints no more help us to realize the features of the living man or woman than those of our own country in medieval times.

Superscriptions upon the obverse are confined to titles, partly abbreviated. The reverse may have a short legend, such as *Gloria Romanorum*, ЄN TOVTO NIKA (alluding to the Cross), IHS CRISTOS REX REGNANTIVM, IHSVS XPISTVS NICA. It will be observed that purity of Greek and Latin is disregarded ; sometimes ' mixed legends ' are found, in which the two languages are frankly confused. Dates giving regnal years occur on bronze coins of the sixth and seventh century, but rarely afterwards. The sacred monogram is seen upon coins chiefly of the First Period. Denominations of value in the form of large capital letters (M, K, I, E) were used on bronze coins from the fifth century to the close of the seventh. The chief mint through all periods was that of Constantinople, which always produced the gold and silver coins. Down to the tenth century coins were struck in various places, Nicomedia, Antioch, Salonika, Cyzicus, Alexandria, Carthage, Sicily, Rome, Ravenna, Cherson, Isaura, and Cyprus ; after the tenth century the capital minted alone.

In addition to coins, large medals were occasionally struck, such as the well-known example (now lost) with a bust of Justinian on one side and an equestrian portrait of the same emperor on the other. Medallions of earlier emperors, or reproductions of them, were used as pendants in jewellery or to form centre-pieces in large gold collars (p. 323). In the Justinian medallion we seem to have a genuine attempt at portraiture, though the heavy face is more disappointing as the presentment of a great historical personality than the severer mosaic portraits at Ravenna.

The first rulers of Islam employed Byzantine die-makers for their coinage, and the Byzantine type, such as the cross upon three steps, was actually used by them. The Ortukid (Turkish) princes of the twelfth century were hardly dependent upon the technical aid of Christians, but they too did not object to such frankly Christian types as representations of Christ, either busts or enthroned.

Seals.[1] In the West, documents were attested by wax impressions from bronze matrices with designs cut in intaglio, which have survived in

[1] *B. A. and A.*, pp. 630 ff. ; G. Schlumberger, *Sigillographie de l'Empire byzantin*, Paris, 1884 ; N. Likhacheff, *Moscow Numism. Soc.*, ii, 1901, pp. 43 ff., and *Earlier Types of Byz. Imperial Seals*, Moscow, 1911 (Russian) ; cf. *Byz. Zeitsch.*, xxi, p. 664 ; K. Regling, *Mém. du Congrès int. de Numism.*, Brussels, 1910, pp. 39 ff., and *Byz. Zeit.*, xxiv, 1923, pp. 96 ff.

great numbers from the medieval centuries. In the East, wax was very rarely used; in the hot climate of Eastern countries clay or lead were both preferable to a substance like wax, which was liable to melt. In the early centuries of our era, clay was employed to seal the wooden tablets discovered in recent years in Chinese Turkestan. But throughout the duration of the Byzantine Empire the usual material used for seals was lead, and the few matrices apparently made for wax date from post-Byzantine times.

The East-Christian seals being of lead were therefore *bullae*, two-sided, and suspended to documents by cords; it was not possible to make an impression directly on the document as with wax. The bulla in the West was adopted by the popes for their 'bulls', in imitation of the Eastern lead seals; and the pendant wax seal with two faces, found on medieval Western documents, is in its turn an imitation in wax of the papal bull. The Byzantine emperors used the gold bulla for important documents, and were followed in this by the Latin emperors reigning in Constantinople in the thirteenth century, as well as by other European princes.[1]

A bulla was made in different ways, according to the metal employed. If this was gold or silver, the metal was thin, and the two disks for obverse and reverse first received their impressions separately. Their edges were then turned over, they were placed back to back, and the box thus formed was filled with some kind of mastic in which the suspending cord was embedded. If the metal was lead, the disks were thicker, and a groove to receive the cord was made across the back of each. They were then placed between the faces of a double matrix, and pressed or struck till they formed a single mass enclosing the cord, previously laid in the grooves. It is remarkable that hardly any Byzantine matrices have been discovered, though the number of lead impressions is very large. Perhaps the metal employed for matrices was iron, and liable to rust away; even so, the non-occurrence of seal-matrices would be something of a mystery, were it not possible that like coin-dies, which are in similar case, they were purposely destroyed to prevent fraudulent use.

The lead seals of the East Roman Empire are of wider interest than the coins because they are associated with persons representing all branches of official and ecclesiastic life; we learn to know all the higher ranks in army, navy, court, church, and civil service. They furnish important geographical information, telling us the names of towns, fortresses, dioceses, churches, and institutions. They afford valuable material for iconographic study; the types of the Virgin, for example, are numerous and well defined, and have aided in the study of early panel pictures. The style in which they are executed is less jejune than that of the coinage, and the work of the tenth, eleventh, and twelfth centuries, to which most of them belong,

[1] In the British Museum are gold bullae of Baldwin de Courtenay, Emperor of the East, dethroned in 1261, of the Emperor Frederick III, and of Edmund, second son of Henry III of England, as King of Sicily.

like the contemporary ivory carvings, often bears clear signs of descent from Hellenistic art ; but despite the charm which many of them possess, they are surpassed by the fine bronze matrices made in Western Europe in the thirteenth century. It is unfortunate that many examples have perished through disintegration of the lead.

The obverse of the seal generally bears a religious type—the Virgin, Our Lord, saints, or the cross. The effigy of the owner is rare ; commoner are representations of animals and monsters. The legends surround the figures, or, when they occupy the whole surface, run in horizontal lines. Seals of the iconoclastic period substitute for religious subjects cruciform monograms, the letters at the extremities yielding the words Θεοτόκε (or Κύριε) βοήθει (*Mother of God* (or O Lord) *help*), while the syllables of the words τῷ σῷ δούλῳ (*thy servant*) fill the angles ; the name and office of the owner are then set out on the reverse.

Engraved gems.[1] Though a number of fine classical gems were un-doubtedly taken from Rome to Constantinople, and Greek gems must have been preserved at Alexandria and in other large cities, glyptic art in hard stones never rose to a high level in the Christian East. The Hellenistic model inspired the Byzantine artist in ivory to more effect than the engraver of gems. The Sassanians, who were also dependent for their models on Graeco-Roman art, were in much the same position, but though the mass of their work is undistinguished, a few of their cameos have more strength and vitality than anything which Byzantine art has left us in this kind.

The intaglio gems belonging to the Early Christian centuries have the faults of late Roman work ; they are roughly executed with the drill, and features and folds of drapery are indicated in a summary fashion ; an intaglio, on amethyst, with the head of the Emperor Constantius II, in the British Museum, is among the better gems which we have belonging to the earlier centuries. Cameos on onyx are also inferior in quality to those of Roman times ; a few with religious subjects, dating from the ninth to the twelfth century, are represented in various museums. The British Museum has an Annunciation of a rare type, and the Cabinet des Médailles at Paris two others with the same subject. The best work in relief is done not on hard onyx with different strata, but upon heliotrope, or jasper, so that the contrast of a white layer with layers of other colours, usually associated with the word cameo, is absent. Busts of Our Lord in heliotrope are found in various collections ;[2] the British Museum has examples, and a standing Virgin and Child in Sicilian jasper. Certain diminutive carvings on steatite are so small as to resemble gems, but most work in that stone is on the scale of ivory carvings and has been considered in relation to them (p. 219).

[1] *B. A. and A.*, p. 637.
[2] If the figure of Christ in the centre of a paten made at Constantinople for the Princess Olga of Russia in the reign of Constantine VII (912–919) was an intaglio, gem engraving must still have been practised at this time. Cf. J. Ebersolt, *Arts somptuaires de Byzance*, p. 65.

Glass pastes simulating gems, like those produced in Roman imperial times, probably continued to be made; but the class is generally represented by cameo pastes in an opaque red, with figures of saints (Theodore, George, &c.) accompanied by their names. These are thought to date from about the twelfth century, when similar pastes with Latin inscriptions occur.

Regarded as a whole, East Christian gem engraving is singularly devoid of interest. The quality of the better Graeco-Roman gems is not approached; there is none of the historical interest provided by the Roman gems with imperial portraits; we miss the simple attractions of the Early Christian gems from the catacombs with their symbolic subjects. For some reason or other the finer craftsmanship of the Christian East does not seem to have concerned itself with gems.

IV

PAINTING

PAINTING was the most important of the formative arts in the Christian East. Figure sculpture ceased to rival it at an early period, falling into a subordinate position from which it never afterwards recovered (p. 164). Long before the time of Justinian the art of the sculptor had begun to follow optical principles and the painted subject to serve him as the base of his ' coloristic ' design. Such monumental reliefs as were still produced after iconoclasm came more and more under the influence of painting, and this was also the case with the minor sculpture best illustrated by ivory carvings.

When we speak of East Christian painting, as opposed to painting in the Christian East, we mean the religious art which began after the fourth century. We have seen that before this time there was no distinctively Christian art; Christian communities were scattered in different countries, and each used the art of the region in which it lived; the work which they produced differed only in subject or content from that of their pagan neighbours. To possess an individual existence, an art must have its own style and its own principles; Christianity had no art in this sense until, in the fifth century, the Church, established as a central power, demanded a single artistic expression (Ch. I). It was only then that a specifically Christian art could arise; until then, there was nothing but the art produced by Christians in Italy or Egypt, Syria or Asia Minor, Mesopotamia or Iran, and this had no organic unity. Thus the earlier painting in the catacombs of Rome or Alexandria is not so much Christian art as Hellenistic art depicting subjects preferred by Christians.

Christian painting was representational because the rulers of the Church demanded a descriptive art. It was so neither in the purely Hellenistic nor in the purely Semitic fashion, but in a manner compounded of the two. This was necessarily the case, because the two chief elements in Christianity, the Greek and the Aramaean, were respectively too strong to give way to each other; the only possible course was a compromise (p. 8). It is clear that neither a Hellenistic nor a Syrian art alone could have served the purpose of the Church. What Hellenistic art was in isolation we infer from its secular branch, which remained green down to the fifteenth century. A persistent and aristocratic tradition lent it endurance; but it tended to exclusiveness, and it was worldly. A faith which desired the deep emotion, the passion and drama of life expressed without reserve, could never rest

content with it ; and this was the demand of Semitic Christianity. On the other hand, Aramaean art, left to itself, was inferior in accomplishment and practical experience ; above all, it lacked the power of composition and logical arrangement. The ordering of the biblical cycles required by the didactic scheme of the Church, and the composition of the numerous individual scenes, were matters in which the facility and invention of the Hellenistic painter were indispensable. The Greeks, especially those of Alexandria, had begun to produce these cycles after the Peace of the Church, as soon as the symbolic phase of the first three centuries began to pass into the historical. They designed such picture-histories as those on the nave-walls of S. Maria Maggiore at Rome or in the prototypes of such books as the Joshua Roll in the Vatican, which provided the models for mosaics of this kind. In so doing they gave Christian art its vertebrate system, but they failed to give it a heart. The tranquil Hellenistic conception of men and things was wholly antipathetic to Aramaeans or Copts. The generalized types were, in their eyes, colourless and vapid ; the restraint which excluded passion and pain, and renounced dramatic action, seemed to them a mark of impotence. The half-light and half-shadow of an art which modelled in tone was intolerable to men used to contrasts of flat colour ; the effort after true perspective taxed intellect at the cost of feeling. The oriental mind which these peoples represented was fundamentally estranged in its outlook from that of the Greek ; the Semitic mind, which played so decisive a part at this juncture, has never appreciated fine grada-tions.[1] The compromise demanded by the Church was a necessary evil ; the sacrifice was made, but with reluctance. Nevertheless, in forming a compromise on grounds of expediency, the Church laid durable founda-tions. The association of the Greek and oriental factors was permanent, though subject to variation as this or that influence predominated at different times and in different places. Down to the fall of the Byzantine Empire, the history of East Christian painting is the story of their action and reaction upon each other.

The assertion of the Aramaean spirit ended the reign of a smooth and pleasant symbolism ; it gave the new art fire and mystery. The Semite had the sense of awe, together with a force and seriousness which were lacking in the Greek. The trend of the Church towards history and towards the concrete accorded with his genius. He cared neither for balance nor for restraint nor for grace ; he did not trouble too much about skilfulness ; he had little power of selection and arrangement. He sought first the

[1] 'Semites have no half tones in their register of vision. They are a people of primary colours, especially of black and white, who see the world always in line. They are a certain people, despising doubt . . . They know only truth and untruth, belief and disbelief.

'Semites are black and white not only in vision. Their thoughts live easiest among ex-tremes . . . they pursue the logic of their ideas to its absurd ends. . . . Their imaginations are keen, but not creative.' (T. E. Lawrence, Preface to the second edition of Charles Doughty's *Arabia Deserta*, 1921, pp. xxix, xxxi.)

immediate rendering of his feeling while the interest and the glow were still alive, not stopping to consider whether or not his subject was logically composed. He had also a lively dramatic sense ; like the child, he could render action in the artless way which sometimes defeats skill, and thus achieved what has been called dramatic expressiveness. Like the child, he insisted upon the whole story with no episode omitted, not even the most distressing. Like the child, again, he believed in magic. But he had also the gravity of the peoples in whom the memory of old subjection has sunk deep. The association of kingship with divinity, so far-reaching in its effect upon life under the ancient monarchies, was not forgotten in the Semitic East of Christian times, which could not dissociate the idea of godhead from that of sombre and tremendous power. The Aramaeans saw Christ as the Ruler of All (Pantokrator) rather than as the carpenter's son, or as the serene youth of Hellenistic art. The visible world was not to them the bright and all-sufficing place of Greek imagination ; behind it they seemed to perceive another world, more significant and more real, of which the forces might at any moment annul the laws of nature. They had a yearning for that which belonged to the hidden and more real world, for the essential, for the spirit of things, independent of the usual forms of vision ; they probably saw in the kind of expression which satisfied the Greeks a mere parody of truth. The recognition upon equal terms of a psychology so vigorous, yet in all things so un-Hellenic, lent the art of Christianity as adopted by the Church a character at once strange and disconcerting to the Mediterranean peoples.

If the artistic liberation of the oriental Christian changed the whole spirit of the Christian expression, it also affected its form. The Aramaeans tended to see the visible world in two rather than three dimensions, sharing in so far the vision of peoples farther to the north and east.[1] Although, with the traditions of old Mesopotamian art behind them, they could not wholly ignore modelling, they instinctively reduced it. In sculpture they sought to flatten relief (p. 162), in painting to diminish modelling in tone, which, in the Syro-Hellenistic art of the Church compromise, is less elaborate than in work more purely Greek in character. But the influence of the Hellenistic partner would have been powerful enough of itself to prevent the triumph of an art of flat colour. Here and there we find an approximation towards this, as in certain ninth-century MSS. of Syria-Palestine,[2] but in sacred art, as opposed to ornament, modelling of some kind held its own throughout the whole duration of Byzantine history, however weak the plastic sense may have become. But a lessened regard for modelling was not the sole result of substituting a new mode of vision for that approved

[1] Cf. above, pp. 160 ff. Cf. also H. Berstl, *Das Raumproblem in der altchr. Malerei*, 1920.

[2] G. Millet, *Iconographie de l'Évangile*, pp. 582, 598. The examples given are Paris MS. gr. 923 (the *Sacra Parallela* of John Damascenus) and the Gregory of Nazianzus in the Ambrosian Library at Milan. The influence of such books affected the style of Ottonian illumination in the West.

by Hellenistic art. The ' vertical projection ', discussed in relation to sculptured relief (p. 163), naturally appeared at the same time in painting ; the method of the Ashburnham Pentateuch, or its prototype, is that of the carved doors of S. Sabina. In process of time the crude treatment which makes the design resemble a geological section gave place to various refining expedients. Remote objects were as far as possible avoided, and often nothing more than a near background was attempted ; or a screen of architecture would be thrown across the picture, like a scene across a stage.[1] Where some suggestion of greater distance was imposed, the old procedure of the Hellenistic picturesque reliefs was adopted ; rocky hills, behind the persons in the foreground, carried the figures supposed to be more distant, and so brought the sheerly vertical projection into some accord with nature ; the typical Byzantine hilly landscape was made to serve this purpose. Some adherence to true perspective is found in sacred art only where early Hellenistic models are carefully reproduced.[2] ' Inverted perspective ' was as common in painting as in sculpture ; but the employment of this method was due less to aesthetic than to what may be called hierarchical requirements.[3] Though the device is based on no aesthetic principle, it is often felt to be strangely effective, especially in scenes of large size on the walls of churches, where the central figure is instantly perceived, and no delaying intellectual process checks the emotional appeal ; it accords also with Majesty figures, and apocalyptic subjects, where the idea of awe is to be conveyed. There were other contrivances by which the complications of true perspective were avoided, by orientalizing copyists of early Hellenistic manuscripts. One was to take down, so to speak, from the background figures which in the Hellenistic model were shown in distance, and set them at one side of those originally occupying the foreground ; a subject conceived in depth was thus converted into a frieze.[4] Landscape and picturesque accessories tended to drop out in this process, which is characteristically ' oriental '.[5] In painting, as in sculpture, a theatrical treatment accompanied frontality ; the drama seems literally to be played on a stage, with the thoughts of the actors as it were always

[1] The resemblance of the background to stage-scenery seems appropriate in an art so essentially dramatic. An actual reminiscence of the stage was sometimes in the artist's mind (cf. below, p. 230).

[2] In secular Hellenistic work, outside the compromise enforced on ecclesiastical art, true perspective, as far as it was known to the later Greeks, continued to be used.

[3] Cf. p. 163. The most important personage received the most conspicuous position, and was presented on a larger scale than persons of less consideration, placed nearer to the eye of the spectator. Good examples of this principle may be seen in the mosaics of Daphni, where in

other respects the Hellenistic influence is particularly strong.

[4] Millet, *Iconographie de l'Évangile*, p. 567. This frieze treatment is adopted in the sixth-century Codex Rossanensis (p. 312). In mural painting it occurs in the early medieval work of the Cappadocian rock-cut churches ; in later, in the churches of Serbia.

[5] True and inverted perspective were not employed together in the same scene by properly trained artists. The confusion exists, as Schmidt has pointed out, in the mosaics of Kahrieh Jami, but this probably resulted from the interruption of the old training caused by the Latin interregnum.

intent upon the spectator, and actual features of the theatre and its scene are occasionally suggested.[1]

A perfect consistency of method was impossible to this art. The almost fierce interest of the Aramaean in personality and in the destiny of the individual soul led him to retain modelling in the face, through which personality is expressed (cf. p. 162). Here he sought exact imitation. But he treated the body on other principles. Its organic structure and proportion had small interest for him; in consequence, his draperies are not considered in relation to anatomy, and their folds almost resemble the elements of a pattern. Yet there are times when the result seems to gain by its contradictions, as a harmony may gain from latent discords.

The East Christian painter conceived his subject simply, in bold outline and mass; he saw it swiftly in a comprehensive view, as if he stood back from it to receive the rapid impression of the whole. He did not labour a deliberate intellectual process, but gave a schematic rendering straight from perception. To see things simply and fast was to him the first essential. But although his methods are explicable from an aesthetic point of view, we are not to suppose that he worked upon a theory; he was impelled rather by racial impulses and local traditions. He designed as he did, not because Plotinus bade the artist discover in the chaos of the presented world forms placed there by the Universal Soul, or because any critical writer had laid down rules for his instruction. He used his simplifying methods because they were customary, because they answered his needs and visibly translated what he felt. Modern aesthetic criticism, which has mastered the theory of such practice, has not failed to perceive his qualities. It has recognized not only the force and the dramatic expressiveness, but also the economy which obtains the maximum effect with the minimum of calculation; it has seen that ignorance of objective shape was no bar to effective expression. It has observed how successfully this work contrasts with that of the tired and sated Graeco-Roman world; what freshness there is in a spontaneous childlike art drawing upon the treasure of the imaginative life, and so simply disengaging the right emotional elements, which indifferent Nature fails to emphasize for man.[2] The eager interest of the artist transpires from his work, which in consequence interprets, and is good illustration.

As a whole, the period between the establishment of a Christian formative art and the rise of Islam was one of orientalization. The Eastern methods were conspicuous through their novelty; and great as appears the change which they wrought, at the time it may have appeared even greater than it was. It must have seemed to many a Greek in the Mediterranean cities

[1] The proscenium is also suggested in sculpture, as in the cases of the large panel with the Archangel (p. 210), and the Chair of Maximianus at Ravenna (p. 205).

[2] R. E. Fry, *Vision and Design*, p. 78. R. L. Stevenson once said: 'There is but one art: to omit.'

that Hellenistic influence was doomed to go down beneath the oriental flood. In mosaics, in mural paintings, in illuminations, the Eastern factor in the Church compromise gained upon the Greek; in mosaic, technique itself favoured its advance. In the churches of Ravenna and in the monasteries of Coptic Egypt [1] the un-Hellenic spirit brought with it the un-Hellenic form. Though in such a subject as the procession of martyrs in the nave of S. Apollinare Nuovo the Greek element holds its own, in other scenes in the same church, and in other churches of Ravenna, it is overshadowed or depressed. The secular Hellenistic painting of the age was doubtless little affected, but we have to infer its character from later work.[2] The orientalizing development of the new religious art may be well followed in the illuminated books which have come down to us. Here there had been the same beginning in a Hellenistic environment where naturalism prevailed, where the figure was plastically conceived, and the scene viewed more or less in true perspective. Then, with the growth of oriental influence, came the rapid abandonment of the 'scientific' attitude towards things seen, and the substitution of a new and ideal conception of space. All was simplified. The complication of receding planes gave place to those methods of presenting the whole scene as far as possible in a single plane which we have discussed elsewhere. Modelling was reduced, though not discarded; a tendency to the flattening of all figures increased. Landscape, and picturesque accessories suggestive of three-dimensional space were confined to the simplest possible terms. It was the object of the painter to produce an immediate general effect, to seize and hold the attention of the spectator by instantly confronting him with the elements of emotional or dramatic value, and with those alone. The change from the first, or Hellenistic, phase of Christian illumination to a phase in which oriental realism claimed the most conspicuous part is well illustrated in the Codex Rossanensis (p. 312). If the miniatures of this book are compared with those of the Cotton Genesis, the emergence of a power in the service of new emotions and of a new mode of vision is apparent. If we compare them with the vanished Hellenistic prototypes which must have inspired such later illustration as that of the Joshua Roll (p. 305) and the Paris Psalter no. 139 (p. 307), we find in presence two opposite conceptions of the visible world.

Wherever the compromise of ecclesiastical art found its first stable equilibrium, whether, as Wulff believes, in Constantinople itself, or in some Anatolian or Syrian centre, the result was reached by the reign of Justinian. Tentative movements may have been simultaneously made in various parts of the extended line along which the Greek and the oriental lived in contact.

[1] Cf. Wulff, *Altchristliche und byz. Kunst*, p. 442.

[2] As at Quseir 'Amra (p. 261), where much of the mural decoration is Hellenistic in a style proving the existence of a living tradition. Even here, however, in the representation of the conquered kings and in decorative features an oriental influence, in this case Persian, is evident.

At the south of this line, Alexandria, at first the purest source of Greek influence, became in the fourth century more and more involved with Syro-Palestinian ideas ; the lively interchange which took place in this area in the fifth and sixth centuries must have had no less significant a share in the creation of a new style than similar movements farther north, in Antioch, and its sphere of influence in Northern Syria and the south-east of Asia Minor. Before the appearance of the Arabs, East Christian illumination, like monumental art, had balanced, if it had not fused, Greek and oriental modes of expression. It had not adopted the flat colouring which was the logical outcome of the oriental point of view, but preserved the body-colour of the Greeks, and a modelling which, if relatively flat, was a concession to an art of plastic tradition. But it had in general replaced the plastic by the optical conception ; and it had largely eliminated both the generalized type and the picturesque ideal. A comparison of illuminated MSS. with mural mosaics and painting shows that from the first the two were in close connexion, and that the inspiration often came from the book. The well-known nave-mosaics of S. Maria Maggiore at Rome (p. 271) reproduce subjects from one of those early illustrated Bibles which were destined to transmit their designs to much later times. For historical and iconographical research reveals the fact that Gospel manuscripts of the tenth and eleventh centuries follow the same early redactions which inspired, for example, the painters of S. Sergius at Gaza (p. 311).

The kind of subjects which the East Christian painter had to employ in decorating the walls of churches and the manner in which they were disposed may be conveniently noted in the present place. In the first years of church decoration, that is to say, during the earlier part of the fourth century, the sacred subject was not always predominant, and in some parts of the Christian East may not have appeared at all. The mosaics of the ring-vault in S. Costanza at Rome show many motives which have no religious significance ; it is not certain indeed that any of them are more than decorative. In the lost subjects of the dome sacred scenes were introduced, but enclosed in so luxuriant and striking an ornament that the eye was perhaps attracted to the framework before the picture.[1] In Asia Minor the use of secular subjects seems to have been general. In the fourth century the eparch Olympiodorus, desiring to build a church, suggests in a letter to Nilus that scenes from the chase or country life may be appropriate. The bishop in his reply dissents from this view, but in a manner which shows that the merely decorative style was recognized at the time, and that argument was required to justify its supersession ; and, indeed, with regard to a region

[1] In this decoration Strzygowski sees Iranian influence. The river scene at the bottom with its aquatic birds and genii fishing from boats he would connect with Mazdaist rather than Hellenistic suggestion, the river representing neither Nile nor Jordan, but the ocean-water of the Avesta. The formal decoration he regards as also clearly Iranian in character. Cf. his *Christian Church Art*, Oxford, 1923, index s.v. *Zend-Avesta*, and *Apse-decoration*.

like inner Asia Minor, where Asiatic feeling was apt to predominate over Hellenistic, we may admit a plausibility in Strzygowski's contention that the old style suggested by Olympiodorus belonged to Iranian rather than to Hellenistic decoration. From the close of the fourth century the spread of historic and dogmatic pictorial teaching drove pure decoration into a subordinate position, though, even as an accessory, it still remained conspicuous and luxuriant down to the Persian and Arab wars ; this the mosaics of Ravenna alone sufficiently prove. The use of historical and dogmatic subjects from the Old and New Testaments is illustrated by the early surviving example in the mosaics of S. Maria Maggiore.[1] Dogma, which became more and more important, was first presented by means of typological scenes from the Old Testament ; such are the subjects on the walls of the sanctuary in S. Vitale at Ravenna, which date from the sixth century (p. 276), and include Abraham entertaining the Angels at Mamre, and preparing to sacrifice Isaac, the first scene typifying the Trinity, the second the Redemption. For this early period the decoration of S. Apollinare Nuovo in the same city is especially interesting. Here, in the nave, above the processions of saints bearing crowns, we see a whole series of scenes from the life of Our Lord historically treated. In the sixth century we already hear of highly developed sacred cycles, such as that of S. Sergius at Gaza, of which an account has been left by Choricius.[2] These were already on a scale which foreshadows the elaborate systems of a later period.

In the eighth century a sudden prospect of victory opened for the vision and the methods of design which, as the transforming leaven in Aramaean representation, had three centuries earlier so powerfully helped to create a new sacred art. Religious enthusiasm and the fortune of war had carried a people averse from 'pictures' from Arabia to Iran, where the invaders found an art of ornament in harmony with their own aesthetic feeling. Then came the iconoclastic struggle in the Byzantine Empire, with its inevitable artistic reaction (p. 15). The iconoclast emperors reintroduced into church decoration the old ornamental system of Hither Asia, combated by Nilus, a system which was at home in Cappadocia and in Iran and contributed more than any other to form the art of Islam ; one of them was accused of decorating the walls of God's house like those of stables. But on the artistic, as on the religious field, the iconoclasts were defeated by the stubborn opposition of the monasteries ; the secular Hellenistic art of Constantinople further contributed to their overthrow. To the latter they paid, perhaps, too little attention ; they were tolerant of this mythological and idyllic art, and only fierce against the ikon. But

[1] For various lost examples see *B. A. and A.*, pp. 258–60. Cf. also Wulff, in *Byz.-neugr. Jahrb.*, ii, 1921, pp. 350 ff.

[2] The cycle in mosaic in the church of the Holy Apostles at Constantinople is also assigned by Heisenberg to the sixth century (*Grabeskirche und Apostelkirche*, vol. ii). But others, notably Dr. N. A. Bees, believe these mosaics to be of later date.

their tolerance prepared the way for a neo-classical revival revealed in its full strength when the religious quarrel ended and a strong dynasty came into power. The re-establishment of settled conditions was followed by a partial return towards Greek principles, the effect of which was soon visible in religious painting both on the monumental and lesser scale. This occurred even in the case of mosaic, where conditions were more difficult for the Greek plastic idea than in other branches of art. In the church of S. George at Salonika, and in that of the Dormition of the Virgin at Nicaea,[1] we mark a finer gradation of the tesserae used in the faces; there was an increase in modelling which was destined to endure; the tendency became general in mural painting, in tempera and in illuminations. In this revival of Greek feeling at Constantinople the illuminated manuscript was an important factor, and its importance was perhaps accentuated by the literary nature of the revival as a whole. For in this imitative age the great libraries of the capital were searched by scholars and writers seeking models to improve their style, and there seems no reason why painters should not have made use of them for the same purpose. The influence of the miniature, great from the beginning, was now increased; it remained the dominant source of inspiration from this time till the fall of the Empire.

During the iconoclastic disturbance the secular illuminators of the capital, working in the old Alexandrian tradition and untroubled by the religious quarrel, produced work almost wholly Hellenistic in manner. In many religious houses, on the other hand, the monastic painters were able to continue their work, always with an oriental bias. When the long struggle drew to its close, each art emerged in a state of vigour. The Greeks produced masterpieces like the Paris Psalter no. 139, evidently based at first or second remove on an Alexandrian original of the fourth century; the monks produced the marginal psalters of the ' monastic-theological ' type (p. 308), in which the dramatic energy and popular appeal of the old Syrian manner appear in unabated force. It was clear that in this time of recovery for Church and State the compromise had to be renewed; and after a period of resistance from the neo-classicism of Constantinople, the eleventh century saw a reconstitution of the old alliance in the Byzantine sacred art of the liturgical period (p. 16). The classicizing style was permeated once more by the realism of a monastic art resting on a popular basis : the old simplifying methods such as inverted perspective were again in evidence. In some of the books now illuminated, especially the octateuchs and the menologies, we note a more complete blending of the Greek and Eastern factors than any before witnessed.

But the Hellenizing sympathies of the capital, however subdued, still lent to much of the religious art produced for royal and wealthy patrons

[1] O. Wulff, *Altchristliche und byz. Kunst*, pp. 548 ff. S. George was one of the churches in which the iconoclasts replaced the original decoration of the apse with a figure of the Virgin by a plain cross.

a pronounced classical quality (cf. above, p. 17). Though the oriental element could not be excluded, the rougher features which it brought with it were modified. Angularities were smoothed away; the thick-set figure and the awkward gesture grew rarer; the exuberance of the earlier Aramaean realism was subdued. The modelling which the Syrians had never been able wholly to avoid was now more often extended from the face to the body; the natural form was more apparent under the conventional lines of drapery. Another effect of the Hellenistic leanings of the capital is seen in a certain tendency to reintroduce elements of scenery, though there is no consistent use of true perspective. In the mosaics of Daphni, frontality is not the universal rule; figures are seen in the three-quarter view, and posed once more in the Greek manner. We find in the art of this monastery a further assertion of Greek sentiment, the influence of which was now so widely extended. In the monumental art of the twelfth century it is best represented by surviving examples in mosaics not on Byzantine soil but on that of Venice and Sicily (pp. 290–2). The Hellenizing style of Daphni was the source of that picturesque manner which, after the Latin inter-regnum, characterized the last two centuries of Byzantine art (p. 21); it returned out of the West, enriched and amplified. But in the later Comnenian period the naturalism to which it tended was opposed and balanced by the art of those monasteries where the Hellenizing influences of Constantinople were not allowed free play. In such places sacred repre-sentation followed different lines, which led it towards formalism and in some ways seems to thwart the didactic ends which monastic art generally had in view. In 787, during the iconoclastic struggle, the second Council of Nicaea had declared the choice and treatment of sacred subjects the concern of the Church, and not of the painter. In the centuries which followed, this decree led to the preparation of authorized manuals, a much later example of which—that used on Mount Athos—is familiar to us through Didron's translation. Religious painters, who at this time were almost always monks, obeyed the direction of these manuals, which they knew by heart, so that many of them were able, with infallible memory and unerring hand, to execute even the most elaborate scene ' out of their heads ', as Didron actually saw an Athonite monk proceed in the nineteenth century; all was so perfectly memorized that the execution proceeded like that of a well practised piece of music. Forbidden to interfere with the content, they insensibly abandoned the part of teacher and interpreter for that of decorator; they absorbed themselves in the relations of form and colour within the limits of the dictated subject. Much of this sacred art would fascinate even if the spectator had no knowledge of the historical or dogmatic message which it was supposed to convey. It impresses us like a pattern, removed from the utilities of the practical or the purposes of the ecclesias-tical life; in this way art was revenged upon Councils and their decrees (cf. above, p. 19).

The occupation of Constantinople by the Crusaders in 1204 caused a violent interruption in the general life and a dislocation of Byzantine art (p. 19). In the capital itself there was a breach in tradition which was hardly made good even after the restoration of 1261. But beyond Constantinople, East Christian art was able to pursue its course with comparative freedom ; in Nicaea and Epirus the Greek life was continued. In Serbia and Italy Byzantine painters found a refuge ; in the former country they began to work for Serbian kings, in the latter they joined the emigrated Greeks already settled at Venice. The *diaspora* was not without compensation ; a new spirit was moving in the world, and the Greek painters were able to share in it in an increased measure. Though some returned to Constantinople after the withdrawal of the Latins, the foreign centres were not abandoned ; in the course of time, indeed, their number was increased. From Macedonia and Serbia there was a penetration of Russia ; when the rule of the Frankish princes came to an end in the south of Greece, a new focus of Byzantine art was established at Mistra in the Morea. In Venice Byzantine influence grew with the political expansion of the city. In the last centuries of the Empire, the art of Constantinople, of Macedonia and Serbia, Venice and Siena, Mistra, Russia and Mount Athos was subtly interrelated ; the different centres were affected by certain general movements, and acted severally upon each other. From this diversity this art derived the freshness which almost startled those with preconceived ideas on the hieratic stiffness of Byzantinism.

It has been suggested above that the period of the Paleologi was not one of fatalism or of a tranquil acceptance of decay (p. 21). In painting we find a tendency akin to that which affected contemporary literature ; there was a revived interest in antiquity, leading to an active study of ancient models, but united with a new attachment to life. The restrictions of the liturgical period no longer found favour ; in the illustration of the Gospels, for example, a wider scope was demanded, and the desire was in great part satisfied by going back to the art of a more expansive age ; painters drew on the primary sources of Christian art, both Hellenistic and oriental, even though they were often obliged to content themselves with copies in the form of tenth- or eleventh-century illuminated books through which the early themes and motives were transmitted. The new humanistic influences inclined them once more towards Hellenistic naturalism, to the picturesque, to a more plastic rendering of the figure, to a livelier movement and gayer colour. But they found the old Syrian realism and dramatic sincerity hardly less to their taste ; its apocryphal episodes, as handed down by Cappadocia, were congenial to their fancy.[1] By incorporating these divers elements they produced a new late-Byzantine art which has been sometimes

[1] Not only iconographical motives of Cappadocian (primarily Syro-Palestinian) origin occur in the mural paintings of Serbian churches of this period, but methods also, such as the disposition of subjects in ' friezes '.

held to mark a veritable Renaissance. It was an art which turned away from the linear and formal manner of the monasteries and from the methods which sought to compress all shapes as far as possible into a single plane, seeking rather to restore plastic forms, true perspective, and the rendering of scenes in depth. The very embarrassment of riches in the models at their disposal (mosaic cycles such as those in the church of the Holy Apostles, MSS. of all kinds preserved in libraries) may at first have confused men no longer trained to the distinction between the methods of a Syro-Hellenistic religious art and a secular art almost wholly Hellenistic; this may at any rate have been the case at Constantinople, where the work of the schools had been interrupted during the Latin occupation, and the models were overwhelming in number and variety. The greatest monument left by this enthusiastic revival is found in the mosaics of the church of the Chora or Kahrieh Jami (p. 293), which date from the early fourteenth century.[1] The miniature, like the mural painting and the mosaic, shows a return towards the picturesque and a new appreciation of Hellenistic models. The illuminator's art shared in the feverish activity, not without its gleams of genius, which flickered up during the last difficult years. There was again assiduous copying of early models, among which was a relatively high proportion of secular works, historical, scientific and sporting, derived from Alexandrian prototypes, or Mid-Byzantine copies of these.[2] Thus in its latest phase East Christian illumination was still unforgetful of the source which gave it birth.

It has been observed above that after the shock of 1204 East Christian painting developed a new life not in Constantinople only, but in many centres. In Serbia the period of activity lasted from the thirteenth century to the middle of the fifteenth, at Mistra from the fourteenth to the fifteenth. In Venice and its sphere of domination the period was more extended, and in the later fifteenth and during the sixteenth century Crete assumed a place of peculiar importance, her artists working largely on Italian soil, and diffusing their influence over a wide area in the east of Europe. We may briefly notice a few facts in connexion with this development.

Serbia was from the beginning of the thirteenth century the home of a painting the importance of which we are only now beginning to realize, an art preserved chiefly on the walls of numerous churches, and in a minor degree in manuscripts. In Macedonia Middle Byzantine art had found expression in the eleventh century, and it was probably through Macedonia that the painters who inaugurated the great period of Serbian national art entered the Slav kingdom. From the place of their origin the school which dominated not only Serbian but Russian religious art down to the close of the fourteenth century was known as the Macedonian.[3] The style of this

[1] For the confusion of styles in certain mosaic subjects in this church see p. 229, n. 5.

[2] For Byzantine painting see an important study by D. Ainaloff, in *Zapiski* of the Russian Arch. Soc., ix, 1917, not accessible to the writer at the time when the above was written.

[3] On Mount Athos the Macedonian school lasted until the second quarter of the sixteenth century. For the school in general see Millet, *Iconographie de l'Évangile*, pp. 630 ff.

school is characterized by a free and bold manner well suited to wall decoration, but by a rather restricted range of colours ; the artists have an appreciation of the picturesque and a sense of pathos ; this already separates them from the men of the time preceding the Fourth Crusade. In these qualities it reflects the general change introduced in the thirteenth century by the increased communication between the Byzantine Greeks and other peoples, especially the Italians. The Macedonian school, though definitely Byzantine in fundamental qualities, derived in its maturity certain characteristics from the primitive art of Siena : grace and tenderness, movement, an ampler and richer composition. It claims the paintings in all the thirteenth- and fourteenth-century churches built by Miliutin and Dushan and their predecessors, of which Studenitza and Gradatz, Grachanitza, Nagoricha, Lesnovo, and Mateitza may be mentioned as notable examples. The decoration of Boiana in Bulgaria, ascribed to the late thirteenth century, should in like manner be assigned to it, as also that of several fourteenth-century churches in Russia ; S. Theodore Stratelates at Novgorod (c. A.D. 1370), Volotovo (A.D. 1363), and Kovaleff (c. A.D. 1380). The earliest frescoes of Mount Athos (now lost) should doubtless also be ascribed to it, and its influence, later in the Holy Mountain than elsewhere, continued till the time of Panselinos of Salonika, the last and best-known Macedonian master, some of whose work, dating from about 1540, is still to be seen in the Protaton.

After the middle of the fourteenth century in Greece, from the beginning of the following century in Serbia, and only from the middle of the sixteenth century upon Mount Athos, the work of another school appears, commonly called ' Cretan ', because the known members of it in its later phases were Cretans. There seems, however, reason to believe that its real place of origin was in Venice, and that its earliest growth may be traced to the thirteenth century, when painters joined the Greek colony in that city, while its full development belongs to the fourteenth. Venice, by her later acquisition of Crete and of other islands did but expand a Greek connexion which already existed. The style of the new school is akin to that of work upon a smaller scale, for example, illumination and ikon painting. It is less bold, and less perfectly adapted to the decoration of large wall-spaces than the freer Macedonian manner, but it is more faithful to Byzantine ideals, and joins to a love of the picturesque and the graceful, much restraint, and a feeling for nobility of type.[1] If, as Millet is disposed to think, the Peribleptos at Mistra (p. 257), despite certain analogies suggesting the sixteenth-century painting of Mount Athos, is really of the fourteenth century, this church is a landmark in the development of the style, which soon afterwards spread rapidly over the Slav area, appearing in the churches built by the Serbian ' despots ' after the fall of the royal dynasty at Kossovo (Ravanitza, Manassiya), and even earlier in Russia, if, as is supposed, the

[1] Millet, *Iconographie de l'Évangile*, p. 683.

fragments on the walls of the church of the Trinity at Novgorod reveal its manner.[1] On Mount Athos the first master known to have employed it was Theophanes, apparently a contemporary of Panselinos.[2] Most of the surviving frescoes in the monasteries of Mount Athos are in the 'Cretan' style. As almost inevitably follows from the qualities above indicated, Cretan masters were distinguished as ikon-painters, in which capacity they are noticed below (p. 265).

The paintings on the walls of the churches at Mistra [3] (p. 257) show affinities, for the fourteenth century, to the work of the Macedonian school in Serbia ; if more monumental work survived in Constantinople, relations with the capital would doubtless be apparent. But their most striking relations are with Mount Athos, manifested first, as above noted, in the case of the church of the Peribleptos and afterwards in the work of the fifteenth-century churches (p. 259). We have noticed that the different centres of art in the late Byzantine period were sensitive to each other's influence. They all experienced the changes from the Macedonian to the 'Cretan' school and are thus generally related in style ; [4] but we may trace particular resemblances in points of iconographical detail, linking Constantinople with Serbia, Serbia with Russia, Venice with Serbia and Mistra,[5] Mistra with Athos. The East Christian world was now no less permeable than a thousand years earlier, and now as then the relations of Italy with the East raised interesting questions.

The work both of the Macedonian and the Cretan schools was affected by the art of Siena, from which it derives elements of delicacy and charm. But, as Kondakoff long ago remarked, this influence in the case of both schools extends no farther than the surface ; the fundamental type, jealously preserved, remains Byzantine.[6] The decoration at Nagoricha in Serbia may be cited as an example. Here Sienese influence is marked in certain details ; we may even discern that of Duccio ; but it in no way affects the thoroughly Greek spirit of the compositions. The resemblances between the Greek and Slav painting of the fourteenth century on the one hand, and that of Italy on the other, are not to be explained by direct borrowing, for the art of the great contemporary, Giotto, does not touch them ; all that is Italian in them is of the thirteenth century. The explanation seems to lie in the fact that both Italy and her eastern neighbours had been employing common formulas for some hundreds of years, since there had been a Graeco-Italian art ever since the tenth century (p. 253), and this had guided the first steps of Italian painting. Thus the only art of Italy which the Greeks understood and utilized was one which they had them-

[1] Millet, *as above*, p. 680.

[2] *Ibid.*, p. 659.

[3] G. Millet, *Monuments byzantins de Mistra*, Album, Paris, 1910, and *Iconographie de l'Évangile*, Index, s. v. *Mistra*.

[4] Thus the cathedral at Mistra shows a development seen 150 years earlier at Nerez, near Skopliye (Millet, *Iconogr.*, p. 634).

[5] e. g. the sponge-bearer in Crucifixion scenes at Gradatz in Serbia and at Mistra shows a peculiar resemblance (*ibid.*, p. 450).

[6] Cf. also Ainaloff, *as above* (p. 237, n. 2).

selves contributed to form. The new things out of Italy which appear in Serbia, at Mistra, or in Constantinople are very largely old Greek things returning home, superficially enhanced by a Sienese attractiveness. This being so, we cannot properly regard the painting either of the Slavs or of the Byzantine Greeks in the fourteenth century as dominated by Western influence. Italy had touched with animation and grace an art essentially unchanged.

The relation between Italian and Greek painting is closer in the case of painting upon wooden panels, which is more fully represented in churches and museums by work of the period following the Fourth Crusade than by that of earlier times, most fully, indeed, by work produced long after the fall of Constantinople. The number of really old panels of importance is so small that in the above pages this branch of the Greek painter's art has not received special mention ; a few words on the subject may therefore be added in the present place.

Most of the early panels which depict sacred persons or saints are in a Syro-Hellenistic style ; few date from before the sixth century. A small group executed by the encaustic method carried on the tradition of the painters who executed the mummy-portraits of the Fayûm, and in the oldest the Hellenistic or Graeco-Roman influence is still strong. But the encaustic process, though lingering on towards the close of the first millennium, had long ceased to be popular ; it was rivalled from the first, and soon distanced, by that of painting in tempera upon a thin coating of gesso applied to the wood, and this is the method of almost all surviving East Christian panels of every date.[1] But by whatever material produced, panel painting pursued the general course of East Christian representational art ; as we know it, it is essentially religious painting, and as such its subjects follow the fortunes of the Syro-Hellenistic compromise through the centuries. But the panels, being of limited size, are more often devoted to the single figure, or to a few figures, than to more extensive subjects, and we may suppose that from a very early time the Virgin, Our Lord, and the principal saints were the favourite subjects ; ancient pictures of the Virgin are said to have been preserved at Bethlehem and Lydda : these early panels were probably destroyed in great numbers in the time of the iconoclasts. Iconoclasm, however, indirectly furthered the production of ikons, for in the monasteries they were saved from destruction, and when the reaction against the iconoclasts came, the work was resumed with renewed vigour and on new lines. It is somewhat surprising that the number of surviving examples from Macedonian and Comnenian times should not be larger than it is ; they are very rare for the period between the ninth century and the later part of the thirteenth. The great increase in their number is due to the fact that the so-called ' Cretan ' school (p. 238) was especially active in their production, disseminating its work from Venice through Italy and

[1] For the early panels see below, p. 263.

the east of Europe from the fifteenth century onwards. It is the late work of this school which supplied churches and monasteries with the numerous 'archaizing' panels which are constantly, but inaccurately, described as Byzantine.

We have records of individual painters living and working in Italy from the twelfth century; and from the direct connexions of that country with the Byzantine Empire at a much earlier date it may be safely assumed that the Kaloianni mentioned as working in the district of Padua in A.D. 1143 was by no means the first Greek artist settled in Northern Italy. It is certain that the Greek mercantile colony of Venice early attracted Eastern painters, of whom Kaloianni was doubtless one. Marcos Indriomeni worked on the mosaics of S. Mark's in A.D. 1153; Theophanes of Constantinople was painting in Venice in A.D. 1242; rather later, Apollonios was invited to help Andrea Tafi with the mosaic designs of the Baptistery at Florence. The Berne diptych (p. 266, n. 1) shows in an early example the interaction between East and West which the presence of Greeks on North Italian soil must necessarily have caused. We may perhaps ascribe to Greek ikon-painters the Byzantine influence observed in the work of the Roman artist Pietro Cavallini (end of the thirteenth century). The early Sienese painters, among them Duccio, were influenced in the same way, but gave much in return, teaching the Greeks, as already noted, a greater freedom and amplitude of style, with particular attitudes and gestures destined to travel far in the Balkan countries, on Mount Athos, and in Russia. The Florentine Cimabue was a more original genius; but he too is not without his debt to Byzantium. East Christian panel-painting in its later phases is associated with the names of Cretan painters. The Russian scholars Kondakoff and Likhacheff consider that the permanent connexion of Graeco-Italian art with Crete began in the fourteenth century at Venice. The city of the Adriatic had acquired the island in A.D. 1204, but the peaceful and progressive era of Venetian rule did not begin until after the local rebellion of 1363–6. With the extension of the Venetian Empire in the Eastern Mediterranean in the fifteenth century, the Latin and the Greek civilizations penetrated each other more intimately than ever before, and it is from about A.D. 1400 that the school of Cretan panel-painters began to flourish. Several old Cretan panels now in Italy were known at an early date; thus the panel of the Virgin and Child, now in the church of the Salute at Venice, was in Candia cathedral in A.D. 1397. The reliquary of Cardinal Bessarione at Venice (p. 265), painted in A.D. 1463, is held to have been the work of Cretan painters. The iconography, however, shows features which connect it with the Macedonian school (p. 237) and with Mistra (p. 239); this seems to prove that the artistic community at Venice kept in touch with all the Greek schools active at the time. Likhacheff held that the ikons of Graeco-Italian style in Italian churches, such as the Virgin *De perpetuo Succursu* (*Madre di Consolazione*) in the church of S. Alfonso, and the Madonna in

S. Agostino at Rome, were not acquired before the close of the fifteenth century or a little later.

With the sixteenth and seventeenth centuries the ikons of the Italo-Cretan school were widely diffused in Europe and the nearer East. We now find pictures signed by their painters, as for instance a Holy Family dated A.D. 1532, signed by Angelus Bizamannus, who with a brother worked at Otranto ; or the Virgin and Child in the Parma gallery, signed by Andreas Rico of Candia ; others whose signed work exists are Emmanuel Zane and Emmanuel Zanfurnari, but the reader desiring information on these late painters is referred to special works relating to their activity.[1] The Russian schools of ikon-painters working at Moscow and elsewhere are largely indebted to Italo-Cretan models. It is from these, and not from purely Byzantine works, that the Russian religious panel descends ; to the Moscow school of the sixteenth and seventeenth centuries belong a number of ikons in the monastery of Vatopedi on Mount Athos. The principal series of Graeco-Italian panels are those in the Vatican Museum at Rome, in the Ecclesiastical Academy at Kieff, at Venice, in the church of the monastery of S. Catherine on Mount Sinai, and in the collection of M. Likhacheff in Petrograd : of these only the latter has been published with good illustration. Examples are scattered in smaller numbers in many churches and monasteries, for instance in Crete itself, and on the island of Patmos, but especially upon Mount Athos, where, as stated above, a ' Cretan ' school of fresco-painters decorated many churches from the sixteenth century. Religious pictures in Greek style with Greek inscriptions, but showing evident Italian influence, are numerous in Europe, and the great majority are the work of the Italo-Cretan school. Their multitude is partly explained by a statement of Gerola that every Venetian family had a ' Byzantine ' ikon which was considered to guard and protect the home.[2]

The choice and disposition of the subjects used to decorate church

[1] The following books may be consulted for the late Graeco-Italian or Italo-Greek panels of the fifteenth century and later. A valuable summary in G. Millet, *Iconographie de l'Évangile*, pp. 661 ff. ; N. P. Likhacheff, *Materials for the History of Russian Ikon-painting*, Atlas, St. Petersburg, 1906 (Russian), and *Historical Significance of Italo-Greek Panel Pictures representing the Mother of God*, &c., St. Petersburg, Imperial Russian Arch. Society, 1911 (Russian) ; N. P. Kondakoff, *Christian Monuments of Mount Athos*, St. Petersburg, 1902, *Macedonia*, 1909, and *Iconography of the Mother of God*, 1911 (Russian) ; A. Dmitrievski, *Sketches on Patmos*, Kieff, 1894 (Russian) ; S. Lambros, Ἕλληνες ζωγράφοι πρὸ τῆς ἁλώσεως, in Νέος Ἑλληνομνήμων, 1908, pp. 270 ff. ; G. Mavrojanni, Βυζαντινὴ τέχνη καὶ Βυζαντινοὶ καλλίτεχναι, &c.,

Athens, 1893 ; G. Gerola, *Monumenti veneti nell' isola di Creta*, Venice, 1905, vol. ii (on pp. 308 ff. a list of painters) ; H. E. Keyes, *American Journal of Archaeology*, 1913, pp. 211 ff. ; J. Wilpert, *Die römischen Mosaiken und Malereien*, 1916, pp. 1101 ff. ; Johann Georg, Herzog zu Sachsen, *Das Katharinen-Kloster am Sinai*, 1912, pp. 12 &c., and in *Zeitschrift für christliche Kunst*, 1911, p. 302, and 1912, p. 211 ; *B. A. and A.*, pp. 263, 316. For the names of artists, besides the list given by Gerola (see above) the reader may consult the articles by E. Müntz and A. L. Frothingham cited in *B. A. and A.*, p. 263, where a certain number of names, derived from these articles, are mentioned.

[2] *Monumenti veneti nell' isola di Creta*, ii, p. 312.

interiors in the centuries which succeeded iconoclasm somewhat differed from those of the earlier period (p. 232). In the time of Justinian subjects relating to dogma and ritual had already taken their place on church walls as we see them at S. Vitale. But in the early period there had still been no uniform scheme of arrangement, no universal system consecrated by authority and carried out everywhere as a matter of course. Such a scheme was perfected in the liturgical period of the eleventh century (p. 16); it may have been immediately foreshadowed as early as the close of the ninth in the decoration of the *Nea*, or new palace church, built by Basil I, the mosaics of which are mentioned in a sermon of Photius. The fixity of the scheme followed from its close association with the rite. Each part of the church had its own significance, with which its decoration was brought into accord. The central dome represents the heavens. At the summit is Christ, Pantokrator; below him are archangels, apostles, or prophets : the type of Christ here is not that of the historic series, but apocalyptic, the majestic and severe form of ' the Ancient of Days '. The *bema*, or sanctuary, separated from the nave by the screen, or *iconostasis*, is still symbolical of heaven. Here in the apse is the Virgin *orans*, making supplication for the world, or seated with the Child as representative of the Church; in the vault of the roof is the *Hetoimasia*, or Preparation of the Throne, an empty throne prepared for the Second Coming, with the instruments of the Passion about it. On the walls about the altar are the priests who prefigure Christ: Abraham, Aaron, Melchizedek, with the great bishops of the Church. In the lateral apses are Old Testament scenes having a reference to the divine sacrifice—Daniel in the Den of Lions, the Three Children in the Furnace. A more direct allusion is seen in the favourite subjects of the Communion of the Apostles, in which Christ, his figure twice repeated, gives the bread and wine to the apostles, divided into two groups of six, or the Divine Liturgy, in which he celebrates aided by angels in ceremonial vestments. While the dome and *bema* represent the suprasensible, the remainder of the church stands for the sensible world. Here is a whole hierarchy of saints placed according to their rank ; near the door at the west end, monastic saints ; next to them, martyrs ; then episcopal saints, and sainted priests and deacons. On the great arches supporting the dome are the warriors Demetrius, George, and the two Theodores, Stratelates and Tyron. The pendentives, by which the dome is joined to the arches beneath, have the Evangelists, whose word joins earth and heaven. Along the walls, above the lines of saints, are the Twelve Feasts of the Church, represented by episodes from the lives of Our Lord and the Virgin celebrated at annual festivals. These are not everywhere the same, but are generally the following: Annunciation, Nativity, Presentation in the Temple, Baptism, Raising of Lazarus, Transfiguration, Entry into Jerusalem, Crucifixion, Descent into Hell (*Anastasis*), Pentecost, Ascension, and Death of the Virgin (*Koimesis*). Among these the Crucifixion and Descent into

Hell were regarded as the most important and were placed in the most conspicuous positions. Some of the Feasts are accompanied by subsidiary subjects : the Crucifixion and *Anastasis* by the Incredulity of Thomas, the Nativity by the Adoration of the Magi, the Entry into Jerusalem by the Betrayal. The west wall is reserved for the Last Judgement, or Doom, well represented by the great example at Torcello (p. 290). In the narthex are scenes from the life of the Virgin based on the apocryphal Gospels, and scenes from the Passion; on the tympanum over the west door the founder of the church is sometimes seen, prostrate before the bust or throned figure of Christ. There may be variation due to local circumstance or peculiarity in structure, yet all belongs to a carefully considered system, the main ideas of which are followed in almost all decorated churches of the period. The principles applied are constant from the eleventh century, and are those followed by the writers of the Painters' Guides. Nothing is admitted to a chief place which has no relation to the ritual. Thus the portraits of founders and princes, once admitted to the *bema*, are now placed in the narthex or on the tympanum of the door. All is centred in the mystery of the suprasensible; history makes way for theology, as at an earlier time primitive symbolism had made way for history. The inter-regnum disturbed but did not change the system, which survived the Byzantine Empire. Though modified by certain variations and additions, it is preserved in its main lines with great fidelity in the sixteenth-century decoration of churches on Mount Athos, and in later churches in Serbia, Greece, and elsewhere, among which that of Kaisariani in Attica may receive especial mention.

The services which East Christian art rendered directly to the medieval art of the West, and thus indirectly to later Western art, are perhaps more conspicuous in the field of painting than in any other. Down to the dawn of the Renaissance in Italy, throughout all the relations between West and East, the initiative came from the Eastern side. The history of European civilization between the fourth and the thirteenth centuries made this inevitable. In the earlier Middle Ages the great religious houses were the chief artistic centres; they patronized and practised all the arts. But the monasteries in Italy, France, and other countries were throughout this period amenable to influences from the Christian East, and the East Christian model was a continual source of inspiration almost from the time of Cassiodorus to that of S. Francis. This was especially the case with the illuminated manuscript, which itself so largely influenced mural painting; but the visits of pilgrims to the Holy Land and to Constantinople must also have been fruitful in suggestion for painting on the larger scale, since the pilgrims and travellers included men trained in the arts, who must sometimes have copied mural decorations seen upon their journeys. Nor was it always necessary to visit the East to obtain the Eastern model, for Italy herself possessed an almost unbroken series of oriental compositions, beginning

with the church frescoes of the ' Syrian ' period at Rome (p. 249), and Italian derivatives such as those in SS. Nereus and Achilleus and S. Bastianello in Pallara. Rome, from the end of the Gothic wars of Justinian the focus of West European religious and monastic art, remained also the great centre of dissemination whence East Christian models passed into the countries north and west of the Alps. In England the early MSS. which reached Ireland and Northumbria towards the year A.D. 700 must have been of East Christian inspiration, though probably obtained in Rome by visitors such as Wilfrid and Benedict Biscop (p. 66). In the south of Italy, in Apulia and Calabria, from quite early times until the eleventh century and later, Basilian monks from the East continued to paint the walls of their chapels and cells in the Byzantine manner. Venice in the north was a centre of Byzantine influence from the eleventh century to the time of Giotto. The older mosaics of S. Mark's are of East Christian origin ; the activity of Byzantine panel-painters from Venice has been noticed above. In France and South Germany East Christian painting exerted its influence once more through illuminated books, which came to the monasteries in considerable numbers from the time of Charlemagne onwards. Under the Saxon emperors this influence continued, and down to the thirteenth century it is clearly perceptible in German sacred art. With the influence of the miniature went that of the ikon ; from these sources the art of the Trecento derived much of its power to render the human form and countenance, and the iconography of individual types and themes. Through the painting of the Trecento, the primary inspirer of the later Primitives in the west of Europe, the spirit of East Christian and Byzantine art was indirectly felt down to the coming of the Renaissance.[1] It was not until the rise of Gothic art that France and Western Europe attained independence, though in particular points traditions born in the East lived on,[2] and, as in sculpture, the general treatment of figure subjects is affected by principles of vision differing from those of classical antiquity.

In our own times the revolt against the Graeco-Roman spirit of the High Renaissance has awakened a new understanding for East Christian painting. It is perceived that the orientalizing painters of the fifth and sixth centuries were engaged in the same reaction, that they too were pursuing a different end than that conformity to natural appearance which had satisfied the Hellenistic mind. It is recognized that developments from the simple expressiveness of the Aramaean to the later Byzantine formalism are reflected in the changes of European art since Cézanne.

[1] L. Bréhier, *Byzance, l'Orient et l'Occident*, in *Revue Arch.*, N.S., vol. vii, 1918, p. 35 : ' ce sont des thèmes créés par des moines de Palestine et de Cappadoce, qui, plus ou moins modifiés et élaborés, ont produit les chefs-d'œuvre de nos Primitifs.' Wulff, *Altchr. und byz. Kunst*, p. 365, observes that the heightened feeling of Crucifixion scenes and figures of the Virgin is due to the influence of Byzantine ikons acting at the time of the Fourth Crusade.

[2] Down to the fifteenth century such landscape features as are introduced still recall the old Syro-Hellenistic methods.

The reformer of the present time follows with sympathy the ceaseless efforts of the Aramaean and Iranian elements against the Hellenistic, conscious that the adversary which they resisted is his own opponent to-day. He sees in the monastic painter of Syria-Palestine or of latter-day Byzantium old champions of his faith, engaged with an earlier avatar of his present enemy. Nor does he respect them less because the adversary was very strong and they never found themselves in sole possession of the field.

A few preliminary words must here be said on the subject of the practical methods employed in mural and in ikon painting.

Though it has been claimed that the method of true fresco was employed in a few cases, almost all East Christian mural painting is executed in tempera. In this method colours mixed with a vehicle or medium (white of egg, size, gum, &c.) were applied to a plastered surface already dry, whereas in true fresco colours were applied without a medium to plaster which was still wet. The plaster, in either case, was applied in more than one coating, that next the wall being coarser and strengthened by an admixture of chopped straw or similar binding matter, the uppermost of finely pulverized lime, with hair or cotton-thread taking the place of straw. True fresco is superior to tempera in durability; the colour is, as it were, incorporated in the plaster, and the formation, after drying, of carbonates or silicates of lime ensures its permanence. Fresco has the further merit of compelling rapid and concentrated work; it is the method of the artist with a sure hand and unerring eye, for it does not admit of second thoughts. Tempera, on the other hand, can be retouched and the design modified; it has moreover a larger palette than fresco, in which the scale of colour is restricted. But the permanence of tempera depends very much upon the quality of the medium; if this is inadequate, the picture will flake away and the whole design perish. Examination of early mural paintings, such as those of Bawît (p. 248), has shown that the painter first outlined his figures, generally in red, then filled in the body-colour. Shading was done in green or blue; the folds of drapery were indicated by lines in some strong colour, and high lights were left white. The amount of modelling suggested depends on the relative strength or weakness of Hellenistic influence. In the more purely oriental work, flat tones contrasting with each other are in favour, and modelling is of a summary character; where, as in the case of portraits, or of secular painting in Constantinople, a Hellenistic tradition prevailed, the modelling in tone was done with elaborate care.

Tempera was also the process most generally adopted in the case of panel pictures on wood. The surface of the wood was first coated with size; this was left to dry, and then covered by three or more successive layers of fine gesso. Gilding was naturally more common on small panel pictures [1] than in work of larger compass. A ground of red size was first laid, to which gold foil was applied, and moistened with alcohol; by this

[1] These panel pictures, almost all of which are ikons, are throughout of small size.

means it held fast enough to admit of burnishing. Panel ikons were also executed by the encaustic process, which descended to Christian art from the Graeco-Roman art of Egypt. The colours were ground up with wax; the composition was then melted and applied by heated spatulae, though there may have been admixture with oil; a fresco at Panticapaeum shows an encaustic painter heating his spatulae.[1] The provenance of the interesting encaustic panels from Mount Sinai, described below (p. 263), suggests the route by which the process may have travelled northwards. Encaustic painting seems to have been sometimes executed on linen.[2] Oil painting in the ordinary sense of the term was not practised in East Christian and Byzantine art.

THE MONUMENTS
Mural Painting : Religious

When it is remembered that few churches, however humble, were without some mural painting, while the walls of a vast number in all parts of the Christian East were systematically covered with sacred subjects, it will be seen that to enumerate even such as are known would be an impossible task; and there remain numbers of ruined sites or churches still unknown, and others of which we have no adequate description. In the following pages only the more notable paintings can receive individual mention.[3]

In Egypt the paintings in the catacombs of Alexandria[4] date from the fourth century and show affinities with those at Rome; they are in the Hellenistic style.

At Kom esh-Shugafa are paintings of the fifth century showing the advance of indigenous (Coptic) feeling against that of the Greeks.[5] It has been noted above that influences from Syria became powerful in Egypt in the fourth century, and since Aramaean feeling with regard to the visible world was more congenial to the Copts than the Hellenistic, the Christian art of the country was henceforward profoundly affected by the Aramaean point of view. In Coptic paintings after the fifth century we witness a gradual encroachment upon Hellenistic forms by an indigenous art assimilating Syro-Palestinian types.[6]

In the funeral chapels in the necropolis of the ruined monastery of

[1] H. Stuart Jones, *Quart. Rev.*, 1909, p. 452.
[2] Stated by Asterius of Amasea (Migne, *Patr. gr.*, xl, pp. 333 ff.).
[3] The mural paintings recently discovered at Sâlihîya (Dura), on the Euphrates 140 m. east of Palmyra, are not Christian, but of great interest as illustrating the oriental style and methods which later penetrated Christian art; they date from about A.D. 80 (J. H. Breasted, *Oriental Forerunners of Byzantine Painting*: vol. i of publications of the Oriental Inst. in the Univ. of Chicago, 1924, and in *Syria*, iii, 1922, p. 177: the first-mentioned work contains a contribution from Prof. Cumont, who in 1924 lectured in London on the subject. Prof. Cumont also contributed the account in *Les travaux arch. en Syrie*, 1920–2.
[4] *B. A. and A.*, pp. 282, 283; Wulff, *Altchr. und byz. Kunst*, p. 283.
[5] *Zeitschrift für bildende Kunst*, 1902, p. 112.
[6] Wulff, *as above*, p. 354.

Bawît [1] we see the Hellenistic style affected by these influences. They include a David cycle, a Baptism, groups of the Virgin and Child with saints or angels, who in one case have censers, the Temptation of S. Pachomius, mounted saints (Phoebammon and Sisinnius), Our Lord between the apocalyptic beasts, personifications of Faith, Hope, &c., a demon, and scenes from the New Testament. A number of interesting secular motives are mentioned elsewhere (below, p. 260), while purely ornamental motives include the plaited band and a geometrical combination of octagons, hexagons, and crosses. Some of the Bawît frescoes are considered by Maspéro to have been executed after the Mohammedan conquest.

The paintings in the ruins of churches and cells on the site of the monastery of S. Jeremias at Saqqara,[2] founded about A.D. 480 and destroyed about A.D. 960, are considered to date from the sixth and seventh centuries. The figures face full to the front and look before them with staring eyes ; Syrian influence predominates. The seated Virgin in a niche is an early representation of the type afterwards known as γαλακτοτροφοῦσα, in which the Child is given the breast.[3]

Other funerary chapels near El-Khargeh [4] are similarly decorated with mural paintings, and here, too, Hellenistic influence is apparent ; the date is fifth–sixth century. The subjects include Old Testament scenes, Susanna, S. Thekla, and S. Paul, with personifications of Prayer and Righteousness recalling those already noticed at Bawît.

Paintings in a rock-chamber at Atripe, near the White Monastery at Sohag, are in red monochrome and perhaps of the seventh century.[5] Those in a crypt at Kom Abu Girgeh, south-west of Alexandria, seem to be of the sixth.[6]

In caves at Wadi Sarga, fifteen miles south of Asyût, rather rough paintings cover the walls, the subjects including a Communion of the Apostles. In the ruins of a villa near the same place was a small panel of stucco painted in monochrome with the Three Children in the Furnace with a Coptic inscription. This was inserted in a plastered wall painted with SS. Cosmas and Damian with their three brothers, and is now in the British Museum.[7]

The earlier paintings in the church of El-Hadra at the Syrian monastery (Deir es-Suriâni) near the Natron Lakes [8] have New Testament scenes with the Death of the Virgin perhaps belonging to the post-iconoclastic period, but below them are traces of earlier paintings which may go back to the

[1] J. Maspéro, Rapport sur les fouilles entreprises à Baouît : Acad. des Inscr. et Belles-Lettres, 1913, pp. 287 ff. ; T. Clédat, in Cabrol, Dict. d'arch. chrét., s. v. Baouît.

[2] J. E. Quibell, Excavations at Saqqara, Cairo, 1908 and 1911 ; B. A. and A., p. 283.

[3] This type was preserved in Coptic art to the eighth century, occurring also at Bawît, but was rarely if ever used in Christian art after this period until the thirteenth century.

[4] B. A. and A., p. 286.

[5] Ibid.

[6] Rapport . . . du Musée d'Alexandrie en 1912 ; cf. Leclercq, in Cabrol, Dict. d'arch. chrét., fasc. lxi, col. 1246.

[7] Journal of Egyptian Archaeology, iii, pt. i, p. 35 (cf. also i, pt. iii) ; Guide to Early Christian and Byzantine Antiquities, 1921, fig. 70.

[8] J. Strzygowski, Oriens Christianus, i, 1901, pp. 356 ff. ; Wulff, as above, p. 442.

eighth or ninth century; the stucco ornament in the *haikal* may be contemporary (p. 200).

As in the case of mural mosaic, Italy is relatively rich in wall-paintings dating from the second half of the first millennium. It need not be supposed that all of them were the work of orientals, but in view of the strong oriental element at Rome it can hardly be doubted that much of the inspiration came directly from the Christian East and that it was ultimately Syrian. Though some of the catacomb paintings [1] in which an East Christian influence is discernible may go back to the fifth century, most of them are of the sixth and seventh. The most remarkable are those in the Catacomb of Commodilla : Our Lord between Peter and Paul ; a lady named Turtura presented to the enthroned Virgin by S. Adauctus, with S. Felix standing on the other side of the throne ; and a representation of S. Luke. In this work we seem to trace analogies to the art of Ravenna, and ultimately to that of Constantinople and Antioch. A greater stiffness marks the figures in the Catacombs of Pontianus and Generosa, as also those in the Catacombs of Albano. Though the style of all these paintings is affected by that of the Christian East both in the treatment of subjects and in details, there is evidence of Roman tradition, and Roman participation in the work may be assumed.

In the churches above ground the mural paintings chiefly date from the seventh and eighth century, though there are both earlier and later examples. The most important example is S. Maria Antiqua,[2] under the Palatine Hill, a church buried by the fall of buildings above it in the ninth century ; it has paintings dating from the end of the fifth to the end of the eighth century.[3] The oldest are in the presbytery ; the layer above is of the seventh century, a third layer of the eighth. The work in the Chapel of the Crucifixion is of the time of Zacharias (A. D. 741–752), that of the presbytery apse contemporary with Paul I (757–767), other work with Hadrian I (A. D. 772–793). The remains of frescoes are numerous, and in part very well preserved ; the walls of the court, the nave, the apse, and various chapels are decorated with a large number of subjects from the Old and New Testaments and Apocrypha, scenes from the story of the Forty Martyrs, Saints, and representations of Popes, among whom are Martin, Hadrian I, and Paul I, the last-named in the apse, adoring Our Lord, who is seen between tetramorphs. In the Crucifixion, between the Virgin and S. John, Our Lord wears the *colobium*, or long sleeveless tunic (Plate XLII). The lower walls are painted

[1] *B. A. and A.*, p. 304. These paintings are reproduced in colour in J. Wilpert's *Die Malereien der Katakomben*.

[2] For older references see *B. A. and A.*, p. 304 ; the most useful is G. McN. Rushforth's essay in *Papers of the British School at Rome*, vol. i. J. Wilpert, *Die römischen Mosaiken und Malereien der kirchlichen Bauten vom*

IV.–XIII. Jahrhundert, Freiburg, 1916, ch. xii, pp. 653 ff. ; V. de Grüneisen, *S. Marie Antique*, Rome, 1911.

[3] Some, according to Wilpert, are as late as the tenth (p. 726). The church was ruined during the occupation of Rome by Robert Guiscard in 1084.

to resemble hangings, as at Saqqarah and Quseir 'Amra (p. 261). The eighth-century frescoes of S. Maria Antiqua reflect, as a whole, that Syro-Palestinian influence which we should expect to find in a city with many Eastern monasteries established within its walls, and often ruled by popes of Syrian origin (p. 59).

Other important paintings are at S. Saba on the Aventine,[1] where they decorate the oratory of S. Silvia below the basilica of the twelfth century. The dates given for the work, which is of different periods, range from the seventh century to the tenth, but the greater part seem to be nearer to the later limit; the scenes from the Life of Our Lord are mostly gone, but it is possible to reconstruct the Healing of the Paralytic, and Christ walking upon the sea. Some of the later work is of a high quality and is perhaps the work of Greek monks. The frescoes of S. Saba are of much icono-graphical interest.[2] For other early Roman mural paintings, including those in S. Clemente, Wilpert's great work may be consulted.

In Asia Minor the numerous rock-cut churches of Cappadocia have revealed an astonishing wealth of mural painting, the walls and roofs of many of these cave chapels being covered to the last square foot.[3]

The earlier Cappadocian paintings represent a crude but vigorous monastic art, not in itself of very high quality but important from the historical point of view, since they reveal a continuity of Syro-Hellenistic art in a remote district undisturbed by the external or internal troubles of the Empire (Plate XLIII). Though none are older than the ninth, or possibly the eighth century, they must descend from an earlier Syrian wall-painting which has not survived in its own country.[4] As with the style, so with the subjects. Here a mass of early iconographical material, largely from the apocryphal sources in which the Aramaean mind delighted, is carried through the iconoclastic period to inspire the art of later centuries. We find Cappadocian influence linking, for example, the fourteenth-century art of Serbia with that of pre-iconoclastic times (p. 258), for in Serbia both

[1] P. Styger, *Römische Quartalschrift*, 1914, pp. 49 ff.; J. Wilpert, *Mélanges d'arch. et d'histoire*, xxvi, 1906, p. 15; O. Wulff, *Altchr. und byz. Kunst*, p. 584.

[2] G. Millet, *L'iconographie de l'Évangile*, p. 676.

[3] The R. P. G. de Jerphanion, who has explored the whole region and studied its art, is in possession of extensive material for its illustration, consisting both of photographs and water-colour drawings by M. Mamboury. Some part has been published in the form of articles; the complete work will be called *Les Églises rupestres de Cappadoce*, Paris, 1924-5. Among incidental papers published by him may be mentioned: *Bull. de la Soc. franç. des fouilles arch.*, iii, 1913, pp. 23 ff.; *Revue de l'art chrétien*, lxiv, 1914, pp. 153 ff.; *Rev. Arch.*, 1921, p. 160. Much useful material will be found in H. Rott, *Kleinasiatische Denk-mäler*, Leipsic, 1908. See also H. Grégoire, *Voyage dans le Pont et en Cappadoce*, in *Bull. de Corr. Hellénique*, xxxiii, 1909, pp. 3 ff.; Wulff, *Altchr. und byz. Kunst*, p. 582.

[4] Wulff, *as above*, p. 582. The lowest limit of date for any of the frescoes is the thirteenth century. More than half a dozen churches are dated by inscriptions; in other cases the type of the church gives an indication of date. An inscription at Soandere states that the work was done in the reign of Constantine and Basil (976-1025); another at Aribsun on the Halys gives the year 1212.

decorative methods and subject-matter in many points resemble those which we find in Cappadocia.[1] Among the most remarkable churches, which are in the curiously eroded district of Urgub, we may notice the Church of the Ascension at Gueremé, and Elmali Kilisse and Tokali Kilisse in the same neighbourhood ; these all present very full series of Gospel scenes, well preserved, rich in colour, and not without distinction of style derived from an old tradition. Traces of paintings of an earlier date have apparently been remarked in certain cases, but these are probably not very much older than those above them ; the inspiration is to be sought in early Syro-Palestinian models not necessarily in the same medium. Rott, to whom we owe a useful preliminary survey of many of the Cappadocian churches,[2] has noted in addition to those mentioned above frescoes in rock-hewn churches at Akchik Serai, at Selme, and at Peristrema, where there is an interesting Last Judgement.

The free-standing churches of Anatolia having lost their roofs, the walls have been exposed to the weather for centuries, and the paintings which remain are naturally less well preserved than those in the protected cave churches, where damp has been the chief danger. Rott has described mural paintings with Gospel subjects at Kürksass near Myra ; a Divine Liturgy and various saints at S. Nicholas at Myra, and, in the domed church at Alaja, Evangelists, a Virgin enthroned, and saints. The same writer has recorded discoloured but interesting decoration of the church of S. Stephen on the island of Nis on Lake Egerdirgöll in Pisidia, where he distinguished New Testament scenes, with a good Descent from the Cross, a Last Judgement, Sacrifice of Isaac, and other scenes : some of the work appeared to the explorer to be as early as the ninth century.

The anchorites' caves on Latmos,[3] near Heraklea, are rich in remains of frescoes, of which the earliest, a painting of Christ, Pantokrator, is dated by Wulff as early as the seventh or eighth century, though Strzygowski would assign them to the eleventh,[4] to which century, or to the twelfth, a later series of scenes from the lives of Our Lord and the Virgin in the ' Cave of S. Paul ' are also ascribed ; there are other frescoes of the Comnenian period. In a cave near the Yediler monastery we find a fluent and free style recalling that of the mosaics of Kahrieh Jami, and these can hardly be earlier than the second half of the thirteenth century. The early fourteenth century witnessed the advance of the Turks in the Maeander Valley and the end of Greek civilization in this part of Asia Minor. Paintings in the cave of Asketarion on the peninsula of Cnidos are ascribed to the

[1] G. Millet, *Iconographie de l'Évangile*, Index, s. v. *Cappadoce*.

[2] *Kleinasiatische Denkmäler*, as above.

[3] *Königliche Museen zu Berlin* ; Th. Wiegand, *Milet: Ergebnisse der Ausgrabungen und Untersuchungen*, &c., iii, Heft 1, *Der Latmos*, Berlin, 1913 ; Wulff, *Altchr. und byz. Kunst*, pp. 584, 587 ; Millet, *Iconographie de l'Évangile*, Index, s. v. *Latmos*, p. 722.

[4] *Byz. Zeitschr.*, xxiii, 1914, p. 336.

tenth century; they include a Virgin and Child between the archangels Michael and Gabriel, and figures of saints.[1]

In Armenia native feeling seems to have been opposed to pictures, and mural painting was introduced through Syrian and Greek (Byzantine) influence. Early frescoes survive in the apse of the cathedral of Thalish,[2] where there is a standing figure of Christ with apostles, and in the apse at Tekor,[3] where angels are seen with the ark of the covenant. At Ani mural paintings are more definitely in a Byzantine style. The Church of the Redeemer has in the main apse Our Lord enthroned between archangels and cherubim above the twelve apostles, and in the other apses the Pentecost, with the Nativity and Crucifixion, the Last Supper and the Anastasis; the church of S. Gregory, built by Prince Honentz in the thirteenth century, has a whole liturgical cycle of Byzantine or Georgian inspiration. At Thalin there are representations of the apocalyptic throne, and of the apostles. Akthamar has a whole New Testament cycle, Syrian in style.

The Armenian influence which was prominent in the Byzantine arts after iconoclasm was not confined to the capital; after the capture of the national capital by the Turks in the tenth century, Armenian craftsmen were scattered through the East Christian world. It is thus that we find painters of Armenian origin at work in Egypt in the eleventh century. The White monastery near Sohag[4] has in the central apse Our Lord enthroned in a mandorla (the head destroyed) between the Four Evangelists, with an Armenian inscription dated by Dashian A.D. 1073; the paintings in both the White and Red monasteries have undergone restoration at different times. In the southern apse the Virgin and S. John stand on either side of a draped cross in a mandorla supported by angels. Armenians may have worked in the Red monastery as well as in the White. Frescoes at Esneh also suggest Armenian influence, as do others in the monastery of S. Simeon at Aswân.

Syria-Palestine is poor in early mural painting,[5] if we except the secular decoration of the eighth-century palace of Quseir 'Amra on the desert border to the east (see below), and that of a third-century sepulchral chamber at Palmyra,[6] too early to come directly within our scope. The first is purely secular and executed for a Mohammedan prince; the second is also non-Christian, but figures holding above their heads medallions containing portraits recall similar forms in later East Christian art upon composite diptychs. In North-Central Syria little more than fragments of stucco with

[1] D. Chaviaras in *Vizantieskie Vremennik*, xv, 1908, p. 444; noticed in *American Journal of Arch.*, xviii, 1914, p. 538.

[2] Strzygowski, *Baukunst*, p. 192.

[3] *Ibid.*, p. 298.

[4] Vladimir de Bock, *Matériaux pour servir*, &c., p. 58 and pl. xxi; Strzygowski, *Baukunst*, p. 731.

[5] The contrast with Egypt and Italy is striking. But as the Holy Land was rich in mosaics from the time of Constantine, the absence of monuments illustrating contemporary mural painting can only be due to chance.

[6] Described by Strzygowski in *Orient oder Rom*, 1901.

such symbolism as crosses, and sacred monograms with vine foliage, water-birds, &c., has been discovered.[1] A painting with the Annunciation, perhaps of the sixth century, is recorded as far south as Esbeita.[2] In the Church of the Holy Cross at Jerusalem seventeenth-century frescoes appear to be based upon much earlier models ; four fragments with heads from this church seem to belong to a much earlier series.[3] The rarity of frescoes of the pre-iconoclastic period is not compensated by any great increase for later periods. In the cells hewn in the rocky face of Mt. Quarantania near Jericho are paintings with the Annunciation, and figures of Our Lord and Saints.[4] Restored paintings in the church of Abu Rôsh are stated to belong to the period of the Frankish occupation, though the painters were probably Greek, and the *Anastasis* and *Deesis* are among the subjects. The figures on the columns of the church of the Nativity at Bethlehem are in the same case ; here also the types are Byzantine. The church of the monastery of Mâr Sâba has wall paintings mostly as late as the fifteenth or even sixteenth century, but some may have originally been done as early as the fourteenth.[5]

A large series of mural paintings is found in the rock-cut oratories and chapels in Calabria and Otranto,[6] which parts of South Italy were long associated with the Byzantine Empire, and were inhabited by settlements of Basilian monks to whom the work is mostly to be ascribed (p. 61). The earliest paintings are of the tenth century, and these are Byzantine ; for the most part they represent a rude monastic art. A freer style appears in the twelfth century, richly developed in the two succeeding centuries. In these periods both Greek and Latin inscriptions accompany subjects, which usually retain Byzantine types, though in some cases we see the influence of contemporary Tuscan art. Paintings in the crypt of S. Maria delle Grazie at Carpignano north-east of Otranto are of great interest because two of them are accompanied by dates: an enthroned Christ, purely Byzantine, has an inscription giving the year A.D. 959, another representation of the same subject is dated A.D. 1020 ; other subjects in the Byzantine tradition are later. In the south-east of Sicily there are also paintings.[7]

In the neighbourhood of Brindisi[8] are various wall-paintings, Byzantine, or in the Byzantine manner of the twelfth to fourteenth centuries ; the Terra d'Otranto is rich in frescoes, among which those in the apse of the chapel of S. Stefano at Soleto are especially worthy of notice, while

[1] H. C. Butler, *Architecture and other arts*, p. 293 (Princeton University Expedition, 1899).

[2] Esbeita is a ruined site in the Sinai peninsula. C. L. Woolley and T. E. Lawrence, *Annual of the Palestine Exploration Fund*, i, 1914–1915, p. 89.

[3] *B. A. and A.*, p. 276 ; *Byz. Zeitschr.*, xxi, 1913, p. 488.

[4] H. B. Tristram, *The Land of Israel*, p. 209.

[5] *B. A. and A.*, p. 277 ; A. Baumstark, *Oriens Christ.*, 1920, p. 123. Cf. *Römische Quartalschrift*, 1920, p. 82.

[6] *B. A. and A.*, p. 309 ; the chief reference is C. Diehl, *L'art byz. dans l'Italie mérid.*, 1844. Cf. Wulff, *Altchr. und byz. Kunst*, p. 584.

[7] P. Orsi, in *Studien zur Kunst des Ostens* (Strzygowski, *Festschrift*), 1923, pp. 112 ff.

[8] *B. A. and A.*, p. 309.

the church has a systematic scheme of decoration, with the Last Judgement on the west wall.

The rock-cut chapels cut in the *gravine*, or limestone valleys, between the mountains and the sea in the Tarentine district have many paintings, chiefly of the thirteenth and fourteenth centuries, though those in the chapel of the Holy Eremites in the *gravina* of Palaggianello appear to be as early as the twelfth century; in some cases older work is covered by later.

In Campania[1] the Byzantine influence in mural paintings seems to have more often emanated from the orientalized Rome of the eighth and ninth centuries than from Monte Cassino; the work in the Grotta dei Santi, the Grotta delle Formelle, in the chapel on Montorso and other places seems to be earlier than the twelfth century. In the frescoes of the much-discussed church of S. Angelo in Formis[2] Byzantine influence is apparent in the conception and treatment of many subjects, while others betray some Western inspiration: both Greek and Italian painters may have been employed.

Some Byzantine influence is visible in mural paintings in South Germany, where the illumination of miniatures was also affected by Byzantine ideals.

Russia has preserved purer examples of Middle Byzantine mural painting than either Cappadocia or Southern Italy. The most important are the frescoes in the cathedral of Kieff,[3] which in spite of various disasters, not the least of which was the drastic restoration of 1843–8, have retained the forms of the originals produced in the first half of the eleventh century. The condition of the work in the chapel of S. Michael, which by imperial command was untouched by the restorer, seems to show that the decoration of the cathedral as a whole must have been in a bad state, for many of the figures are much damaged: in the apse is an archangel with outspread wings; on the roof are remains of scenes in which the angel appears to Joshua, Balaam, and Zachariah. In other parts of the church are Old and New Testament scenes, martyrdoms and figures of saints. For the frescoes on the stairs see p. 262. The monastery of S. Cyril at Kiew has later mural paintings dating from the last quarter of the twelfth century, also in the Byzantine tradition. Down to the Mongolian invasion of the thirteenth century mural painting in Russia remained faithful to Byzantine traditions and the artists may have been largely Greek. The paintings of the church of S. George at Old Ladoga are of the first half of the twelfth century. Like those of the Miroisky Monastery at Pskoff (A.D. 1156), they appear to be purely Byzantine; the same is true of others dating from the end of the same century at Vladimir and at Nereditsi, New Ladoga in the district of Novgorod (A.D. 1199).[4] After the invasion the Macedonian school of

[1] *B. A. and A.*, p. 315.

[2] *Ibid.*, p. 316; Wulff, *as above*, p. 585; he cites the frescoes of the portal and the narthex as most purely Greek in style.

[3] *B. A. and A.*, p. 300; Wulff, *as above*, p. 585.

[4] N. Pokrovsky, *Trudy* of the Sixth Arch. Congress at Moscow, 1890, vol. i.

Serbia extended its influence into Russia, where it is seen in the church of S. Theodore Stratelates (c. A. D. 1370) at Novgorod, at Volotovo (c. A. D. 1363), and at Kovaleff (c. A. D. 1380). The 'Cretan' school displaced the Macedonian in Russia about the beginning of the fifteenth century, if the frescoes in the cathedral of Uspenski, at Vladimir, date, as Russian authorities believe, from A. D. 1408; here the style of the Peribleptos at Mistra is reproduced.[1] A similar style appears in the Church of the Trinity at Novgorod.

At Constantinople, Salonika, and Trebizond, as in Greece and the Balkans, the mural painting which survives dates almost entirely from the period of the Restoration after the end of the Latin interregnum in 1261; it therefore shows the effect of the new influences which at this period modified Byzantine art. But we may perhaps assume that at Nicaea and in Epirus mural painting continued throughout the thirteenth century without interruption unaffected by the Western invasion.

The paintings in the lateral gallery at Kahrieh Jami,[2] though in bad condition, preserve the remains of two cycles, dealing respectively with the Lives of the Virgin and of Our Lord. The style resembles that of the mosaics in the same church and the work should therefore belong to the early fourteenth century; four intrusive portrait figures date from the end of the century, or from the beginning of the fifteenth.

In S. Demetrius at Salonika, after the fire of 1917, frescoes were revealed on the aisle walls representing S. Demetrius mounted, with warriors, the Virgin, and a saint; to the same cause was due the discovery of a series dated 1303 in the small chapel to right of the apse; frescoes representing episodes of the martyrdom of S. Demetrius had been discovered in 1907, but were afterwards covered with whitewash.[3]

Paintings in the narthex of S. Sophia represent Moses receiving the Tables of the Law, the Three Children, and other subjects on a blue ground; on the east wall are busts in medallions, and in the gallery saints also on a blue ground.[4] There are also traces in this church of a Communion of the Apostles, below which are two rows of saints.[5] These paintings may belong to the thirteenth or fourteenth century.

Kazanjilar Jami, built in A. D. 1018, was formerly covered with paintings, of which some remain: on the pier to right after entering (Presentation in the Temple, Adoration of Magi), on the lower part of the arch of the main apse (saints), on the left pier of the narthex (Baptism), and on the right pier the Almighty enthroned and part of a Last Judgement: the oldest of these

[1] Millet, *Iconographie de l'Évangile*, p. 683. These Middle Byzantine churches in Russia follow the general liturgical scheme of decoration usual from the eleventh century. At Nereditsi, the Last Judgement on the west wall is cited as even richer in detail than that in mosaic at Torcello.

[2] *B. A. and A.*, p. 289; Wulff, *as above*, p. 588.

[3] Diehl and Letourneau, p. 113.

[4] Smirnoff, *Vizantieskie Vremennik*, v, p. 369.

[5] Diehl and Le Tourneau, p. 136.

frescoes may possibly go back to the thirteenth century, but some are about
A.D. 1400.[1]

The Church of the Holy Apostles was once covered with paintings, but
these were concealed by whitewash until recent times. In Chauch Monastir,
probably the Church of the Transfiguration, which itself dates from the
fourteenth century, are frescoes of the century following, including a bust
of Our Lord in the dome, the Evangelists in the pendentives, the Virgin
orans in the apse, &c.[2] The chapel of S. Nicholas has within saints and
scenes from the life of S. Nicholas and a Dormition of the Virgin ; on the
exterior are scenes from the infancy of Our Lord, and miracles : the date
would appear to be fourteenth or fifteenth century.[3]

A number of churches in Greece [4] have remains of mural painting of
the later Byzantine period, but in many cases frescoes are concealed by
whitewash ; the decoration of other churches like that of Kaisariani in
Attica dates from after the fall of the Empire. In other cases again, as in
that of the paintings in the dome of the Megalē Panagia and of the Church
of the Redeemer at Athens, subjects preserved until comparatively recent
times have since been destroyed.

In a few cases the work appears to go back to about the tenth century.
At Athens figures of Our Lord, the Virgin, and saints, in a fine style, perhaps
of the late tenth or early eleventh century, are painted in red outline with
slight shading directly upon the marble of the *opisthodomos* of the Parthenon,[5]
which from the seventh century was used as a Christian place of worship.
The figures are now imperfect. Interesting paintings with the Agony in
the Garden and the Betrayal are in S. Michael's, not far from the Megalē
Panagia.

The dome of the greater church of S. Luke of Stiris in Phocis has
paintings which replace lost mosaics and are therefore late ; others perhaps
of earlier date in the crypt are covered by more recent work : the smaller
church of the Theotokos has frescoes beneath the whitewash on its walls.[6]

Some of the churches in Western Mani in the Morea examined by
Traquair [7] have frescoes of the later periods, as the Hagios Taxiarches at
Karuda, where full-length figures of prophets and saints are continued
round the whole church ; above them the walls and vaults are covered with
martyrdoms and scenes from the life of Our Lord. In the apse the Virgin
with the Child is seen above the Divine Liturgy, while Christ in Glory is
seen in the vault above the altar : Traquair states that this scheme is typical
of the Maniote churches. The church of the Dekoulos monastery at Itylo
has complete mural decoration, with the Last Judgement at the west end,

[1] Diehl and Le Tourneau, p. 161.
[2] *Ibid.*, p. 217.
[3] *Ibid.*, p. 218.
[4] A vast amount of material in the Greek churches still awaits publication.

[5] *B. A. and A.*, p. 292 ; Wulff, *as above*, p. 582.
[6] Schultz and Barnsley, *The Church of S. Luke of Stiris in Phocis.*
[7] *Annual of British School at Athens*, xv, 1908–9, pp. 189 ff.

but these frescoes, though completely Byzantine in tradition, are too late for more than a casual mention. For the last two centuries of the Empire, the churches at Mistra in the Morea provide the richest material.[1] Some of the paintings in the cathedral (1310) follow a good old tradition, and are conservative in tendency; others are more picturesque, with backgrounds enriched by conventional architecture and detail, a style also represented in the church of the Brontocheion; this picturesque style may perhaps be brought into connexion with that of the Macedonian school (p. 237). The work of a third school, characterized by elegance and a minuteness which is almost that of illumination, is best represented in the Peribleptos. This church, dating from about A.D. 1365, appears to exemplify the work of the ' Cretan ' school (p. 238), which soon afterwards displaced the Macedonian in the Slav countries, and about a hundred years later on Mount Athos. In the Pantanassa (A.D. 1430) the treatment is again picturesque.

Churches at Geraki in the Morea also possess important fourteenth-century frescoes,[2] as do those in the monasteries of Meteora, north of Trikala in North Greece (Thessaly).[3]

The islands have probably much interesting work on the walls of their churches, though it may well be that much of it lies concealed beneath whitewash.

At Trebizond[4] (p. 30) the early church of S. Anne, restored by Basil the Macedonian, has mural paintings of saints, a Death of Joachim and Anna, and portraits of ecclesiastics; on the west wall of S. Eugenius, restored between A.D. 1340 and 1350, are traces of royal personages. Paintings outside the apses of the above two churches, formerly observed by Fallmerayer, are now almost vanished or covered over; while modern work has concealed the portraits of Alexius III, his queen Theodora, and his mother Irene, on the narthex wall of the Panaghia Theoskepastos. The paintings in the rock-hewn chapel of S. Onuphrios, now the Theoskepastos, executed in A.D. 1411, are better preserved.

The mural decoration of churches in Macedonia and Serbia[5] may be ascribed to three periods. The first, in Macedonia, is the work of Byzantine artists of the Comnenian period. The second comprises the work executed from the close of the thirteenth century to the extinction of the free kingdom at Kossovo in 1389; it thus includes all the churches of the fourteenth century decorated under Miliutin and Dushan, and may be ascribed entirely

[1] G. Millet, *Monuments byzantins de Mistra* (Album, 1910); and *Iconographie de l'Évangile*, Index, s. v. *Mistra*, p. 723.

[2] Millet, *Iconographie*, Index, p. 721, s. v. *Géraki*. Photos by M. N. Poulitsas of Sparta. The painter of Geraki reproduces compositions from the mosaics of S. Luke of Stiris in Phocis (Millet, p. 671).

[3] Millet, *as above*, Index, p. 722, s. v. *Météores*.

[4] G. Millet, *Bull. de Corr. Hell.*, xix, 1895, pp. 419 ff., and *Iconographie de l'Évangile*, Index, p. 727, s. v. *Trébizonde*.

[5] *B. A. and A.*, pp. 296 ff., for earlier references. Add G. Millet, *Iconographie de l'Évangile*, pp. 631 ff., for references to individual churches. Index, pp. 722 and 726, s. vv. *Macédoine* and *Serbie*.

to the Macedonian school (p. 237). The work of the third period, exemplified by the decoration of the churches built by the Despots (p. 52) in the last years of the fourteenth century and the first half of the fifteenth, belongs to the 'Cretan' school (p. 238). It has been noticed above that in both schools an Italian influence is perceptible, but that in neither case does it affect the fundamentally East Christian character of the style and the iconography.

Among the earliest church paintings in Macedonia are some of those in the monastery church of Jerez near Skopliye (Uskub), which are ascribed to the twelfth century; to the same period are assigned representations of Our Lord, the Virgin, the *Hetoimasia*, and various saints and martyrs in the church of Treskavech not far from Prilep, which also has full-length pictures of Miliutin and his consort Simonida, dating from the fourteenth century. At S. Clement, Ochrida, are late fourteenth-century Gospel scenes; in the dome of the church of S. John at the same place are Our Lord with angels and prophets; other frescoes are overlaid with whitewash. Other late fourteenth-century paintings are in the church of Zaum on Lake of Ochrida. Some of the work in the church of Mali Grad, to the south-west of Lake Prespa, may be of the fourteenth century, but most appears to be later. Frescoes at Boria in the same region were executed perhaps about A.D. 1409. To about the same time belongs the decoration of the monastery church of the Archangels near Prilep, and of the church at Matka. The paintings of S. Peter's at Prespa are ascribed to the early fifteenth century.

A Crucifixion and Last Judgement in the earlier church at Studenitza in Serbia appear to be of the thirteenth century. Those in the church of Zicha, with the Bearing of the Cross, and the Forty Martyrs, are of fine quality and the same period.

The fourteenth-century decoration at Liubiten, a church looking down on Skopliye from the hills, has suffered through damage to the roof: it includes a Communion of the Apostles, and Miracles of Our Lord, with portraits of the great King Dushan, his consort Helena, and his son, on the north wall. Kondakoff observed in the frescoes of this church a tendency to naturalistic treatment, which we find fully manifested in the royal church at Studenitza; here we mark the picturesque manner of certain frescoes in the monastery of Vatopedi on Mount Athos, and in the mosaics of Kahrieh Jami.

The cathedral at Nagoricha (first quarter of the fourteenth century) has mural paintings of great merit, considered by Kondakoff contemporary with the structure; the five domes and walls are all decorated, the subjects including the Last Supper, Death of the Virgin, and Last Judgement. The decoration as a whole is admirable in effect, and a careful study reveals many points of interest in relation to the various sources from which the style and subject-matter of the Macedonian school are derived. We find iconographic details transmitted through a manuscript variant of the

Constantinople-Alexandria Gospel cycle, which in their abundance recall the descriptions of the mosaics in the Church of the Holy Apostles ; we have legends both in Greek and Serbian ; we have a manner which Millet describes as ' penetrated by the grace of Siena ', and in certain details an influence which may be that of Duccio himself.

In Miliutin's church at Grachanitza (before A. D. 1321–1322) the decoration was much damaged during the period of Turkish occupation. Kondakoff has described it as representative of the best later Byzantine style, and the Gospel cycle which it follows is that of Constantinople-Alexandria as represented by MS. VI. 23 in the Laurentian Library at Florence. At Mateitza near Kumanovo, founded by Dushan, the paintings have suffered much from dilapidation of the roof. The Gospel cycle followed is that of Antioch, represented by the Paris MS. gr. 74. Other conspicuous subjects are also the Communion of the Apostles and the Death of the Virgin ; and there are also Serbian royal portraits. At Gradatz, and in the older church at Studenitza, oriental (Cappadocian) iconographical details are conspicuous, and the Eastern use of the continuous frieze is freely adopted. But analogies have been remarked both with the paintings in the Brontocheion at Mistra, and with the mosaics of Kahrieh Jami at Constantinople ; the work belongs to the Macedonian school.

The late churches erected by the despots Lazar and his successors— Ravanitza, Manassiya, Kalenik and Liubostinya—have paintings chiefly of the fifteenth century and in the ' Cretan ' style.

The church of Boiana, about five miles south-west of Sofia in Bulgaria, has a series of mural paintings ascribed to the year 1259, under which are remains of earlier work ascribed to the eleventh century. The paintings of 1259 include Christ among the Doctors, the Last Supper, Crucifixion and *Anastasis*, Christ enthroned, the Death of the Virgin, Constantine and Helen, various saints, and the two interesting pairs of full-length portraits described below (p. 263),[1] those of the nobleman who enlarged and redecorated the church, and his wife, and of a king and queen. The religious paintings are of no small merit.

Of the paintings of the fourteenth century in the church of S. Peter and S. Paul at Tirnovo only a few remain, the building and its decoration having both suffered severely through the earthquake of 1913. A good *Deesis* covers the south wall ; there are full-length figures of saints, a Death of the Virgin, and, in the narthex, a whole series of Oecumenical Councils. The legends accompanying these paintings are in Bulgarian, and it is claimed that the artists were of that nation.[2]

The existing mural paintings in the monasteries upon Mount Athos [3]

[1] B. Filow, *Early Bulgarian Art*, pp. 26–8, pl. 12–14; N. A. Bees, *Studien zur Kunst des Ostens* (Strzyg., *Festschrift*), 1923, pp. 104 ff. Cf. also Filow in *Arch. Anz.*, xxix, 1914, p. 429.

[2] *Ibid.*, pp. 27, 28 ; pls. 15, 52–4.
[3] G. Millet, *Iconographie de l'Évangile*, pp. 659, 660 ; and Index, p. 716. For earlier references, see *B. A. and A.*, p. 302.

do not strictly fall within the limits assigned to this book. The fifteenth-century work of the Macedonian school of which we have record, like that in the old Catholicon of S. Paul (A. D. 1447), has perished with all of earlier date; the date of 1423 formerly given to the paintings in the chapel of S. George in the same monastery is no longer regarded as certain; this work seems to belong to the sixteenth century. Both the Macedonian and Cretan schools took part in the decoration of the monastery churches; but whereas the work of the Macedonians has almost entirely perished, dating as it chiefly did from the fourteenth and fifteenth centuries, that of the Cretans can be studied in numerous frescoes of the sixteenth century and later. In the first half of the sixteenth the two schools overlapped. Panselinos, of Salonika, last of the Macedonians, decorated the Protaton about A. D. 1540, and a church of Rossikon (no longer existing) A. D. 1554; the earliest work (A. D. 1571) in the Serbian monastery of Chilandari, now only visible in part beneath later painting, has been claimed for him, but at this date he would have been a very old man. Macedonian work similar to that at Chilandari, in the narthex of Vatopedi, repainted in 1789 and 1819, appears to have been carefully reproduced, since analogies can be traced between motives here and others in Miliutin's church at Studenitza in Serbia, at Mateitza, Castoria, and Churcher, as well as in the mosaics of Kahrieh Jami and in other works with typical motives of the fourteenth century. The existing work of the Cretans begins with the paintings in the Catholicon of Lavra (A. D. 1539) by the monk Theophanes, who was not, as once supposed, a pupil of Panselinos, but a master representing a rival school: Cretans are mentioned in documents as having worked at Meteora as early as A. D. 1527. To this school most of the existing earlier frescoes belong, e. g. Stavronikita (1546), Dionysiu (1547), Meteora (1552), Dochiaru (1568), Kalabaka (1573), and the above-mentioned chapel of S. George in S. Paul, of which the date is not precisely known, but the affinities of which are with the paintings in the Catholicon of Lavra.

It is important to state the main facts with regard to the mural paintings on Mount Athos, even though they are beyond our period, both because exaggerated statements as to their great age are still current, and because from the two standpoints of style and iconography they are closely connected with East Christian work of properly Byzantine times.

Mural Painting: Secular

Pagan hunting-scenes and beast and plant ornament were carried over into Christian art. Such work, equally popular in mosaic, is illustrated by good examples in Egypt. Thus in one of the funerary chapels at Bawît [1] we see a gazelle-hunt, in another a hunt after the hippopotamus; others show a child riding a panther, Orpheus, a Sibyl; baskets of fruit, birds,

[1] *B. A. and A.*, p. 285.

and other motives familiar on early mosaics fill the interspaces. In these designs, of which the art betrays a graceful naturalism, we may trace the Hellenistic influence of Alexandria.

In the remarkably preserved frescoes of the desert palace of Quseir 'Amra,[1] on the edge of the Syrian desert to the east of Palestine, about the latitude of the Jordan mouth, we have an example of secular art on a larger scale, with genre and other scenes illustrating in some ways the kind of art which survived for the decoration of palaces in Constantinople and other Hellenistic cities, but with an admixture of oriental elements. The work was done in the eighth century for a Mohammedan prince of the unorthodox Ummayad line, which freely patronized the art of subject peoples. The painters must have been Greeks in contact with Persian artistic tradition, but perhaps including Persians among their number. It is uncertain to what place they belonged; they may have come from Damascus, or from Seleucia, where, as we have seen, Hellenistic influence long survived.

Quseir 'Amra consists of a large hall with triple barrel vault running north and south, with a central niche and two lateral apsed chambers at the south end. A series of three chambers opens out of the east wall, the third covered by a dome. These chambers formed the bath-house; the great hall was for audience and reception, the lateral apsed rooms for the prince's private use. The whole was designed for the *villeggiatura* of a prince whose permanent home was in Damascus. The hall and all the smaller rooms are painted both on walls and vaults, the surfaces being covered by plaster to which the paint is said by Musil to have been applied while it was fresh, so that the designs may be in true fresco. The scale of colours, as we now see it, is composed of bright blue, dark and pale brown, yellow, and green. The artists modelled in tone, followed the rules of perspective, and worked in the spirit of a picturesque naturalism.

On the west wall of the hall are bathers exercising after the bath. A female figure stands on the edge of a bath in an octagonal building with an upper gallery, from which other women look on, a centralized structure, probably domed. At the opposite end of the wall is a ceremonial scene in another manner, suggestive of Sassanian influence. Six figures with partly effaced names in Greek stand in a frontal attitude, the first four representing the vanquished opponents of Islam—the Byzantine Emperor (KAICAP), the Visigoth Roderic, Yezdegerd of Persia, and the Negus of Abyssinia—after whom come a woman and a boy. Round the composition is a double border of rosettes in circles somewhat recalling those of the ivory caskets (p. 213). On the walls to south and north are a richly-dressed female figure under a canopy, and a woman standing near a ship, by which are sea

[1] *B. A. and A.*, pp. 278 ff. The chief publication is that by A. Musil, with water-colour drawings by Mielich. Quseir 'Amra would have been included in a book on the desert castles for which Savignac and Jaussen had prepared materials (G. Migeon, *Revue Biblique*, 1914, pp. 392 ff.; with illustrations).

monsters. On the east wall hunters are seen pursuing antelopes ; on the north wall antelopes are caught in nets. The south wall shows the dispatch of the game ; above are allegorical figures of History, Poetry, and Philosophy. The barrel vaults of the hall are covered with scenes of men occupied with building and other crafts under double rows of arcades surmounted by birds. The spandrels of the great arches are filled by other figures ; the lower part of the walls is painted to represent hangings, a mode of decoration popular for many centuries and found in the art both of East and West. On the roof of the *caldarium*, or first bathroom opening out of the hall, are figures of men, animals, and birds, including a monkey playing a stringed instrument, a bear, and wild asses, all in the compartments of a lozenge diaper ; this part of the decoration is oriental in design. The central row, however, has busts representing three ages of man ; and in two lunettes are two scenes apparently emblematic of life and death, very Hellenistic in conception, the latter representing a man looking down on a recumbent figure while a winged Eros stands near with extended right hand. In the next room, the *tepidarium*, are three lunettes painted with women and children bathing, with a green field and blue water visible through the architecture, again very Greek in feeling. Vine-scrolls with men and beasts in the convolutions ornament the window. The dome of the third room is painted with the northern stars (the Bears, Erichthonios, Boötes, Ophiuchos, Cassiopeia, &c.) and with the zodiacal signs.

The return to the old pagan scenes of the chase and of amusement, which had formed a feature of church decoration during the iconoclastic period, was soon superseded in general practice. But it probably lingered on in the less conspicuous parts of the sacred building, as did scenes connected with Court life. Examples of the latter are preserved on the walls of the staircase leading to the galleries in the cathedral of S. Sophia at Kieff ;[1] they are representations of performances in the Hippodrome at Constantinople in the presence of the Emperor and Empress, who, with their attendants and guards, are seen in the *Kathisma*. The charioteers are visible behind the barriers ready to start the race, and acrobats, musicians, and dancers display their skill. There are, further, combats between men and beasts, or between pairs of men, one of whom wears an animal mask on his head ; the presence of trees suggests that some of these scenes depict hunting in the open country, and the inclusion of the panther among the beasts suggests that the artist was not a Russian. Another episode shows men carrying a boar's head and fore-quarter as a gift. Elsewhere are remains of monsters, including winged lions and gryphons, or birds, hawks, falcons.

It has been noted above that mural paintings in several of the churches in Serbia and Bulgaria include interesting portraits of rulers or notables and their wives. At Treskavech, near Prilep in Macedonia, we see Miliutin (A. D. 1282–1321) with (probably) Simonida his second queen, daughter of

[1] *B. A. and A.*, p. 300. Add Wulff, *Altchr. und byz. Kunst*, p. 580.

Andronicus II ; the same pair is seen at Grachanitza on the piers of the central dome, and once again at Nagoritza. At Liubiten, near Skopliye, the great Tsar Dushan is depicted, with his consort Helena and his son.[1] At S. George, Novi Bazar, are portraits of Dragutin and other royal persons of the late thirteenth century.

At Boiana in Bulgaria the Tsar Constantine Assen and his Byzantine queen Irene are represented at full length ; the painting, which dates from A.D. 1259, has much character. In the same church are other interesting portraits, those of a nobleman Kaloian and his wife Dessislava, to whose generosity the enlargement and decoration of the church was due.[2] At Mistra there is a remarkable portrait of Theodore I Palaeologus, Despot of Mistra (d. 1407).[3] In Crete there is a whole series of interesting portraits of the fourteenth century and later.[4]

As might be expected in a branch of art which calls for imitation more than others, portraiture is chiefly executed by painters working in the Hellenistic tradition and skilled in modelling in tone. It has been remarked that these portraits may have been the work of special portrait-painters who in sympathy and tradition belonged rather to the secular schools of Hellenistic art than to the monastic schools which usually decorated churches.

Panel painting. The two technical methods employed in the painting of panels on wood,[5] encaustic and tempera, have been already mentioned (p. 246), and the fact has been noted that the former, an early process which did not survive into middle Byzantine times, developed from the Graeco-Roman portraiture illustrated by the mummy portraits of the Fayûm in Egypt. Christian ikons probably began as representations of sacred persons, martyrs and saints, but scenes were depicted at least as early as the sixth century. Though the process by which gilded glasses (p. 347) were decorated is rather etching or engraving than painting, they should be remembered in the present place ; the medallion mounted on a cross at Brescia, with a mother between two children, is of great interest as carrying on the same portrait tradition in another medium.[6]

The chief examples of encaustic painting on panel are to be found in the Theological Academy at Kieff ;[7] the subjects are the Virgin and Child and S. Pantaleemon in half-figure, busts of S. Sergius and S. Bacchus on the same panel, and a whole-length S. John the Baptist. The first-mentioned subject is thought perhaps to date from the sixth century, the rest not to be earlier than the seventh. These panels were obtained in the monastery

[1] Petković, in Strzygowski, *Festschrift*, 1923, p. 159.
[2] B. Filow, *Early Bulgarian Art*, pp. 26, 27, and pls. 50, 51, and *Arch. Anzeiger*, 1914, p. 429 ; N. Bees, in Strzygowski, *Festschrift*, pp. 104 ff.
[3] G. Millet, *Rev. de l'art chrétien*, November–December 1911 ; *Portraits byzantins*.
[4] G. Gerola, *Monumenti veneti nell' isola di Creta*, Venice, 1905.
[5] A rare example of painting on ivory (the diptych at Brescia) is mentioned below.
[6] Doubts have often been expressed as to the authenticity of this medallion, but opinion has changed in its favour (Wulff, *Altchr. und byz. Kunst*, p. 307).
[7] *B. A. and A.*, p. 316 ; Wulff, *Altchr. und byz. Kunst*, p. 308.

of S. Catherine on Mount Sinai. Other examples, some of rather earlier
date, are in the Kaiser Friedrich Museum, Berlin.[1]

Among the earliest panels in tempera is one in the Golenisheff collection
at Petrograd, with the Nativity and Baptism, perhaps of the sixth century.[2]
A small panel discovered in the ruins of a church at Wady Halfa in Lower
Nubia represents an apostle of about the same date,[3] to which also belongs
a panel at Berlin with the bust of a Coptic bishop.[4] Two Coptic book-
covers at Washington, with figures of the four Evangelists, are of the early
seventh century.[5]

Two very interesting early panels with scenes are preserved in Italy.
That discovered in the *arca* of Leo within the altar of the chapel of the
Sancta Sanctorum at the Lateran in 1905 [6] forms the lid of a wooden reliquary
and has a Crucifixion between the two Thieves of very early type, above and
below which are four smaller Gospel scenes. The style points to the sixth
century rather than to the later date sometimes assigned to it. In the
interior of the ivory diptych of the Consul Boethius in the Museum at
Brescia the Raising of Lazarus is seen at the top of one leaf ; and the half-
figures of SS. Augustine, Jerome, and Gregory the Great, probably dating
from the early seventh century.[7]

The lid of a box reliquary of the True Cross from the *Sancta Sanctorum*
at the Lateran has a Byzantine Crucifixion of the early tenth century.[8]
A tempera panel of the same date with a half-figure of S. Panteleemon
at Kieff, preserving the early Christian manner, is in the Museum of the
Theological Academy at Kieff.[9] Panel pictures of Our Lord and the Virgin
in Rome, Campagnano, and Tivoli are dated by Wilpert between the tenth
and thirteenth centuries.[10] A panel of the twelfth or thirteenth century at
Petrograd, with the Crucifixion, shows the Virgin fainting, and is thus
perhaps the earliest example of the *Svenimento* which appears soon after-
wards in Italian art.[11] A gilded panel in the British Museum (Plate XLV)
from one of the monasteries near the Natron Lakes in Egypt [12] dates

[1] Wulff, *Altchristliche Bildwerke* (Catalogue,
Kaiser Friedrich Museum, 1909), nos. 1604 ff.

[2] Wulff, *Altchr. und byz. Kunst*, p. 312.

[3] University of Pennsylvania; Eckley B. Coxe
Exped.; *Churches in Lower Nubia*, frontispiece.

[4] Wulff, *Altchr. und byz. Kunst*, fig. 288.

[5] C. R. Morey, *East Christian Paintings in
the Freer Collection*, 1914, p. 63.

[6] P. Lauer in *Monuments Piot*, xv, pl. xiv,
fig. 2 ; Wulff, *Altchr. und byz. Kunst*, fig. 290.

[7] A. Muñoz, *Nuovo Bull. di Arch. Crist.*, xiii,
1907, pp. 5 ff. ; H. Leclercq in Cabrol, *Dict.
d'arch. chrét.*, s.v. Brescia, fig. 1623 and
col. 1147 ; Wulff, *as above*, p. 309.

[8] Lauer, *as above*, pl. xiv, fig. 1 ; H. Grisar,
*Die römische Kapelle 'Sancta Sanctorum' und
ihr Schatz*, Freiburg, 1908, p. 113, fig. 57 ;

Wulff, *as above*, p. 512.

[9] N. Petroff, Album of . . . the . . . Museum
of the Theological Academy at Kieff, 1912 ;
Petroff's illustration is reproduced by Wulff, *as
above*, pl. xxvii, fig. 1.

[10] *Die römischen Mosaïken und Malereien, &c.*,
1916, plates 226, 244, 260, 263, 271–2, 273–4.
The older panel on linen, representing the Re-
deemer, from the *Sancta Sanctorum*, Wilpert
ascribes to the hundred years between 450 and
550, assigning it a Roman origin (*Römische
Quartalschrift*, xxi, pp. 65 ff.). Others regard
it as East Christian.

[11] V. de Grüneisen, in *Rassegna d'Arte*, 1904,
p. 138 ; Wulff, *as above*, p. 514.

[12] Probably Deir es-Suryâni. *B. A. and A.*,
fig. 155 ; Millet, *Iconographie*, p. 299.

from the close of the thirteenth or early fourteenth century; it has four subjects: the Annunciation, Nativity, Baptism, and Transfiguration. The class of portable mosaics[1] must be considered in close connexion with ikons of the middle Byzantine period, since they only differ from them by their technique. They are in fact small pictures formed of minute cubes of glass, stone, gold, &c., fixed in a wax base applied to a wooden panel. About thirty examples are now preserved, among the best known being the pair in the Museum of S. Maria del Fiore at Florence, with the Twelve Feasts of the Church. There are several in the monasteries on Mount Athos, and in Russia, and two on Mount Sinai; while examples are to be seen in the Louvre, in the Vatican Library, in the Kaiser Friedrich Museum at Berlin, and in the Victoria and Albert Museum at South Kensington. The London example (Plate XLVI) is a fine specimen, with the Annunciation, the ground being formed of gold tesserae. A number of such miniature mosaics are mentioned in inventories and records as once existing in the collections of Popes and European princes.

The series of panels ornamenting the iconostasis in the church of S. Clement at Ochrida in Macedonia are assigned by Kondakoff to the thirteenth and fourteenth centuries; the subjects are mostly busts of the Virgin characterized by rather prominent aquiline nose; the flesh tints are very dark: the subjects of these panels may perhaps rank among prototypes of later Italo-Byzantine paintings.[2] Other ikons of similar dates are in the monastery of Meteora, and of Trikala in Greece. The panel with the Virgin in S. Marco at Venice is held also to belong to the middle Byzantine period.[3] Likhacheff has pointed out the importance of representations of the Virgin and Child upon lead seals of the middle Byzantine period in relation to the later ikon types, his discussion of which, with the help of numerous illustrations, is of great interest.[4]

To the fifteenth century we may ascribe a number of interesting panels, in some of which the interpenetration of Greek and Italian motives is conspicuous. The portrait in S. Maria Novella at Florence of Joseph, Patriarch of Constantinople,[5] who attended the Council of A. D. 1438–1439 and died in Italy, is indeed little affected by Western art; the same may be said of the reliquary of Cardinal Bessarione, consecrated in 1463 at the Scuola della Carità at Venice, where the subjects are by the same Graeco-Venetian school whose work we find sixty years later at Lavra on Mount Athos.[6] But the collection of Commendatore Sterbini at Rome contains

[1] *B. A. and A.*, pp. 430 ff.; Wulff, *Altchr. und byz. Kunst*, p. 512. Add P. Orsi, Strzygowski *Festschrift*, 1923, p. 131.

[2] N. P. Kondakoff, *Macedonia*, pp. 248 ff. and pls. v–xii; Likhacheff, *Historical Significance of Italo-Greek Panel Pictures representing the Virgin*, 1911, p. 13 (in Russian).

[3] Ongania, *Basilica di S. Marco*, pl. xxii;

B. A. and A., p. 319.

[4] Likhacheff, *as above*, pp. 34, 43 ff.

[5] *B. A. and A.*, p. 319.

[6] Millet, *Iconographie de l'Évangile*, p. 668; Likhacheff, *Ist. Znachenie*, p. 13; *L'Arte*, xxv, 1922, p. 144, fig. 4. The reliquary has recently been restored to Italy by Austria and is now at Venice.

works which illustrate the transition from the Graeco-Italian to the Italo-Greek: to the latter category belongs a diptych with the Virgin and Child, the Crucifixion, and various saints, adhering closely to the Byzantine manner, but including the Florentine subject of S. Francis receiving the stigmata.[1] It may be observed that a panel in the Likhacheff collection, which the owner believes to date from the middle of the fourteenth century, was ordered by a Venetian, having relations with Crete, from a Venetian atelier which painted definitely Italian subjects such as S. Francis and S. Dominic.[2]

It is impossible to enumerate even the more important examples of panels painted by masters of the so-called Cretan school (p. 238), chiefly of the sixteenth and seventeenth centuries. Many examples are reproduced in the books by Likhacheff, Kondakoff, and others cited above,[3] for such panels found their way in numbers into Russia, influencing the work of local painters. A number are, or were, preserved in the Vatican, the Museum of the Theological Academy at Kieff, and the Alexander III Museum at Petrograd. Better known to travellers are a few examples in the more frequented galleries of Europe, such as that in the Uffizi at Florence.[3]

Mosaics

In mosaic decoration plane surfaces are covered by cubes or shaped flat pieces of stone, glass, or other material in different colours, combined in such a way as to form designs, and fixed by cement to a base of brick or stone. Though it may be used on a small scale upon portable objects (p. 265), it generally serves to adorn large surfaces, either horizontal, in which case it forms pavements, or vertical or curved, when it covers walls, vaults, and domes.[4] In Greek and Roman times pavement-mosaics were in general use earlier than mural mosaics. Since glass cubes, from their lighter weight, their wider range of colour, and their quality of reflecting light, were really essential for the adornment of walls, and were naturally of later invention than tesserae of marble, it is probable that this was the real order of development. Moreover, the decoration of the walls and vaults of large buildings such as churches involved wholesale manufacture of coloured and gilded tesserae, and it is doubtful whether the industry was established on the requisite scale before Hellenistic times; it was calculated by Texier that in the church of S. George at Salonika the decoration of the dome alone required thirty-six million tesserae. East Christian mosaics are mostly confined to tessellated work executed by means of cubes; but the variety known to the Romans as *opus sectile* is found in the marble linings decorating the lower parts of church walls.

[1] *B. A. and A.*, p. 322; Millet, *Iconogr. de l'Évangile*, pp. 95, 136, 227, 420. The diptych at Berne, executed in Venice for Andreas III of Hungary (1290–1301), is a still earlier example, but the painting is done upon vellum. In the Gospel-scenes represented we find iconographical motives some of which are remotely derived from Syro-Hellenistic art, while others have Latin affinities (Millet, p. 667).

[2] *Ist. Znachenie,* p. 30; Millet, *as above,* p. 665.

[3] *B. A. and A.*, fig. 194.

[4] For earliest mosaics see E. Müntz, *Bull. Soc. Ant. de Fr.*, 1891, 239 ff. (Pompeii, Catacombs, &c.).

In the earlier wall-mosaics, such as those of the nave in S. Maria Maggiore at Rome, the background tends to be white, perhaps a reminiscence of their lowly origin.[1] But Wilpert has observed that blue backgrounds occur at an early date in secular mosaic in the Roman province of Africa, while the fourth-century apses at the Lateran and the dome of S. Costanza had also blue grounds. If white came first, blue followed it very soon.[2] Nor was the appearance of gold delayed so long as some have supposed. The partial gold backgrounds in the nave of S. Maria Maggiore are in Wilpert's opinion original, and not later additions; on the triumphal arch it is used without reserve.

The tesserae used in wall mosaic were almost all of coloured or gilded glass; occasionally other substances, such as mother-of-pearl, were used to heighten the effect. The gold tesserae were made in the same way as the gilded glasses (p. 347); the body was of ordinary glass gilded on one surface, a thin film of clear glass being finally fused to the gilding to protect it. Silvered cubes, made in the same way, appear about the sixth century. Glass mosaic on vertical or curved surfaces appeared on a small scale in niches and on small columns in the first and second centuries. Traces of gilt cubes have been discovered in the baths of Caracalla, and the probability of their use in high vaults even at this time is increased by similar discoveries in the palace of Diocletian at Spalato; there seems no reason why extensive and elaborate decoration on walls and vaults should not have been carried out well before the Peace of the Church.[3] But the recognition of Christianity as a state-religion, with the introduction of churches with large interiors and change from a symbolic to a historical and dogmatic art, brought new and wide opportunities, of which we see an early result in the decoration of S. Costanza at Rome (p. 270). Mosaic art now became the rival, and soon a dominant rival, of painting with pigment; and the splendour of its effect made it the chosen method of adornment in all the greater and more sumptuous buildings, public and private, religious and secular, from the fourth century down to the time of the Fourth Crusade. After the thirteenth century it became uncommon; the Empire was impoverished, and so costly a system could only be adopted by exception. The more economic method of tempera painting, which had throughout coexisted with mosaic, now superseded it; the painted decoration of the Greek and Serbian churches is typical, the mosaics of Kahrieh Jami exceptional.

[1] The earlier pavement mosaics usually have a white ground. All mosaics are supposed to have begun as imitations in a more durable material of carpets and hangings; the region in which they originated was probably West Central or Western Asia—in Strzygowski's opinion, Iran, where such coverings were profusely employed. Cf. his *Christian Church Art*, p. 133.

[2] J. Wilpert, *Die römischen Mosaiken und Malereien*, &c., 1916, i, pp. 8 ff.

[3] Mosaic decoration in churches may have begun in apses, carrying on upon a larger scale the methods applied to niches. Strzygowski would regard the apse and its mosaic decoration as alike oriental, the apse being chosen to receive the richest ornament as the point to which the spectator's eye would naturally be directed.

With artificial light, well distributed, mosaic decoration has its own peculiar splendour. The East Christian church was illuminated by great numbers of lamps, the larger of which, in the form of crowns (*polycandela*), were suspended by long chains from the roof. Ancient writers have compared the innumerable flames to the stars, and there can be no doubt that in great churches the reflections from vaulted roofs and walls must have produced a wonderful effect, even in the vast shadows of such a building as S. Sophia. But the very shortcomings of the old illumination lent a mystery to the effect, lacking to the hard glare produced by modern methods. Mosaic is the decoration peculiarly appropriate to Eastern interiors, where constant and abundant light can be assured in any part of the building; in the West it often disappoints except in bright weather and in a clear atmosphere. It was a right instinct on the part of our medieval architects to make certain of the full effect by staining the glass through which the incoming light had to pass; by this means, even in the gloomy north, they ensured all the splendour which grey skies allow. The great stained windows are in a way the Western equivalent of mosaic; in the Sainte-Chapelle at Paris, where the stone-work is little more than a frame for the glass, the method attains its utmost results.

Mosaic art has its own conventions, partly imposed upon it by its material. Its technique was naturally more adapted to the oriental than to the Hellenistic mode of vision; its noblest results are attained by large contours, by colours decidedly broken, and by subjects intended to be seen at a distance, rather than by fine gradations calculated for the near view. The craftsman trained in the Byzantine tradition did not attempt such experiments as those made in the seventeenth century in S. Mark's at Venice, where naturalistic pictorial effects were essayed with unfortunate results. Early Christian and Byzantine wall-mosaic fulfilled its destiny by doing the opposite. In the earliest examples, for instance, those of S. Maria Maggiore, the Hellenistic point of view is still predominant, but oriental methods are already in evidence. The substitution of gold backgrounds marked the progress of mosaic along the path followed by all the other arts: it represented the abstract ideal space replacing old naturalistic backgrounds, space regarded as having an almost substantive existence, and serving to keep the figures in individual isolation, as did the heavy black shadow in the new sculpture. No other form of painting excelled mosaic in producing boldly drawn and richly coloured forms on large surfaces at a distance from the eye; they have a grandeur and spiritual appeal of their own, enhanced by the light in which they are placed and by the manner in which the cubes composing them give it mysterious reflection.[1]

[1] Cf. R. E. Fry, *Burlington Magazine*, 1923, p. 272, where emphasis is laid on the unique power of mosaic in the realization of vision. The vibrancy of effect produced by decidedly broken colour creates a definite aesthetic stimulant which, in the right surroundings, quickens religious emotion (C. J. Holmes, *The Science of Picture-making*, p. 119, and *The National Gallery: Italian Schools*, pp. 9 and 37).

In the first half-millennium, mosaic followed the steady tendency to orientalization common to all the arts. With the advancing sixth century we meet with figures in which frontality becomes general, the suggestion of action is reduced, and forms take on an ikon-like and ceremonial appearance. The design is more and more linear; modelling is abandoned; only the faces preserve the individual character demanded by Aramaean realism.

The Hellenizing reaction which at Constantinople followed iconoclasm was naturally reflected in mosaic art. Its influence is seen in the modelling of faces with graduated tesserae, and the rendering of shadow usually of a greenish tone; this appears in the mosaics of Nicaea (p. 285), which illustrate a period of transition. Idealized conceptions were introduced among the popular Syrian types of earlier times. But the mosaic of the Macedonian and Comnenian periods inevitably followed the path of compromise imposed on Christian art at its birth; in sacred art frontality still prevailed, inverted perspective was general, modelling was chiefly used for faces and little employed in the rendering of draperies. Even in the fresh Hellenistic movement exemplified in the mosaics of Daphni (p. 288) the Greek victory was not decisive. Not till after the Latin interregnum did the picturesque elements of the Hellenistic style penetrate the religious field in mosaic. And even in Kahrieh Jami the oriental factor was not wholly banished.

The surviving monuments of East Christian mosaic chiefly belong to two periods: that between the fourth century and the seventh, to which the work of Salonika, Rome, and Ravenna belongs, and that between the ninth century and the thirteenth, to which we owe the great Byzantine mosaics on East Christian soil and the kindred work in Italy and Sicily. Iconoclasm and the Persian wars interrupted, though they did not wholly break, continuity between these periods. The Fourth Crusade and the Latin interregnum practically crushed the art in the East, Kahrieh Jami remaining as a splendid exception. But what survives is but a part of that which once existed. From the early mosaics in churches of the fifth and sixth centuries in Gaul,[1] to the great church of the Holy Apostles in Constantinople, which survived until the eighteenth century, the tale of loss and destruction is long. When even the churches have undergone such loss, it is natural that secular buildings, unprotected by the religious sanction, should have suffered yet more severely. We know from the historians that the wars of Justinian's generals were depicted in mosaic on the part of the Imperial palace known as Chalké (p. 121), and that in new constructions in another part of the palace grounds the Emperor Basil I caused chambers to be adorned with mosaics, some of which included portraits of himself with his generals, and with members of his family, probably grouped in the ceremonial style traditional in the East. We know also that the palace of Theodoric at Ravenna was enriched with mosaic. Of all this secular decoration nothing remains, and we are left to form some notion of it from the

[1] Sidonius Apollinaris, *Letters*, II, x; Gregory of Tours, *History of the Franks*, v, c. 45.

chamber of Roger II at Palermo (p. 294), where, however, only hunting-scenes and animals are represented.

The following notice includes the more remarkable among the surviving mosaic decorations in Christian buildings in the Christian East or showing East Christian influence.

Mural mosaics. Pre-iconoclastic period and Transition

The church of S. Costanza in Rome [1] has in its ring-vault and in two niches of the rotunda wall mosaics which concern us, as showing Hellenistic and oriental affinities. The church was built between 326 and 330 as a mausoleum for Constantia, sister of Constantine, and his daughter Helena, whose porphyry sarcophagi, long in this building, are now in the Vatican Museum (p. 181). It is a central structure of composite plan, a rotunda surrounded by a ring-vault, and surmounted by a dome upon a drum. Oriental features in the decoration of the ring-vault are the continuous designs of interlacing circles containing conventional motives, and the geometrical diapers; some of these, built up of hexagons, octagons, and crosses, resemble patterns at Bawît in Egypt and at Amida in Mesopotamia, and perhaps provided the models for wall- and floor-decoration of tiles formed in these shapes, first in the East, later in Italy. The river with genii in boats or on rafts fishing, amid various water-birds, forms the lowest zone of a mosaic composition once covering the whole dome, which consisted of scenes from the Old and New Testaments separated by caryatid figures and scroll-work.[2] Some of the vaults are decorated with a continuous development of vine-scrolls with busts in central medallions, and, along two sides, genii pressing grapes and getting in the vintage; these designs have suggested a purposed symbolism which may or may not have been in the artist's mind;[3] the work is transitional between the first symbolic period of Christian art and the historical period following the Peace of the Church. In the dome the historical style was already introduced. Two opposite niches in the inner wall of the rotunda contain mosaics. In one, Our Lord, bearded according to the oriental conception, stands between SS. Peter and Paul and gives to the former the book of the Gospels (the *Traditio Legis*); in the other, which has been extensively restored, Our Lord, seated on the globe, is approached by a figure advancing

[1] References, *B. A. and A.*, p. 332. Add O. Wulff, *Altchristliche und byz. Kunst*, pp. 320 ff.; J. Wilpert, *Die römischen Mosaiken und Malereien der kirchlichen Bauten vom IV.–XIII. Jahrhundert*, Freiburg, 1916, vol. i, ch. iv.

[2] Strzygowski sees oriental (Iranian) influence both in the formal floral ornament of the dome, and in the ' river ' scene, which, like the other examples of the kind, he derives from Mazdaist symbolism. *Origin of Christian Church Art*, p. 133; *Oesterreichische Monatsschrift für den Orient*, 1914, p. 80; *Jahrbuch der K. Preuss. Kunstsammlungen*, xxiv, 1903, p. 15. Cf. also his Rolleston Memorial Lecture, London (India Society), 1922.

[3] Wilpert, *as above*, p. 291, is against a symbolic interpretation, regarding the designs as ornamental only.

with hands outstretched beneath the mantle, a subject not interpreted with certainty.[1] These mosaics probably date from the fourth or early fifth century, though some critics have believed them to be later; the light backgrounds characteristic of very early work suggest antiquity, and elsewhere appear only in the nave of S. Maria Maggiore, where the work is also assigned to the fourth century (see below); the garland-borders are also of early type, and neither gold nor purple is used. One of the niches round the gallery is enriched with a Chi-Rho monogram on a ground of stars, the remnant of a number filling the whole series.

The mosaic in the apse of S. Pudenziana[2] is now generally assigned to the later fourth century. It represents Our Lord enthroned amid the twelve apostles; S. Peter and S. Paul are seated to right and left hand and are crowned with wreaths by two female figures. The nearer background is formed by a semicircular portico with tiled roof; behind this, in the middle, a great jewelled cross rises from a mound, on either side of which appear the upper parts of domed and basilican buildings. An earlier theory explained the subject as depicting the foundation of the building by the Senator Pudens and his daughters Praxed and Pudenziana, the architecture of the background representing the Vicus Patricius. But more recent opinion concurs in the belief that we have before us Our Lord in the Heavenly Jerusalem, the character of which is suggested by the buildings of the earthly city. Attempts have been made to identify the actual buildings, but such identifications are less certain than that of the large cross with that set up on Golgotha by Constantine. Its form and jewelled decoration we shall find copied upon various works of art of later date, for it soon became celebrated through the descriptions of pilgrims, and was reproduced in miniatures and ivory carvings which travelled to all parts of the Christian world.

The mosaics of S. Maria Maggiore[3] also fall only in part within our province. Those of the nave with scenes from the Old Testament have mostly the light background characteristic of ancient mosaics, and though gold is quite freely introduced in certain scenes their subjects are executed with spirit in a good antique manner. Those on the triumphal arch have a gold background throughout. The scenes here are usually regarded as the Annunciation, Presentation in the Temple, Flight into Egypt, Adoration of the Magi, Christ disputing with the Doctors (?), Massacre of the Innocents,

[1] Probably the giving of a crown to a martyr may have been originally intended. Wulff believes the beard of Our Lord to be an addition (*as above*, p. 323). In the apse opposite the entrance Ugonio saw a mosaic subject which suggested comparison with that in the apse of S. Pudenziana. Wilpert (p. 310) believes that the scene represented the commendation of two deceased persons to Our Lord seated among the apostles.

[2] References, *B. A. and A.*, p. 336 ; O. Wulff, *as above*, p. 328.

[3] *B. A. and A.*, p. 338 ; O. Wulff, *as above*, pp. 333 ff. ; Wilpert, *Mosaiken und Malereien*, i, ch. viii ; Wilpert assigns the work to Roman artists, and attributes nave and arch to different hands.

and the Magi before Herod. The unliteral character of the representation is marked in the Adoration of the Magi, where Christ is seated apart upon a large throne. The gorgeous costumes, some of which have oriental features, suggest the fashions of the Byzantine court. In spite of the more ceremonial style of the work upon the arch, there seems reason to regard all the mosaics as contemporary, the only question being whether they are all of the time of Liberius or all of the fifth century. The nave mosaics clearly reproduce the miniatures of an early Bible.[1] But though the Hellenistic influence is strong, we mark the dramatic manner associated with Syrian art ; some of the figures suggest Syrian physical types ; and the device of vertical projection (p. 163) is used even in the scene of the Passage of the Red Sea ; thus, as observed above, mosaic shows the effect of the new mode of vision in the same way as works of art in other media dating from the second half of the fourth century. The chief reason for assigning the mosaics of the arch to the fifth century has been based on the assumption that the regal character assigned to the Virgin and Child implies a date later than that of the Council of Ephesus, but this is not sufficiently certain to override similarities in technique and style. The original mosaic of the apse, restored by Torriti in 1295,[2] may have been earlier than Liberius ; of this only the lower zone, with its river scene, recalling that once seen in the dome of S. Costanza, remains very much in its original condition. It is interesting to note that the lost mosaics of S. Maria Maggiore at Ravenna appear to have corresponded in subject with those of the Roman church.

Of the mosaics ornamenting the apses of what was once an open portico of the Lateran Baptistery, only that of one end has been preserved.[3] It shows a rich acanthus-scroll on a blue ground, with a lamb, doves, and crosses above and below, the detail recalling in some respects mosaic ornament in the Mausoleum of Galla Placidia and in S. Apollinare Nuovo at Ravenna. The design of the opposite apse, now destroyed, showed shepherds, and the sun represented by a chariot. The work suggests a period not later than the beginning of the fifth century, while some incline to a yet earlier date. The sixth-century apse of SS. Cosmas and Damian (A. D. 526–530), with its nobly impressive design in which Our Lord as central figure stands against a splendour of red cloud, is usually regarded as a work in which the Roman genius triumphed, but the figures in their heaviness and angularity, their frontal pose and ikon-like isolation, remind us of the Ravenna sarcophagi. Strzygowski sees in the treatment of the subject evidence of oriental ideas.[4] Roman mosaics belonging to the

[1] Of a redaction only preserved in the later Octateuchs (cf. p. 306).

[2] Torriti introduced the subject of the Coronation of the Virgin. He left at the sides the Early Christian acanthus scrolls which once spread over the whole surface.

[3] J. Wilpert, Die römischen Mosaiken und

Malereien, Rome, 1916, pp. 247 ff. and pls. 1 to 3. The portico was closed and turned into an oratory or chapel in the twelfth century.

[4] Ibid., pl. 102 ; Venturi, Storia, ii, fig. 184 and p. 266 ; Wulff, Altchr. und byz. Kunst, p. 416. In this case, as in that of the Lateran apses and the apse of S. Maria Maggiore,

orientalizing period between the seventh and tenth centuries have in several cases Eastern characteristics, as in the oratory of S. Venanzio, and in the apse of S. Stefano Rotondo. Those executed for Pope Paschal in S. Prassede, S. Cecilia, and S. Maria in Domnica, with those of the time of Gregory IV (A. D. 830–840), produce a barbaric effect, but have been considered to show analogy to work in the dome of S. Sophia at Salonika; this analogy is more especially evident in the case of the chapel of S. Zeno in S. Prassede.[1]

During the fifth and sixth centuries Ravenna, which, after Milan, had become the residence of the Roman emperors, was the great centre of mosaic in Italy, and decoration in this medium has survived to an extent which has made the provincial town of modern times a place of pilgrimage for students of the history of art.[2] The work falls into three groups, associated respectively with the names of Galla Placidia (A. D. 388–450), sister of Honorius, who made Ravenna her chief residence from the accession of her son Valentinian III in A. D. 424 to her death in A. D. 450; of Theodoric the Ostrogothic king, who resided here after his victory over Odovakar from A. D. 493 to A. D. 526; and of Justinian, who never lived in the West, but was the munificent patron of architecture and its subsidiary arts, and left monuments of his reign in two important churches. To Galla Placidia's time belong the Orthodox Baptistery (about A. D. 430), and the building used as her mausoleum, known also as the church of SS. Nazaro e Celso (about A. D. 440). The mosaics of the chapel of the archbishop's palace date from the end of the fifth century. To the reign of Theodoric are assigned the mosaics of the Arian Baptistery (c. A. D. 500), and the greater part of those of the palace church of S. Apollinare Nuovo (about A. D. 504). The reign of Justinian witnessed the erection and decoration of S. Vitale (A. D. 547) and S. Apollinare in Classe (A. D. 549), Classis being at that time still the harbour of Ravenna.

There has been much discussion as to the origin of the art which finds its expression in the Ravenna mosaics. Some point to resemblances in this or that particular to the work in Roman churches, and to the occurrence of the Evangelist's symbols, which are a Western rather than an Eastern feature. Others note the affinity between the statuesque types and sculptural compositions, e. g. of S. Apollinare Nuovo, and the Hellenistic sculpture attributed to Antioch; they remark the Syrian type of the long-haired

Strzygowski divines Iranian symbolism derived from the *Zend-Avesta*; he lays especial stress upon the red dawn clouds (*Origin of Christian Church Art*, p. 178). The mosaics on the triumphal arch of S. Paul without the walls, restored after the fire of 1823, are said closely to reproduce the fifth-century original (A. D. 450).

[1] Wulff sees Byzantine influence in all this work, though noting that the faces in S. Sophia at Salonika are modelled with some care (*Altchr. und byz. Kunst*, p. 547).

[2] For the older references see *B. A. and A.*, pp. 342 ff. Add A. Colasanti, *L'Arte Bisantina in Italia*; Wulff, *Altchr. und byz. Kunst*, pp. 342, 346, 349, 421 ff.; J. Wilpert, *Die römischen Mosaiken und Malereien*, pl. 78, 89, 97, 101. Wilpert finds Roman influence in Ravenna mosaics.

youthful Christ. They observe the resemblance in style between Raven-nate work and the early mosaics in Cyprus (p. 283) which are not likely to have been touched by Roman influence. And, among other points, they draw attention to indications of oriental origin in the use of colour; for instance, the regular employment of purple for the mantle of Our Lord. They recall the general grounds which tell in favour of a Syrian inspiration, such as the easy direct communication of Ravenna with Antioch by sea, the Syrian nationality of certain bishops, and the known relations main-tained by the city with the East. They argue that if the Roman churches have points of resemblance with those of Ravenna it is because they also were produced under oriental influences. Among those who believe the mosaics to be oriental, Wulff is inclined to ascribe a more extensive and direct influence than others to Constantinople. The weight of evidence inclines decisively on the Eastern side. The Ravenna mosaics illustrate the same development away from naturalism which we find in the contemporary sculpture and painting of the Christian East; the principles governing this development are those of what we have called the oriental mode of vision.

The earliest group

The *Orthodox Baptistery*, or S. Giovanni in Fonte, was decorated in the first half of the fifth century. It is a domed octagon, the interior of which is richly adorned with mosaics and stucco reliefs.[1] The dome has the Baptism in a large central medallion, with a border of vandykes or lambrequins, the ground being gold. Round the sides of the dome is a procession of apostles bearing crowns on a blue ground, the figures separated by tall 'candelabra' composed of floral elements. Below the apostles is a narrower zone of mosaic with sections of church interiors showing the altar or sanctuary, which should be compared with the architectural mosaics in S. George, Salonika (p. 280), and in the church of the Nativity at Beth-lehem (p. 292); the underlying idea is the glorification of the church. The lower part of the walls is disposed in two zones, each relieved by a series of arches. The upper contains the windows, on either side of which are the stucco reliefs mentioned elsewhere (p. 201); the only mosaics are in the spandrels and consist of conventional acanthus ornament. In the bottom zone four of the arches form niches and above these are inscriptions in mosaic relating to the use of the building for baptism, and containing the monograms of four bishops; the other four were filled with coloured marbles forming designs, some of which remain. The spandrels contain figures of apostles and saints amid bold foliage in green and gold on a blue ground. The effect of this interior is rich and beautiful, and its design unites historical, symbolical, and ornamental elements into a harmonious

[1] The interior reproduced, *B. A. and A.*, fig. 208; Wulff, pl. xvi. For the symbolism of the mosaics see Ficker, *Byz.-Neugriech. Jahrb.*, ii, 1921, pp. 319 ff.

whole. In addition to the stucco-reliefs which he regards as an oriental feature, Strzygowski sees Eastern influence in the foliate ' candelabrum ' design and in the ' lambrequins ' round the central medallion.[1]

The so-called *Mausoleum of Placidia*,[2] a small cruciform building with dome at the intersection of four barrel vaults, is covered except on the lower part of the walls with mosaics on a rich blue ground. The vaults of the eastern and western arms are powdered with rosettes, &c. in gold; the other two have vine-scrolls rising from acanthus-leaves and surmounted by the sacred monogram. In the dome is a cross among stars; in the spandrels are the symbols of the Evangelists; on either side of the dome-windows we see apostles in niches, S. Peter carrying a key. Of the four lunettes, those of the transepts have harts approaching water, with acanthus scrolls in the background; the other two have subjects of greater importance. Over the entrance door is the Good Shepherd (Plate XLVII) seated in a rocky meadow among his sheep, with a gold cross in his hand. He is richly clothed in a purple mantle and gold tunic, an oriental feature which enhances the mystical impression; his long hair recalls that of the young Apollo; this fine mosaic is in character Hellenistic, and the type suggests the art of Antioch. In the opposite lunette a man holding a cross and an open book moves towards a gridiron beneath which a fire is burning. This figure is commonly regarded as S. Laurence; if the explanation is correct it takes its place among those early representations of martyrdom in which a realistic treatment is avoided.[3] The mosaics preserve the modelled contours of Hellenistic painting, and half-tones mark the transition between light and shadow. The small and simple interior, with its colouring at once soft and splendid, and the mystical suggestion of its decoration, ranks as one of the most impressive in the world.

Time of Theodoric

The *Arian Baptistery*, or S. Maria in Cosmedin, is, like the Orthodox, octagonal; it further imitates the earlier baptistery in the subjects of the mosaic decorating its dome, the Baptism filling a medallion in the centre, below it the twelve Apostles moving in two groups led by S. Peter and S. Paul towards a throne[4] on which lies a cross, representing Our Lord. The mosaics, which are inferior in execution to their prototypes, are restored in many places.

S. Apollinare Nuovo, built as the church of S. Martin by Theodoric, has mosaics which belong only in part to the time of the founder; the rest

[1] *Altai-Iran*, pp. 169 ff., 266; *Origin of Christian Church Art*, p. 134.

[2] *B. A. and A.*, p. 347; Wulff, *as above*, fig. 310. The building was built for a sepulchral purpose, whether primarily for Galla Placidia or not.

[3] The interpretation as S. Laurence is accepted by Wulff, p. 347. Cf. also C. Ricci, *Bollettino d'Arte*, viii, 1914.

[4] For the symbolism of the Throne see Wulff, *Altchr. und byz. Kunst*, pp. 331, 343.

are of Justinian's time, when the building was transferred from the Arians to the Catholics (A. D. 553–566)[1]. To the former series belong the scriptural scenes along the top of the nave walls and the single figures between the windows; to the later, the processions of male and female saints below. The scriptural scenes depict the Life and Passion of Our Lord; in the former Christ is beardless, in the latter bearded. The scenes from the Life are treated in a manner which sometimes recalls the sculpture of fourth-century sarcophagi, the composition being simple and confined to a few figures (Plate XLVII); in the Passion Scenes there are analogies to the treatment in early orientalizing MSS. such as the Codex Rossanensis. The figures of prophets and apostles between the windows are Hellenistic in style; the same may be said of the processional figures below, where crown-bearing martyrs, male on one side, female on the other, advance from Ravenna and Classis to enthroned figures of Our Lord and the Virgin respectively, the line of Virgins being led by the three magi (restored), carrying their gifts. The outer angels, standing by the two thrones, are also restored. The chapel of All Saints in the left aisle contains a mosaic fragment with a portrait head of Justinian, once on the entrance wall; the corresponding portrait of Bishop Agnellus has not survived.

Time of Justinian

The octagonal church of S. Vitale (p. 156), consecrated under Archbishop Maximianus in A. D. 547, is profusely decorated with mosaics.[2] In the apse a beardless Christ is seated on the sphere, holding out a diadem to S. Vitalis, who is presented by an angel; on the other side Archbishop Ecclesius, who carries a model of the church, is also led forward by an angel. Next the apse are the famous historical groups representing two separate panels, the Emperor with his court and guards, and the Empress Theodora with her ladies (Plate XLVIII), bearing offerings. Farther to the west the lower walls of the sanctuary have subjects of liturgical or dogmatic character, Abel and Melchizedek bringing offerings, Abraham entertaining the angels and preparing to sacrifice his son, Moses among his flocks before the Burning Bush, and receiving the Tables of the Law. On the upper part of the walls are the Evangelists with their symbols; in the centre of the roof, within a wreathed medallion, is the apocalyptic Lamb upon a background of blue strewn with stars; from the wreath radiate four compartments filled with scrolls, recalling the work in the Orthodox Baptistery, amid which stand white-robed angels with arms raised above their heads as if to support the medallion: in the convolutions of the scrolls are creatures (hare, deer, peacock, fish, &c.) which remind us of the carved work on the episcopal chair associated with the name of Maximianus (p. 205). The liturgical character lent to the scriptural scenes is

[1] *B. A. and A.*, pp. 350 ff. [2] *B. A. and A.*, pp. 355 ff.; Wulff, *as above*, pp. 421 ff.

marked by such features as the altar-like table in the scene of Abel and Melchizedek, with its white cloth, chalice, and bread. Their dogmatic significance has led to various theories, upon which we cannot enter here ; the central idea is that of the divine sacrifice.

Though they form a scheme of decoration full of dignity and splendour, the mosaics of S. Vitale do not bear close examination so well as those of the Mausoleum of Placidia. The figures are in part outlined in black, and sometimes look as if hung on wires. But the draperies are well handled, and the range of colour is very rich, tesserae of pearl shell being here included, as at Parenzo, among the glass. The landscape in the biblical scenes has in its treatment a reminiscence of the primitive 'vertical projection', and has reminded one critic of geological strata. There is a ceremonial atmosphere about the subjects suggesting the oriental contribution to the historical and theological phase in which Christian art now moved. In style the decoration of S. Vitale has moved far from that of the Mausoleum of Placidia. The Hellenistic love of beauty is abandoned for a formal and ceremonial treatment. In the figures, as in the landscape, there is a schematism which accords with the dogmatic atmosphere and lends to the whole work an admirably harmonious effect.

The *Archiepiscopal chapel*[1] was completed for a prelate named Peter, perhaps towards the end of the fifth century. In the soffits of the arches are busts of Our Lord, the apostles and saints, the latter accompanied by their names ; four angels (much restored), with arms raised above their heads as in S. Vitale, support a medallion in the centre of the vault containing the sacred monogram. In the presbyterium is the Virgin as *orans*, a mosaic of later date than the rest, brought from the cathedral, and perhaps of the tenth century. In this part of the chapel there is also a restored figure of Our Lord of the youthful Emmanuel type, holding a cross. Most of the mosaics suggest a date later than the foundation of the chapel, and the method of outlining figures in black recalls the same feature in S. Vitale.

S. Apollinare in Classe received part of its mosaic decoration[2] in the sixth century, but in the Life of Archbishop Reparatus in the *Liber Pontificalis* it is related that work was still being executed in the second half of the seventh. The triumphal arch is divided into zones in the uppermost of which is a bust of Our Lord in a medallion flanked by the Evangelists' symbols ; the second zone has lambs issuing from Jerusalem and Bethlehem ; below are archangels with the labarum, and busts of S. Matthew and S. Luke. In the apse is a symbolic treatment of the Transfiguration. Half-figures of Moses and Elias issuing from clouds look towards a jewelled central cross of Golgotha, between the arms of which is a small bust of Our

[1] *B. A. and A.*, p. 360 ; Wulff, p. 350. Wulff notes that there is no evidence connecting the building with Peter Chrysologus. In the characterization and costume of various figures Wulff sees the influence of Constantinople.

[2] *B. A. and A.*, p. 361 ; Wulff, *as above*, p. 417.

Lord : at the end of the arms are the letters A and ω ; above the vertical limb is the word ΙΧΘΥC, below it are the words SALVS MVNDI. In the lower part of the apse, beneath a dividing line, is a landscape with trees and birds, in which are seen three lambs with raised heads, representing the three apostles on Mount Tabor ; below are twelve other lambs, among which stands S. Apollinaris.[1] Between the windows are life-sized figures of the four archbishops of Ravenna with their names in Latin letters, with crowns suspended above their heads. In a line with these figures are two elaborate subjects, the one ritual, the other ceremonial, doubtless suggested by the subjects in the bema of S. Vitale. The first combines the Abel and Melchizedek and the Abraham and Isaac pictures in that church, the inferior style suggesting that the work cannot be earlier than the seventh century. In the second, the Emperor Constantine IV, attended by princes, courtiers, and clergy, presents a scroll inscribed PRIVILEGIA to Archbishop Reparatus of Ravenna : the scene refers to a grant of privileges against Roman claims to ecclesiastical supremacy. A painted inscription below this picture is based on an original one recorded by Agnellus. The mosaics of S. Apollinare in Classe, inferior in execution to those in Ravenna, are thought to have been executed in part at least by local artists under oriental influences.

S. Michele in Affricisco. The mosaics of the apse and triumphal arch of this church,[2] which was built in A. D. 545, were sold in 1847 to William IV of Prussia, and are now exhibited in the Kaiser Friedrich Museum at Berlin. The apse shows Our Lord between the archangels Michael and Gabriel ; above is the Lamb with nimbus, in spandrels to right and left S. Cosmas and S. Damian (restored). In the middle of a broad zone above the apse Our Lord is seen enthroned as Judge, between two archangels holding respectively a reed with a sponge, and a spear ; behind are other angels upon a ground of cloud, blowing long horns : the scene is one of the earliest representations of the Last Judgement. In the style of the mosaics of S. Michele we mark a further stage in the abandonment of half-tones and modelling for a linear treatment already observed in S. Vitale. The predilection for clear contour marks a parallel movement to that observed in contemporary sculpture.

Outside Rome and Ravenna, mural mosaics of the fourth and fifth centuries are not numerous ; the most important are in the south of Italy. The baptistery at Naples (S. Giovanni in Fonte)[3] has New Testament scenes ; the woman of Samaria at the well, the miracle of Cana, the miraculous draught of fishes, Christ giving the Law to Peter (*Traditio Legis*), the Good Shepherd, the Evangelists' symbols (that of S. John lost), figures

[1] The figure of the saint probably replaced the original Lamb. The treatment of this apse again recalls Iranian symbolic elements to Strzygowski (*Origin of Christian Church Art*, p. 137).

[2] Earlier references, *B. A. and A.*, p. 364.

Add Wulff, *Altchr. und byz. Kunst*, p. 428.

[3] *B. A. and A.*, p. 369. To the earlier references add J. Wilpert, *Die römischen Mosaiken und Malereien*, ch. ii, pp. 214 ff. ; Wulff, *Altchr. und byz. Kunst*, p. 325.

of martyrs, and decorative bands of vases, birds, fruits, and leaves, separating the designs. These mosaics, of which much had perished while other parts were in bad condition, have been restored in comparatively recent times. They show some affinity to the art of the Roman catacombs, but more to that of Ravenna, and of Antioch, to which Ravenna owes so much. The iconography is Syro-Palestinian, the treatment of draperies and other features recalls the Antiochene style. It is possible that in some details Iranian influence may be discerned, as Strzygowski argues, insisting at the same time that the use of squinches in the construction of this building points in the direction of Armenia and Iran.[1] The date of the mosaics may fall within the second half of the fourth century.

In a lateral chapel of S. Priscus at Capua[2] we see the Throne, with cushion and scroll with seals, the symbol of S. Matthew, and a bust of Our Lord between Alpha and Omega ; the chapel was decorated in the fifth century, to the first half of which the mosaics belong. At Milan the chapel of S. Aquilinus in S. Lorenzo[3] has late fourth-century mosaics in the upper parts of two apses, the youthful Christ seated among the apostles, and a pastoral scene which may represent the Annunciation to the Shepherds: they were in recent years in bad condition and spoiled by surface-painting. In S. Ambrogio, the chapel of S. Victor has remains of fifth-century mosaics on walls and cupola ; they consist of busts and figures of evangelists and saints, those on the walls representing saints venerated in Milan. At Casaranello[4] there are decorative mosaics suggesting the inspiration of Syrian designs ; a large cross is represented on a ground of stars. In the baptistery at Albenga[5] is also mosaic ornament of the fifth century without human figures ; in the middle is a Golgotha cross flanked by lambs.

Remarkable as are the mosaics still in existence in Italy, they by no means represent the total sum as it was in the time, for instance, of Agnellus. Many churches once richly decorated have vanished ; in other cases disaster has overtaken the decoration alone.[6] The preservation of the surviving examples as a whole is remarkable, and bears testimony to the fine quality of the workmanship. It is, however, natural that damage or decay should have necessitated restoration at different periods, sometimes of an extensive nature. In recent times such work has been executed with the utmost care under the direction of the Ministry of Fine Arts, and an exact record kept of everything done. Some of the more ancient restorations can be readily seen ; others may have escaped detection, either through the carefulness of their execution or through the impossibility of close examination. Probably no restoration remains undiscovered of a scale sufficient to alter in an essential manner any of the more important subjects.

[1] *Origin of Christian Church Art*, p. 134.
[2] *B. A. and A.*, p. 370 ; Wilpert, *as above*, pp. 50, 229, 241 ff., and pls. 74 ff.
[3] Wilpert, pp. 264, 266, and pls. 40, 41.
[4] *B. A. and A.*, p. 372 ; Wulff, *as above*, p. 331.
[5] Wulff, *as above*, pp. 249, 331.
[6] *B. A. and A.*, p. 365.

We have seen that Dalmatia from its geographical position fell early under the political and artistic influence of Italy, and in mosaic art the relationship with Ravennate work is evident. In the apse of the fine basilica at Parenzo[1] (Plate XLIX) the Virgin is enthroned between angels and saints, Bishop Euphrasius, the founder, holding a model of the church. On the wall spaces beyond the windows are the Annunciation and Visitation; between the windows, angels and saints. Above the apse is a zone of mosaic, much restored in recent years, with Our Lord seated on the globe, and apostles. Busts of female martyrs in medallions, after the style of those in S. Vitale in Panagia Kanakaria in Cyprus, and in the monastery of S. Catherine on Mount Sinai, fill the soffit of the arch. The general resemblance of the Parenzo mosaics with those of S. Vitale is very marked, but the figures are inferior, showing the beginning of decadence in the art.

Salonika

S. George.[2] The upper part of the dome has a medallion with Our Lord, surrounded by a wreath of foliage and fruits in an early style; below this is a zone of figures (Apostles?) concealed by whitewash.

The mosaics of the lower part of the dome are divided into eight sections by pilasters of conventional foliage; that above the entrance to the apse is restored. The sections form four pairs, and four designs are repeated. In each section we see the cross-section of a church towards the east end, with figures of saints standing in the foreground in the attitude of *orantes*; we are reminded of the Orthodox Baptistery at Ravenna, where a similar idea is carried out (p. 274). The architecture is treated in a fantastic manner recalling that of the Pompeian frescoes, and the rock-cut façades at Petra themselves based on one of the earlier Pompeian styles; but the primary suggestion may have come from the Hellenistic theatre.[3] Columns and arches are adorned with bands of pearls and jewels; curtains hang from the columns, on the architraves are gorgeous birds; the ornament of the vaults shows diapers filled with birds and fruits in the style found in one of the niches in the rotunda below, at Eski Juma, and S. Demetrius. The date of these mosaics may be the early part of the fifth century; they are older than those of the Orthodox Baptistery, which dates from the middle of that century: some authorities have been disposed to carry them back even into the fourth century. The effect of the decoration is one of amazing richness and variety.

S. Demetrius.[4] The disastrous fire of 1917 has totally ruined the most

[1] *B. A. and A.*, p. 372; Wulff, *as above*, p. 433.

[2] *B. A. and A.*, p. 374; Diehl and others, *Monts. chrét. de Sal*, p. 28; E. Hébrard, *Bull. Corr. Hell.*, xliv, 1920, pp. 5 ff.; Wulff, *as above*, p. 344.

[3] Another suggestion of church interiors by forms adopted from a much earlier Hellenistic source is found in the nave mosaics of the Church of the Nativity at Bethlehem (p. 293).

[4] *B. A. and A.*, p. 378; Diehl and Le Tourneau, pp. 94 ff.; Wulff, p. 446.

interesting mosaics in this church, which extended along the wall above the arcade dividing the left aisle into two parts. Their destruction is a heavy loss, for not only were they as regards technique and composition among the finest examples of sixth-century mosaic art, but they were of an unusual character, representing four separate subjects, the gift of grateful donors ; one of them depicted in a picturesque style with landscapes in the Hellenistic manner, episodes in the life of a child named Mary, perhaps a princess, miraculously born to her parents by the intercession of S. Demetrius, and included a representation of the famous columned ciborium which once adorned the church. Above these episodes was an inscription, beneath three busts representing the saint between two ecclesiastics ; this made mention of restoration after an early fire, referring to a Leo whose identity cannot be determined with certainty. The fire, however, is known to have occurred in the first half of the seventh century, and these busts with the inscription were later than that date ; a line running below them clearly marked the division between the later and the earlier work. The other subjects on this wall were S. Demetrius with donors ; S. Demetrius introducing a worshipper to the Virgin seated between two angels, another saint standing beyond ; and S. Demetrius as *orans* before a niche between two other figures, with busts of S. Cosmas and S. Damian above. Other destroyed mosaics include a fragment in the right aisle representing a woman presenting a child to S. Demetrius, an isolated panel above the door leading from the narthex to the right aisle, and the charming conventional ornament in the voussoirs of the arcades which recalled similar work at Eski Juma, in the style of the fifth century.

Fortunately the fire spared the fine mosaics upon the transept piers. On the left (north) pier are two subjects : S. Demetrius, in his usual costume of a high official, standing between two boys, who also wear the chlamys with purple patch, and the gold fibula indicative of rank (Plate L) ; and the Virgin with S. Andrew as an *orans* standing before a wall, while a bust of Our Lord appears in the sky. On the right pier is a figure of S. Sergius, the collar round his neck marking his rank as captain of the imperial guard ; and S. Demetrius standing between a bishop and a high dignitary, with a metrical inscription. The squares behind the heads of the three figures are not square nimbi, which would prove that the work was done in their time, but the crenellations of a wall behind their heads. The inscription alludes to the two secondary persons as 'founders' of the church ; the one is probably Leo, prefect of Illyricum, by whose generosity the church was built, the other the bishop who added the transept. It also mentions a 'barbarian storm' from which Salonika was delivered. This is perhaps the attack by Slavs between A.D. 617 and 619, said in the Acts of S. Demetrius to have been defeated by the appearance of the saint walking on the waves and throwing the hostile ships into confusion. Probably the two mosaics with S. Demetrius and that with S. Sergius date

from shortly after this event. The other scene, representing the Virgin praying for the universe, as once depicted in the church of Blachernae at Constantinople, is in a later style, and may have been added in the tenth or eleventh century.

The earlier of these pier mosaics are very fine ; the persons are full of individuality, and may be described as veritable portraits. Technically the work is excellent, the tesserae being graduated with great skill. It may at first sight seem strange that mosaics of this distinction should have been produced in the seventh century, generally regarded as a period of decline. But Salonika was at this time a very rich commercial city and could command the best craftsmen ; further, as Diehl remarks, fine work, not dissimilar in style, was being done in S. Venanzio, and S. Agnes without the walls at Rome, and in S. Apollinare in Classe, while the seventh century also witnessed the placing of the first mosaics in the dome of S. Sophia in Salonika itself.

At *Eski Juma*,[1] formerly the historical church of the Virgin ' Acheiropoietos ', or the Hagia Paraskevi, and the first Christian church in the town seized by the Turks for use as a mosque, there are only decorative mosaics in the intrados of the arcades ; but they are of incomparable quality, rich in colour and charming in design, representing the best style of the mid-fifth century. On a gold ground we see garlands of fruits, fluted vases whence issue branching flowers, birds in the centre of wreaths, diapers of flowers and leaves, and geometrical designs, systems of octagons and hexagons, or octagons and crosses, &c.

S. Sophia.[2] The mosaics of this church, disfigured and partly concealed during the time of its use as a mosque by paint and coverings of paper, were for the first time properly seen in 1907, when M. Letourneau was able to have them cleaned : they decorate the bema and the dome.

In the apse is the Virgin seated with the Child upon her knees ; beneath or behind this subject is still visible a large cross on the gold ground ; inscriptions in the apse include the fourth and fifth verses of Psalm lxv, which are found in a similar position in S. Irene at Constantinople. The barrel vault over the bema has a diaper of alternate crosses and vine-leaves ; in the middle at the top is a gold cross on a gold-rimmed silver circle. Below this decoration is an inscription, with the name of Bishop Theophilus and six monograms in circles yielding the names of Constantine VI and his mother Irene. This gives the date as the last quarter of the eighth century, when we must suppose the apse to have been redecorated with the figure of the Virgin, replacing the cross, formerly its sole ornament. This cross and the other mosaics of the bema appear to date from the fifth or sixth century.

In the upper part of the dome is the Ascension on a gold background. Our Lord is seated in a glory supported by angels in the central medallion ;

[1] Diehl and others, p. 53 ; *B. A. and A.*, p. 382.

[2] *B. A. and A.*, pp. 374-8 ; Diehl and others, pp. 137 ff.

in the next zone we see the Virgin as *orans* between two angels and the twelve apostles, above her head the verses from Acts i. 11 : *Ye men of Galilee*, &c. Round the base of the dome is a band of fruits and flowers interrupted by two fragments of an inscription mentioning an archbishop Paul, but not serving to determine the period. There are differences of opinion as to the date of different parts of these dome mosaics. Letourneau believes that the Christ and angels at the top of the dome are earlier than the other figures. Our Lord is of the Syrian type seen in the Gospels of Rossano and the Sinope fragment (p. 312); these may well be of the mid-seventh century, at which time there was a bishop of Salonika named Paul. He considers that the Virgin and apostles belong to a more advanced art, noting their fine colour, their modelling, and the manner in which they are cleverly elongated so as to appear of correct proportions from below. They also show the green shading not usual in mosaics before the eleventh century, to which period he would assign them. Wulff on the other hand regards the whole decoration of the dome as homogeneous, and as dating from the period immediately following iconoclasm. He remarks the vigorous ' popular ' art, which recalls that of the monastic group of Psalters, some-times known as the Chludoff group (p. 308), and draws attention to the close parallels with contemporary mosaics in the Roman churches, especially with the chapel of S. Zeno in S. Prassede, in which he sees Byzantine influence.

In the apse of the monastery of S. Catherine on Mount Sinai [1] there is a Transfiguration now ascribed to the sixth century. Above the apse are two flying angels surmounting two medallions containing busts, possibly of the Virgin and S. John the Baptist, dating from not earlier than the twelfth century. On one side of the apse Moses receives the Tables of the Law ; on the other, he stands before the burning bush : these two scenes appear to be of even later date than the angels. The Transfiguration is surrounded by a border of medallions with silver backgrounds containing busts of prophets, apostles and others, recalling the medallions in the archiepiscopal chapel and S. Vitale at Ravenna, and in Cyprus. Theodore the presbyter, whose name occurs in an inscription as responsible for the work, may have been a Greek from Syria.

Interesting mosaics of early date with affinities of style to work at Ravenna (p. 273) remain in small churches in Cyprus, one at Kiti a few miles west of Larnaka on the south coast, the other the Panagia Kanakaria on the Karpass in the north-east of the island.[2] At Kiti the Virgin, holding the Child, stands on a footstool between S. Michael and Gabriel ; by the

[1] *B. A. and A.*, p. 383 ; Wulff, *as above*, pp. 419, 420 ; F. M. Abel, *Revue Biblique*, 1893, p. 634 ; 1897, p. 107 ; 1907, p. 105 ; P. Renaudin, *Rev. de l'Orient chrétien*, v, 1900, p. 319. Remains of early ornament in mosaic are reported in a niche behind the altar (Johann Georg, Herzog zu Sachsen, *Das Katharinenkloster am Sinai*, p. 15, 1912).

[2] *B. A. and A.*, p. 385 ; Wulff, *as above*, p. 432.

heads are names; the description of the Virgin (Η ΑΓΙΑ ΜΑΡΙΑ) is of an early type, but the presence of the archangels shows that the date must be later than that of the Council of Ephesus in A.D. 436. Smirnoff suggested the fifth or sixth century as the probable date, and in fact the quality of the work is equal to that of anything in Rome or Ravenna. On the other hand, if this is so, we should have to suppose the mosaic reconstructed, since the church itself is stated not to be so ancient. Schmidt has argued[1] that the real date is the second half of the ninth century, and that the work lies half-way between that of Ravenna and of Nea Moni in Chios (p. 288). The period of Basil I has been suggested.[2] The subject in the Panagia Kanakaria is similar; the lower part is badly damaged, and the two angels are imperfect; the group is surrounded by a border of medallions representing the apostles, also damaged. An interesting feature of this mosaic is the dark-blue glory of mandorla form surrounding the figure of the Virgin. Smirnoff assigns the work to the period between A.D. 500 and A.D. 650, regarding it as rather later than that at Kiti; in this judgement Wulff concurs. Here too the difficulty raised by the date of the church must be borne in mind.

A third mosaic representing the Virgin is reported to exist in another church of the Karpass, near the village of Livadia.

S. Sophia, Constantinople.[3] Of the original mosaics little remains, at any rate little that is visible. The seraphim in the pendentives beneath the great dome are accepted as of the sixth century, and it seems possible that a figure of the Pantokrator crowned the dome itself when it was restored by Justin II.[4] The sixth-century mosaics included a great series of New Testament scenes, illustrating the dogma of the twofold nature of Christ; but nothing now to be seen can be certainly identified with parts of this Christological cycle.[5]

Other mosaics within the church, copied by Salzenberg, appear to represent work of the end of the ninth century: an imperfect Virgin and Child and SS. Peter and Paul on the main west arch, and three figures of Fathers of the Church. The enthroned Virgin and Child of the apse would also seem to be of this time rather than of the sixth century, as some have conjectured.

The vaults of the narthex side-aisles and galleries were richly decorated

[1] *Izviestiya* of the Russian Arch. Inst. at Constantinople, 1912, pp. 207 ff.

[2] Wulff, *Altchr. und byz. Kunst*, p. 551.

[3] The mosaics are still concealed by whitewash, except some of those which are purely ornamental in character. Most of our information as to figure-subjects was obtained in 1847, when some of them were uncovered during restorations carried out by Fossati: *B. A. and A.*, p. 391. To the earlier references there given may be added: A. Heisenberg, *Die alten Mosaiken der Apostelkirche und der Hagia*

Sophia, in ΞΕΝΙΑ, *Hommage international à l'Université Nationale de la Grèce*, &c., pp. 171 ff.; O. Wulff, *Altchr. und byz. Kunst*, p. 432, &c.; and *Byz.-neugriechische Jahrbücher*, ii, 1921, p. 376.

[4] Wulff, *Byz.-neugr. Jahrb.*, p. 376.

[5] Whether the lost mosaics in the Church of the Holy Apostles were of the sixth century or not, the disposition of the subjects in that church should be of that date, and recalls that of S. Sophia as mentioned by Corippus.

with geometrical and floral designs, of which much is uncovered. These show analogies to ornamental mosaic at Salonika; the possible relation of all such designs to textiles has been discussed by Strzygowski.[1]

The church of the Assumption (*Koimesis*) at Nicaea[2] has mosaics of different dates in the bema and narthex accompanied by inscriptions biblical and other; the collapse of the dome has resulted in serious loss and damage. On the great arch is the Preparation of the Throne (*Hetoimasia*), the throne supporting a book and cross, and flanked by angels in imperial costume holding orbs; in the apse is a standing Virgin with the Child, with three rays descending from Heaven to her head accompanied by an inscription (Psalm cx. (cix.) 3); these mosaics declare the Trinity in its relation to the Incarnation and the divine motherhood of the Virgin as expressed in the first chapter of the Epistle to the Hebrews. Wulff, to whom we owe an important study of the church, dates the work between A.D. 789 and the middle of the ninth century, for after the triumph of the orthodox party in A.D. 842, the pointed allusion in one of the inscriptions to the sacred character of the figures would hardly be needed; their style also suggests an early date. The mosaics of the narthex, partially preserved, are supposed, from an inscription, to belong to the time of Constantine VIII (late tenth century); they are of fine workmanship, and recall the style of Daphni. In the tympanum over the main door is a fine half-figure of the Virgin as *orans*, a type perhaps derived from that placed by Basil I in his *Nea*, or New Church, and popular on coins and in works of art during the tenth and eleventh centuries; other figures in the narthex include Our Lord, S. John Baptist, the Evangelists, S. Joachim and S. Anna: in the roof is a jewelled cross-monogram on a blue ground with golden stars.

The most interesting Western mosaics outside Italy are to be found in France, in which country, as we know from allusions in Sidonius Apollinaris, churches were decorated in this manner at the close of the fifth century. This writer mentions the church erected towards A.D. 470 by Patiens, bishop of Lyons, his description pointing rather to a scheme of decorative design than to scenes with figures.[3] In a copy of a poem on the church which he encloses in a letter to his friend Hesperius, he describes mosaic green as a blooming mead with sapphire cubes winding through the ground of verdant glass, the words almost suggesting part of a ' Nilotic ' scene like those in S. Maria Maggiore or the lost work in the dome of S. Costanza.[4] The church of S. Germigny-des-Prés in the diocese of Orleans, already

[1] *Jahrb. der K. Preussischen Kunstsammlungen*, 1903, pp. 147 ff.

[2] *B. A. and A.*, p. 388. Chief reference, O. Wulff, *Die Koimesiskirche in Nicäa und ihre Mosaiken*, 1903. See also the same writer in *Altchr. und byz. Kunst*, p. 558.

[3] Dalton, *The Letters of Sidonius*, Oxford, 1915, i, pp. 54, 55. In the Merovingian

period the costly process of mosaic decoration perhaps fell into disuse. In the *History of the Franks*, Gregory of Tours speaks more than once of mural paintings, but these seem to have been executed in tempera, and to have represented scriptural subjects.

[4] Most of the earliest mosaics have been unfortunately destroyed, though a few sur-

noticed for its architectural interest, has in the chief apse the ark of the
Covenant between two great angels, the background being partly gold, partly
blue, powdered with stars ; round the bottom is a metrical Latin inscription
alluding to Theodulf, Bishop of Orleans, a contemporary with Alcuin at
the Court of Charlemagne, and founder of the church.[1] Before the restora-
tion in 1846 the dome and its pendentives were also covered with mosaic,
the spandrels, like those in S. Sophia, Constantinople, having large cherubim.

The pose of the angels is not one common in Byzantine art, though in
details they suggest a remote connexion with the Christian East. Their
animated appearance and gesture, no less than the arrangement of the
draperies, rather suggest Western affinities, which Clemen finds in the
almost contemporary Roman mosaics of the time of Paschal (817–824),
especially those in the chapel of S. Zeno in S. Praxed's. It has been men-
tioned above in connexion with the stucco decoration that there may be
Visigothic influence from Spain in the decoration at S. Germigny. In the
arcading of the bema mosaic ornament as well as stucco has a pronounced
oriental character, the formal ' tree design '[2] recalling Sassanian prototypes,
and suggesting an ultimate origin in Persian Mesopotamia. We may note
that tenth-century mosaics on the *mihrab* of the great mosque at Cordova
also show variants of the formal tree.[3]

The mention of the Cordovan mosaics may naturally lead to that of the
first mosaics produced under Islam, in those regions of Western Asia to
which Mohammedan art owed so many suggestions during the early period
of its development.

The mosaics in the Mosque of Omar (Dome of the Rock, *Kubbet es-
Sakkrah*) and the Mosque of El-Aksa at Jerusalem [4] have mosaic decoration
in the form of purely ornamental designs, foliate and geometrical, in which
a Persian influence may be discerned. The earlier work in the Mosque of
Omar probably dates from the latter part of the seventh century,[5] but that

vived into comparatively modern times. Such
was the considerable cycle in the church
of the Daurade at Toulouse, described by
Dom Lamotte in 1633, and by Jean de Cha-
band in 1625. This appears to have dated
from the eighth century, and to have been
based upon earlier Christian art such as we
find at Ravenna. See P. Clemen, *Die roma-
nische Monumentalmalerei in den Rheinlanden*,
1916, pp. 183 ff.

[1] R. de Lasteyrie, *L'architecture religieuse en
France à l'époque romane*, p. 218 ; P. Clemen,
*Die romanische Monumentalmalerei in den
Rheinlanden*, Düsseldorf, 1916, pp. 719 ff. and
(coloured) plate xlii. Cf. above, pp. 62, 102, 158.
The illustrations commonly published are based
on a water-colour by Lisch, who restored the
church 1867–70. For the history of the
church and its restorations see Prévost, *La

basilique de Théodulf*, and, for the mosaic
decoration, p. 73.

[2] Clemen, *as above*, fig. 475.

[3] *Ibid.*, fig. 477. A closer resemblance, also
noted by Clemen, is that to the tree-motive
on the enamelled ewer of S. Maurice d'Agaune,
ascribed to the ninth century.

[4] *B. A. and A.*, pp. 412–15, with the earlier
references, to which may be added : R. Hart-
mann, *Der Felsendom in Jerusalem*, Heft 69 of
Zur Kunstgeschichte des Auslandes, Strasburg,
1909, and *Geschichte der Aksa-Moschee* in
Zeitschr. des Deutschen Palästinavereins, xxxii,
1909, p. 185 ; Strzygowski, *Felsendom und
Aksamoschee* in *Der Islam*, ii, pp. 1 ff., 1911 ;
Gressmann in *Palästina-Jahrbuch* (ed. Dalmann),
1908, pp. 54–66.

[5] Inscriptions give the date of A. H. 72 (Van
Berchem, *Inscriptions arabes de Syrie*, pp. 8 ff.).

in the dome and on the sides of the drum is of the eleventh. The mosaics of the Mosque el-Aksa date from the late twelfth century. Probably the craftsmen in the case of the earlier mosaic work done for Mohammedan princes were Christians, and they may in part have come from Constantinople, though the evidence as to this is not certain.[1] In the later work and at El-Aksa probably Mohammedan craftsmen were employed.[2]

Before the fire of 1893 there were early mosaics in the transept of the Mosque of Ummayads at Damascus, representing architecture and formal tree motives.[3] Dickie is of opinion that some mosaic work may still be hidden beneath the plaster of the first four arches of the court by the western gate. Two early fires, one in 1069, the other in 1400, make it difficult to say how much of the work still visible before 1893 may have been undisturbed work of the eighth century.

Post-iconoclastic period. Secular mosaics

The two important series of mosaics of the eleventh century are those in the great church of the monastery of S. Luke of Stiris in Phocis, and those at Daphni in Attica.

The mosaics of S. Luke [4] are generally assigned to the early part of the century. The subjects include Gospel scenes relating to the Twelve Feasts of the Church, according to the liturgical scheme of the time (p. 243), with great numbers of saints, martyrs, ascetics, monks, and ecclesiastics. In the dome is a majestic Pantokrator; in the apse, the Virgin with the Child. The decoration is the work of more than one artist, and shows the influence of the orientalizing monastic spirit; it is marked by a noble and at the same time a severe treatment; the representation of S. Luke the Gournikiote is a strong piece of realism, and evidently intended as a portrait. Character is given to this and other heads by modelling with graduated tesserae; but this is only done in case of heads, the draperies being executed by bold lines in flat and contrasting colours. Oriental motives in the iconography are frequent; when we remember the oriental character of the dome-supports in the church (p. 86), and the apparent evidence of direct Eastern influence in Greece during this period, we are tempted to explain these by immediate contact of the artists with the East. But perhaps the oriental motives really come through the medium of illuminations reproducing an early

[1] See Ibn Batutah, Ed. of the Société Asiatique, i, p. 128. Tabari says that Walid applied to the Byzantine emperor when he desired to restore the mosque at Medina (Chronicle, transl. Zotenberg, iv, p. 162).

[2] In the case of El-Aksa, Saladin sent to Constantinople not for workmen but for gilded tesserae (Strzygowski, *as above*, p. 86, n.).

[3] A. C. Dickie, Palestine Exploration Fund, *Quarterly Statement*, 1897, p. 273; A. J. Reinach, *Rev. Arch.*, June 1911; Saladin, *Manuel*

d'art musulman, i, 1907, p. 85. The style of decoration suggests that of the nave at Bethlehem (p. 292). The tones were green and brown. Mosaics in a similar style decorate the tomb of Daher Bibars at Damascus.

[4] *B. A. and A.*, p. 393. Add Wulff, *Altchristl. und byz. Kunst*, p. 554. Th. Schmidt, *Mos. of the Mon. of S. Luke* (Charkoff, Hist. Phil. Soc., 1914), places the mosaics at the end of the century, or even early in the twelfth.

redaction in which such motives were embodied. And in fact the Gospel
scenes in S. Luke suggest inspiration from a variant of the Antiochene
redaction related to the Paris MS. 74 (p. 311).[1]

The church of the monastery known as Nea Moni, in the island of
Chios,[2] has mosaic decorations following the consecrated scheme of the liturgic
period. In the refinement and grace of their Hellenistic style they approach
those of Daphni, which in time they may closely precede ; the foundation
of the church is ascribed to Constantine X (Monomachos, 1042–1054). They
have suffered considerably from various causes, but when complete must
have deserved comparison with those of the two great Greek churches.

The mosaics of the monastery church at Daphni,[3] on the other hand,
inferior in strength, are admirable in restraint and grace ; they are based
upon a book belonging to the other great redaction, that of Constantinople-
Alexandria, in which the Hellenizing element is more pronounced ; it
must have been a variant allied to the Laurentian vi. 23. Daphni, excel-
lently described by Millet, is now well known as a magnificent example of
middle Byzantine mosaic admirable in colour, refinement, and skilful
composition ; the decorative system conforms to the liturgical scheme of the
period (Plate XL). The date is later than that of the decoration in S. Luke's,
but still within the limits of the eleventh century. At Daphni we see a return
towards the neo-classical art of the early Macedonian period, probably
under the direct influence of Constantinople.[4] There is restrained pathos,
but no passion ; the dominant feeling is Hellenistic, the sterner conception
of S. Luke of Stiris is absent. The imitation of a Hellenistic model is obvious
in the pose and modelling of the figures, which are often seen in three-
quarter view, and stand with the weight more upon one leg than another,
in the antique manner. The drapery is not schematic, but logically dis-
posed ; the faces are idealized (Plate LI). But all oriental influence is not
excluded ; inverted perspective is employed, landscape is not expanded in
picturesque variety, but confined to a single type.

The apse of the cathedral of Serres in Macedonia [5] has the Communion
of the Apostles, as represented at Kieff (p. 289) and elsewhere ; the figure
of Our Lord is as usual repeated, so as to face the two groups of apostles
approaching from the right and left. The workmanship is good, and may be
as early as the close of the eleventh century, though Kondakoff believes it
as late as the thirteenth, owing its excellence to the use of good cartoons.

In Constantinople the Hellenizing style of Daphni is only represented
by two mosaic subjects in the Church of the Chora (Kahrieh Jami), isolated
among work of later date (p. 293). These are a figure of Christ as Redeemer

[1] The monastic tradition has introduced
types, e. g. in the Baptism and Nativity,
derived from the earlier art of Cappadocia
(Millet, *Iconographie*, p. 671).

[2] *B. A. and A.*, p. 396 ; Wulff, *Altchr. und
byz. Kunst*, p. 562.

[3] G. Millet, *Le Monastère de Daphni* ; and
Iconographie de l'Évangile, Index, s.v. *Daphni* ;
O. Wulff, *as above*, pp. 565 ff.

[4] Millet, *Iconographie*, p. 671.

[5] *B. A. and A.*, p. 398 ; Wulff, *as above*,
p. 570.

over the door of the present inner narthex, which shows affinity to work at Daphni, and a part of a *Deesis* in the inner narthex itself, dated by an inscription with the name of Isaac Comnenus, who died in 1152.[1]

The cathedral of S. Sophia at Kieff, founded by Yaroslav in A. D. 1037, has mosaic decoration perhaps rather later than that time, but much restored in the course of centuries.[2] The subjects conform to the liturgical scheme of the eleventh century; they are found in the bema and in and beneath the dome. Differences in the style of execution suggest that the work should be ascribed to various hands, but it must have been directed by Byzantine artists, who themselves took part in its execution. It shows, as a whole, more variety, and a greater tendency towards the picturesque, than that in the church of S. Luke of Stiris (p. 287), but the work is coarser and more lifeless than that of Daphni : the artists were not of the first rank.

The monastery church of S. Michael at Kieff[3] has apse-mosaics Byzantine in type, but probably executed by Russian craftsmen, endeavouring to copy the work of S. Sophia; they date from the first quarter of the twelfth century.

The mosaics at present decorating the interior of S. Mark's at Venice[4] are so various in date and manner that the effect as a whole is marred by incongruity of style.

The earliest work appears to belong to the close of the eleventh century, and, though more schematic in style, has analogies with the mosaics of Daphni (p. 288). To this period are assigned the Ascension in the central dome, the Christ and prophets of the eastern, and the Pentecost of the western dome ; the Feasts of the Church (p. 243), the Miracles, and Life of S. Mark, in the vaults connecting the domes and covering the upper walls, and the Christ between the Virgin and S. Mark in the tympanum over the entrance door. In spite of the use of Latin inscriptions, the introduction of Western saints and other features, the essential character of this work is Byzantine. The subjects from the New Testament are based upon the redaction of Antioch, probably reproducing MS. variants related to the Paris 74 or the Gospels of Gelat.[5] The work of Italian artists begins in the mid-thirteenth century, and is seen on the façade (though here the Translation of the body of S. Mark over the left door is alone original) and, according to Saccardo, in the chapel of S. Zeno. But the most important thirteenth-century mosaics are those in the narthex or vestibule, where possibly the whole decoration may be Italian under direct Byzantine inspiration, though the work in the western, or entrance, section has been assigned to the earlier part of the century, and perhaps to Byzantine masters,

[1] Wulff, *as above*, pp. 566–7.

[2] *B. A. and A.*, p. 396 ; Wulff, *as above*, p. 560. Th. Schmidt, *Cathedral of S. Sophia at Kieff*, 1914 (in Russian), gives the date as twelfth century. [3] Wulff, p. 570.

[4] *B. A. and A.*, p 400, for the earlier

references ; Wulff, *as above*, p. 570.

[5] Millet, *Iconographie de l'Évangile*, p. 602. Wulff regards the series as based, with modification, upon that of the (lost) mosaics in the church of the Holy Apostles at Constantinople, the plan of which was reproduced in S. Mark's,

the rest to Italian pupils and to the second half : it has been noted elsewhere that Venice at this time possessed a Greek colony, including painters, while a mosaic worker, Marcos Indriomeni, is mentioned in a document of A.D. 1153. The subjects, derived from Genesis and Exodus, copy, as Tikkanen was the first to show, an early illuminated Bible similar to the Cotton Genesis (p. 305) ; architecture has been introduced and a gold background substituted for white, but otherwise the reproduction closely follows the original : the story is followed from the Creation down to the life of Moses. The (restored) mosaics in the Baptistery were originally executed in the fourteenth century, and are Byzantine in conception only ; those of the chapel of S. Isidore, which are of the same century, are influenced by the art of the followers of Giotto. The two angels over the Treasury door are probably not earlier than the second quarter of the thirteenth century. The remaining mosaics in the church are of the sixteenth century and later. Reproducing the manner of celebrated painters, they abandon the conventions of mosaic to attempt the effects of pictorial art, and in consequence achieve only a relative success.

The cathedral of Torcello,[1] on an island reached from Venice in a few hours, was restored and reconstructed in the early years of the eleventh century ; it has important mosaics in the apses, and upon the west wall. The Virgin and Child (Plate XLVIII) standing aloft in the principal apse above the twelve apostles has affinities with the figures in S. Mark's. In the right apse Our Lord is seen enthroned between Michael and Gabriel above four episcopal saints ; above the apse, angels support a medallion containing the Lamb : all this work seems to belong to the late eleventh or even to the twelfth century. This seems to be also the most probable date for the Last Judgement on the west wall, disposed in a series of horizontal zones covering the whole surface.[2] At the top is the Crucifixion between the Virgin and S. John ; next comes the *Anastasis* flanked by two (restored) figures of archangels. The remaining zones present the Doom in the typical Byzantine manner. It has been already noted that the methods of inverted perspective and vertical projection (p. 163) are both conspicuous in this composition. S. Donato, on the island of Murano,[3] has in the apse a standing figure of the Virgin which should also date from the beginning of the twelfth century. The mosaics of two apses in S. Just at Trieste are of like period.

Sicily and Southern Italy possess a magnificent series of mosaics executed in the time of the Norman princes under conditions similar to those obtaining in Venice, that is to say, partly by Byzantine-Greek masters, partly by Western craftsmen trained by them ; fortunately there has here been less restoration than in the North.

The interesting mosaics of the twelfth and thirteenth centuries at

[1] *B.A. and A.*, p. 404; Wulff, *as above*, p. 571.
[2] Venturi (*Storia*, ii, p. 429) dates this

ninth century, which seems too early.
[3] *B.A. and A.*, p. 404 ; Wulff, p. 573.

Messina, including portraits of royal personages, are mostly destroyed, but a fine group of the Virgin and Child survives.[1]

In Palermo [2] there are two churches with rich mosaic decoration, the Cappella Palatina, or chapel of the royal palace, and S. Maria dell' Ammiraglio, otherwise the Martorana; not far from the town, on the slopes of the hills commanding the bay, is the cathedral of Monreale. In these buildings we find a mixture of Western and Byzantine plans. The decoration of the Cappella Palatina was finished about A. D. 1160, and with the rich marble lining of the lower walls and painted (Saracenic) ceiling, produces an impression of great splendour. The subjects of the choir and transepts include the Twelve Feasts and in so far follow the liturgical scheme of the eleventh century (p. 243). The principal apse has in the upper part a great half-figure of Our Lord, and below the Virgin seated between four saints (restored). Above the triumphal arch is the Preparation of the Throne; below, on the face of the arch to either side, are archangels and saints, two of whom, SS. Gregory and Sylvester, are of post-Norman date; in the secondary apses are busts of Our Lord and the Virgin with other subjects. The dome has the Pantokrator, and round the base an inscription giving the date A. D. 1143. The mosaics in the nave and aisles, with scenes from the Old Testament and the Acts of the Apostles, are assigned a rather later date and are to be compared with those at Monreale.

S. Maria dell' Ammiraglio, a centralized church of Byzantine type, was erected in A. D. 1143 by George of Antioch, admiral of Roger II. In the dome is the Pantokrator, with angels, evangelists, and prophets below. The vaulted roof has scenes of great merit from the Life of the Virgin; elsewhere are archangels and saints; some of the work probably dates from the second half of the twelfth century. Two mosaic pictures now placed near the west end are of historical interest. One represents the founder, George of Antioch, prostrate at the feet of the Virgin; the other Our Lord crowning Roger II; in the first, the Virgin holds a scroll with a prayer on behalf of the suppliant addressed to Our Lord, who is seen in half-figure above. All the inscriptions in the church are Greek, and the work was carried out by the same Byzantine masters who executed the choir in the Cappella Palatina.

The decoration at Monreale,[3] most impressive as a whole, is inferior in execution to that of the two churches in Palermo, most nearly approaching that of the nave in the Cappella Palatina: the work was done in great haste in eight years (A. D. 1174-1182) for William II. The principal apse has a colossal Christ, above the enthroned Virgin and Child and archangels and saints. In the side apses are SS. Peter and Paul and scenes from their lives; the aisles have Gospel scenes (Plate LII), the nave scenes from the Old Testament, based upon MSS. of the Octateuch. On the lower part

[1] H. Glück, Strzygowski *Festschrift* 1923, pl. 81.

[2] *B. A. and A.*, p. 406; Colasanti, pl. 30 ff.

[3] *B. A. and A.*, pp. 410–12; Wulff, *as above*, p. 574.

of the first two piers leading to the choir are two historical subjects : William II offering a model of the cathedral to the seated Virgin, and Our Lord laying his hand upon the king's head. The inscriptions at Monreale are for the most part in Latin, and most of the work was probably carried out by local craftsmen. But the iconography adheres to Byzantine types, and perhaps some of the better work in the choir is Greek. An interesting point in connexion with the iconographic types is the fact that the New Testament themes reproduced appear to be those of the Constantinople-Alexandria redaction, not, as usually elsewhere in the West, that of Antioch. The mosaics of Monreale are richer in scenery than those of earlier date, but show less intensity of feeling ; there is superficiality in their treatment.

The cathedral of Cefalù on the north coast of Sicily was built by Roger II in the first half of the twelfth century, on a plan resembling that of Monreale, but much of the original mosaic decoration is now lost, including several royal portraits. What remains is now confined to the choir.[1] Here the apse has again a great half-figure of Our Lord above the Virgin and other figures ; the walls have standing figures of saints in zones. Six Latin verses round the apse give the date A. D. 1148. The work at Cefalù is admirable in style, and is the finest example of Byzantine work in Sicily.

Mosaics of the twelfth century in the south of Italy are neither extensive nor important ; they occur in the cathedrals of Salerno and Capua ; those of the time of Roger II, once in the cathedral of Messina, have all been destroyed.[2]

Grottaferrata, the Basilian monastery near Rome, founded at the beginning of the eleventh century, has over the triumphal arch in its church a Pentecost, and over the principal door a *Deesis* ; opinions vary whether these are actually Byzantine of the eleventh century or rather later work in the Byzantine manner ; in either case the effect is good.[3] Wulff, observing a relation in style between figures in the Pentecost and others in the Last Judgement at Torcello, suggests the possibility that the masters who executed the work at Grottaferrata came rather from Venice than from Montecassino.

The mosaics decorating the dome of the Baptistery at Florence[4] are attributed to Andrea Tafi aided by a Greek mosaicist, Apollonios, summoned from Venice ; here Greek influence is apparent, but most of the work seems to be by Tuscan craftsmen. To the other mosaics, in the apse &c., the same remarks apply ; all date from the first half of the thirteenth century.

The mosaics in the Church of the Nativity at Bethlehem[5] possesses important remains of an elaborate decoration executed by East Christian mosaicists for the Emperor Manuel Comnenus in 1169. The mosaics of

[1] *B. A. and A.*, p. 410 ; Wulff, p. 574.
[2] *B. A. and A.*, p. 406.
[3] *B. A. and A.*, p. 412 ; Wulff, p. 573. A. Baumstark, *Oriens Christianus*, iv, 1904,

pp. 121 ff., considers the mosaics to date from the end of the twelfth century.
[4] *B. A. and A.*, p. 412.
[5] Earlier references in *B. A. and A.*, p. 414. Add Wulff, *as above*, p. 576.

the nave, above the columns, are generally considered to date from the period of Justinian, though this theory presents difficulties. They consist of conventional cross-sections of churches framing Greek inscriptions relating to the acts of oecumenical and provincial Councils, between which are conventional formal trees and ' candelabra '—designs constructed of vases and foliations in a Perso-Mesopotamian style like the work in the Dome of the Rock and the Mosque el-Aksa at Jerusalem ; the sections of churches should be compared with the architectural ornament in S. George, Salonika, and the Orthodox Baptistery at Ravenna. These ornamental designs, if not of the early date commonly accepted, appear at any rate to reproduce old Syro-Persian motives of the Sassanian period. Their colour scheme, in which green and red predominate, is peculiar, and not that usually found in early mosaic, and the final Councils are too late to find a place in work of the sixth century. The remaining mosaics in the transepts and choir are dated with more certainty, an inscription in the latter place assigning the decoration to the time of Manuel Comnenus and Amaury, King of Jerusalem, in the year A. D. 1169. The work seems all to have been carried out by Greeks; an Ephraim is mentioned in the inscription, while the name Basilius occurs in the nave. The subjects in the transepts illustrated the story of Our Lord, but only the four remain in whole or in part. At the west end of the church was once a mosaic of the Tree of Jesse.

Well-known mosaics of the early fourteenth century adorn the church of the old monastery of the Chora, near the Adrianople gate, rebuilt at the beginning of the twelfth century and now a mosque known as Kahrieh Jami.[1] They are due to the munificence of Theodore Metochites, minister of Andronicus Palaeologus, and were executed between A. D. 1310 and A. D. 1320 ; this personage is represented over the tympanum of the door from the inner narthex to the church, where he kneels before the enthroned Christ, holding a model of the church in his hand. The decoration now visible consists of two cycles illustrating the life of Our Lord and the life of the Virgin (Plates XLI and LIII); it is confined to the inner and the outer narthex. The life of the Virgin is based upon the apocryphal Protevangelium of James, which is followed, with amplifications due to the individuality of the artist presiding over the work. The interest in these mosaics lies on the one hand in their distinction from the liturgical decoration of the eleventh century, and their approximation in style to mural paintings of the Macedonian school in Serbia (especially Gradatz) and at Mistra. It was observed (p. 259) that those paintings were characterized by a freshness of outlook and a tendency to picturesque treatment. While retaining East Christian types essentially unaltered, they are superficially affected by the grace and pathos of early Sienese painting ; these qualities are explained by the

[1] *B. A. and A.*, p. 416; Th. Schmidt, *Izviestiya* of Russian Arch. Inst. at Constantinople, xi, 1906, with Album ; Wulff, *Altchr. und byz. Kunst*, pp. 588 ff. See also G. Millet, *Iconographie de l'Évangile*, Index, p. 720.

interaction of East Christian and Italian art. In both cycles early oriental iconographical features are remarked pointing to Syria-Palestine. But these were probably already embodied in the illuminated MSS. from which the artist must have worked. We have seen that after the Latin interregnum, when old tradition in the arts had been interrupted, recourse was had to ancient models wherever they could be found, and these were in most cases manuscripts preserved in libraries ; upon these the compilers of Painters' Guides must have largely drawn. The style of the cycles is Hellenistic, though Schmidt has drawn attention to occasional confusion of styles, the artist introducing inverted perspective in scenes otherwise conceived according to true perspective as understood by the Greeks. This would seem to point to the use, by a copyist ill-grounded in tradition, of more than one model in more than one style. For the life of Our Lord, the model seems to have been a variant of the Constantinople-Alexandria redaction akin to the Florence Gospel, Laur. vi. 23. The revived Hellenistic manner is apparent in the architecture, in the picturesque landscape, and in the use of genre scenes ; the artistic feeling of the new age in the freedom and amplitude of treatment, and the fresh rendering of details. Draperies are modelled with regard to anatomy. Figures are seen in profile, and the different parts of an action are presented in a ' real ' background. It is a spirit wholly different from that of the old liturgic period.

Mosaics in the central cupola of the funerary chapel of the church of the Pammakaristos (now Fetiyeh Jami) also date from the early fourteenth century.[1] Above is a half-figure of Our Lord, below the Twelve Apostles. Other fourteenth-century work is seen in the Baptistery of Enrico Dandolo in S. Mark's at Venice, and in the monastery of Vatopedi on Mount Athos.[2]

Secular Mosaics

Mosaics were employed by Byzantine princes in the halls and chambers in their palaces, and from the description left to us of rooms in the Kenourgion (p. 122) we may infer that the old tradition of the historical and ceremonial picture survived into a new era ; battle scenes, official and family groups, all formed part of this decoration.[3] The hunting scenes which had enjoyed a renewed popularity during iconoclasm must also have been reproduced. But the only surviving example of a room so decorated is in the place where the Eastern art was practised for Western princes, in Sicily. Here, in the palace at Palermo, the chamber of Roger II still preserves the complete mosaic ornament of its upper walls and vaulted roof.[4]

[1] J. Ebersolt, *Rev. Arch.*, 1909, pt. ii, pp. 37 ff. ; *B. A. and A.*, p. 420.

[2] Wulff, *as above*, pp. 592, 593. At Vatopedi, the mosaicist has not the skill of the mural painters whom he seeks to rival, and uses among the glass tesserae too many cubes of other material.

[3] In the Romance of Digenes Akritas, describing life in the tenth century, the hero's chamber is described as decorated with mosaic figures of scriptural and secular warriors.

[4] Venturi, *Storia*, ii, pp. 394, 427.

Here are all manner of beasts and birds amid conventional trees or enclosed in circles. Another chamber with mosaics is in what remains of the palace of Zisa, built by William II just beyond the walls of Palermo. Above a fountain in the wall, on a background of floral scrolls, are three medallions in which are men shooting with bows at birds.

Mosaic Pavements [1]

Mosaic pavements composed of tesserae of marble and other stone continued to be used in Christian as in Hellenistic and Roman times, but were especially frequent in the first half millennium. Fixed in a horizontal position on the ground floors of buildings, they have survived the ruin of the superstructure, which has indeed often served as a protection; their number is thus liable to be increased by the excavation of ancient sites. They were probably in very general use, and in view of our unequal knowledge of different areas it is hardly possible to say whether they were more popular in one district than another, but Syria-Palestine has yielded a number of remarkable examples, to which a few interesting additions were made between 1914 and 1918. The dates mostly range from the fifth century to some time after the Arab conquest. The designs include allegorical or mythological figures, animal, and floral and geometrical motives; sacred subjects are not favoured, since these might not be trodden under foot. A few of the more notable examples may be mentioned.

The pavements from Kabr Hiram, a suburb of Tyre, and from the neighbourhood of Sidon, now in the Louvre, offer fine examples of the type in which animals are seen in the convolutions of a formal vine issuing from a vase. The well-known mosaic with Orpheus, found near the Damascus gate of Jerusalem and now in Constantinople, is ascribed to the fifth or sixth century. Among other mosaics found at Jerusalem are three with Armenian inscriptions, one, discovered in 1894, having a series of birds in vine-convolutions issuing from a vase; these appear to date from the sixth century; there were Armenian monasteries in Jerusalem perhaps as early as the fourth century, and there was regular intercourse between the two countries before the sixth. A pavement, similar in style but containing beasts as well as birds, unearthed in the Wadi Shellāl south of Gaza in 1917,[2] had a sixth-century inscription dated A. D. 561–2. The most famous of the Palestinian mosaics came from Madeba, a small town in Moab, which has produced numerous specimens. This is the pavement with a map of a part

[1] *B. A. and A.*, pp. 420 ff. For a general account of Palestinian mosaic pavements see A. Baumstark, *Römische Quartalschrift*, 1906, pp. 139 ff.; a full list down to 1909 is given by R. Hornung, *Zeitschrift des Deutschen Palästina-vereins*, xxxii, pp. 113 ff.; in this list the references to the publications of the Palestine Exploration Fund, and French, German, and other publications will be found. On pavement mosaics in the West in Christian times see E. Müntz, *Études iconographiques et archéologiques au Moyen Age*, 1887 (*Petite Bibliothèque d'Art*).

[2] M. S. Briggs, *Burlington Magazine*, May 1918, p. 185.

of Egypt, Syria, and the Holy Land, unfortunately much damaged.[1] Towns, conventionally represented by buildings, are accompanied by their names in Greek, palm trees are seen here and there, with fish in the rivers and ships on the sea. A most important feature is the representation of Jerusalem with its circle of walls and towers, and the Church of the Holy Sepulchre visible on the west side between the broad *Via recta* and the walls; other towns include Gaza, Jericho. The mosaic is regarded as the oldest example of a true geographical map; the artist seems to possess local knowledge, and one of his objects seems to have been to indicate the sites visited by pilgrims.

A few miles south of Gaza, not far from the site on the Wadi Shellāl mentioned above, mosaic floors were discovered in 1917 on the site of a small church.[2] Here carpet-like diaper designs were surrounded with borders, composed of rectangular and round compartments in which were birds and geometrical motives. An interesting feature here is the appearance of the Phoenix upon a fire-altar of Persian form, perhaps a very early example of Physiologus illustration (p. 319). Other details in the mosaic also show Persian influence; this taken in conjunction with the Armenian mosaics of Jerusalem illustrates the relations between the Holy Land and the countries beyond the Euphrates in the sixth century.

Other important discoveries in recent years include a fine pavement in a church at El-Mukhaiyet, an hour north-west of Madeba; in the nave are human and animal figures in the convolutions of a vine; before the altar is represented a tree with seated and other figures.[3]

A mosaic with Daniel between the lions was discovered in 1917 at Jericho.[4]

In the mosaic pavements composed of tesserae the ornament is conventionalized and planned to cover the whole space in the oriental manner, but the human figures, animals, and birds enclosed within it are still represented in the naturalistic style of late Hellenistic art.

Most of the mosaic pavements in the Holy Land date from a period between the latter part of the fifth and the beginning of the seventh century; the majority appear to belong to the time of Justinian, who maintained the close connexion between the capital and Palestine established by Constantine, and extended his patronage to the country. A number of examples are dated; the dates are reckoned by different eras, and in some cases there is not complete certainty as to the era adopted. As an early dated example we may mention the mosaic at Serjilla in Central Syria, of A.D. 473

[1] *B. A. and A.*, p. 422, adding to the references there given I. M. Casanowicz, *Proceedings of the U.S. National Museum*, xlix, p. 359— a useful summary.

[2] F. M. Drake, *Palestine Exploration Fund, Quarterly Statement*, July 1918, p. 122; *Burlington Mag.*, Jan. 1919, p. 3; *Proc. Soc.* *Antiq. London*, xxxii, p. 47.

[3] *Revue Biblique*, 1914, p. 112; *Zeitschr. des Deutschen Palästinavereins*, xxxviii, 1915, p. 236.

[4] A mosaic previously discovered at Jericho was dated to A.D. 566 (*Revue Biblique*, 1911, p. 286; *Zeitschr. d. Deutsch. P.-V.*, xxxvi, p. 235).

(Seleucid era).[1] Late examples are : the pavement in the lower church of S. Elias at Madeba with the year 490, which, if the era is that of Bosra, =A.D. 596, and another mosaic at S. Elias with the number 502, giving A.D. 608 ;[2] and a pavement found near the large church (cathedral) dated to A.D. 604.[3]

There can be little doubt that Asia Minor and other parts of Hither Asia which at present have yielded only a few mosaic floors will prove to possess numerous examples with the progress of excavation. North Africa, a very rich field, only comes within our purview for the period of Justinian ; in general, its designs have a Roman orientation.

In Italy, where mosaic floors continued traditional motives, such as animals in medallions, to a late period in the Middle Ages, and in Dalmatia, early pavements of definitely oriental character are rare. Work at Grado has been ascribed to the sixth century, and at Parenzo there are early votive mosaics with inscriptions in Latin.[4] In the latter place the marble lining of the apse in the basilica, with its inlays of various colours, is itself a species of mosaic which leads us to the decoration of the floors of churches in the post-iconoclastic period. Thus the remains of a pavement in the church of the Pantokrator at Constantinople have disks of coloured marble bordered with glass cubes, genii, the Labours of Hercules, and figures of eagles in *opus sectile*, reminiscent of the technique on the marble-lined walls.

Some of the mosaic floors in S. Mark's, dating from about the twelfth century, have animal forms in slabs of marble, the ground filled in with a chequer of coloured cubes, as is the case also at Monte Cassino and S. Adriano in Calabria. Other Calabrian and Apulian pavements have mosaics with similar animal designs. Byzantine eleventh-century pavements with geometrical designs in which interlacing bands or variegated borders enclose disks of precious marbles are well represented by the example in S. Luke of Stiris,[5] where the bands are reserved in white marble, and the ground is filled in with small coloured pieces forming geometrical diapers. A somewhat similar style was introduced at Monte Cassino by Abbot Desiderius. Sometimes the interlacing bands were not reserved in the white marble base, but themselves formed of variegated pieces, and this was the method transferred to vertical closure slabs and ambo panels in Campanian churches in the thirteenth century.

History has recorded famous floor mosaics, now lost, in the description

[1] De Vogüé, *Syrie Centrale*, pl. 55 ; Butler and Prentice, *Revue Arch.*, xxxix, 1901, pp. 62 ff., and Princeton Univ. Exped., *Architecture and other Arts*, p. 657.

[2] Strzygowski, *Zeitschr. des Deutschen Palästinavereins*, xxiv, 1901, p. 160 ; *Revue Biblique*, 1898, p. 425 ; *Nuovo Bullettino di Arch Crist.*, iii, p. 148. Strzygowski thinks these dates uncertain, as another local era may have been used.

[3] *Revue Biblique*, 1911, p. 437 ; *Nuovo Bull.*, 1911, pp. 111–13; *Zeitschr. d. Deutschen Palästinavereins*, xxxvi, p. 235.

[4] *B. A. and A.*, pp. 426–7. For mosaics at Aquileia see Gnirs, in *Jahrb. des Kunsthist. Inst. der K. K. Zentral-Komm. für Denkmälerpflege*, ix, 1915, pp. 140 ff.

[5] Reproduced by Schultz and Barnsley.

by Constantine Porphyrogenitus of the sleeping chamber of Basil I in the Imperial Palace at Constantinople. We read of a central peacock in Carian marble with four eagles in the spandrels, the ground being apparently filled with green marble of Thessaly.[1]

For miniature mosaics see Panel paintings, p. 265.

Illumination. The illustration of books was first developed in Alexandria, the great centre of Hellenistic painting, where it grew up in Ptolemaic times under the influence of Egyptian painting upon papyrus. The style was pictorial in the Hellenistic manner, and the subjects were chosen to illustrate an accompanying text ; romances, epics, and literary or scientific works were illustrated by continuous scenes without any of the divisions or the rich ornament which we have come to associate with the word 'illumination'. The subjects followed each other upon rolls of papyrus, and on rolls of this kind the earliest classical illustration which preceded the Vatican Virgil and the Milan Iliad must have been produced. Christian illustration had like prototypes. The Joshua Roll in the Vatican is a case in point, and in various early MSS. not in the form of rolls, features are sometimes detected which point to a similar origin for the designs of their miniatures. As early as the second century a rival to the papyrus roll appeared, probably first in Mesopotamia, in the shape of the book, or *codex*, of vellum pages, the form of which was more convenient and the substance more durable : in the fourth century the codex was already predominant. The new form, through the individuality conferred by the separate page, suited the Hellenistic taste for defined compositions ; the presence of margins round the text encouraged a marginal illustration first popularized in oriental centres. It was not until later that pure ornament became an established feature ; its elements were principally derived from oriental sources, among which the Iranian must be specially mentioned. The colours used by East Christian and Byzantine illuminators are more liable to flake off than those used in Western Europe during the Middle Ages, partly because in the West the vellum was rougher, and was sometimes intentionally roughened.[2] The defect has one advantage for the student : it enables him to see how the work was done. Beneath the colour which has flaked away we find the design sketched in with a fine brush or pen, often in a shade of brown which suggests the use of diluted ink. Gold backgrounds were probably put on before the painting in of the figures was completed ; here a red or magenta priming was first applied, over which the gold was laid.[3] When the gilding was done the figures were finished by the application of successive coats of colour, the first being so thin that the outline drawing beneath shows through. Manuscripts illuminated for presentation to imperial persons were often written in gold or silver letters on vellum dyed purple ; the Vienna

[1] See J. P. Richter, *Quellen der byz. Kunstgesch.*, p. 364.

[2] A. P. Laurie in *Archaeologia*, lxiv, p. 331.

[3] This gold is also inferior, both in adhesive power and in brilliance, to the splendid burnished gold of Western MSS. in the thirteenth century.

Dioscorides (p. 317) is of this class. This magnificence was condemned by the Fathers; S. Jerome in his preface to the Book of Job mentions with disapproval writing with gold and silver on purple vellum, and Chrysostom in like manner condemns gold letters. The *codex purpureus* or *codex aureus* was early imitated in the West, and books of this kind were executed for Charlemagne and his successors. The finest purple colour ('Tyrian' purple) was derived from the *murex*, and continued to be used in Byzantine MSS. into the late periods.[1] In the West, it dropped out after Carolingian times in all countries but Ireland, where the monks are said to have learned how to prepare it from the *purpura* shell-fish found on their coasts; 'Tyrian' purple has been found in an Irish MS. dating from as late as the thirteenth century. Another colour which may be especially mentioned is blue. This, at any rate from the seventh century onwards, was not the Egyptian blue used by Roman painters, but an ultramarine prepared from lapis lazuli by a crude washing process, and apparently, in the mass of MSS., never improved, though a remarkable exception, the Melisenda Psalter in the British Museum (p. 309), provides the earliest example of a really fine ultramarine yet known.[2] In Italy in the second half of the twelfth century there was a great improvement in the quality of the ultramarine made from lapis, and this is manifest during the thirteenth century in French and English illumination. But once more Ireland and Byzantium remain apart; the Irish ultramarine blue, like the Byzantine, does not share in the changes made in other parts of Europe. It has been observed that the continuous use of ultramarine in MSS. through the Middle Ages affords a proof that, despite all wars and invasions, trade routes must have been kept open, since the region of the Upper Oxus was the only existing source of the essential lapis lazuli.

Illuminated MSS., by the extent and variety of the material which they offer, are peculiarly qualified to illustrate the conservatism of Christian tradition in the East. It has been stated above that when the Church, as represented by the monasteries, more especially those under Aramaean influence in Palestine, Nisibis, and Edessa, took control of sacred art, there began a tendency to co-ordinate and unify the themes and cycles employed to illustrate the sacred story. Such co-ordination was naturally carried out in the great artistic centres where effect was given to the new art of compromise described as Syro-Hellenistic (pp. 8, 9). Thus the number of really important redactions was very restricted, and as early as the sixth century Gospel illustration, which may be taken as the most conspicuous example, had come to depend upon two only, that of Antioch, and that of Alexandria-Constantinople.[3] When, some four hundred years later, Byzan-

[1] Laurie, *as above*, p. 319.
[2] *Ibid.*, pp. 324 ff.
[3] Wulff has observed that the survival in such numbers of copies from early secular and Christian MSS. proves that Constantinople must have possessed a great store of such early illuminated books, largely from Alexandria. He recalls the foundation of the imperial library in the Octagon by Constantine, and the introduction of Alexandrian scholars. Copying

tine religious art was establishing itself on new foundations after the misfortunes of the Arab wars and the iconoclastic disturbance, we find a general reversion to models dating from the time preceding these troubles : there was little attempt at new invention. In the full illustration of the *Tetraevangelia* of the eleventh century we discover mosaic-types from the Church of the Holy Apostles as described by Mesarites,[1] and of frescoes from the church of S. Sergius at Gaza as described by Choricius, the first representing the Alexandria-Constantinople redaction, the second the Antiochene. Two MSS. of the eleventh century represent the two redactions as perpetuated in the middle Byzantine period and serve as sign-posts on the long road.[2] But it would be an error to conclude from the constancy of iconographical types that there was no change or variety in the illuminator's art. We have seen that in the field of sacred art it participated to the full in the main phases of development affecting East Christian art as a whole. Moreover, new classes of manuscripts came into existence, requiring for their illustration new compositions ; in their case there can be no question of servile imitation. Such a new group was that of the illuminated Menologies, or Calendars with lives of the saints, which only appeared after Simeon Metaphrastes had collected the legends in the tenth century. Let it be granted that in these calendars the endless executions and tortures are monotonous, and that heads seem always to be cut off with the same gesture, yet the variety of compositions is still sufficient to prove that a creative talent still survived. The growing number of portraits found in MSS. no less than in greater works of art during the later centuries proves that the faculty of observation was far from being lost. Occasionally, as in the Octateuch in the Vatican (no. 746), the illuminator clothes traditional figures in the costume of his own day.

The value of a work of art for the history of development is sometimes in inverse proportion to its size, since portability is often a factor of primary importance. The illuminated book is the most striking example of this ; for it combines compactness and portability with an unrivalled comprehensiveness of subject ; a few small pages may contain the material for the decoration of a whole church. The history of East Christian art provides various examples of the influence thus exerted by illumination. We recall the mosaics in S. Mark's at Venice, copied from the miniatures of an early illustrated Bible, like that of which the Cotton Genesis in the British Museum formed a part ; we recall the much older mosaics in S. Maria Maggiore at

indeed began long before, at any rate in the case of secular books ; an early edition of the ' book of plants ' of the physician Dioscorides is partly copied, in the sixth century, by the splendid MS. now known as ' the Vienna Dioscorides ' from the city where it is preserved (*Altchristliche und byzantinische Kunst*, p. 289).

[1] Though it is not certain that these mosaics are of sixth-century date, it is believed that they represent a cycle of that period.

[2] The MS. in the Laurentian Library at Florence (Laur. vi. 23), and that in the Bibliothèque Nationale at Paris (gr. 74). See G. Millet, *Iconographie de l'Évangile*, introductory pages.

Rome, which must also reproduce the miniatures of an early Bible. The illuminated MS. as emigrant probably did more for the development of sacred art in the early Middle Ages than any other agent. In times when the art of multiplying prints was unknown, it spread the knowledge of artistic types and forms, much as the engraving did after the fifteenth century; and though through the absence of mechanical reproduction the radius of its action was less wide, its possession of colour lent it a superior power of attraction. A Western monastery in possession of a MS. containing a rich series of Gospel illustrations had potentially a model for the decoration of its own church walls. A manuscript might be lent, or re-copied; thus cycles and themes might be diffused through wide regions, and translated into local styles. It is hardly possible to over-estimate the services which East Christian and Byzantine manuscripts thus rendered to the West in the earlier Middle Ages. In Italy the connexion with Eastern monasticism began towards the end of the fourth century. In the sixth, we find Cassiodorus establishing in the south monasteries in which the transcription of books can hardly fail to have been accompanied by illumination; and Cassiodorus was an admirer of the theological schools of Nisibis. Through one part or another of her territory Italy was in direct relation to Eastern monasticism and its art during the whole period from the fourth to the twelfth century.

The conquest of Justinian in A.D. 554 introduced a Byzantine influence destined to last for some two hundred years in the north and centre, though the territory held by the East Roman Empire was hemmed in by Lombard aggression (p. 59). It has been noted that the period comprising the seventh century and the first part of the eighth witnessed the reign of thirteen Eastern popes, of whom the majority were Syrians, though some came from Sicily and Calabria, always active centres of East Christian culture. We have seen how the Eastern monasteries were maintained in Rome after the fall of Ravenna in A.D. 751; how iconoclasm led to an influx of fugitives from the Byzantine Empire into Apulia, and how Basilian communities flourished in the south in the tenth and succeeding centuries. The results of this continued contact are apparent in the history of surviving books, and of mural paintings inspired by manuscripts. The Gospels of Rossano (p. 312) are thought to have entered Italy as early as the sixth century; some similar book must have inspired the Latin illuminators, who, perhaps at Rome, painted the Gospels of the seventh century at Corpus Christi College, Cambridge.[1] The latter book was at S. Augustine's, Canterbury, at least as early as the ninth century, and may have been brought to England by the Neapolitan abbot Hadrian who accompanied Archbishop Theodore.[2] It has two illuminated pages, containing a seated figure of S. Luke, and small scenes from the Life of Christ. In the representation

[1] Millet, *Iconographie de l'Évangile*, pp. 594, 595.

[2] M. R. James, *The Ancient Libraries of Canterbury*, p. lxvii.

of the Washing of the Disciples' feet, for example, we trace the Cappadocian type which occurs in the Rossano Gospel.[1] The Ashburnham Pentateuch [2] now in the Bibliothèque Nationale at Paris (Nouv. Acq., Lat. 2334), another seventh-century Italian book, seems in like manner to have been inspired by an early oriental MS., though here the prototype may have been of Jewish origin and produced at Alexandria. The title-page somewhat recalls the canopy under which S. Matthew sits in the Rossano Gospel, but the illustration as a whole is barbaric in its rude energy and the arrangement of the figures in superposed zones illustrates the primitive method of 'vertical projection' (p. 163). Two pages on purple vellum at Munich (Clm. 23631, *Cim.* 2) are also the work of an Italian artist reproducing subjects from an early East Christian book.[3] In the Roman mural paintings of the eighth century we recognize motives which recall early Syrian illumination (p. 249).

The Eastern illuminated book extended its influence beyond Italy as early as the seventh century, for the portraits of the Evangelists in the Lindisfarne Gospels produced in Northumbria about A.D. 700 are derived from Eastern prototypes,[4] and the figure subjects in the Irish Book of Kells must have a similar inspiration. The illuminations of the Southern English schools, especially that associated with Canterbury [5] in the eighth century, are in the same way ultimately connected with the East, as are those of Merovingian France, Italy probably serving as transmitter. When we come to the Carolingian period we find in the Gospels of Godescalc (A.D. 781–783) in the Bibliothèque Nationale at Paris a circular sanctuary surrounded by birds and beasts closely resembling a miniature in the Syrian Gospels of Edgmiatsin (p. 313), a motive reproduced once more in the later Gospels of S. Médard.[6] In the ninth-century Sacramentary of Drogo we find further evidence of oriental inspiration: the treatment of the Betrayal, for instance, is closely allied to that in a thirteenth-century Coptic MS. in Paris, and the prototype of both is an oriental MS. earlier than the Gospels at Florence.[7] But the most interesting Frankish book from this point of

[1] Millet, *as above*, p. xlviii.

[2] A. J. Herbert, *Illuminated Manuscripts*, p. 161.

[3] Millet, *as above*, p. 595.

[4] Perhaps transmitted through early copies made in the south of Italy. Thus the *Codex Amiatinus* in the Laurentian Library at Florence, a Latin Bible written in Northumbria about the same time as the Lindisfarne Gospels, copied an earlier Latin Bible, which may actually have been the *Codex grandior* written for Cassiodorus. Several miniatures prefixed to the *Amiatinus* are of sixth-century date, and must have come from the early model. One of these represents Cassiodorus seated writing in his library, and from this page the seated S. Matthew in the Lindisfarne Gospels must have been

copied. The *Codex grandior*, if such the model was, was brought from Rome to England by Ceolfrid, who accompanied Benedict Biscop on his fourth visit to the papal city. The *Amiatinus* was one of three copies made for Ceolfrid, who set out with it for Rome in 716, intending it as a gift for the Pope. He died on the way, at Chartres, but his wish was carried out. (E. H. Zimmermann, *Vorkarolingische Miniaturen*, 1916, pp. 110 ff., and 260. The illumination with S. Jerome writing is seen in fig. 24, which may be compared with the Evangelist in the Lindisfarne Gospels.)

[5] For this school see Zimmermann, *as above*.

[6] References in *B. A. and A.*

[7] Laur., vi. 23; Millet, *Iconographie de l'Évangile*, p. 312.

view is the well-known Utrecht Psalter, written and illustrated near Reims in the early ninth century, probably by an Anglo-Saxon. Though the original subjects are strongly modified in form by the individual style of the artist, it is clear that the prototype must have been Hellenistic, dating from the fourth or fifth century. The outline drawings give the artist's version of Hellenistic landscape; we have typical Greek personifications of cities, natural features, abstract qualities, &c., and these, like the groups of warriors, especially recall the Joshua roll (p. 305); the curious machine used for casting lots at the Hippodrome at Constantinople serves to illustrate the passage in Psalm xxi about the parting of the garments by lot.

The ninth-century Gospels of Angers (Bibl. mun. 24) contain a Descent from the Cross identical in type with an almost contemporary wall painting at Tavchanle in Cappadocia. Further, the large group of Carolingian illuminated MSS. known as the Ada Group shows numerous traces of Syrian inspiration in ornament and in figure-subjects, all of which are reflected in a whole group of allied carvings in ivory.

German MSS. of the Ottonian period, when, as we have seen (p. 64), relations between Italy and Germany were constant, had been considered to derive their characteristics from two sources : Carolingian MSS. of the Ada Group, in which oriental ornamental motives are conspicuous, and the early Christian art of the West. Millet, revising upon iconographical evidence the theories of Haseloff and others, finds their true prototypes in the work of such Palestinian illuminators as those who towards the ninth century painted in flat tones the Paris MS., gr. 923, and the Homilies of Gregory of Nazianzus at Milan.[1] The Ottonian illuminators were not therefore merely copying their Carolingian predecessors, but drawing more deeply from the same sources, and appropriating not only types, but whole Gospel cycles ; it is known that a Greek Gospel-book had reached the library of Reichenau or S. Gall at a very early date. Iconographical study even enables us to say that the redaction which they chiefly followed is that of the Paris Gospels (no. 74), the redaction of Antioch and Palestine. The Codex of Archbishop Egbert of Trèves and the Gospels of Gotha are alike in this respect.

In the high Byzantine period between the eleventh and thirteenth centuries the Eastern influence in Italian art was general : it was the age of the Venetian mosaics in the north and the Sicilian in the south, the age of the frescoes of S. Angelo in Formis and of S. Urbano in Caffarella. In the second half of the eleventh century the introduction of artists from Constantinople by Desiderius, abbot of the great Benedictine House of Monte Cassino (p. 61), was followed by a marked Byzantine influence in the figure-subjects of MSS. illuminated in the abbey, though in the decorative ornament of initials Celtic and Lombardic elements unite to form a characteristic South Italian style.[2] In the Exultet Rolls used in the

[1] *Iconographie de l'Évangile*, p. 598.　　　　[2] A. J. Herbert, *as above*, p. 164.

consecration of the paschal candle on Easter Eve, Byzantine influence is apparent in many of the compositions. In the great eleventh-century illustrated Bible from the monastery of Farfa near Spoleto in Central Italy, now in the Vatican (Lat. 5729), which draws on the same sources as the later MS. at Milan (L. 58), with extracts from the Gospels and Apocrypha, we find a narrative cycle derived, like that of the Paris Gospels (gr. 74), from the Antiochene redaction. This Paris 74 and its congeners themselves copying much earlier books, we have a chain of evidence connecting the art of Syria-Palestine in the First Period with that of Italy in the advanced Middle Ages. As Millet says,[1] after examining the Farfa Bible we are no longer surprised to discover East Christian iconography, and even technique, in the work of the miniaturists of the thirteenth century at Bologna, Verona, and, above all, at Siena. Farfa, where an active school of illuminators evidently worked in the second half of the eleventh century,[2] may be regarded as a half-way house between the south of Italy and Siena, North Italy and Germany. From Italy, as we have seen, the way over the Alps was open : the *Hortus Deliciarum* of Herrad of Landsperg, Abbess of Hohenburg in Alsace, written A.D. 1165–1195, shows signs of like Eastern influence (cf. the pictures of the Last Judgement), and the Gospels of Goslar do the same ; the whole of German art towards the thirteenth century is permeated by Eastern influences and there is a general absorption of oriental types.

It is not suggested that in any of the Western countries illuminators were mere copyists of Eastern models. If they borrowed types and cycles, or even technical methods, they painted in their own style, and with greater freedom than the later painters of panel pictures (p. 240). Nevertheless the Eastern model rendered all of them a priceless service ; it evoked their latent powers, and started them upon the path of development.

It will be well for the purposes of this abridged survey first to divide existing illuminated MSS. into two main groups, religious and secular, then to subdivide the religious group, which is the most extensive, into : (*a*) Early books of the Old Testament ; (*b*) Psalters ; (*c*) Prophets ; (*d*) Gospels ; (*e*) Theological works ; (*f*) Menologies and Church Calendars. The secular group is largely composed of books of a scientific or semi-scientific character ; since these are based upon Alexandrian sources, and were first illustrated in Alexandria, their style is Hellenistic and little affected by oriental influences unless, like the Christian Topography of Cosmas Indicopleustes, or the Physiologus, they were produced in a monastic environment.

[1] *As above*, p. 610.
[2] Sir George Warner, *The Gospels of Matilda*, *Countess of Tuscany* (Roxburghe Club, 1917), p. 25.

I. *Religious.* (a) *Early Books of the Old Testament*

The earliest remains of Old Testament illustration are the Itala fragments formerly at Quedlinburg;[1] the text is in Latin in a hand of the fourth century, the miniatures perhaps earlier than the text. There are four pages from the Book of Kings, on three of which there are four miniatures to the page. These miniatures are simply inserted in the text, and surrounded by a plain red border : thus even at this early date, when the model of the Joshua Roll (see below) retained continuous scroll illustration, the separation of miniatures proper to the codex or book had begun. In the treatment of the subjects a dramatic influence is apparent, suggesting the influence of the theatre ; the figures are few, and the chief actors are in a frontal position facing the spectator, before a simple background. It is by chance that this series of miniatures is accompanied by a Latin text ; the prototype must have been Greek and produced in Alexandria.

The Cotton Genesis in the British Museum, irreparably damaged by the fire in the Cotton Library[2] in A.D. 1731, has now only a hundred and fifty fragments, mostly so spoiled as to possess small value for the history of art ; it is not without affinity to the Itala fragments. The backgrounds of the miniatures were coloured, generally blue, and executed in a classical style in some respects recalling that of the well-known Virgil in the Vatican, or the Iliad in the Ambrosian Library at Milan. There is landscape treated in the Alexandrian manner, and the figures are well drawn and modelled, though they are surrounded by a thick dark outline ; the colours are rich and harmonious. The MS. may go back even to the fifth century. The subjects of the Cotton Genesis are repeated in the thirteenth-century mosaics in the vestibule of S. Mark's at Venice (p. 290) ; some variant of the same redaction must have been available to the designer of the work. This redaction diverges from the Syrian type, and may have been Alexandrian, like that followed by the carved wooden doors of S. Ambrogio at Milan (p. 189) and the Paris Psalter no. 139 (see below, p. 307).

The Joshua Roll[3] in the Vatican Library is a reproduction of an Alexandrian original dating from the fifth century ; its analogies in style to the Paris Psalter (Bibl. Nat., gr. 139), a product of the period of imitative revival, render almost certain its attribution to that age. The designs, which illustrate the story of Joshua (Plate LV), are outlined in brown ink and tinted ; it is suggested that the roll was intended to supply models for mural paintings, and that for this purpose such slight tinting sufficed. The style of the drawing is Hellenistic, and true perspective is attempted ; personifications of cities, rivers, and mountains are numerous ; orientalizing

[1] V. Schultze, *Die Quedlinburger Itala-miniaturen*, Munich, 1898 ; O. Wulff, *Altchr. und byz. Kunst*, p. 282.

[2] *B.A. and A.*, p. 446 ; W. R. Lethaby, *Archaeological Journal*, lxix, 1912, pp. 88 ff. ; O. Wulff, *as above*, p. 284.

[3] O. Wulff, *Altchr. und byz. Kunst*, p. 280 ; *B.A. and A.*, p. 447.

features are few. The subjects here and there closely resemble some of those in the nave mosaics of S. Maria Maggiore at Rome, and we may presuppose a common source in some fifth-century illustrated Bible such as that of which the Cotton Genesis formed part. The text is of the ninth or tenth century; the names near the figures are contemporary with the illustrations, which may have been executed as early as the sixth century, or rather later. Some examples among the group of secular ivory caskets (p. 214) may have been drawn for certain motives on a roll of this kind.

The famous Genesis at Vienna[1] is considered to date from the early sixth century. It is in good condition, written in silver letters on purple-stained vellum, the text (added after the miniatures) being above, the illustration below. Though personifications and other classical survivals are found in the book, the drawing of the figures is often almost grotesque; the vivid realism and the ardour for direct narration mark oriental influence; it is a vigorous and lively but uncouth art. The work of several hands is clearly discerned, some keeping nearer to Hellenistic rules than others; in the case of the latter, we find gestures and attitudes unknown to Greek art, and such oriental methods as inverted perspective. The prototype is probably to be sought in the north of Syria or in the east of Asia Minor; the Vienna Genesis itself, like the other purple-leaved books which have come down to us, is thought by Wulff to have been illuminated in a Palatine school at Constantinople which produced these sumptuous volumes for use as imperial gifts.

Among later illustration of Old Testament history the first place belongs to the great Bible in the Vatican (Reg. gr. 1) dating from the first half of the tenth century, and produced for Leo, a high official of the palace at Constantinople : only the first volume has been preserved, from Genesis to the Psalms. The work is Hellenistic in style and presents close analogies to the Paris Psalter (gr. 139), p. 307. The illustrated subjects include the Creation, story of Moses, Anointing of David, Coronation of Solomon, Ascension of Elijah, exploits of Judith, the Maccabees before Antiochus, a sealed figure of David, and Leo presenting the book to the Virgin.

The *Octateuchs*, MSS. of the first eight books of the Bible, date from the eleventh and twelfth centuries; five are well known, the best being one in the Vatican (746). They all clearly go back to a Hellenistic roll of the kind from which the Joshua roll is derived. Their illustrations of the Book of Joshua closely follow those of the Vatican roll or of a common ancestor, but are far inferior in execution; so close is the relationship that we can infer the nature of missing miniatures from the Octateuch illustrations. The persistence and fidelity of reproduction remind us of the similar qualities shown in the copying of Gospels, and enable us to bring manuscripts of the most various dates into relation with each other.

[1] *B. A. and A.*, p. 444; O. Wulff, *as above*, pp. 298 ff.

(b) *Psalters*

Chance has decreed that there should be no surviving illuminated Psalter of earlier date than the ninth century. It is nevertheless certain that the illustration of this book must have been undertaken some five hundred years before that time. It is most unlikely that the Psalms should have been omitted when Old Testament illustration was in full course ; the comparative study of ninth-century and later MSS. presupposes the existence of Hellenistic prototypes similar in style to that which we infer from a study of the Joshua Roll ;[1] monuments of different kinds, such as the carved wooden doors of S. Ambrogio at Milan, frescoes at Bawît, and the sixth-century silver treasure from Cyprus, all with scenes from the life of David, show that the story of the Psalmist himself was reproduced by the artists of the early centuries. The absence of an early Christian illustrated Psalter must therefore be attributed to chance rather than to any other cause.

Illuminated Psalters have been divided into two classes—one predominantly Hellenistic, the other produced in a monastic (and therefore, in all probability, an Aramaean) environment, but not without Hellenistic influences. The first of these groups has been described as the ' aristocratic ', because the books which form it were illustrated for members of the Court and the higher classes of Constantinople ; the second the monastic-theological, because the illuminators were clearly monks working in the interest of theological ideas, and partisans in religious controversy.[2] The most famous example of the first (aristocratic) group is the tenth-century psalter in the Bibliothèque Nationale at Paris (gr. 139), the illustrations of which are based upon the Constantinople-Alexandria redaction.[3] These illustrations form veritable pictures, conceived as wholes, and executed in the style of the neo-classical revival which followed the period of iconoclasm. The Hellenistic landscapes, the architecture, the personifications are all present, the figures are idealized and treated in the manner of Alexandrian art ; the prototype must have been a MS. executed in Alexandria in the fourth century or rather later. A few slight traces of Aramaean influence hardly mar the consistency of the Hellenistic style. The eight full-page pictures at the beginning illustrate the story of David ; a second set at the end includes the Crossing of the Red Sea, Moses receiving the Law, Jonah, Hezekiah, and one which has been frequently reproduced : Isaiah standing between the personifications of Night and Dawn. There is a smaller replica of the Paris psalter in the monastery of Vatopedi on Mount Athos (no. 609), dating from the eleventh century, and another ' aristocratic ' book in the monastery of the Pantokrator (no. 49), of the same age : these are the only two copies with perfect illustration ; numerous other

[1] As already observed, this was the case with the (Carolingian) ' Utrecht Psalter '.

[2] Some miniatures refer to the iconoclastic dispute.

[3] Wulff, *Altchr. und byz. Kunst*, pp. 284, 522. For earlier references see *B. A. and A.*, p. 468.

examples have lost their miniatures in whole or part. The great psalter of Basil II in the Marcian library at Venice belongs to the aristocratic group.

The Psalters of the second or monastic group are of greater human interest than those of the aristocratic. They employ the oriental method of marginal illustration which we find in certain Gospels, including those of Rabula (p. 313). Comparative study shows that these books also go back to an early prototype,[1] though less early than that from which the aristocratic group descends : it may be supposed to date from the sixth century, and to have been inspired by the composite art demanded by the Church in the previous century (p. 8), an art in which Aramaean monasticism, under the direction of North Mesopotamian theology, played so large a part. Iconographical studies have made this clear, though they have not yet established with certainty the region which first produced the Psalter with marginal illumination. The place of origin may have been Syria-Palestine or Cappadocia,[2] and to this side we may ascribe the characteristic non-Greek elements.[3] But despite its strong oriental colouring the illustration is yet rich in picturesque Hellenistic detail, so much so that sometimes it seems in the direct line towards the Byzantine Greek Renaissance of the tenth and eleventh centuries.[4]

As the British Museum possesses a fine example of the second or monastic group in the psalter (Add. 19352) written by the priest Theodore of Caesarea for the abbot of the Studium at Constantinople and completed in A.D. 1066, we may draw attention to it as an important representative of the class.[5] The marginal illustrations, which are very numerous, are for the most part well executed and well proportioned ; the action is represented in a lively manner but there are no backgrounds. The text receives a literal illustration of the kind noticed above, and, as Herbert remarks, the monastic and theological character comes out in the scenes from the New Testament, the lives of the Saints, and the history of the Eastern Church. On the reverse of page 27 is one of the scenes referring to iconoclasm : the abbot of the Studium and the Patriarch Nicephorus protest to the Emperor Leo, whose myrmidons are destroying ikons. Ten pages further on we see Arius expelled from the church, and on page 200 Julian the Apostate dragged off by an angel. Other illustrations of interest are figures of the Heavens and the Capture of the Unicorn (p. 124), a rather early Physiologus or Bestiary type.

[1] Millet in A. Michel's *Histoire de l'Art*, i, p. 227, and *Iconographie de l'Évangile*, p. 4.

[2] J. Strzygowski, *Der serbische Psalter*, p. 90 ; Millet, *Iconogr.*, pp. 7, 556. It will be noted below that the Psalter is of great importance to the iconography of the Gospel, especially for the Passion and the Resurrection.

[3] In these Psalters the substance of individual verses or phrases in the text is translated in the most literal manner. Thus Ps. xii. 3 is rendered by an angel standing on the breast of the boastful man and cutting off his tongue ; for Ps. cxxvii. 1 we have workmen building a house.

[4] Millet, *Iconographie*, p. 558.

[5] J. A. Herbert, *Illuminated Manuscripts*, pp. 49 ff. The Museum has also a small Psalter (Add. MS. 40731) of the eleventh century closely related to this group, but introducing the Virtues and Vices.

Other well-known examples of the monastic group are the ninth-century Chludoff Psalter in the monastery of S. Nicholas at Moscow, the oldest illustrated Psalter known,[1] the Hamilton Psalter at Berlin, the twelfth-century Barberini Psalter, and MS. no. 61, in the library of the Pantokrator monastery on Mount Athos, dated A. D. 1084. Psalters of the group continued to be produced in later centuries in Serbia and Russia.

We may mention two other psalters of especial interest. The British Museum Latin Psalter of Melisenda, daughter of Baldwin King of Jerusalem (A. D. 1118–1131) and wife of Fulk, Count of Anjou and King of Jerusalem (A. D. 1131–1144), is in so far allied to the aristocratic group that it has full-page illustrations by an East Christian illuminator at the beginning,[2] as in the case of a Gospel group (p. 310). But the subjects refer to the Life of Christ, not to the story of David. These illuminations are Byzantine in iconography, but are harsh in style and unusual in colouring. Possibly the Basilius whose signature appears on the last of the initial series may have been connected with an Armenian school : the mother of Melisenda was an Armenian princess. The remaining illumination is by a Western hand ; and the whole book, with its carved ivory covers, illustrates in a remarkable manner the blending of Eastern and Western influences in the Latin kingdom of Jerusalem. All the miniatures are in fine condition.

The fifteenth-century Serbian Psalter at Munich is interesting for the frequency of early oriental motives, pointing, according to Strzygowski, to direct relations between Serbia and Eastern monasteries, without Byzantine intermediaries.[3] Others hold that although the work is ultimately based on a Syrian archetype, it is actually derived from a Byzantine model, and may have been produced in the Serbian monastery of Chilandari on Mount Athos.[4]

(c) *Prophets*

The Prophets [5] are illustrated by several fine MSS. in the Chigi Library at Rome, the Laurentian Library at Florence, in the Vatican and elsewhere, dating from the Middle and later Byzantine periods. The Book of Job was a favourite book and was illuminated as a separate volume.

(d) *Gospels*

The illumination of the Gospel followed a similar course to that of other Old Testament books, though it seems to have begun later. The first pictured Gospel was probably a roll with a cycle purely Hellenistic in style,

[1] For this reason the 'monastic-theological' psalters are sometimes called the Chludoff group.

[2] This feature is also found in the Vatopedi MS. 735.

[3] J. Strzygowski, *Denkschriften* of the Vienna Acad., lii, *Phil.-hist. Classe*, 1904 ; *B. A. and A.*, p. 473.

[4] Millet, *Iconographie de l'Évangile* ; Wulff, *Altchr. und byz. Kunst*, p. 521.

[5] References in *B. A. and A.*, pp. 473 ff. ; Wulff, *as above*, p. 526.

executed in the fourth century. The early rolls were followed by codices, where the Hellenistic models were soon modified by intrusion of oriental types, and intensified by the oriental feeling for realism and drama, so that in the age of reproduction in the eleventh century we find both Greek and Eastern elements present in different proportions in the descendants of common prototypes ; as the lost original of the Joshua roll is to the later Octateuchs of Vatopedi, the Seraglio, and Smyrna, so is the unknown Hellenistic prototype of the Gospel to two key MSS. of the middle Byzantine period, Paris 510 and Laur. vi. 23 in Florence (see below). It should be observed that in the study of Gospel motives the actual Gospel books may be supplemented by the marginal Psalters (p. 307), since these have miniatures of the Passion and Resurrection, as well as by the Homilies of Gregory of Nazianzus, and by MSS. of the *Sacra Parallela* of S. John Damascenus, which illustrate the Miracles.[1] The two prevalent systems of arranging the miniatures in the book were both of Eastern origin.[2] In one of these the miniatures were all placed at the beginning, where they form ' a picture-summary ' of the succeeding text : in the other they followed the progress of the narrative, being either inserted in the text or disposed in the margin. In the *Tetraevangelion*, or complete version of the four Canonical Gospels in their order, the illuminations, often very numerous, conform to the historical sequence. In the *Evangelisterion*, or liturgical gospel-book, on the other hand, which begins in the eleventh century, the text consists of the pericopes or lections in the order of the Church calendar, historical sequence being disregarded, and the chosen subjects restricted to those directly illustrating the liturgy ; the series begins with Easter, and the order of the Gospels is John, Matthew, Luke, and Mark. In the mass of surviving Byzantine Gospels, which belong to the eleventh and twelfth centuries,[3] the system of placing the illustrations all together at the beginning is neglected, and marginal illustration is rare. In Tetraevangelia the illustration is generally in the text, either in the form of unbordered ' friezes ', often containing more than one subject each,[4] and without a gold background, or in that of bordered pictures each confined, in the Hellenistic manner, to a single subject.[5] In certain Tetraevangelia, though the canonical order is retained, there is a tendency to reduce the abundant

[1] Millet, *Iconographie de l'Évangile*, p. 4 ; Paris 510 contains the homilies of Gregory.

[2] Millet, *Iconographie*, p. 7.

[3] We have only eight complete or fragmentary Gospels of the earlier centuries, including two Latin copies, one at Cambridge (Corpus Christi College Library), the other at Munich. Of the rest, two are Greek (Codex Rossanensis and Sinope fragment), three Syrian (Rabula ; Paris, Syrian MS. 33 ; and Edgmiatsin).

[4] As in the eleventh century Paris 74, and Laurentian vi. 23.

[5] In Evangelisteria the illustration in the text sometimes takes the form of a single composition filling a whole or almost a whole page. The ancestor of this style, the Petrograd MS. 21, dating from the seventh or eighth century, is probably Anatolian, with affinities to the Codex Rossanensis. Its own descendants are a MS. at Iviron on Mount Athos (no. 1), dating from the tenth or eleventh century, and Ottonian congeners at Trèves and Bremen.

illustration of earlier times to those subjects relating to the liturgy: there is thus a partial approach to the Evangelisteria. The repetition of the same subject in the different Synoptic Gospels is avoided;[1] the old cycles are modified. The logical issue of such reduction is seen in the British Museum MS. (Harley 1810), where only the Twelve Feasts are represented (Plate LVII). These tendencies correspond to those which we found in mural painting during the Liturgical Period (p. 243). In MSS., as on church walls, the Twelve Feasts form the principal subjects; the Miracles and scenes from the Passion fall into a secondary place.

The Gospel MSS. are of high importance as helping us to discover the original redactions through which Gospel iconography was ordered and handed down,[2] and as giving valuable indications of local origin. The tetraevangelia of the eleventh century reproduce iconographical types and features of the sixth, and such a MS. as Paris 115, which is of the tenth century, shows us an earlier link in the chain which connected the two periods. This book has affinities with the Sinope fragments, which in their turn seem to have relations with Cappadocia; a filiation of this kind throws a suggestive light on the strong influence of Cappadocian iconography in the late Byzantine Gospels,[3] an influence equally apparent in late mural painting. We have seen that two eleventh-century books, Paris no. 74, and Laurentian vi. 23 at Florence, have been shown by Millet to represent two main redactions into which Gospel illustration was already divided in the sixth century, that of Antioch, and that of Alexandria-Constantinople; the cycles which they follow correspond respectively to those of the sixth-century mural paintings at Gaza as described by Choricius, and those of the church of the Holy Apostles at Constantinople as described by Mesarites.[4] Early affected by Eastern influences such as those manifest in Gospels like the Codex Rossanensis, cycles originally Hellenistic carried down through the centuries the oriental features which we find in the Tetraevangelia.[5] But despite this penetration, the framework remained Hellenistic; the latest Byzantine transcription never lost the Greek tradition, which remained always a living force. Outside Constantinople the oriental element was relatively stronger. Eastern Gospels often remain faithful to frontispiece

[1] As in Paris MS. gr. 115 (tenth century), and MS. Copte 13. The first of these books has affinities to the sixth-century Sinope fragment (p. 313), and is perhaps of Anatolian origin. The second represents an Egyptian tradition, probably influenced from Palestine (Millet, p. 12).

[2] Especially Paris MS. gr. 74, Laurentian vi. 23, both eleventh century, together with the tenth-century Paris 115.

[3] Millet, *Iconographie*, p. 569. Cappadocian iconography was originally introduced by Aramaean influences, and is therefore only Aramaean

(Syrian) iconography at second remove.

[4] It is noted elsewhere that the mosaics of the Holy Apostles are not accepted by all authorities as of the sixth century. But even if later they themselves reproduce an older cycle.

[5] Compositions were rearranged as 'friezes'. The dramatic energy, and the mystical austere spirit of the old books penetrated the calm and picturesque Hellenistic treatment of the subjects. The paintings in the Cappadocian rock-cut churches perpetuate the same features in a similar way.

illustrations, and do not intersperse them in the text. The practice of the Codex Rossanensis and of the tenth-century MS. of Edgmiatsin [1] is preserved in Syriac [2] and Armenian Gospels, the latter written at Melitene and at Van. [3] In the same way, marginal illustration, also of oriental origin, persisted into late times in cases where oriental influence is present. Even the Psalter of 1066 in the British Museum, with its abundant Hellenistic motives, takes this form, though executed at the Studium in Constantinople, because Theodore, the abbot responsible for its production, came from Caesarea : the fragment from Sinope dating from the sixth century is the earliest known example of Anatolian origin. [4]

The Rossano Gospel book (Codex Rossanensis), [5] of which only about half survives, has analogies to the Vienna Genesis ; it also is written in silver uncials on purple vellum, and dates from about the same time. The resemblances with the Vienna MS. are chiefly in types of face and details of costume or architecture. But in the Rossano book the figures have more repose and dignity, and the miniatures are inspired by an evident theological purpose. It is believed by Kondakoff that they were intended to illustrate the liturgy of Passion Week in the Alexandrian Church, and that their realism is that characterizing monastic art. The date of the manuscript cannot be later than A.D. 500. While in some of the Vienna Genesis miniatures 'illusionist' Hellenistic representation is preserved, in the Codex Rossanensis and its congener (see below) this is almost wholly abandoned. Landscape is reduced to a few schematized features brought into line with the figures ; only in the Gethsemane scene is there any suggestion of perspective. 'Vertical projection' is employed ; the two parts of a scene are placed one above the other. The transition from the illusionist and picturesque methods to this formal treatment of space is probably due to the growing influence of monumental, especially mosaic, art ; the loss in skill of drawing and variety of attitude and gesture is compensated by a logical simplicity of composition. The Codex Rossanensis illustrates for us in a striking manner that Syro-Hellenistic art which in the fifth century resulted from the compromise between Greek and Syrian elements. The miniatures derive from a Syro-Palestinian redaction to which are due new iconographical features, seen for the first time in this book : such is the scene of Our Lord distributing the bread and wine to the apostles. We also

[1] It dates from 986 ; see p. 313.

[2] An example (Add. 7169) of the twelfth century is in the British Museum.

[3] The Van MSS. are the later, dating from the fifteenth to the seventeenth century. For Armenian MSS. see Macler, *Miniatures arméniennes*, Paris, 1913. The Psalter of Melisenda (p. 309) in the British Museum, though written in Latin, also preserves the 'frontispiece system', probably through the influence of an oriental model.

[4] In the Edgmiatsin Gospel dating from 986, and the interesting Gospel of Patmos assigned by Kingstenberg, its discoverer, to the tenth century, but considered rather later by others, the rare marginal illustrations occupy the 'inner margin' between two parallel columns of text (Millet, *Iconographie*, p. 6).

[5] *B. A. and A.*, p. 452 ; O. Wulff, *as above*, p. 300.

meet here for the first time the ' author's portrait ' of secular MSS. pressed into service to represent an evangelist, here S. Mark.[1]

Forty-three leaves of another Gospel of the same recension, also on purple vellum, with miniatures, were obtained at Sinope in 1900, and are now in the Bibliothèque Nationale at Paris.[2] The execution of the miniatures is inferior to that of the illustration in the Rossano book, and perhaps rather earlier; but there is great vivacity and expressiveness. Other fragments in the same style now in the Library at Petrograd were also obtained at Sinope.

While, from the locality of the Sinope discovery, the Rossanensis group has commonly been assigned to Asia Minor, it is attributed by Wulff to Constantinople, where he regards the *codices purpurei* as most likely to have been produced for imperial persons.

The Gospels of Rabula [3] in the Laurentian Library at Florence are so called from the calligrapher whose name is given in an inscription, together with the date A.D. 586 and the place where the work was done, the monastery of S. John at Zagba in Mesopotamia. The miniatures directly illustrate the story in the oriental manner; the illumination is executed in rich colour recalling that of the Rossano codex, to which several scenes and subjects (Entry into Jerusalem, Communion of the Apostles) have analogies. But the present Gospel is distinguished by a profusion of decorative motives, especially arcades surmounted by birds, vases, trees, plants, flowers, &c., at the sides of which most of the figure subjects are disposed. The system of marginal illustration is distinctively Syrian, but Greek tradition is apparent in the marginal scenes no less than in the seven full-page miniatures. Four of these are at the end, have the Crucifixion between the two Thieves, with Longinus and Stephaton, the Ascension, Christ among the Doctors, and the Pentecost; if their date is that of the book, they are of exceptional importance, and the Crucifixion, for instance, would be the earliest example in illumination. Against various critics who hold these leaves to be later interpolations, Ainaloff has pointed to the affinity between their subjects and those on the Monza ampullae, supposed to represent lost mosaic designs on the early memorial churches of the Holy Land. An influence from the monumental art of Palestine may be inferred.

The Edgmiatsin Gospels, in the library of the monastery of that name in Armenia,[4] of which the Armenian text is dated A.D. 986, have inserted at the beginning and end miniatures from two MSS. which appear to be as early as the sixth century, the subjects including the Sacrifice of Isaac, a circular sanctuary symbolizing the Christian Church, a type which seems to have suggested the structure over the Fountain of Life in early Frankish

[1] Cf. A. Baumstark, *Monatshefte für Kunstwissenschaft*, viii, 1915, pp. 111 ff.

[2] *B. A. and A.*, p. 458; Wulff, *as above*, p. 300.

[3] *B. A. and A.*, p. 448; Wulff, *as above*,

p. 293. A MS. from the monastery of Mar-Anania, now in Paris, shows a similar system of decorative arcades.

[4] *B. A. and A.*, p. 450; Wulff, *as above*, p. 296.

manuscript illumination, the Baptism, and the Adoration of the Magi. The figure subjects are executed in a rude style, but though Syrian characteristics are marked there was evidently a Hellenistic prototype, the iconography of which goes back to the fifth century. The ornamental work is analogous to that of the Rabula Gospels, and the arcades are decorated in a similar manner with birds and plants.

Among loose leaves from early illuminated Gospels are two with Eusebian canons in the British Museum (Plate LIV), bound up with a twelfth-century Gospel (Add. 5111, fol. 10 and 11), and others of a similar kind at Vienna (no. 847) ; the rich decoration is of Syrian type, and in the former example suggests an origin on the east side of the country, towards Persia.[1]

We note in connexion with the books above described the great importance assumed by ornament. The early illustrated papyrus scrolls of Egypt had no ornament, but simple illustration (p. 298). The method of combining pictures with ornament, or of using ornament as an end in itself, superseded the plain Egyptian style before the sixth century, when the vellum *Codex* had practically replaced the papyrus roll : the undecorated style is only perpetuated in later times in deliberate copies of models illustrated on papyrus, as in the case of the Joshua roll in the Vatican, and the Octateuchs.

In Gospel books of the period following the tenth century to which most MSS. belong (Plate LVI), ornamental head-pieces of a new kind become common, derived from oriental sources, principally Iranian. The decorative art of Islam, carrying to their logical conclusion ornamental principles of Iranian, Mesopotamian, and Syrian origin, had attained a great mastery of geometrical and conventional design ; the Byzantine decorator adopted the general style, incorporating in it elements of his own ; some of the conventional leaf-work is developed from vine-motives used in the First Period in the Syro-Egyptian area. The colour and design of these square head-pieces has been aptly compared to that of fine Persian prayer-carpets. The number of Gospel MSS. of the eleventh and twelfth centuries preserved in the great libraries is very large. The arrangement of their miniatures has been already described, and no more need be said of these typical books ; but we may note the Armenian Gospels of Queen Mlke (early tenth century) in the Mechitarist Library at Venice. Rich head-pieces, in which Syrian and Persian decorative motives combine, are characteristic of the later miniatures dating from between the tenth and seventeenth centuries, and produced chiefly at Van and Melitene.[2] In Egypt the Copts under Islam continued to illuminate Gospel manuscripts, in which the connexion of types and compositions with those of the ancient redactions is clearly marked.[3]

[1] *B. A. and A.*, p. 451 ; Van Berchem and Strzygowski, *Amida*, p. 203.

[2] F. Macler, *Miniatures arméniennes*, Paris, 1913.

[3] Cf. Paris, Bibliothèque Nat., MSS. Coptes-Arabes 13 ; Millet, *Iconographie*, p. 745.

(e) *Theological Works*

Manuscripts of the *Fathers* [1] were illuminated in numbers after iconoclasm, the favourite author being S. Gregory of Nazianzus, whose homilies provided lections for the different church feasts. The Paris Gregory (gr. 510) was written between A.D. 880 and 886, and contains portraits of the Emperor Basil I, his empress Eudocia, and sons. The profuse illustration is suggested by passages in the text, and comprises numerous miniatures of Old and New Testament scenes. Three distinct manners can be distinguished ; one is devoid of beauty, but has the animation of the Vienna Genesis, and freely employs the continuous method of narration, crowding various episodes into a single picture ; the second aims at magnificence, stately pose and gorgeous costume recalling mosaic art ; in the third, classical (Hellenistic) influence predominates.

The miniatures of the Gregory MS. in the Ambrosian Library at Milan are less various in character, but include pictures of the life of Julian the Apostate, and scenes illustrative of mythological allusions. Another important MS. of Gregory at Jerusalem dates from the eleventh century. Allied to the Ambrosian *Homilies* is the *Sacra Parallela* of John of Damascus at Paris (gr. 923) with parallel passages from the Fathers.[2] Textual criticism connects this book with Palestine, and it is oriental in its marginal illustration, its abandonment of modelling for flat colour, and in its zoomorphic ornament. It is iconographically related to the Paris Gospels (gr. 74), and so to the Antiochene tradition.[3] The importance of the Homilies of Gregory and the *Sacra Parallela* of John Damascenus for the illustration of the Gospels has been already noticed. Another Father whose works were chosen for illustration was S. John Chrysostom. The Paris manuscript of the Sermons contains portraits of the Emperor Nicephorus Botoniates, for whom it was executed, with those of the Empress and other personages. The Homilies of Jacobus Monachus in honour of the Virgin are important for their relation to pictorial cycles representing the Virgin's life, such as we see in the mosaics of Kahrieh Jami, in which episodes from the apocryphal gospels are conspicuous. It has been suggested that the miniatures in the twelfth-century Vatican MS. (1162) and the Paris MS. (1208) may have been inspired by the decoration of some early church.

(f) *Menologia*

These general liturgical calendars are a prominent feature of the eleventh and twelfth centuries. In the reign of Constantine Porphyrogenitus (A.D. 912–959) Simeon Metaphrastes compiled the Lives of the Saints, a work abridged in the time of Basil II. An abridged edition being more strictly a *synaxarium*, the famous Vatican MS. now to be noticed should bear this

[1] *B. A. and A.*, p. 476.
[2] Millet, *Iconographie de l'Évangile*, p. 582.
[3] Wulff, *as above*, pp. 537–8 ; *B. A. and A.*, p. 478.

title rather than that of Menologium, or Menology. This book,[1] made for Basil II (A.D. 976–1025), is imperfect, containing only the Lives from September to February. It is of large size with a miniature on each page, the illustration being carried out by eight illuminators, whose names are inscribed in the margins ; two of the artists are described as of Constantinople, and the fact, taken in conjunction with the general character of the work, which is in the Hellenistic style associated with work done for the Byzantine court, makes it almost certain that it was produced in the capital ; the model was perhaps a MS. dating from the neo-classical revival. Though many miniatures are of fine quality and the standard never falls to a low level, there is little effort to reduce the monotony incident to the subject-matter ; the eye wearies of tortures and executions which take place before almost unvarying backgrounds of conventional architecture and landscape ; the attitudes alike of executioners and victims are tediously repeated from page to page. It is perhaps natural that some of the illuminations which please most are not concerned with sufferings at all, but are New Testament scenes, or miracles of saints. There are many evidences of reproduction of motives from earlier MSS., and frequent reminiscences of classical art. Millet has suggested that many of the churches bear a real resemblance to the actual churches of the localities depicted.

Other Menologies preserved in different libraries differ from the type of the Vatican book in the arrangement of their miniatures. The British Museum possesses a fine MS. of the Lives of the Saints by Simeon Metaphrastes dating from the end of the eleventh or the beginning of the twelfth century (Add. 11870) ; it is smaller than the Vatican Menology, by which some of its miniatures are inspired (Plate LVII). These illustrations, placed at the head of each legend, are framed in a rich decorated border of oriental derivation, a style here displayed with singular attraction. The colour is rich and harmonious throughout, and the figures have the grave dignity characteristic of this period, to which the liturgical scheme of church decoration belongs (p. 18). The landscapes are of the conventional kind seen in the Menology.

Among theological works we may notice the *Climax*, or Spiritual Ladder, of John Klimax, abbot of the monastery of S. Catherine on Mount Sinai in the sixth century.[2] An eleventh-century copy in the Vatican (gr. 394) has many illustrations of religious and monastic life, with allegorical subjects relating to progress up the 'ladder'. A twelfth-century copy in the monastery of S. Catherine on Mount Sinai depicts in genre scenes the effects of vice and virtue.

Of religious poetry, we possess comparatively little illustration. The Akathistic Hymn to the Virgin, so called from the fact that it was sung standing, is believed to have been written by Photius in A.D. 626, and is represented by illuminated copies.[3] The cycle of illustrations was repro-

[1] Wulff, pp. 527 ff. ; *B. A. and A.*, pp. 479 ff.
[2] *B. A. and A.*, p. 480 ; Wulff, p. 536 ; C. R. Morey, *East Christian Paintings in the* *Freer Collection*, 1914, pp. 1 ff. On p. 3 is a list of Klimax MSS.
[3] *B. A. and A.*, p. 481 ; Wulff, p. 537.

duced on the walls of churches of the last Byzantine period, in the Pantanassa at Mistra (fifteenth century) and on Mount Athos.

The Calendar of the Sons of Constantine, originally executed, perhaps at Rome, but under Alexandrian influence, by Filocalus, has survived only in copies from a ninth-century MS. supposed in its turn to have carefully copied a fourth-century original, the date of which was A.D. 354.[1] The seventeenth-century copy, now in the Barberini Library at Rome, was made for the French antiquary Peiresc, and in this most of the original designs are complete; five pictures representing the months, missing in Peiresc's copy, are supplied by an earlier fifteenth-century copy at Vienna; a third copy, is at Brussels. These copies go back in the first instance to a Carolingian copy also lost. The Calendar among its illustrations contains the *Tychae*, or personifications, of Rome, Alexandria, Constantinople, and Trèves, representations of planets, figures emblematical of the months, the signs of the zodiac, and two portraits of imperial persons: Constantius II enthroned, and Constantius Gallus standing, both with the nimbus. The costumes with their applied gems and inwoven figures are of an oriental character and recall those of later consular diptychs. If the ornamental borders or frames surrounding the pictures in the seventeenth-century copy have come down from the fourth century, they show that the first illuminators ornamented as well as illustrated their books, a feature not found in any original MS. of classical times. It is well to remember that the evidence of the Calendar is at the second remove from the original, and that though we may count upon its comparative accuracy in reproduction of arrangement and the general features of composition, we cannot be equally sure that the style is reproduced with equal success.

II. *Secular MSS.*

The well-known *Iliad* in the Ambrosian Library at Milan and the better of the two Virgils in the Vatican Library (Cod. Lat. 3225) may be mentioned as early examples of classical illumination based upon the Alexandrian style, but they do not intimately concern East Christian art. But a Chronicle of the World in the Golenisheff Collection, written on papyrus, perhaps in Upper Egypt, about A.D. 400, follows old Egyptian illustrative methods, the figures are arranged in rows, without background or suggestion of perspective, and there is no ornament. The style is crude and the work suggests a time of reaction against the Hellenistic manner of Alexandria.[2]

The Library at Vienna contains a copy of the medical treatise of Dioscorides illuminated about A.D. 512, for Juliana Anicia, daughter of Galla Placidia and wife of the Consul Areobindus, probably at Constantinople.[3] The style of the illustration is definitely Hellenistic, and oriental influence is only marked in the case of subsidiary features such as ornamental borders; the work is delicate and accomplished throughout in

[1] *B.A. and A.*, p. 484. [2] *Ibid.*, p. 459.
[3] *Ibid.*, p. 460. The chief reference is to

von Premerstein's description in the Vienna *Jahrbuch*, xxiv, 1903, pp. 105 ff.

drawing, and in some of the earlier miniatures splendid in colour. At the beginning it has six full-page miniatures. These include Dioscorides receiving the plant mandragora from the Personification of Discovery, while a dog in the foreground dies the death appointed for all who uproot this plant ; Dioscorides writing at a desk, this page being an early surviving example of the author's portrait copied by Christian art in representations of the Evangelists as we have already seen in the case of the Rossano Gospels (p. 312) ; and the princess herself seated holding a diptych or book between personifications of Magnanimity and Wisdom, while a third figure, Gratitude of the Arts, prostrates herself at the patroness's feet, and a fourth figure holds up a book. Round the central composition and separated by a geometrical arrangement of cabled bands are small genii in grisaille on blue grounds, engaged in building operations, and reminding us of the mural paintings at Quseir 'Amra (p. 261). The body of the book contains numerous illustrations of medicinal plants, and of animals, admirably coloured, and making this manuscript, as Herbert has well remarked, the common ancestor of all the illuminated herbals and bestiaries of the Middle Ages and the Renaissance. This kind of illustration it continued from earlier times ; as we know from Pliny Greek medical writers were in the habit of illustrating their works with paintings of herbs. The Vienna Dioscorides appears to be the oldest MS. known to us in which a gold background is employed.

As the MS. of Dioscorides represents early medicine and zoology, so the *Christian Topography* of Cosmas Indicopleustes represented early geography.[1] The book was written either at Alexandria or on Mount Sinai, about A.D. 547, the author being a native of the great Egyptian city who after a life of travel became a monk in the monastery of S. Catherine. But the oldest surviving version, that in the Vatican (gr. 699), is probably of the ninth century, while two others, one in the Laurentian Library, the other on Mount Sinai, are assigned to the eleventh. Since, however, the illustration in all probability reproduces the essential character of the original it may be conveniently discussed in the present place. The book itself blends science and religion ; natural history, geography, and Chaldaean cosmogony derived from a Persian source, are brought into organic connexion with Christian belief. The geographical and botanical illustrations with the personifications are Alexandrian in manner and derivation, and the naturalistic plants and animals recall those of the Dioscorides. But the religious subjects are treated in a monumental style suggestive of oriental feeling as expressed in mosaic art. The biblical subjects (Plate LV) are chosen to illustrate the parallelism between the two Testaments. The geographical pictures include views of the world, the sun going round a mountain, a planisphere, and the signs of the zodiac.

A copy of Ptolemy's Tables in the Vatican Library (MS. gr. 1291), written about A.D. 814, contained pictures of sun, moon, months, hours and

[1] C. Stornajolo, *Miniature della topografia crist. di Cosmas (Codices e Vaticanis selecti)*, Milan, 1908 ; *B. A. and A.*, p. 462.

signs of the zodiac on blue or gold grounds, many in the form of Hellenistic personifications.

The oldest existing copies of the illustrated Physiologus or Greek bestiary [1] belong to a late period, though, as in the case of Psalters, the absence of older prototypes is due to the misfortune of their destruction, not to any avoidance of illustration. Just as the mural paintings of Bawît and the Kyrenia silver showed sixth-century illustrations of the story of David, themselves 'evidently based on yet earlier models, so the discovery on a sixth-century pavement mosaic near Gaza of the Phoenix burning on a fire-altar [2] suggests that the symbolic book of beasts must have existed at this and probably at an earlier time. For the Physiologus is believed to have been compiled at Alexandria in the first centuries of the Christian Era, and illustration probably spread to Palestine and Syria through Sinai, where, we recall, Cosmas may have produced his *Christian Topography* containing animals of a somewhat similar kind. It is curious that the most ancient pictured version of this Eastern book of symbolic beasts should be a Western MS. of the tenth century at Brussels, [3] with a scheme of illustration apparently free from oriental influences. The oldest illustrated Physiologus at present known is one dating from about A.D. 1100 in the library of the Evangelical school at Smyrna, where the style of the pictures recalls that of the marginal Psalters (p. 308), especially those pictures, common both to bestiary and psalter, in which biblical subjects are introduced to illustrate points in the text or for symbolical reasons. The presiding influence in both cases was monastic. Strzygowski has suggested a possible relation between Physiologus types and the animal art of Buddhist India through the intermediary of Graeco-Asiatic art.

Among purely secular books we may mention the *Theriaca* of Nicander, a second-century writer, extant in an eleventh-century copy at Paris: it is a treatise on remedies against poisonous bites. The illuminations are picturesque, with garden and landscape scenes in an Alexandrian style evidently based on a very Hellenistic model. The *Cynegetica*, a treatise on the chase by Oppian, is represented by a tenth-century copy in the Marcian Library at Venice. Here too we infer early Hellenistic models; in addition to the lively little hunting scenes, represented in narrow zones, across the text, there are numerous historical and mythological subjects, some of them agreeing with those which the hero Digenes Akritas is said to have had represented in mosaic on the walls of his palace.

The history by Skylitzes of the period between A.D. 811 and the middle of the eleventh century is represented by an illuminated copy of the fourteenth century at Madrid, [4] with nearly six hundred miniatures by different hands, the earlier being more finished, the later treated in a broader style. The illuminations are of great interest for their architectural types.

[1] Strzygowski, in *Ergänzungsheft* i of *Byz. Zeitschr.*, 1899; *B. A. and A.*, p. 481.
[2] *Proc. Society of Antiq. of London*, xxxii, 1919, p. 48.
[3] Bibl. Royale, MS. 10074.
[4] A complete set of photos in the Collection des Hautes Études at the Sorbonne; *B. A. and A.*, p. 486.

V

MINOR ARTS

IT is impossible in this short survey to cover the whole field of the industrial arts, illustrated as it is by numerous and miscellaneous objects in the most varied materials ; the reader is referred to published catalogues in which such objects are illustrated and discussed in detail.[1] But we may briefly consider three important groups, Jewellery and Goldsmith's work, Enamels, and Textiles, remembering that other groups, especially in the class of minor sculpture, have already received some notice.

Jewellery and Goldsmiths' Work[2]

Jewellery of the Christian periods has survived in smaller quantities than that of pagan times because the custom of interring jewels with the dead ceased to be a general practice.

During the earlier centuries, largely represented for us by work executed in Alexandria and Antioch, where Hellenistic influence was strong, figures in relief hold their own, generally in the form of subjects upon medallions ; sometimes actual coins were used. Occasionally we have modelling in the round, as in the case of the ring with a coin of Marcian, in the British Museum, where the shoulders take the form of hares. But relief in jewellery, as in other sculpture, succumbed at an early date to the coloristic principle which relies not upon plastic effect, but upon optical contrast of high light and deep shade in designs executed in a single plane. This brought about the development of the pierced method already popular in goldsmith's work of late Roman times and dating back to a much more ancient period (p. 362) ; and it is interesting to note that pierced motives in gold, usually based upon the palmette or the vine, are the same as those carried out in marble on capitals of columns and pierced closure-slabs such as those in S. Vitale at Ravenna. Material and scale may differ, but the same principle prevails in either case. Pierced work is the most characteristic feature of East Christian jewellery during the earlier centuries ; on this it relied very largely for its general effect. But great use was made of rather large stones, of rich colour, usually unfaceted sapphires of pear-shape, and cylindrical beads of plasma (root of emerald), in combination with pearls. All were as a rule longitudinally pierced and held on gold pins or wires either rigid,

[1] British Museum, *Catalogue of Early Christian and Byzantine Antiquities*, 1901, by O. M. Dalton ; Cairo Museum, *Koptische Kunst*, 1904, by J. Strzygowski ; Kaiser Friedrich Museum, Berlin, *Altchristliche Bildwerke*, 1909,

and *Mittelalterliche Bildwerke*, 1911, both by O. Wulff.

[2] *B. A. and A.*, pp. 534 ff. For hist. records with regard to Constantinople see J. Ebersolt, *Les arts somptuaires de Byzance*, 1923.

as on bracelets, openwork medallions, &c., or flexible, as in sections of chains, or pendants attached to collars and earrings. Such being the favourite stones, the prevalent colours in all this jewellery, apart from the yellow of the gold and the white of the pearls, are blue and green. Pearls were threaded on gold wires and often alternate with gold beads to form borders for gems in settings, or for any other central ornament. Stones were never faceted, but ground to rounded surfaces and polished, like the cabochons of the medieval goldsmith in the West; settings were almost always of the plain box type, and less variety was attempted than in Western Europe. Pearls and gems were freely sewn to the rich costumes of imperial personages,[1] to which, if we may judge by the vestments from Palermo now at Vienna, even enamelled medallions bordered by pearls were attached. Remarkable treasures from Cyprus, Egypt, Mersina and elsewhere illustrate this jewellery (Plate LVIII).

Jewellery found along the northern borders of the Empire shows us for the fourth century the same fashion of pierced ornament, here finely illustrated by the borders framing the gold medallions of fourth-century emperors, found at Szilagi Somlyo on the Transylvanian border, and now at Vienna. But it introduces us to the method of decoration by a mosaic of flat gems or coloured pastes set in cells known as *orfèvrerie cloisonnée*. The Asiatic prototypes of this kind of jewellery[2] date from the sixth century B.C., the oldest known example being gold ornaments from Kelermes on the Kuban River, in which the inlay is of amber.[3] The fashion was employed by the Sarmatians in South Russia before the coming of the Goths,[4] who adopted it and transmitted it to other Teutonic tribes as a result of their westerly migration. The fashion early entered the Roman and East Roman Empires, but did not apparently enjoy exceptional popularity in the latter; it survived, however, as late as the tenth century, being found on the well-known reliquary for wood of the true cross in the cathedral of Limburg-on-the-Lahn. The more familiar examples of its use by Byzantine goldsmiths happen to be reliquaries or book-covers, the reliquary of S. Radegund at Poitiers (p. 336) having a border in this style, and a rather later book-cover in the Treasury of S. Mark's being ornamented in the

[1] J. Ebersolt, *as above*, p. 31.

[2] Cf. *B. A. and A.*, p. 547; Dalton, *Archaeologia*, lviii, pp. 237 ff., and *The Treasury of the Oxus* (British Museum, 1905), pp. 24 ff.; M. Rosenberg, *Gesch. der Goldschmiedekunst: Zellenschmelz*, 1921; J. Strzygowski, *Altai-Iran*, p. 274, and *Zeitschr. für bildende Kunst*, N.F., xxxii, p. 159. Stress may be laid on the word Asiatic in this sentence. The writer is still not convinced that this kind of jewellery did not enter the Scythian area from the south (cf. p. 373). It is rather significant that

Kelermes is a site which has yielded objects of marked southern affinities (E. H. Minns, *Scythians and Greeks*, pp. 42, 263).

[3] Pharmakovsky in *Archäologischer Anzeiger*, xx, 1905, col. 58; Strzygowski, *Altai-Iran*, p. 274 (also pp. 140, 213), with illustrations.

[4] Rostovtzeff, *Journal des Savants*, 1920, pp. 57, 120, notes ornaments from a tomb of the second half of the third century (now at S. Germain), and a discovery in 1914 of jewellery with coins of Licinius (307–23). Cf. *Rev. Arch.*, 1920, ser. v, vol. xi, p. 112.

same way. In the jewellery of the northern area modelling is abandoned in favour of coloristic methods even more thoroughly than in the South, and the imitation of nature gives place to geometrical and formal ornament. The design is executed in one colour on a ground of another, or a contrast of light and shadow is substituted for that of colour. We have already seen that this is the principle of pierced ornament. The northern area had, however, another method which affected goldsmith's work in Europe in the time of the Roman Empire; it was discussed by Riegl, who perceived its divergence from the principles of classical art. Here the pattern is executed generally in ' ridges ', with two surfaces meeting along the crest at an angle, so that one surface throws off the light while the other is in comparative shadow, and a coloristic effect is again produced. This method, peculiarly adapted to formal ornament to which, in the Christian centuries, it was practically confined, probably came into the Roman and Byzantine Empires by the same roads as cloisonné jewellery from the steppe region north of Iran, where peoples of different races met each other, and motives from inner Asia were transmitted to the West (p. 366). It is well seen on the handles of bronze knives from Minusinsk in Siberia dating from about the beginning of our era, where the scroll-work shows analogy with the design on gold ornaments from the much later treasure from Albania now in New York;[1] it is seen in a more interesting form on the same gold ornament from Kelermes which afforded the earliest example of cloisonné jewellery, for the contrasting planes are here applied not to a geometrical design but to the body of a quadruped in which some naturalism of treatment remains, but is plainly subordinated to a decorative principle. The method was applied not merely to small articles of jewellery but to large panels of carved wood or moulded stucco, in which form it was freely adopted by the art of Islam. The colour scheme of the northern jewellery differs from that of the southern. The stones or pastes employed are red or green, chiefly the former; the ornaments themselves differ in kind, no longer including necklaces, collars and bracelets, but consisting of brooches or enrichments for leather belts or harness. In this point they seem to betray their nomadic origin.

We may notice a few fine examples of the types of personal ornaments worn principally in the southern area. Gold neck ornaments or collars were often rigid and tubular, terminating over the breast in a plaque set with a large central medallion flanked on each side by a number of gold coins, and having another large medallion set in a broad pierced border of palmettes hanging from it as a pendant : such collars, said to have been found at Siût in Egypt, are to be seen in the Morgan collection in the Metropolitan Museum at New York and the Von Gans collection in the Antiquarium at Berlin.[2] Another form of collar, best illustrated by the fine example in the

[1] Strzygowski, *Altai-Iran*, pl. v.

[2] W. Dennison, *A gold treasure of the late Roman Period*, Univ. of Michigan Studies, Humanistic Series, vol. xii, pp. 99 ff. ; R. Zahn, *Amtliche Berichte aus den königlichen Kunstsammlungen*, xxxv, 1913, pp. 65–6. Cf. M. Rosenberg in *Cicerone*, xiv, 1922, pp. 330 ff.

Von Gans collection, is flat and lunate, composed of a series of gold plaques pierced with foliate designs, set with pearls and gems, and with pendants of gems all along its lower edge. Another collar of this type from Egypt is in the Hermitage at Petrograd. Flexible necklaces were of chains variously formed, either of close-plaited gold wire, or of loosely looped links, or again of links alternating with small globes ; pendants were often attached to them, either in the form of gold medallions in ornamental borders, openwork disks set with stones and pearls, or groups of pearls and gems : the plain gold of the chains is sometimes broken by alternating sections of gems threaded on gold wire. A necklace in the Von Gans collection is of openwork disks with sexfoils, alternating with gems in box-settings surrounded by pearls. In other necklaces, as in one from Cyprus in the Morgan collection, the necklace has the appearance of being composed of plasma beads and pearls, the intervening gold links being inconspicuous. The pendant medallions (*encolpia*) with scriptural subjects in relief are more important for their iconographical interest than for their sculptural merit. The Berlin example has on one side the Annunciation, on the other the Marriage at Cana.[1] A large encolpion obtained in Cyprus, now in New York, has the Baptism ; both exemplify the Syro-Palestinian iconography based upon Jerusalem and the other Holy Places.[2] An encolpion of the sixth century from Adana, now in the Ottoman Museum at Constantinople, and described by Strzygowski,[3] has also the Annunciation and other scenes. The figure subjects on these objects are Syro-Hellenistic in character and recall those of the Ravenna sarcophagi.

Armlets, like collars, were sometimes tubular ; or flat, and cut in pierced work, with a medallion or disk in the same style opening on a hinge, as seen in examples in the Morgan collection from Cyprus, and in the British Museum from Egypt. Sometimes flat armlets with such hinged medallions are ornamented not with pierced work, but with a row of gems in box-settings between two rows of pearls ; or the whole bracelet may take the form of a floral scroll enriched with pearls and gems. Earrings may have three or four pendants of plaited chain ending in pearls hanging from a plain ring of gold wire, or more elaborate pendants of successive box-settings with gems, ending in sapphires and pearls ; or they may be lunate, with a flat crescent commonly having a pierced design, a form which enjoyed a wide diffusion both in the northern and the southern area. The types of finger-rings are too numerous for special mention[4] ; rings are in gold, silver, bronze and iron, the precious metals sometimes nielloed, and are very commonly engraved with monograms or short prayers such as : *O Lord, preserve the wearer.*

Girdles are known to us only through the sumptuous examples from

[1] Dennison, *as above*, pp. 127 ff.
[2] Strzygowski, *Byz. Zeitschrift*, xxiii, p. 349.
[3] *Byz. Denkmäler*, i, pl. vii ; reproduced by

Dennison, fig. 30. Cf. Millet, *Iconographie de l'Évangile*, pp. 91, 580.
[4] *B. A. and A.*, p. 539.

Egypt and Cyprus, where they are formed of a series of linked gold medallions. 'Breast chains' are represented only by the fine example from Egypt in the British Museum,[1] four long chains of gold disks pierced with formal foliage diverge from two large disks in the same style, one on the breast, the other on the back, passing over the shoulders and under the arms.

Our knowledge of the personal ornaments worn in the later periods is not so full as in the case of the earlier. The principal objects now preserved are finger-rings, with a few pectoral crosses, small lockets for relics, &c., some of which have inscriptions and even figure subjects in niello.[2]

East Christian jewellery is frankly designed for immediate splendour of effect; extensive surfaces of gold are displayed, and the stones used are large and of striking colour; there is none of the intimate charm produced, for example, by a Greek jewel set with a finely cut gem, which must be examined at close range before its beauty is apparent. But though it is in the large and brilliant manner, it is not without refinement. Its pierced designs are often admirably executed, and the combinations of colour afforded by its gems and pearls possess a satisfying harmony. It is oriental decoration carried out on the same principles as contemporary work in the major arts, principles which are not tactual, relying upon modelled shape, but optical, based upon flat design in sharply contrasted colours.

Silver plate[3] has a special importance in industrial art because its intrinsic value combined with its utility caused it to be much sought after and carried great distances from the places where it was made; discoveries of 'treasures' may thus give interesting clues to relations commercial or other between peoples of different race and civilization. Further, the designs upon it consisted often of figure compositions which bring it into relation with minor sculpture and with the illuminations from which such sculpture often derived its subjects. During the first six centuries there were two main sources of production: the Hellenistic, with its chief centres at Alexandria, Antioch, and Constantinople, but influencing Syria and Anatolia; and the Persian.[4] Silver of Hellenistic and East Christian origin is occasionally found with Sassanian, because, about the sixth century, silver plate was traded to barbaric tribes in the North, especially in Russia, for furs. The chiefs were fond of drinking out of silver; this predilection is attested by historical accounts of Byzantine embassies to barbaric courts, and by such facts as Attila's insistent claim to the church plate of

[1] Dennison, *as above*, p. 149. Dennison illustrates an example of such a breast and back chain worn by a figure on a Gandhāra relief.

[2] *B.A. and A.*, pp. 544 ff.

[3] The curious second-century disk or dish at Athens (p. 363), so important for the study of ornament, cannot be classed exactly with ordinary silver plate. In this object the usual plain filling of ornamental motives with niello, is supplemented by damascening in silver, and the motives are of Syrian type. The disk combines Hellenistic figure subjects and oriental ornament in a most remarkable manner.

[4] With Sassanian silver we are not directly concerned; the principal source of illustration is Smirnoff, *Oriental Silver* (Russian), but the reader may also consult Kondakoff, Tolstoy, and Reinach, *Antiquités de la Russie méridionale*; Dalton, *The Treasure of the Oxus*, 1905, p. 121, and *Archaeologia*, lxi, p. 381.

Sirmium. Some of the most interesting discoveries are due to the fact that the tribes bartered furs for silver plate brought north by traders from Byzantine and Persian territory; the presence of many remarkable silver vessels discovered at different times in the governments of Perm and Viatka, notably on the Stroganoff estates, is explained by this cause. But sometimes, as in Attila's case, the methods of acquisition were less peaceable, and Christian plate was carried away as plunder, ultimately passing from hand to hand, and being mixed with booty of a different character from other sources. Among examples found in Russia, special mention may be made of a dish found in the Berezoff islands in Siberia,[1] and now in the Stroganoff collection at Rome (Plate LIX). The subject is a jewelled cross between two angels ; the cross is fixed in a starry sphere resting on ground from which flow the four rivers of Paradise.

Among the earlier examples of silver plate with figure subjects are the so-called votive disks or shields, of which eight are in existence,[2] that of Theodosius, at Madrid, that of Valentinian at Geneva, and that of Justinian in Petrograd being the best known. In the second a symmetrical grouping of the seated emperor between his guards before a conventional background of architecture already illustrates the sculpture in which the ceremonial and artistic ideas of the East find definite expression.

Most surviving plate of definitely Christian character was made for the use of churches or monasteries. It is chiefly represented by chalices, patens, gospel-cases, dishes or salvers, censers and relic-caskets. The motives are either in relief—the figure subjects exclusively so—or incised and filled with niello ; designs or their borders are often partly gilded. From the tenth century, church plate of the more sumptuous order, especially the chalice, was sometimes enriched with enamel occasionally bordered by strings of pearls ; but as a rule the enamel was not, like niello, incorporated in the object by the champlevé process, but cloisonné work on plaques applied to the surface. There are, however, rare instances in which a coloured substance is actually embedded, for instance, in the barbaric gold cup from Albania with busts of the Fortunes (*Tychae*) of four cities,[3] which probably copies a Hellenistic original of the sixth or seventh century. It is interesting to note that one of the four ' cities ' is named ' Cyprus ' (cf. p. 328). Sufficient examples remain in various churches, notably in S. Mark's at Venice (Plate LX), and in great European museums to give us an idea of the style and merits of this plate, as compared with that of medieval Europe, though the most splendid pieces, such as those once in S. Sophia, described by historians and pilgrims, have disappeared.[4] There is reason to suppose that Antioch

[1] *B. A. and A.*, p. 571 ; best illustrated by J. Smirnoff, *Oriental Silver*, pl. xv.

[2] *B. A. and A.*, p. 569. The Justinian disk was found at Kerch. Cf. *Rev. Arch.*, 1898, ii, p. 240 ; Zahn, in *Amtliche Berichte*, Berlin, 1916–17, p. 276 ; Ebersolt, *Arts somptuaires de Byz.*, fig. 14.

[3] Strzygowski, *Altai-Iran*, pp. 4, 242. The busts have affinities with the figures on silver book-covers found with the great chalice of Antioch (p. 330, n. 2).

[4] Ebersolt, *as above*, pp. 25, 64.

rather than Alexandria was the chief producer of the plate after the fourth century, though Constantinople must also have been a centre. Important pieces such as the Homs vase, and, in the Louvre, the paten from Riha on the Orontes, with the Communion of the Apostles, have been found in the northern area : the latter object is characterized by that almost startling realism in the rendering of personality which has been traced rather to Syria-Palestine than to Egypt (pp. 7, 8). Treasures like the remarkable find of silver plate in the north of Cyprus have affinities of detail with the pieces found in Syria. Bréhier has stated the case for Syria at some length,[1] and claims as specially Syrian the enrichment of the effect by free use of parcel gilding and niello ; the preference for a monumental background of a definite kind, and the grouping before this of the figures as individual units, placed symmetrically like statues, rather than as living persons ; the treatment of the foreground as an exergue and the covering of it with symbolic objects ; above all, an evident love of actuality, shown in the use of late contemporary costumes for the persons of sacred history, in the exactitude of detail, and (the most important point) in the obvious effort to render the appropriate emotion in its full intensity. The art of Alexandria, he urges, was more purely Greek, more idealistic and symbolic, and more faithfully maintained the connexion with Hellenistic picturesque reliefs ; the plate of later date than the fifth century, that is to say, the larger part of that which has survived, manifests the Syrian rather than the Alexandrian characteristics. There is much weight in these contentions, though the claim can perhaps be pushed too far, for the gold jewellery found in Egypt has very close analogies with that from Cyprus and that from Mersina, and similar analogies might be found in late silver plate if we possessed authenticated pieces from Egypt ; but in view of the well-known contribution of Syria-Palestine to the realistic feeling which is so marked a feature of contemporary art (p. 7) the case made out by Bréhier is a strong one. Nor should we omit to notice such a fact as the mention in an early source of a silversmith from Commagene, working at Lyons.[2] Bréhier suspects Syrian types in pieces of silver plate given by Desiderius (S. Didier), bishop of Auxerre, to his church, and mentioned in his Life.[3]

The following treasures or individual objects may be specially mentioned.[4]

The Esquiline Treasure found on the hill of that name at Rome and now in the British Museum is Hellenistic in character, with certain features showing oriental influence. The principal object, the casket of Projecta, by its similarity in form and design to an engraved ivory casket at Cairo now existing only in fragments, suggests a connexion with Alexandria,

[1] *Gaz. des Beaux-Arts*, March–April 1920, p. 173. This article, like that by the same author in *Rev. Arch.*, 1919, and that of Diehl in *Syria*, i, pp. 81 ff. (1921), discusses East Christian silver as a whole. Cf. also Poglayen-Neuwall, *Byz.-neugr. Jahrb.*, ii, p. 474 (1921).

[2] *C. I. L.*, xiii, no. 1945.

[3] *Acta Sanctorum*, Oct. 12, 362.

[4] For older references to these treasures see *B. A. and A.*, p. 563.

where, if not in Rome under Alexandrian influences, the whole treasure may well have been made late in the fourth century; any affinities with Antiochene art might find their explanation in the influx of motives from Syria which entered Egypt about this time (p. 42).

Similar affinities are suggested in the case of various silver vessels, some with Christian subjects, forming part of the very remarkable treasure of about the same date discovered at Traprain Law, Midlothian, Scotland, in 1919, and now in the Museum of National Antiquities, Edinburgh.[1] The ornament in more than one case recalls parallels connected with Christian Egypt, and one piece, a jug or vase, has in relief Adam and Eve, the Adoration of the Magi, and another subject treated in the manner of the catacomb paintings and the sarcophagi. Both the Esquiline and the Traprain treasures are only in part Christian, most of the objects composing them being purely secular, like those composing the Carthage treasure in the British Museum. On the other hand, a treasure of the fifth to sixth century found at Luxor, and now at Cairo, is definitely ecclesiastical: it includes three rectangular gospel-covers ornamented with the later form of the sacred monogram and a cross, two cup-shaped censers, a silver vase, and a processional cross: on the book-covers are Greek inscriptions giving the names of two bishops and two silversmiths.[2]

Early silver relic-boxes, oval, with domical lids, and subjects in relief, have been found in Italy and in North Africa, but are considered Syrian. The African example, now in the Vatican, has early Christian subjects, in which a Syrian influence has been discerned. Another, also in the Vatican, was found in the *Sancta Sanctorum* at the Lateran; a third, in the Louvre, from Brianza (Castello di Brivio), has an Adoration of the Magi similar in type to that on the vessel in the Traprain treasure. The large and very remarkable casket from S. Nazaro at Milan, with representations of Christian subjects in a free classical style, has generally been regarded as a late Hellenistic or Roman work, though a recent examination has led Morey[3] to regard it as a work of the Renaissance or later. The large silver vase in the Louvre from Homs (Emesa) in Syria, encircled by a series of busts of Our Lord, the Virgin, and others, has points of analogy with the relic caskets, and is not later than the sixth century; the busts upon it have affinity with those on the hexagonal silver censer from Cyprus (p. 328).

A treasure found in 1912 at the village of Little Pereschepinskaya, near Poltava, contained, with a fragment of a Sassanian Persian dish, various vessels of Persian style: a number of gold and silver cups of goblet form; and a flat dish with the sacred monogram in the centre, a border with a vine-scroll enclosing birds and other motives, and a Latin inscription round

[1] A. O. Curle, *Proc. Society of Antiquaries of Scotland*, 5th series, vol. vi, 1919–1920, pp. 59 ff., and *The Treasure of Traprain*, 1923.

[2] Strzygowski, *Koptische Kunst*, nos. 7201 ff.

[3] *American Journal of Archaeology*, xxiii, 919, pp. 101 ff. The article is an able attack on the casket as a product of early Christian times, and will repay perusal. Suspicion had also been felt by Strzygowski (*Byz. Zeitschr.*, xiii, p. 714) and others. Wulff, *as above*, p. 198, accepts the third century.

the monogram referring to a Bishop Paternus, thought to be the Archbishop
of Tomi of that name at the close of the fifth century. The form of the
monogram would suggest an even earlier date, and the dish would appear to
be older than the other objects,[1] which are attributed to the seventh century.

A treasure in the British Museum from Lampsacus,[2] probably dating
from the sixth century at latest, has a pricket lampstand, a chalice-like
cup, two parcel-gilt shallow bowls without feet and ornamented with
monograms in niello, and a number of spoons with Latin and Greek
metrical inscriptions : the lampstand and the bowls have beneath them
' hall marks ' of the kind described below. The Museum has also a number
of interesting objects from what appears to have been the site of a monas-
tery at Karavas, near the ancient Lapithos, about six miles west of Kyrenia
on the north coast of Cyprus ; other objects from the same place and found
at or about the same time are in the museum at Nicosia and the Metro-
politan Museum in New York ; all may be said to form part of the same
treasure. The British Museum examples consist of a dish or plate with
a nielloed central cross within an ivy-leaf border, a bowl with a bust of
S. Sergius in relief, also within a nielloed border, a hexagonal censer with
embossed busts of Our Lord, the Virgin, and saints, and a series of spoons
with embossed animals in a free Hellenistic style in the bowls. The
Nicosia share of the treasure includes at least two plates or dishes with
nielloed crosses enclosed in floral or geometrical borders, one with the
marriage of David (Plate LIX), and two of smaller size with scenes from his
early life. The New York share is the largest, comprising several more
plates of the David series, one, with the combat of David and Goliath, being
of exceptional size. Most if not all of the Cyprus plates have ' hall marks '
on their under sides. A point of interest is the fact that the David scenes
are earlier than any in surviving illuminated psalters, and with those painted
on the walls at Bawît, or carved on the wooden doors of S. Ambrogio at
Milan, help to confirm the belief that older psalters must have existed, one
of which may be assumed to have provided the silversmith with his model ;
the Psalter would have belonged to the ' aristocratic ' Hellenistic group
(p. 307). It is uncertain in what place this Cyprus treasure was made.
There is analogy between the busts upon the censer with those on the Homs
vase and the figures on the paten from Riha (p. 329). The formal alinement of
the figures on some of the plates before a peristyle of definite type recalling
that on the votive shield of Theodosius (p. 325), and the display of symbolic
objects in a foreground resembling an exergue, have also been claimed as
evidence in favour of Antioch, in the region of which so much silver has
been discovered (below). The jewellery associated with the plate resembles
that from Mersina. It is possible that the treasure was produced in Cyprus
itself. The Tyché, or Fortune, of Cyprus, takes its place with others on the

[1] Bobrinsky in *Mem. Soc. Nat. d. Antiq. de France*, 1914, pp. 229 ff. ; Pharmakovsky, *Arch. Anzeiger*, 1913, p. 230 ; Strzygowski, *Altai-Iran*, p. 49. The treasure may have been looted from Tomi by Avars.

[2] *B. A. and A.*, p. 567, Diehl doubts the Syrian origin of this treasure (*as above*, p. 326, note 1).

gold cup from Albania, thought by Strzygowski to reproduce a Cypriote original (above, p. 325); this would hardly be the case unless the island occupied a place of special importance with regard to silversmiths' work.

In enumerating the above treasures, mention has been made of chalices and patens, as to which further details may be given.[1]

A chalice of exceptional type now in New York was discovered in 1910 not far from Antioch.[2] It has applied, to a plain inner cup, pierced ornament of vine scrolls enclosing two rows of figures including Our Lord twice represented with apostles. Eisen, the first to publish this fine cup, now in private possession, has ascribed it to the first century, basing upon the hypothesis elaborate arguments to which wide publicity has been given in the British periodical press. Few archaeologists have been able to accept his reasoning. One or two have inclined to the second or early third century, but the more general opinion, with which the present writer concurs, is that it dates from the fourth century, which produced, also at Antioch, the sculptured figures in the same Hellenistic style on the ivory pyxides at Bobbio (p. 208) and at Berlin (p. 208, and Plate XXXIV). Were the vine-scroll ornament alone in question, the date might be the sixth century, as Conway has pointed out. Comparisons with Roman art are beside the mark, as the object has no obvious connexion with Rome. Eisen's iconographical arguments have been met by Stuhlfauth, who is in favour of a date as late as that proposed by Conway.

A chalice of great size, with hemispherical bowl, round foot, and globular knop, was found at Riha, south-east of Antioch, on the road from Aleppo to Hama. It has the (Greek) inscription: *Thine own out of thine own we offer thee, O Lord*, words of consecration used in the liturgy of Chrysostom, which originated at Antioch,[3] and under the foot are five ' hall-marks ' of the type in use in the sixth century.[4] The British Museum has a large chalice of the same type with a votive inscription round the upper edge, but no ' hall marks '.[5] A cup in the Lampsacus treasure (p. 328), with flat-bottomed bowl, may be a chalice. Some of the sumptuous chalices at Venice,[6] with silver and gold mounts enriched with pearls, gems, and enamel plaques, perpetuate the form of the large Riha chalice in the eleventh

[1] For chalices in general see H. Leclercq in Cabrol, *Dict. d'arch. chrét.*, s. v. *Calice.*

[2] G. A. Eisen, in *American Journal of Archaeology*, xx, 1916; and the large volumes *The great Chalice of Antioch*; Ch. Diehl, *Syria*, i, 1921, pp. 81 ff. (fourth century); O. Wulff, *Altchr. und byz. Kunst*; W. F. Volbach, *Zeitschrift für bild. Kunst*, 1921, pp. 110 ff. (fourth century); G. Stuhlfauth, *Die ältesten Porträts Christi und der Apostel*, Berlin, 1918, p. 243 (fifth–sixth century); W. M. Conway, *Burlington Magazine*, xlv, Sept. 1924, pp. 106 ff. (sixth century); L. Bréhier, *Gaz. des Beaux-Arts*, 1920, p. 175, and *Rev. Arch.* 1919, ii, p. 215 (end of second or early third century); A. B. Cook, *Cambridge Review*, Feb. 15, 1924, approximates to Eisen's date, while F. C. Burkitt, *ibid.*, Feb. 29, p. 253, favours a later date than A.D. 200. Strzygowski (Intr. to Eisen's large work) seems to incline towards an early period.

[3] Bréhier, *G. des B.-A.*, as above, p. 173.

[4] See below, p. 330.

[5] *Guide to Early Christian and Byzantine Antiquities*, 1921, p. 108 (fig.).

[6] *B. A. and A.*, p. 552. A cup of this type, with inscription, was found with the great chalice of Antioch (Volbach, *as above*, p. 112).

century ; another type has a low truncate conical foot with a bowl of similar shape, and two handles. Among the chalices at Venice are examples with the inscription : *Take, drink this is my blood*, &c.

The late fourteenth-century chalice in the monastery of Vatopedi on Mount Athos has a polygonal foot, stem and knop of gilded silver, a shallow bowl of jasper, and two handles in the form of dragons : these hardly suggest Byzantine workmanship.[1]

The most remarkable early paten is that found, like the above-mentioned chalice, at Riha. It bears in relief the subject known as the Communion of the Apostles, and round the border a Greek dedicatory inscription : *For the repose of Sergia, daughter of John, and for that of Theodosius ; also for the salvation of Megalos, Nonnos and their children*.[2] The figures on this paten, which are still grouped with a regard for perspective, and not merely aligned, are marked by great individuality ; we have thus a combination of Hellenistic design and Syrian intensity of expression characteristic of the art of Antioch in the fifth and sixth centuries. A rather later paten with the same subject, now at Constantinople, was found at Stûma near Aleppo, and is ascribed to the time of Heraclius.[3] The shallow bowl-like vessels in the Lampsacus treasure may be patens, but this is by no means certain.

Other patens which have survived belong to about the eleventh century. The example in the cathedral at Halberstadt is eight-lobed and in the form of a shallow dish ; it has the Crucifixion between the Virgin and S. John in relief, surrounded by the inscription : *Take, Eat*, &c. Round the border are eight busts of saints in relief in medallions surrounded by formal scroll designs.[4] This example, though elaborate, is probably nearer to the usual type than the richly ornamented patens of similar date in S. Mark's composed of glass or stone in metal mounts : one, of alabaster with six lobes, has in the centre an enamelled medallion with a bust of Our Lord surrounded by the usual inscription and a silver-gilt rim set with gems.

Silver plate of the sixth century is commonly marked on the under side with stamps or control-marks corresponding to the hall-marks authenticating European plate ; five impressions are usually made, though the same stamp may be used more than once.[5] The stamps are larger than our hall-marks, and vary in shape, some being circular, others hexagonal, square, or arched. They contain names and monograms, apparently of officials, and nimbed busts which may represent imperial persons. Stamps of the sixth or early seventh century were sometimes applied to plate of older date, not necessarily of Christian origin.

[1] *B.A. and A.*, p. 562.
[2] Bréhier, *G. des B.-A.*, as above.
[3] Ebersolt, *Revue Arch.*, 1911, pt. i, p. 407 ; Volbach, *as above*, p. 113. The silver book-covers found with the 'great chalice of Antioch' (*ibid.*, figs. 2 and 4) have affinities with the Stûma treasure.

[4] *B.A. and A.*, fig. 318.
[5] *B.A. and A.*, p. 568 ; M. Rosenberg, *Der Goldschmiede Merkzeichen*, 1911, pp. 1139 ff. For another silver dish or plate of the sixth century, found at Tepe, in Hungary, cf. *Byz. Zeitschrift*, xxiii, p. 349.

Goldsmiths' and Silversmiths' work

Crosses, reliquaries, book-covers, and other objects exist in sufficient numbers to give a general idea of their usual style. Surfaces are embossed, pierced, or engraved, and the effect is sometimes enhanced by the addition of applied enamels. The human figure is freely used in the representation of religious subjects. Ornament largely consists of formal foliate designs and scrolls, or systems of repeating scrolls, in both of which an oriental influence and a relation with similar designs in textiles or decorative sculpture are apparent. Gems and pearls enrich the more precious objects, the former in box-settings or in gold cells (*orfèvrerie cloisonnée*), the latter threaded on gold wire in the method described above, and serving to border medallions or compartments. A few objects of historical or artistic importance may be chosen for notice.

The gold cross (Plate LXI) presented by Justin II and Sophia with dedicatory inscription in Latin is still preserved in S. Peter's at Rome.[1] On one side cabochon gems (not all now original) in box-settings surround the inscription, while a modern medallion with a cross covers the centre; on the other side are embossed foliate ornament of Persian affinities, and five medallions, an Agnus Dei (in the centre), busts of the Emperor and Empress, and two busts of Our Lord. A rich decoration of pearls has been lost and the pendants of agates below the arms are additions. The cross, which contained a relic of the True Wood, may possibly have hung from a votive crown like that of the Lombard King Agilulf at Monza, but this is not certain.

An embossed silver cross with medallions and foliage at Ravenna may be of about the same date as the cross of Justin, and a gold cross at Monza associated with the name of Adalwald is assigned to the seventh century.[2] It has a Crucifixion in niello, as has another early cross in the Dzyalinska collection, which encloses a smaller cross in *orfèvrerie cloisonnée* with the Assumption in niello on the back.

Among reliquaries of various forms, some have been already noticed in the sections relating to enamels and silver plate: the oldest are the silver boxes, usually oval, embossed with New Testament subjects, medallions, &c., noticed on p. 327, above. We may refer to the central panel of a triptych at Poitiers associated with the name of S. Radegund (p. 341), in order more especially to notice the border of coloured glass pastes round the cross-shaped cavity (*orfèvrerie cloisonnée*); this, as we have seen elsewhere, is a feature consistent with a sixth-century date. A reliquary for wood of the True Cross in the treasury of S. John Lateran at Rome[3] also retains ornament of this kind resembling the work at Poitiers; we may recall the borders of the book-cover in S. Mark's at Venice below described for its enamels (p. 340), and note a gold pectoral cross from Kerch.[4]

[1] *B. A. and A.*, p. 548, figs. 336–7.
[2] *Ibid.*, p. 548.
[3] *Ibid.*, p. 520.

[4] In the British Museum; it has inlaid garnets upon one side. (See *Mélanges offerts à M. Gustave Schlumberger*, Paris, 1924, p. 386.)

Other reliquaries for wood of the cross are enriched with embossed figures. That in the church of Jaucourt near Troyes has archangels and figures of Constantine and Helen ; [1] that at Brescia, the same two figures on one side, and the Crucifixion on the other ; in the church of Alba Fucense, a flat reliquary with sliding lid has the Crucifixion. These reliquaries date from about the twelfth century. The flat top of a reliquary in the cathedral of Halberstadt has an embossed S. Demetrius.

The rectangular silver casket from the Sancta Sanctorum, mentioned for its enamels (p. 339), has on the sides standing figures of saints in relief in the dignified Hellenizing style of the Middle Byzantine ivories.[2] In S. Mark's a reliquary of similar form has embossed on the top Our Lord giving crowns to the martyrs of Trebizond. Constantine and Helen are seen on a reliquary at Urbino.[3] Two reliquaries of architectural design, in S. Mark's and in the cathedral of Aix-la-Chapelle respectively, were originally made as *artophoria* for the Eucharistic bread. They represent churches with five domes, and both domes and sides are pierced with foliate ornament ; the sides of the example at Venice are also embossed with figures of two of the cardinal virtues, while panels with animals and monsters in a formal oriental style run round the lower part.[4] The so-called Encolpion of Constantine in the sacristy of S. Peter's at Rome is a gold triptych of about the eleventh century enriched with gems and enamels, and having in the centre of the middle part a relic of the Cross covered with crystal.[5] A single embossed figure, representing Constantine, remains out of four, and the back has a cross rising from between acanthus leaves. The inner sides of the leaves have eight embossed figures with their names, Our Lord, the Virgin, and six saints.

Various triptychs, diptychs, and single panels in the precious metals with figures in relief have been preserved. We may notice the triptych in the Victoria and Albert Museum, probably of the twelfth century, with the seated Virgin and Child and SS. Gregory and John the Baptist ; [6] the fine panel in the same Museum, perhaps from Torcello, with the Virgin standing with the Child on her arm, has been already mentioned (p. 220). The great plaque with the cross between acanthus-leaves in the Louvre is a good example of religious decorative work ; this also is of the eleventh century.[7] The use of continuous scroll designs to cover larger spaces is well illustrated by the embossed silver book-covers in S. Mark's, and the ikon-frames in the church of S. Clement at Ochrida in Macedonia, the former of the eleventh or twelfth century, the latter rather later.[8] This embossed ornament is of the style which became popular in Byzantine art in the middle period. Examples of secular art are a casket in the cathedral of Anagni, once entirely covered with silver plates embossed with mythological subjects in the style and spirit of the ivories with similar designs

[1] *B. A. and A.*, p. 558. [2] *Ibid.*, p. 554. [4] *B. A. and A.*, p. 554.
[3] L. Serra, *Burlington Magazine*, xxxv, 1919, [5] *Ibid.*, p. 549. [6] *Ibid.*, p. 561.
pp. 105 ff., and plate. [7] *Ibid.*, fig. 343, p. 559. [8] *Ibid.*, pp. 552–3.

(p. 213), but later than the better of the ivory caskets ;[1] and a cylindrical silver box in the cathedral of Padua, originally made to hold pigments and having a metrical inscription referring to a scribe named Leo. On the hinged lid is a head of Medusa in relief ; on the sides are Apollo, Ares, and another figure.[2]

The above examples may suffice to show that goldsmiths' work moved on parallel lines with minor sculpture, preserving for figure subjects the Hellenistic tradition, but drawing largely for its ornament on the East.

The examples which remain to us form but a mere fraction of what once existed. The descriptions left by historical writers or by Western visitors to Constantinople show that down to the fatal year of 1204 the Eastern capital contained precious objects extraordinary alike for their number and their splendour. In S. Sophia the altar was of gold, the iconostasis of silver ; even the columns and walls of the sanctuary were overlaid with silver. Archbishop Anthony of Novgorod, visiting Constantinople in A. D. 1200, saw more than thirty votive crowns hanging over the high altar, behind which was a golden cross higher than the stature of two men. In the treasury were countless gold and silver plates, eighty silver candelabra, and many rich censers, chalices, and patens. It is true that the Venetians and the nobles who led the national forces from other parts of the West carried home the examples from which we are now able to form some faint idea of the rest. But the vandalism of the Fourth Crusade must remain a lasting discredit to the West. It was the crusaders who destroyed the altar, the ciborium, and the iconostasis of S. Sophia. As it was in the churches, so it was in the palaces. The pages of Constantine Porphyrogenitus and Anna Comnena cloy by their descriptions of magnificence. It may be that some of the objects described, as the Western envoy Luitprand did not hesitate to assert, were not all that they seemed. But the objects brought to Europe before and after the Crusade are enough to prove that the quality of the best goldsmiths' work was not exaggerated.

Enamel,[3] *and other inlaid work*

East Christian enamelling is almost exclusively of the variety known as *cloisonné*, that is to say, the contours and interior lines of the figure or pattern are formed by thin strips of metal bent to the required shape and soldered on their edges to the metal ground, or base ; these strips form partitions (*cloisons*) within which the enamel is placed in the form of a powder of coloured glass before it is fired. The metal used for cloisons and for bases is seldom anything but gold, either pure or with a slight alloy of silver ; but silver and copper sometimes occur. If the enamelled design was to have a plain gold background, which was very generally the

[1] *B. A. and A.*, p. 557.

[2] *Ibid.*, p. 554.

[3] *Ibid.*, ch. viii, with references to the earlier books on the subject. Add O. Wulff, *Altchr. und byz. Kunst*, pp. 600–3 ; M. Rosenberg, *Gesch. der Goldschmiedekunst : Zellenschmelz*, Frankfort, 1921 ; J. Ebersolt, *Arts sompt. de Byzance*, pp. 29 ff., 62.

case from the tenth century, a cavity as deep as the breadth of the cloisons and following the outline of the figure to be represented was hammered in the thin gold plate forming the base; in this cavity were soldered the strips which rendered the interior lines, features, folds of drapery, &c. An enamel made in this way naturally shows the main contour embossed on the back. Where, as seems to have been the earlier practice, a gold background was not used, and the enamel covered the whole surface, a strip of metal soldered round the edge served as a containing border. Instances in which the whole ground is enamelled are sufficiently numerous; the Sancta Sanctorum cross (p. 339), and the Beresford Hope cross in the Victoria and Albert Museum, may be cited as examples. Medallions so made could be enamelled on both sides, as is the case with two cloisonné on copper in the British Museum, and that found at Risano in Dalmatia (p. 338). After the coloured glass-powder had been carefully disposed in the cells or compartments formed by the cloisons, the piece was fired until the fused enamel was rather more than flush with the tops of the cloisons. It was then ground down, burnished, and polished.

In their preference for gold as a base, enamellers acted in accordance with general experience. Gold only melts at a high temperature, so that there is no fear of cloison or base melting before all the glass is fused; moreover, it is ductile and neither tarnishes nor corrodes. Its disadvantage lies in its liability to bend, which exposes the finished enamel to the risk of cracking if it meets with rough usage. Pure silver seems to have been rarely used, though this metal has most of the qualities required, and in addition brings out to the full the beauty of blues and greens. It may be that silver, melting at a lower temperature than gold, may have been less reliable in the hands of craftsmen whose glass was not of uniform quality and may have required an intenser heat for satisfactory fusion. Copper was employed more often than silver, though cloisonné work in this metal is generally rather coarse in effect; medieval craftsmen in Western Europe enamelled to some extent in copper cloisonné in the eleventh and twelfth centuries in continuation of the Eastern style. The champlevé process on copper is occasionally found, as in the large plaque with S. Theodore at Petrograd, and the still larger panel in the Museo Kircheriano at Rome; the custom of damascening copper with silver, or of filling designs on silver with niello, being so well known, it is rather curious that champlevé was not more commonly used.[1] The difficult method of enamelling embossed convex surfaces, apparently not known in Western Europe until the late fourteenth century, but much favoured during the Renaissance, is exemplified in the figure of S. Michael on one of the book-covers in the Treasury of S. Mark's at Venice, where the face is enamelled in this manner; the date of the work is not later than the twelfth century.

We may, perhaps, gain some notion of the procedure adopted in

[1] Frothingham mentions enamel as used in the bronze doors of S. Paul's without the walls, Rome. See p. 345.

Byzantine times from the description of the enamelling in chapter 54 of the third book of the *Diversarum artium schedula*, a technical treatise by the writer who calls himself Theophilus,[1] and seems to have been acquainted with Greek methods. The fuel used was charcoal. The enamel was put on an iron plate or in a vessel with a handle, and over it was laid an iron cover pierced with holes. Round this the charcoal was heaped, and blown to a fierce heat with bellows. The fired enamel was ground down on a wet stone, and polished on a lead slab smeared with a paste of pulverized earthenware; it was finished off on a piece of goatskin, stretched on a board and covered with a similar paste.

The colours of Byzantine, as of all enamels, were obtained from metallic oxides: white from tin, green from copper, blue from cobalt, and so forth. Among other colours employed were several shades of blue and purple, red, yellow, brown, and pink. Enamellers must have profited by the experience of the chemists who in Roman times had produced fine glass of rich colours to simulate precious stones.

The origin of the enameller's art lies beyond our immediate scope, which confines us to a short review of its history in the Christian East.[2] The earliest known enamel in cloisons is that discovered in 1854–1855 in the upper part of a pyramid at Meroe in Nubia, in association with objects apparently of Roman date.[3] The next examples would appear to be those found with coins of Licinius (A.D. 307–323) at Kertch in the south of Russia in 1914, if they are accurately described as enamel.[4] Such discoveries are rather in favour of the view that the substitution of enamel for stones and pastes set *à froid* took place when the Greeks came in contact with users of cloisonné jewellery.[5] Until it is shown that Iranians were at this time skilful glass makers, like the Greeks and other Mediterranean

[1] His real name was probably Roger of Hamershausen in the diocese of Paderborn, and he is mentioned in a document of about 1190.

[2] For the earlier history cf. *B. A. and A.*, p. 494. The existence of filigree enamel on gold is accepted as certain in the case of Greek jewellery dating from the sixth century B.C. Champlevé enamel on bronze occurs in the cemetery of Koban in the Caucasus, which belongs to the end of the Bronze and beginning of the Iron Age. If Rostovtzeff is right in diagnosing enamel on the fifth-century Graeco-Scythian gold treasure of Vettersfelde (*Iranians and Greeks in South Russia*, p. 173), then enamelled ornaments had been carried as far north as Prussia as early as the sixth–fifth century B.C.; he describes others found at Prokhorovka in Orenburg as of the fourth and third centuries B.C. (*ibid.*, p. 124), others from the Taman peninsula and the Kuban as third century B.C. (*ibid.*, pp. 125, 174).

[3] *B. A. and A.*, as above.

[4] Rostovtzeff, *Journal des Savants*, 1920, p. 57; cf. *Rev. Arch.*, 1920, p. 112, and *Iranians and Greeks*, as above, p. 174.

[5] M. Rosenberg, *Jahrbuch der k. preussischen Kunstsammlungen*, 1918, p. 1, suggests that the Greeks saw in vertical cloisons a support for their enamels superior to that of the gold wire which they had hitherto used. A similar idea occurs to Rostovtzeff, with regard to the earlier Prokhorovka find (*Iranians and Greeks*, p. 124, and pl. xxiv, fig. 4). Since the makers of cloisonné jewellery in Russia in the third and early fourth centuries of our era were (Iranian) Sarmatians, and not Goths, we seem to approximate to the theory of Kondakoff and Strzygowski, who believe the art of enamelling to have originated in Iran or Central Asia (cf. *Zeitschr. für bildende Kunst*, 1921, pp. 159 ff.); but there is no such evidence that Iranians were skilful makers of coloured glass as that which we possess with regard to the Mediterranean peoples.

peoples, it may be regarded as probable that both in Egypt and in Russia the substitution was due to Greek initiative.[1]

The earliest specifically Christian or Byzantine cloisonné enamels at present known can hardly be traced back earlier than the close of the fifth century. Of the sixth century, we have the well-known reliquary of S. Radegund at Poitiers (p. 341), and the remarkable cross with figure subjects from the *Sancta Sanctorum*, now in the Vatican. The period from which we possess a considerable material hardly begins before the tenth century, and practically closes with the beginning of the thirteenth.[2] The first certain literary allusion to Byzantine enamel also belongs to this time ; it is contained in the treatise by the Emperor Constantine Porphyrogenitus (A.D. 913–959), on the ceremonies of the Court, where enamels (ἔργα χυμευτά) are mentioned as used for decorative purpose, or as gifts sent to Mohammedan and barbaric princes. After the Latin conquest enamelling, being a costly process, was less commonly practised than before, but the existence of post-Byzantine examples like those at Serres in Macedonia (p. 341) suggests that it did not quite die out. Surviving enamels are chiefly to be dated by their style ; they present close analogies in subject and treatment to illuminations, ivories, and other works of art. But in rare instances we have precise evidence to help us. The history of the cross of S. Radegund appears to be authentic. The reliquary at Limburg-on-the-Lahn bears on its gold mounting an inscription relating to Constantine Porphyrogenitus and Romanus II, who shared the imperial power between A.D. 948 and 959. The crown at Budapest, enamelled with portraits of the Emperor Constantine Monomachos mentioned on another page (p. 342), must have been made towards the middle of the eleventh century. The triptych in the monastery of Chachuli at Gelat in Mingrelia has among other enamelled plaques one representing Our Lord crowning Michael VII Ducas and his Empress Maria : its date is therefore between A.D. 1071 and 1078. The cross found in the tomb of Queen Dagmar of Denmark, who died in A.D. 1212, is anterior to that year.

Byzantine enamels, being delicately executed on a base of precious metal, take the form of small plaques and medallions, as a rule not more

[1] The examples of *émail en résille sur verre*, of Roman Imperial date, are perhaps of Alexandrian origin : in this birds, leaves, &c., outlined in gold strips and filled with coloured enamel (?) are set or embedded in glass of another colour (examples in the British Museum ; cf. Laborde, *Émaux du Louvre*, p. 95). The tardiness of Egypt in substituting true enamel for inlaid stones or pastes may have been due, as Dillon suggested (*Burlington Magazine*, xi, 1907, p. 373), to her use down to a late date of a glass without lead. China is generally regarded as excluded from among competitors for the honour of having introduced cloisonné enamel by the recorded fact that this art was introduced from the West in the fourteenth century. But Strzygowski is inclined to attach importance to a mirror in the Musée Cernuschi to which an eighth-century date has been conjecturally assigned (*Amida*, p. 353).

[2] Literary evidence is not of much value as to the early cloisonné enamels, but accounts of decoration applied to the altar in S. Sophia at Constantinople seem to point to the use of true enamel (cf. Ebersolt, *Arts somptuaires de Byzance*, p. 30).

than a few inches in maximum length ; when, therefore, they are used to enrich an object of any size, they may be present in considerable numbers, and be arranged in conformity with the shape of the object. Their destination was to adorn crosses, gospel-book covers, ikons, reliquaries, chalices, cups, liturgical fans, and the ceremonial garments of imperial persons. Isolated panels or medallions may have been employed for personal adornment ; for instance they may have been mounted in gold as brooches, as they sometimes were by Goths or Lombards in Western Europe.

Medallions and plaques of Byzantine origin may have been imported into Europe and there copied at an early date, perhaps before the end of the sixth century. The so-called Castellani brooch in the British Museum, with its somewhat barbaric enamelled bust perhaps based on a Byzantine original, has a gold mount identical in certain features with the work on the gold cross of King Agilulf, in the cathedral of Monza. The enamel may date from the end of the sixth century, and be the work of Goths rather than Lombards ; but the latter people, like other Teutonic nations, were probably conversant with the art, which was practised in transalpine monasteries in the eighth century.[1] In any case cloisonné enamelling, originally suggested by Eastern practice, continued in Italy, France, and the South-western German region in Carolingian times,[2] the practice of the art probably extending to England.[3]

It is natural that in the case of an art so cramped and restricted by a troublesome technique, figure subjects should be confined to narrow limits, and that single figures or busts should predominate. Byzantine enamels generally introduce the human figure. But often the plaques or medallions with representations of Our Lord, the Virgin, or saints, are accompanied by plaques with formal floral or geometrical ornament in enamel, in which an oriental influence appears to prevail. An example is seen in one of the book-covers at Venice. The most elaborate ornamental plaques come from Georgia, and remarkable examples were included in the Swenigorodskoi collection, now for the most part in the Metropolitan Museum at New York. The effect of fine decorative designs carried out in rich colours on a gold ground is brilliant and attractive ; we feel that free pattern rather than laborious delineation of persons is the natural province of the art, and that by its diversion into the iconographic field it may have lost as much as it gained.

Enamel, like mosaic on the larger scale, accorded with the artistic genius of Byzantium, and exerted an influence in other fields of art. In illuminated MSS., from the ninth to the twelfth century, we find the painter reflecting the enameller's technique.[4]

[1] For such early cloisonné enamels see M. Rosenberg, *Jahrbuch der K. Preussischen Kunstsammlungen*, 1918, pp. 1 ff. ; Sir W. M. Conway, *Burlington Magazine*, xxi, 1912, and xxiii, 1914 ; H. P. Mitchell, *Arch. Journal*, 1917, pp. 123 ff.

[2] Examples at Milan, Monza, S. Maurice d'Agaune, Conques, &c.

[3] The Alfred and Minster Lovel jewels in the Ashmolean Museum at Oxford.

[4] Millet, in A. Michel's *Histoire de l'art*, i, p. 281.

In *Byzantine Art and Archaeology* a description was given of the principal Byzantine enamels preserved in churches, monasteries, museums, and private collections.[1] As the majority belong to a single (Middle Byzantine) period, and perhaps to a single centre, Constantinople,[2] the Georgian group[3] remaining for the most part in Georgia, the enumeration according to the countries in which the enamels are now preserved may be retained as the most convenient.

Great Britain is not rich in Byzantine enamels. The British Museum has a few small examples without outstanding merit, though two carvings with peacocks may be as early as the sixth century, two disks with saints on both sides (Plate LXII) of the tenth. The Victoria and Albert Museum possesses in the Beresford Hope cross a remarkable example of a type which was probably very popular ; it is a pectoral cross enamelled on both sides, one having Our Lord as crucified, the other the Virgin in the *orans* attitude with both hands raised ; busts of saints occupy the extremities. The whole surface is enamelled, the ground being of a translucent green : the date may be earlier than the eleventh century. The same museum has recently acquired a plaque with a dancing figure from the crown in the Museum at Budapest probably made for Andreas I of Hungary (Plate LXII). The Ashmolean Museum at Oxford has a small gold pendant medallion enamelled on both surfaces, one having a lion, the other a formal rose.[4] It was discovered in 1878 by Sir Arthur Evans at Risano (*Risinium*) in Dalmatia, a town destroyed by the Slavs and Avars in the first half of the seventh century ; this fact suggests that the enamel was made before that time ; if not, like the Castellani brooch, in Northern Italy, then in Dalmatia itself. The enamelled figure upon the celebrated Alfred jewel in the same museum probably also belongs to the class of early Western reproductions of Eastern methods.

In the United States, through the collections formed by the late Mr. J. Pierpont Morgan and now exhibited in the Metropolitan Museum of New York, the representation of Byzantine enamelling is more satisfactory. A reliquary for wood of the True Cross formerly in the Oppenheim collection, is in the form of a box enamelled on the top with the Crucifixion between the Virgin and S. John, and round the sides with

[1] pp. 505 ff. The older references for the individual objects are there given. More recent references only will be added in the present volume.

[2] Such work may also have been produced in Salonika.

[3] *B. A. and A.*, p. 507.

[4] Georgian cloisonné enamelling, as represented chiefly by the examples in church treasures published by Kondakoff and others, is held to have been introduced from Con-stantinople about the eleventh century, when the influence of Byzantine Empire was extended in Armenia and Georgia ; the iconography in general suggests this conclusion. But if Iran was an early home of the art, Armenia and Georgia may have preserved traditions upon which a later Byzantine style supervened. And Kondakoff has assigned more than one of the Georgian examples to an earlier date than the eleventh century.

busts of saints ; the whole surface is enamelled, the ground being trans-lucent green. The style is barbaric ; but the fact, perhaps, points rather to an origin in some remote place than to great antiquity : the date may not be earlier than the eleventh century. The large medallions with busts of Our Lord, the Virgin and saints, formerly in the Swenigorodskoi collection, well known through its publication by Kondakoff, are a conspicuous feature in the Metropolitan Museum. They originally ornamented the frame of an ikon of S. Gabriel in the monastery of Jumati in Georgia, and are among the most splendid examples of the kind ; they are accompanied by larger plaques with continuous floral ornament of the highest decorative quality, to which allusion has been made above. Another remarkable possession of the Metropolitan Museum is the large triptych from Hanau in Germany.[1] This is in the main a Western work, with magnificent champlevé enamels by Godefroid de Claire, but it has mounted on its centre panel two small Byzantine enamelled triptychs (Plate LXII) perhaps of the late eleventh century.

Italy is naturally richest in Byzantine enamels. The Vatican contains the reliquary-cross discovered in the chapel at the Lateran known as the *Sancta Sanctorum*, and covered on one side by five plaques enamelled over the whole surface with six scenes from the life of Our Lord, the icono-graphy of which shows oriental (Palestinian ?) affinities.[2] This is perhaps the oldest surviving enamel with figure subjects, and is remarkable for the pictorial treatment of the scenes. Its place of origin is uncertain, but opinion inclines to the view that it was, perhaps, made in the Christian East in the seventh century, and imported into Italy as early as the time of Sergius I.

The Vatican has another enamelled object from the *Sancta Sanctorum*, a silver casket with the subject of the *Deesis*, and medallions with busts of apostles ; the work appears to date from the eleventh century. In S. Peter's the so-called Encolpion of Constantine has enamelled medallions of the twelfth century. Other Byzantine enamels at Rome are in the Stroganoff collection. The large panel in the Museo Kircheriano[3] with a standing figure of Our Lord is exceptional, almost suggesting an experiment of a thirteenth-century Greek enameller who had seen examples of Limoges workmanship, but perhaps it is wholly Byzantine, and the resort to cham-plevé in the greater part may be explained by its great size. Its date would then be eleventh or twelfth century.

The most numerous Byzantine enamels are to be found at Venice, in the Treasury and Library of S. Mark's, and in the cathedral itself ; the majority were brought from Constantinople after the Fourth Crusade. The *pala d'oro* in the cathedral, originally an altar frontal, is now transformed into a

[1] C. H. Read, in *Archaeologia*, lxii, pp. 21 ff.

[2] P. Lauer, *Monuments Piot*, xv, 1906 ; Leclercq, in Cabrol, *Dict. d'arch. chrétienne*,

p. 3116 (coloured reproduction).

[3] Figured by Wulff, *Altchr. und byz. Kunst*, p. 602.

reredos of Gothic design, dating in its present form from the fourteenth
century. It is enriched with a series of enamelled plaques of which those of
the upper part, with scenes from the Gospel, are the earlier, and may have
come from an iconostasis in Constantinople. The enamels of the lower part
immediately above the altar include the Twelve Feasts, scenes from the life
of S. Mark, portraits of an Emperor or Doge and an Empress, angels,
apostles, prophets, and other subjects. The plaques are of various dates
and unequal merit. The upper series are probably of the eleventh century.
Some of the lower are of about the same date, but the S. Mark scenes, and
the series of prophets, with some other plaques, seem to be of Venetian
workmanship imitating the Byzantine style, and not older than the thirteenth
century. The oldest enamels, which may, according to Kondakoff, go back
to the tenth century or the early eleventh, are the small medallions in the
upper and lower borders with hunting scenes, gryphons flanking a ' sacred
tree ', two peacocks in a similar arrangement, &c., &c. The *pala d'oro*, in
short, is not homogeneous, nor are its enamels the finest in Venice.

The Treasury of the cathedral contains four book-covers enriched with
enamels, of which the central subjects are in two cases the Crucifixion, in
the other two a bust and full figure respectively of S. Michael : all are
enriched with plaques and medallions with sacred persons and saints in
enamel. The finer are the two with S. Michael, especially that with the
standing figure, which is in relief, with the face enamelled, thus affording
a rare example of enamelling an embossed surface, a method which did
not come into fashion in Western Europe until the latter part of the four-
teenth century ; this book-cover may probably be assigned to the eleventh
century (Plate LXIII).

Eight of the chalices in the Treasury retain the plaques on their sides,
enamelled with busts of Our Lord and saints (Plate LX) ; a paten has in the
centre a medallion of Our Lord : the dates of these objects range from the
tenth to the twelfth century. A number of detached medallions are said to
have formerly decorated the high altar in the cathedral. The Treasury also
possesses a flat reliquary for wood of the True Cross with an enamelled
Crucifixion and medallions of saints, and a silver-gilt band (?) adorned with
enamelled plaques representing saints and an Emperor Leo. The Library
of S. Mark's (Bibliotheca Marciana) contains a second group of four book-
covers with enamels. One of these, which has a border of *orfèvrerie cloisonnée*
of very early appearance, has on one side the Crucifixion as a central subject
surrounded by medallions with busts of evangelists, apostles, and angels,
on the other the Virgin as *orans*. The colours in this example are trans-
lucent, and the style suggests an early date which is rather supported by
the character of the border. Some authorities consider the work not later
than the ninth century. The other three covers are less remarkable, but
the enamels on those which enclose a Latin Missal of the fourteenth century
are mostly of fine quality and of tenth-century date. The frame of the ikon

in the cathedral, known as the Madonna Nicopea, has sixteen enamelled medallions of about the same period.

A few other Byzantine enamels in Italy may be mentioned. A book-cover in the Communal Library at Siena is ornamented by about fifty plaques, some, if not all, of which belong to the eleventh century. Enamelled crosses are preserved at Velletri (cathedral), Gaeta, Cosenza, and the abbey of Nonantola near Modena ; Nonantola has also a reliquary for wood of the Cross with enamelled medallions. Cloisonné enamels with decorative ornament in the Byzantine manner executed in Sicily in the twelfth and thirteenth centuries were used to adorn crowns and imperial mantles, gloves, &c.

France, which lost various Byzantine enamels at the time of the Revolution, has now very few. The most interesting is the central panel of a triptych-reliquary in the monastery of Ste. Croix at Poitiers which may with probability be identified with the cross mentioned by Gregory of Tours and Fortunatus as sent by Justin II to S. Radegund in the sixth century.[1] In the middle of the panel is a sunk cross bordered with *orfèvrerie cloisonnée* of coloured glass pastes. The field round this is of dark blue enamel with floral scrolls in gold and leaves of turquoise blue with red pistils : each of the leaves (now lost) had three enamelled busts of saints.

The Louvre possesses a fine medallion from the Swenigorodskoi series, the gift of Mr. Morgan, and one or two small but interesting examples : one, a brooch with a gryphon in the style of the tenth century, the other a copper armlet in the form of a medallion enamelled on both sides. One face has a Medusa-like head surrounded by serpents, the other side the usual Greek inscription regarded as efficacious in cases of stomachic disorder.[2]

In Belgium there is an interesting cross with enamelled medallions of the eleventh century in the Convent of the Sœurs de Notre Dame at Namur ; the cathedral in the same city has a reliquary for wood of the Cross. In Holland, at Maestricht, there is in the cathedral an enamel representing the Virgin as *orans* and Our Lord with incorrect inscriptions in Greek, apparently a late work and perhaps not purely Greek in origin.

The Byzantine enamels in Germany are of considerable importance. The reliquary for wood of the true Cross at Limburg-on-the-Lahn, as usual in such cases, a flat box with sliding lid, was made, as metrical Greek inscriptions show, about the middle of the tenth century. On the lid are nine enamelled plaques in three rows, each with two figures except that in the centre, which has Christ enthroned. The interior contains twenty

[1] If so, it inspired the famous hymn, *Vexilla Regis prodeunt*, composed on the occasion of its processional arrival at the monastery. A coloured photograph is reproduced by Conway in the *Antiquaries Journal*, iii, 1922, pp. 1 ff. The style of the floral scrolls can now be seen to be of an early date, and any suspicion that the work was added at a later period may be dismissed.

[2] From the Gay collection : V. Gay, *Glossaire arch.*, p. 615.

rectangular plaques enamelled with angels and seraphs, with bands of ornament of admirable execution. Both in colour and design the enamels of the Limburg reliquary are of a quality only equalled by those of Shemok-medi in Georgia, and their authenticated date justifies us in assuming that Byzantine enamelling reached its zenith towards the close of the tenth century.

The Reiche Capelle at Munich has a book-cover with a fine Crucifixion in which the Virgin, S. John, and Longinus stand by the Cross, while in the foreground two soldiers rend the seamless garment; it is assigned on account of the picturesque treatment to a rather later date than its fine quality would suggest, and some attribute it to the twelfth century. A Gospel cover in the library of the same city has cloisonné enamels, some of which seem to be Byzantine, others probably Western imitations.

A reliquary for wood of the Cross is in the Museum of Sigmaringen. Gospel-covers at Gotha and Quedlinburg have a few Byzantine plaques among many of Western origin.

· In Austria, the cloisonné enamels in the Schatzkammer at Vienna are for the most part considered to be Siculo-Byzantine. The so-called crown of Charlemagne, however, ascribed to Conrad II (crowned at Rome in A.D. 1027), is thought to be of German work; it has four enamelled plaques representing David, Solomon, Hezekiah, and Our Lord between Seraphim. The enamelled medallions attached to the imperial mantle, dalmatic, and shoes have ornament recalling mosaic designs in Palermo and at Monreale.

In Hungary the cathedral of Gran has a reliquary for the wood of the Cross brought back from the Fourth Crusade, with plaques representing Constantine and Helen, and subjects from the Passion; the date is perhaps the eleventh century. In the National Museum at Budapest is a crown with enamelled plaques representing the Emperor Constantine Monomachos (A.D. 1042–1054), the Empress Zoe (A.D. 1034–1056), her sister Theodora (d. A.D. 1042), three female dancers (cf. p. 338), and figures of Humility and Truth. It is thought that this crown was made for presentation to a Hungarian king, probably Andreas I (A.D. 1046–1061): the figures of the dancers are full of life and movement.[1] The same museum possesses another crown with enamels, probably made for a prince or patrician, but traditionally associated with S. Stephen. The enamelled plaques are here on the crossed bands or hoops, and represent, in addition to Our Lord, archangels and saints, the Emperor Michael Ducas (A.D. 1071–1078) with his son, who probably sent the crown as a gift to some Hungarian prince. The Museum at Budapest also contains two enamelled medallions of the twelfth century with busts of S. Peter and S. Andrew and a baptismal cross with enamels of later date.

There has been much discussion as to the origin of the copper dish at

[1] It has been noted above that another plaque is in the Victoria and Albert Museum.

Innsbruck,[1] enamelled in copper cloisons with the Ascension of Alexander in the middle, round the sides with musicians, birds, beasts, dancers, formal trees, &c., and round the rim with an Arabic inscription relating to an Urtukid prince of the first half of the twelfth century. Some are inclined to see a Byzantine influence in the introduction of such enamel into Mesopotamia,[2] others look towards Central Asia and even China.[3] On the whole the former supposition seems the more probable.

The cross of Queen Dagmar (who died in A.D. 1212) in the Museum at Copenhagen has been already mentioned as one of the enamels providing evidence as to date. On the front is Christ crucified, on the back an arrangement of busts, Our Lord in the centre surrounded by the Virgin and saints.

In Russia, the Hermitage at Petrograd possesses the enamelled armlets from the treasure of Poltava (p. 328) ;[4] it has also the enamel with S. Theodore mentioned above as combining, like the panel in the Museo Kircheriano (p. 339), the champlevé and cloisonné methods. This is a rectangular copper panel of larger size than most Byzantine enamels, and may have ornamented a book-cover ; it apparently dates from a late period, perhaps the twelfth century. The church of Polovsk in Vitebsk has a tenth- or eleventh-century Cross, and S. Sophia at Novgorod another Cross with the Crucifixion. In the cathedral of S. Michael at Moscow, a sixteenth-century book-cover has two Byzantine plaques among the enamels forming its decoration ; in the same city are maniples of the Metropolitans Alexius and Photius, to which enamelled medallions are sewn as in the case of the Sicilian imperial robes mentioned above. Among other enamels in Russia may be cited a reliquary for wood of the Cross in the Palace Church at Livadia with eleven medallions of saints of a good period, and various secular enamelled objects, ear-pendants (*kolts*), &c., in the Khanenko collection at Kieff, many of which are Russian in the Byzantine style.

It has been stated above that from the eleventh century Georgia was an important centre of the enameller's art. The number of these objects is considerable and the quality of many is of the first order. As they are treated at length by Kondakoff,[5] a bare mention of a few examples must suffice. The triptych in the monastery of Gelat framing the panel ikon known as the Virgin of Chachuli is enriched with a whole series of enamelled plaques, mostly representing single saints, but including two Crucifixions, and two coronations of princes ; in one of these Our Lord crowns Michael VII Ducas and his Empress Maria. The dates of the enamels vary from the eighth or ninth century suggested by Kondakoff for two small medallions with the Virgin and S. Theodore to the eleventh. The triptych as a whole

[1] Riegl, *Spätröm. Kunstindustrie*, ii, 1923, pl. xlviii (in colour) ; Van Berchem and Strzygowski, *Amida*, pp. 120 ff., 348 ff.

[2] O. von Falke, *Monatshefte für Kunstwissenschaft*, ii, 1909, p. 234.

[3] Strzygowski in *Amida*, pp. 352–3 ; Migeon, *Manuel d'arch. musulmane*, p. 156.

[4] Bobrinsky, *Mém. Soc. Nat. des Antiq. de France*, 1913, fig. 7, p. 239.

[5] *History and Examples of Byzantine Enamel* (editions in German and in French) ; *B. A and A.*, pp. 528–31.

is of exceptional importance for the study of enamels. The monastery of Martvili has several enamels, a cross, a plaque with the *Deesis* and another with a bust of S. Peter of early date, perhaps the eighth or ninth century. At Chopi there are several fine enamels. Shemokmedi in Ghuria has an ikon with eight rectangular plaques having the Annunciation, the *Anastasis* and figures of saints in a style comparable to that of the Limburg reliquary, and probably also of the tenth century. The medallions from Jumati in the Swenigorodskoi collection have already been mentioned as forming part of the Morgan collection at New York (p. 339).

Enamels are rare in the Balkans, Greece, and upon Mount Athos. The liturgical fans at Serres in Macedonia[1] are too late for our period, but interesting as examples of a survival or revival of the art.

The Church of the Holy Sepulchre at Jerusalem has eighteen plaques with angels and saints on the frame of an ikon representing Our Lord ; and an applied nimbus round the head has finely enamelled ornamental designs. The best plaques are of the tenth and eleventh centuries.

Niello

Niello, a composition of silver, lead, and sulphur, sometimes also of copper, is used in a similar way to enamel to produce designs on a metal base. But niello fuses at a much lower temperature than enamel, is not vitreous, and is always of the same blue-black colour. It was popular throughout the Byzantine periods, as it had been in Roman times ;[2] and producing its most pleasing effect on silver, was generally employed to enrich that metal, especially in the form of plate.[3] It was, however, also used on gold as in the case of the marriage rings and the small reliquary in the British Museum mentioned below. The process of applying niello was always the champlevé method ; cloisons were not used.

Damascening

This craft, in the sense of the inlaying of silver in a base of other metal to produce a design contrasting with its darker background, is mentioned on another page in connexion with a damascened object of particular interest for the study of ornament. The method was known in Mesopotamia from remote times, and, as employed in Christian and Byzantine art was probably taken over by Hellenistic craftsmen from Syria and Mesopotamia. The dish or disk at Athens, discussed below (p. 363), a remarkable example of the method, dates from the second century of our era ; the familiar *exagia* or money-weights, which are often inlaid with silver, date chiefly from the sixth century.[4] Examples of damascening on a greater scale survive in

[1] *B. A. and A.*, p. 531.
[2] M. Rosenberg, *Gesch. der Goldschmiedekunst : Niello*, 1924, pp. 46 ff.
[3] Even the floor of an oratory erected by Basil I in the palace at Constantinople was of silver with niello enrichment (*B. A. and A.*, p. 533). Walls were also so covered (Ebersolt, *Arts somptuaires*, p. 62).
[4] *B. A. and A.*, p. 621.

bronze doors decorated in this manner with figure subjects, monograms, &c. The best known and earliest Byzantine doors are those in the narthex of S. Sophia at Constantinople, made in the year 839,[1] already mentioned (p. 61). Thirteenth-century doors from Novgorod are at Suzdal in Russia.

In the second half of the eleventh century a number of damascened doors, made in Constantinople, were imported into Italy. The monastery at Montecassino has a fine pair ; others are at Amalfi, Monte Gargano, Atrani, and Salerno, to the churches of which they were presented by members of wealthy mercantile families trading with the East.[2] The finest of such doors were once to be seen at S. Paul's without the walls, Rome ; but the great fire early in the nineteenth century has left only a few fragments.[3]

Pottery and Glass

The pottery of the earlier Christian centuries, as at present known, is almost without exception unglazed, and consists of platters, bowls, jugs, dishes, lamps, flasks, &c., of red ware, either plain or, if ornamented, with designs either painted, or moulded in relief or impressed. Egyptian sites are especially prolific, but earthenware is distributed over all districts. We may mention in the first instance examples of a fine ware of rich colour with some analogy to 'Samian', having small impressed designs, or less commonly figures in relief ; a fragment in the Cairo Museum shows half a male figure resembling a type from an ivory diptych. The ordinary moulded decoration is illustrated by the very numerous lamps and flasks[4] brought by pilgrims from shrines, especially those of the shrine of S. Menas in Egypt, where the saint is seen standing between two camels. Terra-cotta medallions in the Treasury of Monza with figure subjects are thought to have come from holy places in Palestine, like the well-known metal ampullae. Coptic sites in Egypt have yielded pottery with modelled faces (jugs), small figures of birds, &c. The painted wares found on Coptic sites have often designs boldly drawn in free hand on white slip, including quadrupeds, birds, fish, human busts, floral and scroll patterns : these are often of considerable merit, and may have influenced the decoration of the early Mohammedan wares made in Egypt. The practice of glazing pottery, though more ancient in Mesopotamia and Persia, seems to have been

[1] B. A. and A., p. 618 ; the panels bear monograms damascened in silver. The doors of Ma'mun in the Mosque of Omar at Jerusalem are seven years older, being made in 831 ; see Becker in Zeitschrift für Assyriologie, 1904, p. 105 ; G. Migeon, Manuel de l'art musulman, p. 165.

[2] B. A. and A., p. 618, for references.

[3] d'Agincourt, Hist. de l'art par les monuments, iv, pl. xiii–xx ; Bayet, L'art byzantin, p. 206 ; E. Bertaux, L'art dans l'Italie méridionale, p. 405 ; Nicolai, Basilica di S. Paolo,

1815, pls. xi–xvii ; A. L. Frothingham, Am. Journ. of Arch., xviii, 1914, pp. 486 ff. A fragment, apparently from these doors, is in the Museo Kircheriano at Rome. The inscriptions were in Syriac and Greek.

[4] B. A. and A., p. 606. For lamps see also H. Häusler, 'Die Lampe, ihre Bedeutung und Entwicklung in Palästina,' in Das Heilige Land, 1914, pp. 13, 65, 149. For pottery see C. M. Kaufmann's accounts of the Sanctuary of S. Menas, and A. Guerra in Faenza, ii, pp. 33 ff., and iii, pp. 21 ff.

introduced into the Mediterranean area about the first century B.C., approximately the same time as its earliest recorded appearance in China under the Han Dynasty (206 B.C.–A.D. 220). Ware discovered by Petrie at Memphis in 1909–10, and dated by him between A.D. 1 and A.D. 50, is glazed in a variety of colours, dark indigo and paler blue, manganese purple, and green. We may note that the designs on this ware appear to be Persian in character ; and this touches the problem of the relation between Chinese and West Asiatic glazing : we recall the tradition that potters from the Indo-Scythian kingdom improved the methods of producing coloured glaze in China in the fifth century. Chinese pottery of the T'ang period is definitely influenced by Hellenistic feeling, and during that dynasty, intercourse with the West being uninterrupted, we find examples of action by East Christian and Sassanian art upon Chinese products, as well as objects imported into China from the west of Asia as early as the eighth century.[1] The 'Constantine bowl' in the British Museum,[2] which has been regarded as the most remarkable example of glazed pottery produced in the early Christian period, is at the present in a dubious position. Wilpert has shown that the design incised under the glaze in the interior bears the closest resemblance to the figure of Our Lord showing his wounds in an eleventh-century exultat-roll at Mirabella Eclano in the south of Italy.[3] It must be admitted that the two figures are almost line for line the same, and Wilpert supposes that the busts filling the two medallions in the bowl, absent in the manuscript, are, like the inscription, evidence of the forger's hand. Unless both the illumination and the incised figure of the bowl go back to a common original of very early date the case against genuineness is formidable, though many still refuse to be daunted by it.[4]

In the later periods, Byzantine glazed ware is of a simple description. A thick red body was coated with a slip, in which designs of animals, monsters, &c., were incised, or under which they were left in relief ; a transparent glaze was then applied. This ware, found at Constantinople, Sparta, and at various sites in Anatolia and on the Black Sea, resembles medieval *tazze* found in Cyprus, and Italian sgraffiato of the period between the thirteenth and fifteenth centuries. A passage in the *Diversarum artium schedula* of the early medieval writer Theophilus (about 1100) states that 'The Greeks' decorated pottery with geometric floral and animal designs,

[1] As in the Temple Treasures of Nara in Japan, which were collected almost entirely in China in the eighth century. For Western influence of the kind above mentioned see R. L. Hobson, *Burlington Magazine*, 1919, p. 212, and F. R. Martin, *ibid.*, 1912, p. 357. Strzygowski (*Altai-Iran*, pp. 262 ff.) notes affinities between Chinese pottery of the Han period and that of Turkestan, and would establish a relation between the latter and pottery assigned by Sarre to Mosul (*Jahrbuch der K. Preussischen Kunstsammlungen*, xxvi, 1905, pp. 69 ff.).

[2] *B. A. and A.*, p. 609, with older references.

[3] Wilpert's article will be found in *L'Arte*, July–October 1920, p. 157.

[4] Practical potters and students of ceramics are still unwilling to believe that the bowl was made in modern times, and will not admit that the incised design could have been added to a genuine antique bowl.

over which they set a glaze.[1] All this pottery is much ruder in character than the fine glazed ware produced at the same time in Syria and Persia, and suggests that the ceramic art of the middle and later Byzantine periods was far behind that of Islam. But new light may be thrown on an·obscure subject by future discoveries. The very interesting glazed wall tiles from the ruined church of Patleina, near Preslav in Bulgaria,[2] said to date from the tenth century, may prove of some importance. The colours are red, green, yellow, and two shades of brown, generally on a white ground. Some tiles have ornamental motives. A number together compose the head of a bearded saint with a nimbus certainly Byzantine in style, and it is a curious fact that in the tenth century the system of distributing a unit of design, such as a human bust, over a number of separate tiles is not known to have been in existence. It will be remembered that Bulgaria is thought in earlier times to have been an intermediary in other ways between the East and the West (p. 50). The glazed dishes inlaid in the walls of churches, especially in Greece[3] and Mount Athos, are probably of Mohammedan origin. Those placed in the same way in the walls of the tower of S. Apollinare Nuovo at Ravenna[4] are built into the spandrels of the three-light windows of the third tier from the top ; the designs show a quatrefoil under a cross, and a six-pointed star. Those in the tower of S. Apollinare in Classe have been examined in recent years.

The glass of the Christian East is no better represented than its pottery.[5] Egypt and Syria must have been the chief centres of production, at any rate in the earlier centuries ; but apart from the phials found in tombs in the Holy Land, not Christian, but of the Christian era, perfect vessels are seldom found.

The gilded glasses of the Catacombs, representing an art practised in Alexandria, are now sufficiently well known.[6] The technique is not represented by discoveries later than the early Christian period, though Theophilus states that in his time gilded glass cups were still being made by ' the Greeks ' (Byzantine craftsmen), who protected the gilded design by an upper layer of transparent glass in the same way.[7] Such work, or fragments

[1] The passage is quoted by J. Ebersolt in his *Catalogue des poteries byzantines et anatoliennes du Musée de Constantinople*, 1910, which the reader should consult for general reasons. For the glazed pottery found at Sparta see Dawkins and Droop in *Annual of the British School at Athens*, xvii, 1910–1911, pp. 23–8 ; in the last centuries of the Empire pottery was used on the imperial table (Ebersolt, *Arts somptuaires*, p. 108).

[2] B. Filow, *Early Bulgarian Art*, pl. xlix.

[3] R. Traquair, ' The Churches of Lower Mani ' in *Annual of the British School at Athens*, xv, 1908–1909, p. 192 ; on p. 183 faience pots are mentioned as built into the gables of a village

church at Vamvaka, above Kouloumi. A. Struck, ' Vier byz. Kirchen der Argolis ', in *Athenische Mittheilungen*, xxxiv, 1909, p. 227 ; the dishes built into the Argolis churches are described as variously painted with rosettes, concentric circles, geometrical designs, scroll, and plant motives, and are thought to have come possibly from Rhodes. The examples on Mount Athos are chiefly to be seen at Iviron and Lavra.

[4] Rivoira, *Lombardic Architecture*, pp. 44–5.

[5] *B. A. and A.*, p. 612 ; Ebersolt, *Arts sompt.*, pp. 11, 12.

[6] References, *ibid.*, p. 614.

[7] *Diversarum artium schedula*, ii, ch. xv.

of it, may yet be discovered ; meanwhile its only representatives are the gilded glass tesserae used in mosaic, where the gilded side was glazed over with a transparent layer.[1]

Sicilian cemeteries have furnished plain beakers and jugs with polychrome beads resembling those of early Teutonic graves in Europe, associated with Byzantine coins of the late sixth century ; Orsi, who has described the finds,[2] believes that the affinities are Syrian. Abundant fragments of glass, generally plain and of a greenish colour, abound on Coptic sites, and it is certain that small bottles, phials, and other vessels were in regular domestic use ; sometimes coloured fragments occur, resembling glass of early Mohammedan times, and possibly a partial source of its inspiration. Familiar objects in glass of early date which have retained their original form are flat circular money-weights about the diameter of a shilling,[3] their monograms and inscriptions moulded in relief point mostly to the sixth century. From Syria come small flat circular glass pendants, probably worn round the neck, with figures of the Good Shepherd and other early subjects.

When we come to the middle period after iconoclasm, we find a series of vessels, bowls of chalices, patens and lamps, mostly of clear or greenish glass in the Treasury of S. Mark's at Venice.[4] Their ornament consists in applied conical or button-like projections, or rings cut in relief. In some cases animals are thus sculptured, and their oriental style, resembling that of beasts cut in rock crystal, suggests a Saracenic origin. The patens are shaped like plates or shallow bowls, the lamps are bucket-shaped, or have a resemblance to the balance pan of a pair of scales. One paten has on its silver mount an inscription mentioning an Archbishop of Iberia named Zachariah, a fact which may point to manufacture in Georgia, to which region, as noticed elsewhere (p. 343), a whole group of contemporary enamels belongs.

The question of relationship between Byzantine and Saracenic glass is definitely raised by a remarkable cup in the treasury of S. Mark's, with silver gilt mounts in Byzantine style, and ornament in enamel colours. It is of purple glass, and has round the body medallions with figure subjects of a classical style, interspersed with smaller medallions containing profile heads with diadems. Round the inside of the rim, and on the base, are pseudo-Cufic inscriptions more thinly applied. Some have regarded this cup as of Roman date, believing the inscriptions to have been added in later times. But as we have seen, pseudo-Cufic inscriptions became a recog-

[1] Glass tesserae for mosaic must have been made in various places ; we may assume Alexandria and Antioch as two of the more important for the early period. But Constantinople may soon have become a great centre, since the victorious Mohammedan prince, desirous of decorating his new foundation in Syria-Palestine with mosaic, appealed for cubes to the Byzantine Emperor. If they had been obtainable in the countries conquered by Islam, he would hardly have done so.

[2] *Byz. Zeitschrift*, 1910, p. 70.

[3] *B. A. and A.*, p. 614 ; W. M. Flinders Petrie, *Num. Chron.*, 1918, pp. 111 ff.

[4] *Ibid.*, p. 614.

nized decorative feature in the eleventh century (p. 377) and were known earlier; while the classical figures, and profile heads recalling coin types, recall a well-known group of carved ivory caskets, the earliest of which may date from the ninth century (p. 213). A Byzantine attribution seems therefore rather more probable than any other; and when its date is more precisely known it may be possible to determine the relation of the cup to the mosque-lamps and beakers with rich enamelled and gilded designs, dating from the thirteenth and subsequent centuries. Fragments of purple glass, with linear ornament in thin white enamel, occur in Arab cemeteries and late Coptic sites in Egypt, to which country the earliest development of enamelling on glass may possibly be traced. It may be that the method was in use among both Christian and Mohammedan populations, and that, as in the case of faience, the artistic development in the countries of Islam outstripped that which took place in the Byzantine Empire.

Textiles

Figured textiles with designs in rich colours were employed from early Christian times for hangings, for canopies, doorways, &c., and for garments; Christian art did not initiate, but followed the custom of earlier times. Our knowledge of textiles is derived from examples used in both ways: the second has been chiefly illustrated by the excavation of Christian cemeteries in Egypt, where garments worn in life were buried with the dead and the corpse was also dressed in special grave-clothes decorated in the prevailing fashion. These figured textiles may be divided into two main classes, that with inwoven designs, which may be subdivided into the two groups of tapestries and silks; and that in which the pattern is embroidered.

We may pass rapidly over the tapestries from Akhmîm, Antinoe, and other cemeteries, which are now well known, and accessible to students.[1] Tapestry was made in Egypt under the eighteenth dynasty, about B.C. 1500, and its manufacture was without doubt continuous, only the character of the designs changing: the process is similar to that employed in much later times in Europe, as well as in Peru; the materials are chiefly linen and wool, silk occasionally forming the weft, though not in the first centuries; the loom was of the upright form. About twelve colours were used, which are fast and resist light well. In what may be called the Egypto-Roman period of the first two centuries the subjects are Hellenistic and the range of colours is somewhat restricted. After this time the colour scheme becomes richer with the freer use of red, green, and yellow, and the greater richness of effect somewhat compensates for the deterioration in the quality of the drawing. Christian subjects now become common, though their elements are often distinguished with difficulty and they are sometimes

[1] *B. A. and A.*, p. 579, with references. Add A. F. Kendrick, *Catalogue of Textiles from Burying-grounds in Egypt*, vols. i–iii, Victoria and Albert Museum, 1920–1922; J. F. Flanagan, *Burlington Magazine*, xxxv, October 1919, pp. 167 ff.

frankly grotesque. The tapestry was applied in the form of strips, disks, &c., to a ground of natural colour. It is now held by some authorities that the weavers of the Graeco-Roman period learned to use the draw-loom and produced a weave closely approximating to the twill-weave which allows an indefinite repeat,[1] a fact of importance in relation to the weaving of figured silks (see below).

Though it does not belong to the class of tapestries, we may just mention in the present place an interesting manner of ornamenting linen fabric by the use of the reserve method. The design was first protected by some covering substance (wax is used in the *batik* cloth of Java and Sumatra) ; the stuff was then immersed in a bath of dye, usually blue or red, on removal from which the subject appeared in the natural colour. Fine examples of these stuffs are to be seen in the Victoria and Albert Museum.[2]

Although there seems good evidence for the weaving of silk in China at a remote date, there is little to show that Chinese designs influenced the earliest figured silks made in the Christian East. The first silk which entered Western Asia from China would seem to have been either raw, or woven without pattern ;[3] be that as it may, Pliny[4] tells us that Chinese silks were unravelled and rewoven at Cos. The new designs do not appear to have been connected with the Far East. Silk was brought from China by a land route across Turkestan through Serindia (Khotan ?) to Sogdiana, or by sea to Trincomalee, Ceylon, or to Barygaza (Broach) at the mouth of the Nerbudda.[5] In either case Roman and early Byzantine traders had to depend upon middlemen, and the Persians were able to interfere with both routes. The early historians relate the efforts made by Justinian to break the Persian monopoly in the Red Sea by the help of the Himyarites of Yemen, and by Justin to support the inhabitants of Sogdiana in the demand which they made upon Persia for the right to weave silk on their own account. The ‘ silk question ’, as we shall see below, became one of the most fertile sources of friction between the Byzantine and the Sassanian Empires.

The origin of the *figured* silks of early Christian times is one of the points most keenly disputed between the representatives of different archaeological schools. Strzygowski argues that their ornament points through

[1] Flanagan, *as above*.

[2] W. R. Lethaby, *Proc. Soc. Antiq. London*, xxiv, 1912, p. 286 ; *Burlington Magazine*, xxvii, 1915, pp. 104–9 ; F. Birrell, *ibid.*, pp. 168–9.

[3] Flanagan, *as above*, p. 215, suggests that the patterned fragments from the Greek tomb in the Crimea are Chinese, but holds that work of this kind did not influence the methods of weavers in Egypt or the west of Asia.

[4] *Hist. Nat.*, xi, 76.

[5] For the relations between China and the Near East see Sir M. A. Stein, *Serindia*, p. 902. Cf. also *B. A. and A.*, p. 583 ; Hermann, ‘ Die alten Seidenstrassen zwischen China und Syrien,’ in *Quellen und Forschungen*, &c., edited by W. Steglin, 1910 ; F. von Richthofen, *China*, i, pp. 442 ff. ; E. Chavannes, ‘ Documents sur les Tsiou-Kiue (Turcs) occidentaux,’ in *Sbornik Trudov Orchonskoye Ekspeditsie*, vi, St. Petersburg, 1903 (published by the Imperial Academy of Sciences).

Hither Asia to an Iran affected by influences from the central regions of the Continent; [1] von Falke maintains the right of Egypt to priority. [2] The controversy largely depends upon the view taken as to the origin of certain forms of ornament, as to which again there is conflict of opinion between Strzygowski and the followers of Riegl, who defended the claim of Hellenistic art. [3] Von Falke contends that not only are the earliest figure subjects Hellenistic, but that even those parts of the ornament which suggest an oriental descent had already become Greek by adoption and entered the textile art through the agency of Greek craftsmen; he further suggests that Sassanian Persia first learned to make figured silk when Shapur introduced Graeco-Syrian weavers into his dominions after his campaign of 355–360. To Strzygowski this appears an inversion of the actual facts. The Alexandrian claim finds another advocate in Lethaby. [4] A point in its favour is that definitely Sassanian silks appear to belong to the later sixth century, while Hellenistic specimens in existence are undoubtedly earlier. A more precise argument in favour of Alexandria is a technical one, put forward by Flanagan, that the Alexandrian twill method of silk weaving in the fifth and sixth centuries must have been derived from earlier Alexandrian weavers in other material (p. 349, n.), who transmitted the method to weavers in silk. [5] In his opinion the Sassanian weavers must have borrowed the twill process from Egypt. The evidence from Turkestan, as far as it at present goes, seems also to be against the Asiatic origin of the methods used in Byzantine and Sassanian silk, for it seems to show that the 'Byzantine twill' did not come from China. That country was making figured silks in the Han period, but both in ornament and method they differ from those of Graeco-Roman, Byzantine, and Sassanian art. The third expedition of Sir M. Aurel Stein to Central Asia (1913–1916) has yielded silk fabrics which seem to confirm this view from what was once Lou-lan territory but is now part of the Lop desert in the most easterly depression of the Tarini basin in Chinese Turkestan. The fabrics were discovered in the cemetery of a fortified site actually upon the route into the Tarim basin opened by the Chinese for their trade to the West in the last decade of the second century B. C., but abandoned for a more northerly road by the fourth

[1] *Altai-Iran und Völkerwanderung*, pp. 79 ff. (with references to his earlier work on the subject).

[2] *Kunstgeschichte der Seidenweberei*, 1913, a volume supplying a text to the album of plates long ago issued by Julius Lessing. Von Falke, who considers Alexandria the earliest great centre, brings forward the evidence (pp. 27–31) for the existence of silk-weaving in the Roman Empire, and in Italy itself, from the fourth century (a fragment from the sarcophagus of S. Paulinus (d. 358) bears the words ORENTIA OF = *Florentia Officina*). For Syria see Ebersolt, *Arts somptuaires*, p. 11.

[3] *Stilfragen*, 1893, and *Spätröm. Kunstind.*, 1901.

[4] His views are summed up in *Burlington Magazine*, xxiv, pp. 185 ff. R. Meyer Riefstahl in *Art in America*, iii, 1915, pp. 231 ff. and 300 ff., iv. 43 ff., sets forth certain advantages possessed by Alexandria in times when land wars disturbed the trans-continental trade-routes. Rostovtzeff, in *Journal of Egyptian Arch.*, vi, July 1920, p. 176, mentions a Russian study on the textile industry in Greek and Roman Egypt by Chvostoff.

[5] *Burlington Magazine*, xxxv, Oct. 1919.

century of our era. Sir M. A. Stein gives reasons for assigning these
fabrics to the first century B. C. when traffic was most active upon the
Lou-lan route. They closely correspond with other fragments discovered
by him in 1907 in one of the stations upon the frontier wall in the desert of
Tun-huang farther to the east, and dated by accompanying records on
wood to the first century.[1]

The fragments from both sites thus date from the Han period, and their
reproduction by Mr. F. H. Andrews [2] shows on one piece a horseman and
grotesque beasts, purely Chinese in style, separated by conventional cloud
scrolls, the type of the horsemen resembling that found on the Han sculptured
reliefs of Shantung ; on another a procession of beasts in cloud, with Chinese
lapidary characters near each beast, one beast carrying a jewel in its mouth ;[3]
on a third a winged goat and other creatures among clouds ; on a fourth
Puck-like sprites and birds among clouds ; on a fifth confronted gryphons
divided by ' trees of life ', a motive treated in a Chinese style but suggesting
a Mesopotamian origin, above which are confronted geese with out-
stretched necks, and below other confronted beasts under arched clouds
with a conventional fire-altar between them ; on a sixth a grotesque beast
with jewelled chain about its neck among bell-flowers and lozenge-volutes ;
on a seventh a duck in a scroll (repeated), with Chinese seal-characters ; on
an eighth *T'ao-t'ieh* ogres, formal trees and winged lions ; on a ninth
phoenixes and dragons confronted in pairs within a ' trellis ' or lozenge
diaper (this is the fragment found on the watch-station on the frontier wall
accompanied by a document dated 98 B. C.). A tenth fragment, found in
the walled-up chapel of the caves of ' the Thousand Buddhas ' near Tun-
huang, is earlier than the T'ang textiles accompanying it, and probably of
the date of the Lou-lan fragments. It has pairs of phoenixes of Han type
with gryphons, and pairs of leopards in a kind of arcading formed of cloud-
maeander. An eleventh fragment has confronted rams in a lozenge
diaper ; other fragments, birds and beasts, and an interesting strip with
' horse-legged birds ' (gryphons ?) and scrolls which could not be later than
the third century A. D. The animals and birds on these Lou-lan textiles
are surrounded by an ornament almost purely Chinese, and the points of
comparison for the former are to be found in Han art ; they are not types
which penetrated the art of Western Asia. But apart from this absence of
features suggesting a Chinese influence on the decoration of East Christian
silks, we have to observe the difference in technique. In the Han fragments
the weave appears to be a variation of that known as the ' warp rib '. Coptic,
Sassanian, and Byzantine figured silks are woven in a twill rib, a superior

[1] *Serindia*, pp. 373, 383 (from Lou-lan), 701,
703 ff. (Tun-huang), 992, 1000.
[2] *Burlington Magazine*, xxxvii, July 1920,
pp. 6 ff., and August, pp. 71 ff., September,
p. 148.

[3] Von Falke, i, fig. 100, illustrates this feature
in a discovery by Grünwedel at Kizil in Turfan,
comparing it with the shroud of S. Germain
(Migeon, *Les arts du tissu*, p. 29).

weave which is said not to appear in China before the T'ang period.[1] The conclusion would seem to be that the stream of influence moved from West to East, and not vice versa. The technical arguments seem to tell equally against Iran and China.

The dependence of Byzantine silk-weaving upon Persian goodwill in transmitting the raw material became in time so galling that it grew into a fertile cause of friction between the Byzantine and the Sassanian Empires. Great efforts were therefore made to obtain silkworms and establish sericulture in the Mediterranean countries. About the middle of the sixth century these were crowned with success;[2] from the second half of that century the raw material was produced on the soil of the Nearer East, especially in Syria.

Down to the late sixth century there seems to be little evidence of immediate Sassanian influence on design; Graeco-Syrian weavers were already in such repute in the fourth century that the Persians apparently sought to learn from them; Shapur introduced weavers from Syria into his country about the middle of the century.[3] But later we seem to find traces of an early Persian reaction; oriental motives appear which had not been filtered through Hellenistic art, but came direct from Iran. Such would appear to be the ibexes, ' sacred trees ', humped oxen, &c. on silks obtained from the cemeteries of Antinoë in Egypt, and now in the Musée Guimet in Paris.[4] At this time, too, Sassanian silks entered China and were imitated there.[5] A more definite Asiatic influence makes itself felt with the ninth century, the period when the East invaded in force the whole field of decorative design. The art of Islam had now had time to exploit the conquered peoples, and had drawn largely upon their artistic motives. It was suggested by Smirnoff that textiles with Persian motives continued to be made in Mesopotamia under Islam after the fall of the Persian Empire, and there can be little doubt that Persian taste in decoration made a particular appeal to the new conquerors of Western Asia. Silks with geometrical ornament and Arabic inscriptions were early manufactured for Mohammedan princes, whose weavers also adopted the ' heraldic ' animals and ' sacred tree ' of Persian art. The early Chinese textile from the temple of Horiuji in Japan proves that the appreciation of Persian designs

[1] The earliest Chinese figured silks are older than the Egyptian wool tapestries, but they cannot have suggested the ' Byzantine twill ', since their ' warp-rib ' technique is essentially different. The Byzantine twill developed from the very similar pattern-making process of the weavers who produced the Coptic tapestries (Flanagan, *Burlington Magazine*, xxxvii, p. 215).

[2] The story of the two Khotan monks who brought the silkworm west in 552–554 is well known. See *B. A. and A.*, p. 586. For the general question of the early silk trade see Stein, *Ancient Khotan*, i, p. 134, and *Serindia*, Index, *s. v.* Silk; cf. Diehl, *Justinien*, iii, ch. iv.

[3] Falke, *as above*, p. 28.

[4] *B. A. and A.*, p. 593 note.

[5] As we know from the examples in the Horiuji temple at Nara, which were collected in China (*B. A. and A.*, p. 591). Pelliot found in Turkestan silks with Sassanian ornament but Chinese marks (Dieulafoy, *Comptes rendus de l'Acad. des Inscr. et Belles-lettres*, June 1911, p. 390).

extended to the Far East ; in Turkestan figured silks of Chinese fabric have been discovered in which the ornament is of Sassanian derivation.[1] After the Mohammedan conquests in Asia, Greece became a great silk-weaving country ; Thebes and Corinth are mentioned as important centres. It was from Greece that the Norman King Roger in the twelfth century imported workmen to reinforce the industry in Sicily, and by introducing the silkworm into the island King Roger established European silk-manufacture upon firm foundations. But the privileged manufactory attached to the imperial palace at Constantinople remained in the highest repute.[2] Here alone in the East Roman Empire could the famous purple fabric be lawfully made. Though the imperial workshops were allowed under certain conditions to sell their products, the sale of purple silk was forbidden.[3]

The subjects upon silks are generally enclosed in circles (the *rotae* or *rotellae* of the early descriptions) forming part of a connected network covering the whole surface, though sometimes they were arranged in zones. The figure subjects, largely of Hellenistic inspiration, include mythological motives, such as Castor and Pollux, or Ganymede, or religious scenes, like the Annunciation from the Sancta Sanctorum now in the Vatican (Plate LXIV), and the scenes from the life of Joseph in the cathedral of Sens.[4] Anastasius in the *Liber Pontificalis* mentions various scenes from the lives of Our Lord, the Virgin, the Apostles and saints ; and the use of such subjects is attested for earlier times by passages in a homily against luxury by Asterius, Bishop of Amasea in the fourth century, and illustrated in the mosaics of S. Vitale at Ravenna, where the Adoration of the Magi is seen upon the robes of the Empress Theodora. The horseman type in which the rider is repeated, the horses back to back, is generally regarded as Persian, especially where the subject is a King shooting wild beasts, though Falke would include this also among Hellenistic motives : it may be common to both spheres. The type was imitated by Chinese weavers in the seventh or early eighth century as is shown by the example in Japan from the temple of Horiuji, where it was deposited in the eighth century.[5] More common than figures of human beings are those of animals or monsters, and these are generally conventionalized in the oriental manner. We see elephants, lions, gryphons, eagles, &c., singly or in pairs, the circles in which they are enclosed and the spaces between them being enriched with formal scrolls or independent designs, generally composed of palmette derivatives.

As would naturally be expected from their portability and their rich and effective designs, silk textiles exerted no small influence upon decorative

[1] *B. A. and A.*, p. 591.

[2] J. Ebersolt, *Arts somptuaires*, pp. 10 ff., 21–2, 51, &c. A number of imperial costumes are illustrated in the book from different works of art.

[3] Liutprand, envoy from the Emperor Otto to Nicephorus Phocas, had trouble at the Cus-toms when he endeavoured to bring such silk away with him (*B. A. and A.*, p. 587). His embassy is described in *Monumenta Germaniae Historica*, iii, p. 359.

[4] For the Sens textiles see E. Chartraire, *Revue de l'art chrétien*, 1911, pp. 261 ff., 371 ff., 452 ff. [5] Cf. *B. A. and A.*, p. 591.

art in other materials. Just as pavement mosaics suggest the inspiration of carpets, so much of the ornamental mosaic or painting on the walls and vaults suggests that of hangings. The arrangement of motives in a trellis-diaper, such as we see in the early example of S. Costanza, at Rome, and at Quseir 'Amra (p. 261), brings such an origin into the mind, and much decorative work in other buildings may have a similar derivation; the bird-tailed Persian dragon on the wall of an early Armenian church certainly appears to imitate a textile motive. We have noticed elsewhere instances of this textile influence, notably in connexion with ornamental sculpture, where woven and embroidered work seems to have been copied on capitals and closure slabs (p. 199).[1] In minor sculpture, ivory carvings, such as the casket at Darmstadt, show the same influence. Byzantine and oriental silks were naturally exported in numbers to the West. In the early Middle Ages Rome had been a distributing centre, the silks being largely employed as altar-coverings and hangings in churches, and as wrappings for the bones of the venerated dead. It was from Rome that Benedict Biscop obtained the fabrics mentioned in his Life by Bede, and the hangings; silk textiles used as hangings at York and elsewhere in Anglo-Saxon times were doubtless obtained from the same source.[2] The *Liber Pontificalis* has many entries describing silks with beasts, monsters, and other motives, commonly disposed in a network of inter-connected circles. These were probably imported from the East, but as some of the subjects are claimed as being associated with Rome, the attempt has been made to show that monks or other members of the Greek colony at Rome may have woven silk in the city about the ninth century.[3]

A few individual examples may now be noticed.[4] The horseman type in which the rider is shooting wild beasts is well represented in the Victoria and Albert Museum; in the same collection, and in the British Museum, are specimens of a derivative type in which a name, Zacharias, probably that of the weaver, appears above the figures. The Victoria and Albert Museum has also a fine textile with a man (Hercules or Samson) at grips with a lion. In the Louvre there is a fabric with a man driving a chariot with four horses; at Maestricht and at Crefeld are examples of a textile with Castor and Pollux (?) with men bringing bulls for sacrifice. The Adoration of the Magi in the Vatican and the Joseph textile at Sens have been already mentioned. These examples, with the possible exception of the first, show Hellenistic influence, and all date from about the sixth century.

From the numerous textiles with beasts we may select those dated by inscriptions or otherwise possessing historic interest. The Catholic church

[1] Sarre (*Erzeugnisse islamischer Kunst*, ii, 1909, pp. 11–13) notices a Seljuk relief with a gryphon or unicorn and an elephant, which he thinks may have been copied from such a textile as that found in the tomb of Charle-magne (see below, p. 356).

[2] *B. A. and A.*, p. 588.

[3] *Ibid.*, p. 589.

[4] The reader is referred to von Falke's work. Cf. also *B. A. and A.*, pp. 590 ff.

at Siegburg has a purple fabric with finely conventionalized lions and an inscription mentioning the Emperors Romanus and Christophorus; its date is thus fixed between A. D. 921 and 931. The Museum of industrial art at Düsseldorf has also a purple silk with lions and an inscription; in this case the emperors mentioned are Constantine VIII and Basil II, so that the date of manufacture lies between A. D. 976 and A. D. 1025.

The well-known textile at Aix-la-Chapelle, from the shrine of Charlemagne, has formal elephants standing before conventional tree motives, and an inscription which unfortunately does not furnish a date. The shrine of Charlemagne was first opened in the Ottonian period, and it is conjectured that the silk was placed in it at that time, as its style suggests the tenth century. The subject of a remarkable fabric from the tomb of Bishop Günther of Bamberg (d. 1064) probably dates from about the time of his interment in the second half of the eleventh century.[1] It represents a nimbed emperor holding a labarum and riding a richly caparisoned white horse; before and behind are personifications of two cities wearing mural crowns and presenting offerings. The ground is purple, with a diaper of green circles containing 'spades', while lozenges fill the intervening spaces.

We may conclude by mention of a remarkable fragment in the Chapter Library at Durham, found with others, among which was one with definitely oriental subject, in the coffin of S. Cuthbert.[2] Within a large circle with grapes and other fruits is a ceremonial vessel (?) rising from water in which ducks and fish are swimming. The complete textile was evidently covered by a network of circles with the same design, spaces between them being filled by ducks. The fabric suggests an Alexandrian origin and a date probably earlier than the sixth century.

Embroidery, like tapestry an ancient mode of decoration, was practised in early Christian times. It was often executed in gold on silk in ceremonial costumes, or on the costlier hangings of churches.[3] But it would seem to have been employed for all important purposes at a rather late period, perhaps when fine figured silks were not easily procurable; at any rate, the fine examples which have survived mostly date from the last two centuries of the Empire. Examples of early embroidery, some in silk, from Egyptian cemeteries may be seen in the Victoria and Albert Museum. Turning to the examples of later periods we may notice in the first instance the dalmatic[4] in the sacristy of S. Peter's at Rome, richly embroidered with gold thread and coloured silk, and commonly associated with the name of Charlemagne. The real date is probably some five hundred years later than the time of that emperor. On the front is Our Lord seated upon the sphere

[1] *B. A. and A.*, p. 596; Bassermann-Jordan, *Bamberger Domschatz*, 1914, no. 48 and pl. x. The emperor may be Constantine XVI, Ducas, and the cities, the Old and the New Rome.

[2] *B. A. and A.*, p. 597.
[3] Ebersolt, *Arts somptuaires*, pp. 40, 44 ff.
[4] *B. A. and A.*, p. 601.

of the world, surrounded by choirs of angels ; on the back is the Trans-
figuration, while the shoulders have the Communion of the Apostles. The
work is graceful, and suggests an origin during the Byzantine revival of
the fourteenth century. Two pieces of embroidery now forming an altar
frontal in the collegiate church of Castell'Arquato were bequeathed in
A. D. 1314 by the Patriarch of Aquileia. The ground is of red silk, the work
executed in gold thread and blue silk, the subjects being the two parts of
the Communion of the Apostles. This fine example of the embroiderer's
art probably dates from the thirteenth century, and is perhaps the oldest
of the important later pieces now surviving. The Treasury of S. Mark's
at Venice possesses a violet silk embroidered with SS. Michael and Gabriel
with an inscription describing it as a gift of Constantine Comnenus, cousin
of the Emperor Manuel.[1]

An interesting naval standard borne by the Admiral Emmanuel Palaeo-
logus, natural son of the Emperor John Palaeologus (A. D. 1373–1391), is
preserved in the monastery of S. Croce at Avellana. It is of red silk,
embroidered, chiefly in gold thread, with a figure of the Archangel Michael
adored by the admiral ; in the border and elsewhere are Greek inscriptions.
In the monastery at Grottaferrata there is an *omophorion* (a vestment corre-
sponding to the *pallium* of the Roman church) of white silk, with applied
panels and bands embroidered with New Testament subjects, the Death of
the Virgin, and the Pantokrator between angels and saints.[2] It has upon it
an inscription dated A. D. 1618, to which period some would ascribe it ;
others, however, believe that the embroidery may be much older.

The *Sakkos* of Bishop Photius, embroidered with the figures of Vasili
Dimitrievich and the Princess Sophia Vitovtovna, with their daughter Anne
and son-in-law John VII, was sent to Russia from Constantinople between
A. D. 1414 and 1417.[3] Ebersolt has brought together interesting details
from inventories and other sources as to the rich embroidered vestments
worn in the Byzantine churches during the last centuries of the Empire.[4]
These were embroidered with gold or silver thread sometimes with the
addition of pearls, small gems, or imitations of gems in coloured paste.
He quotes the description given by the Russian pilgrim, Ignatius of Smolensk,
of the vestments worn in S. Sophia in 1391 at the coronation of Manuel II
Palaeologus. It is clear that, whatever the difficulties of the Empire towards
its close, the splendours of ecclesiastical ceremonial were undiminished,
and the priests were vested as richly as in earlier centuries.

Epitaphioi, or coverings for the ceremonial bier of Christ used in the
Eastern Church on Good Friday, form an interesting group of embroideries.
The principal subject is the dead Christ mourned by angels, the Virgin,
S. John, and others. That in the church of S. Clement at Ochrida in

[1] *B. A. and A.*, p. 602.
[2] L. Serra, *Burlington Magazine*, xxxiv, 1919,
p. 52.
[3] *B. A. and A.*, p. 599.
[4] *As above*, p. 118.

Macedonia bears the name of Andronicus Palaeologus II or III.[1] Others of the fourteenth century are at Salonika and in the Treasury of S. Mark's at Venice. An example in the monastery of Neamţ, Roumania, dates from the year 1437.[2] Later examples of the sixteenth and seventeenth centuries are in the monasteries of Mount Athos.

[1] *B. A. and A.*, p. 602 ; Ebersolt, *as above*, p. 116.

[2] Millet, *Iconographie de l'Évangile*, p. 681.

VI

ORNAMENT

IT was stated in the first chapter that although ornament was regarded by the Church as altogether subsidiary to sacred representation, it has a peculiar interest for the student of development in Christian art as a whole, since in ornament principles are more readily disengaged ; they are unobscured by problems of intellectual content, or by the demand for the reproduction of objects in nature. Ornament is, therefore, of great value, as showing principles in their simplest action. But it is of importance to our subject for other reasons. Decorative design, deeply rooted in popular feeling, is tenacious of life. It is at the same time mobile. Applied to all manner of portable objects, it travels great distances, and often affords the best and most convenient proofs of the course followed by racial influences, among others, by those affecting the growth of Christianity and its art.

The ornament which so widely dispossessed classical decoration tended to cover the whole surface. The design being continuous or repeating, diffusion replaced centralization ; all parts had equal rights. Its principles were ' coloristic ', not less in sculpture than in the graphic arts. For in decorative sculpture the design, executed as far as possible in one plane, stood out against a background of black shadow ; modelling was avoided ; the effect produced was optical and not tactual (p. 161). In the graphic arts there was unmitigated contrast of flat colours ; thus the design was always linear, line being in its essence the division between contrasting colours. As imitation of nature was avoided, natural shapes were not exactly reproduced ; they were denaturalized, and reduced to an equality with other constituents of ornament. Nature thus disregarded, all was subordinated to geometry. The non-classical part of Christian ornament, which rapidly became the predominant part, was thus a system of formal decoration producing its effects by colour contrast and by line, obeying not natural but geometrical laws, avoiding salience, selection, concentration, and covering the whole of a plane surface with a continuous pattern.

The principles which governed it were sharply distinguished from those controlling Hellenic art, though they had to some extent penetrated that of the Hellenistic Greeks, whose tendency to naturalism was modified in the field of ornament by a certain adoption of geometrical schemes from their neighbours.[1] Even in the case of the geometrical scroll from which the

[1] A few old classical motives persisted with little essential change to the close of the Byzantine age ; such are reel and egg-and-tongue mouldings. A few palmette and acanthus forms approximated to classical models, as did adaptations of the maeander or fret.

arabesque was ultimately derived, there is evidence for assimilation on the part of an essentially assimilative race. Riegl, who rightly perceived the importance of the scroll, examined the position of the Greek decorators with regard to this key-motive of post-classical design.[1] Following the descent of Greek ornament from Egyptian and Mycenaean sources, he sought to show that whatever naturalism it may have admitted in the Hellenistic age, at earlier and at later periods alike it treated the scroll on geometrical principles, applying formal leaf-motives to a stem waved with a regularity foreign to nature. Confining ourselves to the centuries nearest to our own period, we observe the geometrical tendency on Greek vase-ornament of the fourth century B. C. We see not only the regular wavy line with applied spiral ' tendrils ', but, in the spaces beneath the handles of vases, the main surface filled by a formal system of palmettes symmetrically united.[2] A parallel for ornament thus symmetrically disposed is seen in the relief designs on the sides of the well-known silver vase from Nikopol in the south of Russia,[3] but in this fine work symmetry of plan is joined with naturalism in detail.

The frank naturalism of later Hellenistic ornament did not exclude geometrical treatment of design. This is shown not only in the case of continuous scrolls, but of other surface-covering systems in which the plant character is not suggested. Soon after the beginning of our era, Hellenistic and Roman mosaic pavements, and the mural paintings of Pompeii, display surface-covering ornament definitely geometrical in character ;[4] we find systems of interlacing bands, spread over the whole surface and forming circles which enclose detached motives ; we find the trellis or lozenge-diaper, also with enclosed forms. The same tendencies, widely enough diffused to mark a tradition, continued in Egypt and Syria during the early Christian centuries before Islam ; in S. Sophia at Constantinople spandrels of arcades are filled with acanthus-scroll formally disposed to cover the whole surface ; the same thing is seen in the ornament of soffits and of capitals in this church, where the principle of interlacing, fundamental for the arabesque, is also introduced.[5] While the use of such diapers extended, the disintegration of the palmette and acanthus became a common practice, and we note combinations of formal stem and leaf which have no relation to nature. The ' candelabrum ' or formal ' tree ', a hybrid composition adumbrated in even earlier times,[6] is suggested in late-Hellenistic art before it appears in Sassanian where it was elaborately and characteristic-

But all these things are survivals ; they have not the living interest of those elements through which post-classical ornament was developed.

[1] See especially his *Stilfragen*, Berlin, 1893, where he attempts to establish a connexion between Hellenistic and Islamic scroll-design.

[2] Such vases, chiefly from the south of Italy, may be studied in the British Museum, the Louvre, and other great national collections.

[3] Reproduced by Riegl, *as above*, p. 233.

[4] Probably derived from Western Asia.

[5] *Stilfragen*, pp. 233 ff.

[6] Scroll forms one above the other on a vertical stem are seen on Phoenician metalwork of the seventh century, and on Proto-Corinthian vases.

ally developed. Thus the essential elements of the new style of ornament were already present in that of later Hellenistic times.

While Riegl stood chiefly for the share of the Hellenistic Greeks in the development of a new ornamental style, Wulff insists on the importance of Syria-Palestine and Mesopotamia.[1] In the opinion of this scholar the changes which took place about the beginning of our era were due to mutual fertilization between Hellenistic and Semitic ornament, Antioch being the earlier centre in which new forms were produced, Palestine, more especially Jerusalem, the later.[2] Wulff insists that Syria possessed its own forms and motives, its own principles of decoration, capable of mingling on equal terms with those of neighbouring regions ; Palestine had non-classical plant-forms of native origin. The Greek forms naturally reached Antioch from Asia Minor : from this quarter probably came the acanthus, and the acanthized palmette. The vine came from the eastern side, probably from Bactria (p. 38), but was established in Syria at an early date ;[3] in Palestine acanthized vine occurs before the beginning of our era. Non-natural plant forms need not all be ascribed to peoples beyond the Euphrates, though certain unorganic arrangements of acanthus elements became characteristic of Sassanian decoration ; we have seen that prototypes of the ' candelabrum ' existed very early in Western Asia. Animals in foliate ornament are found in Syrian as in Hellenistic art,[4] sometimes the forequarters of beasts emerge from the convolutions of running scrolls. This motive, popular in Coptic art, probably entered Egypt from Syria.[5] Wulff argues that through the combination of Syrian and Mesopotamian with Greek motives and methods, Syria assumed a position of great importance in the sphere of ornament. The penetration of plant-motives by geometry, and of geometrical patterns by plant forms, received fresh developments. Not only new treatment of acanthus and vine may be ascribed to this region, but diapers and polygonal forms were disposed in geometrical systems ; the maeander-fret was employed to cover broad surfaces as a diaper.[6] Such

[1] See especially his *Altchristliche und byzantinische Kunst*, pp. 266 ff. Cf. also Weigand, *Byz. Zeitschrift*, 1914, pp. 209 ff., and L. Bréhier, *Revue des idées*, July 1908 (on oriental art at the close of antiquity) and March 1910 (on the origins of Moslem art).

[2] We may recall Louis Courajod's *grammaire orientale* of geometrical motives, as to which Weigand, *as above*, may be also consulted.

[3] *Altchr. und byz. Kunst*, p. 269. In the early fifth century A. D., non-natural treatment of the vine is found both on the wooden doors of S. Sabina in Rome, which are of Syrian origin, and on the cross of Justin in St. Peter's. The blending of vine and acanthus is found in the art of Pompeii (Riegl, *Stilfragen*, fig. 178).

[4] Wulff, *as above*, p. 271. Riegl, p. 206 and

fig. 108, had laid stress upon the introduction of the human form in a scroll on a Greek red-figured vase, perhaps as early as the fifth century. Birds are placed upon the convolutions of the ornament on the silver amphora from Nikopol (*ibid.*, p. 236 and fig. 121).

[5] The occurrence of the motive in the ornament of Diocletian's palace at Spalato, built perhaps by the same masons who erected the rather earlier palace at Antioch, seems to confirm the Hellenistic and Syrian origin.

[6] The diaper of maeander-fret is illustrated by various early examples. The ornament on the columns of the Mosque at Diyarbekr (*Amida*, pl. xv) shows diaper both of maeander-fret, of imbrications and of crosses, as well as systems of polygonal figures, such as octagons

systems were early employed in Mesopotamia, where they always remained popular, and whence they may have passed into Graeco-Roman art. We see them on the dish at Athens (p. 363), and they are found on mosaic pavements in various parts of the Roman Empire, all the inspiration of which need not necessarily have come from Iran. The maeander-fret forming a diaper, with lines crossing in such a way as to form a swastika at regular intervals, which occurs on the sixth-century Buddhist stûpa at Sarnath, may have come from west of the Euphrates ; the Mosul metal-work of the twelfth and thirteenth centuries, so like the much earlier work of the Athens dish, seems to attest a local continuity. In short, during the fifth and sixth centuries the influence of Syro-Hellenistic ornament spread far and wide beyond the borders of Syria ; Syrian influence entering Egypt in force in the fourth century inspired Coptic ornament (p. 43). The ornamental system of Ravenna came from Syria, as in great part did that of Constantinople. Mesopotamia was a principal source of the formal beast-ornament which after the sixth century played so great a part in Byzantine and Romanesque decoration.

The damascening on the above-mentioned dish at Athens, shortly to be described at some length, suggests that Mesopotamia transmitted westwards not only ornament but the technical processes by which it found expression. Pierced work may afford another example of such transmission, though this is open to more question,[1] for while some incline to an Iranian origin,[2] others plead the cause of Hellenistic art,[3] others think of the Celtic craftsmen of La Tène,[4] others again look back to ancient Mesopotamia. The Celtic theory is supported by the existence of fine examples produced in the west of Europe towards the year 400 B. C. These are the Early La Tène pierced bronze ornaments of La Gorge Meilleret and Somme Bionne, where we have circular and other surfaces pierced with designs geometrically planned and without any obvious imitation of natural forms.[5] The design of the circular ornaments might have been set out with the compass, though slight expansions here and there in details of the pattern betray the antipathy of the Celtic craftsman to mechanical regularity. Geometrical design and colouristic purpose are clearly present together in this work, the existence of which may possibly be explained by the early relations between

containing rosettes surrounded by hexagons, with regularly interspersed crosses. These columns were either taken, as Strzygowski thinks, from an early Christian church, or else reproduce ornament of that time.

[1] Rostovtzeff, *Iranians and Greeks in South Russia*, pp. 52, 57, 133–4, has shown that pierced metal-work was produced in the Kuban, north of the Caucasus in the fifth century B. C., and he believes that the technique came northward from Assyria.

[2] Strzygowski, *Altai-Iran*, p. 210 ; he does not, however, regard this as proved.

[3] Riegl, *Spätrömische Kunstindustrie*, p. 140 ; R. Zahn (*Amtliche Berichte aus den K. Kunstsammlungen*, xxxv, 1913, p. 88) thinks that an oriental influence was associated with the Greek.

[4] Baldwin Brown, *The Arts in Early England*, iii, p. 350, in agreement with Bela Posta, *Arch. Studien*, p. 485.

[5] The Somme Bionne examples are in the British Museum (*Guide to the Antiquities of the Iron Age*, 1905, p. 50).

the Celts and the Scythians in the south of Russia. As the technique may have reached the Scythians from Assyria, the Celtic and Mesopotamian hypotheses may possibly be united.

The possible significance of Syria-Mesopotamia both for technique and for design is illustrated by the disk or dish at Athens,[1] to which allusion has been made (figure on p. 386). It is composed of both bronze and silver, and dates from the second half of the second century of our era. The central part of this disk, the *emblema*, is of bronze and slightly convex, the border is of silver. The latter has upon it in applied relief of gold and electrum the Labours of Hercules, and Dionysiac scenes,[2] while the *emblema* is covered with formal ornament, geometrical and floral, inlaid or ' damascened ' in gold, silver, and electrum.[3] The varied technique illustrated by this object is not classical. It may perhaps be Mesopotamian ; at any rate, the methods in which the figures are applied, and the threads of gold and silver ' damascened ', are just those employed in Mesopotamia and Persia in the well-known bronze objects decorated with silver (bowls, caskets, candle-sticks, salvers, cisterns, writing-boxes) dating from the twelfth century onwards. As on these medieval objects ancient designs are also reproduced,[4] we may fairly conclude that this work represents an ancient local style.[5] The method in which the human figures are applied to the base is also similar in the case of the medieval ' Mosul ' work, and the disk, which in this respect is not unique in the period to which it belongs. Silver plate of about the same date, and probably made in Parthia or Bactria, shows the same peculiarity ; the reference is primarily to the silver dish in the British Museum, with Bacchus drawn in a chariot, formerly an heirloom of the Mirs of Badakshan.[6] The technique, which was later adopted by Sassanian silversmiths, is not classical, and was not favoured by Greeks or Romans except by those in close contact with the East. Damascening in silver on a larger scale for the ornamentation of bronze doors is found on the doors of Ma'mun dating from A. D. 831 in the Dome of the Rock at Jerusalem,[7] and rather later on the narthex doors of S. Sophia at Constantinople.[8]

[1] In the National Museum. G. Matthies, *Athenische Mitth.*, xxxix, 1914, pp. 104 ff. The diameter of the whole object is about 13 cm., that of the emblema 8·65 cm.

[2] The border consists of a thick base, to which is soldered a thin plate from which silhouettes of the figures were cut out. The edges of the spaces left by the silhouettes were then surrounded by deeply engraved lines into which the edges of the figures in relief were pressed and soldered.

[3] Best illustrated in the enlargement of a part given by Rosenberg, *Gesch. der Gold-schmiedekunst : Niello*, 1924, p. 41.

[4] e. g. the ' skew-fret ' common on the ' Saracenic ' metal objects occurs in one of the compartments of the emblema. This motive is seen on a Roman mosaic pavement found in Britain, and now in the British Museum.

[5] The Babylonian practice of inlaying bronze or copper with silver justifies us in seeking the origin of this technique in Mesopotamia rather than in Persia.

[6] Smirnoff, *Oriental Silver*, pl. xiii.

[7] Becker, *Zeitschrift für Assyriologie*, 1904, p. 105 ; van Berchem, *Inscriptions arabes de Syrie*, p. 8, pl. ii.

[8] For the damascened bronze doors imported by the South Italian merchants from Constantinople to Amalfi and other towns, and those at Monte Cassino, see p. 345, above.

Small objects, like *exagia*, or money-weights, had been treated in this way from at least as early as the sixth century.[1]

In this chapter, however, we are not so much concerned with the technique of this remarkable object as with the character of the decorative design upon the *emblema*. This consists of a central medallion surrounded by eight others, all filled with ornament. The central medallion is a whorl ; each of the numerous radii has a line of small wave-shaped projections along one side, formed of small metal plates, creating almost the effect of serrations. These small plates, which are of three metals, gold, silver, and electrum, are so arranged that it is not the real straight radii which strike the eye, but apparently curved radii of alternating colour. Each of the surrounding medallions is completely filled with continuous pattern, in most cases without any central point, and cut off at the circumference without any regard to interruption of the design, as if one should cut a circle at random out of a figured stuff ; only in one or two medallions does the pattern radiate from a centre and finish properly at the circumference. All the medallions are enclosed in a wavy border of Greek pattern, and the spandrels are filled by formal rosettes and palmette motives. We find ornament in which a similar ' rainbow ' effect is produced in a mosaic at Athens from the Piraeus, and in another mosaic at Nîmes with the Marriage of Admetus. The designs of the eight circles surrounding the centre are of great interest, since relationships extend both backwards and forwards, and some of them became commonplaces of later ornament in various countries. One is the pattern formed by circles each intersected by four others, so that each contains four lenticular figures round a square with incurved sides enclosing a central motive, e. g. a rosette in a circle. In another, a small central circle with a rosette and six satellites symmetrically disposed round it are engaged in a system of ' swastika frets ' inclined askew. This type of pattern was revived, as we have seen, by the damasceners of Mosul in the twelfth and thirteenth centuries ; it has an early parallel in the upper part of a niche in the theatre of Ephesus dating from A. D. 142–144, in a lost mosaic from Hadrian's villa, and in the above-mentioned pavement-mosaic from Roman Britain. A third has octagons with incurved sides, the spandrels between which have the form of quatrefoils. In a fourth there is a similar alternation, but the figures are straight-sided, so that the spandrels have the form of stars with four points ; both these designs have analogues in painted ornament of the second century at Pompeii and Palmyra. In a fifth circle, a central octagon is surrounded by squares and rhomboids, all containing formal petalled flowers of rectangular outline drawn in perspective, the whole appearing as a series of prismatic figures. A sixth circle has no central design, but a uniform surface of alternating squares and rhombs, enclosing similar formal floral motives, and resembling ornamented floor-tiles in groups of four, each thrust upwards from below, and appearing to

[1] *B. A. and A.*, p. 621.

meet at different angles. Similar effects are also produced in Roman pavement-mosaics. Parallels both for the sculpture and for the ornament thus connect the disk at Athens with late Hellenistic art of the second century of our era. The types of the Labours of Hercules recall those on coins of Alexandria in the reign of Antoninus Pius ; contemporary analogies for different parts of the ornament take us to Palmyra, Ephesus, Pompeii, Athens, and Nîmes. Later analogies are conspicuous in Coptic art still partly under Alexandrian influence, as in the frescoes of Bawît ; and in the mosaics of the ring-vault in S. Costanza at Rome which also have affinities with the East.

When we consider the characteristics of this object as a whole we thus find a remarkable mixture of Greek and Syro-Mesopotamian ornament and technique. The technical methods are oriental, pointing mainly to North Mesopotamia ; the ' rainbow effect ' of the whorl on the other hand points rather to Syria, the ' swastika-fret ' perhaps to the same area ; the perspectival treatment of the squares and rhomboids, the waved border, and the spandrel-ornaments indicate Greek influence, as do the figure subjects. The study of this disk in fact reveals an eclectic art in which Hellenistic, Syrian, and Mesopotamian elements combine. The number and variety of the elements are so striking that involuntarily we ask whether Mesopotamia and Syria were not in truth rich sources from which much Early Christian ornament derived its oriental motives and methods. For we cannot fail to be impressed not only by their ancient origin but by the continuity of their practice in the Euphrates valley, carrying them, as we have seen, from a very early period right down to modern times, such methods as the inlaying of silver designs in a bronze base having been handed down probably without intermission in the region in which they began. Should not this region be regarded as a perennial source from which the art not only of the Christian East but also of Iran was largely inspired ? We recall the suggestion made in the first chapter that a country, the rulers of which have imposed a representational art, may at the same time possess a popular art of ornament obeying quite different principles. In the general uprising of the East against Hellenism which accompanied the decay of the Hellenizing monarchies in West Asia, an old Semitic popular art may have emerged from a long obscurity to join, if not actually to anticipate, fresh influences from Iran and the Altai (p. 366).

We here find ourselves confronted with the fundamental issue already encountered in earlier chapters. Was the combination of Hellenistic and Syrian elements sufficient to explain the development of a new art, or did the result really follow the entrance upon the scene of new factors from beyond the Euphrates ? It is the question which presented itself with insistence in the case of architecture. Just as, in that art, the whole study of Christian building, as we used to know it, is affected by the suggestion that domical construction developed from the wooden house of a Central Asian people, so the study of ornament is in like manner revolutionized by

Strzygowski's rejection of the old theories with regard to the evolution of the running scroll into a surface-covering design, and by his attribution of a whole new ornamental style to the same part of the world, and even to regions more remote. The theory deserves the more serious consideration from the fact that there may really be an essential connexion between the manner in which a people uses constructional forms and that in which it envisages and employs the elements of decoration.[1]

Strzygowski finds the great centre of distribution for ornamental motives in the 'Altai-Iran corner', where the influences of Indo-Germanic and Turkish tribes met, acting directly upon each other, and incorporating Bactrian Greek motives, which they discovered in Khorasan. The purely geometrical scroll, based on the spiral, and ultimately creating the arabesque, he regards as Turkish, and possibly derived from Chinese suggestions.[2] The leaf-like additions finally assuming the form of the volute-like leaves at the base of the palmette he considers to be likewise of Central Asian origin. For him the chief agents transmitting westwards the forms developed in the Altai-Iran corner were the later Sacian tribe, known to Indian archaeology as the Saka, which conquered the Greek kingdom of Bactria in the middle of the second century B. C. ; with them he associates their Parthian kinsmen,[3] and, later, the Armenians, though the last-named were chiefly important for architecture.[4] The non-classical ornament of Christian art is thus, in his view, pre-eminently North-Iranian or Iranian-Turkish ; the Mesopotamian element is secondary. We are to regard the Eurasian land-mass as divided horizontally into three zones : the northern, the middle zone of the steppes ranged by pastoral nomads, and the southern zone of 'hothouse culture', dominated by the art of the great settled civilizations. Of these the second was the creative zone in formal ornament and in domical building ; it established the true methods of decorative design. Out of it came the missionary influences which created both the ornament and the domed architecture of the Christian East, and almost all the art of Islam. The new formal ornament essentially belonged to nomad tribes, the nomadic life having a direct influence on the art of those

[1] Strzygowski's views are most fully embodied in his work, *Altai-Iran und Völkerwanderung*, Leipzig, 1917. The connexion between the architecture of a race and its conception of ornament is more fully brought out in his *Ursprung der christlichen Kirchenkunst*, 1918, translated into English under the title, *Origin of Christian Church Art*, Oxford, 1922.

[2] Though he believes that its significant development for medieval art began in Asia, he admits, with a scrupulous fairness, the possibility of an origin in more than one centre (*Altai-Iran*, p. 73).

[3] In accepting the Saka as Iranian, and there-fore Indo-Germanic, Strzygowski is in agreement with the majority of scholars ; a Mongolian or Turkish strain is admitted by most to have modified to some extent the pure Indo-Germanic stock.

[4] Cf. pp. 80 ff. The practice of domical building was accompanied, in Strzygowski's belief, by a great feeling for spatial unity, leading to the creation of light and well-designed interiors superior to those known under the old Asiatic monarchies and even in Hellenistic times, though some feeling of the kind is conceded to the builders of the Pantheon at Rome (*Altai-Iran*, p. 191).

who live it.[1] This nomad art reached the South and West by two main routes :[2] a southerly, from the south of Siberia through the Trans-Oxus country and Iran, round the salt desert to Arabia and Egypt ;[3] and a northerly, ' the Aryan way ', from Iran, the Caucasus, and the northern shores of the Black Sea, to Hungary and Scandinavia, its course thus extending from Afghanistan to Norway. The process of converting the South began with the Saka victory over the Bactrian kingdom. It was the contact of the Aryan genius, represented primarily by the Saka and Parthians, in a secondary degree by the Bactrian Greeks, with Turkish elements in Khorasan which first set the revolutionary forces in motion. The movement along the southern route was one of gradual and peaceful penetration ;[4] it was the same along the steppe zone until the time of the great migrations which led to the overthrow of the Roman Empire in the West, when the old North Iranian methods, already practised by the Sarmatians settled in Southern Russia, were picked up and carried into Central and Western Europe by the Goths.[5] In Central and Northern Europe they were received by populations to which they were congenial. Admitting some additions from the south, the barbaric kingdoms established the art which we call medieval.[6] The early Teutonic and the Islamic movements can only be understood if their Sacian and Turkish origin in the Altai-Iran corner is first clearly grasped.

Thus to a combination in Central Asia of ' East-Aryan ' (Sako-Parthian and Armenian) with Turkish ideas Strzygowski attributes all the essential ornament, and the methods of craftsmanship embodying it,[7] which superseded the arts and crafts of the classical world. He ascribes to North Iran (Khorasan [8] with the adjoining territory on the north) the introduction of the all-important geometrical scroll [9] and the resultant

[1] The influence of nomadism in the history of art is a doctrine which Strzygowski consistently maintains.

[2] *Altai-Iran*, pp. 187, 218.

[3] Ultimately, carried by Islam, to North-west Africa.

[4] Influences from Central Asia filtered through to the Mediterranean as early as the beginning of the Christian era (*Altai-Iran*, p. 256).

[5] In supposing an early westerly movement along the steppe route (*Altai-Iran*, p. 71), Strzygowski is in general agreement with Rostovtzeff, but he allows less effective action towards Europe to this early penetration than we have considered probable in other parts of the present volume.

[6] Strzygowski would employ the word medieval in a developmental rather than a chronological sense, meaning by it the cultural and artistic phase which intervened between Graeco-Roman art and that of the Renaissance.

As this phase began soon after Alexander, his Middle Age begins in the Hellenistic period. Cf. his *Origin of Christian Church Art*.

[7] e. g. *orfèvrerie cloisonnée*, enamel, bevelled or ' slant-cut ' carving (*Schrägschnitt, Kerbschnitt*) and perhaps pierced-work.

[8] Khorasan is regarded as the heart of the ' Sakische Ecke ' (*Altai-Iran*, p. 218).

[9] He suggests that ultimately the geometrical scroll may have started in China (*Altai-Iran*, p. 124), but, as above remarked, admits that this feature may have been evolved independently in more than one region of the earth ; the Mediterranean area may have been such a region. His own conviction is, however, strongly in favour of the East : ' Die geometrische Ranke, im Baktrisch-Parthischen Kreis stärker von der Palmette durchsetzt, erobert seit dem Ende der Parthischen Zeit die Mittelmeerkunst ' (*Altai-Iran*, p. 229).

arabesque, and consequently the fundamental part in the foundation of Islamic art.

It will be seen that on this theory little is conceded to the combination of Syrian and Hellenistic influence in ornament, defended by Wulff, or to the less modified Hellenistic influences advocated by Riegl. Both influences are admitted as secondary agents ; but as primary forces essential to development they are practically superseded. Hellenistic Greeks are allowed to have contributed elements of decoration such as certain palmette-motives ; they have no predominant voice in determining the principles of arrangement and design. And though the art of Central Asia penetrated Mesopotamia and Syria in its movement towards the West, it was essentially the giver, the active factor ; in relation to it the arts of nearer Asia were receptive. Their share in the development of the scroll and of surface-covering arabesque was subordinate to that of North Iran. The Hellenistic centres which played the principal part were not those of the Mediterranean, but those of inner Asia ; we may think of Seleucia, Balkh, or Merv. We have indeed to deal with an ' Iranian Hellenism ' ; to this belongs Mshatta, the greatest example of surface-covering ornament in which Greek and Persian elements unite. In the decoration of this building Strzygowski sees late-Hellenistic design transformed in an Iranian sense ; the Parthian Saka, who in his opinion built the palace for a pre-Islamic Arab prince, have left the mark of Central Asia upon this work. He is strengthened in this belief by the supposed fact that at Hatra, a palace assigned by common consent to the Parthians and destroyed by the Sassanian Shapur (A. D. 242–273), there was discovered a fragment of sculpture with vine-scroll treated in the style seen at Mshatta.[1] The façade of Mshatta is a very important document in the history of decorative design. If of the age which Strzygowski assigns to it, it proves the early penetration of Hellenistic ornament by Iranian for which he contends ;[2] if the fourth-century date is established, an important advance is made against Riegl's position.

It was natural that the decorative art of India should be brought by Strzygowski into relation with that of North Iran, and through this with the Byzantine world. That art was in the main indigenous (p. 39) ; it treated local animal and plant motives for the most part in a naturalistic manner,[3] but developed upon lines that begin to diverge from nature a

[1] Andrae, *Hatra*, i, p. 12. Dr. Andrae, however, informs me that this fragment is in plain relief, not in *Tiefendunkel*.

[2] It is noted on another page that the early date assigned by Strzygowski to Mshatta is not shared by others, who bring it down as late as the eighth century (p. 118). In his great monograph on the building and its ornament (*Jahrbuch der K. Preussischen Kunstsammlungen*, 1904) Strzygowski regarded the Iranian elements as Sassanian. In his recent works he seeks the Iranian influence farther North, and attributes them, as stated above, to Sacian (Parthian) sources. Cf. *Altai-Iran*, p. 228.

[3] The jack-fruit is freely used as a decorative motive in scrolls, so closely represented after nature, that it cannot be due to anything but direct imitation ; e. g. birds are introduced in a natural way into the foliate design, and at Bharhut small genre-scenes. We find candelabrum formations of plant-elements, like those of Sassanian art, and mounted lion-riders back to

scroll based on the Indian lotus; the tope at Sanchi, dating from about the beginning of our era, affords fine examples of this ornament. It seems doubtful whether palmette-like motives, here seen, treated in a peculiar manner,[1] are reminiscent of an earlier Greek importation, and not rather, like the scroll, of local development. Upon the whole it may be said that Indian influence upon the decorative art of countries lying to the west was confined at most to the transmission of such secondary motives as pass to and fro in the casual intercourse of arts; it did not play a main part in the evolution of Byzantine or Islamic design, for which it was less significant than the influence of Iran. On the other hand, it received during the Christian era from countries lying to the west both motives and systems of ornament. Such is the fret-diaper enclosing rosettes seen on the sixth-century stûpa at Sarnath near Benares. The connexion of the decoration upon this monument with West Asian art has not escaped Strzygowski,[2] who would apparently ascribe it to the ' Iranian-Hellenistic ' influence which created the ornament of Mshatta.[3]

We have seen that the influence of Altai-Iran is held to have travelled westward with accelerated speed both by the northerly and southerly routes after the victories of Islam; we have seen how it had moved at an earlier time from the south of Russia with the Goths and other Teutonic tribes across Northern Europe. On the south it reached Egypt both through Syria and through Bahrein in the Persian Gulf,[4] spreading west to Morocco and Spain.[5] Its penetration of Syrian and Coptic art is held to have taken

back. A remarkable feature is the introduction of jewellery, chiefly in the form of heavy necklaces. For Bharhut see A. Cunningham, *The Stûpa of Bharhut*, 1879, with good photographic illustrations. For Sanchi, Fergusson, *Tree and Serpent Worship*. For both, Vincent Smith, *Fine Art in India*, and J. Marshall in *Cambridge History of India*, vol. i.

[1] The feathery leaves are regarded by Strzygowski as specifically Indian. He compares those seen in the ornament of the gold cross of Justin (Plate LVI), inferring early influence of India on East Christian and Byzantine art. The introduction of jewellery was not confined to Indian art; it forms borders to mosaic at Ravenna, not obviously under any Indian influence; but the jewellery included in the mosaic decoration of the Dome of the Rock at Jerusalem affords a closer parallel. Strzygowski further notes a resemblance between human figures in reliefs at Sanchi and others produced in Coptic Egypt (*Repertorium für Kunstwissenschaft*, xli, 1919, pp. 134 ff.). A. Foucher (*La porte orientale du stûpa de Sanchi*, p. 34) suggests Iranian sources for details at Sanchi, and finds Hellenistic influence in the treatment of groups and individual figures. For the sculptures see

also J. Marshall, *Guide to Sanchi*, 1918; a larger work by him is in progress.

[2] *Altai-Iran*, p. 130.

[3] For this stûpa see Marshall, *Journal of the Royal Asiatic Society*, 1907, p. 1000, and Vincent Smith, *History of Fine Art in India*, p. 168. Strzygowski compares the ornament on the columns now forming part of the mosque at Amida, which may have come from an earlier Christian church (Van Berchem and Strzygowski, *Amida*, pl. x and xi). Wulff sees in the Amida decoration a Syrian rather than an Iranian influence, a point of view for which much can be said, more especially when we remember the numerous affinities with the Mosul silver-inlaid work of the twelfth and thirteenth centuries. In connexion with this damascening, we recall the important silver dish at Athens, mentioned above (p. 363), where this art, with motives which appear to be more Mesopotamian than North Iranian, is found in full development as early as the second century of our era.

[4] For Bahrein see *Altai-Iran*, pp. 183, 258.

[5] Where Islamic ornament met in the Visigothic an art which had travelled by the

place before the coming of the Arabs, and with this art to have reached Lombardy, France, Britain, and Ireland before the birth of Mohammed. Having once entered Syria it naturally soon found its way through Anatolia to Constantinople, though the capital was never a chief centre of its operation. By the northern route the geometric ornament, which Strzygowski would ultimately derive from the Chinese border, passed through Siberia, the Altai, and the steppes of Turkestan ; it did not come by the great Central Asian route which crossed Khotan. This would perhaps be explained by his view, already noted, that nomadic herdsmen were the great developers of formal art on geometric and colouristic principles. On the route through Khotan, on the other hand, the stream of influence in the early centuries flowed rather from West to East than in the contrary direction ; Hellenistic sculpture, Hellenistic motives and forms, Persian textile designs were all moving towards China, where under the Han and T'ang dynasties they made their influence felt in Chinese art.

Like Strzygowski's architectural theories, these views on ornament are contested, or accepted only with qualification. It is urged against them in the first place that they are too exclusive. They seem to deny the capacity to understand abstract ornament too absolutely to all but nomad and northern races ; they apparently assume that the ordinary people in the areas of hothouse culture (i.e. highly organized despotic states like Egypt or Assyria) were for the most part deprived of all art but that imposed upon them by their rulers. But, as already suggested, there may have been a popular art, ill represented by important monuments, yet sharing in a great degree principles manifested in nomadic art, and responsible for the motives and methods which Wulff assigns to Syria and Mesopotamia ; we have seen reason above to suspect that Mesopotamia possessed such an art ;[1] India possessed one. The principles in question, as ethnography shows, may be widely distributed as a common feature of primitive conditions, and may continue under a higher civilization. Strzygowski appears to draw his economic lines too clean ; they are sharply ruled across a world where things are not arranged as in maps, but pass over into each other and are interfused. Because nomadic life is peculiarly favourable to this or that mode of artistic expression, it does not necessarily follow that the converse is true, and that sedentary life is everywhere and always unfavourable. Because Turkish peoples are admittedly predisposed to geometric ornament, it does not follow that Semïtes, Copts or Greeks had to be taught it *ab initio* by Turks ; they may not have been so wholly devoted to it, but it may have been freely practised by them. They may not have started with it ; but if they came round to it in course of time they were none the less possessed of a geometric art of design and could use it to influence others at an important period of development. We find sedentary people of primitive culture

northern route from the same Central Asian place of origin.

[1] In *Amida*, Strzygowski does justice to the importance of Mesopotamian formal decoration ; its animal ornament he has always recognized.

beginning with natural forms and conventionalizing them until they take their place in formal and geometrical pattern of so abstract an appearance that only those well versed in the whole course of the evolution could guess the real point of departure ; in the art of Polynesia and Melanesia there are many examples of this. Need it therefore be assumed as a universal law that the art of a given region or period cannot exert an influence in a geometrical direction unless it has begun with geometry or early received an impulse from a people or a culture which has so begun ? Again, agricultural and trading peoples do not always imitate nature and represent it in their ornament. Minoan and Mycenaean art, often vividly representing natural forms, at some periods turned towards convention ; Greek art had similar leanings, nor did the spirit of its early geometric period entirely die out. It is further objected against the important role assigned to the later Saka, that if, as suggested on an earlier page, North Iranian peoples exerted an influence in the west of Asia at an early period, the infiltration must have begun long before the Saka conquest of Bactria, coming in through contact with Scythian and Sarmatian culture (p. 28). It is agreed that if this was so, Altai-Iran would still have had its part in the development, since both Scythians and Sarmatians were akin to the great Sacian family, and drew the elements of their art from this region. But, on this view, the Sacian influence was much older, and came round by another way ; and it had already affected the Ionian Greeks, among whose descendants Hellenistic culture began. In this way North Iranian and Greek art would have met and interacted long before the relatively late period of the Saka conquests in Central Asia in the second century B.C. Those who incline to this opinion are disposed to doubt whether the later North Iranian wave gathered the compelling force which Strzygowski assigns to it until late Sassanian and early Islamic times. They think, as suggested above, that it may have reinforced rather than initiated, and that the old Mesopotamian formal ornament may have borne a greater part in the movement than the new theory allows. They await a final decision as to the real date of Mshatta. They are also sceptical as to the serious importance assigned to Chinese influences.[1]

In seeking to establish a genetic connexion between his North Iranian ornament and that of China, Strzygowski relies much upon the early bronzes. But the date of these is often very uncertain,[2] and arguments based upon reproductions in the Po-ku-tu are even more so. Moreover, it is possible to admit that the Chinese may have employed a continuous wavy band or scroll to which they added leaf-like appendages, even developing a ' palmette-scroll ' out of the spiral,[3] and yet to remember that similar developments in the Mediterranean area formed the basis of a similar

[1] *Altai-Iran*, p. 71. They further doubt extensive influence on the West from India.

[2] The vase adduced in evidence (*Altai-Iran*, fig. 109 and p. 115) is admitted to be a late reproduction based upon diverse early models.

[3] *Altai-Iran*, p. 124. Comparisons of scrolls on the Nagy Szent Miklos treasure lose force as regards the earlier period of East Christian

argument by Riegl in favour of a Mediterranean origin.[1] We are still confronted by the possibility that the floral scroll geometrically planned may have been used independently at both ends of Asia, and that its first entry into Christian ornament may have been from the Mediterranean end, and not from the Chinese. The thesis that the sole origin of the arabesque was a Chinese-Central Asian scroll developed under the influence of Sacian Hellenism and elaborated by such palmettizing processes as we find on the Mshatta façade at least requires further examination. It is not certain that the palmettes employed in the earliest Islamic art owe their excellence and their purity of form to Bactria ; regions nearer to the Mediterranean were better situated and no less capable.[2] Why, it is asked, should we seek so far afield what may be obtained relatively near at hand ? As for the systems of polygonal units covering whole surfaces, popular in Islamic ornament, it is urged that the claim of Syria-Mesopotamia to have used them earlier than Iran cannot be lightly dismissed.

The position of Scythian and Siberian methods and designs is naturally one of some importance in relation to the new theory. The bronze implements from Minusinsk, which appear to date from about the beginning of our era, show in their foliate designs an undoubted resemblance to ornaments of later date from Albania and Hungary.[3] But we have seen reason to doubt whether these Siberian objects may not have owed their characteristics to a Sarmatian influence moving eastward from a more central part of Asia, and whether much of the early ornament of China may not have been similarly inspired at a much earlier time. Many elements without doubt entered the Scythian and Sarmatian area from Mesopotamia, and among these some appear to have gone eastwards towards China long before the time of the great migrations.[4] But if this is so, the steppe zone was penetrated by influences which down to the time of the great migrations tended as much towards the East as towards the West.[5] We cannot assume a perpetual westerly movement across the steppes of Asia. We may be confirmed in this view by considering the parallel case of the technical methods through which motives or styles of ornament were expressed. Many years

art through the fact that this treasure is now assigned to a period not earlier than the ninth century.

[1] *Stilfragen*, p. 121.

[2] It almost looks as if Bactria was imposed upon the theory through the necessity of finding a Greek source as near the Saka and as far from the Mediterranean as possible.

[3] The Albanian gold treasure in the Pierpont Morgan collection at New York forms the text of *Altai-Iran*.

[4] Cf. Minns, *Scythians and Greeks*, p. 280 : ' Chinese and Siberian art, which have a resemblance, may both have borrowed from Iranian or some other Central Asian art. In

each case we seem to have an intrusion of monsters ultimately derived from Mesopotamia, the great breeding-ground of monsters.' The dragon, tiger, and phoenix only came into China under the Han dynasty, and decidedly recall Persian types, e. g. the Simurg. The Iran of Minns is the Iran penetrated by Mesopotamian influences, not that of Strzygowski, receptive above all from the north and the east. Rostovtzeff also sees in the ornament of Minusinsk the decadence of an art coming from the western side (*Iranians and Greeks in South Russia*, p. 197).

[5] Strzygowski points out a much later instance of such a bifurcation in the case of

ago the present writer, following de Linas, urged that the enriching of gold ornaments by a mosaic of massed coloured stones set in cells (*orfèvrerie cloisonnée*) really started in Egypt, passed northward to Assyria, and thence to Iran, Siberia, and India.[1] The earliest examples in the Scythian area occur on the two gold ornaments from Kelermes in the Kuban valley north of the Caucasus, which date from the sixth century B. C., and are not comparable in age with Egyptian examples such as those in the treasure of Dashur ; though the first of their kind in the North, they are much later than the inlaid and gilded ivories from Nimrûd in the British Museum, which show Egyptian affinities, and, though not of gold, produce the appearance of gold cells filled with gems. The gold armlets and bracelets of Achaemenian date in the Oxus Treasure ornamented by the cloisonné method are closely related to armlets found by de Morgan at Susa in Southern Iran ; it is therefore quite possible that the method entered Achaemenian Persia immediately from Mesopotamia.[2] It is rather significant that objects with Assyrian ornament have been found in various graves in the Scythian lands, and especially significant, perhaps, that Kelermes was itself one of those in which objects showing Southern influence were discovered.[3] From Assyria and Persia, or the steppe regions influenced by those countries, the method entered India[4] on one side and South Russia on the other, to be carried westward from the Sarmatians by the Goths. This theory seems better supported by facts than that which finds the origin of this style in North Iran or in India. It is no valid objection that the use of this ornament involves the colouristic sense, and a love of decorating the flat surface with rich contrasting colours, for this cannot be regarded as the exclusive property of nomads and North Iranians. Egyptian and Assyrian work of the same kind cannot be left out because the major art of those countries was representational. It has been suggested above that even in the great river valleys an aristocratic art of representation may have been accompanied by a popular surface-covering art of ornament and strongly contrasted colour. The distribution of *orfèvrerie cloisonnée* as traced above seems to confirm the suggestion ; so, at a much later time, does the readiness of the Copts to adopt the formal methods introduced into Egypt through Syria in the fourth century A. D. We are thus hardly justified in assuming that the aesthetic principles which inspired the inlaid jewellery of Egyptians or Assyrians were fundamentally different from those operative in Central Asia because the people who made it lived in settled homes and

vine-ornament, which, starting from Bactria, extended to China on the east and Syria on the west (*Altai-Iran*, p. 73).

[1] *Archaeologia*, lviii, 1903, p. 237. We may also note the appearance of inlaid work in Minoan Crete, as evidenced by the work on the Royal Gaming Board (A. J. Evans, *The Palace of Minos*, 1921, p. 472, pl. v). Here also the original influence was probably Egyptian.

[2] Strzygowski denies this (*Zeitschr. für bildende Kunst*, 1921, p. 153.

[3] Apparently they were discovered actually with the objects ornamented with *orfèvrerie cloisonnée*.

[4] The earliest Indian examples date from the second or third century A. D. (*Archaeologia*, as above, p. 262).

in the south. There is no magical power in the points of the compass preventing a southerner and an agriculturist from reacting to colour-effects in the same way as a northern or an eastern man. Though ways of life lead to predilections, these are not always rigidly exclusive.[1] Few would now wish to deny that the method of *orfèvrerie cloisonnée*, being one naturally to their taste, was eagerly adopted by Central Asian people, especially as both gold and precious stones of rich and varied colour were theirs in abundance. These advantages, and the clear field left them by the preoccupation of the Mediterranean area with a predominance of a Hellenic art based on other principles, gave them their opportunity to disseminate this style of work, which they introduced into Europe through the south of Russia. But this late transmission is a different matter from invention, and must not be confused with it.

Nor need any one deny that the life of the tent-dwelling nomad horseman favoured the use of linear surface-covering ornament in flat colours and sharply contrasted light and black shadow, or that Asiatic nomads developed such metal-work on individual lines with originality and skill. But, once more, were they the only folk to do it ?

Such considerations bid us pause before attributing to North Iran other technical methods, without more perfectly established proofs than those as yet produced. Enamelling, for instance, has been thus attributed (p. 335). In this province, for reasons mentioned elsewhere, China is eliminated, leaving, if the Mediterranean area is excluded, only Sacian, Parthian, and Turkish influences. But until we have, with regard to these peoples, solid evidence of skill in the making and colouring of glass at an early date in some degree comparable to that existing with regard to the Mediterranean peoples, prudence enjoins at least a suspension of judgement. Something has already been said of the method of executing designs by levelling or ridging, in order to present slanted surfaces, and so produce effects of sharply alternating light and shadow (*Schrägschnitt, Keilschnitt, Kerb-schnitt*).[2] This method, applied to metal, is especially adapted for nomadic use ; gold or gilded ornaments in the style, fixed to bridles or belts, would produce their maximum effect flashing in the light as the rider moved ; they are strong and not easily damaged. There seems here a stronger case for a Central Asian origin. But here again it is well not to be too categorical as to origins. The style was very early in this region, but may have been even earlier in another.

[1] Ethnography warns us to avoid wide generalization. For example, pierced ornament in turtle-shell, geometrical in design, and backed with disks of white pearl-shell to give the maximum of colouristic effect, is an aboriginal art in the Solomon Islands. Whatever zoomorphic ideas may originally have inspired the island craftsman, he arrived ultimately at a geometric pattern, the linear and colouristic effects he appreciated exactly as the makers of the Somme Bionne ornaments appreciated theirs.

[2] Strzygowski rightly points out that slant-cut or bevelled sculpture is seen in the ornament in the form of a quadruped from Kelermes, which dates from the sixth century.

In reviewing the whole question as to the sources from which the ornament of the early Christian centuries derived its non-classical processes and motives, it is no bad principle to suspend judgement as to any theory which seeks to establish a kind of monopoly for a particular race or combination of races, or a particular corner of the world, during long series of centuries. If we survey the Eurasian continent, and look back upon its ancient history, we cannot fail to perceive that although at different periods certain races and cultures exerted a predominant influence over large areas, and though the movement of artistic influence often set for a long time in the same direction, yet the wind did not blow perpetually from one quarter. Egypt, Minoan Crete, Mycenaean Greece, Assyria, Hellenic Greece, sent their ornament northward and eastward; Egyptian art transmitted forms to Minoan and Assyrian, Minoan to Greek and to the Keltic art of Central Europe,[1] both Assyrian and Greek to Scythian and Iranian, Greek and Iranian to Indian and to Chinese. There is little evidence of durable influence in a contrary direction until about the beginning of our era; the steady westerly movement was not powerful until the Great Migrations of the peoples, when tribe propelled tribe, from the borders of China to the west of Europe. From the time of the migrations we may admit a steady drift of ornamental influence westward out of Asia, producing a marked effect upon the ornament both of the Byzantine Empire and of Central and Northern Europe. But it does not follow from this that all the methods and motives which at that time passed into the Mediterranean area and Northern Europe originally came from the eastern half of Asia. It has been suggested above that some of them may have come up from Mesopotamia long before, and held their ground in Central Asia, whence they were finally pushed westward by the advance of Turkish peoples.

Instead of supposing a perpetual influence from a single quarter, race, or way of life, it may be more philosophical to suppose that the mode of vision demanding formal and surface-covering ornament is a popular and primitive vision corresponding to a widely distributed elementary need,[2] and to be found among peoples in various stages of civilization, among the Solomon Islanders, for instance, no less than among the Saka or the Turks, among Egyptian and Syrian peasants no less than among the early Chinese. Under the great ancient monarchies, it might be regarded as surviving, submerged, indeed, by the grandiose representational art of Court and Church but never destroyed, and merely biding its time for emergence.[3]

[1] Some have even argued that Minoan influence reached China. M. Salomon Reinach's suggestion that the Minoan ' flying gallop ' extended to China through this cause will be remembered.

[2] Strzygowski may himself approach this point of view when he seems to admit that he is not always able to appraise the initiative which may have been exerted by ' the North '. Large parts of the north were not nomadic ; and they were no more Iranian or Turkish than they were Semitic.

[3] The Egyptian ornament which has come down to us through paintings or temples and royal tombs may well include many popular forms. The connexion between it and the

When, with the decay and fall of the kingdoms of the Diadochi, a popular reaction occurred in favour of an art of formal decoration, this may not have been confined to the Iranian area ; it is possible that the peoples in Syria and Mesopotamia, sharing in the revolt, shared also in the restoration of a popular art of their own. Jews and Copts may have done likewise, while the peoples of Central and Northern Europe, with an art of ornament undisturbed by dictation from without or from within, stood ready to greet revivals of Asian forms based on the same principles as their own.[1] The reaction against Hellenism on Mesopotamian, Syrian, and Central Anatolian soil brought to the light of day a submerged popular art to which the first orientalization of Hellenistic art belonged. In fine, a popular art of formal ornament may have been much more widely diffused than Strzygowski is disposed to allow, and much freer of particular economic conditions. Need we suppose that the hothouse culture of the great monarchies wholly crowded out the wild flowers ? Such facts as the quickness of reaction towards formal ornament among both Syrians and Copts seem to oppose the suggestion.

These are some of the difficulties which suggest caution in the full acceptance of what, for brevity, may be called the Central Asian theory. Whatever future evidence may do, the present evidence does not seem to establish so exclusive an initiative on the part of the remoter East before the sixth century as Strzygowski seeks to prove, or so wholly to eliminate an effective influence upon ornament during the first centuries of our era on the part of the peoples west of the Euphrates. The matter stands somewhat differently when we reach the second half of the first millennium ; for that period, the arguments based upon ornament, like those brought forward in the province of architecture, are more surely documented, and less depends on reasoning from presupposition. Yet no such difficulties or doubts need cause the objector to withhold a full meed of admiration for the range of vision, the extraordinary width of knowledge displayed, and the brilliant manner in which the comparative method is applied to the study of decorative design.[2]

Strzygowski's investigation of the scroll and the arabesque, leading to conclusions absolutely opposed to those of Riegl, enforce once more upon the student of early Christian and Byzantine art the close relation of East

scenes depicting gods, kings, and priests, may have been no more intimate than that between the ornament accompanying and framing the sacred subjects in Byzantine churches, and those subjects themselves.

[1] E. Weigand, *Byz. Zeitschrift*, xxxii, justly recalls the universal nature of the reaction against Graeco-Roman art ; all the provinces of the old Roman Empire developed their own ' form-languages ' on the foundation of antique forms. But we should rather read, in place of ' antique ', ' ancient popular and antique ' forms.

[2] The perusal of *Altai-Iran*, and the appreciation of the fresh points of view to which it continually leads the student are stimulating in a high degree. The writer lays upon us a spell like that of the pioneer who recounts his voyages in unexplored regions of the world.

Christian and early Islamic ornament. The two rise from the same roots, but in the one case the ornament is that of an art in which the human figure is retained and awarded the dominant position, in which the Greek heritage even in decoration is more persistent; in the other, it is a system of pure decoration, in which human or animal figures, when they appear at all, are embodied in the system without rights to preferential treatment. Whether we believe, with Strzygowski, that 'Saracenic' art originated in Iran, and that the Greek elements which it early incorporated come from Greek centres in inner Asia, especially the Bactrian; or whether, with his opponents, we ascribe a great share in its composition to the art of the Mediterranean countries, Hellenistic, Semitic, and Coptic, we are made to feel the closeness of this community;[1] acanthus, palmette, and vine[2] motives form the elements of designs symmetrically disposed over flat surfaces in much the same way in the Mohammedan and in the Christian East (Plate LXV), though on the Christian side, and from the eleventh century, Constantinople, with its Hellenizing tendencies, drew farther apart than other areas from the art of Islam, with its love for ever greater intricacy of design. Continental Greece seems, however, to have remained in closer sympathy with Islamic feeling.[3] Oriental features in the eleventh-century architecture of that country have been already noted (p. 146); it appears to have welcomed at the same time Islamic forms of decoration, retaining a preference for these through the later centuries of the Byzantine Empire. Bands of 'flowered Cufic' lettering are seen in the brickwork of the walls of the monastery of S. Luke of Stiris, and this motive remained popular for two or three centuries.[4] Complicated arabesques and stylized falcon-like 'eagles' of Seljūk type occur on thirteenth-century fragments in the church of Episcopi, and on those of an ambo (?) at Ochrida. Greek appreciation of the art of Islam is evident in fourteenth-century decorative sculpture

[1] Riegl held that Saracenic and Byzantine ornament were not really differentiated before the tenth or eleventh century (*Stilfragen*, p. 326). He believed that the elements of early Islamic art were to be sought in the Syrian and Hellenistic ornament, not as Strzygowski maintains in the union of North Iranian (Sakian and Turkish) scrolls with Bactrian Greek foliate elements. Bréhier's view comes between Riegl's and Strzygowski's, since he ascribes a chief part to old Mesopotamian and Syrian influences (*Revue des idées*, July 1908 and March 1910).

[2] While Riegl dwells more upon the palmette and acanthus and their hybrid forms, Strzygowski gives the vine an important place. He states that the arabesque of Islam is the old Bactrian vine-scroll palmettized under the geometrical influence of the Chinese scroll (*Bil-*

dende Kunst des Ostens, 1916, p. 25).

[3] Islamic influence may have come by sea, though Strzygowski suggests that it may have also come round by a land route, Iranian craftsmen working for the Bulgarians (*ibid.*, p. 375).

[4] A fine example is seen on the tomb-slab of Anna Maliasinos in the church of Episcopi which the inscription allows us to date about A.D. 1275 (*Bull. de Correspondance Hellénique*, xliv, 1920, fig. 8, p. 196). Strzygowski traces flowered Cufic from Central Asia, the earliest dated example being as early as the ninth century (*Amida*, p. 370); the older study of de Longpérier (*Œuvres*, ed. G. Schlumberger, i, pp. 381 ff.) is still valuable. For a carved relief at Athens with a Cufic border surrounding lions in relief see below, p. 380.

at Athens, in Phocis, Argolis, Arta in Epirus, Macedonia, and Mount Athos.[1]

Not less important than the emphasis laid by Strzygowski on the relation between East Christian ornament and that of Islam is his insistence on the kinship between the decorative art of Asia and that of the north of Europe in the earlier centuries of our era. This community is not now recognized for the first time ; the function of the Goths as carriers to the West of Asiatic motives learned during their sojourn north of the Black Sea has long been an accepted fact.[2] It was understood that resemblances between Anglo-Saxon decorative design and that of oriental countries was not fortuitous. But new light has been shed upon various points, new possibilities have been revealed ; the study of 'Eurasian' ornament, loose before, and straggling, has been brought nearer to co-ordination. Above all, there has been insistence upon the community of feeling between West and Central Asia in the mode of envisaging natural objects and of incorporating them in a formal decorative art : it has been made clearer that the transmission of oriental design to Europe was swift, and that its elements were readily assimilated, because the northern peoples saw the visible world in a similar way from the Altai to the British Isles ; they all desired ornament diffused over a flat surface, with linear design which did not exactly simulate natural forms. Thus the Kelt, who had his marked idiosyncrasy in artistic method was yet ready to receive and incorporate with his ancient motives forms and types wholly new in their details. They were intelligible to him because conceived and executed under principles similar to those which inspired native work, but dissimilar from those which inspired Graeco-Roman art. The Scandinavian and the Teuton were in the same way predisposed in favour of an anti-naturalistic style. Because of this community in feeling, the European North welcomed the oriental influx which set in about the time of the Great Migrations. But the principles of decorative art being similar in Europe and in Asia, it is scarcely to be expected that all initiative came from Asia. In the search after the effective pattern in contrasted colour, or the nice conduct of line disposed so as to cover a space, the northern craftsman may sometimes have been first to reach the inevitable and logical result in his own crafts. Even where he borrowed an idea he was capable of carrying it out with a singular perfection ; we have already noted the very early appearance of admirable pierced metalwork in Europe, with designs geometrically planned and wholly remote from nature (p. 362).

The affinity is equally manifest in the case of beast-ornament. Where Hellenistic influence was strong, natural shapes were reproduced in a life-

[1] G. Millet, *Bull. de Correspondance Hellénique*, as above, p. 214.

[2] Though the importance of the Sarmatians was not clearly realized before the publications of Rostovtzeff ; see his *Iranians and Greeks in South Russia*, Oxford, 1922, ch. viii, pp. 191 ff., and the references to his earlier work there given.

like manner. Frequently, however, animal forms thus treated were enclosed in a system of foliate design, too symmetrical to be wholly naturalistic, and disposed in such a way as to cover all the field ; we see here late Greek art at one and the same time conforming to the principle of surface-covering decoration, and keeping its natural forms as far as it was able. Mosaic pavements afford good examples of this, especially examples found in Syria-Palestine ; it was a region where such a transitional art was to be expected. Ivory-carvings illustrate the same process (Plate LXVI), and sculpture in stone.[1] A system of interlacing circles, or other geometrical diaper, was early employed for the same framing purpose, as we see in the mosaics of the ring-vaults in S. Costanza at Rome, where the human form is thus enclosed. In Byzantine art the enclosing of animals in foliate design continued after iconoclasm ; it is found still in vigour in the ' Macedonian ' period, which began at the close of the ninth century ;[2] and this was not the end. The naturalistic treatment of beasts and birds in the Hellenistic manner was shared by the Syrians. An interesting example of this is seen in the ornament of the well-known Gospels of Rabula, painted by an Aramaean monk at Zagba in Mesopotamia in the year 586 (cf. p. 313). Here, upon and about the arches resembling Eusebian canons which frame the text of the book, we see a variety of birds and animals natural in form and attitude : peacocks spreading their tails, horses or deer grazing, a fawn scratching its ear with its hind foot, the ibex, the hare, and various water-birds, especially ducks and geese. These creatures are treated in a manner far removed from that borne on the new tide of schematized animal and monster forms from Mesopotamia and Iran which invaded middle Byzantine art. In secular Hellenistic decoration naturalism in beast-ornament never died out. The treatment of the animals at Quseir 'Amra (p. 261) is in the old Hellenistic tradition,[3] and in late MSS., such as the *Cynegetica* of Oppian, the spirit of the old Hellenistic models was reproduced.

After the Persian wars and iconoclasm, schematized beast types and monstrous creatures, especially the gryphon, became more and more popular, coming in immediately from contemporary Iranian sources, but ultimately to be traced back to ancient Mesopotamia, which had transmitted them to Persia.[4] Beasts reminiscent of old Mesopotamian types were still popular in Mesopotamia when the Seljūk Turks entered the country ;[5]

[1] On the carved columns at Constantinople we see even genre scenes thus treated (p. 185).

[2] Examples in the Bible-house cistern at Constantinople (*Byz. Denkmäler*, ii, pp. 100, 228), where animals still appear in vine-scrolls.

[3] The evidently popular motive of the fawn scratching its ear, a motive wholly naturalistic, occurs at Quseir 'Amra.

[4] From Sumer and Babylon they passed to the Altai region at a very early time. It was from this area that the monsters entered Scythian art on one side, and passed to China on the other (Rostovtzeff, *Iranians and Greeks in South Russia*, pp. 200 ff.).

[5] The carved slab from Meiafarqin, now in the British Museum, shows examples (*Proc. Soc. Ant.*, xxix, p. 55).

and after the period of their establishment there in the tenth century, we find evidence of a definite influence from this quarter upon Greece, where, as noticed above (p. 146), oriental influences are apparent in contemporary architecture.[1] A slab at Athens with schematized lions of Mesopotamian style in relief [2] has a border of decorative Cufic, a feature which, as we have seen, is repeated in later Greek decorative sculpture, and on the walls of churches.[3] These ancient Mesopotamian forms, transmitted in post-iconoclastic times, were widely distributed, appearing also in Syrian and Coptic MSS.; we may remark the uniformity of their style in all countries, a feature which was maintained when they entered the field of Romanesque art in the West ; Mesopotamian beasts and monsters triumphed all over Europe down to the thirteenth century, just as, far earlier in the world's history, they had triumphed in China. In Greece they remained popular in the advanced Middle Ages, when, in the West, they had been replaced by the naturalistic forms introduced by French Gothic art. Late decorative sculpture, described by Millet, shows the old types persisting in the thirteenth century, in forms not essentially different from those employed in the ninth.[4] When beast-forms came direct from Mesopotamia, either at the earlier or the later period, they were stylized and retained the schematism of old Asiatic tradition.[5] But, after Alexander, Hellenistic art with its naturalizing tendencies asserted itself by the side of the conventional style ; in Parthia and in Sassanian Persia it produced a Hellenized oriental art, in which the life-like animal is represented.[6] Such animal forms we find not only in the definitely late-Hellenistic mural paintings of Quseir 'Amra, and in early Islamic art, but in the art of the middle Byzantine period in which, as just mentioned, conventional types had become predominant.[7]

Mesopotamia, the ancient home of the animal and the monster, may also have begun the use of the flat band in ornament, a characteristic feature

[1] For the relationship between the beast-ornament of Greece and that of North Mesopotamia see Van Berchem and Strzygowski, *Amida*, p. 367.

[2] *Amida*, fig. 322. Strzygowski has frequently insisted on the probable importance of Bulgaria in the transmission of these Asiatic types to the Balkan peninsula and thence southward to Greece. The carved slabs from Stara Zagora, with the two-headed eagle and the lion, afford concrete evidence (B. Filow, *Bulgarian Art*, pl. ii, figs. 1 and 2). Such influences seem to have passed round Constantinople ; they characterize Balkan and Greek art, rather than Byzantine art in the narrower sense of the term. Kondakoff (*Macedonia*, pp. 53 ff.) also observes the importance of Greek, Slav, and Bulgarian MSS. in the diffusion of the beast style.

[3] For decorative Cufic, perhaps first employed in Central Asia, see above, p. 377.

[4] *Bull. de Corr. Hell.*, 1921, figs. 12 and 13. Analogies may be observed between the beast-forms at Skripù in Boeotia, dating from the ninth century, and the reliefs on the Kharput gate at Diyarbekr, dating from 909–910 (*Amida*, as above, p. 365).

[5] Assyrian and Assyrian-Persian.

[6] From this Hellenized oriental art, according to Rostovtzeff, came the influences under which the Sarmatian beast-style was constituted (*ibid.*, pp. 201, 202).

[7] Cf. the recognizable apes at Quseir 'Amra, on the Meiafarqin slab in the British Museum, and at S. Luke of Stiris in Phocis (Schultz and Barnsley, pl. xiii).

in East Christian and Byzantine decorative art. In discussing the disposition of ornament in geometrical systems, we have mentioned the band without allusion to its ancient descent.[1] In an earlier chapter mention has been made of its free use for enclosing and framing individual motives in decorative sculpture, where it was especially popular in the earlier Middle Ages, both in East and West. But it was naturally employed in painting no less than in sculpture. Early in the Christian era the interlaced band appears as a substantive ornament in pavement mosaics as well as in mural painting and in illumination. It was especially popular in textile designs, but was a universal feature. In the form of a plait, often of great breadth and intricacy, it was exceedingly popular both among Teutonic tribes and in Armenia, to which country it may have come from the Iranian region. The Goths and Lombards introduced it into Europe on a great scale; they flooded Italy with it,[2] especially with the 'striped' or grooved variety, in the sixth and seventh centuries. Later it permeated beast-design in Northern Europe,[3] where, in prehistoric times, interlacing had not been used in decoration. In Armenian architectural ornament it is found in profusion from the seventh century, but may have begun much earlier;[4] in that country it seems to be confined to domed buildings, a fact from which Strzygowski would infer its introduction from Iran. In Armenian illuminated MSS., as in Coptic, complicated interlacing is used in conjunction with scrolls enclosing beasts and birds: the link between Egypt and Asia may in this case be Islam. The wonderful carved wooden mimbar, now at Kairwan, but presumably made in Bagdad in the ninth century, affords fine examples of the grooved interlaced band in pierced work,[5] showing its traditional popularity in the Mesopotamia of medieval times. The flat band was used not only plaited, but looped, or constrained into angular forms; a whole surface might be covered by a system of interlacing circles, as in the ring-vault of S. Costanza (p. 379), or by a system in which lozenges and squares are connected by lesser circles. The main circles and other figures generally enclose a separate ornamental motive, floral or animal, while similar motives may fill the spandrels. Systems of circles were especially popular as a mode of disposing a design on figured silks; in sculpture, angular figures (lozenges

[1] It occurs in Hittite art; in China (on the early bronze vessels of the Chou dynasty); it connects early Greek palmette forms (*Arch. Anzeiger*, 1891, p. 125; Riegl, *Stilfragen*, fig. 84). Strzygowski (*Altai-Iran*, p. 194) justly draws attention to this widely diffused and ancient use even of the type with parallel 'grooves' (*mehrstreifig*), to the popularity of which among Iranians and Teutons in later times he attaches a special importance.

[2] *Altai-Iran*, pp. 74, 194; *Bildende Kunst des Ostens*, pp. 14 ff. Cf. for its appearance on the Mausoleum of Theodoric at Ravenna *Oesterr.*

Monatsschrift für den Orient, xl, 1914, p. 4.

[3] Sophus Müller, *Die Tierornamentik im Norden*, 1881; B. Salin, *Die altgermanische Tierornamentik*, 1904.

[4] For examples, see the illustrations of Strzygowski's *Baukunst der Armenier und Europa*.

[5] *Altai-Iran*, p. 198 and figs. 164–170. The mimbar is important as illustrating a wealth of different space-covering patterns, for some of which we recognize analogies on earlier monuments: e.g. on the (originally Christian) columns now forming part of the mosque at Diyarbekr (Amida).

and squares) were popular, and are found above all on the stone slabs used for enclosing choirs or galleries (closure-slabs) : in these cases one central figure, such as a lozenge, is given a larger scale and dominates the design.

In preceding pages there has been sufficient suggestion of the generally accepted fact that ornament is remote from nature : it may indeed almost be said that ornament is good in proportion as exact imitation of nature is avoided. Ornament may begin with a natural form, as in Egypt it began with the lotus ; but even in such a case it does not develop far before geometrical method intervenes ; the natural form is denaturalized, or unnaturally combined with other forms similarly treated, conventionalized almost beyond recognition, lost in combinations of line with which natural arrangement has nothing to do. Of all this the story of the palmette affords the classical example. Or again, ornament may begin with geometry, which may take to itself natural forms or fractions of these, and constrain them to abstract use ; we have noticed Strzygowski's theory that in farther Asia the plant scroll began with a geometrical waved band, to which floral adjuncts were added in order to enrich the effect. The process of denaturalizing the forms of nature is as old as decoration, necessarily so if the decorative sense is essentially opposed to nature, and under all stylization primitive artistic postulates are concealed.

The ornament employed in East Christian and Byzantine art, coming late into the world and inheriting forms from divers quarters, could not but afford examples of denaturalization. The estrangement from nature varied with local or racial feeling, and with tradition ; in the case of the palmette, a lotus-derivative which had already lost all obvious connexion with its source, it had reached an extreme length. Before the Christian era the palmette was already split into halves, represented by single elements enclosed in encircling lines or stems, or disposed along the wavy lines of scrolls ; the Christian era was to see the single leaves themselves divided. The acanthus, which did not come bodily into ornament direct from nature, as Vitruvius fabled, but by adaptations of a formal and decorative kind through which leaf-forms took on the semblance of acanthus, was received into Christian art from the Greeks not as a natural but as a conventional form, the decorative qualities of which could be imparted with advantage to other types.[1] Before the beginning of our era the process of ' acanthizing ' other forms was already established. The vine and the palmette were both conjoined with acanthus, creating hybrid combinations. The so-called ivy leaf, a not inconspicuous feature in earlier East Christian ornament, may have begun as a conventionalized lotus form.[2] In connexion with this example we may note that while denaturalization may be regarded

[1] The acanthus began in Greek art of the fifth century B.C. and became general in the fourth (Riegl, *Stilfragen*, pp. 196, 215).

[2] Goodyear, *Grammar of the Lotus*, pp. 161 ff.

as the rule, peoples and periods with a tendency to naturalistic art, such as the Hellenistic Greeks, were apt to re-naturalize old conventional types, approximating them to fresh forms in nature which they had by chance come to resemble. If Goodyear's view as to the origin of the ' ivy leaf ' is correct, the naturalistic treatment of this form in late times is likely to have resulted from such perceived resemblance, not from the deliberate introduction of the natural ivy leaf by artists, admiring it in its growth, and determining to make use of it as a fresh motive in design. Other types, such as the ' pine-cone ', are also evolved by ornamental methods, and have no relation to natural growths which they finally come to resemble. Technical processes sometimes contributed to the formation of types which suggest a false natural affinity. For example, silk-weaving produced the ' heart ' motive, often used in repetition to form borders ; this seems really to be derived from a particular stylization of palmette elements.[1]

It may be observed that in East Christian ornament the denaturalization of animal forms was never carried to extreme lengths ; the type is generally recognizable. Nothing like the dismemberment, dislocation, or contortion of Scythian or early Teutonic art [2] is attempted ; extreme conventionalization in which human and animal forms completely disappear in pattern, as in Polynesian and Melanesian art, is never practised. It should be noted that this extreme conventionalization results from the same indifference to nature which prompts the creation of monstrous plant forms.

In this chapter the ornament of the Christian East has purposely been treated upon general lines in order to bring out the essential facts that the principles upon which the mass of it depends are different from those of classical art, and that in so far as they prevail it is not the offspring of Graeco-Roman antiquity.[3] It was further suggested at the outset that the examination of these principles in their simplest operation must be of

[1] Strzygowski, *Jahrbuch der K. Preussischen Kunstsammlungen*, xxiv, 1903, pp. 157 ff.

[2] The beginnings of contortion and, perhaps, of dismemberment are found in Scythian art, and may have entered Europe from the Asiatic side, in which case only the final development would be Teutonic (cf. Rostovtzeff, *Iranians and Greeks in South Russia*, ch. viii). The fact that fantastic treatment of plant elements, building up into odd ' sacred-trees ', ' candelabra ', &c., was especially popular in Persia, is in so far in favour of the argument that this kind of schematism was characteristically Asian ; we have observed above that a tendency in this direction is to be observed in other branches of Asiatic ornament than the Iranian.

[3] No attempt can be made here to enumerate individual motives popular in East Christian and Byzantine art. A certain number are discussed in *Byzantine Art and Archaeology*, ch. xiii ; and the student will find a rich material in Wulff's *Altchristliche und byzantinische Kunst*, in Strzygowski's *Amida* and *Altai-Iran*, in Bréhier's studies of decorative sculpture cited in an earlier chapter (p. 194), and in various works by Millet ; see especially his *Monuments byzantins de Mistra* (*Album*), and the article in *Bull. de Correspondance Hellénique*, quoted in the present chapter. Illustrations in Venturi's *Storia dell' arte italiana* are often valuable ; while monographs on churches, such as Schultz and Barnsley's *Church of St. Luke of Stiris in Phocis*, contain important illustrations ; in the same way, the illustrated monographs on the mosaics in Byzantine churches may be consulted with advantage. The published material is rich, but no monograph on a large scale illustrating East Christian ornament has as yet appeared.

importance to the general study of artistic development in Christian times, because they are the same principles which invaded the provinces of painting and sculpture and changed the character of representational art. In that field they are hard to disengage from the intellectual elements which obscure their action; they are latent, impeded by the requirements of a religious and historical system which often dominates them to such an extent that their operation is disguised. But in ornament they are seen almost in abstraction, and reduced to their simplest terms. We mark them at their beginnings, and understand from what source really came the influences which revolutionized artistic conditions at the close of the classical period, overthrew the Graeco-Roman hegemony in the Roman Empire alike in East and West, and created a new 'medieval' art. We better understand the indifference to perspective and aversion from 'depth', the disregard for nature, the insistence on geometrical disposition over a plane surface, expressed by means of flat contrasting colour and clean line, things which perplex us when we compare the figure compositions of the fifth or sixth century with those of the classical age; in these compositions we seem to be reading involved periods in a new language, to the construction of which we have but a faint clue. Through ornament we learn the alphabet of this strange language, only seeming new, because suppressed in the Mediterranean countries, but in truth exceedingly old, and issuing from long submergence. It matters nothing to the student of historical evolution whether, from the point of view of excellence, the change was for the better or for the worse, whether it marked progress or decay. As observers of an actual development our business is not to judge its merits, but to demonstrate its existence and follow its course through the centuries.

The great change arose through the substitution of one mode of vision for another, a primitive vision, if you will, for a vision compromised by science. And the wide diffusion of the 'new' mode in parts of the world remote from each other and inhabited by different races suggests that we have to deal with facts deeply rooted in human psychology. They are facts generally connected with a simple and undeveloped civilization which has not learned to apply scientific laws, but relies upon rapid and unanalysed perception; which seeks to satisfy without too much reflection a natural feeling for symmetry and pattern, clean-drawn line and vivid colour. We need not deny or minimize the obvious effect of particular racial influences, or the demonstrable transmission of methods or designs from one region to another across great distances in space and time; the story of the palmette and other well-known instances of genetic descent in ornament should alone suffice to prevent the error. But, as already suggested, the study of ethnography leads us to reflect that like forms, even when intricate, need not always issue from a single source, but from quite different starting-points. Principles of the same kind, no less than opposing principles, may be

brought together by the movement of peoples, or by religious, commercial, or political intercourse ; so, in the broad field of Christian art, even such a feature as the geometrical scroll need not necessarily have arisen in a single quarter. In short, we should beware of thinking that an influence must always pass into an enemy country, or into the desert ; it may enter regions already penetrated by influences distinct in origin, but of its own kind. Though it cannot be shown that formal ornament is earlier in the history of culture than representation, the art of cave man warning against such an assumption, yet the love of it is found among peoples of simple or primitive culture between which there is no demonstrable contact or relation. It is too old and too widespread to be regarded as the property of one or two peoples alone. A further point must be remembered, a point to which attention has already been drawn in the first chapter. When many centuries have passed, and humanity has become stratified, it seems possible that the use of formal ornament and that of representation may coexist in the same region, especially in a country of ancient occupation, where different cultures have supervened upon each other and conditions have often changed. Formal ornament may persist among the people, while the rulers may prefer representation. It may find its expression for the most part on cheap or perishable things which are lost, while representation upon its durable monuments has survived ; it may, therefore, leave few and inconspicuous traces which escape even the trained explorer. We have suggested that formal ornament and representation do not always and everywhere exclude each other. The predominance of representation in the Greek lands, and in Syria and Mesopotamia, need not signify the absence in those countries of all taste or capacity for formal design ; it may only imply that this taste and capacity are concealed from us by circumstances, or that we overlook them through pre-occupation with other things. We may believe that they existed and joined the revolt against Graeco-Roman art without waiting for the lead of Central Asia. That they subsequently accepted reinforcement from that quarter is not to be denied ; but there may have been a confluence of likes, not a clash of opposites.

Of all the characteristics marking the ornament which overcame that of Greece and assumed the chief place in East Christian decoration perhaps the most fundamental was its replacement of concentration by diffusion, its preference of geometrical system, of convention, and of unreal elements to natural form. It has been well observed by more than one writer that in this it draws near to music, an approximation especially clear in that Islamic ornament which, rising from the same sources, carried the new principles to their extreme logical conclusion. In the one art are combinations of sounds, in the other the intercourse of lines, but in both arts there is a life of rhythm, a delight in fantasy disjoined from this real and solid world. The decorative art of Islam and music alike represent the great effort of man to escape from the world of reality and to express in forms perceptible

3 D

to sense the idea of that which is beyond finality and definition.[1] The artists of Islam advanced farther than any others along this path ; but those of Eastern Christianity were ready to move as far as their allegiance to a faith committed to representation allowed. They also possessed an art allied to music by virtue of its share in the diffused rhythm and harmony of existence, and helping to justify in its degree the wide and philosophical sense applied by Plato to that word. The harmonies are relieved by more obvious discords, but they rise from the same profound and human source.

[1] Cf. L. Bréhier, *Revue des idées*, 1910, in a suggestive article on the origins of Moslem art.

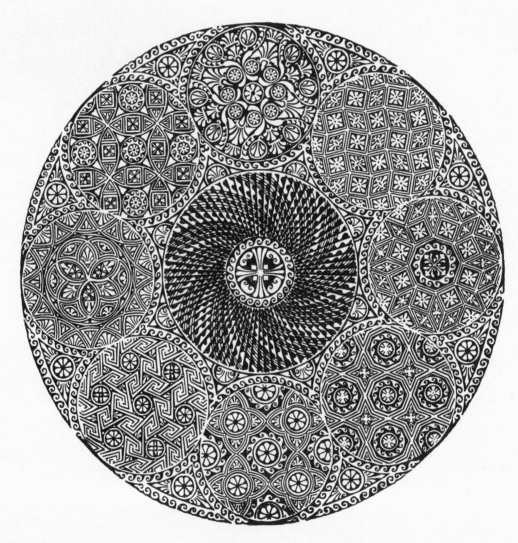

Emblema from a silver dish, after G. Matthies (p. 363)

GENERAL INDEX

INDEX OF AUTHORS